STUDIES IN
ARAB ARCHITECTURE

Collected Papers in Islamic Art
Series Editor: Professor Robert Hillenbrand

Series titles include:

Studies in Islamic Painting, Epigraphy and Decorative Arts
Bernard O'Kane

Studies in Persian Architecture
Bernard O'Kane

Studies in Arab Architecture
Bernard O'Kane

The Production of Meaning in Islamic Architecture and Ornament
Yasser Tabbaa

edinburghuniversitypress.com/series/cpia

STUDIES IN ARAB ARCHITECTURE

Bernard O'Kane

EDINBURGH
University Press

For Brian

Edinburgh University Press is one of the leading university presses in the UK. We publish academic books and journals in our selected subject areas across the humanities and social sciences, combining cutting-edge scholarship with high editorial and production values to produce academic works of lasting importance. For more information visit our website: edinburghuniversitypress.com

© Bernard O'Kane, 2021

Edinburgh University Press Ltd
The Tun – Holyrood Road
12 (2f) Jackson's Entry
Edinburgh EH8 8PJ

Typeset in Trump Medieval by
Servis Filmsetting Ltd, Stockport, Cheshire,
and printed and bound in Malta by Melita Press

A CIP record for this book is available from the British Library

ISBN 978 1 4744 7488 7 (hardback)
ISBN 978 1 4744 7490 0 (webready PDF)
ISBN 978 1 4744 7491 7 (epub)

The right of Bernard O'Kane to be identified as author of this work has been asserted in accordance with the Copyright, Designs and Patents Act 1988 and the Copyright and Related Rights Regulations 2003 (SI No. 2498).

Published with the support of the University of Edinburgh Scholarly Publishing Initiatives Fund.

Contents

Figures

Preface

The precipitous drop from the battlements of Mandu to the Deccan plain below underlines its position as a natural hill fort, helping its rulers in the fifteenth century to become virtually independent of the Delhi sultanate. The Hindola Mahal, a ruined meeting hall within its palace complex, is a fine example of their patronage. On an April evening in 1972 I rested on the adjacent lawn, having just met an American couple who furnished me with the names of specialists in the field of Islamic art that I wished to pursue: Oleg Grabar and Richard Ettinghausen. At Poste Restante in Kabul two months later a letter from each had arrived, warning me of the improbability of financial aid and the necessity of prior credits in art history courses (I took none for my LL.B), but warmly welcoming my field experience. A month later still found me in the library of the British Institute of Persian Studies in Tehran, perusing Donald Wilber's magnum opus. Sensing a neophyte in need of guidance, the director advised me, if I wished to pursue my interest in Iranian Islamic architecture, to contact Robert Hillenbrand. This happy accident ultimately led me to my mentor and now friend of many decades.

With him as a model, I have tried to resist narrow specialisation, and so articles in the present volume include material not just from the Arab world but from Morocco to India (excluding the subject of volume 2, Iran); China and Indonesia will have to wait for a subsequent volume. Much of the material is concentrated on my adoptive country of Egypt, and the papers range, as in the other volumes, from detailed studies of individual monuments to thematic overviews.

I am grateful to Robert Hillenbrand for the invitation to submit these articles for publication at Edinburgh University Press, to the staff at the Press, Nicola Ramsey, Kirsty Woods and Eddie Clark, for their support, and to the copy editor, Michael Ayton.

CHAPTER ONE

Mughal Tilework: Derivative or Original?

ALTHOUGH CONCENTRATING ON Mughal tilework, this piece also discusses its predecessors elsewhere in the Islamic world, particularly in Iran, Central Asia and Sultanate India. A brief survey of the development of the main techniques, namely monochrome-glazed tiles, sgraffito, tile mosaic, underglaze-painted and *cuerda seca*, both in Sultanate India and in other parts of the Islamic world, precedes the discussion of Mughal examples in the body of the piece. The piece highlights the initial links with Sultanate tilework, whether underglaze-painted, as in the Punjab, or with tile mosaic, in northern India. The development of Mughal tile mosaic is emphasised, as this was the medium most frequently used for tile decoration. Changes in the colour palette and in the introduction of new patterns are examined, highlighting the extensive use of figural imagery at the Lahore Fort and the simultaneous introduction of naturalistic vegetal panels. The less-frequent Mughal use of underglaze-painted and *cuerda seca* tiles is also examined. The conclusions summarise the characteristic features of Mughal tilework and suggest areas for future study.

Given the importance and long-standing history of the use of tiles on monuments in India,[1] both in the pre-Mughal and Mughal periods, it is surprising that there have not been many publications on the subject. There are frequent mentions in older publications (whose usual mention of 'enameled tiles' did little to classify different techniques), and fortunately in recent decades the pace of publication has increased somewhat,[2] but – particularly in comparison to the well-studied fields of Central Asian, Iranian and Anatolian tilework – it remains a relatively underdeveloped field. This piece aims, not to plug this gap, for such would entail a monograph, but to undertake preliminary classifications and analysis. In particular, I hope to address the extent to which Mughal tilework can be seen as original. The originality of Mughal architecture has been recognised in its reworking of forms and motifs from Sultanate India, Central

Bernard O'Kane (2019), 'Mughal Tilework: Derivative or Original?', *South Asian Studies* 35, 25–42.

Asia and Iran – so to what extent did each of these areas contribute
to the development of Mughal tile-work? Although they are well-
known this will entail a brief look at the tilework precedents in
these areas.

By the fifteenth century Anatolia, Iran and Central Asia had
evolved the world's most extensive repertory of tile techniques,
as well many of the finest examples of each. Monochrome glazed
tiles constituted the earliest examples. In the Saljuq period these
could be flat or moulded, or further cut into shapes; another way of
increasing their apparent range of colour was scratching (*sgrafitto*)
to reveal the underlying biscuit. Some Saljuq tiles preserved within
museums display the *mina'i* technique, although their paucity, and
complete absence on standing monuments (apart from the frag-
ments discovered at the Rum Saljuq palace at Konya of c. 1174),[3]
suggest they were always a rarity. At about the same time, in
the late twelfth century, underglaze-painted tiles were also used
on architecture.[4] Within the Khwarizmshah period we see on the
madrasa at Zuzan attempts, other than the *mina'i* and underglaze-
painted examples cited, to place more than one colour in a tile, in
a prototype of carved and glazed terracotta, where grooves were
placed between the loci where colour was applied in an attempt
(not always successful) to prevent them running into one another
(Figure 1.1). Almost simultaneously lustre tiles began to be used in
architecture.[5]

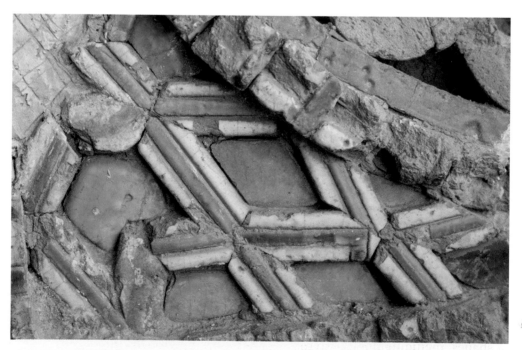

Figure 1.1 *Detail of tiles on qibla* ayvan, madrasa, Zuzan *(1219) (photo: O'Kane)*

With the arrival of the Mongols in Iran and Central Asia in the thirteenth-century innovation in tilework was transferred to Anatolia, where tile mosaic began to be favoured. At first it was used in combination with the underlying white mortar to provide a colour contrast,[6] but contiguous tile mosaic also soon appeared.[7] The colours were limited at first to white, light-and dark-blue, and the shades produced by the use of manganese, which, depending on the concentration, could range from black to purple. It was in Iran in the fourteenth century that the range increased with the addition of first ochre and then dark-green. In Timurid architecture in the late fourteenth century a new luxury type of overglaze-painted tile became popular for the finest monuments: *cuerda seca* (colourless line).[8] In Safavid Iran, however, this technique was used as a cheaper and lower quality substitute for tile mosaic to decorate a large surface area, notably in the Masjid-i Shah in Isfahan (1611–30).

How did tilework develop in pre-Mughal India, and subsequently in Mughal architecture? Did Indian tilework avail itself of the same range of decorative techniques in use elsewhere, for example monochrome glazing, underglaze-painting, tile mosaic, and *cuerda seca*? Were these techniques introduced by way of Iran, and at roughly the same times? Were they used in the same ways in India, or did they develop along different lines? Did Indian tilework evolve any new techniques of its own? I will attempt to answer these questions below during the course of, or after, surveying the extant material.

The first significant use of tilework in Sultanate India[9] is at the four mausoleums at Lal Mohra Sharif.[10] These have been variously dated from the eleventh to the sixteenth century,[11] but to me, at least, it seems clear that they must be thirteenth-century, earlier than the extensive use of underglaze-painted tiles found on the Rukn-i 'Alam mausoleum (c. 1335) at Multan. These four tombs fit perfectly as the link between that monument and the Ghurid brick-decorated monuments of the late twelfth century at Kabirwala, Muzaffargarh and Aror.[12] The vast bulk of their tilework is monochrome glazed, sometimes moulded. One hitherto unnoticed feature would also fit well with a thirteenth-century date: the fact that two of the mausoleums[13] incorporate underglaze-painted tiles (Figure 1.2).[14] Their designs are crude, as noted by Holly Edwards, but they are reflective of the formative period of the technique which was for the following centuries, and even up to the present, a hallmark of architectural decoration in the Punjab plains.

Significant advances in the use of underglaze-painted tiles in this geographical area are seen in the Rukn-i 'Alam mausoleum (c. 1335) at Multan; it employs them, as well a large repertoire of monochrome-glazed tiles, more extensively and in a much greater variety of shapes, including floral patterns, than was seen previously. In the mausoleums of Baha al-Halim (c. 1370) and Bibi Jawindi (1493) at

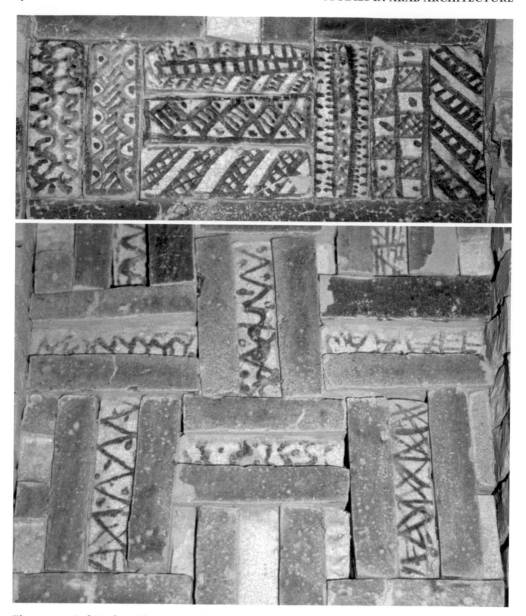

Figure 1.2 *Lal Muhra Sharif, details of underglaze-painted tiles from Mausoleums A (top) and B (bottom) (photo: O'Kane)*

Uchch, south of Multan, the horizontal bands of the brick-decorated exterior of the tomb the Rukn-i ʿAlam in Multan are translated into tiles, both monochrome- and underglaze-painted, a spectacular increase in the amount of colour found on the buildings.[15] They paved the way for the continuation of the technique in many buildings in Thatta in the Mughal period, which we will explore further below.

Lustre tiles are unknown in India, unsurprisingly given the absence of the pottery tradition present in other areas where they were used.[16] What then of other Sultanate-era uses of tilework? What is interesting is how independent from Iranian examples was the slow movement (particularly in the Delhi sultanate) towards tile mosaic. But more extensive uses of tilework, sometimes of extremely fine quality, are found in other sultanates, particularly at Bidar, Mandu, Hyderabad and Bengal.

The area around Gaur has the highest concentration of tiled monuments in Bengal. The Lattan mosque (c. 1500) is representative of Bengali examples; like the others in the area, its impact is hugely diminished today because of the very poor weathering of the glaze. The exterior was almost completely covered in glazed brick, many moulded, but although most of the original bricks survive, they display a small fraction of the original glaze. They have a unique colour scheme and glaze technique: although monochrome-glazed blue, yellow and green tiles are found, most of its tiles have two glazes on them (usually blue and white or yellow and green) – although up to five colours (yellow, orange, white, blue and green) can be found on a single tile (Figure 1.3). They seem to be simply glaze-painted,[17] with each opaque matte colour painted side by side on the biscuit.[18]

More variety is found on the monuments of the Bidar sultanate, which suddenly display some of the most developed examples. The tomb of 'Ala al-Din Shah (d. 1458) has very extensive tilework on each façade.[19] These are mainly underglaze-painted blue and white tiles (Figure 1.4), set within borders of monochrome-glazed yellow.[20] The madrasa of Mahmud Gawan (1472), a much larger building, also had extensive exterior tilework on its minarets and upper walls. The upper inscription band and the friezes above and below are it are tile mosaic, with the *thuluth* inscription in particular being, not just the finest example in this technique to appear in India to this date, but arguably unsurpassed by later Indian examples.[21] The tilework framing the two stories of arches below is, however, not tile mosaic,[22] but again underglaze-painted, mostly blue and white, but with the occasional surprising addition of yellow.[23] This fine quality of tile mosaic is even surpassed in another Bidar monument, at the Rangin Mahal (1543–80) in the Fort, where unglazed red is added to the palette.[24] Contemporary with it is, also in Bidar, another monument with an exceptional use of tilework; the tomb of 'Ali Barid (1577) (Figure 1.5). This uses exclusively underglaze-painted tiles, extensive bands and medallions of which are found on the interior.[25] The palette includes yellow monochrome-glazed tiles again as well as underglaze yellow and blue and white, like the Mahmud Gawan madrasa.[26] There are parallels with Bidar in the use of tilework under the Khalji dynasty of Malwa (1402–1526).[27] Yves Porter has noted that a local history, Kermani's *Ma'asir-i Mahmudshahi*, specifically mentions the employment, in 1442, of Persian tileworkers on the

Figure 1.3 *Detail of tilework, Gaur, Lattan mosque (c. 1500) (photo: O'Kane)*

decoration of the now ruined Bam-i Bihisht madrasa there.[28] Whether or not those tileworkers might have found employment in nearby Bidar, the extraordinary close cultural ties of the Bahmanid sultanate with Iran and the Ni'matullahi Sufi order[29] would explain the taste and quite possibly also the expertise for the tilework (even if the tiles

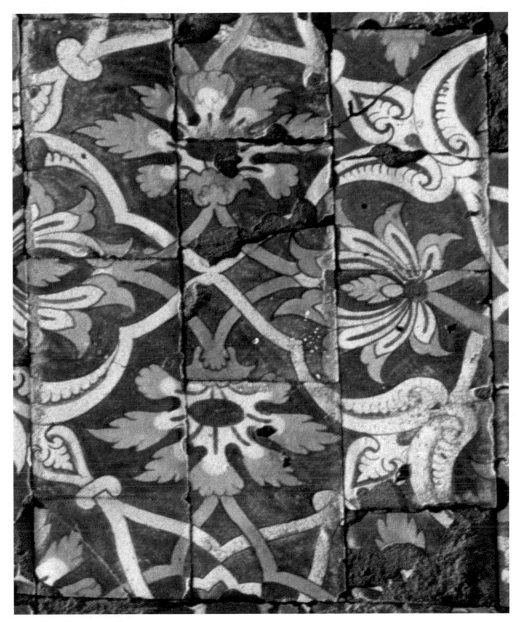

Figure 1.4 *Detail of underglaze-painted tiles, Tomb of ʿAla al-Din Shah (d. 1458), Bidar (photo: O'Kane)*

must have been produced locally); we will see how the equally close ties of the Mughals with greater Iran affected their tilework below.

In the Delhi Sultanate, which of course was the territory over which the Mughals first ruled, tilework was not as advanced as it had been at Bidar.[30] The tomb of Sikandar Lodi in Delhi (1518) is a good example, where tiling is found only on the interior zone of transition.

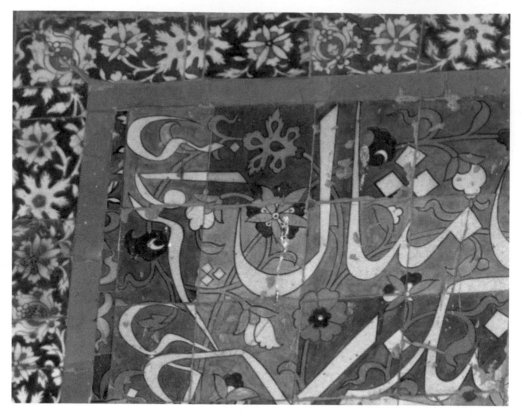

Figure 1.5 *Detail of interior inscription panel of underglaze-painted tiles, tomb of
'Ali Barid (1577), Bidar (photo: O'Kane)*

Framing the inner arches is a band of very basic tile mosaic with
yellow half-octagonal tiles bordering dark-blue cross tiles. Framing
this in turn, and the outer arch and spandrels are sgraffito dark-blue
and green tiles (Figure 1.6).[31] This, even if the palette is uncharacter-
istic of any Iranian or Central Asian examples,[32] is not therefore very
sophisticated. The work carried out some two decades later (prob-
ably by Sher Shah Sur[33]) at the Qal'i-i Kuhna mosque at Delhi shows
great similarity: the interior hexadecagonal zone of transition of the
main dome uses the same colours, techniques, and virtually the
same patterns (Figure 1.7). Sher Shah Sur's interest in tilework is also
seen in his mausoleum at Sasaram: beneath the eaves on the lower
storey are impressive sun-disk medallions supported on arabesque-
filled stands, all made of dark-blue sgraffito tiles. Below it was a band
of simple lozenges tiled in light- and dark-blue. The mihrab seems to
have had denser tile mosaic, now very poorly preserved.[34]

Little tilework is found on early Mughal monuments. A singular
early example is the mausoleum of Jamali Kamali at Delhi (c. 1536)
which, in addition to typical Sultanate style monochrome-glazed
tiles, has a frieze of underglaze-painted tiles, rare in Delhi.[35]

Figure 1.6 *Tile mosaic and sgraffito tiles on interior, tomb of Sikandar Lodi, Delhi (1518) (photo: O'Kane)*

Figure 1.7 *Tile mosaic and sgraffito tiles on zone of transition, Qal'i-i Kuhna mosque (1540s), Delhi (photo: O'Kane)*

Figure 1.8 *Tile mosaic, Khayr al-Manzil mosque (1561), Delhi (photo: O'Kane)*

We saw in the previous paragraph that the tilework of the Surid interim also followed Sultanate models closely. Major advances in tilework during the Mughal era are not seen until the 1560s.[36] On the mosque of Khayr al-Manzil (1561) at Delhi, for instance, the prayer hall façade now has much more of the surface decorated with tile than previous Sultanate or Surid examples, with tile mosaic used for the spandrels and framing arches (Figure 1.8). The colour palette is similar to characteristic pre-Mughal examples – light- and dark-blue, yellow and green. But the patterns here are repeating geometric ones, even on the spandrels where, in a Timurid, Safavid or Uzbek context one always would find arabesques. Two other features connect it with Sultanate tilework: the incorporation of unglazed stone elements and areas, such as the frieze above the carved stucco inscription, where larger tiles with sgraffito decoration are found.[37] One other unfortunate, but very common characteristic, is the poor quality of the glaze which in many parts has disappeared due to weathering.

The west wall of the enclosure of the mausoleum of Atgah Khan in Delhi (1566) also displays extensive tile mosaic on

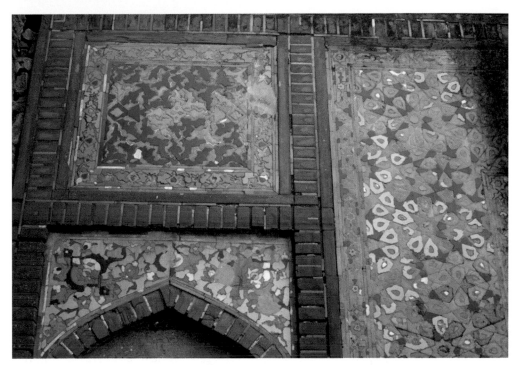

Figure 1.9 *Tile mosaic on west wall, mausoleum of Atgah Khan (1566), Delhi (photo: O'Kane)*

the west (qibla) wall (Figure 1.9).[38] In addition to the panels of geometric ornament, we now have for the first time in Mughal architecture arabesque patterns deployed in this technique. These are very much in the style of both earlier Timurid monuments and contemporary Safavid and Uzbek ones, although again they use a distinctive colour palette of the characteristic bright yellow and light-green, with little use of the light-blue so common in Iran and Central Asia. The mausoleum itself is built of marble and sandstone, as is the most famous of its contemporary monuments, the tomb of Humayun (c. 1566). Marble and sandstone remained the favoured building materials for the Mughals' most prestigious projects, but now that the restoration of the tomb of Humayun has taken place it is possible to see that domes of the twin *chhatris* above each of the four faces of the mausoleum had a simple but bold floral tile mosaic pattern in white, yellow, blue and green.[39]

There is little tilework of note on subsequent Mughal architecture until that on the exterior of the Lahore fort.[40] It has been attributed to both the late Jahangir and early Shah Jahan periods (1624–1631), although, as Ebba Koch has pointed out, the work is homogeneous in style and was probably executed by the same group of artists.[41] The first important point is that this is, or certainly was (much is now missing), the most extensive use of tilework found on any

one Indian monument. In this, it follows from what was previously the most extensive, on the Hindu Man Mandir fort at Gwalior.[42] Both patrons evidently viewed the Fort walls as a suitable location for advertising their riches and ideology. Koch has noted that, in addition to the scenes of daily life of the Mughal court and symbols of rulership and power, they contain Solomonic angels subjugating djinn, a theme mirroring the Jahangir period paintings in the Kala Burj within the Fort, which associated the ruler with the one of the most revered pre-Islamic prophets, forever linked with justice.[43] A foundation inscription (1617) of Jahangir in the fort also refers to him as 'a Solomon in dignity'.[44]

Regarding the quality of the tile mosaic, however, it has to be said that the tesserae of the figural panels are, first of all, mostly larger than on previous examples such as the Khayr al-Manzil mosque or the mausoleum of Atgah Khan. The panels are admittedly mostly high up on the walls and therefore difficult to see from afar, but the frequent plain ground, devoid of detail at the edges of the panels, reveals a distracting grid pattern where the uncut square tiles have been placed side by side. Some indication that this was taken into account is seen in the tile mosaic on the Elephant Gate adjacent to the curtain wall of the Shah Burj: the tesserae here are much smaller, more suitable for the arched panels of flowering shrubs that are found at the top and bottom of the sides of the gate. Those on the bottom are noteworthy for their asymmetry.[45] Similar panels of asymmetric and naturalistic trees can be seen in painted stucco on the rear of the inner side of the gateway to the tomb of Akbar at Sikandra (1612–14). These may therefore have preceded the examples in tilework, the best-known examples of which are the highlight of the Wazir Khan mosque (1635) in the same city (Figure 1.10), to which I now turn.

The same team of craftsmen may have worked the Wazir Khan mosque, so similar are their asymmetrical panels. Its entrance portal is remarkable for its emphasis on epigraphy. The projecting balconies on the middle of each side preclude the framing inscriptions that are seen on many other portals (as on the Chini-ka-Rauza, discussed below), but this is compensated by the smaller twin rectangular panels on each side and the bottom arched panels, all filled with dark-blue *nasta'liq* on a white ground. Tile mosaic features extensively on the minarets and their bases, but pride of place within the prayer hall is given instead to painted plaster.

Also roughly contemporary with those two monuments is another in Lahore, the tomb of Jahangir (1628–38).[46] Like its imperial funerary predecessors, Humayun's tomb at Delhi and Akbar's at Sikandra, it also greatly emphasises marble and sandstone but displays tile mosaic on the dadoes of the external arcade and in the corridor leading to the cenotaph. The mosaic patterns in the corridor are all symmetrical, but they now show a motif borrowed from the *pietra*

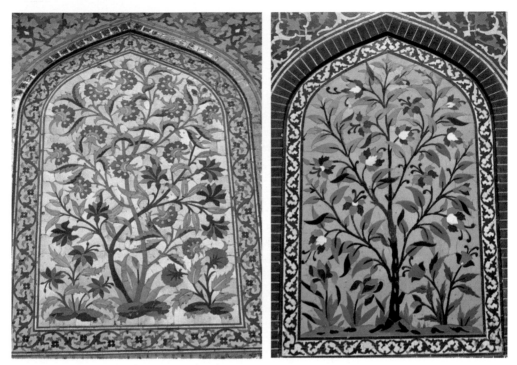

Figure 1.10 *Left: tile mosaic panel, Elephant Gate, Lahore Fort (1624–31) (photo: O'Kane). Right: tile mosaic panel, Mosque of Wazir Khan (1635), Lahore (photo: O'Kane)*

dura on the lowest tier of the cenotaph, a naturalistic curving leaf that distinguishes the upper and lower sides by different shades of tile, in this case dark-green and dark-blue (Figure 1.11). As one might expect, the interior location of these tiles has spared their glaze from the effect of weathering, although it must also be said that the Lahore monuments have consistently fared much better than those of Delhi and Agra in this respect.[47]

Still contemporary, but at Agra, is the Chini-ka-Rauza, probably the tomb of Afzal Khan (d. 1638), the finance minister of Shah Jahan. Tile mosaic originally covered all of the exterior of this structure. Although much of the glaze has disappeared due to weathering, the overall design is still clear. Where in other monuments the façade would be articulated through a series of arched niches, here it is flat. Instead the impression of articulation is given by the different-sized rectangular panels of the tilework design, each filled with a variety of ogee or polylobed arches, in turn containing central stems with symmetrical floral designs to either side.[48]

Even in its truncated state, the otherwise perfectly preserved tile mosaic (Figure 1.12) of the tomb of Asaf Khan (1642–4)[49] at Lahore is an impressive ensemble, as befits the status of its exalted dedicatee, Shah Jahan's father-in-law (Mumtaz Mahal was his daughter).

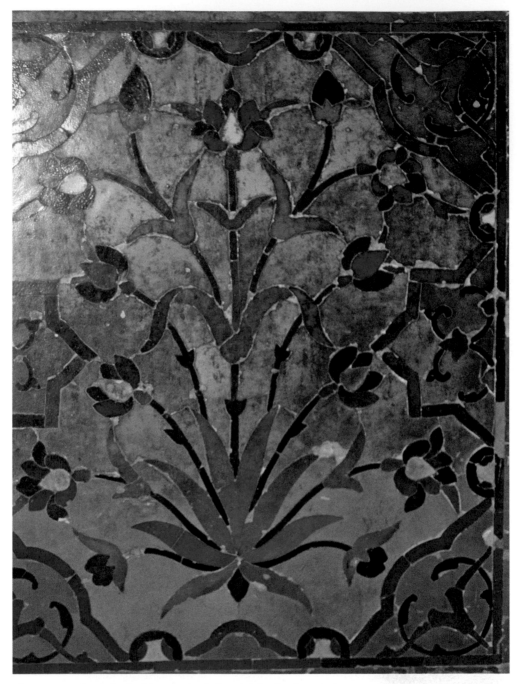

Figure 1.11 *Detail of tile mosaic dado, tomb of Jahangir (1627–37) Lahore (photo: O'Kane)*

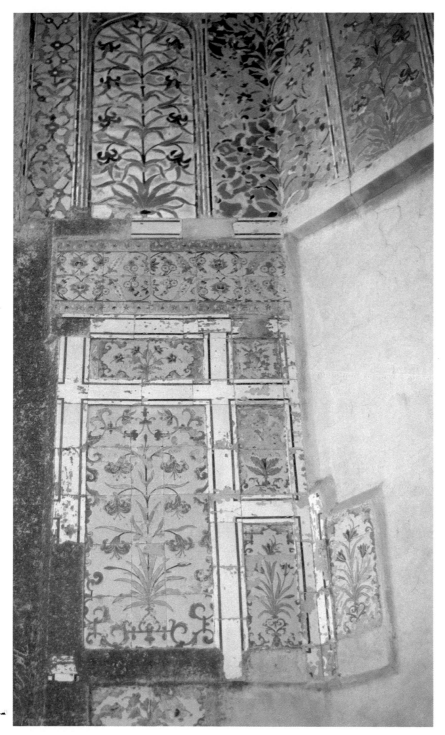

Figure 1.12 *Tile mosaic (upper) and* cuerda seca *tiles (lower), tomb of Asaf Khan (d. 1641), Lahore (photo: O'Kane)*

The building itself and surrounding garden were ordered to be constructed by Shah Jahan.[50] It too apparently had much marble on its lower walls, now sadly all plundered.[51] We should notice how the colour palette has shifted, with the formerly dominant blue yielding mainly to orange[52] and yellow, with some black, white and green also occasionally used as a ground.[53] The floral designs are once again all completely symmetrical. The palette might have been chosen to match the *cuerda seca* tiles on the lower walls which appear here possibly for the first time in India. They all have a yellow ground,[54] with mainly orange stems and flowers, although some green and dark-blue is found too. The attempt to depict the upper and lower sides of leaves is shown both in two shades of green (as at the tomb of Jahangir, Figure 1.11), and in dark-blue and orange (Figure 1.12).

What is most surprising is firstly, how long it took *cuerda seca* tiles to appear in Mughal architecture, given its frequent appearance in Timurid and Safavid tilework,[55] and secondly, how extremely limited then was its further use, with very few later examples known.[56] One other prominent example was at the tomb complex of al-Madani in Srinagar, where a gateway dated to the reign of Shah Jahan was decorated with *cuerda seca* tiles.[57/57*] The Tomb of al-Madani was unique in India in having a figure of Sagittarius on its spandrels, much like those in tile mosaic at the north side of Shah 'Abbas's Maydan-i Naqsh-i Jahan.[58]

One of India's finest tiled monuments is Shah Jahan's Friday mosque (1647) at Thatta.[59] I mentioned above the continuous use of underglaze-painted tiles in the monuments around Multan and Uchch.[60] They had also become widespread in monuments from the sixteenth century onwards at Thatta. The Dabgir mosque (1588) there (Figure 1.13) already uses many of the same forms and techniques found in Shah Jahan's mosque. Thin turquoise monochrome-glazed tiles are used instead of mortar for the spaces between bricks. *Banna'i* technique is found on the soffits of the arches connecting the three qibla dome chambers. An indication of how much more comfortable the tileworkers in this part of India were with their traditional underglaze technique than with tile mosaic is seen on the semi-dome of the mihrab niche: a curved surface is ideal for tile mosaic as the small pieces mould themselves to the surface, but here with large flat tiles they had to resort to faceting of triangles instead (Figure 1.13). At Shah Jahan's mosque, underglaze-painted tiles are again dominant, although here they are also frequently seen in geometric panels with unglazed brick tiles in a variation of the inset-technique found in Timurid architecture.[61] Within the central qibla dome chamber, the framework of the tile panels is in dark- and light-blue *banna'i* tiles, with wide bands of mortar between them, a colour contrast highlighted by the recent restoration of the white mortar.

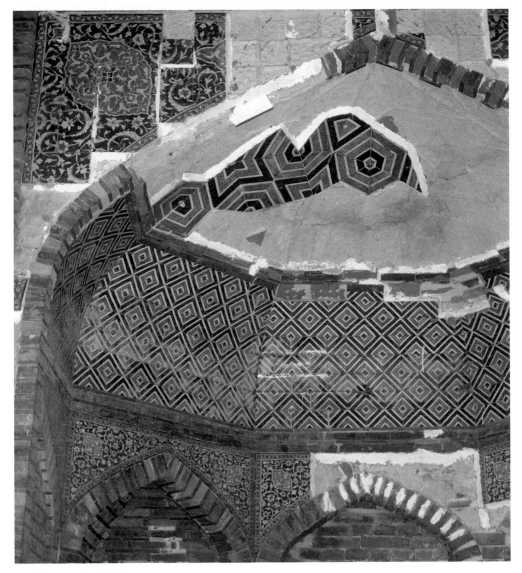

Figure 1.13 *Detail of underglaze-painted tilework on mihrab, Dabgir Mosque (1588), Thatta (photo: O'Kane)*

One further example of tile mosaic may be mentioned, to show its sharp decline in the eighteenth century. The tomb of Sharaf al-Nisa Begum at Lahore (Figure 1.14) is a simple rectangle, with large panels of tile mosaic encircling the upper walls. Whether the borders of the square white background tiles were better concealed on its erection is unclear, but now their all-too apparent dividing lines resemble, to the modern viewer, bathroom tiles. There is an attempt at variation in the use of different colours for the crossing of leaves, but the stiffness of the cypress trees is also apparent.[62]

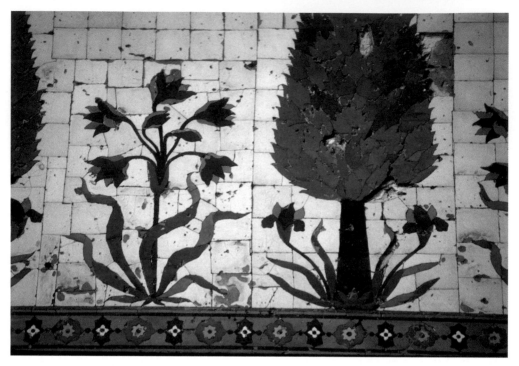

Figure 1.14 *Detail of tilework, tomb of Sharaf al-Nisa Begum at Lahore (second quarter eighteenth century) (photo: O'Kane)*

We have seen that Indian tilework evolved in substantially different ways from its Iranian predecessors. This is hardly surprising. The South Asian peninsula has vast stone quarries, and the skill of the Hindu stone-masons was everywhere evident in the ornate carvings on their temples. We normally find that, where good building stone is available, as in Egypt, Syria and Turkey, for example, then it tends to be used as the medium both of construction and decoration. The use of marble and sandstone by the Mughals in some of their finest buildings was another way to achieve colour contrast without the use of tiles. The most prestigious buildings of the Mughals – the mausoleums of the rulers the Friday mosques in Delhi and Lahore, the major buildings within the forts of Agra, Delhi and Lahore, were all executed in stone. In central India therefore, tiles were essentially second rank decorative material.

The situation was different in the Punjab, where stone was in comparatively short supply and brick, as in Iran, was the usual medium of construction. The main tilework technique in the Punjab was underglaze-painting. From its introduction in the thirteenth century at Lal Mohra Sharif to its burgeoning in the Rukn-i 'Alam mausoleum and the tombs of Uchch, Punjabi underglaze-painted tilework owes little to its Anatolian or Iranian predecessors[63] in terms of placement and patterns, and can be considered a quite separate development.

Underglaze-painted blue and white tiles cover much greater propor-
tions of the monuments than any in Iran, and were used over a much
greater span, through Sultanate architecture right up to the demise
of the Mughal empire, at a time when they had become virtually
forgotten in Safavid and, to a lesser extent, in Uzbek architecture.

Tile mosaic took almost a century and a half to appear in India
after its appearance in fourteenth-century Iran, at first sparsely in
Northern India, but more confidently in the Deccan. Its first tenta-
tive uses in Sultanate architecture owe little to Iranian prototypes. It
only came into regular extensive use in the Mughal period, a change
most likely connected with the rulers' heritage of tile-covered
Timurid architecture and its successors in Safavid Iran and Uzbek
Central Asia. However, in Mughal India, the colour palette was
quite different, with white and orange or yellow backgrounds being
more popular than the dark- or turquoise-blue of Iran and Central
Asia. The motifs are also different, beginning in the seventeenth
century with greater use of naturalistic trees and flowers,[64] and,
on the Lahore Fort, figural panels.[65] The tesserae are larger, with
plainer backgrounds. Tile mosaic was also used as a device to give
the appearance of breaking up a solid wall into smaller panels, rather
than reflecting the existing architectural subdivisions in the form of
niches, as in Timurid and Safavid Iran.

As for the limited use of *cuerda seca* tiles used on Mughal build-
ings, the initial unfamiliarity of Indian masons with *cuerda seca*
technology would have been a barrier to their switching from the
labour intensive – but technologically simpler – tile mosaic.[66] *Cuerda
seca* tiles are extremely rare, and were never used, as in Safavid
examples, as a cheap substitute for tile mosaic. In addition, none of
the surviving Mughal examples exhibits any of the overglaze gilding
of the early Timurid examples.

What were the decisions that led to the choice of a particular
kind of tilework? Obviously, patrons wanted their buildings to be as
prestigious and attractive as possible, although this also presented a
range of choices, from a large sparsely decorated structure to a small
heavily decorated one. For buildings in Lahore, Delhi and Agra, the
main cities of the Mughal empire, sandstone and marble were the
favoured medium for prestigious decoration, with tile mosaic coming
in a distant third. However, in the southern part of Punjab, as at
Thatta, lack of locally available stone and marble and the continuing
expertise of the ateliers in underglaze-painted tiles, only rarely found
further east than the Indus valley,[67] ensured that they continued to
be extensively used along with tile mosaic in the Mughal period.

The distinctiveness of Mughal tilework can now be recognised.
Its initial tile mosaic colour palette of yellow, dark-blue and green
was strongly influenced by the preceding Sultanate period. Changes
in the reign of Akbar occurred in two ways, firstly with the intro-
duction of more varied colours, with white and some light-blue

becoming more common, and secondly with the introduction of panels with arabesque patterns. While the seventeenth century saw a move towards more naturalistic designs, earlier than comparable Iranian examples, it also gives us the single most extensive use of tile mosaic figural imagery of any Islamic monument in the picture wall of the Lahore Fort.

Underglaze-painted tiles continued to be the main medium of decoration in Mughal Punjab, where their extensive use with monochrome-glazed light- and dark-blue tiles produced a style unknown elsewhere. *Cuerda seca* tiles were used much less frequently, although the surviving examples also show a distinctive colour palette, with an orange ground unknown in Iranian examples.

There are still unanswered questions, such as the reasons for the frequent abrasion of the tile mosaic glazes, and for their strangely matte quality when compared to the best Timurid or Safavid examples. Further technical analysis may provide the answers. However, the above examples can permit us to celebrate Mughal tilework for its original contribution to the history of Islamic decoration.

Notes

1. Rather than using the historically more accurate Hindustan to describe the region of South Asia ruled by the Mughals, I use India throughout in its pre-partition historical sense. My thanks go to Mehreen Chida-Razvi, the editor of this volume, for her constructive comments on an earlier version of this piece.

2. In particular Yves Porter, 'Revêtements émaillés des premiers Moghols à Delhi', in *Adle Nāmeh: Studies in Memory of Chahriyar Adle*, ed. Alireza Anisi (Tehran, Research Institute for Cultural Heritage and Tourism, 2018), pp. 263–99; Abdul Hamid Akhund and Nasreen Askari, *Tale of the Tile: The Ceramic Tradition of Pakistan* (Karachi, Mohatta Palace Museum, 2011); Gerard Degeorge and Yves Porter, *The Art of the Islamic Tile* (Paris, Flammarion, 2002), Chapter 5; Yves Porter, 'Décors émaillés dans l'architecture de pierre de l'Inde centrale: les monuments islamiques de Mandu, XVe-XVIe s', *Archéologie islamique*, 7 (1997), pp. 121–46, Tanvir Hasan, 'Ceramics of Sultanate India', *South Asian Studies*, 11 (1995), pp. 83–106; and, for technical studies of glazes, Maninder Singh Gill and Thilo Rehren, 'Material Characterization of Ceramic Tile Mosaic from Two 17th-Century Islamic Monuments in Northern India', *Archaeometry* 53, 1 (2011), pp. 22–36; Saima Gulzara et al., 'Characterization of 17th Century Mughal Tile Glazes from Shahdara Complex, Lahore-Pakistan', *Journal of Cultural Heritage*, 14 (2013), pp. 174–9; M. S. Gill and Th. Rehren, 'The Intentional Use of Lead-Tin Orange in Indian Islamic Glazes and Its Preliminary Characterization', *Archaeometry* 56 (2013), pp. 1009–23; M. S. Gill, Th. Rehren and I. Freestone, 'Tradition and Indigeneity in Mughal Architectural Glazed Tiles', *Journal of Archaeological Science* 49 (2014), pp. 546–55; Maninder Singh Gilla and Thilo Rehren, 'An Analytical Evaluation of Historic Glazed Tiles from Makli and Lahore, Pakistan', *Journal of Archaeological Science: Reports*, 16 (2017), pp. 266–75.

3. Richard McClary, *Rum Seljuq Architecture, 1170–1220: The Patronage of Sultans* (Edinburgh: Edinburgh University Press, 2017), pp. 31–3, discusses the Konya examples and, given the absence of *mina'i* produced anywhere other than Kashan, suggests they were imported from there. In addition to the figural *mina'i* examples we also find overglaze-painted tiles in the colour scheme of what becomes later known as *lajvardina* (white and gold on a dark-blue ground), and figural underglaze-painted tiles, such as the ensemble in the Metropolitan Museum of Art: <https://www.metmuseum.org/art/collection/search/452817> (last accessed 20 April 2018).

4. What may be the earliest surviving underglaze-painted tile, from the Raqqa Jami' masjid, is possibly Zangid: Bernard O'Kane, 'The Development of Iranian *Cuerda Seca* Tiles and the Transfer of Tilework Technology', in *And Diverse Are Their Hues*, ed. Sheila Blair and Jonathan Bloom (Yale: Yale University Press, 2011), p. 179, fig. 111. The technique was widely used in Saljuq Anatolia before it also became common in Ilkhanid Iran and Mamluk Syria and Egypt. Early examples are found at the Sivas Great Mosque minaret (1212–13) and the Sivas 'Izz al-Din Kay Kawus Hospital: McClary, *Rum Seljuq Architecture*, pp. 46–7, 144, 159. See also Michael Meinecke, *Fayencedekorationen seldschukischer Sakralbauten in Kleinasien*, 2 vols (Tübingen: Wasmuth, 1976), vol. 1, pp. 22–7 and *idem*, 'Syria Blue and White Tiles of the 9th/15th Century', *Damaszener Mitteilungen*, 3 (1988), 203–14.

5. In the Astan i Quds, Mashhad: Sheila Blair, 'Art as Text: The Luster Mihrab in the Doris Duke Foundation for Islamic Art', in *No Tapping around Philology: A Festschrift in Honor of Wheeler McIntosh Thackston Jr.'s 70th Birthday*, ed. Alireza Korangy and Daniel J. Sheffield (Wiesbaden: Harrassowitz, 2014), pp. 409–10, Figures 5–6.

6. It may also have given more margin for error in laying out the design. The tilework on the façade of the main *ayvan* of the Sırçalı Madrasa, Konya (1242) provides a good example.

7. The Eşrefoğlu Mosque (1296), Beyşehir, is one of the finest examples: Bernard O'Kane, *Mosques: The 100 Most Iconic Islamic Houses of Worship* (New York and Paris: Assouline, 2019), no. 36.

8. O'Kane, 'The Development of Iranian *Cuerda Seca* Tiles', pp. 174–203.

9. A useful overview of the topic is found in Hasan, 'Ceramics of Sultanate India'.

10. Heinz Gaube, 'Die Mausoleengruppe in Adheri, NW-Pakistan', in *Studies in Honour of Clifford Edmund Bosworth: 2 – The Sultan's Turret*, ed. Carole Hillenbrand (Leiden, 2000), pp. 96–108; Shaikh Khurshid Hasan, 'Pakistan: Its Seraiki Style of Tomb Architecture, *East and West* 51 (2001), pp. 167–78; Holly Edwards, *Of Brick and Myth: The Genesis of Islamic Architecture in the Indus Valley* (Karachi: Oxford University Press, 2015), pp. 145–57, 211–29.

11. The extensive earlier literature is reviewed in detail in Edwards, *Of Brick and Myth*, pp. 147–8.

12. The Ribat of 'Ali ibn Karmakh (Kabirwala), and the mausoleums of Suhagan and Duagan (Aror) and Shaykh Sadan (Muzaffargarh). For the first three see Holly Edwards, *The Genesis of Islamic Architecture in the Indus Valley*, Ph.D. dissertation, New York University, 1990, and *idem*, *Of Brick and Myth: The Genesis of Islamic Architecture in the Indus Valley* (Karachi: Oxford University Press, 2015). For Shaykh Sadan the most comprehensive publication is Finbarr Barry Flood, 'Ghurid

Architecture in the Indus Valley: The Tomb of Shaykh Sadan Shahid', *Ars Orientalis*, 31 (2001), pp. 129–66. See now also Abdul Rehman and Talib Hussain, 'Expression of Paying Tribute to the Saint: Decorative Vocabulary on the Tomb of Ahmad Kabuir, *Journal of Research in Architecture and Planning* 10 (2011), 59–75.

13. They correspond to tombs A and B in the catalogue in Edwards, *Of Brick and Myth*.

14. Described on tomb A in Edwards, *Of Brick and Myth*, p. 213 as 'glazed in two colours', and, appropriately, as 'hastily executed in crude hatching patterns'; and as indicating that 'the potential of the medium of glazing was being exploited'; and on tomb B (ibid., p. 217) as 'two-colour tiles'.

15. For an overview of similar later mausoleums, all of which extensively employ underglaze-painted tiles, see Hasan, 'Seraiki Style', p. 177, 11–15.

16. As in Abbasid Mesopotamia (O. Bobin et al., 'Where Did the Lustre Tiles of the Sidi Oqba Mosque (AD 836–63) in Kairouan Come From?', *Archaeometry*, 45, 4 [2003], pp. 569–77), Raqqa and Saljuq Anatolia (Marilyn Jenkins-Madina, *Raqqa Revisited: Ceramics of Ayyubid Syria* [New Haven and London: Metropolitan Museum of Art, 2006] and Iran (Oliver Watson, *Persian Lustre Ware* [London and Boston: Faber, 1985]).

17. I am grateful to Oliver Watson for his comments of a photograph of these tiles, who also notes that 'it has just been shown that opaque white and opaque yellow glazes are essentially the same thing, one or other colour occurring because of small differences in the making procedure (both being tin–lead compounds)'.

18. Very similar tiles are in the V&A collection: <http://collections.vam. ac.uk/item/O82264/tiled-panel-tile-panel-unknown/> (last accessed 2 April 2018).

19. Described in detail in Giovanni Curatola, 'Un percorso di lettura sulle arti decorative nel Deccan', *Rivista degli studi orientali*, 64 (1990), pp. 221–5.

20. Yolande Crowe, 'Some Glazed Tiles in 15th-Century Bidar, in *Facets of Indian Art*, ed. Robert Skelton et al. (London: Victoria and Albert Museum, 1986), p. 44, seems to assume that they are tile mosaic; Merklinger, *Deccan*, p. 114: mosaic tiles; Curatola, 'Percorso', p. 221, majolica; George Michell and Mark Zebrowski, *Architecture and Art of the Deccan Sultanates* (Cambridge: Cambridge University Press, 1999), *cuerda seca*. I must admit that there is some possibility that they are in fact *cuerda seca* tiles, as the resolution on my photograph is not so high as to determine conclusively the technique. The glaze surface looks matte rather than shiny, and some of the designs are outlined by a black line (both suggesting *cuerda seca*). However, there is some running of the dark-blue and light-blue on the white base, and many details of the petals are not outlined at all, suggesting underglaze painting. Testing, or more detailed photography, may permit a conclusive verdict (I am again grateful to Oliver Watson, and to Robert Mason for their comments on my photographs of these tiles, and on those mentioned in n. 24 below).

21. One should perhaps mention another impressive use of tile mosaic in pre-Mughal India here, but on a Hindu monument, the Man Mandir in Gwalior (1486–1517). Ducks, parrots, elephants, lions and human figures all feature amongst both geometric and foliate designs, using green, yellow and light-blue tiles, often in combination with unglazed sandstone. As noted in Degeorge and Porter, *Islamic Tile*, p. 233, the

only Mughal fort to rival this ensemble in it use of tilework is that in Lahore, which shall be examined further in the piece. However, although the Man Mandir probably exhibits the most extensive use of tile mosaic on an Indian pre-Mughal monument, the tesserae are much larger in size than at the Bidar madrasa (admittedly, as befits, in most cases, the greater viewing distance).

22. Elizabeth Merklinger, 'The Madrasa of Mahmud Gawan in Bidar', *Kunst des Orients*, 11 (1977), pp. 147–8, mentions only the tile mosaic.

23. The same colour scheme is noted in Porter, 'Décors émaillés', p. 136, on the fifteenth-century *hammam* of the palace at Mandu, which he identifies however as *cuerda seca*. Yellow is admittedly an extremely unusual colour in underglaze painting, although two fifteenth-century Ottoman examples are known: O'Kane, '*Cuerda Seca* Tiles', pp. 193–5; and see the later example of 'Ali Barid mentioned further in the piece. Again, my photos are not detailed enough to allow for an absolute identification of this technique, but it seems likely on the balance of probability.

24. Helen Philon, 'Architectural Decoration', in *Silent Splendor: Palaces of the Deccan 14th-19th centuries*, ed. Helen Philon (Mumbai: The Marg Foundation, 2010), p. 120 mentions the red, but describes the technique as underglaze painted. Bianca Maria Alfieri, *Islamic Architecture of the Indian Subcontinent* (London: Laurence King, 2000), p. 153, notes the resemblance to Persian designs but claims that the tiles were almost certainly imported from Kashan. Apart from the logistical difficulty, the colour palette would rule out an Iranian provenance for them.

25. Not tile mosaic, as described in Michell and Zebrowski, *Architecture and Art*, p. 137.

26. Their technique is not mentioned by Merklinger, *Deccan*, p. 121, or Curatola, 'Percorso', p. 225, although the latter comments extensively on their patterns. The tilemakers had trouble maintaining colour control. For instance, the blue ground of the epigraphic panels at the springing of the arches ranges from light- to dark-blue, and the yellow can shade, even on adjacent tiles, to a much darker orange. This shading and the tile division are not represented in the reproduction of the painting of one panel of the inscription in G. Yazdani, *Bidar: Its History and Monuments* (Oxford: Oxford University Press, 1947), Pl. XCV.

27. Porter, 'Décors émaillés'.

28. Ibid., p. 125.

29. Most recently explored in detail in Peyvand Firouzeh, *Architecture, Sanctity and Power: Ne'matollahi Shrines and Khanqahs in Fifteenth-Century Iran and India*, PhD thesis, Cambridge, 2106.

30. The Delhi examples are now published in detail in Porter, 'Revêtements émaillés'.

31. Ibid., p. 267, describes the techniques here as being tile mosaic and (underglaze-) painted tiles ('des carreaux découpés et – fait plus exceptionnel – des carreaux peints'), but I see no sign of underglaze painting there. Surprisingly, in light of this, Porter later affirms just two examples of underglaze-painted tilework in his Delhi corpus, those of the Shisha Gunbad and Jamali Kamali: ibid., p. 283.

32. Also noted in Porter, 'Revêtements émaillés', pp. 270.

33. On this see Catherine Asher, 'The Qal'a-i Kuhna Mosque: A Visual Symbol of Royal Aspirations', in *Chhavi II*, ed. Anand Krishna (Varanasi: Bharat Kala Bhavan, 1981), pp. 212–17.

34. I was unable to access the interior; Catherine Asher, 'The Mausoleum of Sher Shāh Sūrī', *Artibus Asiae*, 39 (1977), p. 292, mentions that, regarding the mihrab, 'the archivolt with its impost is set with delicate floral tilework'. Her black and white photograph suggests this might have been fine tile mosaic, but I have been unable to find any colour photographs that would enable us to confirm this.

35. Porter, 'Revêtements émaillés', pp. 267–9; Figures 1–2, 4. As he notes, however, underglaze-painted tiles are also found on a late Sultanate building in Delhi, the early sixteenth-century Shish Gunbad in the Lodi Gardens: ibid., Figure 3.

36. Given the confines of this piece, it is not possible to select more than some of the more important Mughal monuments to analyse prevailing trends. Similar tilework is found on the possible contemporary Nila Gunbad, for which see ibid., 276–7, Figures 16–17.

37. Sgraffito is also used for the tiles on the friezes above the interior mihrabs which alternate reciprocal green and blue lobed medallions, Porter, 'Revêtements émaillés', pl. 19.

38. Described in detail in Porter, 'Revêtements émaillés', p. 280; also mentioned in Degeorge and Porter, *Islamic Tile*, p. 256.

39. Ratish Nanda, 'The Area of Humayun's Tomb', in *Heritage of the Mughal World*, ed. Philip Jodidio (Munich: Prestel, 2015), p. 159; Aga Khan Trust for Culture, *Humayun's Tomb Conservation 2007–2013* (Delhi: Aga Khan Trust for Culture, 2015), <https://archnet.org/publications/10601> (last accessed 20 April 2021). The Amar Singh gate of the Agra Red Fort (c. 1565–73) also has tile mosaic very similar to that of the mausoleum of Atgah Khan.

40. With the continuing exception of the monuments with underglaze-painting in Punjab (at Thatta, Multan and Uchch), discussed further in the piece in connection with Shah Jahan's Jami' Masjid at Thatta. For the Lahore Fort see J. Ph. Vogel, *Tile-Mosaics of The Lahore Fort* (repr. with additions, Karachi: Pakistan Publications, n.d.).

41. Ebba Koch, *Muhgal Art and Imperial Ideology* (New Delhi: Oxford University Press, 2001), p. 33, n. 62.

42. See n. 22 above.

43. Koch, *Muhgal Art*, pp. 32–3.

44. Ibid., p. 19.

45. The pair at the top is symmetrical; those at the bottom of the gate are identical to each other (rather than being mirror image), showing use of the same pattern. As noted in Degeorge and Porter, *Islamic Tile*, p. 256 (caption), their naturalism may have been derived from European herbals which became available in India at the same time.

46. For a chemical analysis of the glazes used here see Saima Gulzara et al., 'Characterization'.

47. At a lecture on tilework in the time of Shah Jahan at Pembroke College on 27 April 2018, Susan Stronge suggested that other contemporary examples of tile-work in Lahore might have had elements of their decoration restored. While this could also explain the unusually good state of preservation of the tile-work of some Lahore monuments, I believe that the example of the Asaf Khan mausoleum, discussed further in the piece, suggests that some original tile mosaic from this period shows little signs of weathering of the glaze. Its dilapidated state, missing much of the original tilework (both tile mosaic and *cuerda seca*), makes it unlikely to have been subject to any restoration, yet its exterior tile mosaic shows

absolutely no signs of weathering of the glazes. Similarly, a tile mosaic gateway of the Shalimar Bagh (1636–42) at Lahore is fraying at the edges, but the tiles that remain show no sign of the glaze itself weathering. However, on the gateway to the Gulabi Bagh (1655) at Lahore, there are some signs of weathering, although nowhere as bad as the Delhi and Agra examples. Analysis of the glazes of tile mosaic at Lahore and Delhi has revealed significant chemical differences, with the latter having a 'high alumina mineral soda signature' (Gill, Rehren and Freestone, 'Tradition and Indigineity', p. 554). My knowledge of chemistry is not sufficient to know whether could this explain the difference in weathering; future chemical analysis of the glazes or tile biscuit may produce an answer. I also wondered whether heavier precipitation might have an effect, although the difference is not that great: the average annual for Lahore is 628.8 mm vs. 795.4 mm for Delhi: 'Climate of Lahore', <https://en.wikipedia.org/ wiki/Climate_of_Lahore> (last accessed 25 April 2018) and 'Climate of Delhi', <https://en.wikipedia.org/ wiki/Climate_of_Delhi> (last accessed 25 April 2018). Both are much greater than the average for, for instance, Herat of 238.9 mm: <https://en.wikipedia. org/ wiki/Herat#Climate> (last accessed 23 January 2019).

48. Well-illustrated in Degeorge and Porter, *Islamic Tile*, p. 265. For an analysis of some of the glazes used on the mausoleum, see Maninder Singh Gill and Thilo Rehren, 'Material Characterization'. The authors refer to a purple glaze, that derived from manganese oxide. Its shade here varies, depending on its density, from black to dark purple.

49. The dating range is established in Anjum Rehmani, *Lahore: History and Architecture of Mughal Monuments* (Karachi: Oxford University Press, 2016), p. 245.

50. Ibid., 244.

51. Ibid., p. 245. A detail of the tile mosaic is illustrated in Degeorge and Porter, *Islamic Tile*, p. 264.

52. The orange seems to be an innovation of the late sixteenth century; its first use may be on the tomb of Sultan Ibrahim Quli Qutb Shah at Golconda (1580), as mentioned in *Aga Khan Development Network, Qutb Shahi Heritage Park Conservation & Landscape Restoration* (n.p., n.d.): <https://arch net.org/system/publications/contents/10206/original/DTP102591.pdf?1434963592> (last accessed 23 April 2018), pp. 26 and 79 (the latter unnumbered). Gill and Rehren, 'Intentional Use', analyse orange glaze samples from four seventeenth-century Mughal buildings in Northern India; in addition to those four they also analyse tiles from the Sabz Burj in Delhi, supposedly sixteenth-century, but only yellow tiles were sampled from it. The use of a special recipe called 'lead-tin orange' in the Punjab monuments for the orange colour, as opposed to the mixing of lean-tin yellow with other substances found in the Delhi monuments, is also noted by them in ibid., p. 14.

53. A similar palette is found on the tile mosaic of the Badshahi Ashurkhana at Hyderabad in the Deccan. The monument is usually dated to 1596, and it has been suggested that the tilework dates to 1611: Michell and Zebrowski, *Architecture and Art*, p. 138. But a tiled medallion there is in the name of Abu'l-Muzaffar 'Abd Allah Qutb Shah (r. 1626–72), suggesting it was restored by him.

54. For the main field; green is used on the borders.

55. As far as I know, they are unknown in Uzbek architecture, although Ilse Sturkenboom kindly informed me that in a lecture on 5 April 2018 at

St Andrews University Mustafa Tupev mentioned some Uzbek *cuerda seca* tiles; I have been unsuccessful in contacting him. In any case, it is clear that they never formed a significant part of the Uzbek tile decorative repertoire.

56. Anjum Rehmani, 'The Persian Glazed Tile Revetment of Mughal Buildings in Lahore', *Lahore Museum Bulletin*, 10–11 (1997–8), Pl. 1 left, illustrates (but does not discuss in the text), in black and white, tiles from the tomb of Nadira Begum (d. 1659), which seem to be in *cuerda seca* technique. Degeorge and Porter, *Islamic Tile*, p. 271, illustrate the late seventeenth-century Dargah of Qutb Sahib, Delhi (reign of Aurangzib), which has tiles on a dark-green ground in addition to the orange ground seen previously.

57. Susan Stronge (see n. 47) showed a photograph of this gateway taken by Ebba Koch of a painted inscription (no longer extant) that mentioned its erection within his reign.

57.* See now Susan Stronge, 'The Tomb of Madani at Srinagar, Kashmir: A Case Study of Tile Revetments in the Reign of Shah Jahan', in Ebba Koch (ed.), *The Mughal Empire from Jahangir to Shah Jahan: Art, Architecture, Politics, Law and Literature* (Mombai, 2019), 220–45.

58. As Susan Stronge has ascertained, many of its tiles are now in the collection of the Victoria and Albert Museum. Her detailed publication of the tiles of the monument is imminent. Some pertinent information and photographs of the tiles can also be found in Vinayak Razdan, 'Beast at Madin Sahib': <https://www.searchkash mir.org/2014/12/beast-at-madin-sahib.html> (last accessed 19 April 2018).

59. Henry Cousens, *The Antiquities of Sind with Historical Outline* (Calcutta: Government of India Central Publication Branch, 1929), pp. 120–1, Pls LVIII–LXII; Ahmad Hasan Dhani, Thatta: *Islamic Architecture* (Islamabad, Institute of Islamic History, Culture and Civilization, 1982), pp. 190–7; Akhund and Askari, *Tale of the Tile*, pp. 90–5.

60. For analyses of these tiles see Gill and Rehren, 'Analytical Evaluation'.

61. Bernard O'Kane, *Timurid Architecture in Khurasan* (Costa Mesa: Mazda, 1987), pp. 70–1. For good colour illustrations of the tilework at the Shah Jahan mosque see Degeorge and Porter, *Islamic Tile*, pp. 266–70, and Akhund and Askari, *Tale of the Tile*, pp. 70–95.

62. Also noted in Asher, *Architecture*, p. 316.

63. See n. 4.

64. Panels comparable to those of the Wazir Khan Mosque at Lahore appear in Iran only in the nineteenth century, such as those in the Masjid-i Vakil at Shiraz. The mosque was constructed by Karim Khan Zand in 1766, but most of the tile panels, in *cuerda seca* technique, were added or restored by Husayn ʿAli Mirza ibn Fath ʿAli Shah in 1827–8: see Jennifer Scarce, 'The Arts of the Eighteenth to Twentieth Centuries', in *The Cambridge History of Iran, v. 7: From Nadir Shah to the Islamic Republic*, ed. Peter Avery, Gavin Hambly and Charles Melville (Cambridge: Cambridge University Press, 1991), 908–9.

65. An exception is a fascinating underglaze-painted tile (sixteenth-century) showing a bird with a snake in its mouth above a horse, on the tomb of Rajan Shah at Layyah in Punjab, illustrated in Hasan, 'Ceramics', Fig. 19. The closest parallel to the use of figural imagery in the Lahore fort on an Iranian building would be that of the Hasht Bihisht pavilion at Isfahan (1669), for which see Ingeborg Luschey-Schmeisser, *The*

Pictorial Tile Cycle of the Hašt Bihišt in Isfahan and Its Iconographic Cycle (Rome: IsMEO, 1978).

66. As helpfully pointed out by one anonymous reviewer.
67. Mainly in Bahmanid monuments, as noted above. Some badly worn traces of (previously unnoticed) underglaze-painted tiles are present on the Mughal tomb of Firuz Khan, Agra (c. 1647).

CHAPTER TWO

Architecture and Court Cultures of the Fourteenth Century

RECENT SCHOLARSHIP HAS argued that the thirteenth century was a turning point in world history, when the creation of a Mongol empire stretching from China to Iran caused not only great devastation but was part of the formation of a world system extending the length of the Eurasian landmass (Abu-Lughod 1989). Other scholars have argued that Islam itself could be seen as a world system, one whose complex of social relations was greatly strengthened from the thirteenth century onwards by the spread of Sufi orders (Voll 1994). Until the emergence of the Black Death in the mid-fourteenth century began to weaken it, several interlinked economic systems comprised this world system. It was dominated by the Middle East heartland with land routes stretching across Mongol Asia, with sub-systems of the Mediterranean basin, the Indian Ocean, Southeast Asia and China.

Scholarship in Islamic art on this period is usually fragmented on geographic or dynastic lines, but a broader perspective on the period can be useful both in differentiating it from earlier centuries and in highlighting cultural connections to parallel economic ones. With the Mongols' extinction of the Abbasid caliphate in 1258, the former *de facto* political fragmentation of the Islamic world was cemented, with fewer dynasties even paying lip-service to the idea of unified caliphal authority. The arrival of the Mongols brought immediate Chinese artistic influences that only partially penetrated western Islamic lands. But with their conversion to Islam the spread of the religion reached central China in substantial numbers for the first time.

For most of the fourteenth century much of the Muslim world was controlled by four dynasties, the Marinids in the west (1217–1465), the Mamluks in Egypt and Syria (1250–1517), the Ilkhanids in Iran (1256–1335) and the Tughluqs in India (1320–1401). By the end of the century the Timurids (1370–1507) had emerged as dominant in most

Bernard O'Kane (2017), 'Architecture and Court Cultures of the 14th Century', in Finbarr B. Flood and Gulru Necipoglu (eds), *A Companion to Islamic Art and Architecture*, London, 585–615.

of the area formerly ruled by the Ilkhanids. This chapter will focus on these dynasties, and in particular on the wealthiest and most active patrons, the Mamluks and Mongols, including their rivalry for prestige (O'Kane 1996).

The large amounts of territory ruled over by all these dynasties meant that substantial revenues from trade and agriculture were available for state patronage, frequently expressed in architecture. Beyond that, what connections existed between these geographically disparate areas? To a major extent, all were outsiders. The Marinids were from the Berber-speaking Zanata tribe, the Mamluks were Turkish-speaking, imported as slaves and manumitted; the Ilkhanids, in the period we are considering, recently converted Mongolian-speaking nomads; the Timurids Turkish-speaking nomads, and the Tughluqs, Turkish- (and Persian-) speaking former amirs, ruling over a territory the bulk of whose population was non- Muslim. All therefore needed legitimisation, and conspicuous architectural construction, whether to display might through imposing buildings, to cement relations with the ulama (the religious classes) by the sponsorship of mosques and madrasas, or with more popular forms of piety through the erection of zawiyas, khanaqahs (respectively, less and more formal monastic institutions for Sufis), and pilgrimage complexes, was one of the surest ways to attain this.

Each of these dynasties inherited not just styles of building from their predecessors, but a physical landscape that to some extent limited their architectural choices. The primacy of available building materials dictated the choice of stone or brick, which in turn informed the decoration; usually tile with brick or carving on stone, supplemented by some stucco and carved or painted wood. There are many possible ways in which the architectural output of these dynasties can be studied. I will concentrate on two themes, the first secular, focusing on palatial and other domestic architecture, the second religious, focusing first on mosques and then on other religious ensembles.

Secular architecture

The Mamluks

We have more information and extant monuments in this category from the Mamluks than any of the other dynasties, so we may start there. The Mamluks were manumitted Turkish slave troops who usurped power from their predecessors, the Kurdish Ayyubids, in the middle of the thirteenth century, and went on to control the core of the Middle East: Egypt, Syria, and the holy cities of Mecca and Medina in the Hijaz. Having severed all family ties, they would be, at least in theory, fiercely loyal to their masters, but on the death of a sultan a nominal successor would be appointed while amirs jockeyed

behind the scenes to see who could muster the most support. There was a fast turnover of Mamluk sultans, but the efficacy of the system is demonstrated by the Mamluks' lengthy tenure of over 250 years, during which time they were the principal power in the Middle East.

Their seat of power in Cairo was also that built by their Ayyubid predecessors, the citadel. Of the actual royal palaces on the Cairo citadel nothing remains, but we do at least have drawings and a plan of the single most impressive Mamluk building there, the Iwan al-Kabir (Great Iwan), a domed ceremonial hall rebuilt by al-Nasir Muhammad in 1333–4. Its puzzling name for a domed hall arose because it replaced an earlier building on the same site that had an iwan as its main form. The hall was used for sessions of the *dar al-'adl* (court of justice) where the sultan held court on petitions from commoners to redress wrongs, and on separate occasions to distribute land grants to his amirs, and receive foreign ambassadors. It was monumental in scale, with, at just over 16 m diameter, the single largest dome in Cairo, supported on massive re-used Pharaonic columns. Like the other large domes there, it was made of wood but decorated with green tiles, as was its neighbour, the mosque of the same patron, also refurbished in 1335. The plan of the Iwan al-Kabir is an unusual one for the period, being partly basilical. This has been seen as a deliberate attempt to invoke the early eighth-century throne halls of the Umayyad palaces of Syria, harking back to a golden age of the caliphate in an area also under Mamluk rule (Rabbat 1995: 256–63).

Another Mamluk throne hall was built by Jakam, the Mamluk governor of Aleppo in 1406; it shared with its predecessor in Cairo its monumentality and high visibility, also being built in a prominent place on the citadel, in this case on top of the Ayyubid entrance. In the wake of Timur's invasion of Syria and the Mamluk sultan Faraj's unwillingness to confront him, Jakam made his own bid for the office of sultan (to which the throne hall can be related), although his premature death in battle in 1407 obviated a direct contest. The plan of Jakam's hall in Aleppo was quite different from the Iwan al-Kabir in Cairo, being a nine- bay one. But its span of just over 8 m diameter proved too long for the beams he had ordered from Baalbak; only ten years later under Sultan al-Mu'ayyad was the work finished with beams from the Damascus area (Herzfeld 1955: 94–5).

Although the sultan's residence at the Cairo citadel, the Qasr al-Ablaq (Striped Palace), has disappeared, the fragments that remain of some of the amirs' palaces in Cairo give us crucial information on the scale, form, and decoration of the finest Mamluk domestic architecture. The Palace of Qawsun (1336) has a main entrance portal unmatched in Cairo save for that of the adjacent complex of Sultan Hasan. Its enormous ground floor vaulted storeroom and stables[1] supported an upper floor *qa'a*, a reception hall consisting of two main axial iwans, each provided with deep recesses, and two small cross

iwans, with a sunken courtyard, probably covered, between them. The colossal scale of this space is evident in the distance between the back of the recesses of the iwans on the main axis: just over 40 m. The courtyard itself was 12.5 × 11.1 m. Its wooden roofing, probably also supporting a lantern, must have been an impressive technical achievement – the span is much greater than that of the Aleppo hall which Jakam was unable to finish.[2]

Other surviving fourteenth-century *qa'a*s in Cairo show that, even if the scale of Qawsun's palace was exceptional, they were only slightly less monumental. That of Bashtak in the centre of the old city has well-preserved ceiling decoration in its main iwan (1337). Like the nearby mausoleum of Qalawun, it displays octagonal wooden coffers painted with similar motifs, and of similar high quality.

Another of al-Nasir Muhammad's amirs, Tankiz, built the Dar al-Dhahab (Golden Palace) in 1328, reputedly at the time the single most valuable property in Damascus, of which he was governor. It has not survived, but some of its stonework, including a unique glass mosaic inlaid fountain, was incorporated in the late Ottoman 'Azm Palace that replaced it on the same site and shows that, whether for fine inlay or carved work, it was the equal of the better known religious buildings that have survived from the Mamluk period (Meinecke 1992: cat. no. 9C/222).

The fifteenth century shows a reduction in the scale of *qa'a*s. All now have much smaller vestigial side iwans, and the main iwans, instead of stone arches, have wooden corbels (known as *kurdi*s in the sources) leading to a flat arch. That of Sultan Qaytbay in the Bayt al-Razzaz is the largest, but that of the merchant Muhibb al-Din (c. 1400–50) preserves the most detail in its extensive decorative programme.[3]

Three *maq'ad*s (reception halls) from this period have been preserved. The only open one, part of the palace of the amir Mamay (1496), has an elevated balcony fronted by an arcade of five arches that originally overlooked an interior courtyard. It too has a superbly decorated wooden ceiling. Two closed *maq'ad*s, in which the open arcade is substituted by windows, were attached to the complexes of the sultans Qaytbay (1474) and al-Ghawri (1504–5). They point to an otherwise unusual gender segregation in Mamluk architecture, as they were reserved for family members of the founder.

The Marinids

The Marinids were a Berber dynasty of the Zanata group who ruled the western Maghrib (mostly equivalent to modern Morocco) from the mid-thirteenth until the mid-fourteenth century. They were the heirs of the Almohads (see Balbale, chapter 14) but were initially not inspired by their religious fervor. However, after the foundation

of their capital at Fas Jadid (New Fez) in 1276, they tried to harness the spirit of *jihad* (holy war) for the reconquest of Spain. They were unable to gain a permanent foothold there, although for a while in the mid-fourteenth century they controlled North Africa as far as Ifriqiyya (Tunisia).

The survival rate of Marinid palaces was poor. The principal monuments would have been in Fas al-Jadid, the administrative and royal foundation (by Abu Yusuf, begun 1276) that had its own walls, adjacent to the older town of Fez. The mosque has survived from this ensemble but not the palaces. However, what has survived is a very interesting account of the detailed involvement of the sultan Abu'l-Hasan in the planning of a house in Fez to accommodate his new Tunisian bride. Unable to find a suitable house, he specified that one be built with four domed rooms, each different and adjacent to two other rooms. The cedar wood used was to be carved and painted with floral and polygonal patterns; the ceilings of the abutting rooms were to differ from those of the dome chambers. The courtyard was to include columns and marble basins, and be paved with tile mosaic and marble. The doors, cupboards and grilles were to be made of marquetry, enhanced with gilded copper or silvered iron.

Some possible fourteenth- and fifteenth-century houses have survived in Fez, which may be simplified versions of the house above. They have rooms around a central rectangular courtyard, with columns supporting a portico on the lower floor and a balcony on the upper. There are large rectangular rooms on the main axes, with smaller rooms or staircases in the corners. The elevation and decoration of the finest showed much in common with contemporary fourteenth-century madrasas in Fez (Marçais 1954: 313–14).

With regard to Abu'l-Hasan's house at Fez, it has been remarked how its plan could be compared to the fourteenth-century Court of the Lions in the celebrated Nasrid palace at the Alhambra of Granada (Marçais 1954: 311; see Robinson, chapter 28). The comparison should not be regarded as too fanciful. The Marinid patrons were as wealthy as their Nasrid contemporaries and had similar tastes; the remaining fragments suggest that their vanished palaces may have been worthy competitors to the Alhambra. Some of the same elements can be seen in the remains of a palace at al-'Ubbad near Tlemcen, down the hill from the mosque and mausoleum of Shaykh Abu Madyan (also by Abu'l-Hasan, 1337), and presumably built as a royal residence for the sultan's pilgrimage visits. Three courtyards of varying size were surrounded mainly by long rectangular rooms; the most spacious had a basin, and a portico fronting it. The quality of its remaining stucco decoration was also comparable to that in the Fez madrasas.

The Ilkhanids and Timurids

The founder of the Ilkhanids was the Mongol Hulagu, grandson of Chinggis Khan. His successors ruled over Iraq, Persia and Transcaucasia, with the Seljuqs of Anatolia paying tribute to them. After the conversion of Ghazan Khan (r. 1295–1304) to Islam, state patronage of monuments greatly increased. Uljaytu (r. 1304–16), his successor and brother, moved the capital to his new foundation of Sultaniyya in north-west Iran, but it proved ephemeral (Blair 1986). After the death of the last ruler Abu Sa'id (r. 1316–35) the empire disintegrated rapidly into small principalities. Timur (r. 1370–1405) (known as Tamerlane in the West) was Turkish-speaking but raised in a Turko-Mongol milieu. He came to power in Central Asia, from where he expanded to control Iran, leaving his sons in charge of various provinces. He was also undefeated in his campaigns as far apart as Delhi (1398), Damascus (1401) and Ankara (1402), bringing back vast amounts of booty that he used for monuments large enough to match his ego. His successors ruled from Herat, with their domain reduced to Khurasan, Afghanistan, and Transoxiana in the second half of the fifteenth century.

Both the Mongols and Timurids were nomads, heirs to a tradition in which tents were the setting for the most important aspects of royal life, from ceremonies of allegiance, to reception of ambassadors, to celebratory feasts. The *urdu* (imperial encampment) that accompanied the Ilkhanid ruler on his travels was essentially a tented city, with, for instance, separate camps for the ruler and each of his wives. Even though none of these tents have survived, textual sources and manuscript painting provide abundant evidence of their monumentality and sumptuousness. For example, a tent with a thousand gold pegs was made for the Ilkhanid sultan Arghun (r. 1284–91) (O'Kane 1993: 250).

But the Irano-Islamic traditions that the Ilkhanids and Timurids encountered were oriented toward sedentary monarchs. Abaqa Khan was the Mongol patron of one of the first palace buildings at Takht-i Sulayman (Throne of Solomon, c. 1265–75), although its remote location, in Azerbaijan, far from any urban centre, perhaps made it more attractive to the patron's nomadic heritage. It seems to have had four irregularly spaced iwans around the central lake, partially built on the former Sasanian fire temple and palace at the site. Particularly important were the tiles recovered in and around two octagonal rooms attached to the western iwan: they displayed the first examples seen in Islamic art of Chinese phoenixes and dragons. Also important were lustre tiles with verses of the *Shahnama* (Book of Kings), relating the exploits of ancient Persian kings such as Kay Khusraw and Alexander the Great, heroes to whom the Ilkhanids wished to be compared. Nearby kilns show that, exceptionally, lustre potters were moved from their native Kashan to make tiles on the spot (O'Kane 2011: 179).

Timur's major foray into this genre, his Aq Saray (White Palace, 1379–96) at Shahr-i Sabz near Samarqand, was probably the largest of its kind, if we can judge by the staggering monumentality of its surviving entrance portal, still one of the most impressive walls of tilework ever built. It led into a courtyard just under 100 m wide, and judging by the Castilian ambassador Clavijo's comments, its interior was as impressive as its entrance (Golombek and Wilber 1988: 273–4).

The most common fusion of the nomadic and sedentary was in gardens. Ghazan Khan built a *chahar bagh* (partitioned garden) at Ujan near Tabriz with towers, pavilions and a bath, at whose centre were a golden circular trellis tent with a (much larger) tent of state provided with awnings. This was a precursor to the many Timurid examples, for which Timur himself set the standard, with some half dozen encircling the outskirts of Samarqand (Golombek 1995). Although some of these included pavilions, the most magnificent receptions areas, such as those seen by Clavijo in a feast hosted by Timur's wife Saray Malik Khanum, were in the tents erected within them (O'Kane 1993: 250). On occasion Timur could also transform a religious ensemble, such as the madrasa of Saray Malik Khanum in Samarqand, into the equivalent of a palace by pitching his tents in its courtyard. An added twist to his patronage is that some of his gardens seem to have been constructed in association with the marriage celebrations held there, and thereafter remained associated with those particular wives (Golombek 1995).

This method of maintaining a nomadic lifestyle in the vicinity of a city was retained by Timur's successors at their new capital Herat. The combination of pavilion and tent within a garden setting is best conveyed by the frontispiece to the Cairo National Library's copy of Sa'di's *Bustan*, illustrated by the celebrated Herati painter Bihzad. It shows Sultan Husayn, the last major Timurid ruler (1470–1506), within a courtyard presiding over a feast with a circular trellis tent with an awning behind him as well as a garden pavilion (O'Kane 1993: fig. 12). However, the inseparability of a pavilion and a formal partitioned garden is confirmed by the *Irshad al-zira'a*, an early sixteenth-century agricultural manual written by one who was formerly in Timurid employ, who takes it for granted that a pavilion, not centred but near one end of the main axial prospect, should be present (Subtelny 1993).

The Tughluqs

The Tughluqs (1320–1414) came to power by defeating a previous usurper. Ghiyath al-Din and his son Muhammad (r. 1325–51) were successful in defending their kingdom against Mongol Chaghatayid incursions, but Muhammad Shah's military acumen was not matched by leadership abilities. Excessive taxation and the move-

ment of the capital to Dawlatabad (1323–7) in the Deccan region of south India proved extremely unpopular. Timur's invasion in 1398 fatally weakened the sultanate, and various independent dynasties were established in the provinces.

The Moroccan traveller Ibn Battuta, who served nearly nine years as a *qadi* (judge) in Delhi for the ruler Muhammad ibn Tughluq, provides an invaluably detailed account. The paucity of Tughluq palace architecture may be explained by his remark that when a sultan died his palace was abandoned and a new one built. This was taken to extremes by the three main Tughluqid rulers, who built three successive capitals around Delhi at Tughluqabad, Jahanpanah and Firuzabad. Still, enough remains of the plan of the palace in the citadel at Tughluqabad of Muhammad ibn Tughluq's predecessor and the founder of the dynasty, Ghiyath al-Din Tughluq, to show that it was largely composed of two adjacent peristyle courtyards, the innermost with a four-iwan plan (Shokoohy and Shokoohy 1994: fig. 8).

The main audience hall of Sultan Muhammad at Jahanpanah, the Hizar Sutun (Hall of Thousand Columns) was composed of painted wooden columns and a carved wooden roof. Like the Tughluqabad palace, it was reached after passing through several gates. The name conjures up a hypostyle palace, but, although not mentioned by Ibn Battuta, it must also, like the Tughluqabad palace, have been fronted by a courtyard, since the ceremonies he mentioned involved the participation of over a hundred horses and elephants, together with many more soldiers. Sultan Muhammad, and presumably the other Tughluqid rulers, had also not quite left behind the nomadic habits of their predecessors, for Ibn Battua also mentions a number of special occasions on which state tents were erected within the palace complex (Ibn Battuta 1958–71: vol. 3, 667).

The frequency of wooden pavilions can also be adduced from the circumstances surrounding the death of Ghiyath al-Din Tughluq. He had asked his son Muhammad to build a riverside wooden pavilion (*kushk*), but he was fatally crushed when it collapsed (according to Ibn Battuta by design) during an elephant parade.

Mosques and other religious architecture

The Marinids

The foundation of Fas al-Jadid or New Fez (1276) was accompanied by the building of a congregational mosque there. Like many previous Maghribi mosques, it has a T-plan with a dome over the ante-mihrab bay, although its relatively small size (54 × 34 m) is reflected in the single bays that surround three sides of the rectangular courtyard. The much larger mosques in the adjacent older town obviated the need for a new building of any great size, and this applied to most of the towns that the Marinids occupied, with the

exception of Mansura, their new foundation, built while they were besieging Tlemcen.

The Mansura mosque has a foundation inscription on its portal mentioning Sultan Abu Ya'qub as the founder (1303); although it was worked on by Sultan Abu'l-Hasan when the Marinids retook Tlemcen (1336), it remained unfinished (Bouroubia 1973: 159–70). The plan has been uncovered by excavation and is exceptional in many ways. Unlike most earlier Magribi monuments it has a projecting entrance portal, surmounted in this case by the minaret. The courtyard is square rather than rectangular, and while it has a T-plan, the dome that in other mosques takes up the ante-mihrab bay is here replaced by a space 14 m square, covered by either a dome or, more likely, a pyramidal roof, that takes up nine bays in front of the mihrab. This element, as we shall see, is surprisingly close to the plan of the mosque built by the Mamluk sultan Baybars at Cairo (1267–9). Three sides of the monumental 38 m high minaret survive, and give some idea of the fine tile and carved decoration that might have graced other parts of the building.

Closer to Tlemcen, in the suburb of al-'Ubbad, is the mosque of Abu Madyan (1339), part of the shrine complex built by Sultan Abu'l-Hasan. This shares with Mansura the emphasis on a *pishtaq* (elevated portal), embellished on the outside with some of the finest tile mosaic in the Maghrib, and an impressive carved wooden cornice. It leads to a vestibule decorated with stucco panels on the walls and a *muqarnas* vault whose delicacy and complexity is matched only by those of the Alhambra. Unusually, from the vestibule a staircase leads down to the ablutions area, and up to a Qur'an school, another feature that suggests the influence of Mamluk Egypt. The mosque could be considered a simplified version of that of Fas al-Jadid, but it has some unusual features in its decoration, notably a grilled dome over the ante-mihrab bay that, instead of the more common ribs, has a naturalistic design of flowering shrubs, and in the arcades on the qibla side, barrel vaults decorated with plaster coffers that imitate the similar designs in wooden *artesonado* (coffered wooden) ceilings (Bouroubia 1973: 159–70).

The fame of Marinid architecture rests principally on the cluster of madrasas they erected, mostly at Fez, during eighty years of dynastic rule. After Abu 'Inan's madrasas at Meknes (1350) and Fez (1350–5), however, no Marinid building of importance was constructed. But by this time the madrasas may have fulfilled their primary purpose, which was to educate a group of Berber-speaking jurists loyal to the Marinid rulers and who would be able to challenge the former, principally Arabic-speaking members of the ulama (Shatzmiller 2000: 87–93). At this time the most prestigious location in which teaching was held would still have been the Qayrawiyyin Mosque in Fez (tenth century and later), so these madrasas had much to prove. The founder of the dynasty, Abu Yusuf Ya'qub, built the first, the

Saffarin madrasa in Fez (1271). It lacks the intricate decoration of its successors but contains many of the same ingredients: small scale, no exterior façade, a basin within the courtyard, a prayer hall that is large relative to the other spaces, student cells[4] and a minaret. It is the jewel-like courtyards of its successors such as the Sahrij (1321, Figure 2.1) and 'Attarin (1346), however, that typify the genre. Columns and dadoes are clad in tile mosaic and sgraffiato epigraphic tiles. Densely packed stucco fills the walls above, broken only by the equally complex carving of the wooden lintels and, crowning one's vision, intricate carved wooden cornices. The courtyard is normally surrounded by a corridor that leads to the student cells, but privacy is maintained by a wooden screen that has the further effect of limiting the space of the courtyard. What redeems these spaces from visual surfeit is indeed their restricted space, since the viewer can never be so far away that the details are imperceptible.

The situation is different in the largest of the Marinid madrasas, the Bu 'Inaniyya (1350–5). Ibn Battuta, asserting its superiority to madrasas elsewhere in the Islamic world claimed that 'this madrasa has no rival in size, elevation, or the decorative plasterwork in it' (Ibn Battuta 1958–71: vol. 2, 53; vol. 3, 584). He was of course mistaken in terms of its size and elevation, but it is precisely this combination of larger size and equally involved stucco that, despite the lack of a tiled floor, still results in details that blur when seen from the other side of the courtyard. In terms of plan, however, the Bu 'Inaniyya was exceptional in its accommodation of a two-aisled prayer hall provided with a minbar, which presents a façade of five open arches to the courtyard. This is a reflection of its dual character, for its foundation inscription mentioned that it was also designed as a venue for the obligatory Friday prayer. The prayer hall would normally have been used for teaching in these madrasas, but here it is made more accessible by an adjacent rear entrance. Perhaps because of this there is another innovation: two square chambers with wooden domes on the cross axis of the courtyard, just where one would expect to find an iwan in madrasas further east in the Islamic world. There are also many links between madrasas and residences, and in addition to the small scale of the Moroccan examples, these dome chambers provide a parallel with a larger scale residence, the roughly contemporary Court of the Lions of the Alhambra Palace in Granada (see Robinson, chapter 28). The exterior of this madrasa is also more interesting than usual. The entrance is marked by two arches that form a bay in front of the entrance; each of the four sides is decorated with stucco. And adjacent on the opposite side of the street was a unique water clock with bowls supported on finely carved wooden brackets. One final feature should be mentioned, its bronze-revetted main entrance door. This, also seen on some earlier Almoravid monuments (see Balbale, chapter 14), is typical of many of Marinid madrasas, forming a corpus surpassed only by those of Mamluk Cairo.

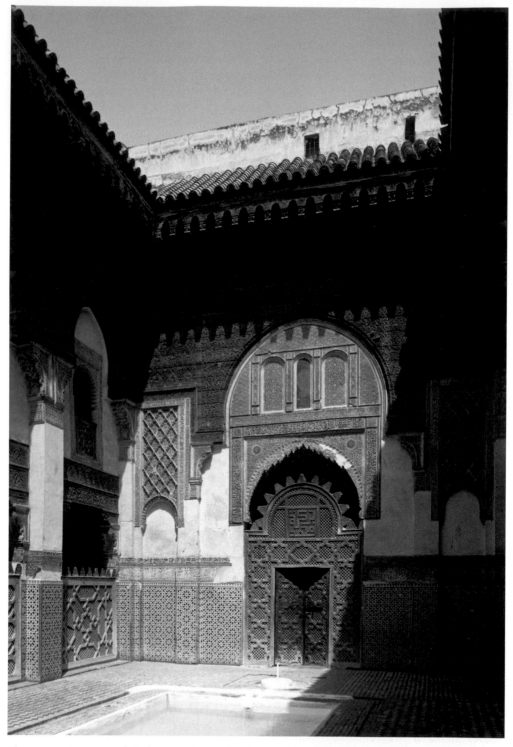

Figure 2.1 *Courtyard, Sahrij madrasa, Fez (source: B. O'Kane)*

The Mamluks

The major cities of Egypt and Syria had long had Friday mosques when the Mamluks came to power, so the scope for building new ones was limited. Cairo was the city where the sultans ruled from and on which they concentrated their patronage. Although the position of the Shafi'i law school (one of the four great law schools of Sunni Islam) on the building of Friday mosques was that there should be only one in each urban entity, the Hanafi school had no such restriction. This has a bearing on the first major Mamluk mosque, that of Baybars (r. 1260–77). The Hanafi Mamluk amirs had previously had disputes with the Shafi'i judges; in response Baybars abolished their judicial monopoly and made the four schools of law virtually equal.

Baybars needed a large clear site, and picked al-Husayniyya, north of the old Fatimid walled city, in close proximity to the *zawiya* of Shaykh Khidr (his spiritual adviser) which Baybars had previously erected for him. In 1266 Khidr advised Baybars not to travel to Kerak; Baybars set out but fell from his horse and injured his thigh. Shortly after his recovery two months later, he ordered the construction of the mosque. Since Ibn Shaddad, a contemporary historian, mentions that the sultan named the mosque al-'Afiya (Good Health), there was possibly a connection between these events. Baybars also ordered that the mosque should have a portal like that of his madrasa and a dome like that of the tomb of the famous jurist Imam al-Shafi'i (1211) erected over the mihrab. The wooden dome is no longer extant, but it was clearly built in competition with the almost equally large dome of the Ayyubid tomb of Imam al-Shafi'i, as shown by Baybars's appointment of a *khatib* (preacher) belonging to the rival Hanafi law school to his mosque, completed in 1269. In addition, when Jaffa was captured from the Crusaders in the following year, Baybars supervised the demolition of its citadel, and specified that its wood should be used for the *maqsura* (royal enclosure) of his mosque and its marble for the mihrab (Behrens-Abouseif 2007: 121–6).

The mosque has a hypostyle plan, in which the dome in front of the mihrab takes up the space of nine bays and constitutes the *maqsura*. This harks back to the Seljuq sultan Malikshah's insertion of a dome into the hypostyle prayer hall of the Isfahan Friday mosque in the late eleventh century; several Anatolian mosques had used variations on this plan in the meantime. The mosque of Baybars had three projecting portals, but the resemblance to the portal of his earlier madrasa in Cairo lay in the placing of a minaret above the gate; recently it has been shown that all three portals probably had minarets (Behrens-Abouseif 2007: 124).

This remained the largest of Mamluk congregational mosques. Under al-Nasir Muhammad, however, when the Mamluk economy was at its greatest and the population of the city was expanding,

the sultan and his chief amirs considerably increased the number of mosques. Al-Nasir Muhammad himself built two, one in the citadel (1318, rebuilt 1335) and another, the Jami' al-Jadid (New Congregational Mosque, 1312), on the Nile shore north between Fustat and the Fatimid city. The latter has not survived, but from its detailed description by the historian Ibn Duqmaq it seems to have been very similar to the citadel mosque. Both, like Baybars's mosque, had a domed *maqsura* taking up the space of nine bays in the hypostyle plan, and the Jami' al-Jadid may also have had three projecting entrance portals like Baybars's mosque. The Jami' al-Jadid also had a *maqsura* on its northern side for Sufis. This was presumably just a grilled enclosure, but it presages the building of complexes which would blur the distinctions between *khanaqah*, madrasa, and mosque in Mamluk society. The most notable complex is that of Sultan Hasan (1356–63), designated a congregational mosque (*jami'*) in its *waqfiyya* (endowment deed), although the space was also used by students of its madrasa. And in the fifteenth century such was the flexibility of these terms that on occasion the endowment deed and foundation inscription are at odds with the appropriate term, it being called madrasa in one and mosque in the other. Given this interchangeability, discussion of religious complexes is now in order.

There are several interrelated aspects of Mamluk patronage of complexes that should be considered. The prime consideration was undoubtedly piety, which is related to the concept of *baraka* (grace or blessing). This in turn led to other considerations: principally the building of mausoleums, but also to their inclusion within complexes and their siting in relation to the street and the qibla area. Building a mausoleum was still to some extent a controversial matter, but religious objections would clearly be less likely if the tomb chamber was attached to a larger building that had a specific religious function such as a mosque, madrasa, or *khanaqah*. Secondly, closely related to the building of complexes was the *waqf ahli*, the family endowment, whereby family members controlled the disbursement of *waqf* income, and were permitted to keep any surplus to the needs of maintaining the religious institution. For an official whose tenure of power was precarious and whose wealth could be confiscated if he fell into disgrace, this had the added advantage of securing most of his wealth for his family, since *waqf*s, at least in theory, were inalienable.[5] Thirdly is the question of street–qibla alignment in the most prestigious location for monuments, the densely settled old city and neighbouring quarters, which in turn is related to *baraka* and the siting of the mausoleum within complexes. Fourthly is the popularity of Sufism, which was reflected in the composition of complexes from the early fourteenth century onwards. We will explore how these concepts intersect in some of the most important examples erected in Cairo.

Sultan Qalawun's complex (1283–4) consisted of the combination of madrasa, hospital, and mausoleum (Figure 2.2). While fighting

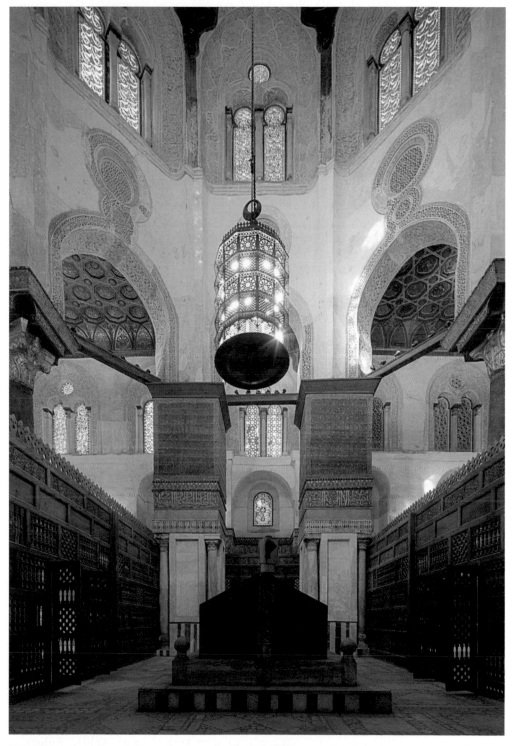

Figure 2.2 *Interior of mausoleum, complex of Qalawun, Cairo (source: B. O'Kane)*

against the Crusaders in Syria he had been injured and was subsequently treated at the hospital complex of Nur al-Din in Damascus (1154), also comprising the founder's madrasa and mausoleum. On his recovery he vowed to build a hospital in Cairo. The site was a central one of great prestige: that of the former western Fatimid palace in the centre of the Fatimid city, on the west of Bayn al-Qasrayn (the square between the two palaces).

Qalawun's complex has the mausoleum and madrasa adjacent to the street, but no part of the hospital façade abutted it. The site of the hospital may have been in part decided by the availability of at least part of a courtyard from the old Fatimid palace, since the northern iwan of the hospital has a T-plan whose closest parallels are with Fatimid housing in Fustat. But siting the mausoleum on the street was always a priority, since passersby were thereby more likely to offer prayers for the repose of the soul of the deceased. The *waqfiyya* ensured that the street outside reverberated with the chant of the Qur'an, since teams of Qur'an readers were employed to sit in the window niches for the benefit of those passing. The provision of a mihrab within the mausoleum, normal in earlier mausoleums in Egypt, would also have encouraged prayer for the occupant of the tomb, as would the six muezzins who gave the call to prayer from the adjacent minaret (despite it not being a building in which a *khutba* (sermon) for the Friday prayer could be given). The site of the minaret too was carefully chosen to ensure maximum visibility for those coming down the *qasaba*, the main artery of the old city of Cairo, from the north.

The building is also noticeable for its references to the plan and decoration of Umayyad predecessors. This is evident in the basilical plan of the qibla iwan of the madrasa, in the octagon made up of four piers and four columns supporting the mausoleum dome, all set within a square, a simplification of the plan of the Dome of the Rock in Jerusalem, and in its decoration with a variation of the *karma*, the vine scroll that was originally so significant in the interior of the prayer hall of the Great Mosque of Damascus (Flood 1997). Qalawun had spent a significant amount of time fighting the Crusaders in Syria and was presumably aware of the powerful messages of splendour and success that his models conveyed. This splendour was increased by the use of intricate polychrome inlay of stone and precious materials in the mihrab of the mausoleum, combining tiers of dwarf columns and variegated joggled voussoirs, a reworking of Ayyubid Syrian models that was to be copied in turn for decades in Cairene examples.

Although the street façade of the building was very narrow relative to its depth, its articulation was designed to bring maximum visual impact. For the first time it was provided with a regular series of deeply recessed niches framing triple-tiered windows, the highest consisting of novel double round-headed niches topped by a bull's-

eye. Running the length of the façade between the first and second tiers is a large foundation inscription band that devotes the bulk of its content to the founder's titles; polychromy would have made its impact even greater.

Baybars al-Jashinkir's complex (1307–10), consisting of a mausoleum and a *khanaqah*, was the first Mamluk one to make Sufis its prime focus. It is sited on a plot with a very limited street façade. The patron had the choice of placing his mausoleum far away from the street, beside the qibla iwan of the *khanaqah* to receive prayer from the Sufis, or far away from the qibla iwan, but on the street where passersby would be more likely to notice it (especially as it projected forcefully into the street); clearly street trumped qibla here. The two structures are also contrasted in terms of decoration, with the mausoleum receiving the finest marble inlay and painted ceilings (in its vestibule) of the time. Presumably it was thought that elaborate decoration would be a distraction for the austere Sufis, as even the mihrab of the *khanaqah*, the area usually reserved for splendour, is plain.

Although not a ruler of any great political or military distinction, Sultan Hasan has the honour of being responsible for the single most impressive Mamluk complex mentioned above (Kahil 2008; Figure 2.3). In one sense he was lucky to rule when the Black Death ravished Egypt, since so many complete families died that their inheritance passed to the state, swelling the amount available for building.

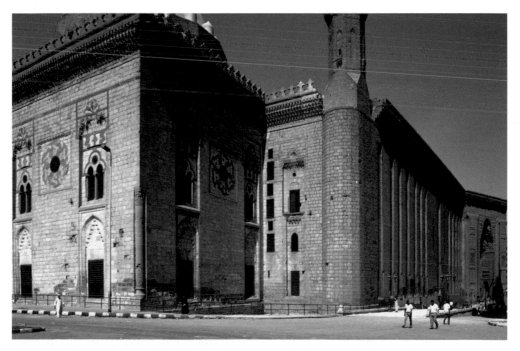

Figure 2.3 *Exterior, complex of Sultan Hasan, Cairo (source: B. O'Kane)*

Its location was carefully selected to display its huge bulk domi-
nating one side of the square beneath the citadel. So solid were its
foundations that on occasions rebelling Mamluks were able to drag
cannons up to its roof and fire towards the citadel. The return fire
barely caused pockmarks in the masonry, but subsequent sultans
ordered the staircases of the building destroyed to prevent any further
similar attacks.

The complex consists of the aforementioned four-iwan congrega-
tional mosque, with four madrasas, one for each Sunni school of law,
in its corners, a domed mausoleum (but which was also designated a
masjid or mosque in the *waqfiyya*) jutting out into the square, and a
vestibule preceded by a massive portal that was subtly tilted to make
it visible from the citadel. A doctor and ten medical students were
also mentioned in the endowment deed as occupying an upper floor
behind the entrance vestibule, an area now ruined (and which may
never have been completed) (Kahil 2008: 35–6).

The portal is the largest in Cairo. Its unfinished state (the patron
was assassinated before the complex was completed) shows how the
stone carving was at first lightly etched on the wall as guidelines for
more skilled masons to finish later. It was originally provided with
the largest of Cairo's metalwork-revetted doors (later transferred by
Sultan Mu'ayyad to his own complex), surpassed in craftsmanship
only by the door in the same complex leading from the qibla iwan to
the funerary dome chamber behind it.

Behind the street portal is the largest vestibule in Cairo, a dome
chamber that surpasses in height and decoration many of the finest
mausoleums in the city. Its octagonal lantern compensates for the
lack of windows, and spreads light evenly on its three *muqarnas*-
filled recesses. The mostly dark passageway from here to the court-
yard brings the viewer opposite the largest iwan in Cairo and makes
it all the more impressive. Mamluk chronicles reported that the
patron asked that it be made higher than the Taq-i Kisra, the still-
extant fabled iwan of the pre-Islamic Sasanian palace at Ctesiphon in
Iraq, and that this was duly accomplished. In fact, it is smaller, but
the assumption of superiority kept everyone satisfied.

One of the most striking features of the qibla iwan functioning
as a congregational mosque is the large stucco inscription band that
encircles it; the style is so-called Eastern Kufic, more common in
contemporary Qur'anic manuscripts. The supervisor of works, the
amir Muhammad ibn Bilik al-Muhsini, is known to have penned a
Qur'an as well as at least one of the inscriptions within the complex,
and it is quite possible that he himself designed many of its motifs,
which have much in common with the illumination of contemporary
Qur'anic manuscripts.

The ablutions fountain in the centre has a bulbous wooden
dome; this was probably also the shape and material of the mauso-
leum dome, later replaced in masonry. The projection of the tomb

chamber on three sides of the adjacent square gave it unprecedented prominence, one that was further emphasised by the provision in the *waqfiyya* for 24 groups of five Qur'an reciters to remind passersby to pray for the occupant of the tomb and to admire his beneficence.

The complex of Faraj ibn Barquq (1400–11), by contrast, was built in an isolated area in the desert – indeed the name in contemporary chronicles for the location is just that, the *sahara'*, desert, the area now known as the Northern Cemetery. The architect was thus unencumbered by the variations in street and qibla found within the old city. Its main components are a *khanaqah* and two mausoleums, together with ancillary rooms near the entrance, including two water dispensaries (*sabils*) combined with a *maktab* (Qur'an school) above, and small apartments for the founder's family. We also see here, as with the earlier *khanaqah* of Baybars, a dichotomy in the treatment of the mausoleums and the *khanaqah*: the asceticism of the Sufis apparently called for a lack of possibly distracting luxurious decoration, unstintingly applied to the mausoleums. Here, since this was a newly settled area, positioning the mausoleums beside a street for passersby was not an issue, so proximity to the main prayer area, the qibla prayer hall, was chosen instead. The mausoleums themselves have the largest stone domes in Cairo, with a diameter of 14.3 m and height of 30.4 m. Instead of the usual ribbing they display a more developed form of ornamentation with a zigzag pattern, above an undulating zone of transition.

By the time al-Ashraf Barsbay built his complex in the Northern Cemetery (1432) the urban context had changed; the area outside the main façade had become a well-travelled street leading towards the citadel. This meant that the siting of the mausoleum within the complex had to take into account this traffic of passersby. But the architect (or the patron) wanted the best of both worlds, that is, to also have it adjacent to the main prayer space. In the *waqfiyya* this prayer hall is designated as both a madrasa and as a *masjid* for the people of the neighbourhood to gather and hear the *khutba* on Fridays. But a regular plan of four iwans would have given this a much greater depth than that of the mausoleum, so a two-iwan plan was employed instead. Although described as iwans in the *waqfiyya*, they are in fact each simply wide rectangles fronted by an arcade of three arches; in between them is a *durqa'a*, a courtyard here modified into a strip, that also acts as a passageway to the mausoleum, emphasising its continuity with the prayer hall.

Adjacent to this madrasa/mausoleum unit was the *khanaqah* itself, whose major element was ten residential duplexes, as well as seven other cells for the Sufis, together with the usual service functions such as kitchen, stable, cisterns, and a large burial courtyard (*hawsh*).

The importance of the street was recognised not only in the placement of the mausoleum but now, for the first time, by splitting

the complex into units separated from the main one. Across the street was a *zawiya* (no longer extant) for poor Muslims, and a dome chamber for the Rifa'iyya Sufi order, indicative of the patron's desire to curry favour with both the official Sufis (at the *khanaqah*) and the more popular Rifa'iyyas.

At the complex of Qaytbay (1472–4), also in the Northern Cemetery, the earlier focus of Mamluk architecture on monumentality has given way to smaller scale buildings with a concentration on decoration. The living unit (*rab'*) for the students is not completely separate from the main building, which consists of a *sabil-maktab*, a madrasa, and a mausoleum with an adjoining funerary courtyard. The profile of the building on the exterior has the dome perfectly balanced with the minaret over the portal. The dome itself is the cynosure of carved stone domes in Cairo, with a unique combination of geometric and arabesque ornamentation carved on many levels.

The Ilkhanids and Timurids

Pre-Ilkhanid Iran was notable for the variety of its mosque plans, and this wide range continued in the Ilkhanid period. As in other areas, the larger cities were already provided with major mosques, so not many Ilkhanid congregational mosques were built; however, one stands out for its monumentality: that of the vizier 'Alishah in Tabriz (c. 1318–22). It was actually part of a complex consisting of a mosque, a mausoleum, a surrounding bazaar, a madrasa, a *khanaqah* and two baths, but given the fame of the only surviving element, which was part of the mosque, we will discuss it here. The walls were part of the qibla iwan, but their scale may be judged from the name by which it was later known, the *arg* (citadel). Indeed the qibla iwan was later used as a citadel, as the pockmarks caused by cannonballs on its façade show. Its size resulted from a deliberate order on 'Alishah's part to make it 10 cubits wider and higher than the Sasanian Taq-i Kisra, with which Sultan Hasan's later funerary mosque complex in Cairo is also said to have competed, as we have seen above. But the attempt backfired when the iwan in Tabriz fell not long after its construction. The Ilkhanid historian Mustawfi attributed its collapse to its having been built in too much haste, but a seventeenth-century drawing appears to show part of a semi dome on the qibla end; perhaps an experiment with transverse vaulting leading to this semi-dome led to its instability. Adding to the importance of the complex of 'Alishah is the influence that it and its architect had on the development of Mamluk architecture. For the Mamluk ambassador Aitamish, who visited Tabriz shortly after its completion, was so impressed by the minarets of the building that he brought their builder back to Egypt, where he inaugurated a short-lived fashion for tile decoration (Meinecke 1976).

We are not sure of the rest of the mosque's layout, but it is likely that it had a four-iwan plan. Its most surprising feature was a large pool in the middle of the courtyard, 150 cubits (63 m) square, which contained an octagonal pavilion in the centre with four lions at the corners from whose mouths water poured into the pool. Four boats provided access to it; the tradition of boating in it was maintained in the time of the Safavid Shah Tahmasp (d. 1576), when it may have become part of his palace at Tabriz (Grey 1873: 168).

The Friday mosque of Yazd was begun under the Ilkhanids in 1324 but proceeded slowly; its main iwan was only finished in 1334, and the revetment of the qibla dome chamber in 1375. But it displays three important innovations. The first is the opening of the back of the iwan to almost it full height so that from the courtyard a full view of the interior of the qibla dome chamber is possible. The second is the incorporation of upper-storey galleries both in the dome chamber and the iwan leading to it. The purpose of these is still not clear, although it is unlikely that they were meant for women. The third is a trend occurring in other monuments: namely the vastly increased use of tilework on the interior of the dome chamber. This varies from the brick and tile used for geometric patterns on the dome and for sacred names on the zone of transition to the complete tile mosaic on the mihrab spandrels, incorporating a unique epigraphic medallion with the names of 'Ali and Muhammad intertwined. Finally, one should note the cross-axial entrance iwan surmounted by two minarets, with a height and slenderness unmatched by any earlier combination of these elements.

The monumentality that characterises these Ilkhanid monuments was also characteristic of the monuments built by the Central Asian ruler Timur (r. 1370–1405). It was uppermost in Timur's mind when he ordered the building of his Friday mosque in Samarqand (1398–1405) (Figure 2.4), later known as the Mosque of Bibi Khanum, Timur's principal wife, on account of the earlier building of her funerary madrasa opposite. Started before Timur's Indian campaign, he was so dissatisfied with its scale on his return that he ordered the two supervisors executed and its height to be increased. Apart from its size it was also innovative in several ways. It had an exterior that was decorated on every side. Normally, in a large city it would be hard to obtain the free space necessary to achieve an unobstructed view of the building from the exterior, but Timur's earlier arrogant treatment of those who had objected to their houses being destroyed to make way for a bazaar shows his total disregard for the norms of Islamic property law in this matter (O'Kane 1987: 89).

The mosque's portal and qibla iwan incorporate minarets whose buttresses descend all the way to the ground. This reflects the design of the now vanished Friday mosque of Sultaniyya in Iran, the aforementioned capital built by the Ilkhanid ruler Uljaytu (r. 1304–16). The interior has the usual four-iwan plan, but for the first time in

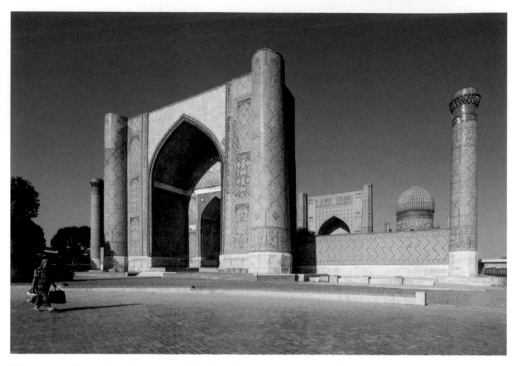

Figure 2.4 *Exterior of Mosque of Bibi Khanum, Samarqand (source: B. O'Kane)*

Iran dome chambers are found behind the two side iwans, a feature that was copied in the Safavid shah Abbas I's seventeenth-century new Friday mosque at Isfahan. This arrangement is found in the Jahanpanah mosque of Delhi (1343), which Timur had seen in 1398, and which may have inspired its counterpart in Samarqand. Timur's mosque was also unusual for the amount of carved stone used in it; this may be partly due to craftsmen taken back from his Indian campaign; at any rate elephants were used to transport the stone, as shown in a later painting by Bihzad depicting its construction process.

The only other two major Timurid mosques were built by Gawhar Shad, the wife of Timur's son Shahrukh, at Mashhad and Herat. That at Mashhad (1418) borrowed the Yazd Friday mosque's feature of the open qibla iwan. It also adapted the two-storey galleries of Yazd by placing them around the courtyard, although since the prayer halls below are of just one storey, they are merely façade architecture (O'Kane 1987: cat. no. 2).

As with the Mamluks, family *waqf*s were permissible in the Hanafi school of law followed by Iranian sovereigns in this period, so it is not surprising that the most impressive Ilkhanid and Timurid ensembles were erected by royal patrons, and that, like those of the Mamluks, they were also of a funerary nature.

Most of the greatest Ilkhanid ensembles have either not survived, or just a small fragment of them is extant. Chief among them must

have been the suburb of Ghazan Khan (Shanb) built near Tabriz (1295–1304). It was groundbreaking in the variety of functions collected in one place. In addition to a palace and garden for the founder, the monuments mentioned in the *waqfiyya* included his monumental tomb, a congregational mosque, a Hanafi and Shafi'i madrasa, a *khanaqah*, a *dar al-siyada* (a hospice for visiting sayyids, i.e. descendants of the Prophet), an observatory, a hospital, a library, a *bayt al-qanun* (House of Laws, serving as a repository for Ghazan Khan's promulgations), an academy of philosophy, a house for the overseer, a cistern and a bath. The tomb was 12-sided, with a sign of the zodiac decorating each side. It was the largest in the Islamic world at that time, with a height of 54.6 m and a diameter of 21 m (O'Kane 1996: 507).

Ghazan's brother Uljaytu made his tomb the centrepiece not just of a complex but an entirely new city, Sultaniyya. Earlier, he had sponsored many additions to the shrine of a ninth-century saint, Bayazid Bistami, including a mausoleum for one of Uljatyu's sons (Wilber 1955: cat. no. 28). Not all historians give the same list of components of Uljaytu's complex, but it seems to have included a mosque, madrasa and *khanaqah*, as well as a *dar al-siyada*. The remaining octagonal tomb (1310–20) is what gives the building its fame; at a height of 50 m and diameter of 25 m it clearly rivalled Ghazan's in monumentality (Figure 2.5). Original features included the eight partially preserved minarets that encircle the dome, and

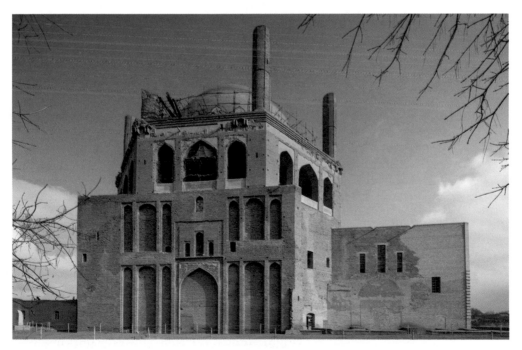

Figure 2.5 *Exterior of mausoleum of Uljaytu, Sultaniyya, Iran (source: B. O'Kane)*

below them, a stucco enriched gallery, much bigger that its possible model at the tomb of Sultan Sanjar (d. 1157, the last major Seljuq ruler) in Merv, eastern Iran, and a key landmark en route to later mausoleums such as the Taj Mahal in Agra. Its interior decoration was remodelled from tile to painted plaster after its dedication in 1313. The most plausible explanation for this momentous change is that the selection of Qur'anic inscriptions was designed to reflect Uljaytu's ambitions, supported by a contemporary military campaign, to be the protector of the holy shrines at Mecca and Medina (Blair 1987).

Another vanished complex was the Rashidiyya, a suburb of Tabriz, built by Uljaytu's vizier Rashid al-Din (c. 1300–18). The survival of its *waqfiyya* permits an accurate reconstruction. It included a hospice, a *khanaqah*, a hospital, and a tomb complex arranged around a four-iwan courtyard with summer and winter mosques and a room in which Rashid al-Din's works were to be copied for distribution within Ilkhanid territory (Blair 1984).

Many Timurid complexes also incorporated a mausoleum. Timur again showed his penchant for the grandiose in the shrine he built at the tomb of Shaykh Ahmad Yasavi at Yasa (now Turkistan city in Kazakhstan, 1397–9). He replaced its original twelfth-century mausoleum with an impressive double-shell domed structure, and adjoined it with an even bigger dome for the centrepiece of the shrine, a meeting hall (*jama'at khana*) for Sufis. The massive entrance iwan was never finished, but all the other sides of the buildings were completely faced with *banna'i* tilework.

Timur was himself ultimately buried in the Gur-i Mir in Samarqand (1404), the tomb that he himself had erected for his grandson Muhammad Sultan, beside the latter's madrasa and *khanaqah*. As with his Friday mosque in Samarqand, it was reputed that he expressed dissatisfaction with its size and ordered it to be built higher. It is unlikely that the whole building was pulled down and re-erected in ten days, as Clavijo reported, but it is possible that the drum was made higher to compensate, explaining its rather ungainly proportions.

A novel funerary structure is the shrine of 'Abdallah Ansari at Gazur Gah, just outside of Herat, built by Timur's son Shahrukh (1428) (O'Kane 1987: cat. no. 9). Where a grave already existed, the Timurids were inclined to leave it uncovered in a building commemorating its occupant. The shrine at first appears similar to contemporary madrasas, with an entrance complex leading to a courtyard surrounded by cells, but the eastern side of the courtyard, in which the grave is located, has a curtain wall instead, intended to solemnify the surroundings of 'Abdallah Ansari's resting place.

This building, like Gauhar Shad's complexes at Mashhad and Herat, was built by Qavam al-Din Shirazi, the sole Timurid court architect to be mentioned in contemporary histories. The complex at Herat

consisted of the mosque, mentioned above, and a funerary madrasa, now the only surviving element (apart from a minaret) (O'Kane 1987: cat. no. 14). It is notable for its innovative vaulting, consisting of intersecting vaults producing a smaller square that is in turn roofed by a shallow dome on *muqarnas* squinches. An even more impressive example of this scheme was used by Qavam al-Din in the madrasa at Khargird (1444) (founded by the vizier Pir Ahmad Khafi), where it is topped by a lantern (Figure 2.6). The accompanying axial recesses in these rooms lend further ambiguities to their spatial quality, the whole leading to a blending of the older tripartite division of cube, zone of transition and dome (O'Kane 1987: cat. no. 22).

The Tughluqs

Early mosques of the Tughluqs did not lack for scale: that (now ruined) of Ghiyath al-Din Tughluq at his eponymous city was 110 m each side; the Begampur Mosque (1343) of his successor Sultan Muhammad at Jahanpanah is 90 × 94 m. The Begampur Mosque is largely intact. Its plan has been often described as the first four-iwan one in India, but this is inaccurate. There are indeed iwans on the main axis, in conjunction with a dome chamber, but on the side axis the dome chambers stand alone, not preceded by any *pishtaq*. However, this arrangement is still innovative, recalling, surprisingly, that of the Marinid Bu 'Inaniyya madrasa in Fez, discussed above. A characteristically Indian feature is the stone eaves that project from the courtyard arcades. Another innovation is the nine-bay *maqsura* adjoining the north-west corner, provided with its own mihrab, presumably for the royal entourage; an analogous feature appears in the Qutb Mosque, the first Friday mosque of Delhi (1192), and may have its origins in the Ghaznavid and Ghurid mosques of Afghanistan. Like other Tughluq buildings, the mosque features sloping walls, and stucco covered rubble masonry. However, the meager decoration within the qibla dome chamber is a disappointing contrast to the scale of the building, although around the interior of the courtyard the remains of carved stucco ornament are still visible, while the spandrels of the arches on the exterior façade were filled with blue-glazed lotus flowers, one of the earliest occurrences of such tilework in the architecture of the Delhi Sultanate (Welch and Crane 1983).

The Jami' of Firuzshah (c. 1354) at Firuzabad is raised on a plinth, the lower stories presumably being used for rent-producing shops. Like the Begampur mosque it had a staircase leading to a domed entrance pavilion, but the interior is too ruined to be sure of its layout. However, its importance to the founder is shown by the reports that his *Futuhat*, an apologia for his reign, was carved on a dome chamber supported on eight pillars at the centre of the courtyard. This is a sharp contrast to the usual, but surprising, lack of epigraphy on Tughluq architecture. But its text exemplified another interesting

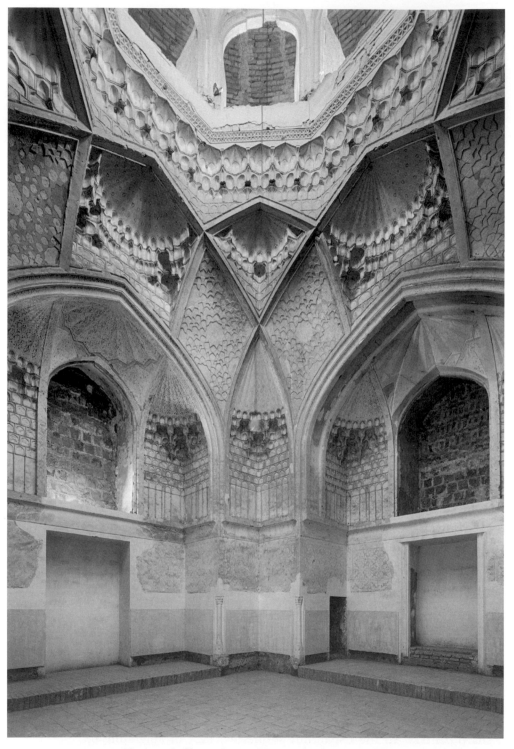

Figure 2.6 *Interior of lecture hall, madrasa, Khargird (source: B. O'Kane)*

trend in Sultanate India, the adoption of Persian for important inscriptions, especially foundation texts, before this became normal in other parts of the Persian-speaking world (O'Kane 2009). Adjacent to the mosque is its minaret, the so-called Lat Pyramid, almost a step well in reverse in that the lower part of its core is solid. However, contemporary sources refer to it as the *minar* of the mosque, and to the re-used third-century BCE Ashokan pillar that crowns it as the *minar-i zarrin*, the gilded minaret. Firuzshah clearly had in mind as its prototype the fifth-century Iron Pillar re-used in the Qutb Mosque of Delhi, and the contemporary history the *Sirat-i Firuzshahi* celebrates this re-use of a Hindu monument in an Islamic setting, made all the more meritorious through the difficulties of transporting it from its place of origin nearly 200 km away (Flood 2003).

The Khirki Mosque at Jahanpanah is now thought to date from the early part of Firuzshah's reign, probably before Firuzabad was begun. It is also raised on a plinth, and shares the same squat square stone pillars for the hypostyle area as the Begampur Mosque. The plan is totally different, however, taking symmetry to the ultimate level. The core is the nine-bay plan, itself one of absolute symmetry. This is set within a five by five grid, producing 25 units, of which four are opened for courtyards. The three axial projecting domed entrances are also mirrored by the projecting mihrab dome. It looks great on paper, but in practice the gloom that envelops the main axis from the entrance to the mihrab betrays the poverty of invention, one again exacerbated by the lack of decoration.

Of much greater aesthetic appeal is the Adina Mosque (1374) at Pandua in Bengal, built by Sultan Sikandar Shah of the rival Ilyas dynasty. It is even bigger than any of the Tughluq examples, being 154 × 87 m. The plan is hypostyle, with a monumental iwan inserted on the qibla side. Like the Begampur Mosque, it has a nine-bay annexe, although in this case it leads into the *zenana*, a mezzanine floor for the founder's family inserted into part of the qibla prayer hall. The great appeal of the building lies in the quality of its decoration: the carved stucco, brick and stone show remarkable variety and invention. The tympana of the 34 bays along the qibla wall show an outstanding variety of carved brick ornamentation. The mihrab in the qibla iwan combines the lushness of Hindu-derived ornamentation with panels of impeccable classical *thuluth* calligraphy, the latter enriched by a floriated scroll in light relief. Almost more impressive are the three polylobed stone mihrabs in the *zenana*, with the same combination of Hindu-derived plus geometric ornamentation and classical Islamic calligraphy, and in addition, on their tympana, astonishing variations on chinoiserie lotus and peony floral elements, the like of which is seen nowhere else in pre-Mughal India.

As in Ilkhanid Iran, the single most impressive extant monument from the Tughluq period is a mausoleum: that of Shaykh Rukn-i 'Alam at Multan (c. 1335–40), now in Pakistan (Figure 2.7)

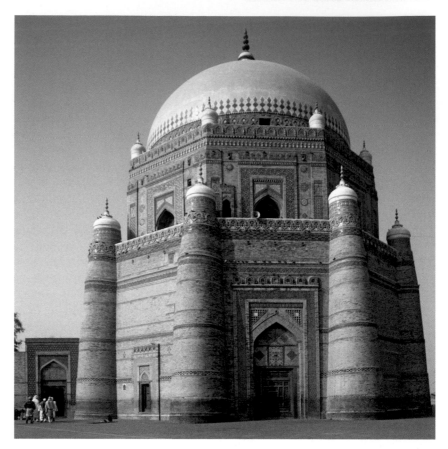

Figure 2.7 *Exterior of mausoleum of Rukn-i 'Alam, Multan
(source: B. O'Kane)*

(Hillenbrand 1992). Astonishingly for such a magnificent building, we have no information from epigraphy or the sources on who built it or when it was built. The oft-quoted story that Ghiyath al-Din Tughluq built it while he was governor of Dipalpur (240 km northeast of Multan) for himself is not borne out by any contemporary text. When the shaykh died in 1335 he was at first buried in the tomb of his grandfather, and only later transferred to the present mausoleum. The most likely possibilities are that it was completed shortly after his death, and commissioned either by the reigning Sultan Muhammad, or by the members of the wealthy Suhrawardi Sufi order to which the shaykh belonged.

The 30 m high dome is made more imposing by its elevated location in the citadel. The octagonal exterior is emphasised by eight massive buttresses, each capped by a domed finial, in turn echoed in smaller versions on the cornice of the upper gallery. This gallery can be seen as a variation on the earlier external galleries of equally monumental tombs such as those of Sultan Sanjar at Merv and Uljaytu

at Sultaniyya, culminating in the seventeenth century at the Taj Mahal. The exterior as a whole is enlivened by bands of terracotta, set off against inventive combinations of brick and tile, the latter encompassing mostly monochrome glazed white, turquoise and dark blue, but which are also occasionally merged in the relatively new technique of underglaze-painted tiles.

The interior is distinguished by its wooden mihrab, prominently displaying the seal of Solomon on the spandrels, a favourite decorative motif in later Mughal architecture. Its mastery of shallow-relief vegetal ornament is a surprising contrast to the awkwardness of the calligraphy of its framing inscription. The use of tile-work is more restrained on the interior, being chiefly concentrated on the shallow squinches, which also display a unique wooden artichoke-like pendent.

Ghiyath al-Din's tomb at Tughluqabad near Delhi (1325) is much smaller but impresses on account of its materials, one of the first sultanate buildings, after the 'Ala'i Darwaza, the monumental gateway added to the Qutb Mosque of Delhi by Sultan 'Ala al-Din Khilji (r. 1290–1316) to use the combination of red sandstone and marble that was to become a favourite of the Mughals. But even with this use of expensive ashlar masonry, so different from the usual plaster-covered rubble walls of other Tughluq buildings, restraint is the order of the day. The polylobing of the outer arched niches is the only exception; even the interior marble mihrab has just this polylobing and carved engaged columns, the rest is plain. The original setting of the tomb was within an artificial lake, recalling the later tomb of Sher Shah Sur at Sasaram. However, the high walls that surround the mausoleum would have made the distant lakeshore view less effective.

The combination of madrasa (1352) and mausoleum (1388?) is also found at the madrasa founded by Firuzshah at the Hauz Khas in Delhi, although their chronology is not secure – the mausoleum may even have been built by Firuzshah's successor Nasir al-Din Muhammad Shah. The two-storey madrasa is an extremely imposing structure, built in two stories in an L shape (the façades are 76 m and 138 m long) at the side of the pool (hauz), with arcades punctuated by large and small domes that are further articulated by projecting balconies with wide eaves. The mausoleum is a domed square, made of plaster-covered rubble masonry. The exterior is plain, but elaborate stucco decoration is used for the squinches and dome. It has been suggested that this belongs to the restoration of the tomb by Sikandar Lodi (1507),[6] but the style is in keeping with fourteenth-century work.

Conclusions

The major dynasties of the fourteenth-century Islamic world inherited vastly different subjects, territories, and cultural traditions,

leading naturally to equally forceful differences in the architecture produced under their patronage. But one feature is common to them all: patronage was very much a top-down affair, with the rulers commanding most of the resources and therefore commissioning the most important buildings.

The Marinids controlled the least amount of territory. Whether their own architectural patronage was affected by the over ambitious grandiose architectural projects of their predecessors, the Almoravids (such as the unfinished mosque of Hassan at Rabat) is unclear, but their preferences for jewel-like miniatures is striking, unlike the monumental structures of the other three dynasties. This is reflected in two trends that, not surprisingly, have been noted in contemporary Nasrid work at the Alhambra: interiorisation and sensuousness. The confinement of exterior decoration to portals leads to an even greater sense of awe at the finish of the interiors.

Even when the opportunity arose, as at Fas Jadid, to impress their aesthetic upon an urban blank slate, its Friday mosque was smaller than its predecessor in the neighbouring old city. This could be categorised as pragmatic restraint, an admirable recognition of the unlikelihood of their new foundation outstripping the older city, but it remains in stark contrast to the other dynasties. Types of Marinid foundations also differ radically from the others, with not a single mausoleum known for a secular ruler. The Maliki school of law's antipathy both to tombs and family endowments was clearly a major social and architectural force here.

In addition, the preponderance of madrasas should be noted. In the three other territories considered in this piece there were tensions between organised and popular religion, usually between the *khanaqah* and the madrasa; but the lack of Sufi institutions in the Maghrib exposed a conflict instead between the ruling Zanata Berber-speaking jurists and the entrenched Arabic-speaking urban ulama. The madrasas were the rulers' chief weapon in this conflict.

Mamluk patronage is exceptional in many ways. Some of the interrelated concepts that characterise it, such as *baraka*, the building and placing of mausoleums within complexes, and the *waqf ahli* have been discussed earlier. But we should also notice the concentration of monuments in the dynasty's capital, Cairo. While it is true that sultans occasionally erected important monuments in Jerusalem or Medina (places of pilgrimage rather than the commercially more important urban centres of Aleppo and Damascus), they preferred Cairo for the vast bulk of their projects, leaving patronage in the provinces to the amirs who were appointed as governors there. It is surprising that the Mamluk aesthetic progressed from the monumental to a concentration on ornamentation. In the fifteenth century one way in which this was manifested was in a series of carved stone domes that are unique in the Islamic world.

The nomadic background of the Mongol Ilkhanids and Timurids ensured that their taste for palaces was oriented towards tents. But from the point of Ghazan Khan's conversion to Islam onwards they invested in the conventional range of Islamic structures, and more than that, in an unusual number of complexes, some with an equally unusual variety of functions.

Both the Ilkhanids and Timurids, at least until the end of Timur's reign, invested heavily in monumentality. This was partially accompanied by attenuation of proportions, leading to taller and narrower iwans and dome chambers, the latter, in the Timurid period, exaggerated by double domes. It was also accompanied by greatly increased use of tilework, to the point where it could be used to sheathe whole interiors or exteriors in colour. The corollary was that now exteriors of large building were meant to be seen. Chinoiserie decoration, only rarely present in Mamluk architecture, and not at all in the Maghrib, was pervasive.

The Tughluqids commanded probably the largest territory of all, although much of their efforts went into protecting it from Mongol incursions and internal feuds. Their peripheral status is shown by their extensive use of Persian, also their literary language, for foundation inscriptions, rather than the Arabic than was standard elsewhere (O'Kane 2009). Nevertheless, their ambitions are shown in the foundation of three separate cities within Dehli by the first three sultans. But this came with a price: the use of more ephemeral building materials, rubble and stucco, permitted fast large-scale construction, but left them at an aesthetic disadvantage that was not compensated for by sheer monumentality. Only in the Punjab, where the available building materials necessitated brick and tile decoration, did they produce a single building (the Rukn-i 'Alam) that was the equal of the finest monuments of their contemporaries.

The fourteenth and fifteenth centuries mark the period before what has been considered a major turning point in Islamic history, the rise of the three major early modern empires, Ottoman, Safavid and Mughal. Were the earlier centuries of similar import?

The fourteenth century witnessed the remarkable growth of the madrasa, frequently allied to a multifunctional complex, and, except for the Maghrib (because of antipathy to it by the dominant Maliki legal school), a concomitant rise in institutions for Sufis such as zawiyas and khanqahs. This reflects, especially in the fifteenth century, the growing blurring of the roles of the ulama and Sufis. Ibn Battuta's peregrinations in the fourteenth century between the Maghrib and China, either staying in Sufi institutions or gaining employment as a qadi, anticipates this change. Under the Mamluks, Ilkhanids and Timurids domed dynastic mausoleums were frequently added to these institutions, reflecting both a lingering hostility to individual tombs by the ulema, and the wish to control complexes through family endowments.

The three succeeding dynasties, Ottoman, Safavid and Mughal, each borrowed much from the Timurids, particularly in the decorative arts. The Ottoman vogue for Iznik tiles might not have been so pervasive without the work of an atelier from Tabriz in the fifteenth century (O'Kane 2011). Safavid architecture, although not directly derivative like that of the Uzbeks, owes many of its features to Timurid models. And given that the Mughals still called themselves the Timurids, the continuity in forms of double domed mausoleums, vaulting and decorative motifs is hardly surprising.

Notes

1. The palace was actually referred to as an *istabl* (stable) in the sources.
2. The huge scale of these buildings is reflected in the household expenditures of the Mamluks, besides which the construction of a mosque was a modest expenditure: Behrens-Abouseif 2007: 48.
3. It has an inscription with a fourteenth-century date, but on stylistic grounds it cannot be other than fifteenth-century.
4. Here on the ground floor, supplemented in later madrasas by ones on the upper storey.
5. Even sultans such as Qaytbay and al-Ghawri skewed the surplus to be as much as 90 per cent of the *waqf* income: Petry 1998: 57.
6. Perhaps because of a restoration inscription added by him: Welch 1989: 190, n. 38.

Bibliography

Abu-Lughod, J. (1989), *Before European Hegemony. The World System A.D. 1250–1350*. Oxford: Oxford University Press.

Behrens-Abouseif, D. (2007), *Cairo of the Mamluks*. London: I. B. Tauris.

Blair, S. (1984), 'Ilkhanid Architecture and Society: An Analysis of the Endowment Deed of the Rab'-i Rashidi'. *Iran* 22: 67–90.

Blair, S. (1986), 'The Mongol Capital of Sultaniyya, "The Imperial"'. *Iran* 24: 139–51.

Blair, S. (1987), The Epigraphic Program of the Tower of Uljaytu at Sultaniyya: Meaning in Mongol Architecture'. *Islamic Art* 2: 43–96.

Bouroubia, R. (1973), *L'Art religieux musulman en Algérie*. Algiers: S.N.E.D.

Flood, F. B. (1997), 'Umayyad Survivals and Mamluk Revivals: Qalawunid Architecture and the Great Mosque of Damascus'. *Muqarnas* 14: 57–79.

Flood, F. B. (2003), 'Pillars, Palimpsests, and Princely Practices: Translating the Past in Sultanate Delhi'. *Res* 43: 95–116.

Golombek, L. (1995), 'The Gardens of Timur: New Perspectives'. *Muqarnas* 12: 137–47.

Golombek, L. and Wilber, D. (1988), *The Timurid Architecture of Iran and Turan*. Princeton: Princeton University Press.

Grey, C. (trans. and ed.) (1873), *A Narrative of Italian Travels in Persia*. London: The Hakluyt Society.

Herzfeld, E. (1955), *Inscriptions et monuments d'Alep. MCIA, deuxième partie, Syrie du Nord*, 2 vols. Cairo: Mémoires de l'IFAO, no. 76.

Hillenbrand, R. (1992), 'Turco-Iranian elements in the medieval architecture of Pakistan: The case of the tomb of Rukn-i 'Alam at Multan'. *Muqarnas* 9: 148–74.

Ibn Battuta (1958–71), *The Travels of Ibn Battuta A.D. 1325–1354*, 3 vols. Trans. from the Arabic by H. A. R. Gibb. Cambridge: The Hakluyt Society.

Kahil, A. (2008), *The Sultan Hasan Complex in Cairo 1357–1364: A Case Study in the Formation of Mamluk Style*. Beirut: Orient-Institut.

Marçais, G. (1954), *L'Architecture musulman d'Occident*. Paris: Arts et Métiers Graphiques.

Meinecke, M. (1976), Die mamlukischen Fayencemosaikdekorationen: Eine Werkstätte aus Tabrız in Kairo (1330–1350). *Kunst des Orients* 11: 85–144.

Meinecke, M. (1992), *Die Mamlukische Architektur in Ägypten und Syrien (648/1250 bis 923/1517)*. 2 vols. Glückstadt: Abhandlungen des Deutschen Archäologischen Instituts Kairo. Islamische Reihe, Band 5.

O'Kane, B. (1987), *Timurid Architecture in Khurasan*. Costa Mesa, CA: Undena Press and Mazda Publications.

O'Kane, B. (1993), 'From Tents to Pavilions: Royal Mobility and Persian Palace Design'. *Ars Orientalis* 23: 245–64.

O'Kane, B. (1996), 'Monumentality in Mamluk and Mongol Art and Architecture'. *Art History* 19: 499–522.

O'Kane, B. (2009), *The Appearance of Persian on Islamic Works of Art*. New York: Encyclopaedia Iranica Foundation.

O'Kane, B. (2011), 'The Development of Iranian *cuerda seca* Tiles and the Transfer of Tile-work Technology', in J. Bloom and S. Blair (eds), *And Diverse Are Their Hues: Color in Islamic Art and Culture*, New Haven: Yale University Press.

Petry, C. (1998), 'A Geniza for Mamluk Studies? Charitable Trust (*waqf*) Documents as a Source for Economic and Social History'. *Mamluk Studies Review* 2: 51–60.

Rabbat, N. (1995), *The Citadel of Cairo*. Leiden: Brill.

Shatzmiller, M. (2000), *The Berbers and the Islamic State*. Princeton: Markus Wiener.

Shokoohy, M. and Shokoohy, N. (1994), 'Tughluqabad, the Earliest Surviving Town of the Delhi Sultanate'. *Bulletin of the School of Oriental and African Studies* 57: 516–50.

Subtelny, M. (1993), 'A Medieval Persian Agricultural Manual in Context: The Irshad al-Zira'a in Late Timurid and Early Safavid Khorasan'. *Studia Iranica* 22: 167–217.

Voll, J. (1994), 'Islam as a Special World-system'. *Journal of World History* 5: 213–26.

Welch, A. (1989), 'A Medieval Center of Learning in India: The Hauz Khas Madrasa in Delhi'. *Muqarnas* 13: 165–90.

Welch, A. and Crane, H. (1983), 'The Tughluqs: Master Builders of the Delhi Sultanate'. *Muqarnas* 1: 123–66.

Wilber, D. N. (1955), *The Architecture of Islamic Iran: The Il Khanid Period*. Princeton: Princeton University Press.

CHAPTER THREE

The Mausoleum of Yayha al-Shabih Revisited (with Bahia Shehab)

The shrine of Yahya al-Shabih is the most monumental surviving Fatimid dome chamber. The decision to place its foundation inscription at the apex of the dome, where it is very difficult to read, was peculiar. However, now that it has been deciphered, it yields a narrow range for the building of 1154–60 and a term in connection with the founder, 'amal, that is usually reserved for craftsmen. Rather than invoking Iranian parallels, its plan should be seen as a variation of earlier Fatimid shrines. It contains excellent examples of Fatimid calligraphy showing the simultaneous work of different craftsmen on the wooden cenotaph surrounds, as well as an unusual twentieth-century cenotaph.

THE MAUSOLEUM OF Yahya al-Shabih in the southern cemetery of Cairo has long been a notable place of pilgrimage.[1] It was the burial place of several notable 'Alid descendants who died in the ninth century, including Yahya al-Shabih, named for his resemblance to the Prophet. The dome chamber later erected over their graves by the Fatimids has a span of 7.5 m, making it the widest and tallest of any surviving Fatimid dome chamber. It is of interest not just because of its monumentality, but because of its unusual plan, with an ambulatory on three sides and an attached oratory with an open courtyard. Until now there was no firm information regarding its dating but the decipherment of a previously unread inscription shows that it was erected in the reign of Caliph al-Fa'iz (r. 1154–60).

Creswell was the first to study its architecture in detail. He was able to show how the arcades within the courtyard of the oratory were a later addition, possibly dating from the time of Isma'il 'Asim Pasha, an official of Muhammad 'Ali, who is buried in the small room on the *qibla* side of the oratory. (Figure 3.1, D) More evidence for the later dating of the arcades is the recent uncovering of the

Bernard O'Kane (2016), (with Bahia Shehab) 'The Mausoleum of Yayha al-Shabih Revisited', in Alison Ohta, Michael Rogers and Rosalind Wade Haddon (eds), *Art, Trade, and Culture in the Near East and India: From the Fatimids to the Mughals*, London, 48–55.

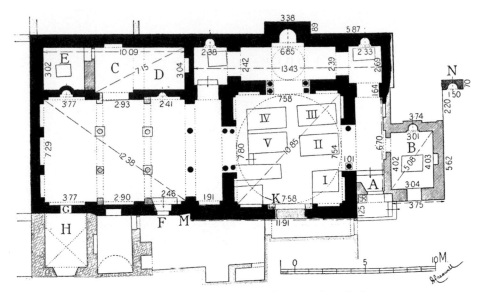

FIG. 160. MAUSOLEUM OF YAḤYĀ ASH-SHABĪH: plan. Scale 1:200.

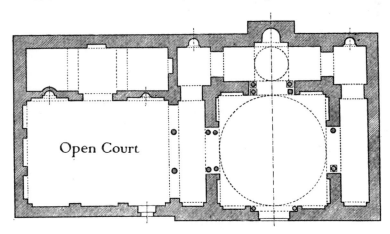

FIG. 161. MAUSOLEUM OF YAḤYĀ ASH-SHABĪH: proposed reconstruction.
Scale 1:200.

Figure 3.1 *Shrine of Yahya al-Shabih, plan (after Creswell,* The Muslim Architecture of Egypt, *vol. 1, Oxford, 1952, figs 160–1)*

base of a column between the ambulatory and the oratory, which is at a much lower level than the column bases within the courtyard, marking the difference between the twelfth-century and nineteenth-century floor levels (Figure 3.2).

However, the original plan may have been even less symmetrical than Creswell's reconstruction shows. Yusuf Raghib has noted that the medieval pilgrimage guides mention the dome chamber adjacent to the south-west wall as being the tomb of one Yusuf al-Mutawwaj,

Figure 3.2 *Shrine of Yahya al-Shabih, view of courtyard (photo: O'Kane)*

a miracle-working brother of Sayyida al-Nafisa.[2] The flat ceiling of this room is modern, as seems to be much of its masonry; Creswell averred that it dated no earlier than the nineteenth century. However, this is to ignore its mihrab, which, as Raghib noted, has a fluted hood and ends in *muqarnas* similar to the three mihrabs that are to be found on the ambulatory. Because the other walls of this room may indeed be later, it is not clear whether there was any link with yet another mihrab that stood a little way to the south of this room (Figure 3.1, N). This no longer extant mihrab had stucco decoration, a cast of which was made and placed in what is now the Museum of Islamic Art.[3] Although its spandrels and upper frieze display work whose closest stylistic parallels are with tenth-century work, its hood is fluted like the other four within the mausoleum, suggesting that it was reworked when the mausoleum was built. Because of the evident extensive rebuilding on this side, it is impossible to be sure of the original plan with complete accuracy. But it should be noted that the placement of mihrab N is aligned with the south-east wall of the dome chamber. There is at least a possibility that the mihrab was

incorporated into a larger extension on the south-west side, possibly open.

The fame of the monument rests on it being the burial place of one popularly called Sidi al-Shabih or al-Shabihi, although, as Raghib pointed out, he is also known in the medieval sources as Yahya the brother of Nafisa or as Ja'far al-Sadiq.[4] Four of the large cenotaphs in the main dome chamber display a total of five marble tombstones dating from the ninth century (Figure 3.3). Another ninth-century tombstone was discovered by Raghib in room E of the annexe.[5]

The epigraphy

The evidence for dating the monument comes from the epigraphic medallion at the apex of the dome. At first glance this is insignificant, especially since, due to its small size and height, its decipherment by the naked eye is impossible (Figures 3.4 and 3.5). Van Berchem did not mention it;[6] Creswell only noted that there was a small calligraphic medallion at this point;[7] Raghib stated it was made of plaster and simply asserted that it contained the Shi'i profession of faith.[8] It does indeed but this is just the beginning of the outer circle which reads as follows:

لا اله الا الله علي ولي الله، الفائز بنصر الله أمير المؤمنين الملك الصالح وزيره

la ilaha illa allah ali wali allah, al-Fa'iz bi-nasr Allah amir al-mu'minin al-malik al-salih waziruhu
There is no deity but God, 'Ali is the friend of God. Al-Fa'iz bi-Nasr Allah, the Commander of the Faithful; al-Malik al-Salih.

'Amir al-Mu'minin' is written in smaller letters above 'al-Malik al-Salih'. The two personages referred to here are the Fatimid Caliph al-Fa'iz (r. 1154–60) and the vizier al-Malik al-Salih Tala'i', whose tenure in that office was just one year longer, 1154–61. The monument therefore dates from the reign of al-Fa'iz. The inner medallion also has interesting information:

عمله احمد ابن اسماعيل الطرابلسي

'amalahu Ahmad ibn Isma'il al-Tarabulsi
Ahmad b. Isma'il al-Tarabulsi made it.

We can be quite sure of this reading, for the same person is mentioned in the earliest surviving pilgrimage guide to the Southern Cemetery. The author of the *Murshid al-ziwar* notes that the *mashhad* of Yahya al-Shabih is a large building (*mashhad kabir*) and that it was built (*banahu*) by Abu'l-Khayr and his relatives, or, in a variant reading of the manuscript, by Abu'l-Khayr Ahmad b. Isma'il al-Khazraji

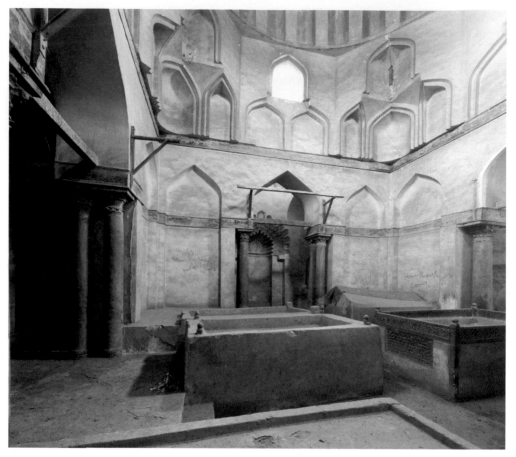

Figure 3.3 *Shrine of Yahya al-Shabih, view of main dome chamber (photo: O'Kane)*

al-Tarabulsi.[9] What is particularly interesting in this, is the verb in
the medallion used to indicate al-Tarabulsi's activity: *'amal.* Had
we not had the account in the *Murshid al-ziwar*, we would have
assumed that al-Tarabulsi was the craftsman. A related example may
be an inscription at the mosque of al-Lamati at Minya.[10] There are
two inscriptions at the entrance to the mosque. This first is engraved
on a terracotta panel above the entrance to the mosque and tells us
that the mosque was ordered to be built on 26 Muharram 578/June
1182. The other inscription, also incised, and in an identical script,
on the lintel of the mosque, reads: 'Murtafi' ibn Mujalli ibn Sultan
al-Misri built (*sana'ahu*) this blessed mosque. May God have mercy
on whoever reads this and asks for mercy for him and his mother
and father.'[11] Garcin interpreted this as the signature of the architect
and suggested it was a restoration inscription, the original having
been built at the time of al-Salih Tala'i'. But it seems unlikely to us
that an architect would have received such prominence without any
mention of the patron having been made; the presence of prayers

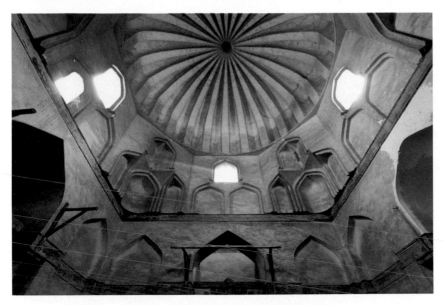

Figure 3.4 *Shrine of Yahya al-Shabih, view of dome interior (photo: O'Kane)*

for his family would also be more to be expected in the context of a patron, rather than an architect or craftsman. Given both of these examples, it would behove scholars to revisit the automatic assumption that an inscription beginning with *'amal* will be followed by the name of a craftsman rather than that of a patron.

The placement of the foundation inscription at the apex of the dome is surprising. However, we have very few surviving Fatimid foundation inscriptions with which to compare it. At al-Guyushi and al-Aqmar they are over the entrance portal; at al-Hakim on the entrance and minaret;[12] and at Sayyida Ruqayya on the base of the dome. At Sayyida Ruqayya the small size of the letters makes the inscription barely more legible that that of Yahya al-Shabih.

At the time of the Fatimid construction of the dome chamber the cenotaphs were rebuilt and wooden friezes were added to three of them. Each of these contains part of Quran 2:255, usually known as 'The Throne Verse'. But although these were added at the same time and were part of the same decorative scheme, what is most interesting about these panels is their differences. Each of the four cenotaphs ends on a different part of the verse (Figures 3.6–3.8).

The text coloured grey at the end of the throne verse on each cenotaph shows where the artisan ran out of space. The blue number marks in brackets placed within the text indicate the divisions of the text on each of the four sides of the cenotaphs and the red letters on cenotaphs II and III are ones that the artisan mistakenly omitted.

The placement of the inscription is not consistent on the three cenotaphs. On I and III it goes clockwise continuously from right

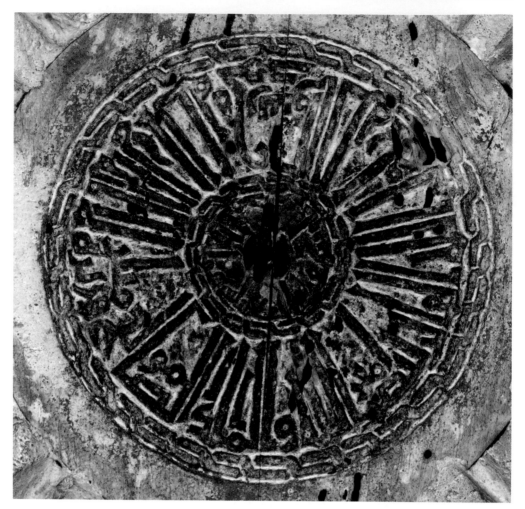

Figure 3.5 *Shrine of Yahya al-Shabih, detail of epigraphic medallion (photo: O'Kane)*

to left, as one would expect, although the beginning is on opposite sides. On II at the moment the panels are placed to be read in an anti-clockwise direction. It is unlikely that this was planned originally; sides two and four were probably switched in a later restoration of the tomb.

A comparison of the same parts of the text from the different cenotaphs yields some interesting findings. Although the three bands are in a very similar style of Kufic with vegetal scrolls with trefoil leafs in the background, a close inspection of the individual letters reveals differences on every side; no two words are drawn in precisely the same manner. On side one of cenotaph III (Figure 3.8) the letter *ra* of *al-rahman* and *al-rahim* moves in a straight line towards the end, but on cenotaphs I and II it curves up into two different vegetal scrolls. The letter *ha* on the word *huwwa* in the first line on the

بسم الله الرحمن الرحيم اللّهُ لاَ إِلَـهَ إِلاَّ هُوَ

الْحَيُّ الْقَيُّومُ لاَ تَأْخُذُهُ سِنَةٌ وَلاَ نَوْمٌ لَّهُ مَا فِي السَّمَوَاتِ وَمَا فِي الأَرْضِ مَن ذَا الَّذِي

يَشْفَعُ عِنْدَهُ إِلاَّ بِإِذْنِهِ يَعْلَمُ مَا بَيْنَ أَيْدِيهِمْ

وَمَا خَلْفَهُمْ وَلاَ يُحِيطُونَ بِشَيْءٍ مِّنْ عِلْمِهِ إِلاَّ بِمَا شَاء وَسِعَ كُرْسِيُّهُ السَّمَاوَاتِ وَالأَرْضَ

Figure 3.6 *Shrine of Yahya al-Shabih, inscriptions of cenotaph I, sides 1–4*

three cenotaphs is drawn in three different ways. Cenotaph II has the most knotting of the *lam-alif*s and has more scrolling on the letter *waw*. There is a distinctive shape of the *lam-alif* that curves to one side which can be seen on cenotaph II only, (Figure 3.7) where it is repeated three times on side 2 on the words *wa la nawm* and *al-ard*, and on II, side 4, on the word *ila*. Cenotaph II has the most text from the Throne Verse, with only the last four words missing; cenotaph I has the last eight words missing and cenotaph III the last nine.

It can be concluded from this that the artisans who carved the wooden beams did not work from a drawing. Had they done so the three inscriptions would have started and ended in the same place and would have been carved in the same style. Different artisans, possibly from the same workshop, could have carved the beams. The epigraphy on cenotaph II is slightly more elaborate than the other two and more of the text of the Throne Verse is included on it. One could argue from this that the artisan of cenotaph II was more skilled than the artisans who engraved the other two cenotaphs. Another possibility is that one artisan carved cenotaph II after finishing cenotaphs III and I respectively, since III is the cenotaph with slightly less floriation and much more text missing at the end. However, it may be unlikely that one artist's style and competence would

بسم الله الرحمن الرحيم اللّهُ لاَ إِلَـهَ إِلاَّ هُوَ ا

الْحَيُّ الْقَيُّومُ لاَ تَأْخُذُهُ سِنَةٌ وَلاَ نَوْمٌ لَّهُ مَا فِي السَّمَاوَاتِ وَمَا فِي الأَرْضِ مَن ذَا الَّذِي يَشْفَعُ

عِندَهُ إِلاَّ بِإِذْنِه يَعْلَمُ مَا بَنْنَ أَيْدِيهِمْ وَمَا خَلْفَهُمْ

وَلاَ يُحِيطُونَ بِشَيْءٍ مِّنْ عِلْمِهِ إِلاَّ بِمَا شَاء وَسِعَ كُرْسِيُّهُ السَّمَاوَاتِ وَالأَرْضَ وَلاَ يَؤُودُهُ حِفْظُهُمَا

Figure 3.7 *Shrine of Yahya al-Shabih, inscriptions of cenotaph II, sides 1–4*

have changed so much in the course of carving the three cenotaphs; different craftsmen from the same workshop is a more plausible explanation.

A parallel example at the Museum of Islamic Art, Cairo, is a group of three wooden friezes with palmette designs taken from an unknown monument, probably dating from the fifth/eleventh century (Figure 3.9).[13] These three panels are quite curious because they contain the same exact phrase, *al-mulk li'llah al-wahid al-qahar*, and were removed from the same site, but the quality of epigraphy and engraving is very different. The frieze displayed on the lower tier is very crudely engraved and the last word *al-qahar* is spelled with a *mim* instead of a *ha*. The top frieze has very thick and crude letters. The middle one is much more refined. The letters are slimmer and more elegant than the other two, which have cruder, much thicker letters. This difference in the quality of carving is also reflected on the design of the palmettes decorating the sides of each panel. One might think that the frieze in the middle is a final artwork, while the other two friezes are tests in preparation for it.

One other cenotaph, ignored until now, merits some discussion. (Figures 3.1D and 3.10) According to Creswell, Isma'il 'Asim Pasha was a high official of Muhammad 'Ali.[14] We have been unable to verify this, although he apparently had a son, Muhammad Pasha

بسم الله الرحمن الرحيم اللَّهُ لاَ إِلَـهَ إِلاَّ هُوَ

الْحَيُّ الْقَيُّومُ لاَ تَأْخُذُهُ سِنَةٌ وَلاَ نَوْمٌ لَّهُ مَا فِي السَّمَاوَاتِ وَمَا فِي الأَرْضِ مَن ذَا ا

الَّذِي يَشْفَعُ عِنْدَهُ إِلاَّ بِإِذْنِه يَعْلَمُ مَا بَيْنَ أَيْد

ِيهِمْ وَمَا خَلْفَهُمْ وَلاَ يُحِيطُونَ بِشَيْءٍ مِّنْ عِلْمِهِ إِلاَّ بِمَا شَاء وَسِعَ كُرْسِيُّهُ السَّمَاوَاتِ وَ

Figure 3.8 *Shrine of Yahya al-Shabih, inscriptions of cenotaph III, sides 1–4*

'Asim (d. 12 December 1896), who in turn had a son named Isma'il Pasha 'Asim (d. 16 May 1936).[15] However, the cenotaph is dated with a restoration inscription of 1374/1944–5. Why he was buried here in the first place and what occasioned a renewal of the cenotaph are still to be determined. However, it is worth celebrating on account of several unusual features for such a late period: it is made of wood, the calligraphy is *nasta'liq*, and the quality of the calligraphy is excellent.

The plan

In an uncharacteristic flight of fancy, Creswell suggested that the resemblance of the plan of the building to a Sasanian fire temple[16] 'does not need emphasizing', although 'how its design came about remains a mystery, for the two are separated by seven centuries and fourteen hundred miles'.[17] Equally surprising, Raghib was also taken by the resemblance, although he correctly noted that the lateral galleries were favoured in several pilgrimage sites for their aid to circumambulation.[18] However, much closer geographical and chronological parallels are at hand, namely the shrines of al-Guyushi and Sayyida Ruqayya.[19] Each has a dome chamber surrounded on three

Figure 3.9 *Inscription panels, Museum of Islamic Art, Cairo, inv. nos 12934–36 (photos: Shehab)*

sides by ambulatories. The main difference is the orientation: at al-Guyushi and Sayyida Ruqayya the gallery is missing on the qibla side, while at Yahya al-Shabihi it is missing on the side opposite the qibla. And, as Creswell pointed out, the plan of Yahya al-Shabihi was quite possibly replicated in two other Fatimid shrines, those of Qasim Abu Tayyib and Umm Kulthum.[20] One could even argue that the courtyard of Yahya al-Shabihi is a variation of al-Guyushi and Sayyida Ruqayya. At Yahya al-Shabihi it is at the side instead of being axial, perhaps due to some previously existing structure on the side opposite the qibla that made an axial plan impossible.

The decoration

Apart from the wooden panels discussed above, three main carved mihrabs, each displaying

Figure 3.10 *Shrine of Yahya al-Shabih, cenotaph of Isma'il 'Asim Pasha (photo: O'Kane)*

fluting emanating from a central medallion, are the principal decoration within the building, Creswell used this as a dating criterion, claiming that the shrine should be dated about 1150, 'but not later, on account of the circular medallion in the centre, a feature which is wanting in all dated scalloped niches, from the mosque of al-Salih Tala'i' (555/1160) onwards, with two exceptions only'.[21] The exceptions he notes are the mausoleum of the Abbasid caliphs and the entrance of the mosque of Baybars. This was also a principal reason for his placing of the mausoleum of al-Hasawati in the first half of the twelfth century.[22] Now we know that this feature at Yahya al-Shabihi dates from 1154–60, the possibility should be entertained that al-Hasawati may similarly be later.

The shrine of Yahya al-Shabih is the most monumental surviving Fatimid dome chamber. The decision to place its foundation inscription at the difficult to read location of the apex of the dome was peculiar. However, now that it has been deciphered, it yields a narrow range for the building of 1154–60 and a term in connection with the founder, 'amal, that is usually reserved for craftsmen. Rather than invoking Iranian parallels, its plan should be seen as a variation of earlier Fatimid shrines. It contains excellent examples of Fatimid calligraphy showing the simultaneous work of different craftsmen on the wooden cenotaph surrounds, as well as an unusual twentieth-century cenotaph.

Notes

1. The main sources are van Berchem, M., *Matériaux pour un Corpus Inscriptionum Arabicarum*, part I: Égypte, Mémoires de l'IFAO 19, Cairo, 1894–1903, pp. 23–7; Creswell, K. A. C., *The Muslim Architecture of Egypt*, vol. 1, Oxford, 1952, pp. 264–9; Su'ad Mahir, *Masajid Misr wa awliya'uha al-salihun*, Cairo, 1971–6, vol. 2, pp. 1315; Raghib, Y., 'Les sanctuaires des gens de la famille dans la cité des morts au Caire', *Rivista degli Studi Orientali* 51, 1977, pp. 61–72; Williams, C., 'The Cult of 'Alid Saints in the Fatimid Monuments of Cairo. Part II: the Mausolea', *Muqarnas* 3, 1985, pp. 50–1; Muhammad 'Abd al-Sittar 'Uthman, *Mawsu'a al-'imara al-fatimiyya*, al-kitab al-thani, 'imarat al-mashahid wa'l-qibab, Cairo, 2006, pp. 90–110; Faraj Husayn Faraj al-Husayni, *al-Nuqush al-kitabiyya al-fatimiyya 'ala al-'ima'ir fi masr*, Alexandria, 2007, pp. 330–2. It is a great pleasure to offer this piece to Doris, an excellent companion on many field trips to Cairo's monuments.
2. Raghib, Y., 'Les sanctuaries', pp. 70–1.
3. Creswell, K. A. C., *Muslim Architecture of Egypt*, pp. 15–18; Flury, S., 'Ein Stuckmihrab des IV. (X.) Jahrhunderts', *Jahrbuch der Asiatischen Kunst* 2, 1925, pp. 106–10.
4. Raghib, Y, 'Les sanctuaires', p. 63.
5. Raghib, Y., 'Les sanctuaires', p. 70.
6. Van Berchem, M., *Matériaux pour un Corpus Inscriptionum Arabicarum*, pp. 23–7;
7. Creswell, K. A. C., *Muslim Architecture of Egypt*, p. 264.

8. Raġib, Y., 'Les sanctuaires', p. 64.

9. Al-Muwaffaq Ibn 'Uthman, *Murshid al-zuwwar ila qubur al-abrar*, ed. Muhammad Fathi Abu Bakr, 2 vols, Cairo, 1995, p. 419; this passage was first noted in Raghib, Y., 'Les sanctuaires', p. 65.

10. Garcin, J.-C., 'La mosquée al-Lamati à Minya', *Annales Islamologiques* 13, 1977, pp. 101–12.

11. Garcin, J.-C., 'La mosquée', pp. 103–4.

12. Now disappeared, van Berchem, M., *Matériaux pour un Corpus Inscriptionum Arabicarum*, p. 50.

13. Museum of Islamic Art, Cairo, top frieze inv. no. 12934; middle frieze inv. no. 12935; bottom frieze inv. no. 12936.

14. Creswell, K. A. C., *Muslim Architecture of Egypt*, vol. 1, p. 266.

15. We are grateful to both Khaled Fahmy and Hussein Omar for providing us with this information.

16. For a good summary of current research, see Dietrich Huff, ČAHĀRṬĀQ, *Encyclopedia Iranica*, <http://www.iranicaonline. org/articles/cahartaq> (last accessed 20 June 2015).

17. Creswell, K. A. C., *Muslim Architecture of Egypt*, vol. 1, pp. 268–9.

18. Raghib, Y., 'Les sanctuaires', pp. 64–5.

19. Creswell, K. A. C., *Muslim Architecture of Egypt*, vol. 1, pp. 155–60, 247–53.

20. Creswell, K. A. C., *Muslim Architecture of Egypt*, vol. 1, pp. 269–70.

21. Creswell, K. A. C., *Muslim Architecture of Egypt*, vol. 1, p. 268.

22. Creswell, K. A. C., *Muslim Architecture of Egypt*, vol. 1, p. 260.

CHAPTER FOUR

The Mosques of Egypt:
An Introduction

What is a mosque?

> Whenever the time of prayer comes, pray there, for that is a
> mosque. (The Prophet Muhammad)[1]

THE WORD MOSQUE is derived from the Arabic *masjid*, meaning
a place of prostration. The other main word used is *jami'*, meaning
a congregational or Friday mosque. As can be seen from the above
saying of the Prophet Muhammad, there are no architectural require-
ments for prayer, making the definition of a mosque as a building a
difficult if not impossible task.

In many Islamic countries, but perhaps especially in Egypt, the
multiplicity of building types in which prayer was regularly carried
out cautions against any attempt to apply a narrow definition. One
of the simplest ways to recognise a place where prayer is encouraged
is to look for the presence of a mihrab, a niche, frequently deco-
rated, in the qibla wall. There have been various interpretations of
the meaning of the mihrab. Popular opinion has it that it serves to
identify the qibla wall in a mosque, but its frequent invisibility from
most areas within the building makes this unlikely. The form was
an honorific one in the pre-Islamic world, and many early sources
report that its first appearance was in the enlargement of the Mosque
of Madina by al-Walid in the early eighth century. There it was not in
the centre of the qibla wall, but marked the spot where the Prophet
had led the prayers as the imam of the first Muslim community.[2] It
has been suggested that it reflected the throne niche of pre-Islamic
palaces,[3] but its subsequent appearance not only in congregational
mosques but also in all neighbourhood mosques implies that it
served to commemorate the Prophet in his role as the first imam,
the leader of the community in prayer. Its intimate connection with
prayer then led to its being incorporated into other buildings such
as mausoleums.[4] This latter option became more common where
crypts were introduced into mausoleums, letting designers designate

Bernard O'Kane (2016), 'Introduction', *The Mosques of Egypt*, Cairo, xi–xliv.

the main storey as an oratory, and so lessening the objections of some religious scholars to the building of mausoleums in the first place.[5] In Egypt the preference for a multiplicity of mihrabs is indeed first apparent in Fatimid mausoleums, and the slightly later Ayyubid Mausoleum of Imam al-Shaf'i even has a fourth mihrab, correcting the orientation of the earlier triple-mihrab. Another indication of the importance of not just private but communal prayer in shrines is the number of portable wooden mihrabs made for them; they must have been needed when the attendees spilled out on to the areas adjoining the shrine.[6]

Some of the basic tenets of Islam have traditionally been described as its Five Pillars. The first is the *shahada*, bearing witness that there is but one God and that Muhammad is His prophet. Not surprisingly, this is one of the most common inscriptions found on mosques. The second is the requirement to pray five times a day. The centrality of prayer is reflected in the preponderance of neighbourhood and congregational mosques in the Islamic world. Muslims are encouraged to pray together, but this is obligatory only at the noon prayer on Fridays. It was desirable that a mosque should be able to accommodate all of the local inhabitants, so clearly there was a need for large buildings in many towns. However, washing is necessary to achieve a state of ritual purity, so ablutions facilities were a normal adjunct to mosques. The call to prayer was given by the sound of the human voice, originally from the rooftop of the mosque. The benefit of tall towers for this purpose, both to aid the dispersion of the call and to advertise the presence of mosques, soon led to minarets becoming standard features of larger mosques, although exactly when this happened in Egypt is a matter of dispute.[7] In congregational mosques a sermon (*khutba*) preceded the prayer, during which the imam sat on a minbar (pulpit); these, usually made of wood, attracted some of the finest craftsmanship of the day.

Another pillar of the faith was the requirement to perform the pilgrimage to Mecca. One of the unexpected consequences of this was the ease with which ideas, including artistic innovations, were quickly spread across the Islamic world. Artists and craftsmen who made the pilgrimage increased their opportunities for contacts. They may already have travelled a considerable distance to the Hijaz, and so if patronage had withered in their homeland they could more easily take their expertise to a patron in a neighbouring country. We will see many buildings in Egypt that are reflective of forms and styles coming from other areas of the Muslim world, east and west.

Most of the buildings in this book are exclusively or primarily mosques – but in addition, mausoleums, madrasas, *khanqah*s (residences for Sufis), and shrines are also represented here. The distinction between mosques, madrasas, *khanqah*s and *zawiya*s (small Sufi residences) became very fluid in the Mamluk period; from the second quarter of the fourteenth century, Friday prayer

began to be permitted not only in some of those institutions but even in *turba*s (funerary complexes) in the cemeteries of Cairo.[8] Prior to the Mamluk period the primary legal school in Egypt was the Shafi'i, which permitted only one Friday mosque in each urban entity. But the Hanafi school, favoured by the Mamluks, had no such restriction. The expansion of Friday prayer into multiple institutions is reflected in the number of buildings in Cairo by the end of the Mamluk period in which Friday prayer was permitted: 221 in total.[9] The function of buildings thus often changed over time, and of course, in contemporary Egypt, where Sufis no longer live in *khanqah*s and where religious students are educated in universities, former madrasas and *khanqah*s have become the equivalent of not just *masjid*s, or neighbourhood mosques, but also of congregational mosques for much of the population. As noted above, the presence of a mihrab within a monument is an indication that it was intended for prayer, of at least a private nature. This applies to almost all mausoleums, whether the body was buried in a crypt or in the ground well below any grave marker that signalled the presence of a burial. This surprising development is emphasised by endowment deeds that occasionally specifically stated that the dome chambers were designated as *masjid*s, with that of Sultan Hasan, for instance, having its own imam for Friday prayers. Prayer within or in the proximity of mausoleums was encouraged by founders for the spiritual merit (*thawab*) that they could convey for the soul of the deceased. In the case of shrines, the transfer of blessings could also be reciprocal. Pilgrims prayed for the pious intercession of the person buried at the site, but also wished to partake of the grace or blessings (*baraka*) bestowed there on visitors.

This array of building types also reflects the multiplicity of functions that the mosque performed within Muslim society. It was always a place of social gathering, and it was not unusual for commercial transactions to be carried out in it as well. Meals could be eaten within, and some of the major mosques, such as al-Azhar, at times even acquired many permanent residents. Recitations of the Quran or of the hadith were regularly performed, sometimes by personnel appointed in the *waqf*. During Ramadan especially, it was a place of retreat for many inhabitants of a city. Before the rise of the madrasa it was the main place of education, and before the rise of *zawiya*s and *khanqah*s in the thirteenth century, a place for ascetics who preached to their followers. Nasir-i Khusraw's description of the mosque of 'Amr in Cairo, which he visited in the middle of the eleventh century, conveys some of this diverse activity:

> Inside there are always teachers and Quran-readers, and this mosque is the promenade of the city, as there are never less than five thousand people – students, the indigent, scribes who write checks and money drafts, and others.[10]

Early Islamic Egypt to the end of the Ayyubids (640–1250)

Byzantine rule in Egypt had already been considerably weakened by the beginning of the seventh century, when the Sasanians launched a successful invasion of Syria and Egypt. They were forced to retreat, but it was only in 628 that the Byzantine emperor Heraclius succeeded in gaining back the territory that had been lost. Heraclius celebrated his return to power in Egypt by appointing Cyrus, formerly a bishop of Phasis in the Caucasus, to rule from Alexandria. Cyrus was a militant Diophysite, a follower of the orthodox Byzantine interpretation of the two natures of Christ, unlike the Copts who followed the Monophysite party. This had major consequences following the astonishing early conquests of the Muslim armies in Syria. The Muslim general 'Amr ibn al-'As took complete control of Egypt in the short span of three years, from 639 to 642. The ease with which he was able to do this may partly be attributed to the divided loyalties of the Copts, who formed the bulk of the rural population, as to whether they should be ruled by their persecutors, the Byzantines, or a new conquering power.[11]

'Amr established his capital at Fustat beside the old Byzantine fortress of Babylon, now the heart of what is today called Coptic Cairo. It was here that he built the first recorded mosque in Egypt. The present mosque has been so altered that almost nothing of the premodern building has been preserved. However, we have considerable knowledge of its earlier gradual enlargements from written sources and previous studies of the building. From the beginning and through its many alterations its plan has been what is called Arab hypostyle, one in which a courtyard is surrounded by arcaded bays supported on columns. This plan remained the basis of mosque design in Egypt for centuries, so it is worth asking where the design came from.

For this, we need to go back to Madina at the time of the Prophet Muhammad. Muhammad and his followers had made a migration (*hijra*) to Madina in 622, a date so important that it marks the beginning of the Muslim calendar. The preeminent building associated with the Prophet had a very large open courtyard, with shade on the side facing Mecca provided by two rows of palm trunks covered with thatched palm leaves. It was here that Muhammad led the first Muslim prayers. Another smaller shaded area on the north was roofed in the same way. Near the courtyard were houses in which Muhammad and his wives lived. Although some earlier scholars thought of this as Muhammad's house, which was coincidentally used as a mosque, more recent scholarship has stressed that it was intended as a mosque from the outset.[12] The importance of this structure in the communal memory of the Muslim community would help to explain why so many early mosques adopted the plan of a courtyard building with a roof supported by columns on the side facing Mecca.

There is very little information on other mosques in Egypt before that of Ibn Tulun. The ʿAbbasids settled in a new location north of the town of Fustat called al-ʿAskar, although it never replaced the previous settlement. As was the case in some earlier Muslim foundations, such as Basra, al-ʿAskar included a governor's palace (dar al-imara) and a congregational mosque adjacent to it. This, the Jamiʿ al-ʿAskar, was built in 786, but we have no information on what it looked like, either from descriptions or archaeological remains.

A major shift in Islamic Egypt occurred with the governorship of Ahmad ibn Tulun, beginning in 868. By this point, the ʿAbbasids, ruling from Samarra, north of Baghdad, had been concerned for some time with putting down revolts in Iraq and with the rebellion of the Saffarids, rulers of eastern Iran. The caliphate itself had been weakened through its manipulation by the Turkish troops who formed the most powerful section of the ʿAbbasid army. They were resident in Samarra, and Ibn Tulun rose to prominence from their ranks. After Ibn Tulun became governor of Egypt, he soon had to raise a large number of troops to put down rebellions in Palestine and Syria, and having wrested control of the finances from the ʿAbbasid administrator he extended the boundaries of his authority as far as the borders of Iraq. In 877, the caliph dispatched an army to replace Ibn Tulun, but there were insufficient funds to pay the caliph's soldiers, who returned to Iraq without having fought a battle. Thus began Ibn Tulun's autonomous rule, one that was marked by sound financial administration and particularly by investment in irrigation, improving agricultural yields.

One of the reasons for the ʿAbbasid caliphate's move from Baghdad to Samarra was the disruption caused by the Turkish troops. Similar complaints were made about Ibn Tulun's large contingent of Turkish troops, and may have been a factor in his decision to build a new city at al-Qitaʾiʿ, north of the two previous foundations. His ability to build on a large scale was also facilitated by the fact that he no longer had to send any but a nominal tribute to Baghdad.

His mosque at al-Qitaʾiʿ is the earliest surviving one in Egypt that is mostly intact. Medieval historians credit a Christian architect with designing the piers of the building so that Christian churches would not have to be destroyed for their columns (as may have been the case at the mosque of ʿAmr). This is clearly an attempt to explain the novelty for Egypt of using piers instead of columns, but in Samarra, bereft of stone, this technique was the norm for mosques. Other features such as the ziyada, the helicoidal minaret (even if the current one is a Mamluk replacement), and the style of the stucco all point to an architect familiar with Ibn Tulun's ʿAbbasid heritage. This is also an early example of what was to become a familiar feature in Cairo and Egypt: the adoption and adaptation of traits from outside the area. While this is a characteristic of virtually all major regions, Cairo's prestige as a centre of patronage proved a lure for craftsmen from the main centres of the Islamic world.

Little is known about other mosques in this period before the coming of the Fatimids, but one very different form can be identified from various sources: the nine-bay type. The plan was used in diverse pre-Islamic contexts, and proved to be very popular not just in the early period but throughout the history of Islam. It consists of a square room with four evenly spaced supports dividing the interior into nine equal spaces. The reasons for its perennial appeal are several. Its three-by-three bays create a plan of perfect symmetry, always a pleasing aesthetic consideration. In terms of practicality, it is a very economical way of roofing a space with a minimum number of supports. It is true that the most economical solution would be one column that would produce four bays of equal size, but this has the ugly result of encumbering the centre of the room. This would be particularly unfortunate in a mosque, where the column would block the view of a centrally placed mihrab.[13]

At Raya, near the southern tip of the Sinai Peninsula, there is a sixth-century fort that was altered in the ninth to tenth century to include a mosque.[14] Three of its walls are aligned, like the earlier fort, on the cardinal points, while the fourth, the qibla side, is inclined slightly toward the south-east, making the building marginally trapezoidal in plan. It had four one-metre-diameter pillars that divided the interior into nine almost equal bays. The excavators uncovered painted decoration on plaster of vegetal motifs, inscriptions, and, in a frieze along all the walls, a series of rosettes.

In the southern cemetery of Cairo are the remains of the Tomb of al-Sharif Tabataba (d. 943) (Figure 4.1), a building that medieval pilgrimage guides describe as both a shrine (*mashhad*) and a *masjid*.[15] It may date from around the middle of the tenth century, around the date of death of the supposed occupant. When K. A. C. Creswell surveyed the building, the walls stood only to a level of around

Figure 4.1 *Tomb of al-Sharif Tabataba (tenth century), reconstruction (after Creswell)*

one metre high. His restoration of cross arcades is suggested by the central cruciform piers, although the 'domes' above this that Creswell drew could equally have been tunnel vaults or groin vaults.[16] The entrances are at least certain: three on each side with the exception of the qibla, which had a mihrab in the central bay – a plan identical to that of the earlier Bab al-Mardum Mosque at Toldeo in Spain, dated to 1000.[17]

The Fatimids (909–1171) were able to establish one of the longest-lasting Shi'i states in the Middle East. They claimed descent from the Prophet's daughter, Fatima, the wife of 'Ali and the mother of Hasan and Husayn – all figures of great reverence for Shi'is. An emissary of the Fatimids was able to convert the Berbers of Tunisia to their cause and to overthrow the Aghlabids, who had previously governed on behalf of the 'Abbasids. The Fatimid ruler, 'Abd Allah al-Mahdi, was then enthroned in 909. Al-Mahdi (his name means the Rightly-Guided One) declared himself caliph in opposition to the 'Abbasids, putting an end to the semblance of unity that had prevailed in Muslim polity until then. He built a new capital named Mahdiya after himself, furnishing it with a palace, a harbour, and a congregational mosque that was to be important in its shaping of later Fatimid religious buildings in Egypt.

The Fatimids' ultimate goal was to supersede the 'Abbasids, and they made several probing raids toward a much richer prize: Egypt. In 969, they finally succeeded in overthrowing the 'Abbasid governors there, and consolidated their position by expanding into Syria. Their prestige also greatly increased with subsequent control of the holy cities of Mecca and Madina in the Hijaz, although they were never able, as they had hoped, to push on to Baghdad and eliminate the 'Abbasids.

In Egypt, the Fatimid ruler al-Mu'izz founded a new princely city, naming it al-Qahira (the triumphant), the name from which Cairo and its synonyms in other European languages are derived. Al-Qahira is also the name used for the modern city of Cairo. This city was exclusively for the rulers and their followers; the common people continued to reside in Fustat farther south, from where they would have commuted by donkey to serve in al-Qahira. At the centre of the new city was the royal palace, and near it to the south-east was the Mosque of al-Azhar (972).[18] The mosque borrowed from Mahdiya doubled columns in the transept and the dome in front of the mihrab, although the stucco that decorates its walls is of purely Egyptian invention.

In 976, Durzan, the wife of al-Mu'izz and the mother of the new imam-caliph, al-'Aziz, built the second Fatimid mosque that we know of in Egypt, in partnership with her daughter, Sitt al-Malik. This, the no longer extant Jami' al-Qarafa, was situated in the cemetery between Fustat and Cairo. Whether this location was chosen to promote the Isma'ili cause among the inhabitants of Fustat or

because a female patron was not permitted to build in the urban enclosure of Cairo is not clear; at any rate, her mosque proved popular with the whole Fatimid establishment, becoming a favourite place in which to pass Friday evenings. In the summer the courtyard, and in the winter the prayer hall near the minbar, were used for socialising, eating and sleeping.[19] We also have more specific information about the building, which was supposedly based on al-Azhar Mosque. Its entrance portal, probably projecting, had a door revetted with iron plaques. Above it was a minaret.[20] Although we cannot be certain, these features were probably also present at al-Azhar. While the mosque at Mahdiya did not have a minaret, it being proscribed by earlier Fatimid legal texts, in Egypt the Fatimids evidently saw the need to compete for the skyline with the towers of Christian churches, more frequent in Egypt than in Ifriqiya (modern Tunisia). In al-Qarafa Mosque, Maqrizi particularly singles out the colourful painted decoration of the ceiling for praise, reminding us of how much is missing from the surviving pre-Mamluk mosques.

Al-ʿAziz himself in 990 began the mosque outside Bab al-Futuh that was finished by his successor al-Hakim after a gap of twenty-three years. It was earlier known as the Mosque of al-Anwar, 'the brilliant', although it is called the Mosque of al-Hakim today. It remained the largest of the Fatimid mosques, and even increased in size with the addition of a *ziyada* erected by al-Hakim's successor, al-Zahir.[21] Its layout combined much from the two major previous Cairene mosques, borrowing the piers with engaged columns from Ibn Tulun, and the clerestory and dome above the mihrab from al-Azhar.[22] However, its two extra domes on the qibla side, and its two minarets on the opposite side, were novel.

Al-Hakim also erected major mosques at al-Maqs (modern Bulaq in Cairo), and at al-Rashida near Fustat. In 1005, he led prayers at the end of the Ramadan fast at the Rashida Mosque, the procession there being made more memorable for the six horses with jewel-studded saddles, six elephants and five giraffes that preceded it.[23] This mosque also seems to have had a minaret with, like that at the Mosque of al-Hakim, the name of its founder prominently displayed on it.[24]

During the long reign of the caliph al-Mustansir (1036–94), there were insurrections and fighting between Berber, Turkish and Sudanese troops, accompanied by famine in the years 1062–72. Al-Mustansir called on the vizier Badr al-Jamali, governor of Acre in Palestine, to restore order in 1073. Al-Jamali, known as the amir al-Juyushi, brought his troops with him and was singularly successful in routing the various factions. However, there was a price to pay: henceforth, the vizier had almost as much actual power as the caliph. Badr al-Jamali was an active patron, building the new stone walls around Cairo with its famous gates of Bab al-Futuh, Bab al-Nasr and Bab Zuwayla, as well as the Shrine of al-Juyushi. He also

erected a mosque at the Nilometer, where the Monasterly Palace now stands. Its hypostyle plan was recorded in the *Description de l'Égypte*, although since it was restored by the Ayyubid sultan Najm al-Din it is not clear how much should be attributed to Badr al-Jamali. The *Description* also recorded an inscription of Badr al-Jamali on the outer wall facing the river traffic, in which his name was visible in letters nearly a metre high – at the time, a novel way to advertise the munificence of a patron.[25]

Al-Juyushi's shrine on the Muqattam cliffs bears a strong resemblance to the later Shrine of Sayyida Ruqayya (1133), except that the latter's courtyard has disappeared. It is worth noting that the mausoleums erected by the Fatimids in their propagandising zeal[26] almost always included mihrabs, and many even had multiple mihrabs. The Shrine of Sayyida Ruqayya, for instance, has five surviving mihrabs, and even had a further, portable mihrab, presumably for use in the adjacent street or open space on feast days when the crowds could not be accommodated within the shrine (Figure 4.2). The mausoleum of Ikhwat Yusuf even has a triple mihrab on the qibla wall, a feature also found in the Ayyubid Shrine of Imam al-Shafi'i.

The nine-bay plan mentioned above continued to be part of Fatimid architecture. At Aswan, the Shrine of the Sab'a wa Sab'in Wali (seventy-seven governors, eleventh-century) is now known only from its plan, the original having been destroyed in 1901. It had cross arcades surmounted by nine domes, and a projecting mihrab on the qibla side. There was one entrance opposite the qibla, and another in the middle of the east side. It is not known whether the adjacent minaret was contemporary, but it showed that the building functioned as a funerary mosque. A related plan is that of the Mashad al-Qibli, or Bilal, near Shillal, also probably eleventh-century.[27] This has a plan of six domed bays, with the three on the qibla side each having a mihrab. Here too a minaret, in this case certainly original, was adjacent to the prayer hall.[28]

Another mosque that was considered to have this plan was the Jami' al-Fiyala built near Birkat al-Habash in Cairo, founded by al-Afdal, the son of Badr al-Jamali, dating from 1104.[29] Maqrizi states that there were nine specially decorated domes at its highest point on its qibla side.[30] Some earlier discussions of this monument have assumed that the mosque contained nine domes and nothing else. However, Maqrizi's statement could mean either that the main (or only) prayer hall had just nine domes, or, more likely – especially with the qualifier 'at its highest point' – that only these nine bays had this special form; the parts of the mosque with a lower roof would then have had some other form. This would suggest a nine-bay *maqsura* (royal enclosure) with distinctive vaulting, perhaps analogous to that in the Umayyad congregational mosque of Wasit.[31] This is made more probable by the fact that the Jami' al-Fiyala was a congregational mosque in which Friday prayers were held (Maqrizi

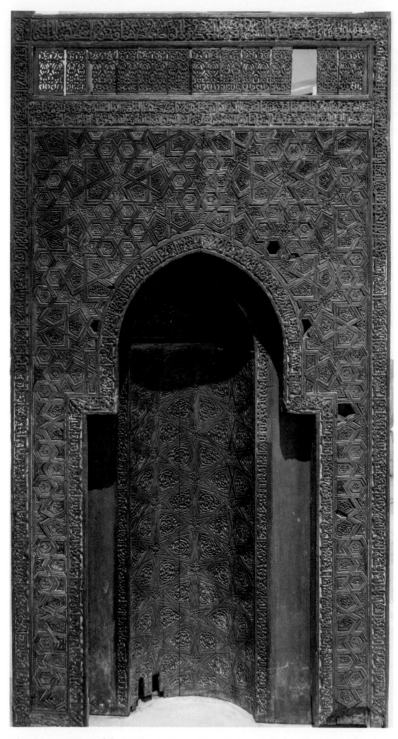

Figure 4.2 *Portable mihrab from the shrine of Sayyida Ruqayya, Cairo (1154–60), Museum of Islamic Art, Cairo*

specifically mentions its first *khutba*), and that it cost the princely sum of 6,000 dinars. A nine-bay mosque by itself would hardly be big enough to accommodate a large congregation; all the other known Fatimid congregational mosques of Egypt, including those of the much smaller towns of Bahnasa and Qus, had courtyards.

It is only from the end of the Fatimid period that we have two surviving neighbourhood mosques, or *masjids*: al-Aqmar (1125) and al-Salih Tala'i' (1160). Both are significant in different ways. Al-Aqmar was the first of many in the old city of Cairo to have its façade parallel with the street instead of the qibla. Isfahan has two seventeenth-century mosques that exhibit the same dichotomy, but there is really no other city besides Cairo in the Islamic world that displays with such consistency similar concerns with a façade parallel to the street. Al-Aqmar also has Cairo's first façade to display decoration across its entire length, a feature greatly favoured in later architecture. The Mosque of al-Salih Tala'i' also has a first in façade decoration in Cairo: continuous open or blind arches across the main and side façades, this too much favoured in later architecture. Its entrance bay is novel in being open to the exterior. However, this was probably due to the special requirements of its patron and so was never repeated.

Even before the coming of the Ayyubids, state sponsorship of Shi'ism was greatly weakened by the increasing power of the viziers, who from 1149 onward acted as regents to child caliphs. Some of the viziers now were even Sunni, the first being Ridwan ibn al-Walakhsi, who was also the first to sponsor a new and henceforth vital building type in Egypt: the madrasa. Before becoming vizier, Ridwan had been governor of al-Gharbiya, the province in the west Delta, and his madrasa, for the Maliki school, was founded in 1138 in the neighbouring city of Alexandria. Egypt's second madrasa was also founded in the same city, in 1151, by another Sunni vizier, Ibn al-Sallar, a former governor of Alexandria.

Just before the fall of the Fatimid dynasty, the Sunni vizier Salah al-Din, better known in the West as Saladin, founded two madrasas in Cairo in 1170. He, together with his uncle, Shirkuh, had previously been in the service of the Zangids, who were originally based in Aleppo. The Zangids expanded westward, and were notable for their victories against the Crusaders. The dynasty's founder, Zangi (r. 1127–46), captured the Crusader city of Edessa in 1144, and his son, Nur al-Din (r. 1146–74), carried on the struggle in Syria against both the Crusaders and the Fatimids. Despite this, the Fatimids sought Nur al-Din's help in warding off Crusader attacks – in 1168 the Crusader king of Jerusalem, Amalric, had succeeded in invading Egypt. In 1169, Nur al-Din gladly sent them his deputy Shirkuh and Shirkuh's nephew, Salah al-Din. By 1171, Salah al-Din was able to depose the Fatimids; he remained in Egypt until Nur al-Din's death in 1174 enabled him to expand his power into Syria.

As noted above, Salah al-Din built two madrasas in Fustat in
1170 just before the fall of the Fatimids, but supplemented these in
1177 with a madrasa in the royal Fatimid city of Cairo and, more
importantly, one in the Qarafa at the tomb of the saintly champion
of religious orthodoxy, Imam al-Shafi'i. Regarding this last-named
madrasa, the traveller Ibn Jubayr said:

> Over against it [the Tomb of al-Shafi'i] was built a school the like
> of which has not been made in this country, there being nothing
> more spacious or more finely built. He who walks around it will
> conceive it to be itself a separate town. Beside it is a bath and other
> conveniences, and building continues to this day.[32]

No less than twenty-five madrasas are known to have been built by
the Ayyubids in Cairo or Fustat, but of these we have the remains of
only two, the Kamaliya (1225) and Salihiya (1243), both in the centre
of the old Fatimid city. The primacy of prayer in the latter is shown
not only by the mihrabs in its qibla iwans, but also by the promi-
nent minaret that formed a visual climax to the sweep of niches on
either side of its façade. Both of these introduce a new element that
henceforth was to be prominent in religious architecture in Egypt:
the iwan. Both monuments had two-iwan courtyards, paired in the
case of the Salihiya.[33] The iwan had earlier been a renowned part of
the Fatimid palace, where it designated the main audience hall, but
only under the Ayyubids did it become a regular feature of religious
architecture, particularly madrasas. In the Ayyubid funerary enclo-
sure (*turba*) of Abu Mansur Isma'il (1216), an iwan (with a mihrab)
may have been used as a mausoleum,[34] as in earlier examples in
Anatolia. However, this proved to be a failed experiment in Egypt, at
least until revived (but even then very rarely) by those more familiar
with Anatolian precedents: the Ottomans.

This proliferation of madrasas stands in contrast to Ayyubid policy
on mosques. Their adherence to strict Shafi'i orthodoxy meant only
one Friday mosque in each urban entity. Accordingly, at Cairo they
stopped Friday prayer in al-Azhar and allowed it only at al-Hakim;
at Fustat, the Mosque of 'Amr continued in use; all of these were
refurbished by the Ayyubids. A handful of smaller mosques were
built in this period by non-royal patrons, but none has survived.[35] As
we have seen, this class channeled patronage into other institutions
such as madrasas.

Another significant Ayyubid development that became the norm
in Mamluk Cairo was initiated by Shajarat al-Durr, the wife of the
last Ayyubid sultan, al-Salih Najm al-Din (r. 1240–9). She bridges the
Ayyubid and Mamluk periods. Her husband died in 1249, and she
concealed his death while awaiting the arrival from Anatolia of al-
Salih's son and heir Turanshah. The Mamluks were al-Salih's manu-
mitted Turkish slave troops. Fearing that Turanshah would replace

Figure 4.3 *Reconstruction of the Salihiya complex (1242–4) and Madrasa of Baybars, Cairo (1263) (after Hampikian)*

them with his own mamluks, they murdered him and appointed Shajarat al-Durr sultana in May 1250. However, on the objection after three months of the Syrian Ayyubid ruler she was compelled to marry Aybak, the atabeg (commander-in-chief) of the army, who thus became the first Mamluk sultan. Shajarat al-Durr continued to sign royal decrees for at least another five years. In 1257, she heard that Aybak was planning to marry the daughter of the Zangid prince of Aleppo, and had him murdered – a step too far, as she herself was killed in retaliation eighteen days later.

The complex that she created (Figure 4.3) was the combination of a mausoleum with another religious institution, already common in Syria at the time. She added a tomb for her husband to the Salihiya Madrasa after his sudden death. It was not envisaged in the original layout, as has sometimes been thought; it occupies part of the space of the former living quarters of the Maliki shaykh of the madrasa. It juts out six metres into the street, an attention-grabbing technique that was used by the later sultans Baybars, Qalawun and al-Ghawri in their complexes on other parts of the same thoroughfare, the Qasaba, the main artery of the old Fatimid city.

Shajarat al-Durr also built a complex in the Qarafa al-Sughra, near the earlier shines of Sayyida Nafisa and Sayyida Ruqayya,[36] consisting of a mausoleum, a madrasa, a palace and a hammam, of which only the mausoleum survives. Fortunately, in the early nineteenth century Pascal Coste recorded the madrasa in a detailed drawing, enabling us to see that it was a large, lavishly decorated building with a minaret that rivalled that of the Salihiya.[37] The inscription

Figure 4.4 *Interior from the tomb of Shajarat al-Durr, Cairo (c. 1250): a newly uncovered painted decoration*

in her mausoleum has titles that suggest that it was drafted between the death of Turanshah (3 May 1250), the short-lived successor of her husband, and the appointment of Aybak as her second husband on 31 July 1250. However, given the size and components of the funerary complex, it was undoubtedly begun quite some time before this and should be considered an Ayyubid foundation. The mihrab of her mausoleum is of glass mosaic, with a design in mother-of-pearl that reflects her name, 'the tree of pearls'. Newly uncovered wall paintings in the tomb[38] display arabesque medallions from which emerge elegant Pharaonic lotuses, a stunning confirmation of the quality of the complex (Figure 4.4).

Mamluk Egypt (1250–1517)

The Mamluks went on to control the Arab core of the Middle East – Egypt, Syria, and the holy cities of Mecca and Madina in the Hijaz – for a long time. They were Turks, usually from the Kipchak Steppes near the Caspian Sea, recruited as boys who were brought up as Muslims in the Cairo citadel, trained as cavalry and manumitted. Having severed all family ties, they would be, at least in theory, fiercely loyal to their masters. However, it frequently happened that on the death of a sultan a nominal successor would be appointed while amirs jockeyed behind the scenes to see who could muster

the most support. The efficacy of the system is demonstrated by their lengthy tenure of over 250 years, during which they were the principal power in the Middle East.

The first major Mamluk sultan was Baybars (r. 1260–77), who secured the future of the dynasty by energetically warring on two fronts, against the Mongols and the Crusaders. These campaigns took place in Syria, and served to rally the disparate segments of the population there to his cause. He is estimated to have covered a staggering distance of more than forty thousand kilometres in his almost constant campaigning. However, given the status of the Mamluks as Turkish-speaking former slaves, and the suspect way in which they rose to power, they had a strong need for legitimisation. The last 'Abbasid caliph had recently (in 1258) been killed by the Mongols in Baghdad, and when a supposed uncle turned up in Damascus, Baybars had the brilliant idea of recognising him as the current 'Abbasid caliph, while ensuring that his political power was entirely nominal. Even though many contemporaries recognised the puppet nature of the subsequent 'Abbasid caliphate in Cairo, the caliph's investitures were still sought by outlying Muslim rulers and so conferred lustre on the Mamluks.

Another sure way to attain legitimisation was by conspicuous architectural construction, whether to display might through imposing buildings, to cement relations with the ulema by the sponsorship of mosques and madrasas, or with more popular forms of piety through the erection of zawiyas, khanqahs and pilgrimage complexes. These buildings were a highlight of Mamluk patronage, both of sultans and amirs.

Baybars's first major construction, like that of many of his Ayyubid predecessors, was a madrasa (1263). This particular educational establishment had several novel features that would reappear in later Cairene architecture, including a four-iwan plan (in this case two of the four schools of law) and a muqarnas portal (Figure 4.5) topped by a minaret. Its location was also in the most prestigious place in Cairo, at Bayn al-Qasrayn, the centre of the old Fatimid city, next to the Salihiya Madrasa.

Cairo remained the city from which the Mamluks ruled and on which they concentrated their patronage. While it is true that sultans occasionally erected important monuments in Jerusalem or Madina (places of pilgrimage rather than the commercially more important urban centres of Aleppo and Damascus), they preferred Cairo for the vast bulk of their projects, leaving patronage in the provinces to the amirs who were appointed as governors there.

The major cities of Egypt and Syria had long had Friday mosques when the Mamluks came to power, so the scope for building new ones was, in theory, limited. Although the position of the Shafi'i law school (one of the four great law schools of Sunni Islam) on the building of Friday mosques was that there should be only one in

Figure 4.5 *The* muqarnas *portal (1263) from the madrasa of Baybars, Cairo; sketch by James Wild (1840s)*

each urban entity, the Hanafis, as noted above, had no such restriction. This has a bearing on the first major Mamluk mosque, that of Baybars. The Hanafi Mamluk amirs had previously had disputes with the Shafi'i judges; in response, Baybars abolished their judicial monopoly and made the four schools of law virtually equal. The first Mamluk Friday mosque in Egypt, that of Baybars, was also the first to incorporate a very large dome chamber in front of its mihrab – one that, unlike the previous Fatimid examples, took up the space of not just one but several bays (in this case, nine). Almost all of the subsequent Mamluk purpose-built congregational mosques in Cairo followed this scheme: a hypostyle plan with a large dome taking up the space of nine bays in front of the mihrab.

Further consolidation of Mamluk power took place with Sultan Qalawun (r. 1279–90), who also spent much time campaigning in Syria against the same enemies as Baybars had: the Crusaders and the Mongols. It was on one of these campaigns that he received treatment in the Hospital of Nur al-Din in Damascus, and vowed that he would build its equal in Egypt if he recovered. As a result, his complex in Cairo consisted of a hospital, a madrasa and a mausoleum. This was in the same area of Bayn al-Qasrayn in which Baybars's madrasa had been built, on the site of a palace occupied by female descendants of the Ayyubids who had to be forcefully evicted. The location was coveted by Qalawun because of the proximity of the mausoleum of his former master, al-Salih Najm al-Din. In fact, we know that Qalawun rebuked the officer in charge of construction, al-Shuja'i, for building the madrasa (rather than the mausoleum) opposite al-Salih's mausoleum, as Qalawun had intended.[39] Two important facts can be deduced from this: first, the involvement of the patron in the conception of the original design, and second, his complete delegation of the works, in this case, to a subordinate.

This is the earliest surviving complex by a member of the Mamluk elite that includes a tomb. As usual, it contains a mihrab, and even has the minaret of the complex beside it, further suggesting its suitability for prayer. The mausoleum remained a staple of most later Mamluk complexes, and it is worth exploring the reason why this was so, and the relationship of building complexes to *waqf*.

The prime consideration for sponsoring a building for one's fellow Muslims was undoubtedly piety, which is connected with the concept of *baraka* (grace or blessing). This in turn led to other considerations: principally the building of mausoleums, but also their inclusion within complexes and their siting in relation to the street and the qibla area. Building a mausoleum was still to some extent a controversial matter in Islam, which some clerics thought reprehensible. However, religious objections would clearly be less likely if the tomb chamber was attached to a larger building that had a specific religious function, such as a mosque, madrasa, or *khanqah*. A more modest commemorative complex, often sponsored

by non-royal patrons, was the *turba*, usually built in a cemetery, which included a mausoleum and various other functions such as a mosque, a *sabil* (water dispensary), and occasionally provision for Sufis or for teaching.[40] Closely related to the building of complexes was the *waqf ahli*, the family endowment, whereby family members controlled the disbursement of *waqf* income and were permitted to devote any surplus to the needs of maintaining the religious institution. For an official whose tenure of power was precarious and whose wealth could be confiscated if he fell into disgrace, this had the added advantage of securing most of his wealth for his family, since *waqfs*, at least in theory, were inalienable.[41] Next is the question of street–qibla alignment in the most prestigious location for monuments, the densely settled old city and neighbouring quarters, which in turn is related to *baraka* and the siting of the mausoleum within complexes. In her pioneering work on the siting of mausoleums, Christel Kessler wrote about the unwritten rules involved.[42] With hindsight, we can enunciate some of them. The preferred characteristics of a mausoleum were that it should have a mihrab to encourage prayer, and be exposed to as many Muslims as possible. The latter requirement could be fulfilled by having windows facing the street or onto the main prayer space (usually the qibla iwan) of the complex to which the mausoleum was attached. If only one of these was possible, a street façade trumped proximity to the prayer hall. And if size did not permit a window and a mihrab (as in the mausoleum at the Mosque of Shaykhu), then a window was preferable to a mihrab.

In the case of Qalawun's complex, the single largest element, the hospital, was relegated to the area farthest from the street, leaving the façade for the madrasa and mausoleum. The provision, common in major foundations, for a team of Quran readers to recite day and night in the deep window recesses made the mausoleum even more evident to passersby: the expectation was that a prayer would be offered in return for the repose of the soul of the founder. Qalawun's tomb also played a ceremonial role, as it replaced the Tomb of al-Salih across the street as the place where newly appointed Mamluk amirs swore allegiance to their sultan. In Qalawun's tomb and those of many later Mamluk sultans, eunuchs were employed as guardians.[43] Although they were highly jealous of their role in preventing unauthorised access to the tombs, a telling passage by the bureaucrat al-Nuwayri (d. 1332) that lists the personnel of the Qalawun complex mentions that this duty to prevent access to the tomb applied at any time 'other than at the times of prayer', an indication that commoners were probably permitted to pray at the regular appointed hours within the mausoleum.[44]

Descendants of Qalawun filled most of the posts of sultan up to the advent of Barquq (r. 1382–8, 1390–9). Of these the most prolific in terms of architectural patronage was al-Nasir Muhammad (r. 1293–4, 1299–1309, 1310–41), facilitated by his long periods of rule from

childhood to middle age. His own complex, consisting of a madrasa and mausoleum, was begun by an amir, Kitbugha, who had earlier displaced him as sultan. Although its location was favourable, being next to that of Qalawun, it was relatively modest in size. In later buildings, al-Nasir Muhammad's taste tended toward the monumental,[45] but he may have decided to continue with this small structure to spite Kitbugha, who had been forced into exile in the meantime. It was the first four-iwan structure in Egypt[46] for the four schools of law, an arrangement that proved popular thereafter.

Al-Nasir Muhammad also managed to undermine the complex of the second amir to usurp his sultanate, Baybars al-Jashinkir. This Baybars built the first combination in Egypt of *khanqah* and mausoleum (1309) – evidence of the increasing popularity of Sufism in society, and one that was enthusiastically embraced by many later patrons, including amirs of al-Nasir Muhammad such as Qawsun.[47] In addition to the insult of removing Baybars al-Jashinkir's royal titles from its façade, al-Nasir Muhammad also ensured that the complex remained closed for sixteen years after he regained power, just after he himself had built a *khanqah*, mosque and mausoleum at Siryaqus north of Cairo.[48]

Al-Nasir Muhammad's third reign of thirty-one years was the longest in Mamluk history, and permitted a huge expansion in his own architectural patronage as well as that of his amirs, whom he partially funded and greatly encouraged.[49] He himself built Friday mosques, one in Cairo's citadel (1318, rebuilt higher in 1335), and another, the Jami' al-Jadid (New Congregational Mosque, 1312), on the Nile shore between Fustat and the Fatimid city. The latter has not survived, but from its detailed description by the historian Ibn Duqmaq it seems to have been very similar to the citadel mosque. Both, like the mosque of the early Mamluk sultan Baybars, had a domed *maqsura* taking up the space of nine bays in the hypostyle plan, and the Jami' al-Jadid may also have had three projecting entrance portals like Baybars's mosque. On two of its sides there were gardens. It also had a *maqsura* on its northern side for Sufis. This was presumably just a grilled enclosure, but it presages the building of al-Nasir Muhammad's complex at Siryaqus and those of later Mamluks, which would blur the distinctions between *khanqah*, madrasa and mosque in Mamluk society. The amir al-Maridani's mosque (1334–40), for which al-Nasir Muhammad provided materials, has a similar layout to those of al-Nasir Muhammad. The simple hypostyle plan, with or without a dome in front of the mihrab, also remained popular, as is shown by the mosques of the amirs Bishtak, Husayn, Ulmas, and slightly later, those of Shaykhu and Aqsunqur.

The architectural landscape after al-Nasir Muhammad's reign was thus enormously widened (Figure 4.6), both on account of his own building activities and those of his amirs, whom he greatly encouraged. With the Crusader and Mongol threats to Mamluk territory

eliminated, the state coffers were now replete. One of the reasons
that al-Nasir Muhammad stayed in power so long was that he
curried favour with all ranks of Mamluks, not just the amirial elite,
by means of largesse and by facilitating easy promotion through
the ranks. There was a price to pay for this profligacy, however:
the rank-and-file Mamluks now realised their power as kingmakers.
Their ability to side with different factions in struggles for succes-
sion could sway the balance. Al-Nasir Muhammad's successors were
usually selected from his descendants – children plucked from the
harem, short-lived on the throne, and only nominally in control –
until the arrival of the Circassian sultan Barquq in 1382 put paid to
the nominal Qalawunid dynastic succession.[50]

However, during the Qalawunid period Sultan Hasan (1356–63)
managed to build the most impressive of all Mamluk complexes, des-
ignated a congregational mosque *(jami')* in its *waqfiya* (endowment
deed), although the space was also used by students of its madrasa.
The addition of four single-iwan madrasas in its four corners is one
of the several unique features of this complex, another being the
location of the domed mausoleum behind the qibla iwan.

One excursus may be made here regarding a phenomenon men-
tioned earlier: Cairo's receptivity to outside influences. The model-
ling of the entrance portal of Sultan Hasan's complex on Anatolian
Seljuq models has been noted by J. M. Rogers,[51] and its decoration
also contains the first chinoiserie motifs to be seen on local architec-
ture,[52] plus reused Crusader carvings.[53] The vestibule has an inlaid
marble panel that is very likely the design of a Damascus work-
shop.[54] But it also has, on a tympanum of the mausoleum, what
may be the last example by an atelier that introduced Iranian tile
techniques to Egypt. It is unlikely that the Mamluks brought with
them any clear consciousness of architecture or material culture
from their homelands. But Aytamish, the Mongol-speaking Mamluk
ambassador to the court of Abu Sa'id, was so impressed by the
minarets of the Mosque of 'Ali Shah in Tabriz that he brought their
builder back to Egypt.[55] There, the latter erected a similar minaret
for Aytamish's complex of a *zawiya* and *hawd-sabil* (animal trough
and water dispensary) in the town of Fishat al-Manara in the Delta.
The same person also worked for the amir Qawsun, as Maqrizi tells
us that the *banna* (architect) of Qawsun's congregational mosque in
Cairo was a Tabrizi who built its minarets in the style of those of the
mosque of 'Ali Shah at Tabriz.[56] Michael Meinecke traced the work
of this atelier until it petered out. Why did it fall out of fashion?
Probably because of a combination of reasons: the ready availability
of stone, which could compete with tilework by carving or painting
or both, and the inexperience of the potters, who never managed to
make tile mosaic that had the lustrous intensity of the glaze that
made the Iranian examples such a sensuous pleasure. An attempt in
the early fifteenth century to simulate Anatolian-style tile mosaic

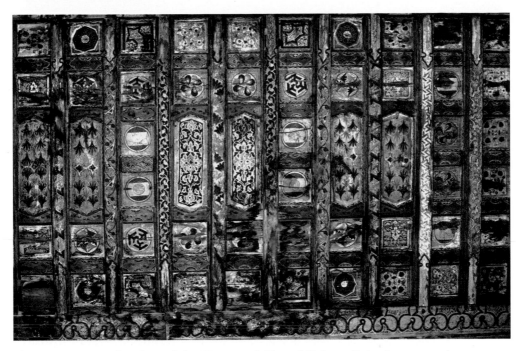

Figure 4.6 *Painted ceiling of the Mosque of Ahmad Kuhya, Cairo (c. 1325–45)*

in the complex of Badr al-Din al-ʿAyni also proved a dead end; there, the Turkish-speaking patron probably experimented with it in order to underline his affinity with the ruling Mamluks.[57]

Barquq, the founder of the Circassian line of Mamluk sultans, borrowed several features from Sultan Hasan for his own complex (1386), but his mausoleum, like those of Qalawun and al-Nasir before him in the same location, lay parallel with the façade of the madrasa on the street. All three of these had another feature in common, which is harder to recognise nowadays since nineteenth- and twentieth-century restoration has transformed them: they all had wooden domes, as had both of the other earlier large dome chambers in Cairo: those of Imam al-Shafiʿi and the Mosque of Baybars.[58]

A major change in this tradition was s tarted by Faraj, the son of Barquq. The two domes over his mausoleums in his complex in the northern cemetery were made of stone, and decorated with a zigzag pattern. There had been earlier stone domes in Cairo, but not on this scale. Almost all patrons of large mausoleums were now so excited by the possibilities of the new patterns and techniques of dome decoration that they insisted on a carved stone dome for their complex.[59] This brings us to one of the major and most surprising changes that characterised later Mamluk architecture: it proceeded from the monumental to a concentration on ornamentation on smaller buildings. In the four-iwan structures that remained the most popular for major foundations, a noticeable influence from domestic architecture is

also apparent, resulting in vestigial side iwans, laterally extended qibla iwans and covered courtyards.[60] Given the number of earlier houses that had been converted into mosques, this is hardly surprising.[61] Two other trends are important, the first illustrated by Faraj's complex. It was the first of several royal complexes in the northern cemetery. Building here had the advantage of unencumbered surroundings. Yet, unlike their contemporaries the Timurids,[62] for instance, this did not lead the Mamluks to fashion symmetrical complexes, except in the case of Faraj's. We can even detect a fissiparous tendency, exemplified by the complexes of al-Ashraf Barsbay and Qaytbay. The building for the students of Qaytbay's complex, as well as the *qaʿa* for the female members of his family, was located well away from the main structure. Only al-Ghawri tried to break the mould, returning to the Fatimid city but even then splitting his complex into two facing ensembles.[63]

Artifacts in mosques

Since so many of the finest artifacts still within mosques or in the collection of the Museum of Islamic Art in Cairo are from the Mamluk period, this is a good place to attempt an overview of furniture and other objects created for use within mosques. This might help us to envision their original surroundings without some of the distractions that have been introduced in recent decades.

Lighting

Before the introduction of electricity, mosques were dependent on oil lamps for illumination. Many mosque endowment deeds mention a position of *waqqad*, the person in charge of maintaining the lamps and procuring olive oil for them.[64] The lamps themselves were of various types. One of the earliest, also known from Byzantine prototypes,[65] was the *tannur* (polycandelon), usually in the form of a bronze circle with spokes and compartments for small glass containers that would have been filled with oil floating on top of water. The Fatimid ruler al-Hakim in particular seems to have favoured magnificent silver polycandela; he gave two of each to the Azhar and Rashida mosques, and his own mosque at Bab al-Futuh had four.[66] The most impressive must have been that which he donated to the Mosque of ʿAmr, which was over four metres in diameter, held seven hundred lamps, and was so large that one of the doors of the mosque had to be dismantled to get it inside.[67] It was one of the hundred lamps that, according to the Persian traveller Nasir-i Khusraw, burned there every night.[68] Unlike the earlier one-tier Byzantine examples, these must have had many tiers in order to support such a large number of lamps; they may have been pyramidal in shape like those currently in the nave of the Great Mosque of Qayrawan,[69] or possibly cylindrical, with enough

space between the tiers to allow for the glass containers to hang. In the last-named category are several of the most impressive Mamluk examples, including those made for Amir Qawsun[70] and the sultans Hasan and al-Ghawri. Simpler Mamluk polycandela are also known, with a lower circular tray for suspending glass bulbs covered by a bulbous dome, perforated to allow the light to be filtered gently onto the surroundings.[71] Another category of perforated lamps is vase-shaped, which, like all these examples, were meant to be suspended on chains.[72] Yet another type appears only at the end of the Mamluk period: those in the shape of a truncated pyramid, usually hexagonal. They were also perforated, with an arched door on one or two sides to allow access to the bulbs. That of Asalbay from her mosque in Fayoum is one of the finest examples (Figure 4.7).

The most spectacular lamps were the enamelled vase-shaped glass ones, a Mamluk specialty that produced a corpus unparalleled not just in the Islamic domain but in the world of glassware.[73] The earliest known example is from the beginning of the fourteenth century; they increased in size from 25 cm high to the magnificent group made for the Sultan Hasan complex, where examples 42 cm high are known. In addition to the usual inscriptions and blazons, those for Sultan Hasan are decorated with a wider variety of colours and motifs than any others, including pseudo-Kufic and chinoiserie. After the economic decline at the beginning of the fifteenth century, production of this kind of lamp almost ceased.[74]

Quran boxes and stands

Recitation of the Quran was a practice from early times in mosques. For instance, Muqaddasi (d. c. 990) mentions that in the Mosque of 'Amr Quran readers sat in circles every evening and recited.[75] In 1013, al-Hakim sent seven boxes containing 1298 Qurans to the same mosque, and 814 Qurans to the Mosque of Ibn Tulun.[76] Furniture of various types was associated with Quranic recitation. In later buildings cupboards with shelves were built to store the volumes, some Mamluk examples of which had particularly attractive painted decoration (Figure 4.9). Other methods for storing particularly valuable Qurans were boxes, frequently compartmentalised into seven or thirty units – a helpful division for reading the text within a week or a month. A hexagonal wooden box from the Madrasa of Umm al-Sultan Sha'ban (1369) is one of the finest surviving examples, showing marquetry patterns of hexagons on the sides and an arcade of joggled voussoirs on the lid (Figure 4.10).

Once taken out of the box, the Qurans, if they were small, could be placed on a *rahla* (folding wooden stool). Although common elsewhere in the Islamic world, only one medieval example from Egypt seems to have survived, from the period of al-Ghawri (dated 911/1505–6), which has an inlaid ivory inscription in large letters,[77]

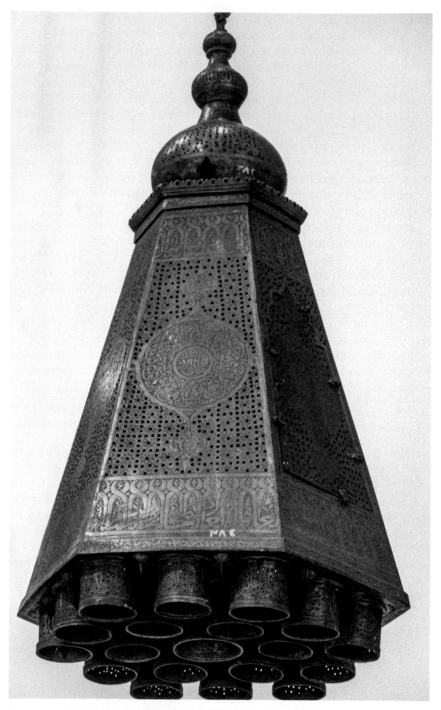

Figure 4.7 *Lamp, brass inlaid with silver, Qaytbay period (c. 1480s–90s), from the Mosque of Asalbay, Fayoum (1498–9)*

Figure 4.8 *Lamp, brass, from the Mosque Qawsun, Cairo (1330)*

perhaps the start of a trend that is reflected in slightly later Ottoman woodwork.[78] It is likely that the teams of Quran readers employed to recite in the windows of major mausoleums in complexes (for instance, those of sultans Qalawun and Hasan) would have used *rahla*s.[79]

Figure 4.9 *Cupboard doors, painted wood, from the* khanqah *of al-Ghawri, Cairo (1502–4)*

But the most impressive Quran holders were the stands (a *kursi* or *mashaf*), which included room for a reader to sit cross-legged in front of the volume. These were no mere conceit, as Mamluk Qurans over one metre tall are known.[80] That of Sultan Hasan is, again, the

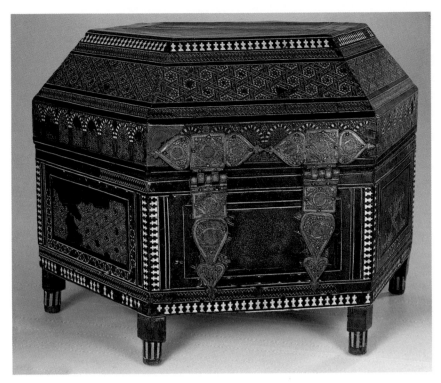

Figure 4.10 *Quran box, wood, inlaid with ebony, ivory and tin, complex of Umm al-Sultan Sha'ban, Cairo (1369)*

largest that has survived, displaying the same kind of marquetry with geometric star patterns as contemporary minbars (Figure 4.11). A smaller, plainer one, sponsored by an amir, has survived at the 'Amri Mosque at Qus.

The arches mentioned above on the hexagonal wooden box from the Madrasa of Umm al-Sultan Sha'ban also feature prominently on its companion piece, a hexagonal table[81] from the same building (Figure 4.12). This has an arched doorway on one of its sides, showing that it was used for storage – although exactly for what is unknown. As a table, its height (115 cm) is awkward for someone sitting on the ground, but neither would it have been well suited for reading from a Quran placed on top. A table of similar shape and size, but made of inlaid bronze, was found in Qalawun's complex; its inner compartments are also too small to have stored Qurans (Figure 4.13. It is dated 1327–8, and must have been a gift from al-Nasir Muhammad, who is mentioned as the patron, to his father's complex. The main storage compartments are perforated. The only other items of Islamic perforated metalwork are lamps and incense burners. Incense burning would make more sense in this case, but that certainly could not have been the case for the wooden table. The purpose of these tables must remain a mystery for the moment.

Figure 4.11 *Detail of inlaid wooden* mashaf, *complex of Sultan Hasan (c. 1360)*

Minbars and *dikkas*

The major element of mosque furniture was the minbar, although it can hardly be considered portable since it was a permanent fixture of congregational mosques.[82] The earliest surviving one in Egypt is that of al-Salih Tala'i', from his mosque at Qus.[83] This is already an extremely accomplished piece, as we would expect from earlier surviving examples of woodwork in Egypt such as the cenotaphs and portable mihrabs found in older and contemporary shrines.[84] It has one design that covers its entire sides, although the dividing line between the area below the stairs and the seat is emphasised by matching it with one of the vertical axes of the pattern. Some of the early Mamluk minbars (no Ayyubid ones in Egypt have survived) follow this scheme,[85] although they now use ivory or bone inlay and their patterns are more sophisticated. Later examples (Figure 4.14) make the pattern yet more intricate by varying the sizes and numbers of stars that form the basis of the patterns, and sometimes have different patterns for the areas below the balustrade and for the balustrade itself. The panel below the seat may be differentiated from an arched space below, either open or with doors inlaid with yet another pattern. A painted bulbous dome usually tops the composition. The minbar of the Mosque of Burdayni (1616–30) closely copies its Mamluk prototypes, although like many Ottoman examples it makes extensive use of mother-of-pearl. Even though the Mosque of Muhammad Abu'l-Dhahab (1774) is Ottoman in style, its minbar is still firmly in the Mamluk tradition.

Even more prestigious were stone minbars, as the examples at the complexes of Aqsunqur, Sultan Hasan and Faraj (the latter donated by Qaytbay) show. That of Aqsunqur is particularly attractive in its use of inlaid coloured marble and the interweaving of the curves of its design. The stone *dikka* of Sultan Hasan is rather plain by comparison, but the survival of the drawings of one made for the Mosque of Bishtak (1337)[86] (Figure 4.15) shows that we may be missing some significant examples. Two Ottoman stone minbars in Cairo buildings are known. That at the Mosque of Sulayman Pasha (1528) is relatively plain, but Malika Safiya's (1610), with its delicate grilled ten-pointed star pattern set within a circle, is worthy of Istanbul's finest.

Carpets

One might have expected carpets to be a usual fixture of mosque interiors, but references to them are not common, with reed mats instead being the norm. Nasir-i Khusraw did mention that the Mosque of 'Amr always had ten layers of coloured carpets spread on top of one another.[87] There are also references to

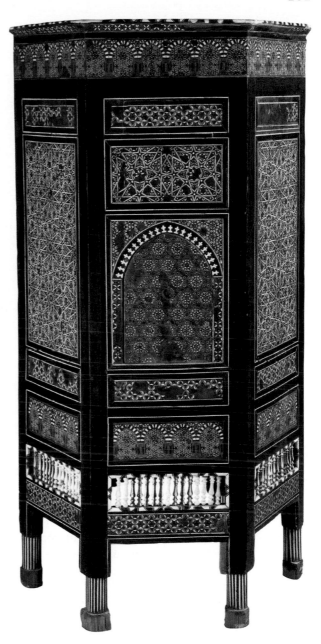

Figure 4.12 *Table, wood inlaid with ivory, bone redwood and ebony, complex of Umm Sultan Sha'ban, Cairo (1369)*

carpets made for the Taybarsiya and the Barquq complexes.[88] But it would also be strange if the superb marble inlay patterns that are found in many Mamluk prayer halls were usually hidden,

Figure 4.13 *Detail of table (1327–8), copper alloy inlaid with silver, complex of Qalawun, Cairo*

suggesting that whatever floor covering was used it was gathered up after prayers or at least with some regularity.

The famous examples of Mamluk carpets known to us seem to have been a new type, whose creation was due to the influx of Turcoman immigrants from western Iran in the second half of the fifteenth century. Their production seems to have been intended primarily for export.[89]

Costs

Doris Behrens-Abouseif has recently collated fascinating information on building costs throughout the Mamluk period. She shows how, great as the building expenses were, they were still only a fraction of the amounts expended on household expenses by sultans and amirs, with costs for an average mosque equivalent to only the monthly wage of an amir, varying from twenty thousand dinars in the late fourteenth century to forty-six thousand in the late fifteenth.[90]

Figure 4.14 *Detail of minbar of the Mosque of Abu'l-ʿIla, Bulaq, Cairo (1490)*

Figure 4.15 *Detail of* dikka *from the Mosque of Bishtak, Cairo (1336); sketch by James Wild (1840s)*

These figures pale, however, before the one hundred thousand dinars spent by Sultan Abu Bakr, the successor to al-Nasir Muhammad (whose reign was a mere fifty-nine days), on the bridal veils of two of his slave girls.[91] The same amount was the cost of the tiara of another slave girl, Ittifaq, who was the favourite of three successive sultans: al-Salih Isma'il, Sha'ban and al-Muzaffar Hajji.[92]

Ottoman Egypt (1517–1805)

The disregard for personal loyalty and the manoeuvring for power and influence of the Mamluk amirs noted above further contributed to the unravelling of the Mamluk state. In 1515 the amir Khushqadam, falling afoul of the ruling sultan al-Ghawri, sailed to Istanbul where he advised the Ottoman sultan Selim of the lack of morale of Mamluk troops and the desirability of invading their dominions.[93] Selim, having previously vanquished the Safavids of Persia, needed little encouragement. At the decisive battle near Aleppo, Khayrbak, the governor of Aleppo, who had secretly agreed earlier with the Ottomans to defect, abandoned the battlefield with his troops, leading to the quick rout of the Mamluk forces.[94]

From being the capital of a sultanate ruling parts of Anatolia, Syria, Egypt and Arabia, Cairo was reduced to being an Ottoman province. Revenue that formerly was brought into Egypt from these territories now flowed to Istanbul, so it is not surprising that the number and scale of Ottoman building projects in Egypt compare unfavourably to their Mamluk predecessors. The most plausible patrons for such

edifices, the governors, did not usually spend long in the post (there were 153 of them before the advent of Muhammad 'Ali). Some of them, such as Çoban Mustafa Pasha (1522–3), Sinan Pasha (1567–9, 1571–3) and Damat Ibrahim Pasha (1583–5), preferred to invest in complexes in their Ottoman homelands, while 'Ali Pasha (1559–60) endowed a mosque in Sarajevo, another city in which he had been governor.

The older view of the Ottoman period as one of continual decline for Egypt and Cairo has recently been challenged. The Ottoman Empire brought an enormous area from Baghdad to Tunisia and from Hungary to Yemen under one rule, with a concomitant increase in internal trade, of which Cairo was well placed to take advantage. Within the empire, pilgrimage travel to Mecca also greatly increased, another bonus for Cairo as it lay on more than one of the main routes to the Hijaz.[95]

Cairo expanded under the Ottomans, particularly in the suburbs to the west of the old city. One of the mosques examined in detail later, that of Malika Safiya (1610), was eventually built in an area to the west of Bab Zuwayla in which the tanneries had been located. The noxious smell from this industry[96] precluded nearby urban development. However, the wish of the Ottoman sultan Muhammad III (r. 1595–1603) for a mosque in his mother's name was so strong that he ordered the removal of the tanneries to Bab al-Luq. Birkat al-Fil, to the south-west of the mosque, was already a place of elite residences by the Mamluk period, and with the tanneries gone the area became even more popular for both amirial residences and other large-scale buildings. Shortly after the Malikiya Safiya Mosque came the nearby Burdayni (1616) and Yusuf Agha al-Hin (1625) mosques.

The major mosques built in Egypt in this period were mostly sponsored by government officials, usually the governor himself. The grandest of these, those of Sulayman Pasha, Sinan Pasha, Malikiya Safiya and Abu'l-Dhahab, were all built in the Ottoman tradition, with a central dome forming the focal point of the design. But they are not mere slavish copies; none has the sheer size nor, for instance, the extensive use of Iznik tilework that is found in major Ottoman mosques. Even though by Ottoman standards it was a little anachronistic for the period, the Sulayman Pasha Mosque achieves an equally colourful interior by its use of painted plaster on the dome and vaults above the dado, previously unseen in Egypt. Its dado and mihrab, however, carry on Mamluk traditions. The Sinan Pasha Mosque's unencumbered dome chamber is close to Ottoman models, even if its zone of transition is taken from a Mamluk model. The purest expression of Ottoman mosque architecture on Egyptian soil is that of Malika Safiya, with a square courtyard preceding a prayer hall that has a hexagonal dome chamber. But here again, we need to allow for the originality of the designer, for although we know of eight sixteenth-century Ottoman mosques with hexagonal

supports for the domes,[97] all of them have supporting semidomes
(not present at Cairo), and none of them has the six freestanding
columns that support the dome of Malika Safiya. Where were these
mosques designed? From documents sent by the Porte (Ottoman
administration) in the name of the famous architect Sinan in 1584
and 1585, we know that the very high degree of centralisation of the
Ottoman bureaucracy extended to architectural matters.[98] But all of
the previous examples have some Mamluk-inspired features – even
the most Ottoman of the above, the Malikiya Safiya, has an inlaid
marble mihrab.

The *waqfiya* of the Malikiya Safiya Mosque informs us that it
employed two knowledgeable gardeners charged with tending the
plants, although their salary was only two-thirds of that given to
the two 'strong men' charged with watering the plants.[99] The newly
settled location permitted the space necessary for a surrounding
garden, and, although it is not a feature normally associated with
mosques in Egypt, it is worth remembering that several no-longer-
extant Fatimid and Mamluk religious institutions, particularly in
the cemetery area between Fustat and Cairo, were also provided with
gardens.[100]

The plethora of madrasas and *khanqah*s erected by the Mamluks
was not matched by the Ottomans. Those that we do have, such
as the madrasas of Sulayman Pasha (1534–5) and Sultan Mahmud
(1750), differ from their Mamluk counterparts in having no minaret
and only a small area set aside for prayer.[101] The Madrasa of Sultan
Mahmud is interesting in incorporating another area for prayer
that we have not encountered before: the *sabil*. *Waqfiya*s from
the Qaytbay period of no-longer-extant *sabil*s document examples
with imams appointed to them to lead prayers.[102] According to
its *waqfiya*, the *sabil* of Sultan Mahmud had an imam to lead
prayers, as well as eleven Quran readers and ten men who per-
formed invocations to the sultan.[103] Its carved stone mihrab has
recently been made more attractive by red, gold and black paint,[104]
but the cynosure of the decoration of the whole complex is the
back wall of the *sabil*, which contains the best Iznik tiles in Cairo,
in particular in its two arched panels (Figure 4.16). These are from
the sixteenth century, the period of Iznik's finest production, and so
have obviously been reused in this later building. Behrens-Abouseif
has already noted how some of the original tile borders are missing,
and that the design is a patchwork.[105] But even the two best panels,
symmetrical at first glance, turn out on close inspection to have
been fitted together with many lacunae (Figure 4.17). Extensive tile
panels were not a feature of architectural decoration in Egypt before
the Ottoman period; the conquerors imported their own aesthetic.
Other large-scale examples include the revetment of the qibla wall
and tomb chamber of the Aqsunqur Mosque added by Ibrahim
Pasha (1652), and the qibla wall of the Sini Mosque (1788) at Girga.

Figure 4.16 *Detail of interior of the* sabil, *madrasa of Sultan Mahhmud, Cairo (1750)*

Figure 4.17 *Detail of interior of the* sabil, *madrasa of Sultan Mahhmud, Cairo (1750)*

Both of these feature reused tiles; unlike Damascus, where a thriving industry of Iznik-style tiles with a different palette arose,[106] Cairo never developed significant tile production in the Ottoman period.

Most buildings in Ottoman Cairo, including mosques, were spon-
sored by nongovernmental figures who were not bound by any cen-
tralised system of architectural design and were happy to continue
building in the tradition of previous centuries. This was true whether
the patron was a local merchant (as in the case of the Mosque of al-
Burdayni, 1616) or even a member of the Janissary corps (Mosque of
Shurbaji Mirza, 1698).

If this was true of the capital, it was even more the case in
the Egyptian provinces, where a more traditional model was the
norm. Most of these mosques are small, although some larger ones,
like that of al-Mitwalli at Mahallat al-Kubra, were restorations or
rebuildings of much earlier ones. All are hypostyle, and their usual
lack of a courtyard was a sensible complement to their mostly
small size. The material is usually brick, with columns either of
reused stone or made of wood. Wooden columns were never seen
in Cairo, but had occasionally been earlier used in some Anatolian
buildings.[107] The decoration is usually restrained, with geometric
brick patterns or stucco imitating brick in red and black used on
entrances and mihrabs. The qibla wall may also be enlivened by
tiles, of Iznik or Tunisian manufacture, although the inferior quality
of the latter shows not only in their design and colours but in the
flaking of the glaze.[108] The most exuberant part of the mosque may
be the minaret, up to four stories tall in the case of al-Mujahadin
Mosque at Asyut.

Several examples of elevated mosques are known. The rising
ground level has disguised the extent to which this was the case in
the mosques of al-Aqmar, al-Salih Tala'i' and Shurbaji in Cairo. But
it is still very apparent in the Abu'l-Dhahab complex at Cairo and in
the examples, closer to the Mediterranean, of Duqmaqsis at Rosetta
and the Shurbaji (Figure 4.18) and Tarbana mosques at Alexandria.[109]

Muhammad 'Ali (r. 1805–48) to the mid-twentieth century

By the second half of the eighteenth century, the power of the old
Mamluk beys, such as the patrons 'Abd al-Rahman Katkhuda and
Muhammad Abu'l-Dhahab, had begun to rival that of the gover-
nors sent from Istanbul. Both, however, proved unable to resist
Napoleon's forces in 1798. Although short-lived, the French invasion
was followed by major changes in Egypt's status. Muhammad 'Ali,
an officer initially only second in command of the Ottoman army's
Albanian Corps, managed to seize power in the confused situation
in Egypt shortly after his arrival there in 1801. His de facto control
over Cairo was recognised by the Porte in 1805, when he was made
governor. He cemented his position by massacring the remnants of
the Mamluks in 1811. He then expanded into Syria and the Hijaz,
and in 1841 the Ottoman sultan granted him Egypt and Sudan as a
hereditary domain.

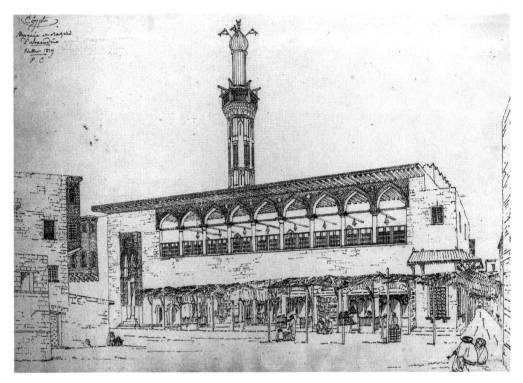

Figure 4.18 *Exterior of the Shurbaji mosque, Alexandria (1758) (after Coste)*

Thus Egypt was only nominally under Ottoman control at this time, and in his attempts to develop the country Muhammad ʿAli looked to Europe, whose nations became his main trading partners. In consequence, Alexandria increased enormously in size in this century, from a village of ten thousand to a city of nearly a quarter of a million inhabitants. Europe, and especially France, also figured more prominently in the cultural sphere. An example of this is Pascal Coste, who was employed as Muhammad ʿAli's architect and engineer from 1817 until 1829.[110] Not content with merely massacring the Mamluks, Muhammad ʿAli also obliterated most of their remaining buildings on the citadel, determined to erect a large mosque in his name. However, the plan that Coste produced for him had its origins in the complex of Faraj ibn Barquq, and although the minarets were Ottoman in style its major focal points, five large domes, were very much in the Mamluk manner.[111] Coste's plan remained unbuilt. Ironically, despite Muhammad ʿAli being the most independent governor since the post had been instituted three centuries earlier, he instead sponsored the only truly monumental mosque based on the plan of imperial Ottoman examples.

The first major built example of Mamluk Revival, the style that was to dominate Egyptian mosque architecture for over a century,

came in 1869 at the Mosque of al-Rifaʿi. By this time, the Muhammad ʿAli dynasty had reoriented itself away from Turkey and had begun to think of themselves primarily as Egyptians.[112] This change may have been accentuated when in 1867 Ismaʿil Pasha, Muhammad ʿAli's grandson, received the title of *khedive* (viceroy) of Egypt rather than that of *wali* (governor). The architect of the mosque of al-Rifaʿi, Husayn Fahmi, was also a member of the royal family and had studied in France;[113] his client was the patron, Ismaʿil's mother, Khushyar Hanim. We have no specific information on why this style was chosen, but presumably it answered to a wish to assert a newfound adherence to Egyptian identity. Unlike Coste's proposal, however, the plan of this building was not specifically related to Mamluk models.[114] Like almost all subsequent examples, the Mamluk Revival style here was only skin deep, a decorative revetment on an unfamiliar core.

The style was also used for villas and government buildings,[115] but it cemented its popularity in the Egyptian imagination by being employed for several shrines in Cairo, including those of Awlad Inan (1896) and the extremely popular ones of Sayyida Zaynab (1887), Imam al-Shafiʿi (1892) and Sayyida Nafisa (1896).[116] The architects of these were both foreign (Julius Franz) and Egyptian (Saber Sabri). Saber Sabri's position as chief architect of the Ministry of Waqfs was also important for the continued success of the Mamluk Revival style, as was its employment by his successor from 1906 until 1916, Mahmud Fahmi, in secular as well as religious buildings.[117]

Coste had also designed a Mamluk Revival style mosque for Alexandria; like his Muhammad ʿAli Mosque for Cairo, it remained unbuilt.[118] It fell to another chief architect of the Ministry of Waqfs, Mario Rossi, to stamp this style on the rapidly growing second city with the funerary Mosque of Abu'l-ʿAbbas al-Mursi (1929–45). Rossi had initially come to Cairo from Italy in 1921 as an assistant to another Italian, Ernesto Verrucci, who was the chief architect for Sultan, later King, Fouad (r. 1917–36). Rossi became chief architect of the Ministry of Waqfs by winning an international competition in 1929 to design a portal for the Neo-Mamluk Ministry of Waqfs building at Bab al-Luq in Cairo. During his subsequent tenure, lasting until 1955, he designed, or at least supervised the design of, no less than 260 new mosques for the ministry – including what was then the largest congregational mosque in the United States, at the Islamic Centre of Washington DC.[119]

Rossi was consistent in cladding his buildings inside and out with mostly Neo-Mamluk motifs. He also used familiar Mamluk forms such as minarets, portals, domes and lanterns, sometimes combining them with Egyptian Ottoman motifs.[120] Most of his buildings have a centralising tendency, but this is focused on what might have been the courtyard in earlier buildings, which was now roofed, usually by a lantern. As a result, the mihrab is usually (and

unfortunately) darker than the central portion of the mosque. The square central cores of the buildings are frequently emphasised by a stepped exterior. He also liked to incorporate, often as part of the ablutions facilities, a semi-circular extension, the most obviously Europeanising element of his designs.[121] His usual elimination of the courtyard could also be interpreted as a Western element, although even as monumental a mosque as the earlier al-Rifaʻi had omitted it. Such was the ubiquity of Rossi's model that even in the second half of the twentieth century, many Egyptian architects struggled to move on from it: later closely related examples include, for instance, the Cairene mosques of Salah al-Din (1962) by Aly Khairat (also employed by the Ministry of Waqfs) and al-Sayyida Safiya (1980) by Mohammad ʻIsa.[122]

Modern mosques

When I first accepted the commission to write this book, I looked forward to the chance to research not just the pre-modern mosques which I was familiar with, but also those from the twentieth and twenty-first centuries. As an ardent admirer of modern architecture, the possibility of finding fusions of contemporary design and historical consciousness excited me. What bold new work had been produced in recent decades? What hidden gems deserved to be uncovered?

I confess that I found the available choices disappointing. I am not alone in this evaluation. Egypt is absent from the appendix of 'Key Mosques and Islamic Centres' in Holod and Khan's *The Contemporary Mosque* (1997).[123] An even more up-to-date bellwether is the Aga Khan Award for Architecture, presented every three years since 1980 to a variety of projects, the most recent being in 2013. Not one of these prizes has been awarded to an Egyptian mosque. Even more surprising, perhaps, is that out of the total of 110 buildings that were premiated, only eight were mosques, and the last was in 1995.[124] Egypt is not as rich as some of its neighbours, but throwing money at the problem does not guarantee success: despite the vast amounts of wealth lavished on state mosques in this period, none has been given prizes.[125]

Perhaps part of the reason for this is that the choice of building styles for modern mosques has increased enormously, as internationalisation has become the cultural norm in societies. One recent analysis by Ihsan Fethi puts forward five categories for mosques, the first four on a sliding scale from vernacular to conventional to 'New Classic Islamic' to modern, and a fifth for an eclectic 'Arabian Nights' model.[126] These are by no means equally weighted in modern Egyptian examples, with most coming from the first two categories. Ironically, given the conservative models adopted for mosques, architectural education since the early twentieth century

in Egypt, as in many other Middle Eastern countries, privileged the modern West, frequently omitting the local heritage altogether from the curriculum.[127]

It was the backlash against this that produced one of Egypt's most feted architects, Hassan Fathy. The story of his struggle to populate his settlement at Gourna was published in Egypt in 1969 as *Gourna, A Tale of Two Villages*, but struck a much more resonant chord with a wider public when republished in Chicago in 1973 as *Architecture for the Poor*.[128] Hc is also widely celebrated as one of the chief exponents of the vernacular school, and his influence has been spread by numerous disciples. The virtues of the mosques by him and his followers are a return to basics with their elimination of the highly decorated façades of the preceding Neo-Mamluk style, and the careful balancing and placement of the elemental forms of courtyard, arcade, iwan, dome and minaret. However, the extent to which this can truly be called vernacular architecture is questionable in view of the importation of vaulting forms that had been previously been confined to Nubia; rather than being traditional, it has been suggested that they were in fact an invented tradition.[129] Even the material that Fathy was so proud of using, mud brick, was not one which was then in common use in Egypt outside of Nubia, and his refusal to engage with modern materials such as steel and concrete has limited the potential impact of his work.

As mentioned above, the success of Mario Rossi's designs led to their aesthetic being continued in the second half of the twentieth century by his successors at the Ministry of Waqfs. The Imam Hasan Mosque (1973) is related to this tradition, but its reduction of decoration, its bold simplification of forms, and their juxtaposition in new relationships lifts it above the bulk of other examples in this category.

Fethi's third category, the New Classic Islamic, varies from the second in the degree to which modern building materials and methods are used in its execution. At the small mosque (1959) beside the entrance to the Italian memorial at El-Alamein, the main forms, a low dome and minaret, are placed on opposite sides of a courtyard that has three round-headed arches on each side (Figure 4.19). The only exterior decoration is on the slightly battered walls: they are completely veneered with an irregular reticulated pattern that unifies the disparate elements. But the plain interior is an anti-climax.

Several of the recent large mosques in Cairo might fit into this third category, although the extent to which any modern aesthetic is included is arguable. Some colleagues suggested the Cairo al-Rahman al-Rahim Mosque as one of the better examples. Its plan is a quincunx, dominated by the massive central dome. Even this is dwarfed on the exterior by the pair of four-storey Neo-Mamluk minarets

Figure 4.19 *The mosque at the Italian memorial, El Alamein (1959)*

(Figure 4.20). Inside, however, the dome lowers over the adjacent spaces: both the four massive supporting corner piers and the zone of transition seem squat beside the immense width and height of the cupola. As in many modern mosques dominated by a central dome, the mihrab area is relatively gloomy (Figure 4.21).

A more ambitious candidate in this category was the Jami' al-Zahra, built for the campus of al-Azhar at the relatively new suburb of Madinat Nasr in Cairo.[130] The entrance is a *pishtaq* that recalls examples in Iran and Anatolia, with its twin minarets and semi-octagonal entrance leading to a squinch-net (part of a dome formed by intersecting arches). Also unconventional for Egypt are its round-headed arches, used throughout, and the employment of its most distinctive feature, the cross vaults that cover the interior spaces at three different levels and whose open sides flood the interior with light.[131] The massing of forms leads to the visual climax of the dome, whose rows of differently sized and shaped windows provide a satisfying decorative effect (Figure 4.22). However, the architect may have been compromised by his multifunctional brief: the interior spaces needed to be able to be partitioned so that they could function as classrooms when not being used for congregational prayer. But this necessitated the isolation of the prayer hall from the courtyard by doors, which in turn was accomplished by making the openings between the two lower than usual.[132] As a

Figure 4.20 *Exterior of the Mosque of al-Rahman al-Rahim, Cairo (Hassan Rashdan architects, 2003–9)*

Figure 4.21 *Interior of the Mosque of al-Rahman al-Rahim, Cairo (Hassan Rashdan architects, 2003–9)*

Figure 4.22 *Jamiʿ al-Zahra, Cairo (Abdelbaki Mohamed Ibrahim, architect, 1995)*

result, even when the courtyard is not closed off with the available doors, the vista that should obtain from the interior toward the qibla is compromised.

Thankfully, there are no contemporary mosques in Egypt that quite fit into the 'Arabian Nights' category, but the number in the modernist camp is almost equally small. The unfortunate desire for originality at all costs is shown in two recent mosques, sponsored by the Shurta (the Police Force), in the centre of Cairo (Figure 4.23) and in an outlying suburb (Figure 4.24). Their form is amusingly similar to the characterisation by Gulzar Haider of such cravings as producing 'mosques with flying saucer domes and rocket minarets'.[133]

One candidate that looked promising at first was on the north coast, west of Alexandria, at the holiday village of al-Ruwwad (Figure 4.25). The small mosque makes attractive use of stepped forms on the exterior, small crenellations at the corner of the mosque and the adjacent ablutions area, and a tall minaret that repeats and magnifies their zigzag effect on different axes. It also uses round-headed arches throughout, supplemented by bull's-eye windows on the side. But here too, the nondescript interior disappoints.

Another interesting candidate was the small mosque at the International Garden at Alexandria (1990).[134] In plan, this was a rectangle situated within a narrow reflecting pool. The concrete frame was softened on the outside by crenellations and keel-arched brick infills, each with a narrow window in the centre. The main lighting on the interior was through a narrow triangular skylight that ran the length of the roof. The herring-bone pattern of the slightly sloping oak ceiling to either side softened the mostly plain plaster walls below. However, it is a sad commentary on the response to a building of such striking originality and unassuming repose that recently it should have been demolished and a more conventional mosque[135] built in its place.

The one example that I have included, the Hidayat al-Islami Mosque at Rosetta, is in an unlikely provincial setting. The almost brutalist exterior is softened by planters and by careful attention to repeated forms at different scales. However, the architect may have tried to avoid the fate of the International Garden mosque by playing it safe with an interior that is more in the tradition of the conventional neo-Mamluk designs seen elsewhere.

Egypt and Cairo have long been at the geographic and cultural centre of the Arab world. Cairo in the Middle Ages was, as it is today, one of the world's most populous cities. Unlike Baghdad or Damascus it was never sacked by invaders, and its primary position under the Tulunids, Fatimids, Ayyubids and Mamluks has resulted in an architectural legacy unequalled in the Arab world. The momentum that this created meant that even under the Ottomans it was a prosperous centre of construction and trade. Its resurgence as an intellectual and cultural centre in the Middle East has continued from the time of

Figure 4.23 *Mosque of al-Ruwwad village*

Muhammad ʿAli to the present day. Even if the legacy of recent years is outshone by those of previous centuries, its panorama of mosques from the earliest days of Islam to the present is unrivalled.

Figure 4.24 *Shurta mosque, 6th October City (Hakim Afifi, architect, 2012)*

Figure 4.25 *Shurta mosque, Cairo (c. 2006)*

Notes

1. *Sahih Muslim: Kitab al-masajid wa mawadiʿ al-salat,* http://sunnah. com/ muslim/5.
2. Grabar 1997, 115.
3. Sauvaget 1947, Chapter 6.
4. The earliest surviving examples of mihrabs in mausoleums seems to be from tenth-century Transoxiana: Grabar 1966, 21, nos 20, 23.
5. Behrens-Abouseif 2007, 18. The existence of numerous pilgrimage guides to the cemeteries of Cairo shows that in Egypt, at least, objections of the ulema to mausoleums was very much a minority view: Taylor 1999.
6. O'Kane 2012a, 84–7.
7. O'Kane 1992.
8. Loiseau 2010, 191, and Hamza 2008, 143.
9. Loiseau 2010, 185. The phenomenon was also observed in Mamluk Syria: Talmon-Heller 2007, 48.
10. Nasir-i Khusraw 1986, 53.
11. The view that they actively collaborated with the Muslims, or indeed the extent to which they can be seen to have been acting as a single body, has been superseded by recent scholarship: Mikhail 2014.
12. Johns 1992.
13. O'Kane 2006.
14. Kawatoko 2005, Fig. 7, 852.
15. Ibn ʿUthman 1995, 1: 235; Creswell 1952, 1: 11–15.
16. Such as are seen on earlier nine-bay mosques in Tunisia – for instance, the mosques of Bu Fatata at Susa and the Muhammad ibn Khayrun at Qayrawan: O'Kane 2006, 204.
17. O'Kane 2006, 204.
18. Although the mosque is famed as a place of unbroken education, since teaching was established there by the vizier Yaʿqub ibn Killis in 988 (Dodge 1961), there was probably a long hiatus between the death of the vizier in 991 (after which the teaching endowment was not replenished: Walker 2009b, 149) and the re-establishment of teaching there at the time of Baybars in the early Mamluk period (Dodge 1961, 60–1). Even then, it did not take its place as the pre-eminent teaching institution in Cairo until the Ottoman period: Behrens-Abouseif 1994, 269.
19. Maqrizi 1853, 2: 318–20, 444.
20. Raghib 1994.
21. O'Kane 1999.
22. Which in turn was a feature of the Mahdiya great mosque, and before it the Qayrawan great mosque; its continuing popularity may also be related to the building of a shallow dome in front of the mihrab at the Mosque of Madina in al-Walid's reconstruction: Khoury 1996, 90.
23. Walker 2009a, 28.
24. Bierman 1998, 175 n. 54. The columns of the building were later re-used in the building of the Mosque of al-Maridani: Maqrizi 1853, 2: 308.
25. Bierman 1998, 105–6.
26. Williams 1983.
27. Creswell 1952–9, 1: 144–5; Monneret de Villard 1957, 56–7.
28. Creswell 1952–59, 1: 150–1.
29. Maqrizi 1853, 2: 289–90. Maqrizi's date of 478/1094 results from confusion between the Arabic 7 and 9; the correct date is given by

al-Nuwayri, after al-Juwwani and Ibn Khallikan: Sayyid 1998, 471. As the founder of the mosque, al-Afdal, only succeeded his father in 1094, the date of 498H is much more likely.

30. 'Fi qiblatihi tisa' qubab fi a'lahu'.
31. As postulated by Allen 1988, 84.
32. Ibn Jubayr 1952, 40; Ibn Jubayr 1992, 42.
33. O'Kane 2009, 431–2.
34. O'Kane 2009, 429–30.
35. Mackenzie 1992, 130–40.
36. The proximity of her mausoleum to those of Sayyida Ruqaya and Sayyida Nafisa may have been to profit both from the *baraka* of these nearby mausoleums of noted females and from the possibility of increased visits to her own tomb by pilgrims to those shrines. I would like to thank Jere Bacharach for this suggestion.
37. Behrens-Abouseif 1983.
38. I am most grateful to May al-Ibrashy, Shajar al-Durr Conservation Project, Athar Lina 2, funded by the American Research Center in Egypt with the Barakat Trust, UK, for showing this to me and for permission to reproduce it here. Unpublished fragments of painting in the zone of transition of the mausoleum she built for her husband, al-Salih Najm al-Din, suggest that it too had painting of lotuses in Pharaonic style.
39. Northrup 1998, 119.
40. See Hamza 2008 and Hamza 2015. The solicitation and desirability of prayer in connection with the dead is illustrated by the *turba* of Ibn Taghribirdi in the Northern Cemetery, where the burial iwan consisted of five arcades, with the middle one being reserved for prayer: Hamza 2008, 143.
41. Even major sultans such as Qaytbay and al-Ghawri skewed the surplus to be as much as 90 per cent of the *waqf* income: Petry 1998, 57. It was also not unusual for the palaces of defeated amirs to be looted of their treasures: Levanoni 1995, 196.
42. Kessler 1972.
43. This included those of al-Nasir Muhammad at his madrasa (where they were stationed in the vestibule of the complex adjacent to the mausoleum); of Sultan Hasan, al-Muayyad and Qaytbay, where they were in the tomb chamber itself; and of Barquq, where they were installed in a *qa'a* adjacent to the tomb chamber: Marmon 1995, 15–18.
44. Marmon 1995, 125.
45. In the so-called Iwan at the citadel: Rabbat 1995, 244–56; O'Kane 1996, 510–11.
46. The Mustansiryya Madrasa in Baghdad was earlier: Creswell 1952–9, 2: 124–47.
47. For his complex in al-Qarafa al-Sughra, see Ibrahim 1974.
48. An upgrade, or at least a change in the status of *khanqahs* at this time, is indicated by the fact that the *khanqah* of Baktimur became the first to be approved for Friday prayer, in 1326: Loiseau 2012, 191.
49. Doris Behrens-Abouseif has noted how, unlike Qalawun, al-Nasir Muhammad personally supervised the building works of which he was patron: Behrens-Abouseif 1995b, 271.
50. Levanoni 1995, 185–7; see also Ayalon 1994.
51. Rogers 1972.
52. Rogers 1972, 53, n. 26.

53. These excited the admiration of orientalists at an early age: see the drawing of one, possibly by Jules Bourgoin, in Volait 2013, 89.

54. Meinecke 1992, vol. 1, pls 68a, c.

55. Little 1979, 397–8.

56. Meinecke 1992, 91–2.

57. Ibrahim and O'Kane 1988.

58. As well as the dome over the qibla iwan of the Sarghatmish complex.

59. O'Kane 2012c. The major exception was Sultan al-Ghawri, whose decision to opt for a brick dome was probably based on his predilection for tile decoration. However, it seems to have been over-ambitious, as it repeatedly collapsed: Behrens-Abouseif 2007, 297.

60. O'Kane 2000.

61. O'Kane 2000.

62. O'Kane 1987.

63. However, its monumentality was supposedly disparaged by Sultan Selim, who compared it to a merchant's house: Rabbat 2010, 119.

64. Behrens-Abouseif 1995a, 8.

65. http://www.christies.com/lotfinder/ancient-art-antiquities/a-byzan tinebronze-polycandelon-circa-6th-century-5671192-details.aspx. For a related tenth- to eleventh-century example for the Great Mosque of Qayrawan, see http://www.discoverislamicart.org/database_item. php?id=object; ISL;tn;Mus01;14;en.

66. Behrens-Abouseif 1995a, 8.

67. Nasir-i Khusraw 1986, 53; Behrens-Abouseif 1995a, 11.

68. Nasir-i Khusraw 1986, 53. He also, in his description of the Dome of the Rock in Jerusalem (p. 32), mentions the many silver lamps there that were donated by the Sultan of Egypt; they were later plundered by the Crusaders: Behrens-Abouseif 1995a, 9.

69. https://en.wikipedia.org/wiki/Great_Mosque_of_Kairouan#/media/ File:Great_ Mosque_of_ Kairouan,_prayer_hall.jpg. For an Almohad one at Fez dated 1204 see Behrens-Abouseif 1995a, pls 1–2.

70. O'Kane 2012a, 344, no. 509.

71. Known as *thurayya* in the sources: Behrens-Abouseif 1995a, ch. 3.

72. Behrens-Abouseif 1995a, ch. 2.

73. The best guide to their development is now Ward 2012; see also Wiet 1932a. Some were unfortunately destroyed in the bombing of the police station opposite the Museum of Islamic Art in Cairo in 2013, but the museum still has the world's most extensive collection.

74. Behrens-Abouseif 2007, 40 suggests that Pierre de Lusignan of Cyprus's raid on Alexandria in 1365 may have been the cause of decline in the industry, but the numerous lamps made for Sultan Barquq's complex (1396) show that it continued. The location of the workshops is still uncertain.

75. Muqaddasi 1877, 205.

76. Walker 2009b, 151.

77. There are three lines of inscriptions on each face: Museum of Islamic Art, Cairo, No. 4,114: Weill 1936, 85 and pl. 33.

78. For a comparable example, see Atıl 1987, 170–1.

79. But Jere Bacharach points out to me that their status as *hafiz*es (memo-rizers of the Quran) may have made this unnecessary.

80. O'Kane 1996, 513.

81. Referred to as a *kursi* in modern Arabic literature, but we have no knowledge of the original term.

82. Despite the recent theft of one from the complex of Qanibay.
83. O'Kane 2013.
84. For portable mihrabs, see O'Kane 2012a, 85–6; for cenotaphs, see those of Sayyid Ruqayya, 1139 (Creswell 1952–9, pl. 88a) and Imam al-Shafi' (Figures 9.3–4).
85. Such as those of Sultan Lajin at Ibn Tulun, Manjak al-Yusufi and al-Maridani: Karnouk 1981, pls 1, 4.
86. O'Kane 2012b.
87. Nasir-i Khusraw 1986, 53.
88. Behrens-Abouseif 2007, 40, 95.
89. The most authoritative publication of these is Thompson 2012. The most common mention of the use of carpets in the Mamluk sphere seems to have been in connection with processions: Behrens-Abouseif 2007, 29–30.
90. Behrens-Abouseif 2007, 49.
91. Levanoni 1995, 187.
92. Levanoni 1995, 188.
93. Petry 1993, 212.
94. Petry 1993, 224–6.
95. Raymond 2001, 217–18.
96. The fixative used for the dyes in the open pits was largely urine.
97. Necipoğlu 2005, 18.
98. Bates 1985.
99. Williams 1972, 463.
100. Fatimid examples: the Qarafa (Maqrizi 1853, 2: 318; Maqrizi 2002–3, 4: 288) and Fiyala mosques (Maqrizi 1853, 2: 289; Maqrizi 2002–3, 4: 148); Mamluk examples: the Jami' al-Jadid of al-Nasir Muhammad, mentioned above, and the *khanqah*s of Baktimur (Maqrizi 1853, 2: 423–4; Maqrizi 2002–3, 4: 772) and Tughaytimur (Maqrizi 1853, 2: 425; Maqrizi 2002–3, 4: 783). Hani Hamza kindly informs me that the *waqfiya*s of the complex of Khayrbak and of the *turba* of Azdumur min 'Ali Bay (Index 174, 908/1502) mention an attached *junayna* (garden) rather than a *bustan* (orchard) as in the previous examples.
101. Just a small iwan for the former, and a square dome chamber for the latter.
102. I am indebted to a personal communication from Doris Behrens-Abouseif for this information.
103. These were separate from the twenty schoolboys, and the Quran teacher and his assistant, belonging to the *maktab*: Behrens-Abouseif 2011, 197.
104. Behrens-Abouseif 2011, Fig. 15.
105. Behrens-Abouseif 2011, 198.
106. For an example, now in the Islamic Museum in Cairo, see O'Kane 2012a, 198–9. Red is absent from these and light blue very sparsely used, the main colours being green and dark blue on white.
107. Otto-Dorn 1959.
108. Iznik examples include the mosques of Aqsunqur and Shurbaji in Cairo, the *sabil* of Mahmud I in Cairo, and the mosques of Sini at Girga, and Duqmaqsis at Rosetta; Tunisian ones can be seen at, again, Duqmaqsis at Rosetta, and at the Shurbaji and Tarbana mosques at Alexandria.
109. For the Alexandrian examples, see Behrens-Abouseif 1998.
110. He produced the first major book dedicated to illustrations of Islamic architecture in Egypt, *Architecture arabe; ou Monuments du Kaire* (1839),

now also available online at http://gallica.bnf.fr/ark:/12148/bpt6k10583
9g and http://digitalcollections.nypl.org/collections/architecture-arabe-
o u -monumentsdu-kaire-mesurs-et-dessins-de-1818-1825#/?tab=about.
Earlier, of course, drawings of major monuments had appeared in the
Description de l'Égypte /État moderne, Paris, 1812.

111. *Pascal Coste: toutes les Égyptes* 1998, 112–13.
112. Hunter 1998, 192, references a speech in which Sa'id Pasha, the son of
Muhammad 'Ali, spoke of himself as an Egyptian.
113. Al-Asad 1993, 119. For further details on the construction, see Volait
2005, 173–8.
114. Even if the nine-bay element of the main prayer hall had appeared
in several earlier Islamic buildings in Egypt from the tenth century
onward: O'Kane 2006, 189, 206.
115. Ormos 2009, 2: 375–6; Volait 2006, 137–38.
116. Ormos 2009, 2: 376; Volait 2005, 153; Volait 2006, 135–7. As Mercedes
Volait demonstrates, the Awlad Inan Mosque was dismantled in 1979
and, rebuilt, took on a new life as the Shrine of Sayyida 'A'isha in
Cairo.
117. Volait 2005, 77–8.
118. Hill 1992, 321–2.
119. Sedky 2001, 71.
120. Such as the dome of the Muhammad Kurayim Mosque at Ras al-Tin,
based on the Sinan Pasha Mosque in Cairo (Turchiarulo 2012, 305), or
the fluted curving corbel flanking the entrance of al-Thawra Mosque
at Heliopolis (Turchiarulo 2012, 248), reminiscent of those found in
eighteenth-century Ottoman domestic architecture in Cairo.
121. For example, at the mosques of Kurrayim, al-Thawra, Qaid Ibrahim,
'Umar Makram and Zamalek: Turchiarulo 2012, 266.
122. Serageldin and Steele 1996, 86–7.
123. Holod and Khan 1997, 274–9.
124. In 1983, mosques in Mali and Bosnia; in 1986, mosques in Niger,
Pakistan and Indonesia; in 1989, a mosque series in Sauda Arabia; in
1995, mosques in Turkey and again in Saudi Arabia: http://www.akdn.
org/architecture/.
125. Exemplified most recently by the Sheikh Zayed Grand Mosque of Abu
Dhabi (for which, see Hillenbrand 2012), at a construction cost of $545
million. Apart from the costs involved, perhaps the availability of the
al-Rifa'i Mosque (used for the state funeral given to Mohammad Reza
Pahlavi, for instance) has inhibited calls for an Egyptian state mosque.
126. Fethi 1985, 55–7.
127. Ozkan 1986; al-Naim 2006, 143; Alsayyad 2008, 258.
128. Fathy 1969; Fathy 1973.
129. Elshahed 2013; Alsayyad 2008, 259–60.
130. http://archnet.org/sites/1276; Serageldin and Steele 1996, 83–5.
131. The cross vaults recall those of the Ahle Hadith Mosque in Islamabad,
built ten years earlier: http://archnet.org/sites/97/media_con t e n t s /
17048.
132. The openings are less than half the height of the round-headed arches
within the courtyard; a wooden grille disguises the blind upper section.
133. Haider 1990, 158.
134. Serageldin and Steele 1996, 81; http://archnet.org/sites/741/media_
contents/14986.
135. http://www.lotusgroup.com/Mosque.htm.

Bibliography

'Abd al-Gawad, Nafida Muhammad (1993), *al-Athar al-mi'mariya fi wust al-Dilta fi qarn al-tasi' 'ashara*. MA thesis, Tanta University.

'Abd al-Wahhab, Hasan (1956–7), 'Tarz al-'imara al-islamiya fi rif Misr'. *Bulletin de l'Institut d'Égypte/Majallat al-Majma' al-'Ilmi al-Misri* 38/2, 5–40.

Abdel Wahab, Mohamed A. (1998), *Marble Paving in Mamluk Cairo*. MA thesis, American University in Cairo.

'Afifi, Muhammad (2005), *al-Qibab al-athariya al-baqiya bi-Dilta Misr fi'l-'asr al-islami*. Cairo.

Alhamzah, Khaled A. (2009), *Late Mamluk Patronage: Qansuh al-Ghuri's Waqfs and His Foundations in Cairo*. Boca Raton, FL.

Allen, Terry (1988), *Five Essays on Islamic Art*. n.p.

Alsayyad, Nezar (2008), 'From Modernization to Globalization: the Middle East in Context', in Sandy Isenstadt and Kishwar Rizvi (eds), *Modernism and the Middle East: Architecture and Politics in the Twentieth Century*, Seattle and London, pp. 255–66.

Amin, Naguib (ed.) (2008), *The Historical Monuments of Egypt. Volume 1: Rosetta*. Cairo.

Anorve-Tschirgi, Conchita (2009), 'The Mosque of Mustafa Shurbagi Mirza: Reasserting Egypt's Mamluk Roots', in Bernard O'Kane (ed.), *Creswell Photographs Re-examined: New Perspectives on Islamic Architecture*, Cairo, pp. 71–98.

Al-Asad, Mohamad (1992), 'The Mosque of Muhammad 'Ali in Cairo'. *Muqarnas* 9: 39–55.

Al-Asad, Mohamad (1993), 'The Mosque of al-Rifa'i in Cairo'. *Muqarnas* 10: 108–24.

Atıl, Esin (1987), *The Age of Sultan Suleyman the Magnificent*. Washington, DC and New York.

Ayalon, David (1994), 'The Expansion and Decline of Cairo under the Mamluks and Its Background', in Raoul Curiel and Rika Gyselen (eds), *Itineraires d'Orient. Hommages a Claude Cahen*, Res Orientales 6: 14–16. Bures-sur Yvette.

'Azab, Khalid Muhammad (1989), *Fuwwa: madinat al-masajid*. Fuwwa.

Bakhoum, Diana (2009), *The Mosque of Emir Altunbugha al-Maridani in Light of Mamluk Patronage under al-Nasir Muhammad Ibn Qalawun*. MA thesis, American University in Cairo.

Bakhoum, Dina (2009), 'The Madrasa of Umm al-Sultan Sha'ban before and after Creswell', in Bernard O'Kane (ed.), *Creswell Photographs Re-examined: New Perspectives on Islamic Architecture*, Cairo, pp. 9–120.

Bates, Ulku U (1985), 'Two Ottoman Documents on Architects in Egypt'. *Muqarnas* 3: 121–7.

Behrens-Abouseif, Doris (1983), 'The Lost Minaret of Shajarat ad-Durr at Her Complex in the Cemetery of Sayyida Nafisa'. *Mitteilungen des Deutschen Archaologischen Instituts, Abteilung Kairo* 39: 1–16.

Behrens-Abouseif, Doris (1989), *Islamic Architecture in Cairo: An Introduction*. Leiden and Cairo.

Behrens-Abouseif, Doris (1992), 'The Facade of the Aqmar Mosque in the Context of Fatimid Ceremonial'. *Muqarnas* 9: 29–38.

Behrens-Abouseif, Doris (1994), *Egypt's Adjustment to Ottoman Rule: Institutions, Waqf and Architecture in Cairo (16th and 17th Centuries)*. Leiden.

Behrens-Abouseif, Doris (1995a), *Mamluk and Post-Mamluk Metal Lamps.* Cairo.

Behrens-Abouseif, Doris (1995b), 'Al-Nasr Muhammad and al-Ašraf Qaytbay – Patrons of Urbanism', in U. Vermeullen and D. de Smet (eds), *Egypt and Syria in the Fatimid, Ayyubid and Mamluk Eras*, Leuven, pp. 267–79.

Behrens-Abouseif, Doris (1998), 'Notes sur l'architecture musulmane d'Alexandrie', in Christian Decobert and Jean-Yves Empereur (eds), *Alexandrie medievale 1*, Cairo, pp. 101–14.

Behrens-Abouseif, Doris (2007), *Cairo of the Mamluks.* London.

Behrens-Abouseif, Doris (2010), *The Minarets of Cairo.* Cairo.

Behrens-Abouseif, Doris (2011), 'The Complex of Sultan Mahmud in Cairo'. *Muqarnas* 28: 195–219.

Bierman, Irene A (1998), *Writing Signs: The Fatimid Public Text.* Berkeley, CA.

Bloom, Jonathan (1982), 'The Mosque of Baybars al-Bunduqdari'. *Annales Islamologiques* 17: 45–78.

Bloom, Jonathan (1983), 'The Mosque of al-Hakim in Cairo'. *Muqarnas* 1: 15–36.

Bloom, Jonathan (2007), *Arts of the City Victorious.* New Haven and London.

The Cambridge History of Egypt (1998) I. *Islamic Egypt, 640–1517*, ed. Carl F. Petry; II. *Modern Egypt, from 1517 to the End of the Twentieth Century*, ed. M. W. Daly. Cambridge.

Coste, Pascal. 1839), *Architecture arabe; ou Monuments du Kaire, mesures et dessines, de 1818 a 1825.* Paris.

Creswell, K. A. C. (1940), *Early Muslim Architecture. II. Early 'Abbasids, Umayyads of Cordova, Aghlabids, Tulunids and Samanids.* Oxford.

Creswell, K. A. C. (1952–59), *The Muslim Architecture of Egypt*, 2 vols. Oxford.

Creswell, K. A. C. (1969), *Early Muslim Architecture. I, parts I–II Umayyads A.D. 622–750.* Oxford.

Darrag, Ahmad (1961), *L'Égypte sous le règne de Barsbay 825–841/1422–1438.* Damascus.

Decobert, Christian, and Denis Gril (1981), *Linteaux à epigraphiques de l'oasis de Dakhla. Supplément aux Annales Islamologiques 1.* Cairo.

Description de l'Égypte (État moderne) (1812), Paris.

Dobrowolski, J. (1998), 'The Funerary Complex of Amir Kabir Qurqumas in Cairo', in U. Vermeullen and D. de Smet (eds), *Egypt and Syria in the Fatimid, Ayyubid and Mamluk Eras*, Leuven, pp. 265–82.

Dodge, Bayard (1961), *Al-Azhar: A Millennium of Muslim Learning.* Washington, DC.

Elshahed, Mohamed (2013), 'Hassan Fathy: Architecture for the Rich'. http://cairobserver.com/post/39866891829/hassan-fathy-architecture-for-the-rich#.VaYQHGCE4Wx (posted 6 January 2013).

Fathy, Hassan (1969), *Gourna: A Tale of Two Villages.* Cairo.

Fathy, Hassan (1973), *Architecture for the Poor: An Experiment in Rural Egypt.* Chicago.

Fehervari, Geza, et al. (2006), *The Kuwait Excavations at Bahnasa/Oxyrhynchus (1985–1987).* Final Report. Kuwait.

Fethi, Ihsan (1985), 'The Mosque Today', in Sherban Cantacuzino (ed.), *Architecture in Continuity: Building in the Islamic World Today*, New York, pp. 53–63.

Garcin, Jean-Claude (1976), *Un centre musulman de la Haute-Égypte medievale: Qus.* Cairo.

Garcin, Jean-Claude (1977), 'La mosquée al-Lamati a Minya'. *Annales Islamologiques* 13: 101–12.

Garcin, Jean-Claude, and Mustapha Anouar Taher (1994), 'Un ensemble de waqfs du IXe/XVe siècle en Égypte: les actes de Jawhar al-Lala', in Raoul Curiel and Rika Gyselen (eds), *Itineraires d'Orient: Hommages à Claude Cahen, Res Orientales* 6: 309–24. Bures-sur Yvette.

Garcin, Jean-Claude (1995), 'Enquête sur le financement d'un waqf égyptien du XVe siècle: Les comptes de Jawhar al-Lala'. *Journal of the Ecomonic and Social History of the Orient* 38: 262–304.

Grabar, Oleg (1966), 'The Earliest Islamic Commemorative Structures: Notes and Documents'. *Ars Orientalis*, 7–46.

Grabar, Oleg (1997), *The Formation of Islamic Art*. New Haven and London.

al-Haddad, Muhammad Hamza Isma'il (1997), *Mawsu'a al-'imara al-islamiya fi Masr min al-fath al-'uthmani hata 'ahd Muhammad 'Ali, 923–1265H/1517–1848M*. 2 vols. Cairo.

Haider, Gulzar (1990), '"Brother in Islam, Please Draw Us a Mosque". Muslims in the West: A Personal Account', in Hayat Salam (ed.), *Expressions of Islam in Buildings*, Geneva, pp. 155–66.

Hampikian, Nairy, and May al-Ibrashy (2009), Documentation of the Mosque of Abu'l-Hajjaj inside the Temple of Luxor: Final Report, commissioned by ARCE–EAC (The American Research Center in Egypt-The Egyptian Antiquities Conservation Project), grant agreement no. EAC-12-2007. Unpublished. Cairo.

Hamza, Hani (2008), 'Some Aspects of the Economic and Social Life of Ibn Taghribirdi Based on an Examination of His Waqfiyah'. *Mamluk Studies Review* 12: 139–72.

Hamza, Hani (2015), 'Turbat Abu Zakariya Ibn 'Abd Allah Musa (Chief Surgeon of al-Bimaristan al-Mansuri) and His Social Status According to His Endowment Deed (waqfiya)', in Daniella Talmon-Heller and Katia Cytryn-Silverman (eds), *Material Evidence and Narrative Sources: Interdisciplinary Studies of the History of the Muslim Middle East*, Leiden, pp. 317–40.

Hautecoeur, Louis, and Gaston Wiet (1932), *Les mosquées du Caire*. Paris.

Al-Hijaji, 'Abd al-Jawwad 'Abd al-Fattah (2009), *al-Uqsur fi 'ahd al-shaykh Abu'l-Hijaj*. Luxor.

Hill, Kara Marietta (1992), *Pascal-Xavier Coste (1787–1879): A French Architect in Egypt*. Ph.D. dissertation, Massachusetts Institute of Technology.

Hillenbrand, Robert (2012), *The Sheikh Zayed Grand Mosque; A Landmark of Modern Architecture*. Abu Dhabi.

Holod, Renata, and Hasas-Uddin Khan (1997), *The Contemporary Mosque: Architects, Clients and Designs since the 1950s*. New York.

Hunter, F. Robert (1998), 'Egypt under the Successors of Muhammad 'Ali', in M. W. Daly (ed.), *The Cambridge History of Egypt. II. Modern Egypt, from 1517 to the End of the Twentieth Century*, Cambridge.

Ibn Jubayr (1952), *Rihla*, trans. R. J. C. Broadhurst as *The Travels of Ibn Jubayr*. London.

Ibn Jubayr (1992), *Rihla*, ed. Husayn Nassar. Cairo.

Ibn 'Uthman, al-Muwaffaq (1995), *Murshid al-zuwwar ila qubur al-abrar*, ed. Muhammad Fathi Abu Bakr. 2 vols. Cairo.

Ibrahim, Laila (1974), 'Ḥānqāh of the Emir Qawṣūn in Cairo'. *Mitteilungen des Deutschen Archaologischen Instituts. Abteilung Kairo* 30: 37–64.

Ibrahim, Laila (1978), 'The Zāwiya of Šaiḫ Zain ad-Dīn Yūsuf in Cairo', *Mitteilungen des Deutschen Archaologischen Instituts. Abteilung Kairo* 34: 79–110.

Ibrahim, Laila, and Bernard O'Kane (1988), 'The Madrasa of Badr al-Din al-'Ayni and Its Tiled Mihrab'. *Annales Islamologiques* 24: 253–68.

Isma'il, Husam al-Din (2008), 'Jami' Duqmaqsis bi-madinat Rashid fi daw' wathiqat al-asliyya', in *Kitab tadhkari li'l-ustadh 'Abd al-Rahman Mahmud 'Abd al-Tawwab, dirasat wa bahuth fi'l-athar wa'l-hadara al-islamiyya; al-kitab al-awwal, al-juz' al-awwal: al-'imara*, Alexandria, pp. 525–67.

Johns, Jeremy (1992), 'The "House of the Prophet" and the Concept of the Mosque', in Jeremy Johns (ed.), *Bayt al-Maqdis: Jerusalem and Early Islam*, Oxford Studies in Islamic Art 9/2, 59–112. Oxford.

Kahil, Abdullah (2008), *The Sultan Ḥasan Complex in Cairo 1357–1364: A Case Study in the Formation of Mamluk Style*. Beiruter Texte und Studien, 98. Beirut.

Karim, Chahinda (1988), 'The Mosque of Aslam al-Baha'i al-Silahdar (746/1345)'. *Annales Islamologiques* 24: 233–52.

Karim, Chahinda (2000), 'The Mosque of Ulmas al-Hajib', in Doris Behrens-Abouseif (ed.), *The Cairo Heritage: Essays in Honor of Laila Ali Ibrahim*, Cairo, pp. 123–48.

Karnouk, Gloria (1981), 'Form and Ornament of the Cairene Bahri Minbar'. *Annales Islamologiques* 17: 113–39.

Kawatoko, Mutsuo (2005), 'Multi-Disciplinary Approaches to the Islamic Period in Egypt and the Red Sea Coast'. *Antiquity* 79: 844–57.

Kessler, Christel (1972), 'Funerary Architecture within the City'. *Colloque international sur l'histoire du Caire*, 257–67. Cairo.

Khoury, Nuha N. N. (1996), 'The Meaning of the Great Mosque of Cordoba in the Tenth Century'. *Muqarnas* 13: 80–98.

Kishk, Omar (2005), *Acquiring Islamic Identity through Architectural Style: The Sun-Dried Brick Architecture of Qasr al-Dakhla*. MA thesis, American University in Cairo.

Kuhn, Miriam (2015), 'Two Mamluk minbars in Cairo: Approaching Material Culture through Material Sources', in Daniella Talmon-Heller and Katia Cytryn-Silverman (eds), *Material Evidence and Narrative Sources: Interdisciplinary Studies of the History of the Muslim Middle East*, Leiden, pp. 216–35.

Leiser, Gary (1985), 'The Madrasa and the Islamization of the Middle East: The Case of Egypt'. *Journal of the American Research Center in Egypt* 22: 29–47.

Levanoni, Amalia (1995), *A Turning Point in Mamluk History: the Third Reign of al-Nasir Muhammad ibn Qalawun 1310–1341*. Islamic History and Civilizations. Studies and Texts, vol. 10. Leiden.

Little, D. P. (1979), 'Notes on Aitamiš, a Mongol Mamluk', in U. Haarman and P. Bachmann (eds), *Die islamische Welt zwischen Mittelalter und Neuzeit, Festschrift fur Hans Robert Roemer zum 65. Geburtstag*, Wiesbaden, pp. 387–401.

Loiseau, Julien (2010), *Reconstruire la maison du sultan. Ruine et recomposition de l'ordre urbain au Caire (1350–1450)*, 2 vols. Cairo.

Loiseau, Julien (2012), 'The City of Two Hundred Mosques: Friday Worship and Its Spread in the Monuments of Mamluk Cairo', in Doris Behrens-Abouseif (ed.), *The Arts of the Mamluks in Egypt and Syria – Evolution and Impact*, Bonn, pp. 183–201.

MacKenzie, N. D. (1992), *Ayyubid Cairo: A Topographical Study*. Cairo.

Mahir, Su'ad (1966), *Muhafazat al-Jumhuriya al-'Arabiya al- Muttahida wa atharha al-baqiya fi'l-'asr al-islami*. Cairo.

Mahir, Su'ad (1971–76), *Masajid Misr wa awliya'uha al-salihun*, 4 vols. Cairo.

al-Maqrizi, Taqi al-Din (1270/1853), *al-Mawa'iz wa'l-i'tibar bi-dhikr al-khitat wa'l-athar*, 2 vols. Bulaq.

al-Maqrizi, Taqi al-Din (2002–2003), *al-Mawa'iz wa'l-i'tibar bi-dhikr al-khitat wa'l-athar*, ed. Ayman Fouad Sayyid, 4 vols. London.

Marmon, Shaun (1995), *Eunuchs and Sacred Boundaries in Islamic Society*. New York and Oxford.

El-Masry, Ahmed M. (1991), *Die Bauten von Ḥadim Sulaiman Pascha (1468–1548): nach seinen Urkunden im Ministerium für Fromme Stiftungen in Kairo*. Berlin.

Meinecke, Michael (1971), 'Das Mausoleum des Qala'un in Kairo. Untersuchungen zur Genese der mamlukischen Architekturdekoration'. *Mitteilungen des Deutschen Archaologischen Instituts, Abteilung Kairo* 27: 47–80.

Meinecke, Michael (1973), 'Die Moschee des Aqsunqur an-Nasiri in Kairo'. *Mitteilungen des Deutschen Archaologischen Instituts, Abteilung Kairo* 39: 9–48.

Meinecke, Michael (1977), 'Die mamlukische Fayencemosaikdekorationen: Eine Werkstätte aus Tabriz in Kairo'. *Kunst des Orients* 11: 85–144.

Meinecke, Michael (1992), *Die mamlukische Architektur in Ägypten und Syrien (648/1250–912/1517)*, 2 vols. Glückstadt.

Mikhail, Maged S. A. (2014), *From Byzantine to Islamic Egypt: Religion, Identity and Politics after the Arab Conquest*. London.

Mols, Luitgard E. M. (2006), *Mamluk Metalwork Fittings in Their Artistic and Architectural Context*. Delft.

Monneret de Villard, Ugo (1957), *La Nubia Medioevale, Mission Archeologique de Nubie, 1929–1934*. Cairo.

Mostafa, Saleh Lamei (1968), *Kloster und Mausoleum des Farag ibn Barquq in Kairo. Abhandlungen des Deutschen Archaologischen Instituts, Abteilung Kairo. Islamische Reihe 2*. Glückstadt.

Mostafa, Saleh Lamei (1972), *Moschee des Farag ibn Barquq in Kairo. Abhandlungen des Deutschen Archaologischen Instituts, Abteilung Kairo. Islamische Reihe 3*. Glückstadt.

Mubarak, 'Ali (1306/1888–89), *al-Khitat al-jadida al-tawqifiya*. Cairo.

Muqaddasi, Shams al-Din (1877), *Ahsan al-taqasim fi ma'rifat al-aqalim*, ed. M. J. de Goeje. Leiden.

al-Naim, Mashary A. (2006), 'Crisis of Modernity and the Lack of Architectural Criticism in the Arab World', in Mohammad Al-Asad with Majd Musa (eds), *Architectural Criticism and Journalism: Global Perspectives*, Turin, pp. 137–44.

Nasir-i Khusraw (1986), *Safarnama*, trans. W. Thackston as *Naser-e Khosraw's Book of Travels*. Albany, NY.

Necipoğlu, Gülru (2005), *The Age of Sinan. Architectural Culture in the Ottoman Empire*. London.

Northrup, Linda (1998), *From Slave to Sultan: The Career of al-Mansur Qalawun and the Consolidation of Mamluk Rule in Egypt and Syria (678–689 A.H./1279–1290 A.D.)*. Freiburger Islamstudien 18. Stuttgart.

O'Kane, Bernard (1987), *Timurid Architecture in Khurasan*. Costa Mesa, CA.

O'Kane, Bernard (1992), 'The Rise of the Minaret'. *Oriental Art* 38: 106–13.

O'Kane, Bernard (1996), 'Monumentality in Mamluk and Mongol Art and Architecture'. *Art History* 19/4: 499–522.

O'Kane, Bernard (1999), 'The Ziyada of the Mosque of al-Hakim and the Development of the Ziyada in Islamic Architecture', in Marianne Barrucand (ed.), *L'Égypte fatimide: son art et son histoire*, Paris, pp. 141–58.

O'Kane, Bernard (2000), 'Domestic and Religious Architecture in Cairo: Mutual Influences', in Doris Behrens-Abouseif (ed.), *The Cairo Heritage: Essays in Honor of Laila Ali Ibrahim*, Cairo, pp. 149–82.

O'Kane, Bernard (2005), 'The Arboreal Aesthetic: Landscape, Painting and Architecture from Mongol Iran to Mamluk Egypt', in Bernard O'Kane (ed.), *Studies in the Iconography of Islamic Art in Honour of Robert Hillenbrand*, Edinburgh, pp. 223–51.

O'Kane, Bernard (2006), 'The Nine-Bay Plan in Islamic Architecture: Its Origin, Development and Meaning', in Abbas Daneshvari (ed.), *Studies in Honor of Arthur Upham Pope*, Survey of Persian Art, vol. 18, 189–244. Costa Mesa, CA.

O'Kane, Bernard (2009), 'Ayyubid Architecture in Cairo', in Robert Hillenbrand and Sylvia Auld (eds), *Ayyubid Jerusalem: The Holy City in Context 1187–1250*, London, pp. 423–34.

O'Kane, Bernard (2012a), *The Illustrated Guide to the Museum of Islamic Art in Cairo*. Cairo.

O'Kane, Bernard (2012b), 'James Wild and the Mosque of Bashtak', in Doris Behrens-Abouseif (ed.), *The Art of the Mamluks*, Bonn, pp. 163–81.

O'Kane, Bernard (2012c), 'The Design of Cairo's Masonry Domes', in *Proceedings of the Masons at Work Conference*, University of Pennsylvania. http://www.sas.upenn.edu/ancient/masons/OKane_Domes.pdf.

O'Kane, Bernard (2013), 'A Tale of Two Minbars: Woodwork in Egypt and Syria on the Eve of the Ayyubids', in Robert Hillenbrand, A. C. S. Peacock, and F. Abdullaeva (eds), *Ferdowsi, the Mongols and the History of Iran: Art, Literature and Culture from Early Islam to Qajar Persia. Studies in Honour of Charles Melville*, London, pp. 16–26.

O'Kane, Bernard, *The Monumental Inscriptions of Historic Cairo*: https://islamicinscriptions.cultnat.org (The Egyptian Antiquities Project of the American Research Center in Cairo, Inc. [ARCE] under USAID Grant N. 263-0000-G-00-3089-00).

O'Kane, Bernard (ed.) (2009), *Creswell Photographs Re-examined. New Perspectives on Islamic Architecture*. Cairo.

Organization of Islamic Capitals and Cities (1992), *Principles of Architectural Design and Urban Planning during Different Islamic Eras: Analytical Study for Cairo City*. Prepared by Center for Planning and Architectural Studies, Center for Revival of Islamic Architectural Heritage. Jedda.

Ormos, Istvan (2009), *Max Herz Pasha (1856–1919). His Life and Career*, 2 vols. Cairo.

Otto-Dorn, Katharina (1959. 'Seldschukische Holzsaulenmoscheen in Kleinasien', in *Aus der Welt der islamischen Kunst: Festschrift für Ernst Kühnel zum 75. Geburtstag am 26. 10. 1957*, 59–88. Berlin.

Ozkan, Suha (1986), 'An Overview of Architecture Education in Islamic Countries', in *Architecture in the Islamic World, Proceedings of Seminar Ten in the Series Architectural Transformations in the Islamic World*. Singapore.

Pascal Coste: toutes les Égyptes (1998), Exhibition catalog, Bibliotheque Municapale de Marseille.

Petry, Carl (1993), *Twilight of Majesty: The Reigns of the Mamluk Sultans al-Ashraf Qaytbay and Qansuh al- Ghawri in Egypt*. Seattle and London.

Petry, Carl (1998), 'A Geniza for Mamluk Studies? Charitable Trust (waqf) Documents as a Source for Economic and Social History'. *Mamluk Studies Review* 2: 51–60.

al-Qadi, Galila Gamal, Muhammad Tahir Sadiq, and Muhammad Husam Isma'il (1999), *Rashid*. Cairo.

Rabbat, Nasser (1995), *The Citadel of Cairo*. Leiden.

Rabbat, Nasser (1996), 'Al-Azhar Mosque: An Architectural History'. *Muqarnas* 13: 45–68.

Rabbat, Nasser (2010), *Mamluk History through Architecture: Monuments, Culture and Politics in Medieval Egypt and Syria*. London.

Raghib, Yusuf (1987), 'Un oratoire fatimide au sommet du Muqattam'. *Studia Islamica* 65: 51–67.

Raghib, Yusuf (1994), 'La mosquée d'al-Qarafa et Jonathan M. Bloom'. *Arabica* 41: 419–21.

Raymond, Andre (1990), 'L'Activité architecturale au Caire à l'époque otto-mane (1517–1798)'. *Annales Islamologiques* 25: 343–59.

Raymond, Andre (2001), *Cairo: City of History*. Cairo.

Repertoire Chronologique d'Épigraphie Arabe (1931–1991), 18 vols. Cairo.

Rogers, J. M (1972), 'Seljuk Influence on the Monuments of Cairo'. *Kunst des Orients* 7: 40–68.

Sauvaget, Jean (1947), *La mosquée omeyyade de Medine*. Paris.

Sayyid, Ayman Fu'ad (1998), *La capitale de l'Égypte jusqu'à l'époque fatim-ide: al-Qahira et al-Fustat*. Beiruter Texte und Studien 48. Beirut.

Sedky, Ahmed (2001), 'L'oeuvre de Mario Rossi au ministère de Waqfs: une réinterpretation italienne de l'architecture islamique', in Mercedes Volait (ed.), *Le Caire – Alexandrie. Architectures européennes 1850–1950*, Cairo, pp. 65–74.

Serageldin, Ismail, with James Steele (eds) (1996), *Architecture of the Contemporary Mosque*. London.

Shahata, 'Azza 'Ali 'Abd al-Hamid (2008), *al-Nuqush al-kitabiya bi'l-'ama'ir al-diniya wa'l-madiniya fi'l-'asrayn al-mamluki wa'l-'uthmani*. Dasuq.

Sherif, Lobna Abdel Azim (1988), *Layers of Meaning: An Interpretive Analysis of Three Early Mamluk Buildings*. D. Arch. dissertation, University of Michigan.

Steele, James (1997), *An Architecture for People. The Complete Works of Hassan Fathy*. New York.

Swelim, M. Tarek (1993), 'An Interpretation of the Mosque of Sinan Pasha in Cairo'. *Muqarnas* 10: 98–107.

Talmon-Heller, Daniella (2007), *Islamic Piety in Medieval Syria: Mosques, Cemeteries and Sermons under the Zangids and Ayyubids (1146–1260)*. Leiden and Boston.

Taylor, Christopher S. (1999), *In the Vicinity of the Righteous: Ziyara and the Veneration of Muslim Saints in Medieval Egypt*. Leiden.

Thompson, Jon (2012), 'Late Mamluk Carpets: Some New Observations', in Doris Behrens-Abouseif (ed.), *The Art of the Mamluks*, Bonn, pp. 115–39.

Turchiarulo, Mariangela (2012), *Building 'in a Style': Italian Architecture in Alexandria, Egypt: The Work of Mario Rossi*. Rome.

'Uthman, Majdi (2013), *Ma'adhin al-'asrayn al-mamluki wa'l- 'uthmani fi Dilta al-Nil*. Cairo.

'Uthman, Muhammad 'Abd al-Sittar (1988), 'Girga wa atharuha al-islamiya fi'l-'asr al-'uthmani'. *Dirasat Athariya al- Islamiya/Islamic Archaeological Studies* 3: 209–68.

van Berchem, Max (1894–1903), *Matériaux pour un Corpus Inscriptionum Arabicarum, part 1: Égypte. Mémoires de l'IFAO 19*. Cairo.

Volait, Mercedes (2005), *Architectes et architecture de l'Égypte moderne (1930–1950)*. Paris.

Volait, Mercedes (2006), 'Appropriating Orientalism? Saber Sabri's Mamluk Revivals in Late-Nineteenth Century Cairo', in Doris Behrens-Abouseif and Stephen Vernoit (eds), *Islamic Art in the 19th Century: Tradition, Innovation and Eclecticism*, Leiden and Boston, pp. 131–55.

Volait, Mercedes (ed.) (2013), *Emile Prisse d'Avennes. Un artiste antiquaire en Égypte au xixe siècle*. Cairo.

Walker, Paul (2009a), *Orations of the Fatimid Caliphs: Festival Sermons of the Ismaili Imams*. London.

Walker, Paul (2009b), *Caliph of Cairo: al-Hakim bi-Amr Allah, 996–1021*. Cairo.

Ward, Rachel (2012), 'Mosque Lamps and Enamelled Glass: Getting the Dates Right', in Doris Behrens-Abouseif (ed.), *The Art of the Mamluks*, Bonn, pp. 55–75.

Warner, Nicholas (2005), *The Monuments of Historic Cairo*. Cairo.

Weill, Jean David (1936), *Catalogue général du Musée arabe du Caire: les bois sculptes depuis l'époque mamlouke*. Cairo.

Wiet, Gaston (1932a), *Catalogue général du Musée arabe du Caire: lampes et bouteilles en verre émaillé*. Cairo.

Wiet, Gaston (1932b), *Catalogue général du Musée arabe du Caire: Objets en cuivre*. Cairo.

Williams, Caroline (1983), 'The Cult of 'Alid Saints in the Fatimid Monuments of Cairo. Part 1: The Mosque of al-Aqmar'. *Muqarnas* 1: 15–36.

Williams, Caroline (1985), 'The Cult of 'Alid Saints in the Fatimid Monuments of Cairo. Part 2: The Mausolea'. *Muqarnas* 3: 39–60.

Williams, John Alden (1972), 'The Monuments of Ottoman Cairo', in *Colloque international sur l'histoire du Caire*, Cairo, pp. 453–63.

CHAPTER FIVE

Residential Architecture of the Darb Zubayda

THE DARB ZUBAYDA is the pilgrimage route between Kufa and Mecca. Some stations along the route are mentioned in Umayyad sources, and must have had at least rudimentary facilities, but the person who is credited with its largest number of buildings is the wife of Harun al-Rashid, Zubayda, hence the eponymous name of the route. Later Abbasid caliphs also contributed to the facilities, but use of the route declined in the tenth century after pilgrims were subject to attack by the Qarmati Isma'iliyyas. There continued to be some traffic in later centuries, but the introduction of roads for cars fortunately bypassed the route and ensured that the sites were not built on in the modern period. To what extent can the buildings be taken as representative of any one particular period? Where substantial excavations have been carried out, as at Rabadha for instance, the finds are predominantly of the ninth–tenth century,[1] and I operate under the assumption that most of the architecture is also from this range.

The stations of the route are in greatly varying states of preservation. For some only preliminary reconnaissance has been undertaken and just the outlines of large and some small buildings have been recorded.[2] With others more detailed plans have been obtained from surveys and, in the case of Rabadha, from excavations.[3] Although the most densely settled sites have an unclassifiably large variety of buildings, a conspectus of all the sites shows a number of residential building types that occur regularly, enabling us to obtain a typology. These range from the simplest individual units, to repeated examples of multi-unit structures, to villas, and to the caravanserais that are the largest and most imposing of these structures. This piece will survey this range of building types, elucidating parallels in the wider Abbasid world, and analysing the extent to which original developments in residential architecture are to be found here.[4]

Bernard O'Kane (2014), 'Residential Architecture of the Darb Zubayda', in Julia Gonnella (ed.), *A Hundred Years of Excavations in Samarra: Beiträge zur islamischen Kunst und Archäologie*, Jahrbuch der Ernst-Herzfeld-Gesellschaft e.V. Vol. 4, Wiesbaden, 202–19.

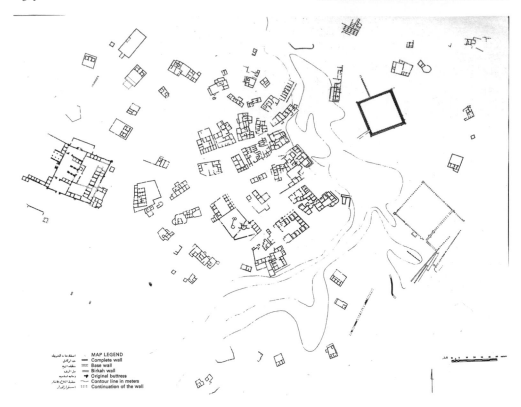

Figure 5.1 *Al-ʿAqiq, plan of site (after* Atlal*)*

The plan of one of the sites, al-ʿAqiq, is representative of most of the building types we shall encounter (Figure 5.1). At the extremities of the area are the largest buildings, the caravanserai on the west, and on the east two cisterns, one completely ruined, but one that, surprisingly, is still in working condition.[5] The mostly residential buildings in between vary from the simplest single unit, to rooms placed side by side, to multiple rooms adjoining a courtyard. The configurations of these smaller, apparently random groupings, mostly fall into categories that will be detailed below. In addition, the outward orientation of some of the rooms indicate that they probably functioned as shops, and the internal division of others that they were stables.

Small houses: 1–3 in a row, no courtyard

Occasional examples of one room dwellings can be found scattered in sites where large clusters of buildings are present, but they are overall very few in number. Two or three in a row, the rooms being unconnected from the inside, are much more common. In one case, at al-Wausayt East, there is an extraordinary concentration of three-

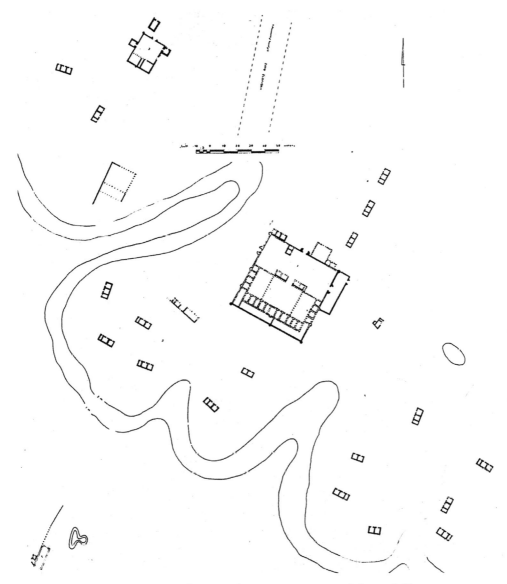

Figure 5.2 *Al-Wausayt East, showing three-in-a-row units (after* Atlal*)*

in-a-row buildings, almost to the exclusion of other kinds (Figure 5.2).[6] At this site another feature of most of these examples is apparent: two of the rooms are of the same size, while the third one, at one end, is about half the width of the others. One might think that this is because it was added, but since there are so many examples this seems unlikely.[7] It probably reflects a different usage, such as a kitchen or storage area rather than a dwelling. Similar rows of small rooms with a narrower one at the end can be seen at Palaces A and B at Raqqa, there situated within a courtyard.[8]

Small houses: 3 or 6 in a row with one or two courtyards

Three in a row with a courtyard is a very common configuration, although it also appears as a mosque plan, where the three rooms are communicating. The differences are not always as obvious as at al-ʿAraʾish South, where there are two compounds with non-communicating three-in-a-row rooms,[9] beside the mosque that has communicating three-in-a-row rooms with a mihrab, the compound being oriented at rights angles to the others. As with the isolated three-in-a-row groups, almost all have one smaller room at one end of the row. One larger conglomeration recurs surprisingly often, that of three three-in-a-row compounds together with one mosque unit of similar size (Figure 5.3).[10]

There are five examples known of a doubling of this plan, with a wall within the courtyard dividing the space into two equal parts.[11] These also have unequal-sized rooms; the two at the ends being smaller. In three of them[12] the dividing courtyard wall is pierced with an opening, although it two of these (Figure 5.4),[13] there are, like the two with completely divided examples, also entrances to the courtyard on the side opposite the rooms. The lone exception is Saʿid, where there is only one entrance to the compound, on the narrow side of the building.

A variation on this may be the three examples of six in a row with one courtyard. All have smaller rooms at both ends. Two, Shamat Kibd and Qasr Umm Jaʿfar, had one entrance on the long side, the other, al-Jumayma, had three entrances to the courtyard, two on the long side and one on the narrow.[14]

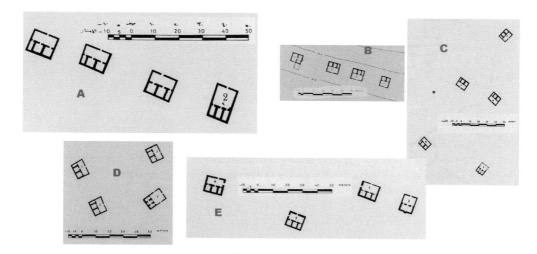

Figure 5.3 *A) al-Hamra B) al-ʿAraʾish South C) Jafaliyya B D) al-Saqiyya E) Humayma North showing three-in-a-row units with courtyard (after Atlal)*

Figure 5.4 *A) al-Shaghwa B) Qibab Khalsa showing doubled three-in-a-row with courtyard units (after* Atlal)

Larger compounds

Apart from the simple doubling of the three-in-a-row unit, there are several other plans which can be seen as expansions of this. One way was to create a kind of small corridor surrounding the triple unit at the back and at the sides. Three examples of this, each slightly different, can be seen at al-ʿAqiq in close proximity to the caravanserai (Figure 5.1). In one the central room is slightly bigger, but the corridor still goes all the way around. In another the central room extends as far back as the outer wall of the courtyard, so that the corridor is blocked by it.[15] In the third, that closest to the caravanserai, the corridor goes all the way around, but the central room of the three is an iwan, and the three rooms are preceded by a vestibule with three entrances. This is nothing other than the Samarra T-plan, but what is more surprising is that this is the only occurrence of it to be seen in all of the buildings on the Darb Zubayda.[16]

Another variation on this comes from expansion by adding another room on each side, producing five in a row. In two examples, at al-Makhruqa and al-Wusayt West, the two rooms flanking the middle one are divided into two, and there is no flanking corridor. Much more common is the five-in-a-row with a larger and deeper central room, flanked by corridors on each side and at the back (Figure 5.5).[17]

What was the purpose of these dead-end corridors? It would help if we knew whether they were vaulted or not. There are similar passages round the sides and back of many other Abbasid larger buildings. On the Darb Zubayda itself, the living units at the back of the caravanserais invariably have a corridor behind. At Raqqa, they are to be found behind the main living units in the Abbasid Palaces A, C and D.[18] At Samarra it is difficult to distinguish any obvious examples, but the caveat should be made that poor preservation and incomplete excavations make it difficult to differentiate access corridors from those that were dead ends. What is probably the most relevant parallel is at Ukhaydir, where the four *bayts* surrounding the large central court and reception area each had two facing groups of triple rooms, and

Figure 5.5 *A) al-Gharibayn B B) al-Jafaliyya A C) al-Jafaliyya B D) al-Shahuf, showing five-in-a-row units with courtyard and back passages (after* Atlal*)*

each of these had a dead end corridor running on the side and behind. In this case enough of the vaulting was preserved to show that they were all covered except for a roughly square section at the middle of the back corridor.[19] The vaults in this area contained terracotta pipes which evidently functioned as chimneys, confirming that these areas were used as kitchens. It is likely that the dead-end corridors of the Darb Zubayda functioned in a similar fashion.

A third way of expanding this plan is by having six rooms, three back to back, within a longer courtyard, seen at al-ʿAraʾish North, at structures nos 1 and 2 at Barud and, with a slight variation, at structure no. 1 at Umm al-Damiran (Figure 5.6). There was however an ambivalence in the designs of this type, evidenced in several ways. Structure no. 2 at Barud and al-ʿAraʾish North have two entrances, on the narrow sides of the courtyard, the other two have one. Each site has the rooms positioned not in the middle of the courtyard, but dividing it into unequal parts. The six rooms are also not equal in size, those at the back, facing the smaller courtyard, always being smaller themselves. At al-ʿAraʾish North the rooms are attached to one side of the court, leaving a passageway at the side. Umm al-Damiran has passageways at either side, but marked with a gateway in the

A. Structure No. 1 ١ مبنى رقم - ·

C

B. Structure No. 2 ٢ مبنى رقم - ·

D

Figure 5.6 *A) Barud B) Barud C) Umm al-Damiran D) al'Ara'ish North, showing six rooms, three back to back, within long courtyard (after Atlal)*

Figure 5.7 *A) al-Zafiri B) al-Thulayma C) al-'Ara'ish Middle, showing mosque and two courtyard plan (after* Atlal)

wall extending from the façade of the main rooms. It is also irregular in that at its centre is one long room, not divided into two like the others.[20] The two compounds at Barud have not just passageways but narrow rooms at the side, with that on the west at structure no. 2 being divided into two rooms. The dividing wall of these two rooms is not aligned with those of its neighbours, suggesting its origin is still the three-room type, rather than it being a unique four-room type.[21]

Towards the northern end of the route, three sites exhibit an interesting further enlargement of this plan (Figure 5.7). Each is oriented similarly, and is divided into two courtyards. At al-Thulayma and al-'Ara'ish Middle the southern courtyard has three rooms on the western and eastern sides, although at al-'Ara'ish Middle the central room on the west was used as an entrance to the complex. At al-Zafiri the west side of the southern courtyard had only an entrance. The northern courtyard in each had two rooms on the east with a corridor running behind. The third element is what makes these complexes rather than compounds: the north-west corner is occupied by a rectangular room with four piers and a separate entrance from the north; these were almost certainly mosques. In my earlier study of mosques along the route I failed to recognise these examples as mosques, possibly because of their lack of mihrabs.[22] However, they are all qibla oriented, they all have separate entrances opposite the qibla, and, more importantly, they bear a striking resemblance to the plans of the mosques that adjoin almost all of the caravanserais (Figure 5.10 B–D), several of which, in their present state of preservation, were also lacking mihrabs.[23] A further point that should be stressed is that in these complexes the mosque seems to have been an integral part of the plan, not an addition; it may even therefore have been a model for the mosques attached to the caravanserais.

Villas

Al-'Alwiyya (Figure 5.8) and structure no. 21 at Barud (Figure 5.9) are two compounds for which the term villa is appropriate, each with living quarters smaller than a palace, and each connected with a substantial pool or cistern. 'Alwiyya has two main courtyards, one on the north with irregular rooms on three sides, one of the south with

MAP LEGEND
━━ Complete wall
═══ Birkha wall
⌐ Original buttress
▨▨ Modern wall

Figure 5.8 *Al-'Alwiyya, plan of villa (after* Atlal)

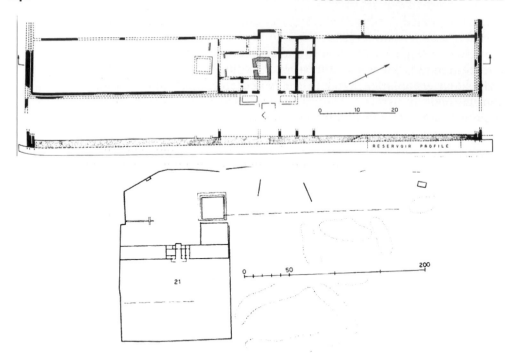

Figure 5.9 *Barud, plan of villa (after* Atlal*)*

a reservoir taking up most of the space, and a wing with a colonnaded courtyard separating them. The reservoir had an octagonal pavilion at its centre, connected to the courtyard on the north side by a narrow walkway.[24] The remains of stucco carving showing a scroll of vine leaves, the only original architectural decoration to be seen along the Darb Zubayda, confirms the high status of the ensemble. The style is very close to the work of the Abbasid palaces at Raqqa.[25]

Terry Allen has recently published a thorough account of the 'Alwiyya villa,[26] making it unnecessary to repeat his research. He reasonably concluded that the reservoir pool may well have been a fishpond, mentioning the Roman and Maghribi parallels and well as that which is most relevant, the lake of al-Mutawakkil at Samarra, whose fish are mentioned in a poem of al-Buhturi:

> *The fish it contains cannot reach its limits because of the distance between its nearest and its furthest point*[27]

He compared the villa with Abbasid residential architecture at Raqqa and Samarra, but before commenting on this we should examine the other candidate for a villa, structure no. 21 at Barud.

The living quarters of the villa at Barud are much smaller than 'Alwiyya, and they are not centred on a courtyard, being more in the nature of a very large (27 × 15 m) pavilion, but the attendant

reservoirs, canals and surrounding gardens (c. 123 × 190 m) indicate that it was also a high status compound. The rooms of the villa are poorly preserved to the extent that the doorway locations on the plan are sometimes absent and are partly hypothetical,[28] but it seems to have been organised around a central iwan with a room behind it; the importance of this room is emphasised by the way in which it projects to the north-west beyond the other rooms. It resembles the audience room behind the iwan of the main court at Ukhaydir, for instance, and could also have been used for formal receptions. Smaller rooms were placed on either side of this central axis. The iwan faced towards the largest courtyard. To each side of the villa was a wide terrace with a water basin, alongside which were canals connected to a large reservoir, 25 m square, to the north. Fragments of surface canals on the terraces also indicate that they were well irrigated, forming gardens flanking the villa.

Barud also had a caravanserai for important travellers, so the villa compound was more likely a country retreat for an official permanently stationed at Mecca, at a distance of less than a day's ride away, some 22 km. ʿAlwiyya is just a further 13 km from Barud, and the villa there could also have functioned in the same way.

With regard to ʿAlwiyya, Terry Allen has noted many parallels in the houses of Samarra (nos 1–4, 11)[29] and the palaces of Raqqa[30] to the two-courtyard plan separated by a formal wing. He posits that the examples in this scheme had similar functions: the courtyard nearest the entrance, surrounded by rooms, was used for public receptions, while the second courtyard (perhaps provided with a garden, or, as at ʿAlwiyya, a pond), usually more difficult of access, was for more private outdoor entertainment with a narrower range of guests.

Some of the houses at Samarra mentioned above, in addition to the main courtyards fore and aft, also have smaller courtyards to either side (nos 1, 3, 11). This, which is what we find for the Barud villa, is also essentially a reduced version of the great caliphal palaces at Samarra, those of the Dar al-ʿAmma and the Balkuwara.[31] It is found also at Samarra in the palace of the general Afshin at Sur Jubayriyya.[32] As at Barud, the possibility should also be entertained that the smaller lateral courtyards there were furnished with gardens.

Caravanserais

Eleven buildings of a similar size and plan have survived along the route; other stations have unexcavated mounds of roughly the same size[33] that are also likely to have been khans or caravanserais.[34] Donald Whitcomb has provided an analysis of the group, showing that they roughly conform to a similar plan (Figure 5.10).[35] This usually has projecting wings and a rectangular mosque (frequently a later addition) to the left of the entrance. The interior is divided into two main areas: an initial courtyard with small rooms on three

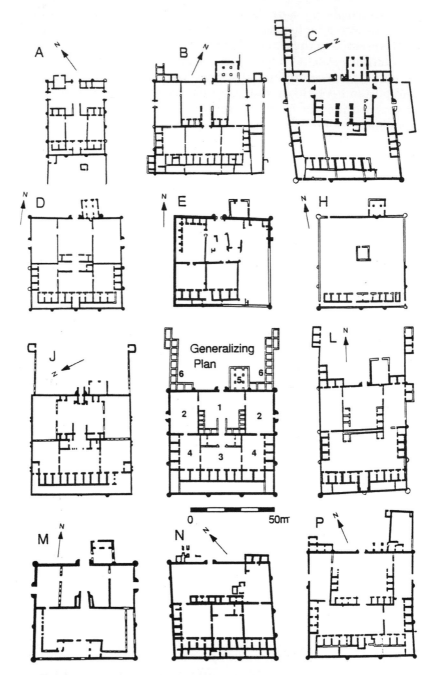

Figure 5.10 *Darb Zubayda, plans of caravanserais A) Barud B) Umm al-Damiran C) al-ʿAqiq D) Kuraʿ E) Maʿdan Bani Sulaym H) Sinaf al-Lahm J) al-Makhruqa L) al-Wusayt West M) al-ʿAshar N) al-Shihiyyat P) al-Qaʿ (after Whitcomb 1996)*

sides, flanked by open courtyards. The central courtyard in turn leads to an inner one with rooms at the back, and again flanked by two courtyards, but which in this case also have rooms.

This arrangement, like so many other buildings of the Darb Zubayda, is for the most part different from earlier known caravanserais.[36] The projecting wings, one consisting of a mosque, are also seen at Qasr al-Hayr al-Gharbi,[37] but the two courtyard structure is unknown in the earlier examples.[38] Later echoes of it are seen in the eleventh-century Ribat-i Malak, situated between Samarqand and Bukhara,[39] and at the twelfth-century Ribat-i Sharaf.[40]

It is striking, however, how many of the units within the courtyards of the Darb Zubayda caravanserais can be seen to be derived from the smaller buildings discussed above. The two flanking courtyards usually have groups of three rooms, one at right angles to the back wall, the other parallel with it and also, like so many of the smaller ensembles mentioned above, with a corridor behind it. The central unit of the rear courtyard may have the five-in-a-row scheme with a larger and deeper central room, also with a corridor at the back.

The similarity of the larger ensembles with a nine-bay mosque (Figure 5.7) to those of the caravanserais was mentioned above. In many cases the mosque was added to the plan, but at least in one case, Barud, it must have been integral from the start, since in it is situated partly behind the wall at the entrance side of the building (Figure 5.10 A), and also has an entrance from within the courtyard. The importance of the accessibility of mosques within or adjacent to secular buildings, and of the greatest possible access to them, is shown by their disposition in Umayyad and other Abbasid buildings. At Khirbat al-Minya and at the large enclosure of Qasr al-Hayr East, both complexes with limited access, entrances were provided from their exterior directly into the mosque.[41] Palaces C and D at Raqqa also have small mosques beside their entrance, each also probably an afterthought.[42] The caravanserai at Qasr al-Hayr East has a niche in its vestibule, almost the last place one might have thought suitable for a place of prayer, given the passage of animals, but perhaps an indication of its importance even in these commercial surroundings.[43]

One final point with regard to the caravanserais on the Darb Zubayda is that they frequently had three entrances, one axial, the other two leading to the frontal courtyards from the side. This suggests that they were built at a time when security was not a major issue, before the Qaramatis had begun their raids, from the 930s on, that led to the abandonment of many stations.

Forts

This also raises the questions of the forts along the route – were they provided for extra safety before the Qaramati raids, added

for protection at the time of the raids (which continued for over a hundred years after the first major attacks in 930[44]), or could they have been added at a later time, before the route fell into complete disuse some one hundred years ago?[45] The surveys give just a few pointers in these matters; it is possible that subsequent fieldwork might alter the chronologies somewhat.

The forts that survive in good condition are clustered at the northern and southern ends of the route, with six at the north ('Atshan,[46] Ummu Qarun,[47] Hammam,[48] Talhat,[49] al-Qa', al-Shihiyat), two closer to Mecca (al-Mudiq, Husn) and one in the middle (Makhruqa).

The similarities of those at the northern end have already been noted:[50] they are close in size, have three-quarter round towers at the corners, semi-round on the sides, and two semicircular towers flanking a gateway. Rooms are usually disposed around the four sides of the courtyard, sometimes in a nearly regular fashion. Like Talhat, the fort at al-Qa' was within an outer enclosure (Figure 5.11), but unlike Talhat, at al-Qa' the outer enclosure seems to have been as heavily fortified as the inner one. Unlike the others, at al-Qa' both enclosures were rectangular, although the exact disposition of the inner one is conjectural.[51] Al-Shihiyat was also slightly rectangular (c. 34 × 27 m), although its poor state of preservation makes its internal disposition speculative.

The Makhruqa fort was also rectangular, with regular buttressing. The entrance has not been completely preserved; rooms around the courtyard were only on the side of the entrance and of that opposite.

The fort at Mudiq was smaller than those above, being only 15 m on its longest side. Husn was of comparable size, differing mainly in the provision of a bent entrance. The surveyors describe the masonry as being similar to that of other stations on the route,[52] but as the bent entrance in military architecture did not become common in the Islamic world until the twelfth century,[53] the questions remains open whether the fort could be any earlier, or whether it was an alteration to a previous building.

Only at al-Qa' and al-Shihiyyat does there seem to have been a substantial fort as well as a caravanserai; reinforcing the possibility that the forts could also have doubled as caravanserais.[54]

Stable and shops

Two other categories may be briefly examined. The identification of stables is problematic. A small buttress, or internal division within a room, could represent two stalls for animals, to it could be, as in the case of relatively isolated units at Musmar and Khasna, in the words of the surveyors, 'a common feature for such small units and is thought to be a structural device for shortening the span required for a main roof beam'.[55] Where, however, there are clusters of rooms that have internal buttresses opposite one another, or up to three paral-

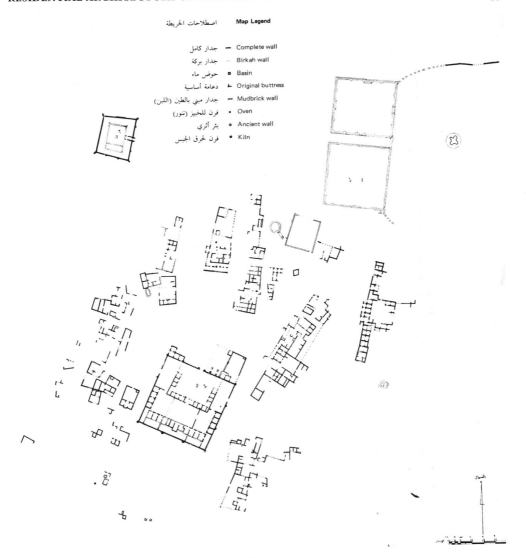

اصطلاحات الخريطة **Map Legend**

جدار كامل	— Complete wall
جدار بركة	- Birkah wall
حوض ماء	▪ Basin
دعامة أساسية	┗ Original buttress
جدار مبني بالطين (اللبن)	▬ Mudbrick wall
فرن للخبيز (تنور)	• Oven
بئر أثري	○ Ancient wall
فرن لحرق الجبس	● Kiln

Figure 5.11 *Al-Qaʿ, plan of site (after* Atlal*)*

lel buttresses, there is a better case for recognising them as stables.
There are two such clusters at al-ʿAqiq (Figure 5.1), one at the north-
ern extremity of the site, and another at the south-east side of the
main central square, midway between the birka and the caravanserai.
Roughly on the opposite side of this square is a building that has four
rooms overlooking the square, three of which are adjoining and have
a single buttress. This buttress is opposite the entrance in each case.
As the wall above a doorway would be less efficient in supporting a
main roof beam, these too were probably stables.

At al-Shihiyyat there is a long row of units to the north-west of
the caravansaray. Near the southern end of these are five rooms,

mostly adjacent, with two buttresses to each room which are good candidates for stables. Finally, at al-Qaʿ (Figure 5.11), there is a row of units at the eastern extremity of the site four of which incorporate buttresses opposite one another.

Not surprisingly, these same sites, which are some of the largest and most comprehensively surveyed on the route, also provide plausible candidates for commercial centres with shops.

At al-Qaʿ there are several clusters of buildings between the caravanserai and birka that may well have been included shops, particularly those that have a perhaps colonnaded façade in front of small rooms (Figure 5.11). A building at the south-west corner of the al-Shihiyat settlement may have had such a colonnade at one corner. At al-ʿAqiq the courtyard building on the south-west side of the main square mentioned above has indications of a colonnade in front of rooms facing towards the outside.

There was also a colonnaded building at Kharaʾib Abu Nawas, with a forecourt in front of it. The rooms behind the colonnade are not oriented towards it in the manner of shops elsewhere; perhaps the forecourt here housed temporary stalls.

At the northern end of the Umm al-Damiran site there is a bend in the road with three nearby units, and a fourth on the opposite side of the road further west. These are remote from the main area of settlement at the site, and all have a wall at their back, and at least one room adjacent to the others with internal buttressing. It is likely that they were commercial units that included stables.[56]

Conclusion

What can we learn from the residential architecture of the Darb Zubayda? It provides a conspectus of buildings from the simplest two room units to villas, sophisticated caravanserais, and everything in between. It is surprising for its independence from some major Abbasid trends, such as the T-plan, which is, with a sole exception,[57] entirely lacking in the Darb Zubayda examples. One consistent form, the corridors at the back of adjacent small units, is however paralleled at Ukhaydir and Raqqa, showing that the basic buildings blocks that are found on the Darb Zubayda could be recombined in buildings that range from the simplest all the way to palaces. The basic examples, three rooms within a courtyard, or their doubled form, often present surprising conformity along many stations of the route.

This building block is also the basis of the caravanserai plan that is one of the unique features of the route. The buildings are very different, on the whole, from other Abbasid examples of domestic architecture, whether at Samarra or, for instance, at equally nearby Siraf on the Persian Gulf.[58] One particularly novel example is the compound that contains residential units in two adjacent courtyards

in combination with a mosque, found at al-Thulayma, al-'Araish Middle and al-Zafiri (Figure 5.7).

The largest of the purely residential compounds, the villas at 'Alwiyya and Barud, were evidently surrounded by gardens, which may also help us to posit the existence of similar surrounding planted are as in the major Abbasid palaces at Raqqa and Samarra.

In the future excavations may provide more detailed plans that would permit a closer analysis of such matters as urban planning. But even with the preliminary surveys carried out so far, the rich variety of buildings along the route expands considerably our knowledge of the development of architecture under the Abbasids.

Notes

1. Al-Rashid 1986, 53–89.
2. For instance, at al-Dariba/Fayd, see note 3.
3. The main sources are Knudstad 1976; al-Dayel/al-Helwah 1978; al-Dayel/al-Helwah/MacKenzie 1979; MacKenzie/al-Helwah 1980; Morgan/al-Helwa 1981; al-Helwah/al-Shaikh/Murad 1982; al-Rashid 1980; *idem* 1986; *idem*, 'Darb Zubayda'; Whitcomb 1996. A study of its mosques can be found in O'Kane 2006, 191–4. Rather than footnote every site later in the piece, for convenience the sites discussed relative to the main publications above are listed alphabetically here:
 Abu Rawadif: *Atlal* 4, 46, pl. 49A
 al-'Alwiyya/'Ulwiyya, *Atlal* 2, 53, Pls 49, 60.
 al-'Amya': *Atlal* 6, 61, pl. 78
 al-'Aqiq: *Atlal* 2, 61, pl. 48; al-Rashid, *Darb Zubaydah*, 276
 al-'Ara'ish Middle: *Atlal* 5, 104, pl. 108C
 al-'Ara'ish North: *Atlal* 5, 104, pl. 109
 al-'Ara'ish South: *Atlal* 5, 102, pl. 108B
 al-'Asafir: *Atlal* 6, 50, pl. 70
 al-'Ashar: *Atlal* 6, 43, pl. 64
 Barud: *Atlal* 1, 47, pl. 39A
 al-Bida': *Atlal* 5, 98, pl. 106B
 al-Dariba: *Atlal* 2, 59, pl. 59B
 Fayd (near Qasr Khrash): *Atlal* 4, 47, pl. 51; al-Rashidi, *Al-Rabadhah*, loose pl.
 al-Gharibayn B: *Atlal* 4, 46, pl. 50
 al-Hamra: *Atlal* 6, 45, pl. 67
 al-Humayma North: *Atlal* 4, 41, pl. 38
 al-Humayma South: *Atlal* 4, 38, pl. 35
 Hurayd: *Atlal* 4, 41, pl. 40A
 Husn: *Atlal* 1, 60, pl. 44
 al-Jaffaliyya A: *Atlal* 4, 44, pl. 41
 al-Jaffaliyya B: *Atlal* 4, 44, pl. 42
 al-Jifniyya: *Atlal* 3, 53, pl. 39
 al-Jumayma: Atlal 6, 55, pl. 75
 al-Kharaba: *Atlal* 2, 63, pl. 50
 Khara'ib Abu Nawas: *Atlal* 1, 45, pl. 30
 Khashna: *Atlal* 1, 55, pl. 33A
 Kura': *Atlal* 3, 46, pl. 32A
 Kutayfa: *Atlal* 4, 41, pl. 39

Ma'dan Bani Sulaym: *Atlal* 3, 47, pl. 34A
al-Makhruqa: *Atlal* 4, 45, pl. 45; 45, pl. 47
al-Mitaiyya: *Atlal* 5, 100, pl. 108A.
al-Mudiq: *Atlal* 2, 56, pl. 57
Mudarraj II: *Atlal* 1, 60, pl. 42B
Musmar, *Atlal* 1, 57, pl. 33B
al-Qa': *Atlal* 6, 60, pl. 77A
Qasr Umm Ja'far/Khunayfis North: *Atlal* 6, 46, pl. 68
Qibab Khalsa: *Atlal* 6, 58, pl. 77B
al-Rabadha: *Al-Rabadhah*, figs 35–7
Sa'id: *Atlal* 3: 49, pl. 35
al-Saq'a: *Atlal* 3, 52, pl. 38
al-Saqiyya: *Atlal* 4, 49, pl. 53B
al-Shaghwa: *Atlal* 4, 49, pl. 52A
al-Shahuf: *Atlal* 6, 50, pl. 71
Shamat Kibd: *Atlal* 5, 95, pl. 105
al-Shihiyyat/al-Shuquq: *Atlal* 6, 46, pl. 69
Sinaf al-Lahm: *Atlal* 4, 38, pl. 36
al-Thulayma: *Atlal* 6, 58, pl. 76
Umm al-Damiran: *Atlal* 1, 65, pl. 47
al-Wausayt East: *Atlal* 5, 92, pl. 104
al-Wausayt West: *Atlal* 5, 94, Pls 102–3
al-Zafiri: *Atlal* 6, 62, pl. 79
Zubala: *Atlal* 6, 54, pl. 72.

4. I am very grateful to Barbara Finster for encouraging me to work on this topic. Full disclosure: I have not, alas, visited any of the Darb Zubayda sites.

5. For a photograph showing it filled with water, see Covington 2006.

6. Nearby al-Wusayt West also has four three-in-a-row buildings close to the main caravanserai; at al-Makhruqa a cluster of six buildings consists of three two-in-a-row, and three three-in-a-row, the latter with the third room at the end much smaller than the others.

7. Other examples can be found at al-'Amya'.

8. Siegel 2009, figs 2–3.

9. As well as one two-in-a-row with a courtyard, a rare type.

10. At al-'Ara'ish South, al-Saqiyya and Humayma North; at al-Jafaliyya B there are four units with a mosque. At al-Hamra there are three-in-a-row units plus a fourth that has a larger courtyard and where the three rooms are, unlike the others in the group of equal size. Even though the rooms are separate and though it does not have a mihrab it is possible that it was a mosque, both on the analogy of the other examples mentioned above, and because we have elsewhere at a station on the Darb Zubayda, al-'Amya', a building of five non-communicating rooms in a row fronted by a courtyard, where the central room has a mihrab (O'Kane 2006, fig. 3.11). Also, at al-Shahuf, we have three three-in-a-row units with a courtyard plus a fourth with three equal and open bays; its *qibla* orientation is a little off at almost due south, but it too may well have been a mosque (the mosque at Shamat Kibd, identifiable as such by its mihrab, is even oriented a little south-east). My earlier remarks here are relevant: 'As noted by Allen, "Early Nine-Bay Mosques," n. 8, the published plans only represent the low stone course on which mud-brick walls were built. It is thus possible that the mihrabs were present within the thickness of the mudbrick walls above the stone courses.'

11. At ʿAsafir, al-Mitaiyya, Qibab Khalsa, Saʿid and al-Shaghwa.
12. Qibab Khalsa, Saʿid and al-Shaghwa.
13. Qibab Khalsa and al-Shaghwa.
14. At al-Shahuf, there are two examples of four-in-a-row with a courtyard.
15. An identical plan type is also seen at al-ʿAraʾish North.
16. There are two interesting variations on this plan. At structure no. 6 at Umm al-Damiran (*Atlal* 1, pl. 46) the three rooms are of identical size, but the corridor extends round the back from one side only. At Shamat Kebt the 'corridor' is such only at the back, as at the sides it has gained doorways forming a small room on each side.
17. At al-Gharibayn B, al-Jafaliyya A, al-Jumayma and al-Shahuf.
18. Siegel 2009, figs 2, 4–5.
19. Creswell 1932–40, II, 72, fig. 64.
20. It had one entrance on the north facing the entrance from the courtyard; the foundations at the southern end were insufficiently well preserved to be certain whether it had a door or not, but the surveyors dotted in the lines of the plan.
21. It also had several extra rooms at the entrance to the courtyard, but the three-quarter round buttresses there indicate that the wall was originally unencumbered; the rooms must be later additions.
22. The importance of this complex as a type is also noted by Creswell 1989, 284, although he interprets the whole as a residence.
23. As mentioned above, n. 10, 'the published plans only represent the low stone course on which mudbrick walls were built. It is thus possible that the mihrabs were present within the thickness of the mudbrick walls above the stone courses.'
24. Allen, 'Fishpond', notes the parallels of the pavilion in the pool of the court at Khirbat al-Mafjar and at the Aghlabid cistern at Qayrawan. He mentions also later parallels from Toledo (eleventh century) and Mughal India. Another later example is the mosque of ʿAlishah at Tabriz (1318–22), which had a pool with an octagonal dome on a square base in the middle: O'Kane in press.
25. Daiber, 'Palace B'.
26. Allen, 'Fishpond'.
27. Sperl 1989, 197.
28. *Atlal* 1, 52.
29. See Northedge 2005, 221, fig. 98; Leisten 2003, 121–6.
30. Siegel 2009.
31. Northedge 2005, 137, fig. 56 and 199, fig. 85.
32. Ibid., 188, fig. 83.
33. These include three which are preserved in outline, possible with a projecting mosque: al-Saqʿa, al-Jifniyya and Kutayfa; and a similar example at al-Makhruqa, which had a mosque-like appendage, although it is not *qibla*-oriented.
34. The surveyors of the route in the original publications in *Atlal* (see n. 3) refer to these buildings as 'formal building complex'; Allan in Creswell 1989, 281, refers to them as palaces; O'Kane 2006 uses '*qasrs*'; Allen, ''Alwiyya', mentions the 'known function of these buildings – to accommodate highstatus travelers for short periods'.
35. Whitcomb 1996, 25–32.
36. A list of comparable Umayyad khans is given in ibid., 31, n. 51; he includes the large, possibly Abbasid, building at Humeima, published by Foote/Oleson 1996. It may resemble the Darb Zubayda caravanserais

in size and in the location of a small mosque just outside the *qasr*, but a major difference is its series of rooms continuously around one courtyard. The presence of remains of a wall painting in one room also points to the building being closer in function to a palace than a *khan*.

37. Creswell 1989, 136, fig. 78.
38. The Umayyad palace at Muwaqqar, ibid., 132, fig. 77, no longer survives. Even the descriptions of it from 1898 indicate that it was then in a ruinous state. It seems to have consisted of an inner courtyard fronted by a terrace entered through an arcade; an alternative reading of the remains could suggest that it had two courtyards, although the outer one would still have had one largely open side.
39. Nemtseva 1983, 125; *idem* 2009, fig. 5.
40. Godard 1949, 9, fig. 2. The Saljuq Anatolian scheme of covered halls preceded by a courtyard at first sight also reflects functional divisions present at the Darb Zubayda, but there is an opposite spatial progression, from an outer courtyard surrounded by many rooms to an undivided hall.
41. For plans of these see Creswell 1989, 92, fig. 57 and 155, fig. 91. The mosque at Khirbat al-Mafjar (ibid., 178, fig. 100), was accessible from its courtyard in addition to a private one within the palace. However, Donald Whitcomb has kindly informed me that it is probably a later addition.
42. Siegel 2009, figs 4–5.
43. Creswell 1989, 151, fig. 90.
44. Madelung, 'Karmati'.
45. The fort at Mudarraj II, for instance, is suggested to have been a late medieval addition to the route.
46. Creswell 1989, 259, fig. 160.
47. Ibid., 281, fig. 175.
48. Finster 1978, 69, fig. 12.
49. Ibid., 71, fig. 15.
50. Finster 1978; Creswell 1989, 283.
51. It is not commented on in the text (*Atlal* 6, 58–60); Fig. 77A shows the outer wall as intact, but only provides an outline for the inner enclosure.
52. *Atlal* 1, 61.
53. An exhaustive analysis is given in Creswell 1932–40, II, 23–9, after the discussion of the bent entrance at the round city of al-Mansur.
54. Creswell 1989, 283.
55. Knudstad 1977, 56.
56. 'The simplest interpretation of these features, perhaps, is as a surviving length of the Darb Zubayda within the confines of the station, complete with walls and rows of shops': Knudstad 1977, 67.
57. See n. 15 above.
58. The most convenient discussion of its domestic architecture is in Whitehouse 1970, 150–2. The bazars at Siraf, ibid., 152–3, also show little similarity with the commercial centres along the Darb Zubayda.

Bibliography

Allen, Terry (2009), 'An 'Abbāsid Fishpond Villa Near Makkah', <http://sonic. net/~tallen/palmtree/fishpond/fishpond.htm#doe559> (last accessed 6 March 2012).

Covington, Richard (2006), 'The Art and Science of Water', *Saudi Aramco World* 57.3 (May/June), <http://www.saudiaramcoworld.com/issue/200603/the.art.and.science.of.water.htm> (last accessed 23 February, 2012).

Creswell, K. A. C. (1932–1940), *Early Muslim Architecture*, 2 vols. Oxford.

Creswell, K. A. C. (1989), *A Short Account of Early Muslim Architecture*, Cairo (rev. and supplemented by James Allan).

Daiber, Verena, 'Palace B, Raqqa, Syria', <http://www.discoverislamicart.org/database_item.php?id=m onument;ISL;sy;Mon01;30;en> (last accessed 20 March 2012).

al-Dayel, Khaled and Salah al-Helwah (1978), 'Preliminary Report on the Second Phase of the Darb Zubayda Reconnaissance 1397/1977', *Atlal* 2: 51–64.

al-Dayel, Khaled, Salah al-Helwah and Neil MacKenzie (1979), 'Preliminary Report on the Third Season of Darb Zubaydah Survey 1978', *Atlal* 3: 43–54.

al-Helwah, Salah, Abdalaziz A. al-Shaikh and Abduljawwad S. Murad (1982), 'Preliminary Report on the Sixth Phase of the Darb Zubaydah Reconnaissance 1981 (1401)', *Atlal* 6: 39–62.

Finster, Barbara (1978), 'Die Reiseroute Kufa – Sa'udi-Arabien in frühislamischer Zeit', *Baghdader Mitteilungen* 9: 53–91.

Foote, Rebecca and John Oleson (1996), 'Humeima Ecavations Project, 1995–1996', *Bulletin of the Fondation Max van Berchem* 10, 1–4, most easily accessible at <http://www.maxvanberchem.org/en/ scientific-activities/ projets/?a=46> (last accessed 12 March 2012).

Godard, André (1949), 'Khorāsān', *Āthār-é Īrān* 4: 7–150.

Knudstad, James (1977), 'The Darb Zubayda Project: 1396/1976. Preliminary Report on the First Phase', *Atlal* 1, 41–68.

Leisten, Thomas (2003), 'Excavation of Samarra. Volume 1: Architecture. Final Report of the First Campaign 1910–1912', *Baghdader Forschungen* 20, Mainz am Rhein.

MacKenzie, Neil D. and Salah al-Helwah (1980), 'Darb Zubayda Architectural Documentation Program. a. Darb Zubayda – 1979: a Preliminary Report', *Atlal* 4: 37–50.

Madelung, Wilferd, 'Karmati', *Encyclopaedia of Islam*, 2nd edn, <http://www.brillonline.nl.library. aucegypt.edu:2048/subscriber/entry?entry=islam_COM-0451> (last accessed 22 March 2012).

Morgan, Craig A. and Salah M. al-Helwa (1981), 'Preliminary Report on the Fifth Phase of Darb Zubayda Reconnaissance 1400 A.H./1980 A.D.', *Atlal* 5: 85–107.

Nemtseva, N. B. (1983), 'Rabat-i Malik', in L. I. Rempel (ed.), *Khudozhestvennoya kultura Sredney Azii IX–XIII Veka*, Tashkent.

Nemtseva, N. B. (2009), *Rabat-i Malik, XI-nachalo XVIIIvv. (arkheologicheskiye issledovaniya)*, Tashkent.

Northedge, Alistair (2005), *The Historical Topography of Samarra*, Samarra Studies 1, London.

O'Kane, Bernard (2006), 'The Nine-Bay Plan in Islamic Architecture: Its Origin, Development and Meaning', in Abbas Daneshvari (ed.), *Studies in Honor of Arthur Upham Pope, Survey of Persian Art*, Vol. XVIII, Costa Mesa, pp. 191–4.

O'Kane, Bernard (2021), 'Taj al-Din 'Alishah: The Reconstruction of His Mosque Complex at Tabriz', in *idem*, *Studies in Persian Architecture*, Edinburgh, 616–36.

al-Rashid, Sa'ad bin 'A. (1980), *Darb Zubaydah. The Pilgrimage Road from Kufa to Mecca*, Riyadh.

al-Rashid, Sa'ad bin 'A. (1986), *Al-Rabadhah*. Riyadh.

al-Rashid, Sa'ad bin 'A. 'Darb Zubayda', *Encyclopaedia of Islam*, 2nd edn, <http://www.brillonline.nl.library.aucegypt. edu:2048/subscriber/ entry?entry=islam_SIM-8460> (last accessed 23 February 2012).

Siegel, Ulrike (2009), 'Frühabbasidische Residenzbauten des Kalifen Hārūn ar-Rašīd in ar-Raqqa/arRāfiqa (Syrien)', *Madrider Mitteilungen* 50: 483–502, 568–9.

Sperl, Stefan (1989), *Mannerism in Arabic Poetry*. Cambridge.

Whitcomb, Donald (1996), 'The Darb Zubayda as a Settlement System in Arabia', *ARAM* 8: 25–32.

Whitehouse, David (1970), 'Siraf: A Medieval Port on the Persian Gulf', *World Archaeology* 2: 150–2.

Illustration credits
All drawings after *Atlal* (see n. 3).

CHAPTER SIX

The Design of Cairo's Masonry Domes

OVER SIXTY MASONRY domes have survived from pre-modern Cairo. There are several reasons for this number, unequalled by any other Islamic city. Continuing debate by the ulema on the lawfulness of building tombs meant that it was often politic for a patron to incorporate them within a larger religious complex. The benefit of building a religious complex was not just the main one, that of assuring one's place in heaven, but probably also, by means of the *waqf ahli* (family endowment), of putting the family finances out of reach of the government should a patron, as not infrequently happened to amirs who backed a wrong candidate, fall into disfavour.[1]

Serious study of the designs our main topic began with the publication in 1976 of Christel Kessler's classic: *The Carved Masonry Domes of Medieval Cairo*.[2] This was particularly concerned with the ways in which decoration and construction were at first uncoordinated, but gradually were adapted to each other in increasingly sophisticated ways with the development of designs from ribbed, to zigzag, to geometric, and to arabesque patterns. This was such an authoritative publication that it was not until almost thirty years later that another milestone occurred, a workshop at MIT entitled *The Mamluk Domes of Cairo*.[3] A number of related publications soon appeared, notably by Barbara Cipriani[4] and Christophe Bouleau.[5]

One of the main questions regarding these domes has been that of whether they were carved on the ground or in situ on the dome. This is a still unresolved matter to which I do not have any definitive solution, but it is a topic that will come up again in the course of this piece. I will also refer to other topics mentioned in the sources above, but I will be principally concerned with a slightly different approach to the geometry of Cairo's dome design: that of the number of repetition of units of design around the circumference of a dome, and the ways in which this fits, or does not fit, with the layout of the windows and niches of the drum or zone of transition below it. The

Bernard O'Kane (2012), 'The Design of Cairo's Masonry Domes', in *Proceedings of the Masons at Work Conference*, University of Pennsylvania, published online.

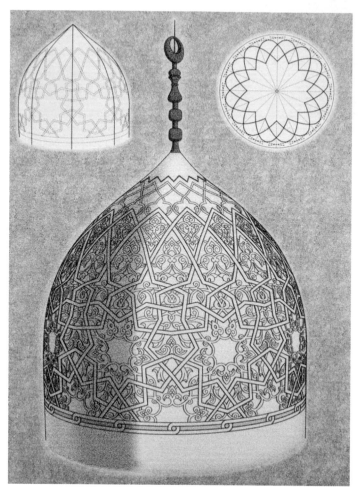

Figure 6.1 *Dome of Qaytbay mausoleum, northern cemetery (after Sutton)*

natural assumption is that of Barbara Cipriani, who wrote that 'The decoration of Mamluk domes is in a tiling pattern which is repeated until it forms a sphere. This repetition is based on multiples of 4 (4, 8, 16, 32) in all Cairene brick ribbed domes and decorated carved stone domes.' However, this, as we shall see, is far from being the case. A similar assumption was made in a recently published drawing of what is arguably the finest of all carved stone domes, that of Qaytbay in the northern cemetery, where the pattern is shown to have been repeated 16 times (Figure 6.1);[6] this too, as we shall see, is incorrect. I will be discussing the design options that were open to the makers, and by makers here I include those who may have designed the decoration as well as those who carved and assembled it, as they may not have been the same people. I hope to show that there was a much greater variety than has been realised up to now in the pattern generation, and also to highlight the frequently surprising lack of correspondence between the design of the dome decoration and what immediately precedes it on the building at a lower point, namely the drum and its arrangement of windows and blind niches.[7]

I group the Cairo domes into the following four categories, according to whether the number of repetition of units of design around the circumference of the dome is based on a power of 2 (regular) or not (irregular), and whether the dome design is aligned with the axis of the square base of the dome chamber (regular) or not (irregular). We thus have four categories:

1) Regular geometry, regular orienting
2) Regular geometry, irregular orienting
3) Irregular geometry, regular orienting
4) Irregular geometry, irregular orienting

which I will deal with in turn. I will not discuss all of the examples of each type, dwelling on some that present particular points of interest.

Regular geometry, regular orienting

The earliest variation on the smooth masonry dome in Islamic architecture is the ribbed design,[8] and the earliest examples of these, at Ukhaidir, Qayrawan (Figure 6.2) and Tunis, are indeed based on multiples of four.[9] The same applies to the earliest Islamic ribbed domes in Egypt, from the Fatimid dynasty, for example at Sayyida Atika (16 ribs) and Yahya al-Shabihi (24 ribs).

Two other early Mamluk brick domes, al-Sawabi (c. 1285) and Sanjar (1302), also each have 32 ribs. The first stone dome in the sequence, that of Ahmad al-Qasid (c. 1335), much smaller than any of the previous examples, has a mere eight.[10]

Figure 6.2 *Great Mosque of Qayrawan, Tunisia. Detail of dome (photo: B. O'Kane)*

Figure 6.3 *Sultaniyya complex, Cairo (photo: Creswell archive, American University in Cairo)*

Dating from c. 1360, the Sultaniyya twin-domed mausoleums (Figure 6.3) have several features that place them apart from the Cairo series. They have muqarnas at the base of the ribs, a typical feature of Iranian ribbed domes. Also typical of Iranian brick double domes are the inner brick buttresses that can be seen in a pre-restoration photograph; these are not needed in stone dome construction, and most of the Cairene series, if they have a double dome, have much less space between the inner and outer shells than here. The 32 ribs are exactly aligned with the 16 windows in the drum.

The twin domes of the complex of Faraj ibn Barquq (1400–11) (Figure 6.4) are the largest masonry domes in Cairo, at 14.4 m diameter. Rather than the usual flat wooden roofs, the prayer halls of this complex are covered with brick masonry domes. It has been suggested that this was because wood was less affordable after the damage caused to the Mamluk economy by Timur's invasion of Syria in 803/1401–2. This in turn might argue for methods of reducing centring suggested by Cipriani and Lau.[11] However, as they also point out, the paintings on the inside of the dome here indicate that centring must have been in place. If this expense was undertaken at a time of economic hardship, it is more likely that it was because it was an essential part of dome construction. Each of the domes here has 32 ribs, which are integrated with the *mims*[12] at their base. The drum below has 24 niches, of which 12 are windows. Unusually, the

Figure 6.4 *Faraj ibn Baquq complex, Cairo (photo: B. O'Kane)*

windows are placed on the diagonal axes, which means that on the main axes blind niches are found.

At the madrasa of Jawhar al-Qunuqbayi (Figure 6.5) attached to the mosque of al-Azhar before 1440, the pattern is one of the earliest arabesques. This also has a drum of 24 niches, half of which are blind and half windows, but here the windows are on the main axis. The arabesque pattern is coordinated with the *mim*s that are also placed above the windows on the main axis.

There are many more examples of domes with regular geometry and regular orienting,[13] but more interesting in many ways are those with irregular orienting that follow.

Regular geometry, irregular orienting

The dome at the complex of Tatar al-Hijaziyya (1360) (Figure 6.6) has 32 ribs and flanges, and 16 niches in the drum, half of them windows, oriented on the main axes. The ribs and flanges have scallops at their base, with the flanges aligned with the points of the scallop.

Figure 6.5 *Madrasa of Jawhar al-Qunuqbayi (photo: B. O'Kane)*

But neither the scallop points nor the mid-point of their curves are aligned with the niches of the drum below.

Thanks to the work of the team of Christophe Bouleau, we have drawings of every stone of the Khayrbak dome (1502) (Figure 6.7). It has a 16-sided arabesque pattern, at the base of which are 16 *mims* exactly aligned with the 16 windows of the drum. But the arabesque pattern itself is placed unmistakably with its axis halfway between the *mims*. Given the emphasis on absolute symmetry in general in Islamic art and architecture, and on dome design in particular, this lack of correspondence is all the more surprising.

At the dome of the Qanibay complex (1503) (Figures 6.8 and 6.9) at the foot of the citadel the lack of correspondence is more subtle, and even more surprising. There are 32 niches on the drum of which half are windows. The mouldings above and below the inscription that is immediately above the windows each have 16 *mims*. The lower *mims* are situated exactly above each of the 16 windows on the drum. The upper *mims* are spaced exactly with the 16-sided arabesque pattern of the dome. But the two are very slightly out of alignment. It's almost as if another team of masons took over the work when the patterning on the dome began, and, even though the

Figure 6.6 *Complex of Tatar al-Hijaziyya (photo: B. O'Kane)*

pattern had been worked out carefully beforehand to fit exactly, they were careless of, or oblivious to, the lower axial correspondence – or it simply didn't matter that much to them.

Further up this dome we see a feature that is found on several others that I shall mention later. Between many of the risers we see unusual infilling of plaster, as if the stones of the horizontal courses were cut before they were placed in position, but when hoisted up it was found that large vertical gaps remained between them. Does this make it any more likely that the pattern was carved on the ground, partially or completely, before being put in position on the dome? We can return to the evidence for this later.[14]

Irregular geometry, regular orienting

This category can be divided in turn into domes that have patterns based on a multiple of 5, 6 or 7.

Multiple of 5

Like its slightly later companion in the *khanqah* at Muqattam,[15] the dome of Tankizbugha in the southern cemetery (1359) (Figure

Figure 6.7 *Khayrbak complex (after Bouleau)*

6.10) has alternating convex and concave ribs, evenly spaced. Here however, there are 20 of each. The drum has 16 niches, half of which are windows on the main axes. The convex ribs are oriented above the four orthogonal axes, but, despite the mismatch of 20 ribs and 16 niches, the even spacing of the ribs contributes to apparent visual regularity in that the concave ribs are thus aligned exactly on the diagonal axes.

The mausoleum of al-Ashraf Barsbay at his complex in the northern cemetery (1432) (Figure 6.11) is the subject of a major analysis by my colleagues Ahmad Wahby and Dina Montasser in this same conference proceedings. It is indeed a landmark, being the first example of a geometric star pattern on one of Cairo's domes. It also has other interesting features. There are 32 niches on the drum, half of which

Figure 6.8 *Qanibay complex (photo: B. O'Kane)*

are windows. It has a 20-sided star pattern, which coincides with the *mim*s at the base. On the orthogonal axes the *mim*s are above the windows of the drum, on the diagonal they flank evenly the drum windows. The ashlars courses are spaced to match the vertical alignment of the star pattern, as was the case with the earlier zigzag patterns, but at this experimental stage, the horizontal divisions are

Figure 6.9 *Qanibay complex, detail of dome (photo: B. O'Kane)*

still arbitrary, awkwardly cutting across the geometric lines of the pattern (Figure 6.12a).

The cynosure of Cairo's carved domes is indeed that of Qaytbay (Figure 6.12b) in the northern cemetery, elegantly, and uniquely,[16] combining geometric with arabesque patterns. It has 16 windows in the drum, but the pattern on the dome is a 20-sided one, marked by the *mim*s at the base. However, the pattern is different above each alternate *mim*, so there are four ashlars at the base before the pattern begins to repeat.[17]

Multiple of 6

The mausoleum of Janibak (1432) (Figure 6.13) in the northern cemetery has a complicated pattern on the dome. The upper half of 6 12-pointed stars appear at the base, with two rows of smaller 10-sided stars and one row of 10-sided stars further up. This 12-sided pattern is reflected in the 24 *mim*s at the base. Here there is an exact match with the 24 niches on the drum, with its 12 windows directly below each of the *mim*s.

Close examination of the ashlars on the dome reveals another interesting feature that was commented on for the first time by Bouleau and Cipriani in their discussion of the Khayrbak dome:[18] one face of very small wooden pegs are visible, two usually being usually placed towards either side of the base of an ashlar, within

Figure 6.10 *Tankizbugha mausoleum (photo: B. O'Kane)*

the mortar course (Figure 6.14). At the *Masons at Work* conference,
John Ochensdorf mentioned that similar pieces have been observed
in the masonry of the chapel at King's College. Their function, as
noted by Cipriani, was probably to help level the blocks. They would
also have helped to spread the mortar between them more evenly.
Cipriani also noted that they appear at different locations on the
inner and outer faces, indicating that they do not do go all the way
through.[19] This is the earliest example of this feature that I have
noted; it may well not be the earliest actually employed, with others
disguised by a coating of plaster.

 This is another dome, like that of Qanibay mentioned above,
where there are large gaps in the risers of the ashlar (Figure 6.15).
Here the feature is even more pronounced, suggesting much more

Figure 6.11 *Complex of al-Ashraf Barsbay (photo: B. O'Kane)*

was allowed than necessary for the decrease in diameter towards the top of the dome.

The dome of Qansuh Abu Saʿid in the northern cemetery (1499) (Figure 6.16) has 24 niches in the drum, now all blind, but half of which were probably windows originally. The pattern on the dome is 12-sided, but an unusually complicated one which at the base alternates 10-pointed stars (the upper half alone is visible) with a triple-arrow motif. Above the triple arrows are 9-pointed stars, a most unusual example of an odd-numbered star in a geometrical pattern.[20] Unlike other domes with complicated arabesque or geometric patterns, where the pattern repeats after four ashlars at the base, this is the only one that needs six.[21]

Multiple of 7

The mausoleum of Inal, built by him in 1451 when he was an amir, and before he enlarged his complex on attaining the sultanate,

a

b

Figure 6.12 *a) Complex of al-Ashraf Barsbay, detail of dome (photo: B. O'Kane). b) Complex of Qaytbay, detail of dome (photo: B. O'Kane)*

has 32 niches on the drum, of which 16 are windows. It has 28 zigzags which are integrated with the *mim*s; the latter are made more striking by having dark- and light-blue glass globes inserted within them.

The zigzag was one of the most popular patterns after it appeared at Mahmud al-Kurdi (1394–5); some fourteen examples subsequently use it. However, this has a novel feature. Kessler lauds the first example of the zigzag, at Mamhud al-Kurdi, as the first dome where decoration and structure were properly coordinated, with 'the

Figure 6.13 *Mausoleum of Janibak (photo: B. O'Kane)*

Figure 6.14 *Mausoleum of Janibak, detail of dome showing wooden pegs (photo: B. O'Kane)*

Figure 6.15 *Mausoleum of Janibak, detail of dome (photo: B. O'Kane)*

Figure 6.16 *Mausoleum of Qansuh Abu Saʿid (photo: B. O'Kane)*

equidistant disposition of the jointing . . . used as a reference grid for the pattern'.[22] However, while here and subsequently, the ashlars were cut so that the vertical joints were in alignment with the pattern, this was certainly not the case with the horizontal joints. But here at Inal the pattern of the zigzag is so carefully planned so that the horizontal join is at exactly the same place all the way up (Figure 6.17a), very close to the inner part of the V-shape, in such a way that the ashlars could be inverted and still fit into the pattern. 'All the way up' is a slight exaggeration, even if the drum is proportionally taller than most other domes. But it is also exceptional how, even when the dome begins to curve and the ashlars become smaller, the horizontal alignment of the zigzag pattern remains exactly the same, until it is replaced by triangles five courses from the top.

The slightly later dome of Barsbay al-Bajasi (1456) (Figure 6.17b) also has a 28 sided zigzag with the *mim*s at the base emphasised by glass bosses. It has 24 niches in the drum, 12 of which are windows. Here there is also a careful attention to the proportionality of the horizontal jointing, but the design repeats only on every second course rather than on each one as at Inal.

Irregular geometry, irregular orienting

Here again I divide this category into domes that have patterns based on multiples of 5, 6 or 7.

Multiple of 5

We saw above how the dome of Qaytbay's mausoleum in the northern cemetery was based on a 20-sided pattern. The Gulshani dome (c. 1470) (Figure 6.18) that he built nearby when he was an amir is also based on a multiple of five, reflected in the 20 *mim*s at the base of the design, although the design itself at the base alternates between arabesques and the upper half of 12-pointed stars (with curving sides[23]). There are eight windows on the drum, directly above the eight sides of the zone of transition, aligned neither with the arabesques nor the star pattern.

The dome of Qurqumas (1506) (Figure 6.19) at his complex in the northern cemetery is one of the most intriguing for its combinations of mismatches. There are 40 lozenges at the base (which change to a zigzag when the dome beings to curve), and 16 windows, but the main surprise is the number of *mim*s at the base, 42. It is difficult to think of any logical reason for this. Neither the lozenges nor the *mim*s are aligned on the main axes. The *mim*s with their mouldings are made up of individual ashlars,[24] of a different size than the band below that separates them from the inscriptions on the drum. This difference in size means that at several point the ashlars of the *mim*s

Figure 6.17 *a) Mausoleum of Inal, detail of dome (photo: B. O'Kane).*
b) Mausoleum of Barsbay al-Bajasi, detail of dome (photo: B. O'Kane)

cannot be placed at the optimum point for strength of bond with the course below, that is, at the mid-point of the lower course. This could be another reason to suggest that a different team of masons was responsible for the dome construction.

Another peculiarity is the irregularity of some of the lozenges (Figure 6.20). Where they meet the adjacent ashlar there is a slight bump (mostly visible on the lozenges on the west side of the drum),

Figure 6.18 *Gulshani mausoleum (photo: B. O'Kane)*

for which I can think of no other explanation than that the ashlars were sculpted before they were put in position and the work of smoothing out the irregularities was never finished.[25]

Multiple of 6

In the courtyard within the complex of al-Ashraf Barbay in the northern cemetery (1432) (Figure 6.21) there is a smaller funerary dome chamber. It has 24 niches in the drum, half of which may have been windows originally. The pattern on the dome is a complicated one, with the upper half of 6 12-pointed stars at the base, with a row of smaller 8-sided stars and one row of 12-sided stars further up. The 8-pointed stars and the *mim*s (of which there are 12 in all) are aligned

Figure 6.19 *Complex of Qurqumas (photo: B. O'Kane)*

Figure 6.20 *Complex of Qurqumas, detail of dome (photo: B. O'Kane)*

with the diagonal axes, but the main 12-sided star pattern is off-axis. This was certainly deliberate, for the ashlars at the base of the dome pattern, beginning with the *mim*s, are a different width than the ashlars of the inscriptions band on the drum below. This again leads many of them to be positioned off-centre, at less than optimum position for strength of bond. It also suggests again that a different team, whether specialised masons, or masons and designers, was responsible for the planning and execution of the dome. Like its exact contemporary, the nearby dome of Janibak, this also displays surprisingly large gaps between the risers of the ashlars towards the top of the dome (Figure 6.22).

Figure 6.21 *Complex of al-Ashraf Barsbay, courtyard dome chamber (photo: B. O'Kane)*

Figure 6.22 *Complex of al-Ashraf Barsbay, detail of courtyard dome chamber (photo: B. O'Kane)*

Figure 6.23 *Mausoleum of amir Sulayman (photo: B. O'Kane)*

The Amir Sulayman dome (1544) (Figure 6.23) in the northern cemetery is the only Ottoman one in our series. It has a 12-sided arabesque pattern on the dome above eight drum windows, with the pattern aligned with neither the main nor the diagonal axes. Kessler noted the lack of correspondence here of the design with the ashlars, and concluded that that by then the masons' knowledge of coordinating the design with the ashlars had been lost: 'The stone workers employed were deficient both in skill in handling the chisel and in know-how of pattern adaptation – there are mistakes in the symmetry of the design in the weave of the interlace and the pattern is not spaced evenly, especially at the base of the dome.'[26]

Multiple of 7

The dome of Yunus al-Dawadar (c. 1385) (Figure 6.22) is one of the most unusual in Cairo, with its elongated drum and tall narrow proportions. It is also the only other ribbed dome than Sultaniyya that has muqarnas at the base of its ribs. It has 12 niches on the drum, half of them windows, and 28 ribs unaligned with them.

Figure 6.24 *Mausoleum of Yunus al-Dawadar (photo: B. O'Kane)*

Figure 6.25 *Isfahan Friday Mosque, north dome (photo: B. O'Kane)*

Finally, a mention of two which do not fit into any of the other categories. The first is Muzaffar 'Alam al-din Sanjar with 18 ribs above a drum with 12 niches (half of them windows). The second is Aljay al-Yusufi (1373), with 34 ribs above 32 niches (half windows).

Spherical geometry

The problems involved in designing domes were faced by other craftsmen. One of the most spectacular examples from the Mamluk period is a basin from the Qaytbay period in the Museum of Turkish and Islamic Art, Istanbul (Figure 6.26). This has a 12-sided star on its base and six half-stars aligned around the edges. But here the craftsman had to produce a pattern in which the central star at the base matched the half-stars on the circumference, as both could be

Figure 6.26 *Basin, Qaytbay period, Museum of Turkish and Islamic Art, Istanbul (after Şahin)*

seen simultaneously. This was never the case with the carved stone domes, where it could have been matched only by a bird's eye view.

One of the surprises of the inventory above was the substantial number of domes that have patterns based on a multiple of five. There is a major precedent for this, in the design on the inner surface of the north dome of the Isfahan Friday mosque (1088), which has a five-sided star, oriented with the two windows at the base of the dome (Figure 6.25). Another Saljuq dome chamber with an inner star pattern is the mausoleum of Sultan Sanjar (mid-twelfth century), with a more conventional 8-sided star pattern.[27] The Turbat-i Shaikh Jam dome chamber of 1236 also uses ribs to make a smaller octagon at its apex.

Figure 6.27 *al-Azhar mosque, dome of al-Hafiz (photo: B. O'Kane)*

The six-sided pattern is also unusual, but there is one Fatimid example of the pattern on the inner side of a dome, at the entrance to the narthex of al-Azhar, added by the caliph al-Hafiz (Figure 6.27). It displays six unusual polylobed arches that merge to form a six-sided scalloped circle, with a six-sided star at the apex.

Conclusions

What can we conclude from this mass of material? Firstly, the use of small wooden pegs that was first discovered by the restorers of the Khayrbak mausoleum, started much earlier, and was probably widespread in Cairene domes from at least the earliest example noted, that of Janibak, datable to around 1432.

Most importantly, we should note that the pattern generation of Cairene domes was more sophisticated and more varied than has been previously thought. But the often surprising lack of accord between the design of the dome chamber up to the level of the windows of the drum, and the part above it, can, I think, most easily be explained by them having been the work of two different teams of masons and/or designers.

Is there anything in this material that brings us closer to under-standing whether the patterns were carved in situ on the dome, on the ground beforehand, or a mixture of both?[28] The coordination of design and structure could have made it easier for carving to have been done in on the ground. The large gaps between ashlars noted in several dome chambers (the smaller dome at al-Ashraf Barsbay's complex in the northern cemetery; the nearby Janibak dome; Qanibay) could also be explained most easily by them having been cut and carved mostly first on the ground, and not in situ, although the degree to which this applies to the other domes cham-bers, in other words, most of them, where this is not present, is still a matter of speculation. Other mistakes, such as the irregularities on the Qurqumas dome noted above, could similarly be more easily explained by the ashlars having been cut to a pre-determined pattern before they were assembled on the dome itself.

Against this, however, we know, from the unfinished carving of the façade of Sultan Hasan, that it was worked on in situ with the aid of scaffolding. The masons in charge of dome design are hardly likely to have been afraid of heights. And surely the coordination of the pattern would have been easier if done in situ on the dome? One would also have thought that the masons could just as easily have worked from a blank slate, that is, a smooth stone surface, as on the façade of Sultan Hasan, which just needed guidelines lightly incised to aid the carving. But the latest in the sequence, the Amir Sulayman dome (1544), perhaps argues against this: its ashlars and pattern were no longer coordinated, resulting in irregularities in the spacing of the pattern.

Perhaps there is no need to argue strictly for one or the other. The known dimensions of the circumference and its division into the units of repetition would have enabled the ashlars and basic pattern-ing to be blocked out ring by ring on the ground first; most of the detailing of the carving could then have been finished in situ.

Finally, as noted by John Ochsendorf, there are still many unan-swered questions regarding the construction of Cairo's stone domes including the most basic one; how do such tall thin structures manage to stand at all, contrary to the known laws of mechanical engineer-ing? Other questions that need investigation include the necessity and use of centring. I hope this piece will encourage other interested scholars to explore this fascinating body of material further.

Notes

1. See, for instance, Doris Behrens-Abouseif, *Cairo of the Mamluks: A History of the Architecture and Its Culture* (London, 2007), 18.
2. American University in Cairo Press, Cairo.
3. <http://web.mit.edu/akpia/www/sympdomes.html> (last accessed 4 June 2012) programme, with some abstracts. I am happy to record here

the detailed discussions I have had on the topic with one of the speakers at this conference, Dina Bakhoum, which have been of great assistance.

4. *Development of Construction Techniques in the Mamluk Domes of Cairo*, MA thesis, Massachusetts Institute of Technology, 2005, <http://dspace.mit.edu/handle/1721.1/33745> (last accessed 4 June 2012); with Wanda Lau, 'Construction Techniques in Medieval Cairo: the Domes of Mamluk Mausolea (1250 A.D.–1517 A.D.)', <http://www.arct.cam.ac.uk/Downloads/ichs/vol-1-695-716-cipriani.pdf> (last accessed 4 June 2012); with John Ochsendorf, 'Construction Techniques in Medieval Cairo: the Domes of Mamluk Mausolea', abstract, <http://www.dapt.ing.unibo.it/nuovosito/docenti/gulli/seminario_gulli/Abstract%20Giusto zzi/2-STORIA%20E%20SCIENZA/Cipriani-ocksendorf.pdf> (last accessed 4 June 2012).

5. 'Bâtir une coupole en pierre de taille. La coupole du mausolée de l'emir Khayr Bek au Caire: dessin, construction et décor', *Annales Islamologiques* 41 (2007), 209–28.

6. Daud Sutton, *Islamic Design: A Genius for Geometry* (Glastonbury, 2007), 47.

7. Two comments, one on methodology and one on presentation. First, ideally for every building we would like to have the carefully measured drawings that the restorers of buildings in the Aga Khan project have produced, where, as at the dome of Khayrbak (Figure 6.7), the location of every ashlar is recorded faithfully. Sadly this option was not available to me, and I have had recourse to counting the units of patterns from photographs. This is not a simple matter; it entails at least three photographs of a quarter circumference of a dome orientated on the main axes and on the diagonal. Secondly, I have usually greatly increased the mid-level contrast of the accompanying photographs in order to show more clearly the joints between the ashlars. However, it is a tribute to the skill of the masons that these joints are usually invisible to the naked eye from ground level.

8. Arguably because, in the reconstruction of the Prophet's mosque at Madina by the Umayyad caliph al-Walid in the early eighth century, a shell-shaped dome was incorporated in the space above the ante-mihrab bay: Nuha N. N. Khoury, 'The Meaning of the Great Mosque of Cordoba in the Tenth Century', *Muqarnas* 13 (1996), 90–1.

9. Ukhaidir, 32 ribs: K. A. C. Creswell, *Early Muslim Architecture*, 2 vols (Oxford, 1932–40), 2: 59, fig. 40; Great mosque of Qayrawan, 24 ribs (fig. 2); Zaytuna Mosque, Tunis, 16 ribs. The Qayrawan example, unlike the others in the 4, 8, 16, 32 series, is not a power of two, and, unlike the others, is divisible by three. I treat it as irregular. It may be mentioned, however, that at Qayrawan the impression of regularity is enhanced by the arched windows on the main and diagonal axes, and the same-sized niches between them, also 24 in number and directly aligned with the ribs above. In the case of the mihrab dome of al-Hakam II's extension to the Cordoba mosque, where the dome is literally shell-shaped, the emphasis on just one axis, from the entrance to the back of the mihrab room, resulted in the designers making the concave rib on that axis larger than the other nine flanking it to either side, resulting in a unique dome with 19 ribs: <http://artencordoba.com/MEZQUITA-CATEDRAL/FOTOS/INTERIOR/MEZQUITA_CATEDRAL_MIHRAB_06.jpg> (last accessed 10 June 2012).

10. The dome has a plaster coating, and it must be admitted that it is not clear whether it is in fact made of brick or stone.

11. *Construction Techniques*, 712, fig. 12.

12. I use this term, meaning the letter 'm' in Arabic, for the knotted loops at the bottom of the ribs. The same loop is often found as a decorative element on mouldings.

13. The brick masonry examples include al-Sawabi (c. 1285) with 32 ribs and 16 niches in the drum, 8 of which are windows oriented on the main and diagonal axes; Sanjar (1302) with 32 ribs and 24 windows in the drum; *khanqah* of Qawsun (c. 1335) with 32 ribs; Khawand Tughay/Umm Anuk (1348) with 32 ribs and 24 niches in the drum; Anonymous, north of Tankizbugha, southern cemetery (c. 1350 with 16 ribs and flanges; Khawand Tulbay (1363) with 32 ribs and flanges and 16 niches in the drum, half windows. The stone masonry examples include Aydamur al-Bahlawan (1346) with 16 ribs and eight windows in the zone of transition; Abdallah al-Dakruri (1466) with 32 ribs and flanges, the ribs oriented above the four windows in the zone of transition; Sudun (c. 1505) with 32 ribs and 16 windows in the drum and Baybars al-Khayyat (1515) with 32 zigzags and 16 windows in the drum.

14. One other dome in the category of regular geometry with irregular orienting is that of Tankizbugha at Muqattam (1362) with 32 ribs not quite aligned with the 16 niches (half of which are windows on the main axes) on the drum below.

15. See n. 14 above.

16. When I delivered this piece a second time at the Netherland-Flemish Institute in Cairo, Jere Bacharach raised the question why there were not more domes that combine arabesque and geometric patterning. One speculation: Qaytbay found it so appealing that he forbade his amirs from copying it. This is impossible to prove, but it is indeed surprising that, while there were many subsequent arabesque domes, none combined it with a geometric pattern, and no other explanation occurs to me.

17. Two other examples of irregular geometry with regular orienting are, firstly, Inal al-Yusufi, 1392, which has, like Tankizbugha's two domes, alternating concave and convex ribs. Its 20 *mims* correspond with the bases of concave ribs, making a total of 40 ribs in all. There are 24 niches in the drum, half of which are windows. Secondly, Tarabay (1503–5), which has 40 zigzags and 8 windows in the drum.

18. Bouleau, 'Bâtir une coupole', 214, fig. 20; Cipriani, *Development*, 23–4.

19. *Development*, 23.

20. Perhaps the most celebrated example of this was on Ayyubid doors at the lower *maqam* of the Aleppo citadel, displaying 11-sided stars: Ernst Herzfeld, *Inscriptions et Monuments d'Alep, Matériaux pour un Corpus Inscriptionarum Arabicarum. Pt. 2, Syrie du Nord I-II* (Cairo, 1955–6), 126, fig. 56.

21. Like others mentioned above, this also has wooden pegs visible at several places between the ashlars.

22. *Carved Masonry Domes*, 18.

23. The pattern on the minbar from the mosque of al-Ghamri (1446; now installed in the complex of al-Ashraf Barsbay in the northern cemetery) provides the closest prototype. For a photograph see the slip cover of *The Cairo Heritage: Essays in Honour of Laila Ali Ibrahim*, ed. Doris Behrens-Abouseif (Cairo, 2000).

24. Unlike many others (e.g. the small dome of al-Ashraf Barbay's complex in the northern cemetery; Qansuh Abu Saʿid), where they are split horizontally in two, the upper half being part of the pattern on the dome.

25. Ahmad Wahby and Dina Montasser in their presentation also commented on one of the small diamond shapes in the middle of the large lozenges that was clearly, unlike its neighbours, unfinished. Another example in the category of irregular geometry, irregular orienting is the dome of the Janibak madrasa complex which has 24 niches in the drum, half of them windows, and 20 unaligned *mim*s corresponding to the base of the zigzags.

26. *Carved Masonry Domes*, 36.

27. Mukhammed Mamedov, *Mausoleum of Sultan Sanjar* (Istanbul, 2004), 146, fig. 10.

28. This is a topic that is also discussed in these proceedings by my colleagues Ahmad Wahby and Dina Montasser.

CHAPTER SEVEN

James Wild and the Mosque of Bashtak, Cairo

CAIRO IS FORTUNATE in that the foundation of the Comité de Conservation des Monuments de l'Art Arabe in 1881 led to the early documentation and preservation of many of Cairo's most important buildings Even before their work, however, starting from the famous *Description de l'Égypte*, a number of Europeans had recorded the monuments with varying degrees of enthusiasm, thoroughness and accuracy, either through drawings (such as Pascal Coste and Jules Bourgoin) or through photography (Francis Frith and Lekegian). This article makes use of unpublished material from one such collection, that of the architect James Wild in the Victoria and Albert Museum, of whom more is said below.

In 1866, Mustafa Fadil, the brother of the Khedive Isma 'il (d. 1895), the reigning viceroy of Egypt, was exiled to Paris from Istanbul, having been critical of the Ottoman powers who had issued a decree (*firman*) authorising his brother to restrict the khedival succession to Isma 'il's direct descendants (thus eliminating Mustafa Fadil as a candidate).[1] Earlier, in 1851, Mustafa Fadil had acquired two palaces in Cairo at Darb al-Jamamiz, on the edge of Birkat al-Fil, one of which was beside the mosque that the emir Bashtak had built in 1377.[2] Mustafa Fadil's mother, Ulfat Hanim, was presumably living there in 1863–4 when she, on behalf of her son, with the exception of the portal and its minaret, knocked down the mosque of Bashtak adjacent to the palace and built a new mosque. In addition, she erected a *sabil* (public water dispensary) across the road from the mosque,[3] on the spot where Bashtak had erected a *khanqah* (monastery for Sufis) that was joined to his mosque by means of an elevated passage (*sabat*). Both Mustafa Fadil and his mother were buried in a tomb that was added to the mosque in 1878.[4]

The nineteenth-century mosque is of no great architectural interest, but the remaining Mamluk portal and minaret have been recognised as outstanding works of architecture. The undulating zone of

Bernard O'Kane (2012), 'James Wild and the Mosque of Bashtak', in Doris Behrens-Abouseif (ed.), *The Arts of the Mamluks in Egypt and Syria – Evolution and Impact*, Bonn, 163–81.

transition that characterises many stone domes from the period of Faraj ibn Barquq (d. 1412) onwards appears in Cairo for the first time at the base of the minaret. The inscriptions on the minaret begin, surprisingly, not at the front of the mosque, but at the side facing Birkat al-Fil, a suggestion, as Doris Behrens-Abouseif has noted, of the substantial urbanisation even of the side away from the street.[5] The portal's dripping muqarnas decoration (Figure 7.1), leading to a coffered decagonal rosette, ranks it, along with those of its contemporaries at the mosque of Ulmas and the palace of Qawsun, as among the finest examples of Mamluk vaulting.[6]

Fortunately, before its destruction, detailed notes and drawings of many parts of the building were made by the British architect James Wild, who was resident in Cairo from 1842 to 1847. Wild, born in 1814, was an established architect before his arrival in Egypt, having already been responsible for the design of six churches.[7] He had married Isabella Jones, the sister of Owen Jones, author of *The Grammar of Ornament*, in 1841, a year before coming to Egypt as a draughtsman for Karl Lepsius's Prussian expedition. In Cairo, he and another member of the expedition, the English architect Joseph Bonomi, soon became frequent visitors to the Orientalist Edward Lane and his circle of friends,[8] with Wild presumably acquiring a modicum of Arabic in the process that would have helped him in his visits to the religious monuments. Wild's obituary in *The Art Journal* details the clandestine nature of these visits; when drawing under an umbrella was insufficient to afford the necessary attention to detail, he noted the objects he wished to copy, 'prepared his dampened paper for squeezes, and in the darkness set forth and obtained impressions with ... perfect exactness of details'.[9] The exactness of detail in some of the drawings may well have come from squeezes, although a more important factor may have been the mosque's location on the then outskirts of Cairo; its isolation would have given Wild an opportunity to work unobserved, or perhaps to be admitted when it was not open to the public, after coming to an arrangement with its custodian. The Victoria and Albert Museum owns forty-seven drawings and around a dozen sketchbooks that Wild made of Islamic architecture in Cairo, donated by Wild's daughter in 1938. Some of them supplied the details for the ornamentation of the Anglican Church of St George in Alexandria, built in an unusual combination of early Christian and later Islamic styles[10] Many of the Islamic monuments that he drew are still standing, but fortunately he devoted thirty-two pages of one sketchbook, more than for any other religious building,[11] to the mosque of Bashtak.

Before reviewing the evidence for the original building, I will give a brief account of the founder.[12] Ibn Hajar al-'Asqalani begins his account of Bashtak by noting that he was a slender, handsome youth with whom al-Nasir Muhammad (d. 1341) was infatuated. This

Figure 7.1 *Portal of the mosque of Bashtak (photo: B. O'Kane)*

would certainly explain his preferment under the sultan; in fact, the
purchase of Bashtak as a slave in the first place may have been due
to his beauty, as al-Nasir Muhammad had asked his merchant, Majd
al-Din alSallami, to bring him back a *mamluk* who looked like the

Ilkhanid ruler Abu Sa'id (d. 1335).[13] Bashtak was a seller of drinks, that is, a free man rather than a *mamluk*, before he was purchased, so his traditional *mamluk* training was curtailed and he was able to rise quickly through the ranks, becoming emir of one hundred in 1327 and commander of a thousand in 1331.[14]

Ironically, in view of the great rivalry that later developed between them, Bashtak was first put under the tutelage of Emir Qawsun.[15] In 1332, al-Nasir Muhammad arranged the death of the most senior Mamluk emir, Baktamur; Bashtak inherited his land estate (*iqta's*), as well as his palace, his stables, and his wife, whereas Qawsun only received his armoury (*zardakhana*). This arrangement, which had to be kept secret from Qawsun in order to prevent his envy, was engineered by al-Nasir Muhammad in an effort to prevent Qawsun from becoming too powerful.[16]

By the time al-Nasir Muhammad was on his deathbed in 1341, Bashtak and Qawsun were positioning themselves to succeed him. Bashtak had earlier favoured the succession of al-Nasir's eldest son, Ahmad, who was in exile at Karak, but on his deathbed al-Nasir Muhammad got Bashtak and Qawsun to agree on a younger son, Abu Bakr, who turned out to be no more than a figurehead. Qawsun moved rapidly: three weeks later he obtained Abu Bakr's permission to arrest Bashtak. Bashtak was sent to Alexandria, where he was put to death. Surprisingly, his body was returned to Cairo and later buried in the complex of Salar and Sanjar in 1347–8.[17]

In 1332, Bashtak had acquired a prime building site in Cairo, the palace of Baktash, north of the old Fatimid palace, and set about destroying it and building himself an even more magnificent dwelling on its site. The part that remains contains one of Cairo's most magnificent reception halls (*qa'a*), both in terms of size and decoration, and enables us to gauge the quality of his patronage.[18]

Maqrizi gives detailed information on the mosque and *khanqah*, in part based on an earlier account by al-Yusufi:[19]

This congregational mosque [*jami'*] is outside Cairo on Qabw al-Kirmani street on Birkat al-Fil. The emir Bashtak founded it and it was finished in Sha'ban 736 [March/April 1336]. Its sermon [*khutba*] was [first] given by Taj al-Din 'Abd al-Rahim ibn Qadi 'l-Quda Jalal al-Din al-Qazwini on Friday 17th [of that month] [31 March 1336].[20] He also founded opposite it a *khanqah* on the Great Canal, and arranged for a covered passageway (*sabat*) leading from one to the other. A group of Franks and Copts was living in this street who perpetrated abominations, as is their wont. But when the mosque was built and the calls to prayer began to be announced, they were disgusted, and left the area. This is one of the most splendid mosques in the city with respect to its attractiveness, decoration, use of marble, and outstanding beauty.[21]

Regarding the *khanqah*, Maqrizi adds:

> This *khanqah* is outside Cairo on the eastern bank of the canal,
> opposite the mosque of Bashtak. The emir Sayf al-Din Bashtak
> al-Nasiri founded it. Its inauguration was on 1 Dhu'l-Hijja 736
> [19th July 1336]. Shihab al-Din Qudsi was appointed as its shaykh,
> and a number of Sufis were established, who received bread and
> meat every day. That lasted for some time then was cancelled;
> and a sum of money was substituted instead. The building is [still]
> inhabited at present by a group [of Sufis]. Its renowned scholarly
> shaykh is Badr al-Din Muhammad ibn Ibrahim, known as Badr
> al-Bashtaki.[22]

The anonymous chronicle edited by K. V. Zerstéen adds that it
accommodated fifty Sufis[23]

The dates given in this account are contradicted by the inscription
at the entrance to the minaret, which says that it was started at the
beginning of Ramadan 736/13th April 1336 and completed at the end
of Rajab in the year 737/4th March 1337.

To what degree can we rely on Wild's drawings for an accurate
reconstruction of the mosque? Fortunately, since the original portal
and minaret are extant, we can compare his drawing with what
remains As Figure 7.2 shows, his freehand drawing of the extraor-
dinarily complicated muqarnas of the portal is remarkably accu-
rate. The same applies to the minaret; in fact, his drawing, made of
course before the Comité was active in restoration, is sufficiently
detailed to show that the unusual arrangement of the solid third
storey and upper bulb was original, as Doris Behrens-Abouseif had
earlier suspected.[24]

By combining several of the pages in the sketchbook, it is pos-
sible to reconstruct most of the plan and elevation of the original
with some accuracy (Figures 7.3, 7.4).[25] It was, like many others of
its time, hypostyle in plan, a matter that we will return to later.
There were two bays on the qibla side and one on the remaining
three sides. One question that cannot be resolved with certainty
from the drawings is whether there was a dome in front of the
mihrab. The only reason to suspect that there was one is that this
bay is the only one in the qibla area to have arches perpendicular
instead of parallel to the qibla. However, the lack of any notation
of such a feature in Wild's otherwise fairly comprehensive set of
drawings argues against it.

Perhaps the most intriguing feature is the drawing of the *sabat*,
the elevated passageway connecting the mosque with the *khanqah*,
although this also raises problems. The first is that the structure,
when recorded by Wild in the1840s, may not have been complete.
As shown, it stops where, today, the street outside begins; across
the 6.5-metre distance of the street now is the *sabil* of Ulfat

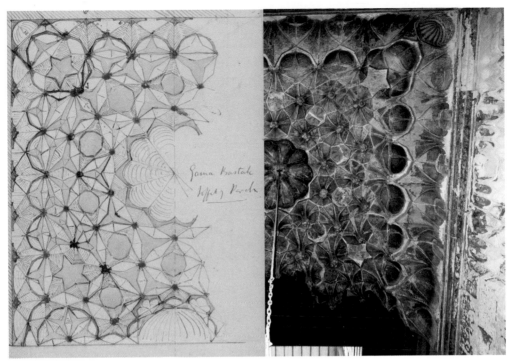

Figure 7.2 *James Wild, drawing of vault of entrance portal of mosque, notebook 91 A. 78, Prints and Drawings Collection, Victoria and Albert Museum, ff. 20b–21a, compared with its extant form (photo: B. O'Kane)*

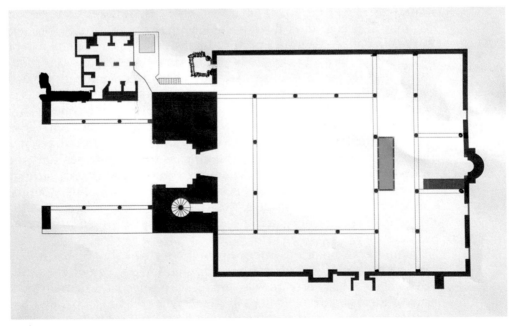

Figure 7.3 *Sketch reconstruction of plan of mosque of Bashtak*

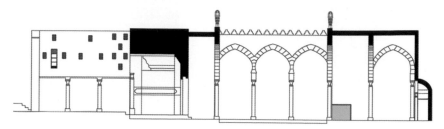

Figure 7.4 *Sketch reconstruction of elevation of mosque of Bashtak*

Hanim that was approximately on the site of the *khanqah*[26] We should, therefore, bear in mind that the original *sabat* was probably longer.

The second problem is that, on Wild's sketch plan, a *sabat* is shown as projecting from both sides of the doorway (Figure 7.5). The historical sources mentioned above give no indication of a double *sabat* here. Given the dearth of either surviving examples or historical references,[27] it is hard to be sure whether this symmetrical arrangement was as unusual as it seems. The third surprise is the irregular pattern of fenestration (Figure 7.6). Could this be due, as has been suggested, to a later Ottoman restoration?[28] One might expect symmetry, whether it was a Mamluk or an Ottoman structure. An identical arrangement of fenestration on another *sabat* on the opposite side would have provided one measure of symmetry, of course, but each wall in itself would have remained asymmetrical. The one remaining *sabat* in Cairo, that at the later complex of Qijmas al-Ishaqi, does have irregular fenestration, but it was not wide enough to generate a pattern in any case. From the clusters of windows of the *sabat* depicted in Wild's drawing, it looks as if there were two living units at either end. These were probably in two storeys, comparable to those in other Mamluk religious complexes and apartment buildings (*rab '*), or less likely, could conceivably have been two separate cells on two storeys. In between these clusters there is one group of two windows in a vertical line, and another isolated window, perhaps annexes to the previous units or storage rooms. We do not have enough information to be sure of interpreting it accurately, but it suggests that, as usual in Mamluk architecture, as little space as possible was wasted, with the corridor between the mosque and *khanqah* opening on to living or storage units.

Wild's drawing of the interior plan (Figure 7.7) shows that it was hypostyle, with two bays on the qibla side and one bay on the other three sides. The courtyard was square, with three bays on each side. Two drawings show elevations of these arches (Figure 7.8); they were bichrome (*ablaq* or *mushahhar*[29]) and horseshoe-shaped. At the top of the courtyard wall were stepped crenellations, and at each corner

Figure 7.5 *James Wild, plan of forecourt of mosque. (Notebook 91 A. 78, Prints and Drawings Collection, Victoria and Albert Museum, ff. 18b–19a)*

of the courtyard was a finial, consisting of a miniature fluted dome supported on three tiers of muqarnas, rising from a square base. These are similar (although not identical) to those known from the mosque of al-Nasir Muhammad at the Citadel and that of al-Maridani. The only purpose that has been suggested for them is as bases on which to anchor awnings held by ropes that could have provided shade for the courtyard.[30] However, the lateral stresses caused by such awnings would have been considerable, and since the finials (at Basktak and the other two examples) are not anchored at the base of the wall but rest on top of the crenellations, they are unlikely to have been able to support such stresses. A solely decorative role for them is more likely.

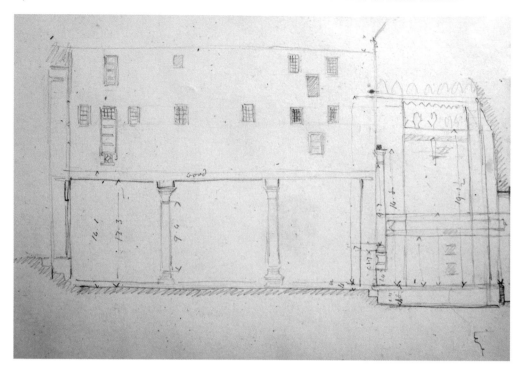

Figure 7.6 *James Wild, elevation of forecourt of mosque. (Notebook 91 A. 78, Prints and Drawings Collection, Victoria and Albert Museum, f. 39b)*

Wild also drew some of the varieties of columns, column bases and capitals to be found around the courtyard,[31] showing that, as was quite normal in the Mamluk period, all of these elements were reused. Wild was evidently very impressed by the decoration of painted wood used on the ceiling, since he devoted many pages of his notebook to it (ff. 29b–34a). One of these is interesting in showing the name ʿAli arranged in a series of triangles, with the word alternately inverted (Figure 7.9).[32] The *lam* and *ya'* are in the form of straight lines, almost, but not quite, like square Kufic. This is not a common treatment of the word in Cairo, although parallels are to be found at the *zawiya* of Shaykh Zayn al-Din Yusuf (1298),[33] where hexagons in the zone of transition of the domed tomb of the founder each contain three interlocking ʿAlis (Figure 7.10), and on the painted ceiling of the reception hall (*qaʿa*) of Ahmad Kuhya (before 749/1348–9),[34] also in a hexagonal pattern (Figures 7.13, 7.14). There is no evidence that the ʿAdawiyya order of Sufis, to which those in the *zawiya* of Shaykh Zayn al-Din Yusuf belonged, were anything other than Sunni,[35] so this and its other manifestations can merely be seen as reverence for the fourth Sunni caliph.[36]

The details that Wild gave of other motifs range from the expected to the unusual. The overall scheme and many of the details are closely paralleled in the ceiling of the *qaʿa* of Ahmad Kuhya (Figures 7.13,

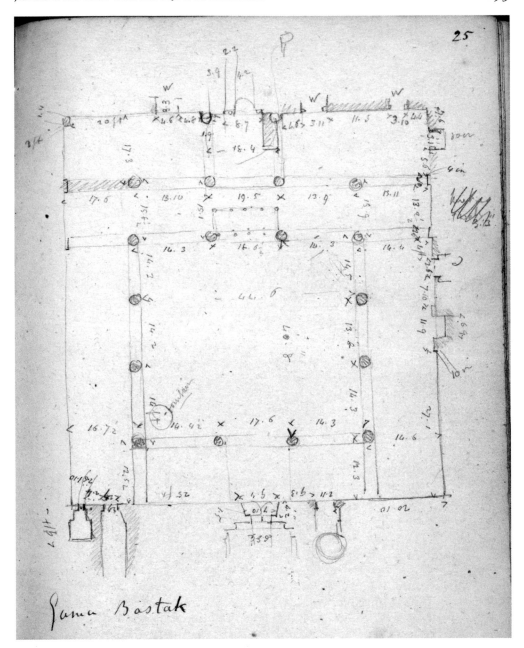

Figure 7.7 *James Wild, plan of interior of mosque. (Notebook 91 A. 78, Prints and Drawings Collection, Victoria and Albert Museum, f. 25a)*

7.14). Both had crossbeams alternating with recessed panels. The initial portion of each crossbeam was decorated with an arabesque pattern at the edges identical to that of the framing beams, an effect that earned Wild's approval: 'It is noticeable the manner in which the crossbeams are united with the beams parallel to the wall in [the]

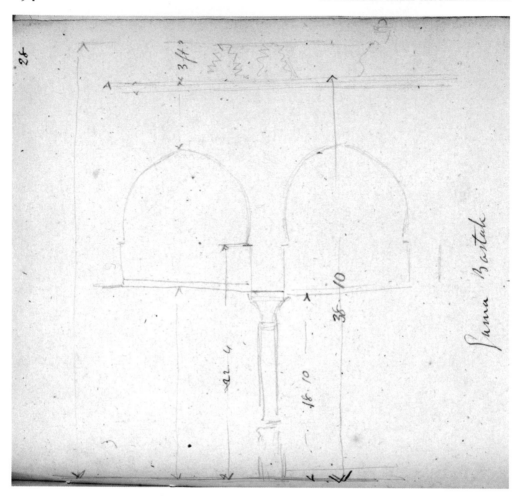

Figure 7.8 *James Wild, elevation of courtyard of mosque. (Notebook 91 A. 78, Prints and Drawings Collection, Victoria and Albert Museum, f. 28a)*

ceiling – a certain portion of each end – along with the pattern of the wall beam.'[37] The remainder of each crossbeam was decorated with a simpler repeating pattern that could be geometric (like the inter-locking ʿAlis mentioned above) or vegetal. One of the geometric pat-terns, a series of interlocking Zs, is present almost identically at both Bashtak and Kuhya (Figures 7.11, 7.13). Both also display cartouches with pointed ends, filled with arabesques. One of Wild's drawings shows a motif that seems to be a simplified version of the Pharaonic lotus (Figure 7.15). There is also a more colourful drawing of a shorter, more stylised version of this Pharaonic lotus motif, with the three-pointed flowers depicted in red, green, blue, and black and white, arranged in a pattern of triangles, the alternating placement of which fits perfectly within a narrow border (Figure 7.11). One might ques-tion Wild's accuracy here, since the usual interpretation of ancient

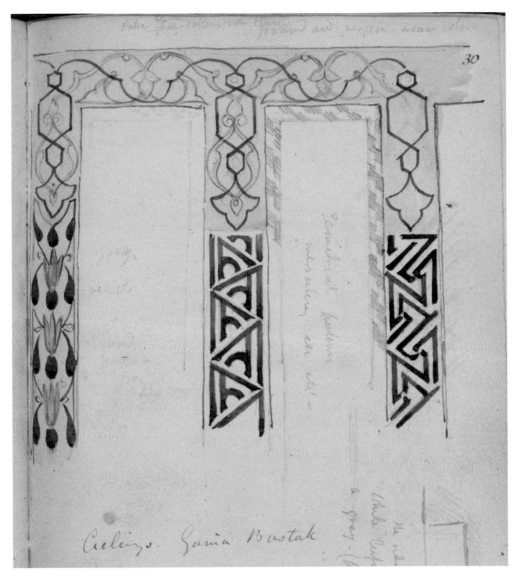

Figure 7.9 *James Wild, detail of painting on ceiling, notebook 91 A. 78. (Prints and Drawings Collection, Victoria and Albert Museum, f. 30a)*

Egyptian borrowings in Mamluk art is that they did not occur before their appearance in carpets of the late fifteenth or early sixteenth century. However, we find both these motifs on the Ahmad Kuhya ceiling mentioned above, the longer lotus flowers in the cartouches between the beams, and the shorter three-pointed leaves on one of the connecting beams (Figure 7.13). The same three-pointed lotus leaves are also found as a fill-in design on one of the three interweaving arabesque patterns on the carved stone balustrade of the minbar of the mosque of Aqsunqur (1346–7, Figure 7.16).[38]

Figure 7.10 *Shrine of Shaykh Zayn al-Din Yusuf (1298), detail of zone of transition in mausoleum (photo: B. O'Kane)*

Another drawing of the ceiling by Wild (Figure 7.12) shows medallions surrounded by interlacing bands forming octagons. The identical scheme is found again on the ceiling of Ahmad Kuhya (Figure 7.14), although there the three-'Ali motif replaces the stylised version of the design found at Bashtak.

Next to the ceiling, Wild reserved the largest collection of drawings (ff. 40b–43a) for the *dikka*, a tribune raised upon columns; it is described in waqf documents as *dikkat al-mu'adhdhinin*, indicating that it was use by the muezzin to perform the *iqama*, performed within the mosque. This is not surprising, as it must have been the finest example of its kind in Cairo. Stone *dikka*s are known at the mosques of al-Maridani, Sultan Hasan and Shaykhu, but only at the latter is the balustrade decorated, with a surrounding inscription, arabesque panels and medallions. At Bashtak the decoration was even more elaborate, with an openwork arabesque all the way around the balustrade, bordered by two different foliate patterns. The narrow sides of the balustrade had a large arabesque pattern in one band (Figure 7.18); those on the long side were probably in two registers, a smaller arabesque at the bottom and a series of trefoils at the top (Figure 7.17). Wild's notes to this drawing read, 'part of the balcony of the *dekka*', 'broken at the top' and 'front red with white lines spandrels green'. It is quite possible that the marble or stone was painted to bring out the different patterns, although whether this was the original colour scheme is impossible to determine.[39] The *dikka* was clearly a masterpiece of stone carving, belonging to the Cairene tradition that included the screens of the complex of Salar and Sanjar, the less well-known ones of the courtyard of the mosque of al-Maridani, and the balustrade of the minbar of the mosque of Aqsunqur (Figure 7.15).

The mosque of Bashtak is one of many hypostyle Friday mosques that were built during the reign of al-Nasir Muhammad. The

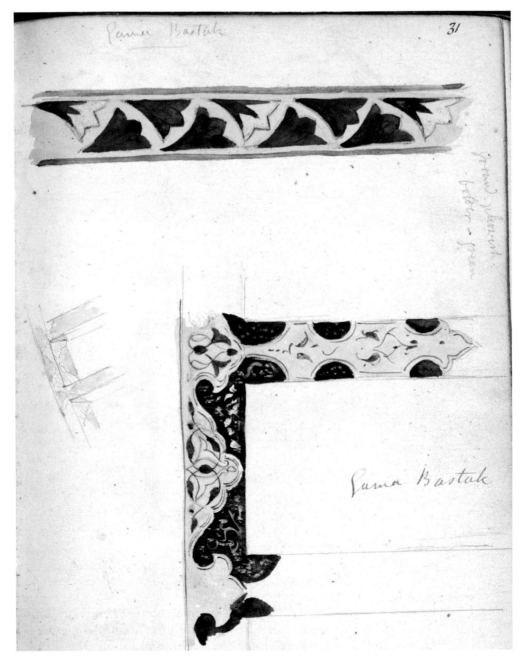

Figure 7.11 *James Wild, detail of painting on ceiling, notebook 91 A. 78.*
(Prints and Drawings Collection, Victoria and Albert Museum, f. Wild 31a)

others include three by al-Nasir Muhammad himself (two, the Jami ʿ
Nasiri – also called al-Jami ʿal-Jadid – north of Fustat[40] and another
jami ʿ near the shrine of Sayyida Nafisa,[41] have not survived; the third
is that at the Citadel), and several by his emirs: Husayn (1319),[42]

Figure 7.12 *James Wild, detail of painting on ceiling, notebook 91 A. 78.*
(Prints and Drawings Collection, Victoria and Albert Museum, f. 34a)

Qawsun (1329), Ulmas (1329), al-Maridani (1337–9), and one by the
chief of his harem, Sitt Miska (1345). Doris Behrens-Abouseif has esti-
mated the number of new congregational mosques in the period of
al-Nasir Muhammad's third reign as around thirty.[43] Commentators
have noted that this indicates al-Nasir Muhammad's love of build-
ing as well as his concern for urban expansion, and that his concern
for building congregational mosques rather than the madrasas of his
predecessors may reflect his desire to be seen as a ruler in the caliphal
tradition.[44]

Reflecting its location on the outskirts of Cairo and the smaller
population to which it would have catered, Bashtak's mosque
was one of the smallest of this group. But Maqrizi's description
of it as 'one of the most splendid mosques in the city with respect
to its attractiveness, decoration, use of marble, and outstanding

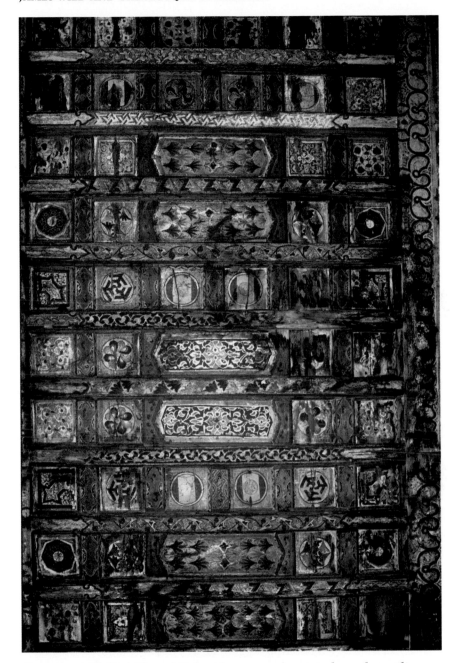

Figure 7.13 *Hall of Ahmad Kuhya (c. 1325–45), painted wooden ceiling (photo: B. O'Kane)*

beauty'[45] was not mere hyperbole, as its extant majestic portal and Wild's drawings of the exquisite decoration of its ceiling and *dikka* affirm. It conceded little to its larger rivals in terms of architectural splendour.

Figure 7.14 *Hall of Ahmad Kuhya (c. 1325–45), detail of painted wooden ceiling (photo: B. O'Kane)*

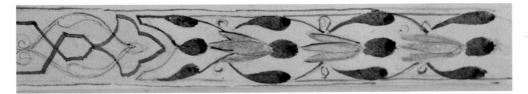

Figure 7.15 *James Wild, notebook 91 A. 78. (Prints and Drawings Collection, Victoria and Albert Museum, f. 29b)*

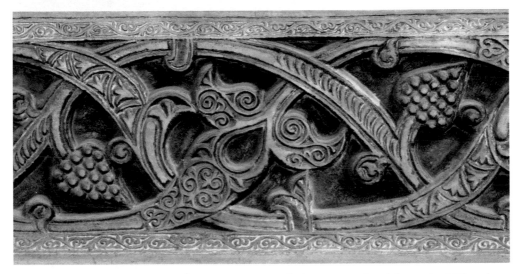

Figure 7.16 *Mosque of Aqsunqur (1346–7), detail of stone minbar (photo: B. O'Kane)*

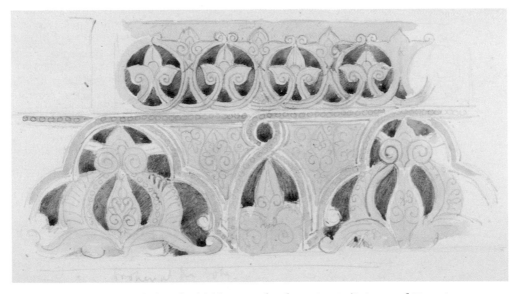

Figure 7.17 *James Wild, detail of* dikka, *notebook 91 A. 78. (Prints and Drawings Collection, Victoria and Albert Museum, f. 41a)*

Figure 7.18 *James Wild, detail of* dikka, *notebook 91 A. 78. (Prints and Drawings Collection, Victoria and Albert Museum, f. 43a)*

Notes

1. E. Kuran, 'Muṣṭafā Fāḍ il Pasha, Mıṣırlı', *Encyclopaedia of Islam*, 2nd edn (Leiden, 1954–2002), s.v.

2. ʿAbd al-Munṣif Sālim Najm, *Quṣūr al-umarāʾ waʾl-bāshawāt fī madīnat al-Qāhira fiʾl-qarn al-tāsiʿashar: dirāsa tārīkhiyya wathāʾiqiyya*, 2 vols (Cairo, 2002) 1, 387. For a map showing the relation of the mosque of Bashtak to Birkat al-Fil see M. Georges Salmon, 'Études sur la topographie du Caire: la Kalʿat al Kabch et la Birkat al-Fîl', *Mémoires de l'Institut Français d'Archéologie orientale du Caire* 7 (Cairo, 1902), Pl. II. The palaces were later used in the winter of 1867–8 by ʿAli Mubarak as headquarters for his new educational initiative, see Timothy Mitchell, *Colonising Egypt* (UC Press E-Books Collection, 1982–2004): <http://publishing.cdlib.org/ucpressebooks/view?docId=ft587006k2&chunk.id=doe1437& toc.depth=1&toc.id=doe1437&brand=ucpress, 64> (last accessed 2 February 2012).

3. The foundation inscriptions of the mosque and sabil are published in Robert Mantran, 'Inscriptions turques ou de l'époque turque', *Annales Islamologiques* 11 (1972), 224–5.

4. Nicholas Warner, *The Monuments of Cairo* (Cairo, 2005), 182: monuments U68 and U69.

5. Al-Harithy, 'Patronage', 231, states that the inscription on the door of the minaret is dated 1326–7, but in fact it says it was begun in April–May 1336 and finished in February–March 1337.

6. Michael Meinecke, *Die mamlukische Architektur in Ägypten und Syrien (648/1250 bis 923/1517)*, *Abhandlungen des Deutschen Archäologischen Instituts Kairo. Islamische Reihe*, 5; Timothy Mitchell, *Colonising Egypt* (UC Press E-Books Collection, 1982–2004),

2 vols (Glückstadt, 1992), 1: 93, Pl. 56c; Behrens-Abouseif, *Cairo of the Mamluks*, 86.

7. Helen Dorey, *Oxford Dictionary of National Biography* (online edn, accessed 30 June 2010), s.v. 'Wild, James William (1814–1892)'.

8. Jason Thompson, *Edward William Lane 1801–1876: The Life of the Pioneering Egyptologist and Orientalist* (Cairo, 2010), 513.

9. T.P., 'The Late Curator of Sir John Soane's Museum', *The Art Journal*, new series (1893), 120–1. The same source also relates how Wild was the first European to enter the Great Mosque of Damascus; even with a decree (*firman*) his command of Arabic language and dress was evidently necessary to do so in safety, ibid., 120.

10. Mark Crinson, 'Leading into Captivity: James Wild and His Work in Egypt', *Georgian Group Journal* 5 (1995), 51–64; idem, *Empire Building: Orientalism and Victorian Architecture* (London/New York, 1996), 98–123.

11. Most of the sketchbooks are devoted to domestic architecture, where of course he was able to draw at leisure, as opposed to the subterfuge that frequently had to be resorted to when sketching religious monuments.

12. Many primary and secondary sources give both overviews and details: al-Maqrīzī, *al-Mawaʿiz wa'l-iʿtibār fī dhikr al-khiṭaṭ wa'l-āthār*, ed. Ayman Fuʾād al-Sayyid, 5 volumes, 3: 99–101; Ibn Ḥajar al-ʿAsqalānī, *al-Durar al-kāmina fī aʿyān al-miʾa al-thāmina*, 3 vols, 3: 477–9; Ibn Taghrībirdī, *al-Nujūm al-zāhira fī mulūk miṣr wa'l-qāhira*, 16 vols (Cairo, 1963–71), 10: 18–20; Robert Irwin, *The Middle East in the Middle Ages: The Early Mamluk Sultanate 1250–1382* (London and Sydney, 1986), 125–6, 189–91; Jo Van Steenbergen, 'Mamluk Elite on the Eve of al-Nāṣir Muḥammad's Death (1341): A Look Behind the Scenes of Mamluk Politics', *Mamluk Studies Review* 9 (2005), 189–92.

13. Ibn Hajar, *Durar*, 478; Ibn Taghribirdi, *Nujum*, 10: 19.

14. Levanoni, *Turning Point*, 35–6.

15. Ibn Hajar, *Durar*, 477.

16. Levanoni, *Turning Point*, 54; Jo Van Steenbergen, 'The Amir Qawsun, Statesman or Courtier? (720–41 AH/1320–1341 AD)', in U. Vermeulen and J. Van Steenbergen (eds), *Egypt and Syria in the Fatimid, Ayyubid and Mamluk Eras*, 3 (Leuven, 2001), 458.

17. al-Maqrīzī, *Kitāb al-sulūk li-maʿrifat duwal al-mulūk*, ed. M. Ziyāda and S. ʿĀshūr, 4 vols (Cairo, 1934–72), 2: 748.

18. Jacques Revault and Bernard Maury, *Palais et maisons du Caire*, 2 vols (Cairo, 1977), 2: 1–20.

19. *Nuzhat al-nāzir fī sīrat al-Malik al-Nāṣir*, ed. Aḥmad Ḥuṭayṭ (Beirut, 1986), 381–2.

20. According to modern conversion tables this date was a Sunday. This does not imply, however, that Maqrizi was mistaken, as conversion tables apply uniform rules to the Islamic year that can differ one or even two days from the correct date on the basis of the appearance of the new moon.

21. Maqrizi, *Khitat*, ed. Sayyid, 4: 236–67.

22. Ibid., 4: 746.

23. K. V. Zetterstéen, *Beiträge zur Geschichte der Mamlukensultane in den Jahren 690–741 der Higra nach arabischen Handschriften* (Leiden, 1919), 228.

24. Doris Behrens-Absouseif, *The Minarets of Cairo* (Cairo, 1985), 82; she notes that Hasan ʿAbd al-Wahhab had claimed that it was restored

when the rest of the mosque was demolished and rebuilt by Ulfat Hanim.

25. I am grateful to Rola Haroun for these drawings.

26. Most easily seen in Warner, *The Monuments of Cairo*, sheet 29.

27. M. M. Amin and Laila A. Ibrahim, *Historical Terms in Mamluk Documents (648–923H) (1250–1517)* (Cairo, 1990), *sabāt* – refer to eleven examples, all of which use the term in the singular, 60–1.

28. I am grateful to Doris Behrens-Abouseif for raising this possibility during the symposium.

29. *Ablaq* is alternating black and white, *mushahhar* alternating red and white; for the definition of the latter see Nasser Rabbat, *The Citadel of Cairo: A New Interpretation of Royal Mamluk Architecture* (Leiden, 1995), 267. The bichrome arrangement is shown in a drawing on f. 27a, not reproduced here.

30. Doris Behrens-Abouseif, *Cairo of the Mamluks*, 178.

31. *Notebook* 91 A. 78 (E.3837–1938), ff. 28b, 29a.

32. Wild's notation on the same page reads: 'the sides of the beams white Kufic inscriptions on a grey (perhaps blue) ground'.

33. The mausoleum is the earliest dated part of the shrine, with other inscriptions indicating that major work took place in 1325 and 1335–6 (Behrens-Abouseif, *Cairo of the Mamluks*, 149–52). Although the mausoleum could theoretically have been redecorated at those later dates, its exterior wall, dating from the earliest period, is already finely decorated, and the form of the decoration of the mausoleum has nothing that suggests a later date.

34. This monument is usually dated, following its listing in the Comité's *Index of Muhammadan Monuments*, to 1310. However, Meinecke has suggested that the blazon visible in the ceiling was that of Baktut al-Qaramani, whose death in 1348–9 would give a terminus ante quem for the building: *Die mamlukische Architektur*, 2: 210. The detail of the decoration of the ceiling (fig. 12) shows chinoiserie lotus decoration, which did not enter the repertory of motifs in Mamluk art until after peaceful relations were established with the Mongols in the early 1320s: Rachel Ward, 'Brass, Gold and Silver from Mamluk Egypt: Metal Vessels for Sultan al-Nasir Muhammad', *Journal of the Royal Asiatic Society*, 3rd series, 14 (2004), 66. The building was converted into a mosque in 1740–1.

35. A. S. Tritton, *Encyclopaedia of Islam*, 2nd ed., s.v. ''Adī b. Musāfir al-Hakkārī'.

36. A parallel can be found in the decoration of one of the iwans of the Timurid madrasa at Khargird, which has the names, alone, of Muhammad and 'Ali; Bernard O'Kane, 'The Madrasa al-Ghiyāsiyya at Khargird', *Iran* 14 (1976), 90.

37. *Notebook* 91 A. 78, E.3837–1938, f. 32a.

38. I am grateful to Iman Abdulfattah for pointing this out to me.

39. Recent restoration of the complex of Umm al-Sultan Sha'ban, under the supervision of Dina Bakhoum (to whom I am grateful for showing it to me as work was progressing), has shown that the stone carved inscriptions at the top of the courtyard façade and on the interior drums of the mausoleums were painted; it is likely that all stone carved patterns and inscriptions on Cairene monuments were similarly treated.

40. A reconstruction, from the detailed description by Ibn Duqmaq, is given in Victoria Meinecke Berg, 'Quellen zu Topographie und Baugeschichte

in Kairo unter Sultan an-Nāṣir Muḥammad b. Qalāʾūn', *Zeitschrift der Deutschen Morgenländischen Gesellschaft*, Suppl. 3/1 (1977), 541. A translation of the description of Ibn Duqmaq is to be found in Howayda al-Harithy, 'Patronage', 226–7.

41. Discussed in ibid., 227.
42. Its original appearance is discussed in Chahinda Karim, 'The Mamluk Mosque of Amir Husayn: A Reconstruction', in Bernard O'Kane (ed.), *Creswell Photographs Re-examined: New Perspectives on Islamic Architecture* (Cairo, 2009), 163–85.
43. Behrens-Abouseif, *Cairo of the Mamluks*, 56.
44. Ibid., 56; al-Harithy, 'Patronage', 236.
45. See n. 27 above.

CHAPTER EIGHT

The Great Mosque of Hama Redux

IN ANY COLLECTION of photographs, those of vanished monuments, or of monuments that have been substantially altered in later years will naturally hold pride of place. The value of these for Cairene monuments is readily seen by many other articles in this volume.

This piece discusses some aspects of a Syrian monument whose main features are well known, but which has elements that are worth analysing in greater detail, particularly as the original building and its furnishings have disappeared. Incredibly, this was not by accident, but was apparently a deliberate act of retaliation by the Syrian government following the 1982 uprising instigated by the Muslim Brotherhood in which scores of party officials were killed. The rebellion was put down by the massacre of at least 10,000 of the inhabitants, and the partial destruction of its old town.[1] When I visited the site a few years after this event the Great Mosque was, for the most part, a mound of rubble (Figure 8.1).[2] In more recent years the rebuilding of the mosque was undertaken, probably motivated by the embarrassment of the gaping hole in the landscape. This did re-employ some of the older masonry, including the columns of the *bayt al-māl* and part of the east courtyard arcade which were studded with Mamluk proclamations,[3] but the variations in masonry and wall size that Creswell used to identify different building periods[4] can no longer to be discerned, nor can the examples of fine woodwork of the minbar and the double cenotaph in the adjacent mausoleum be found (Figures 8.7–8.17). The major sources for the re-evaluation of the history of the building and its furniture are now photographic archives; I have used both those of Creswell and my own in this piece.

Bernard O'Kane (2009), 'The Great Mosque of Hama Redux', in *Creswell Photographs Re-examined: New Perspectives on Islamic Architecture*, Cairo, 219–46.

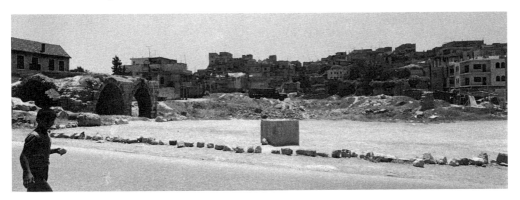

Figure 8.1 *Great Mosque of Hama, site in 1988 (photo: O'Kane)*

The Umayyad mosque

The earliest periods of the building are those that have been most discussed in the literature. Its previous status as a Roman temple transformed into a church, probably in the sixth century, and its subsequent transformation into a mosque are well established (Figure 8.2).[5] The date of this transformation, however, needs to be revisited. The earliest author to mention a date for it is Abu'l-Fida, who says that it took place in 15/636–7, which was the date of the conquest of the city.[6] However, it is unlikely that at the time of the conquest the Muslims settled or planned to settle a population in Hama so sizeable that they would have needed a large space for prayer.[7] Other more populous cities such as Jerusalem and Damascus did not receive large mosques until much later. Abu'l-Fida was writing eight centuries after the events in question, and being a native of Hama, may have been inclined to increase its prestige amongst the Muslim audience for whom he was writing by exaggerating its Islamic credentials.[8] In addition, his story runs counter to the treaties with Syrian provinces and with Jerusalem promulgated by the caliph 'Umar at the time. These are reproduced by Tabari, and state that the 'churches will not be inhabited [by the Muslims] and will not be destroyed. Neither their churches, nor the land where they stand, nor their rituals, nor their property will be damaged.'[9]

One controversy associated with the Umayyad transformation of the building into a mosque is the date of the arcades surrounding the court. Sauvaget was the first to argue that the south section of the east arcade included remnants of the Umayyad mosque, on account of two features: the semi-circular profile of their arches, which, as he notes, was only exceptionally used in Syrian Islamic architecture after the Umayyad period, and on account of the alternation of piers and columns for supports.[10] Creswell noted that the alternation of piers and columns is present as late as the Jami' al-Hanabila of the Salihiyya quarter in Damascus of 599/1202, so that too is not

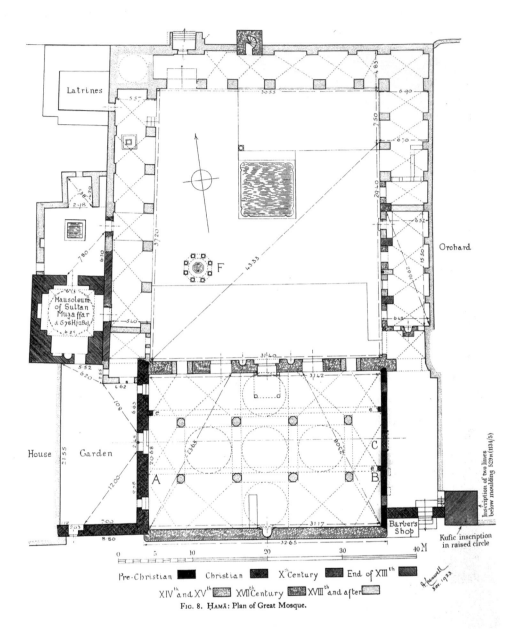

FIG. 8. ḤAMĀ: Plan of Great Mosque.

Figure 8.2 *Great Mosque of Hama, plan (after Creswell)*

conclusive in itself. An additional argument could be their employ-
ment of bi-coloured masonry, which again, since many Ayyubid[11]
and Mamluk examples are known, cannot serve as a terminus ante
quem. Bi-coloured masonry is also seen, however, on such Umayyad
monuments at Qasr al-Hallabat and the Damascus Great Mosque.[12]

Bi-coloured masonry of limestone and basalt was also present in two other places in the Hama Friday Mosque, on the upper courses of the west wall of the main prayer hall, and most noticeably, on the minaret. These links will be explored further below.

Sauvaget went further and maintained that the west and east walls of the prayer hall were of Umayyad date. Creswell was sufficiently roused by Sauvaget's interpretation to write an article of rebuttal,[13] yet at the very end he concluded that

> the south part of the present east riwāq is part of the ancient riwāqs which ran round three sides of the sahn, but we are not bound to believe that *they go back to the beginning* for it is quite possible that there were no riwāqs at first, as we have seen above.[14]

This reluctance to make concessions to Sauvaget on Creswell's part may be splitting hairs to some extent, however. Even if we do not know exactly when the church was converted into a mosque, it certainly had *riwāq*s at some stage in the Umayyad period, as it is inconceivable that the *bayt al-māl* would have been built in a location other than within a courtyard. Creswell did not actually discuss the date of the *bayt al māl*, but the attribution of anything other than an Umayyad date to it is unthinkable, as Sauvaget noted.[15] From this it also follows that that by the time of its erection there were *riwāq*s around the courtyard, since they would have been essential for its security. They may well also have been used for access, as the following description of the *bayt al-māl* at the Mosque of ʿAmr at Fustat makes clear:

> it is separated from its roofs and is not in contact with any part of them. It stands on stone pillars and is a kind of raised dome . . . There is a bridge of wood there and when it is desired to enter that bayt they draw that bridge by means of cords until its end rests on the roof of the mosque. When they leave the chamber they restore the bridge to its former position. It has an iron door with locks. When the last prayer is finished they make everyone leave the mosque permitting none to remain. The doors of the mosque are locked.[16]

The above description does not make it clear whether the roof of the mosque in question was part of the roof of the prayer hall or that of the *riwāq*s. In the case of the Great Mosque of Damascus the *riwāq*s are too tall to have been used to facilitate entrance to the *bayt al-māl*, and its doorway consequently faces south, from which direction a ladder must have been employed for access. The position of the door on the west side of the Hama *bayt al-māl*[17] makes it quite clear that such a bridge, if that was also here the means of access, would have been from the west *riwāq* (as one would also expect from

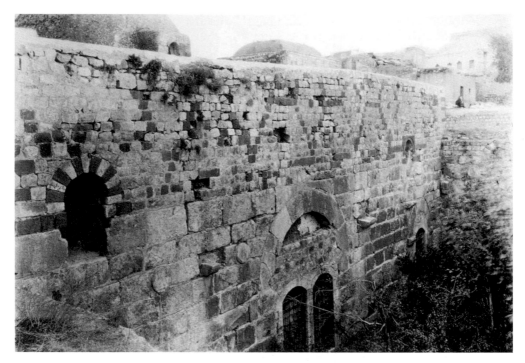

Figure 8.3 *Great Mosque of Hama, west side of prayer hall (photo: Creswell)*

its proximity), since the higher elevation of the roof of the prayer
hall would have precluded a bridge from that side, or at least have
rendered access more precarious.

The use of bi-chrome masonry for the Umayyad arcades men-
tioned above is also found on the upper courses of the west side of the
prayer hall (Figure 8.3). Although one of the two small windows in
this area does have bi-chrome masonry and a rounded profile, at first
suggestive of an Umayyad date, the design on the adjacent wall of
large lozenges with a dot in the middle connected by a horizontal bar
links it with the bold geometric patterning on the twelfth-century
minaret, suggesting that this is a twelfth-century repair. The only
close parallel for the striking decorative treatment of this minaret
is that of the Nuriyya mosque in the same city, so this exceptional
decoration is worth examining in detail.

The south minaret (Figures 8.4–8.6)

The minaret has these same lozenges towards the lower and upper
portions of its square shaft. Narrow rectangular windows are present
above and below the points of the lower lozenges,[18] and in the middle
of the upper lozenges. Circular windows, present on each face,[19]
mark the approximate mid height of the decorated area. There are
two further major areas of decoration; hexagons with six-pointed

Figure 8.4 *Great Mosque of Hama, south minaret (photo: Creswell)*

stars below the bull's-eye windows (effectively incorporated into the decorative scheme) and interlacing bands above. It is these interlacing bands that are found, but in pairs, on the Nuriyya *jami'*, including both the simple knotted band and the Z-shaped motifs of the minaret of the Great mosque.[20] The Nuriyya minaret is crowned by a *muqarnas* course which is a later addition; at the Great mosque there was a reciprocal bi-chrome pattern of stepped crenellations.

Figure 8.5 *Great Mosque of Hama, south minaret (photo: O'Kane)*

The similar decoration of lozenges on the upper part of the west wall of the prayer hall (Figure 8.3) is presumably the result of repairs made at the same time as the building of the minaret.

The minaret of the Great Mosque rested on seven uneven courses of limestone masonry, varying in height from four metres above ground on the east to five on the west (where the ground level was lower). Sauvaget argued that this limestone plinth was Umayyad,[21] but this is unlikely for three reasons. Firstly, as Creswell pointed out, it has an inscription giving the date 529/1135; secondly, as Shahada notes,[22] the unevenness of the courses suggests that the blocks were reused, and thirdly, the closest

Figure 8.6 *Great Mosque of Hama, detail of inscription on south minaret (photo: Creswell)*

parallel for the minaret, that of the Nuriyya mosque in Hama, similarly consists of smaller limestone and basalt masonry on a plinth, much taller there, of large limestone blocks.

No account seems to have been left of the interior of the minaret. Shahada's plan[23] shows it as having a narrow spiral staircase at its lowest point. Perhaps its narrowness relative to the thick walls accounts for the regularity of the windows: where a relatively narrow circular minaret would typically stagger the windows up the length of the shaft, the architect here could pierce the wall on one level from all directions without compromising the stability of the structure. The bulls-eye windows in the middle of the shaft again have analogs in the Nuriyya minaret.

Before discussing the patron of the minaret and the reasons for its erection, its location should be mentioned. This is indeed unusual, on the outer edge of an open space to the east of the prayer hall. And in connection with this, the placing of the courtyard *riwāq*s must also be discussed, since, unlike the great mosques of Damascus, Aleppo[24] and Homs, where the rear of the *riwāq*s is aligned with the edge of the prayer hall, at Hama it is the front that is aligned. Empty space thus ensues to the east and west of the prayer hall. Although ostensibly having access to the street on the qibla side of the mosque, that to the west became a garden,[25] but the space to the east seems to have been used as a passageway from this street into the mosque, and it was from here that access to the minaret was obtained. Riis's reconstruction of the original Byzantine structure provides the explanation: the remaining Roman wall at the east side of the prayer hall was not the easternmost end of the church, which was extended by the addition of the three (sometimes apsidal)

rooms typical of the Eastern liturgy, the prothesis, diaconicon and altar.[26] On the west side was a narthex or an atrium. The rooms on the east were superfluous to the open space of the basilica, and may have contained decoration that was objectionable to Muslims. We do not know when they were demolished, but even if it was before the construction of the minaret in 1135, the right of way established by the passageway was evidently enough to cause the minaret to be sited beyond this free space.[27]

There were two inscriptions on the minaret, a foundation inscription in three lines below the cornice of the large blocks on the east side, and a signature in a medallion at roughly the same height on the south. One might have thought that the obvious placement for the foundation inscription was on the west side, in the passage that led from the street to the mosque, but evidently that must have been too cramped at the time of its erection, so one has to assume that, as was the case when I photographed it in 1979, there was sufficient clear space on the east side for the inscription to be appreciated. Unfortunately a photograph of the foundation inscription never seems to have been published, and Creswell did not photograph it. The inscription on a column end on the southern side of the minaret is visible in one of his photographs (Figure 8.6), but unfortunately the resolution is such that, while of help in determining which of the conflicting readings, van Berchem's in the *RCEA* and that of Shahada,[28] is more likely to be correct, not all of the problems can be resolved.

The signature follows the *shahāda* and a prayer for the long life of the builder of the 'blessed minaret'. Van Berchem reads the last line as '*umila* Bāqī ibn Sālim ibn Asad', a person who is otherwise unknown.[29] Shahada read it as Abū Sālim Yahyā ibn Sa'īd, the same name as the person charged with overseeing the work at the end of the foundation inscription (see below). The photograph as least makes it certain that the last line begins with *umila*; the remainder is less clear but still favours van Berchem's reading.

The two are in agreement on the foundation inscription, which says that the minaret was ordered to be erected by 'the amir, the most illustrious chamberlain, the great lord, Salah al-Din Nasir al-Islam, the trust of sultans, the hero of kings, the commander of the army, the pride of the amirs and the chamberlains[30] . . . Abu Ja'far Muhammad ibn Ayyub al-'Imadi[31] the auxiliary of the commander of the faithful, may God prolong his days. The great lord Abu Salim Yahya ibn Sa'id[32] was entrusted with its commission. It (was finished) in the year five hundred and twenty nine (22 October 1134–10 October 1135).'

Who was this particular Salah al-Din, and why did he want to erect such a prominent minaret at this time? He is not to be confused, of course, with the later Salah al-Din Yusuf, the Saladin of European sources. Our Salah al-Din, referred to as al-Yaghibasani

or al-Yaghisiyani in the chronicles, was a significant figure in the rise of the Zangids and Ayyubids to power, and one of ʿImad al-Din Zangi's most trusted officers. He is first noted as a chamberlain of the father of Zangi, Qasim al-Dawla Aqsunqur al-Bursuqi.[33] Salah al-Din played a part in obtaining Zangi's succession to his father, and was rewarded with a continuance of the post of chamberlain.[34] In 1128 he was sent to secure the governorship of Aleppo in preparation for Zangi's arrival in Syria. At this time the Burid ruler Taj al-Muluk was in control of Damascus and his son Savinj governor of Hama. Zangi tricked Savinj into joining him for a campaign against the Crusaders, promptly arrested him and took control of Hama.[35] Zangi was unsuccessful, however, in his desire to gain control of Damascus, and intervening problems in the Jazira enabled the successor of Taj al-Muluk (who died in 526/1132), Shams al-Muluk, to retake Hama in 527/1133.[36] Shams al-Muluk however quickly became mentally unstable, acting capriciously and conspiring with Zangi to take possession of Damascus, a move that not surprisingly led to his family in Damascus instigating his assassination. Zangi besieged Damascus unsuccessfully in 529/1135, and consoled himself on 28 Jumada 529/15 March 1135 by installing Salah al-Din as governor of Hama.[37] In 1137 Salah al-Din participated with Zangi in an unsuccessful siege of Hims.[38] Upon Zangi's assassination in 541/1146 Salah al-Din backed Nur al-Din against his brothers for the succession, and was rewarded with retention of his governorship of Hama. He later aided Nur al-Din in the sieges and capture of Apamea and Damascus, eventually dying in 552/1157, having been made the governor of the larger town of Hims in the meantime.[39]

Given Zangi's previously short tenure of Hama, the order for the building of the minaret upon its retaking in Jumada 529/March 1135 (the minaret was built by the end of 529, i.e. within seven months of this date) was thus both courageous and prescient. As an advertisement of the power of the Zangids and Salah al-Din it could hardly have been bettered, and in fact Salah al-Din managed to retain his lordship of the surrounding area for the next twenty-two years. Its main competition in succeeding years on the Hama skyline would have been the one that most closely copied its design and decoration, the minaret of the mosque erected by Nur al-Din in 558/1163.[40]

The Turbat al-Malikayn and its cenotaph

After Nur al-Din's death, Salah al-Din Yusuf of course gained control of Syria, and appointed his nephew Taqi al-Din ʿUmar al-Malik al-Muzaffar as governor of Hama. As it happened, this Ayyubid line survived in Hama for over a century and a half, well into the Mamluk Sultanate, although as vassals of the Mamluks after the defeat of the Mongols at ʿAyn Jalut, and even then, as Bosworth points out, only on account of their obscurity and docility.[41] Its members that

concern us are the occupants of the turbat al-Malikayn, adjacent to the west riwaq of the mosque. They are al-Malik al-Mansur, who ruled from 642–83/1244–84, and his successor al-Malik al-Muzaffar Mahmud who died in 698/1299, at which point al-Nasir Muhammad initiated direct rule by his amirs until the appointment of another member of the Ayyubid family, the famous polymath Abu'l-Fida in 1310. Abul-Fida erected his own mosque and mausoleum not far from the Great Mosque in Hama.[42]

The Turbat al-Malikayn was not a particularly distinguished piece of architecture, but the double cenotaph over the grave was noteworthy (Figures 8.7–8.8). The pyramidal tops bore inscriptions giving the names, titles, prayers for, and dates of death of the two rulers. However, the Quranic inscription that runs around the rectangular lower part of the cenotaph is continuous, and shows that the cenotaph was built at one time. There is a remarkable discrepancy between the space given to the names of the two rulers as given on the cenotaphs. That of al-Muzaffar Mansur (Figure 8.7) gives his full genealogy and takes up, with his titles, five and a half lines in the RCEA. That of al-Muzaffar Mahmud (Figure 8.8) is given simply as al-Sultan al-Malik al-Muzaffar Taqi al-Din Mahmud. In addition, the formulae of introduction also differs; that of al-Muzaffar Mansur begins with '*amara bi'umila hadhā al-dharīh al-mubārak*'; that of al-Muzaffar Mahmud more simply as '*hadhā al-dharīh al-mubārak dharīh . . .*'. This at first sight would be consistent with a later sultan exulting in his glory at the expense of one of his ancestors. When the inscription was first published by Gaulmier (and reproduced in the RCEA)[43] the date of death of al-Muzaffar Mahmud was given as 12 Dhu'l-Qaʿda 678. It is notoriously difficult sometimes to differentiate *saba ʿin and tisa ʿin* in inscriptions; here the correct reading is not obvious from either the epigraphy or the dotting (Figure 8.9). Visually it is possible to group the four teeth before the *ʿayn* of the decade so that the first or the second three form a *sīn*. There are three dots in a triangle at the beginning of the decade and three in a line below it, either of which could signify the *sīn*, but both of which are defective when reading a *tā ʾ* of *tisa ʿīn* or a *bā ʾ* of *saba ʿīn*. The date was read by Shahada[44] as 22[45] Dhu'l-Qaʿda 698, and this corresponds exactly with the date of death of al-Muzaffar Mahmud as recorded by his grandson Abu'l-Fida.[46]

How then can one explain the fulsome titles of al-Muzaffar Mansur, and the record of his ordering the cenotaph, with the inscription of the later occupant mentioning only that 'this cenotaph is the cenotaph of al-Sultan al-Malik al-Muzaffar Taqi al-Din Mahmud'? There is also a discrepancy between the quality of the epigraphy of the two historical inscriptions and the decoration on the pyramidal tops adjacent to them. The earlier (Figure 8.7) is by far the finer. Its epigraphy displays deeper undercutting of the letters, as opposed to the flatter forms of the later one. Compare too the extremely

Figure 8.7 *Great Mosque of Hama, detail of cenotaph of al-Muzaffar Mansur (photo: O'Kane)*

Figure 8.8 *Great Mosque of Hama, detail of cenotaph of al-Muzaffar Mahmud (photo: O'Kane)*

delicate arabesque medallion at the corner of the earlier inscription with the thicker and lighter relief of the later one (Figure 8.8). The most obvious difference is the lack of carving within the polygons of the adjacent interlacing strapwork. Even the earlier one has suffered from more recent restoration, and is missing some of its pieces that had ivory or bone inlay, but it is surprising to find that the later has none at all.

What then can be the explanation for the poorer decoration of the later top portion of the cenotaph?[47] I presume that the sudden rupture in Ayyubid power in Hama after the death of al-Muzaffar Mahmud was responsible. It seems that the top of an earlier cenotaph of al-Muzaffar Mansur was reused and its decorative scheme roughly copied. The new Mamluk ruler of Hama, Qarasunqur, may have been

Figure 8.9 *Great Mosque of Hama, interior or prayer hall showing minbar (photo: O'Kane)*

willing to show his predecessor the respect of commemorating him with honour, or, more likely, allowing him to be commemorated by members of his family, but not so grandly as to maintain the pretensions of the family to continue to rule in the city. The date of death of al-Muzaffar Mahmud need not be the date of execution of the

cenotaph, of course, merely a terminus post quem. But had it been done, for instance, as late as the accession of Abu'l-Fida in 710/1310, I imagine that as a grandson of al-Muzaffar Mahmud he would have wished to provide a memorial at least as fine as that of al-Muzaffar Mansur. The most likely period therefore is indeed shortly after the death of al-Muzaffar Mahmud in 698/1299.

The minbar

And in fact shortly after this date another even finer piece of wood-work was added to the Hama Friday mosque, its minbar, ordered by Zayn al-Din Kitbugha in 1302. Just after Qarasunqur became governor of Hama the Mongols one again invaded Mamluk terri-tory, with Ghazan Khan leading a force that went as far south as Damascus, although it was unable to besiege successfully any of the citadels on the way.[48] In the aftermath of the Mongols' withdrawal in 1300 there was a reshuffle of amirial positions; Qarasunqur was transferred to Aleppo, where he had been governor previously, and Zayn al-Din Kitbugha was given the governorship of Hama.[49] This is the former sultan of Egypt, who deposed the child sultan al-Nasir Muhammad in 1294. Recognising the ascendant power of Lajin (and prompted by an assassination attempt), he had been able prior to his transfer to Hama in 1296 to negotiate retirement to Syria as castellan of Sarkhad.[50]

The minbar of Hama (Figures 8.9–8.16) was one of the finest mar-quetry pieces of its age. It is dated the middle of Sha'ban 701/15 April 1302, about eleven months after Kitbugha's appointment as governor, so it was probably ordered soon after his accession.

The inscriptions on the minbar (Figure 8.10)[51] also name Ahmad ibn Ahmad al-Hanafi as the supervisor of the work, and exception-ally no fewer than four craftsmen, the work of (*'amal*) 'Ali ibn Makki and 'Abd Allah Ahmad (Figure 8.10), inlay (*ta''ama*) by Abu Bakr ibn Muhammad and design (*naqasha*) by 'Ali ibn 'Uthman. There are close similarities between Cairene minbars and the Hama example, although Cairene Mamluk woodwork is almost always unsigned. Nearly contemporary with the Hama example is the minbar of Ibn Tulun installed by Lajin, a particularly close match in the carved arabesques on the polygonal panels (Figure 8.11),[52] although the Hama pieces sometimes include small bunches of grapes[53] (Figure 8.12) which are lacking in Lajin's. In both the arabesque stems and leaves cross under and over each other on several levels, unlike some earlier compositions, such as Nur al-Din's minbar for al-Aqsa, where they are on one level.[54] The balustrade of both minbars consists of *mashrabiyya* in which cubes carved with trefoils are joined by lathe-turned pieces. The carving of the Lajin minbar trefoils[55] is however much simpler than the overlapping leaves of the Hama example (Figure 8.13). Another element that is similar in both is the frieze of

Figure 8.10 *Great Mosque of Hama, detail of front of minbar (photo: O'Kane)*

Figure 8.11 *Great Mosque of Hama, detail of side of minbar (photo: O'Kane)*

Figure 8.12 *Great Mosque of Hama, detail of polygon from side of minbar (photo: O'Kane)*

a spiral vegetal scroll at the bottom of the balustrade, between the inscription and the strapwork below (Figure 8.11).[56]

Despite the similarity in details, the overall design of the minbar differs from contemporary Cairene examples. The latter usually have one geometric pattern that extends unbroken from the front to the area below the seat at the back.[57] Syrian minbars however, from that of Nur al-Din onwards, make one pattern for the triangular area beneath the balustrade, and another, or several, for the rectangle beneath the seat, sometimes, as at Hama, opening an arch at the bottom of this part. Another tendency for Syrian minbars is to have a bulkier *muqarnas* cornice above the door of the minbar than Egyptian ones. The Hama minbar has three tiers (Figures 8.9–8.10), as does that of Lajin, but those of Hama project outwards much more than the flatter, less arcuated ones of Lajin.

The pattern of the main triangle below the balustrade at Hama is of twelve-pointed stars set on a grid pattern with octagons at the interstices, a popular arrangement on later Cairene minbars (Figure 8.15).[58] The pattern above the arch at the back of the minbar also features twelve-pointed stars, but in a very different arrangement, set on a diagonal axis, and with nine-pointed stars on the main axis (Figure 8.14). Despite its ostensibly more complicated layout, this was also a popular pattern, occurring for instance in many

Figure 8.13 *Great Mosque of Hama, detail of balustrade of minbar (photo: O'Kane)*

earlier metal-revetted doors in Cairo, such as that of the madrasa of Sultan Baybars I (dated to 1262–3).[59] The main stars at the centre of this part, as well as those on the triangular area, were originally made of coloured wood and bone[60] marquetry, although many of these had been damaged or lost by the time my photographs were taken in 1978.

It is not clear whether the doors of the minbar were the original ones. The uppermost inset panels were not symmetrical (Figure 8.10), as one would expect, and they were painted in a crudely stenciled floral pattern, also seen on a repair plank on the less-well preserved right side of the minbar. The backs of the central panels of the doors had patterns consistent with Mamluk carving, but were quite different from one another (Figure 8.16), although this may merely be an indication that they were reused.

Finally, one can ask why Kitbugha might have wanted to commission such an impressive and expensive object shortly after his accession. The studies that have been made of the minbar that Nur al-Din commissioned for the Aqsa Mosque in Jerusalem and which was eventually transferred there by Saladin, have clearly shown how it was 'designed from the beginning to fulfill a political as well as a religious function'.[61] The politicised context of *jihād* in which Nur al-Din's minbar was conceived is obviously absent in Hama, but

Figure 8.14 *Great Mosque of Hama, panel above arch, left side of minbar (photo: O'Kane)*

political rivalry with another Mamluk amir could be a relevant factor. We saw above that in the reshuffle of amirs subsequent to the Mongol invasion, Qarasunqur had been transferred from Hama to Aleppo and Kitbugha had been appointed to Hama. In the Friday mosque of Aleppo

Figure 8.15 *Great Mosque of Hama, left side of minbar (photo: O'Kane)*

is another of the finest Syrian minbars.[62] It is unfortunately undated, but has an inscription mentioning al-Nasir Muhammad, and another which names Qarasunqur *al-malikī al-manṣūrī* (i.e. functionary of al-Malik al-Mansur Qalaʾun) as the patron. Qarasunqur was governor

Figure 8.16 *Great Mosque of Hama, rear of doors of minbar (photo: O'Kane)*

of Aleppo from 681–89/1282–90, again from 699–709/1300–10 (when he was transferred to Damascus), and briefly from June 1311 until his flight in February 1312.[63] From the first period is a restoration inscription in his name, Qarasunqur . . . *al-manṣūrī*, above the mihrab, dated Rajab 684/September 1285.[64] Herzfeld read the inscription on the

Aleppo minbar as Qarasunqur . . . *al-malikī al-naṣirī*, and thus argued that it must be from his second period as governor, probably on the occasion of his return[65] – but his reading, as I can confirm from a recent visit to the site, is mistaken. Mayer noted that Qarasunqur was styled *al-manṣūrī* on the minbar and not *al-manṣūrī al-naṣirī*, and argued that the order to build therefore was given under the reign of Qalaʾun (d. 689/1290) but it was not completed until al-Nasir Muhammad's first accession in 693/1293. There are two objections to this, firstly that over three years is too much time for the minbar to be in the making, and secondly that Qarasunqur continued, as least for a while, to use *al-manṣūrī* alone after the accession of al-Nasir Muhammad in 698/1299. He is styled thus on an inscription in a column in his madrasa in Cairo, for instance, dating from 700/1300.[66] Kitbugha himself on the Hama minbar, dated 701/1302, also used *al-malikī al-manṣūrī*. On the *sabīl* dated Muharram 703/October-November 1303 attached to his mausoleum in Aleppo, Qarasunqur used *al-manṣūrī al-naṣirī* for the first time, although on his son's cenotaph of 709/1309[67] in the mausoleum itself, he is again only *al-manṣūrī*.[68] Although we are safe in assuming that the minbar dates from Qarasunqur's second tenure of the Aleppo governorship, given the inconsistent use by amirs of *al-manṣūrī* and *al-naṣirī*, it would be unwise to narrow the date on epigraphic grounds.[69] Herzfeld may be right after all in suggesting the occasion of his return to the governorship prompted the order for it to be constructed. Kitbugha's example at Hama could then be seen as a response. It is possible that the chronology could be reversed, of course, but, in two minbars geographically and chronologically so close, it would not be surprising if news of one patron's activity spurred the other on.[70]

The north minaret

In Michael Meinecke's catalogue of Mamluk architecture this minaret is listed under the reign of Qaytbay, with the south-west minaret of the Great Mosque of Damascus, dating from 887/1482, suggested as a terminus ante quem for the Hama minaret.[71] More recently, the minaret was illustrated in a photograph of Creswell in Carole Hillenbrand's *The Crusades, Islamic Perspectives*, with a caption attributing it to the fourteenth century.[72]

The plain square shaft of the minaret changed just above roof level via a pyramidal zone of transition to an octagon (Figure 8.17). The octagonal shaft was divided into three, with a bull's-eye windows with *ablaq* voussoirs in each of the upper and lower portions. The central section had *ablaq* bull's-eye windows (a visual reference to those of the south minaret?) in blind niches with alternating cushion and *ablaq* voussoirs framed in a denticulated moulding. The columns supporting the arches were carved in an interlace rope pattern that is very similar to the columns in the earlier mosque of

Figure 8.17 *Great Mosque of Hama, detail of north minaret (photo: O'Kane)*

Abu'l-Fida in the same town, which because of these is also known as the Jami' al-Hayyat, the mosque of snakes.[73] A two-tier muqarnas cornice led to a wooden balcony above which projected an octagonal tholos, of much smaller diameter than the shaft below, with a three-tier muqarnas cornice leading to a small dome.[74]

Stylistically the minaret is therefore an interesting mix of archaic elements – the smaller tholos top and the interlace columns – with the emphasis on ablaq and decoration that characterise the later minarets of Qaytbay. But there is no need to agonise over its dating, as it originally had an inscription at its base in the northern arcade staring that this minaret (manāra) was built by Ibrahim al-Hashimi in Jumada II 825/23 May–22 June 1422. Although published by Shadada, it seems to have been overlooked by later commentators.[75] The patron was the Mamluk governor of the town,[76] who two years earlier, in Rabi' II 823, was also responsible for the restoration of the eastern riwāq of the mosque,[77] and had built a madrasa against the western riwāq adjacent to the Muzaffariya tomb.[78]

Conclusion

The rebuilt Great Mosque of Hama is unfortunately no substitute for the original. Like the Friday mosques of most major Syrian cities, its intricate layering of buildings periods bore witness to the desire of patrons to leave their mark upon the mosque and the town. Fortunately the photographic archives used in this piece still afford us a glimpse of the riches that it once contained. Many of the detailed points of interpretation in this piece, such as the dating of the repairs on the upper west wall of the prayer hall, the verification of the inscriptions on the south minaret and cenotaphs, the differentiation of the work on the cenotaphs of al-Muzaffar Mahmud and al-Muzaffar Mansur, and the appreciation of the quality of the minbar, would have been impossible without them.

Notes

1. See 'Hama Massacre', <http://en.wikipedia.org/wiki/Hama_Massacre> (last accessed 18 July 2008).
2. Ironically, when discussing the possibility of further archaeological explorations, Riis wrote that 'Systematic research will hardly be possible, as the holiness of the building must be respected'; P. J. Riis, Temple, Church and Mosque, Historisk-filosifiske Meddelelser, Det Kongelige Danske Videnskabernes Selskab, 40 (Copenhagen, 1965), 36.
3. Most of these have been published by Max van Berchem, 'I. Arabische Inschriften', in Max Freihern von Oppenheim, Inschriften aus Syrien, Mesopotamien und Kleinasien, Beiträge zur Assyriologie und Semitischen Sprachwissenschaft, vol. 7, no. 1 (Leipzig, 1909), 23–9; Jean Sauvaget, 'Décrets mamelouks de Syrie, (deuxième article)', Bulletin d'Études Orientales 3 (1933), 1–13; Kamal Shaḥada, 'al-Jāmi' al-'alā

al-kabīr fi Ḥama', *Les annales archéologiques arabes syriennes* 26 (1976), 213–22.

4. K. A. C. Creswell, *Early Muslim Architecture* (Oxford, 1932–69) (here-after *EMA*), vol. 1/1, 19–20; idem, 'The Great Mosque of Ḥamā', in *Aus der Welt des islamischen Kunst: Festschrift für Ernst Kühnel* (Berlin, 1959), 50–1.

5. Creswell, 'Great Mosque'; idem, *EMA*, 1/1, 17–21; Jean Sauvaget, *La mosquée omeyyade de Médine* (1947), 103–7; P. J. Riis, 'Remains of a Roman Building in Ḥamā, Syria', *Berytus* 2 (1935), 34–9; idem, 'Note on the Early Christian Building in Hama', *Berytus* 4 (1937), 116–20; idem, *Temple, Church and Mosque*, Historisk-filosofiske Meddelelser udgivet af Det Kongelige Danske Videnskabernes Selskab, 40/5 (Copenhagen, 1965).

6. Creswell, *EMA* 1/1, 21.

7. I am grateful to my colleague Jere Bacharach for pointing this out to me. I would also like to thank him for his critical comments on an earlier draft of the piece.

8. Creswell's criticism (*EMA* 1/1, 21; 'Great Mosque', 53) of Sauvaget's remark (*mosquée*, 107) that, failing textual or epigraphic evidence, we are ignorant of the date of its conversion into a mosque, may thus be misplaced.

9. Al-Ṭabarī, *Ta'īrkh al-rusul wa'l-mulūk*, trans. Yohanan Friedmann as *The History of al-Ṭabarī*: vol. XII, *The Battle of al-Qādisiyyah and the Conquest of Syria and Palestine* (Albany, 1992), 191–2. Heba Mostafa has kindly pointed out to me that, in line with Umayyad practice in other parts of Syria, Abu'l-Fida's suggested dating may relate not to the actual construction of the mosque but to its designation as a place for prayer.

10. *La mosquée*, 105–6. In the modern rebuilding the arcades do not have quite the same profiles as the original.

11. See, for instance, the twelfth-century doorway of the Damascus Great Mosque, for which the most convenient source is Terry Allen, *Ayyubid Architecture*, <http://www.sonic.net/~tallen/palmtree/ayyarch/ch1.ht m#aa14.1> (last accessed 18 July 2008), Fig. 10 and n. 15.

12. Also pointed out by Sauvaget, *La mosquée*, 105. Althought contested by Creswell, the most thorough recent discussion of the originality of the use by the Umayyads of voussoirs of alternating colours is by Jerrilynn D. Dodds, *Architecture and Ideology in Early Medieval Spain* (University Park, PA and London, 1990), 164–5, where she concludes that it is a 'healthy possibility'.

13. 'The Great Mosque'; repeated in the revised text of *EMA* 1/1, 17–21.

14. 'The Great Mosque', 53.

15. *La mosquée*, 105. Van Berchem had earlier pointed out the similari-ties of the Hama and Damascus *bayt al-māl*s. He showed that the Great Mosque of Homs probably also had a similar structure, and quoted Istakhri's discussion to the effect that placing the treasury in the Great mosque was a Syrian custom: Max van Berchem and Edmond Fatio, *Voyage en Syrie*, Mémoires Publiés par les membres de l'Institut Français d'Archéologie Orientale du Caire, 37, pt. 1, fasc. 2 (Cairo, 1914), 165–6, 174–6.

16. Creswell, *EMA* 1/2, 483–4.

17. <http://digitalcollections.aucegypt.edu/digital/collection/p15795coll 30/id/2050> (last accessed 20 April 2021).

18. As can be seen from Creswell's photo (which shows the north and west sides), no window was present below the lozenge on the W side. I do not have a photograph that shows the south side before rebuilding; the rebuilding is not completely reliable as it does not incorporate the window that was present below the lozenge on the north and east sides.

19. Again with the caveat that an earlier photograph of the south side is not available to me.

20. See n. 38.

21. *La mosquée*, 107.

22. Shahāda, 'al-Jāmi'', 199.

23. Ibid., 243.

24. This is admittedly a partial exception, in that the rear of the west riwaq extends beyond the west side of the prayer hall: Ernst Herzfeld, *Inscriptions et monuments d'Alep, Matériaux pour un Corpus Inscriptionum Arabicarum*, deuxième partie, Syrie du Nord, 2 vols, Mémoires de l'Institut Français d'Archéologie Orientale du Caire, vol. 76. (Cairo, 1955), vol. 2, Pl. LIII. However, the hatching on the plan shows that Herzfeld thought that this *riwaq*, unlike that on the east, was later than the date of the prayer hall.

25. Creswell, 'Great Mosque', Fig. 1.

26. For two possible reconstructions of this, see Riis, *Temple*, Pls XVI–XVII.

27. One might think that the outer limits of the mosque represent the ancient Roman temenos, but Riis (*Temple*, 13) was of the opinion that the only standing Roman wall, the east wall of the prayer hall, was in fact part of the temenos rather than being a part of a separate Roman basilica within the temenos.

28. 'al-Jāmi'', 211.

29. *Répertoire Chronologique d'Epigraphie Arabe* (Cairo, 1931–91) (hereafter *RCEA*) no. 3074, vol. 8, 96.

30. One word here is illegible.

31. The *nisba* is from 'Imad al-Din Zangi.

32. Equated by Shahada as the Yahya ibn Sa'id ibn 'Abd Allah Abu Salim al-Bahrani al-Hamawi mentioned by Ibn 'Asakir in a manuscript in the Zahhiriyya Library at Damascus as a litterateur who wrote *qasīda*s, including one in praise of Damascus: 'al-Jāmi'', 211, n. 35.

33. On him see Claude Cahen, ''Āk Sunkur al-Bursukī (Abū Sa'īd Sayf al-Dīn Kasīm al-Dawla)', *Encyclopaedia of Islam*. Edited by: P. Bearman, Th. Bianquis, C. E. Bosworth, E. van Donzel and W. P. Heinrichs. Brill, 2008. Brill Online. AMERICAN UNIVERSITY IN CAIRO. 06 May 2008, <http://o-www.brillonline.nl.lib.aucegypt.edu:80/subscriber/entry?entry=islam_SIM-0452> (last accessed 18 July 2008).

34. Nikita Elisséeff, *Nūr al-Dīn: un grand prince musulman de Syrie au temps des Croisades (511–569H./1118–1174)* (Damascus, 1967), 329–32.

35. Ibn al-Qalanisi, *Dhail ta'rikh Dimashq*, trans. H. A. R. Gibb as *The Damascus Chronicles of the Crusades* (London, 1932), 200–1. This is given under the year 525/1129–30; Ibn al-Athīr, *al-Kāmil fi'l-ta'rīkh*, trans. D. S. Richards as *The Chronicle of Ibn al-Athīr for the Crusading Period*, part 1. *The years 491–541/1097–1146: The Coming of the Franks and the Muslim Response*, Crusade Texts in Translation, 13 (Aldershot, 2006), 279, places it under the year 523.

36. Ibn al-Qalanisi, *Dhail ta'rikh Dimashq*, trans. Gibb, 218–20. On the background to this period see also Jean-Michel Mouton, *Damas et sa*

principauté sous les Saljoukides et les Bourides 468–549/176–1154 (Cairo, 1994), 38–43, and also Claude Cahen, *La Syrie du nord à l'époque des Croisades et la principauté franque d'Antioche*, Institut Français de Damas, Bibliothèque Orientale, 1 (Paris, 1940), 347–57.

37. Ibn al-Qalanisi, *Dhail ta'rikh Dimashq*, trans. Gibb, 218–20; Elisséeff, *Nūr al-Dīn*, 355.

38. Elisséeff, '*Nūr al-Dīn*', 361.

39. Ibid., 432–4, 485–6, Ibn al-Qalanisi, *Dhail ta'rikh Dimashq*, trans. Gibb, 340.

40. The most complete publication is still Ernst Herzfeld, 'Damascus – Studies in Architecture, II', *Ars Islamica* 10 (1943), 40–5. The minarets can be compared in Figs 68 and 71.

41. Clifford Edmund Bosworth, *The New Islamic Dynasties: A Chronological and Genealogical Manual* (Edinburgh, 1996), 74. For a full account of the dynasty see P. M. Holt, *The Memoirs of a Syrian Prince. Abu'l-Fidā', Sultan of Ḥamāh (672–732/1273–1331)*, Freiburger Islamstudien 9 (Wiesbaden, 1983), 1–5.

42. E. Graf von Mülinen, 'Das Grab Abul'Fidā's in Ḥamā', *Zeitschrit der Deutschen Morgenländischen Gesellschaft* 63 (1909), 657–60.

43. J. Gaulmier, 'Pèlerinages populaires à Hama', *Bulletin d'Études Orientales* 1 (1931), 146–7; *RCEA* vol. 12, p. 251, no. 4778, under the year 678; *RCEA* vol. 13, p. 26, no. 4839, under the year 683. Michael Meinecke, *Die mamlukische Architektur in Ägypten und Syrien (648/1250 bis 923/1517)*, Abhandlungen des Deutschen Archäologischen Instituts Kairo. Islamische Reihe, Band 5, 2 vols (Glückstadt, 1992), 2: 61–2 also lists it under the date 683.

44. Kamal Shaḥada, 'al-Turab wa maqāmāt al-ziyāra fī Ḥamā', *Les annales archéologiques arabes syriennes* 25 (1975), 167–70.

45. I do not have a detailed photograph of this part of the inscription, but it would also be difficult to differentiate *'ashara* and *'ashrīn* in inscriptions, with the elongated *nūn* of the latter easy to mistake for a *rā'*.

46. Holt, *Memoirs*, 34.

47. The inscription on the lower rectangular portion of the cenotaph, read by Shahada, 'al-Turab', 169 as the Quran 2:255 followed by prayers, must of course have been completed at one time, presumably at the later date when the earlier top of the cenotaph of al-Muzaffar Mansur was incorporated into the double cenotaph. Unfortunately neither the published photographs of Shahada nor my own are of sufficient detail as to verify this by comparison of the marquetry or carving of the epigraphy with that on the pyramidal tops.

48. Reuven Amatai, 'The Mongol Occupation of Damascus in 1300: A Study of Divided Loyalties', in *The Mamluks in Egyptian and Syrian Politics and Society*, ed. Michael Winter and Amalia Levanoni (Leiden, 2004), 21–41.

49. Holt, *Memoirs*, 36.

50. Ibid., 27; Robert Irwin, *The Middle East in the Middle Ages: The Early Mamluk Sultanate 1250–1382* (London, 1986), pp. 85, 90.

51. *RCEA* no. 5136, vol. 13, 225–6 and vol. 14, 285; L. A. Mayer, *Islamic Woodcarvers and Their Works* (Geneva, 1958), 34; Shahada, 'al-Jāmi'', 211–13.

52. Stanley Lane-Poole, *The Art of the Saracens in Egypt* (London, 1886), Figs 35–8; Gloria Sergine Ohan Karnouk, *Cairene Bahri Mamluk Minbars, with a Provisional Typology and a Catalogue*, 1977 MA

thesis, American University in Cairo, 1977, fig. 25; *idem*, 'Form and Ornament of the Cairene Baḥrī Minbar', *Annales Islamologiques* 17 (1981), Pls VI 1–2.

53. Familiar in Cairene woodwork since the portable mihrab of Sayyida Nafisa dating from the first half of the twelfth century: Bernard O'Kane (ed.), *The Treasures of Islamic Art in the Museums of Cairo* (Cairo, 2006), 89, no. 81.

54. Sylvia Auld, 'The *minbar* of al-Aqsa: Form and Function', in *Image and Meaning in Islamic Art*, ed. Robert Hillenbrand (London, 2005), 51, pl. 7.

55. Karnouk, *Bahri Mamluk Minbars*, 55, Fig. 22.

56. Ibid., 54, Fig. 18.

57. E.g. those of Lajin at Ibn Tulun, al-Maridani and Manjak al-Yusufi (Karnouk, 'Form and Ornament', Pls 1.3, IV. 2–3). For an exception, see the minbar of Sitt Miska, ibid., Pl. IV.1.

58. E. g. on the minbars of the mosque of al-Maridani and Aslam al-Bahai; Karnouk, *Bahri Mamluk Minbars*, Figs 52, 68; and on the mosques of ʿAbd al-Ghani, 1418 and the mosque and mausoleum of Gani Bek, 1426–7: Manual D. Keene, *Geometric Art in Islam: a Contribution to the Work of J. Bourgoin*, MA thesis, American University in Cairo, 1971, fig. 120.

59. Luitgard E. M. Mols, *Mamluk Metalwork Fittings in Their Artistic and Architectural Context* (Delft, 2006), cat. no. 1, pls 1–2.

60. It is now too late to ascertain for sure whether bone or ivory was used.

61. Sylvia Auld, 'The *Minbar* of al-Aqsa: Form and Function', in *Image and Meaning in Islamic Art*, ed. Robert Hillenbrand (London, 2005), 42. This is the most complete study of this topic; she includes a bibliography of earlier relevant studies, 59–60.

62. Mayer, Islamic Woodcarvers, 55; RCEA nos 5292–3, vol. 14, 59–60 (under the year 711); Herzfeld, *Matériaux pour un Corps Inscriptionum Arabicarum, deuxième patrie: Syrie du nord, inscriptions et monument d'Alep*, Mémoires Publiés par les Membres de l'Institut Français d'Archéologie Orientale du Caire 76 (Cairo, 1955), 1: 168; 2: pls LXVb, LXVId.

63. Holt, *Memoirs*, is the most easily accessible source for the details of the frequently shifting governorships of the Syrian provinces in his period. For a sketch of Qarasunqur's life see Moritz Sobernheim, 'Die arabischen Inschriften von Aleppo', *Der Islam* 15 (1926), 178–80.

64. Herzfeld, *Alep*, 1: 166–7.

65. Ibid., 168.

66. RCEA no. 5089, vol. 13, 199.

67. The date of death is given as the end of Jumada II 709/4 December 1309. The cenotaph and its inscription must have been put in place some time after. Qarasunqur had supported al-Nasir Muhammad's return to power in January 1310, so it is unlikely that Baybar al-Jashinkir's eleven month interregnum had any effect on the inscriptions on the cenotaph.

68. Herzfeld, *Alep*, 1: 321–2.

69. RCEA 14: 59–60 lists the minbar under the year 711 but does not clarify why.

70. It was also at this period (dated 699/700) that another Mamluk amir, Baktamur, commissioned an outstanding minbar for the mosque of al-Salih Talaʾi in Cairo: RCEA no. 5073, 13: 190–1.

71. *Die mamlukische Architektur*, 2: 438, cat. no. 42/206, illustrated in Pl. 121c (general view) and 121e (detail).
72. (Edinburgh, 1999), 229, Pl. 4.27. The same photograph of Creswell is also reproduced in Robert Hillenbrand, *Islamic Architecture, Form Function and Meaning* (Edinburgh 1994), 138, fig. 101.
73. Graf von Mülinen, 'Das Grab', Fig. 2. The motif also recurs in some Cairene monuments, such as column in the window above the entrance to the hospital of al-Muʾayyad.
74. Similar in form, but thinner and more elegant than that built by Lajin at the mosque of Ibn Tulun in Cairo.
75. Shahada, 'Jāmiʿ', 216. The location of the inscription, but not its content, is marked on the plan in Sauvaget, 'Décrets', 3, Fig. 4.
76. Shahada, 'Jāmiʿ', 207.
77. Ibid., 213; the term used was *jadada*, and referred to this place (*hadhā al-makān*), which could be localised to the *riwāq* or could mean more extensive repairs throughout the whole mosque.
78. Shahada, 'al-Turab', 168, n. 8; *idem*, 'Jāmiʿ', 207–8.

CHAPTER NINE

Ayyubid Architecture in Cairo

THE AYYUBIDS RULED in Cairo for less than a hundred years, a period which was characterised by internecine and Crusader warfare, plagues, famines, and not infrequent squandering of the public purse by rulers either dissolute or desperate to survive.[1] Within these constraints, the wonder is perhaps not that we have so few monuments surviving from the Ayyubid period, but that there are so many. Although the constant warfare was a huge drain on resources, it did bring at least one huge benefit to buildings operations: a ready supply of labour. Ibn Jubair noted that the citadel was being worked on by 'the foreign Rumi prisoners whose numbers were beyond computation. There was no cause for any but them to labour on this construction. The Sultan has constructions in progress in other places and on these too the foreigners are engaged so that those of the Muslims who might have been used in this public work are relieved of it all, no work of that nature falling on any of them.' The second major Ayyubid citadel at Cairo, that of al-Salih Najm al-Din on the island of Roda, was also the work of foreign prisoners, as was his madrasa.[2]

As usual, the surviving buildings are much fewer that those known from the sources. For instance, of the twenty-five madrasas known to have been built by the Ayyubids in the Cairo area (i.e. including Fustat), we have the remains of only two. None of the six mosques, three zawiyas, three ribats, two hospitals and numerous commercial establishments, or the single khanqah, has survived. But the extant monuments do include two of Cairo's iconic buildings, the citadel and the tomb of Imam al-Shafi'i, which, together with the madrasa of al-Salih Najm al-Din Ayyub, became touchstones that encouraged embellishment and emulation or challenged subsequent patrons to surpass.

The number of madrasas shows clearly the importance of this institution to the Ayyubids. The waning of Fatimid caliphal power in the latter decades of their reign meant that several had already appeared

Bernard O'Kane (2009), 'Ayyubid Architecture in Cairo', in Robert Hillenbrand and Sylvia Auld (eds), *Ayyubid Jerusalem: The Holy City in Context 1187–1250*, London, 423–34.

in Alexandria before the coming of the Ayyubids. Salah al-Din lost
no time, even when only the vazir of the Fatimids, in founding two
madrasas in Fustat, one Shafi'i, the other Maliki, these being the two
most populous *madhhab*s of the time.[3] The proliferation of madrasas
was formerly seen as a counterweight to previous Fatimid propa-
ganda, but it has been suggested that the Ayyubids used it as a tool to
a variety of ends. Christians had attained great prominence in govern-
ment circles under the Fatimids, and the establishment of madra-
sas was one way in which the Muslim community could reassert
itself in the face of a large and active Christian population.[4] These
madrasas were well, or even lavishly endowed,[5] and the stipends from
their *waqf*s were a way of rewarding ulama, many of whom were
imported into Egypt by the Ayyubids, and of ensuring their continued
loyalty.[6] The importance of the ulama to the Ayyubid polity was
further underlined by their preferment for important governmental
positions, rather than those trained within the *diwan*s, as had been
the case previously under the Abbasids and Fatimids.[7]

The citadel (Figure 9.1)

Even after Salah al-Din had overthrown the Fatimids, his position
in Egypt was precarious, not so much from Fatimid sympathisers
as from Nur al-Din. In 1172 he excused himself on the grounds of
Cairo's instability from Nur al-Din's request to join him in besieg-
ing Karak, knowing full well that the latter's suspicions would be
aroused. The following year Salah al-Din's brother Turanshah was
dispatched to conquer Yemen; it was to be a fallback for Salah al-Din
and his family if Nur al-Din did decide to attack.[8] As it turned out,
just when Nur al-Din's preparations to invade Egypt were complete,
he suddenly died. The citadel in Cairo was not begun until two years
later, but the decision to build it was no doubt due to a combina-
tion of factors. Nur al-Din's repair of the major citadels of Aleppo,
Damascus, Hims and Hama, including residential quarters at the
first two, undoubtedly provided a model, one that was followed by
virtually all the Turkish or Kurdish rulers of the Jazira and Syria in
his time.[9] Defence was advisable against a number of quarters: the

Figure 9.1 *Cairo. The citadel (twelfth–nineteenth centuries)*

Crusaders, who had advanced very close to Cairo in 1169; Fatimid sympathisers (although they were probably the least of Salah al-Din's worries), and, most importantly, given the near conflict with Nur al-Din, other ambitious family members or local rulers. In addition, there would have been a stigma to continued residence at the Fatimid palaces or Dar al-Wizara;[10] an imposing citadel and palatial residence sent a strong message of a new order of increased power to the surrounding population. The message is made clear on the foundation inscription of Salah al-Din, which notes that it combines utility, beauty and comfort, but in the context of the victory Sura which opens the inscription, and the phrase 'Reviver of the Dominion of the Commander of the Faithful' which is appended to Salah al-Din's name.[11] What is surprising is the location and size of this inscription: high up on the wall, on a plaque only 1.25 m wide. True, it would have been visible to everyone as they passed the main gate, but given its dense and, it must be said, pedestrian script, reading it from the ground would have presented great difficulty, as it does today.[12]

The citadel gave Cairo its first bent entrances, a military improvement from the earlier Fatimid gates. But the lack of archaeological excavations within the citadel, and its continuous habitation, means that we have little knowledge of the Ayyubid buildings that were within the citadel.[13] Arguably of more importance was its effect on the urban growth of the city, which now stopped expanding towards the north; the citadel drew buildings towards it from the southern end of the Fatimid city, and also due west towards the canal. The crossroads (ṣalība) of this latter with the qasaba, the main artery continuing south towards Fustat from Bab Zuwaila, thus became another prime architectural locus.

The mausoleum of Imam al-Shafi'i

Salah al-Din's successor al-'Adil, like his brother before him, spent most of his time campaigning in Syria. Apart from continued work on Cairo's fortifications, his only known foundation in Cairo was a small madrasa at Fustat. It is therefore not surprising that it was his son al-Kamil, governor of Cairo in al-'Adil's absence, who erected the most memorable building of al-'Adil's reign. Why should al-Kamil have decided to lavish his attention on Imam al-Shafi'i's mausoleum? Several reasons can be adduced. Salah al-Din had already enhanced the area by erecting a madrasa at the site, about which Ibn Jubair had the following to say:

> Over against it [the tomb of al-Shafi'i] was built a school the like of which has not been made in this country, there being nothing more spacious or more finely built. He who walks around it will conceive it to be itself a separate town. Beside it is a bath and other conveniences, and building continues to this day.[14]

Ibn Jubair also says of the mausoleum itself that it was 'a shrine superb in beauty and size'. This probably indicates that the tomb was rebuilt, or at the least renovated by Salah al-Din and incorporated into the plan of his madrasa at the site. Certainly, the asymmetrical entrances into al-Kamil's buildings can be best explained by passages leading to the madrasa which we know was on the site now occupied by the adjacent nineteenth-century mosque. Salah al-Din's foundation may have been designed to call to mind the madrasa tomb complex of Syria and to supplant the *ziyāra* to the mausoleums of the 'Alids which the Fatimids had cultivated so assiduously.

When Salah al-Din's son al-'Aziz died suddenly after a fall from a horse in 1198, he was buried beside the tomb of al-Shafi'i. The pilgrimage guides that abounded for the cemetery stressed the holiness of the gravesites and the efficacy with which prayers were answered there. Al-Kamil buried his mother at the site. He himself was first interred in Damascus immediately after his death there; but the re-interment of his body within the tomb of al-Shafi'i was presumably the result of his previously expressed wish, suggesting that he was acutely aware of the baraka to be accrued from burial in the vicinity of the saintly champion of religious orthodoxy. Indeed, many graves that were previously at the site had to be moved to make way for the new construction.[15] His erection of a spacious mausoleum also made pilgrimage to the site easier, and correspondingly increased the possibilities for *baraka*, as pilgrims would be more inclined to pray for a patron whose family cenotaphs were conspicuous within its walls.[16]

At the time of its erection the domed mausoleum of Imam al-Shafi'i was one of the biggest in the Islamic world.[17] Its diameter of 15 m was equalled in the contemporary Islamic world by the qibla dome chamber of the Isfahan Friday mosque, and surpassed only by the tomb of Sultan Sanjar at Marv (17.28 m) and the Dome of the Rock (20.4 m). Of course, its wooden dome is less of a technical achievement than the masonry examples of Iran, but it bears equal witness to the desire for its donor's munificence to be as conspicuous as possible. Such was the unprecedented size of the dome that the designer took no chances by making the lower walls extremely massive (2.75 m thick), much more than was actually needed. We do not know for certain whether the present dome reflects that of the original, since Qaitbay made major repairs to the zone of transition, and therefore probably replaced the dome at the same time.[18]

The siting of the adjacent madrasa explains the asymmetrical entrances to the building. That on the side opposite the qibla is the largest; although it is off-centre, it is aligned with the cenotaph of al-Shafi'i. Presumably this was the axis of the mausoleum at the time of Salah al-Din, and in the rebuilding of the mausoleum by al-Kamil its area was expanded on the west, the location of the cenotaphs of the patron and his mother.

Despite the lack of a major entrance, the exterior is still commanding. One advantage of the extreme thickness of the walls was that it permitted successive setbacks that successfully lighten and disguise the zone of transition. The slim bevel of the lower square is echoed in that of the larger one in the intermediate zone; the frieze of stylised shells that surrounds the latter has an added refinement on one of these bevels, loops in the surrounding vegetal frieze (Figure 9.2).[19]

It is at the top of the lower square and on this zone of transition that we have an early example in Cairo of stucco that is, or reflects, the work of Maghribi craftsmen. The vertical panels that interrupt the geometric frieze which crowns the lower storey have either dense geometric or arabesque ornament. Some of the latter includes Kufic in which the uprights are extended to form an interlacing frame in the form of a polylobed arch, a scheme that is similar to the decoration of many of the Almohad gates of Morocco.[20] Another Maghribi trait, that of mirror-writing, can be seen for the first time in Cairene epigraphy on one the spandrels of the north corner (Figure 9.2).[21]

The interior of the mausoleum has been much restored. The question of whether the zone of transition reflects the original is a controversial one.[22] Creswell noted that the splayed muqarnas of the top tier has no parallel until the late thirteenth century, and that an exact match is found only in a mid-fifteenth-century building (the Qadi Yahya mosque at Habbaniyya), causing him to attribute them to Qaitbay's restoration of 1480. Against this, Behrens-Abouseif has noted that the profile of the dome resembles that of the mausoleum of al-Salih Najm al-Din, and that such a zone of transition would be very archaic for the Qaitbay period. A wooden zone of transition of unprecedented size may indeed, as Behrens-Abouseif suggests, have necessitated unprecedented solutions, but part of the problem is that the comparative material in both the Ayyubid and Qaitbay periods is largely masonry domes. The dome of the Qadi Yahya mosque that Creswell noted to be an exact match is indeed virtually identical, even to the detail of the unusual faceting of the single unit of muqarnas in the centre of the upper tier.[23] Just as important, it is of the same material, wood; even if it would be archaic for the Qaitbay period, it may have been thought that a wooden model, even from some thirty years previously, may have provided the best model for the restoration. The alternative, that the architect of the Qadi Yahya dome suddenly reverted to a model over two centuries older, is less likely.

The qibla wall has three mihrabs, a scheme frequently found in late Fatimid mausoleums. Its reuse here shows that no sectarian meaning can be attributed to it. They are now decorated with inlaid marble in a scheme probably dating from the restorations of Qaitbay; the original Ayyubid decoration is unknown.

The main material of Ayyubid interest in the interior is the variety of woodwork (Figures 9.3–9.7). Of primary importance is

Figure 9.2 *Cairo. Mausoleum of Imam al-Shafi'i (608/1211). Detail of exterior*

the wooden cenotaph of Salah al-Din, dated to 574/1178–9, donated at the time of the founding of the adjacent madrasa. This uses cursive script for the first time in Cairo, in the pyramidal upper section (Figure 9.3), although Kufic is found on the more extensive

Figure 9.3 *Cairo. Mausoleum of Imam al-Shafiʿi (608/1211). Detail of cenotaph of Imam al-Shafiʿi (574 (1178–9)*

inscriptions on each of the lower rectangular sides (Figures 9.3–9.4). The carpenter, ʿUbaid, known as Ibn al-Maʿali, composed and crafted the cursive inscription that surrounds the top of the cenotaph, although it is otherwise inconspicuous, being barely one third of the height of the Quranic inscriptions below it. Well might he celebrate his virtuosity: this is one of the finest examples of medieval woodcarving to have survived. The geometric basis of the pattern is hexagonal, but with slightly different approaches on each of the upper, lower, wider and short panels. For the lower cube the long sides have five six-pointed stars each surrounded by a hexagon with one elongated side; on the narrow sides the single five-pointed star at the centre of the composition is surrounded by smaller regular hexagons.

The upper pyramid is more complex, with a twelve-sided star in the centre within which is an off-axis six-pointed star; the arms of the latter are decorated with a continuous pearl band. The arabesque decoration is where the skill of the carpenter can be most appreciated; at first apparently symmetrical, more careful examination reveals differences within every polygon (Figure 9.4). It is surprising that the motif of the grape still appears frequently, and even occasionally pairs of cornucopiae, motifs that had previous enjoyed a brief renaissance in late Fatimid woodcarving.[24]

Figure 9.4 *Cairo. Mausoleum of Imam al-Shafiʿi (608/1211). Detail of cenotaph of Imam al-Shafiʿi (574 (1178–9)*

The cenotaph of the mother of al-Kamil[25] shows further developments. The central star is again a twelve-sided one, but the pentagons that surround it are of unequal size as they are connected to the eight-pointed stars that flank it. The apparent intersection of star patterns was seen earlier on the portable mihrab of Sayyida Ruqayya, but there the pattern was simpler as all the stars were six-sided, framed by hexagons of equal size.[26] The carving has now also undergone development, the framing bands of the polygons displaying a continuous vegetal scroll in very light relief.[27] The carving within the polygons is even more delicate, with thinner stems and more background space visible. Only a fragment remains of what must have been a magnificent openwork Kufic inscription that ran around the four sides.[28]

The main entrance from the exterior seems to have been the one opposite the cenotaph of Imam al-Shafiʿi in the north wall. It has a ceiling of coffered octagons, the inner ones with eight-pointed stars enclosing a lobed rosette. This is at the beginning of a series in Cairo that stretches well into the fourteenth century.[29] The smaller entrance in the east wall has another decorated wooden ceiling; at its centre is an eight-pointed star from which radiate lobed rosettes (Figure 9.5).

Running all around the dome chamber, including even the entry and the mihrabs, is a band of arabesques (Figure 9.6). It was difficult

Figure 9.5 *Cairo. Mausoleum of Imam al-Shafi'i (608/1211). Ceiling of east doorway*

to appreciate the complexity of this design until its cleaning and repainting some years ago; like the stucco on which it may have been based, it is in deep relief. Another frieze (Figure 9.7), this time of Kufic, encircles the four walls of the dome chamber at the height of brackets that supported the lighting system, and even runs along the sides and front of the brackets. These brackets are therefore original, another early surviving example of a feature that was to become standard in large Mamluk dome chambers.

The funerary enclosure of Abu Mansur Isma'il (613/1216)

The portal and *iwan* in the cemetery, some way to the south of the mausoleum of Imam al-Shafi'i, known as the mausoleum of

Figure 9.6 *Cairo. Mausoleum of Imam al-Shafiʿi (608/1211). Arabesque frieze*

Figure 9.7 *Cairo. Mausoleum of Imam al-Shafiʿi (608/1211). Kufic frieze*

amir Abu Mansur Ismaʿil, is a structure whose function is controversial. It consists of a stone portal with a corridor behind, and an *iwan* (the earliest surviving in Cairo) 21 m away. The portal is of interest on account of its outstanding decoration (Figure 9.8), consisting of a frieze of square billets above a *naskh* inscription on a floral ground. The billets, the central two of which have *al-mulk li'llah* in a delicate Kufic, the others containing arabesque and geometric decoration,[30] are at first sight symmetrically arranged, but a closer inspection shows subtle changes between each pair. The Quranic inscription below is equally a masterpiece of carving, with letters of rounded profile upon an unusually crisp vegetal scroll that recalls the cenotaph of the mother of al-Kamil; such a detailed background was never again attempted in Cairene stone-carved epigraphy.

The inscription identifies the building as a mausoleum (*turba*), although now in its rightful place within the portal to the monument, had been earlier moved to the cenotaph within the *iwan*. Van Berchem had earlier noted that its measurements indicated

Figure 9.8 *Cairo. Funerary Enclosure of Abu Mansur Isma'il (613/1216). Detail of portal*

that it had originally been over the portal, an argument accepted by Creswell. But Creswell added: 'the fact that the slab has been *moved* deprives it of any evidence that the building in which it now rests [i.e. the *iwan*] was ever now connected with the portal.'[31] It must be admitted that the portal is some way from the *iwan*, is not quite in exact alignment with it, and has an internal doorway that led to the north as well as the south, making the reconstruction of a burial courtyard with an *iwan* problematical.[32]

Yet Creswell accepts that the style of the *iwan* is of the same period as the portal, and in fact himself surmises that portal and *iwan* were part of a complex that included a two-*iwan* madrasa with a domed mausoleum of the founder to the right of the portal.[33] But Abu Mansur Isma'il had already founded a madrasa within Cairo, the Shafi'i madrasa of al-Sharifiyya.[34] Even though a wealthy vazir (he was the supervisor of the hajj pilgrimage), there is no known instance of a non-royal Ayyubid patron building more than one madrasa in Cairo. And had the complex consisted of a madrasa and tomb, then, as is the case with all the known foundation inscriptions on complexes in Cairo that include both functions, a common doorway would most likely have mentioned the foundation of the madrasa only, it being the institution most likely to draw merit and least likely to raise objections.[35] Creswell notes that there is not a single instance in Egypt and Syria where an *iwan* is used as a mausoleum. While this is certainly a strong point, it ignores examples from a region not far beyond, Anatolia, where the *iwan* tomb is also a rarity, but where four thirteenth-century examples exist.[36] The earliest, at Seyidgazi, is ascribed to the mother of Ala' al-Din Kayqubad, and therefore possibly contemporary with the *iwan* of Abu Mansur Isma'il. Perhaps we should regard *iwan* tombs as an experiment that never really caught on, as seen by this and the few that are known from Anatolia and slightly later in Iran.[37] It is probably best to view this ensemble as a fashion that similarly failed to take hold, but which, as the foundation attests, should be seen as a funerary enclosure.

The citadel on Roda Island

Despite its destruction, we have sufficient information from the sources to understand the extravagance of this construction. Why was it needed? On purely military grounds it could hardly have rivalled the Qal'at al-Jabal (as the citadel of Salah al-Din was called). Several reasons have been suggested: al-Salih's mistrust of the troops stationed in the citadel and, the corollary, a need to feel safe in a base manned by his own mamluks;[38] a necessity to isolate these same mamluks from the resentment they stirred up in the army;[39] a desire for a defensive and palatial complex in a suburban setting near to water, and the yearning for a legacy as the founder of a new centre of administration.[40]

According to Maqrizi al-Salih was passionately addicted to polo playing,[41] and the huge space sequestered for the Roda citadel would certainly have allowed for this. It even had space for a game park,[42] another pastime eminently suitable for the outstanding horsemanship that being an avid polo player denotes.

Thanks to the drawing and description of the part of the palace in the *Description de l'Égypte* we have the plan of a *qāʿa* (reception hall) from the palace.[43] It consisted of two vaulted *iwan*s facing each other and a dome in the centre which, judging by its oblong base and flimsy supports of groups of three columns, must have been wooden (Figure 9.9). The vaulting of the *qāʿa* relates it to the only other vaulted example in Cairo, the Qaʿat al-Dardir, which may also be Ayyubid.[44] Some idea of the vanished splendour of the rooms of the citadel may be gained from the four enormous columns that form the main support within the mausoleum of Qala'un, which came from the Roda citadel.

As mentioned above, one reason for the affordability of al-Salih's constructions was the availability of Crusader prisoners to work on them.[45] A rare example of their involvement in the style of architecture on which they worked is seen in a doorway from the courtyard that lead to the *qāʿa* mentioned above; the slim engaged colonettes and capitals of the portal are thoroughly Gothic.[46]

The Salihiyya (641/1242–3) (Figures 9.10–9.12)

After Salah al-Din's coup, his troops and amirs were quartered within the old Fatimid palaces. Only seventy years later was this arrangement transformed, when a large portion of the Eastern palace was demolished to make way for al-Salih's madrasa (1242–3). This had an unusual plan (Figure 9.10), consisting of two parallel courtyards, each with two *iwan*s, each *iwan* being assigned to one of the four legal *madhhab*s. Earlier in 1225, not far away, al-Salih's father, al-Kamil, had constructed a madrasa for teaching hadith with a single two-*iwan* courtyard.[47]

Creswell used this madrasa as the starting point for an excursus on the origins of the cruciform plan of Cairene madrasas, insisting on their primacy. Yet, as Hillenbrand has pointed out, the earliest examples are Anatolian Seljuk ones of which Creswell was ignorant, and these in turn were quite possibly dependent on now lost Iranian or possible Syrian models.[48] We can similarly find in Anatolia a model for the plan of the Salihiyya: even if does not have a passageway between its two courtyards, the Çifte Madrasa at Kayseri (602/1205) is a close analogue.[49] But here too, it is possible that a now lost Iranian or Syrian example provided a model for both the Salihiyya and the Kayseri Çifte madrasas.[50]

The façade is the most impressive element of the remaining madrasa (Figures 9.10–9.12). Recent excavations within the

Figure 9.9 *Cairo. Roda Island, citadel, plan* (after Description de l'Égypte)

mausoleum of al-Salih have revealed that 11.25 m of the original
façade were destroyed to make room for the dome chamber, so that
the whole of the original façade would have had a length of just over
100 m.[51] This is indeed an impressive figure, and given that each
window (there were twelve to either side of the central bay) was

Figure 9.10 *Cairo. Salihiyya complex (641/1242–3; 1250). Reconstruction (after Hampikian)*

carefully carved in a style different from its neighbour, and that the whole formed a carefully graduated crescendo towards the central portal, this was certainly one of the most impressive façades of its time in the Islamic world. The minaret that topped the central portal was not at all necessary in the context of the madrasa, but was both an appropriate visual climax to the sweep of niches on either side and an attention grabber. No wonder the façade was aligned with the street rather than the qibla: the desirability of advertising one's patronage was not lost on al Salih's successors who, since they could not match his buildings in width, competed with it in height instead. Al-Salih's munificence was also advertised by the inscriptions with his name and titles both in the band above the portal and within the arched panel above it (Figure 9.10); the first readily visible Ayyubid foundation inscription of their remaining buildings in Cairo.

The tomb that Shajarat al-Durr built for her husband after his sudden death was not envisaged in the original layout, as has sometimes been thought; it occupies part of the space of the former living quarters of the Malikite shaikh of the madrasa. It juts out six metres into the street, another attention-grabbing technique that was used by Baibars, Qala'un and al-Ghawri in their complexes on other parts of the same street. Prominent on the exterior are several examples of the seal of Solomon, a motif also present in Ottoman Jerusalem.[52] The recent restorations uncovered the crypt, decorated with a fine painted plaster Quranic inscription running around its walls. Its interior has two notable features: a zone of transition that incorporates three tiers of muqarnas, instead of the two normal under the Fatimids; and a mihrab revetted with marble, common earlier in

Figure 9.11 *Cairo. Salihiyya complex (641/1242–3). Overall view*

Syria, but the earliest surviving example in Cairo.[53] Cairo also lagged behind Syria in complexes like this which combined a mausoleum with another religious institution,[54] but Shajarat al-Durr's model soon became the norm within Mamluk Cairo. The mausoleum also

Figure 9.12 *Cairo. Salihiyya complex (641/1242–3). Detail of entrance portal*

played a prominent role in Bahri Mamluk history, it being a vital part of the inauguration ceremonies of every sultan.

Shajarat al-Durr herself, possibly during the period of her regency, incorporated a mausoleum in her own complex near the mausoleum of Sayyida Ruqayya; it also included a madrasa, a palace, a bath and a garden. The madrasa seems to have had an *iwan* that faced outwards, possibly towards a garden, as in the case of the Firdaws madrasa at Aleppo.[55] Her mausoleum is notable for the hood of its mihrab, which is decorated with a mosaic *shajarat al-durr* (tree of pearls) (Figure 9.13).[56]

Conclusion

Ayyubid architecture in Cairo has elements both of rupture and continuity. The style and forms of decoration for the most part continued Fatimid models. This is seen for instance in the stylised scallop shell which was employed on the tombs of Imam al-Shafiʿi, al-Salih and Shajarat al-Durr, and the Salihiyya madrasa, and in the geometric interlace of the balustrade of Imam al-Shafiʿi, which follows those on the crowns of many Fatimid mihrabs. The same mausoleum also employs the triple mihrab that was commonplace in Fatimid examples. Although signed by a craftsman possibly of the same family as the Aleppan master of the minbar made for the al-Aqsa mosque, the carving and geometric design of the woodwork of the cenotaphs of Imam al-Shafiʿi and the mother of al-Kamil

Figure 9.13 *Cairo. Mausoleum of Shajarat al-Durr (1250). Detail of mihrab*

develop naturally out of the portable mihrabs of Sayyida Nafisa and
Sayyida Ruqayya.

The most obvious rupture is in the introduction of new building
types such as the citadel, the *khanqah*, the *ribat* and the *zawiya*,[57]
or in their great expansion, as was the case with the madrasa.[58]
The *iwan* appeared, probably for the first time in Egypt,[59] and became
an integral part of madrasas from this time onwards, its importance
underscored by the first four-*iwan* madrasa in which one *iwan* was
allotted to each of the four *madhhab*s, a feature that was to become
commonplace under the Mamluks.

The element of size was clearly of more importance to the Ayyubids than the Fatimids. The Shafi'ite *madhhab* to which they adhered did not permit building more than one Friday mosque in each town. The plethora of available mosques thus eliminated the option of building a new congregational one, so that the citadel, the tomb[60] and the madrasa became the beneficiaries of this new monumentality. The over 100 m length of the decorated façade of the Sahiliyya, for instance, was made even more striking by orienting it with the street pattern rather than the qibla, reinforcing a dichotomy that would be characteristic of all subsequent intra-mural Cairene monuments.

The Ayyubids made a decisive administrative break with the past and, with al-Salih's reliance on mamluks, brought about the means of their own overthrow that determined the history of the city for many centuries. Their citadel was an equally important force for change; by being the focus of administration, the military, and the ruler's residence, it initiated the urban settlement of the areas between and Cairo and Fustat and altered forever the future growth of the city.

Notes

1. For historical summaries of the period, see Chamberlain, 'Crusader Era', and Raymond, *Cairo*, Chapter 3. The portion of Maqrizi's *Kitāb al-Sulūk* relative to the Ayyubids has been conveniently translated by Broadhurst, *History*.
2. Broadbent, *History*, 264.
3. Leiser, 'The *Madrasa*', 41.
4. Ibid., 45–7.
5. Al-Khabushani, the director of Salah al-Din's madrasa at the tomb of Imam al-Shafi'i, had a salary of 40 dinars a month, about four times the normal: ibid., 42.
6. Chamberlain, 'Crusader Era', 232 and Leiser, 'The *Madrasa*', 42.
7. Rabbat, 'My Life', 280.
8. Broadbent, *History*, 46–7.
9. Bacharach, 'Administrative Complexes', 123–5; Rabbat, *Citadel*, 16–17.
10. Raymond, *Cairo*, 83.
11. *Muḥyī dawlat amīr al-mu'minīn*. Pace Rabbat, *Citadel*, 71, Salah al-Din had used this title earlier, in 576/1180–1, in an inscription relating to a gate and attached wall: Van Berchem, CIA, *le Caire*, 727. A foundation inscription of Salah al-Din dated to 573/1177–8 on the Bab al-Barqiyya also carries the title: Frédéric Imbert, 'Une nouvelle inscription de Saladin sur la muraille ayyûbide du Caire,' *Annales Islamologiques* 42 (2008), 409–21.
12. Slightly later Ayyubid inscriptions on citadels, such as that at the Lion Gate of the Aleppo citadel (al-Malik al-Zahir, 606/1209–10), were much larger and closer to the ground: see Allen, *Ayyubid Architecture*, <http://www.sonic.net/~tallen/palmtree/ayyarch/images/acit6.jpg> (last accessed 12 December 2008). Allen also noticed that the serpent

gate has traces of an effaced original inscription; presumably also of al-Malik al-Zahir: <http://www.sonic.net/~tallen/palmtree/ayyarch/images/acit14.jpg> (last accessed 12 December 2008).

13. The most celebrated Ayyubid structure within the citadel is probably Joseph's Well, an extremely impressive technical achievement. For the textual evidence for the internal Ayyubid structures, which included a Dar al-ʿAdl, see Rabbat, *Citadel*, 78–80, 85–6.

14. Ibn Jubair, trans. Broadhurst, 40.

15. Taylor, *Vicinity*, 42.

16. Various fragments from wooden cenotaphs now in the Islamic Museum of Cairo suggest that the interior might have had a much more cluttered appearance than it does now. See Weill, *Les bois*, 1–2, 32–40.

17. The most thorough account of the building is still Creswell, MAE, 2: 64–76.

18. In another major repair by ʿAli Bey al-Kabir in 1772 the outer lead sheeting and the inner shell were replaced: ibid., 73.

19. Ibid., 2: Pl. 23a.

20. The comparable decoration of the Wadayya gate is not stucco, pace ibid, 2: 75, but stone. For the most comprehensive readings of the epigraphy of the Wadayya gate at Rabat see now Ali, *Three Muwahhid Gates*. The closest Maghribi stucco decoration is that of the Almoravids at the Qairawiyyin mosque at Fez (Terrasse, *La mosquée*, Pls 42–3), work that was so ornate that it was considered offensive to the ascetic tastes of the new dynasty and which was covered up by them. The virtuoso talents of the stucco workers trained under the Almoravids must have been frustrated with the lack of opportunities to show what they were capable of; their descendants must have relished the opportunity to give free rein to their skill.

21. Creswell, MAE, 2: Pl. 23a.

22. Ibid., 2: 70.

23. Ibid., 2: Fig. 32.

24. Whether this suggests that the craftsman, probably a member of the Syrian family of carpenters responsible for the mihrab (1167–8) of the Maqam Ibrahim at Aleppo (Maʿali b. Salam) and the minbar (1168–9) for the Aqsa mosque had spent time in Egypt, or whether one should attribute the late Fatimid pieces to Syrian craftsmen, remains to be investigated.

25. Her name is not known, probably because she was of servile origin.

26. Weill, *Bois à épigraphes*, Pl. 16.

27. Although a late-Fatimid parallel can also be found for this in the portable mihrab of Sayyida Nafisa: ibid., Pl. 14.

28. Cf. that of a wooden lunette from the Sayyida Nafisa. that has also been attributed to the Ayyubid period: ibid., Pl. 26.

29. Creswell, MAE., 2: 68.

30. The arabesques are recessed, the geometric billets raised.

31. MAE, 2: 79.

32. This will remain so unless it ever becomes possible to reconstruct the plan through excavation.

33. Creswell, MAE., 2: 80.

34. Maqrizi, *Khitat*, 2: 373.

35. All the inscriptions in medieval Cairo that use *turba* are found on mausoleums, frequently within complexes; the one that appears on an entrance to a complex, the mosque and tomb of Ahmad al-Mihmandar

(dated 1325), begins: *amr bi-bina hadhi'l-turba wa'l-masjid al-mubarak*; i.e. mentioning both functions of the complex.

36. Aslanapa, *Turkish Art*, 146.
37. A fourteenth-century example is the *iwan* at Garladan, near Isfahan: see Wilber, *Architecture*, cat. no. 56; for fifteenth-century examples at Marv see Golombek and Wilber, *Timurid Architecture*, cat. no. 98.
38. Rabbat, *Citadel*, 86, although given al-Salih's iron grip on the reins of power one wonders whether he could not have achieved the same end by a re-organisation within the earlier citadel.
39. Ibid., 86.
40. MacKenzie, *Ayyubid Cairo*, 76.
41. Maqrizi, tr. Broadbent, *History*, 296. MacKenzie, *Ayyubid Cairo*, 76 notes in this context al-Salih's revitalisation of the Qaramaidan, and the polo grounds at Bab al-Luq.
42. 'Part of this area was enclosed by a fence, which preserved the sultan's wild game'; Ibn Sa'id, *apud* MacKenzie, *Ayyubid Cairo*, 74.
43. Creswell, MAE, 2: 86.
44. O'Kane, 'Domestic and Religious Architecture', 152–3. The document from this period show that the design of *qā'as* in this period was in a state of flux, with single-*majlis*, *majlis-iwan* and single-*iwan* *qā'as* occurring most often: Sayed, 'Development'.
45. See n. 1 above.
46. Creswell, MAE, 2: 87. The only other example in Cairo is in the curlicue window grilles of the Qala'un complex: ibid, 2: Pl. 66c.
47. Ibid., 2: 80–3. The monument is currently under restoration; preliminary soundings seem to indicate that the monument did have student cells on its northern side; an arrangement doubted by Creswell on account of a Mamluk amir's bath of 1261 that replaced a house.
48. Hillenbrand, *Islamic Architecture*, 183–6.
49. Aslanapa, *Turkish Art*, 130.
50. Golvin's theory that its unusual disposition could have been the result of a transformation of a *qa'a* of the Fatimid palace that existed on the site has been rebutted by the discovery of the remains of the Fatimid palace in recent rescue excavations beneath one of the courtyards: it can be seen that the palace was on the street, not the qibla orientation: O'Kane, 'Domestic and Religious Architecture',
51. Hampikian, *Complex*, 59–60, Fig. 49c.
52. Creswell, MAE, 2: Pl. 39a, c; for the Jerusalem examples see Hillenbrand, 'Structure', 21.
53. Ibn Jubair describes the interior of the Mashhad al-Husain as follows: 'There too are various kinds of marble tessellated with coloured mosaics of rare and exquisite workmanship such as one cannot imagine nor come near to describing. The entrance to this garden [mausoleum] is by a mosque like to it in grace and elegance, with walls that are all marble in the style we have just described': tr. Broadhurst, 37. Salah al-Din instituted a madrasa within this shrine (MacKenzie, *Ayyubid Cairo*, 112–13); the marble revetment may have been carried out at the same time.
54. Hillenbrand, *Islamic Architecture*, 190–1.
55. Behrens-Abouseif, 'Lost Minaret'.
56. One building that has not been discussed here is the mausoleum of the Abbasid caliphs (Creswell, MAE, 2: 88–94). Those reading this volume will be familiar with the concept of inhumation and re-interment,

since Jerusalem was so often a favoured destination for this practice. There is a possibility that the body of the caliph Abu Nadla (d. 1242) was moved there after his death. The mausoleum contains the ceno-taphs of two sons of the Mamluk sultan Baibars, and one can surmise that Baibars may have built it as a family mausoleum even if he was eventually buried in Damascus (a view first put forward in Ibrahim, 'Zāwiya, 82, n. 23). Baibars had a burial enclosure within the *qarāfa al-sughrā* (Behrens-Abouseif, 'Waqf', 57; I am grateful to the author for this reference), that is, in this vicinity, although its exact location had not been pinpointed – could this be it?

57. On the latter three categories see MacKenzie, *Ayyubid Cairo*, 140–2.
58. The two hospitals at Cairo and Fustat of Salah al-Din should also be mentioned here; they were extravagantly praised by Ibn Jubair, tr. Broadhurst, 33–4. They were not strictly a new institution, since Ibn Tulun has built one earlier at Fustat, but his of course had long been moribund.
59. A building known as the *iwan* was a major component of the Fatimid palace, but it is not known whether it was in the shape of the hall known to art historians, or whether it was a synonym for a palace: Grabar, 'Īwān'.
60. Two thirteenth-century pilgrimage guides, which only exceptionally point out monuments to pilgrims, note that the mausoleum of Yahya al-Shabihi was considered large (Rāġib, 'les sanctuaires', n. 93); how much more imposing must the tomb of Imam al-Shafi'i then have been to all visitors, being visible from far off in every direction.

Bibliography

Ali, Rasha (2001), *Three Muwahhid City Gates in Morocco.* Unpublished MA thesis, The American University in Cairo.
Allen, Terry *Ayyubid Architecture*, http://www.sonic.net/~tallen/palmtree/ayyarch/index.htm
Aslanapa, O. (1971), *Turkish Art and Architecture*. London.
Bacharach, J. L. (1991), 'Administrative Complexes, Palaces, and Citadel', in I. A. Bierman, R. A. Abou-El-Haj, D. Preziosi (ed.), *The Ottoman City and Its Parts: Urban Structure and Social Order*, New Rochelle, NY, pp. 111–28.
Behrens-Abouseif, D. (1983), 'The Lost Minaret of Shajarat ad-Durr at Her Complex in the Cemetery of Sayyida Nafīsa', *Mitteilungen des Deutschen Archäologishen Instituts, Abteilung Kairo* 39: 1–16.
Behrens-Abouseif, D. (2000), 'Waqf as Remuneration and the Family Affairs of al-Nasir Muhammad and Baktimur al-Saqi', in D. Behrens-Abouseif (ed.), *The Cairo Heritage: Studies in Honor of Laila Ali Ibrahim*, Cairo, pp. 55–67.
Broadhurst, R. J. C.: see Maqrizi and Ibn Jubair.
Chamberlain, M. (1998), 'The Crusader Era and the Ayyūbid Dynasty', in C. F. Petry, *The Cambridge History of Egypt*. Vol. 1: *Islamic Egypt, 640–1517*, Cambridge, pp. 211–41.
Creswell, K. A. C. (1952–9), *The Muslim Architecture of Egypt*, 2 vols. Oxford (MAE).
Golombek, L. and D. Wilber (1988), *The Timurid Architecture of Iran and Turan*, 2 vols. Princeton.
Grabar, O., 'Īwān', *Encyclopaedia of Islam*, 2nd edn, 4: 287.

Hampikian, N. and M. Cyran (1999), 'Recent Discoveries Concerning the Fatimid Palaces Uncovered during the Conservation Works on Parts of the al-Salihiyya Complex', in M. Barrucand (ed.), *L'Égypte fatimide: son art et son histoire*, Paris, pp. 649–57.

Hampikian, N. H. K. (1997), *Complex of al-Salihiyya: Transformations through Time and a Proposal for the Future*. Unpublished Ph.D. dissertation, University of California, Los Angeles.

Hillenbrand, R. (1994), *Islamic Architecture: Form, Function and Meaning*. Edinburgh.

Hillenbrand, R. (2000), 'Structure, Style and Context in the Monuments of Ottoman Jerusalem', in R. Hillenbrand and S. Auld (eds), *Ottoman Jerusalem: The Living City: 1517–1917*, London, 1: 1–23.

Ibn Jubair (1952), trans. R. J. C. Broadhurst as *The Travels of Ibn Jubayr*. London.

Ibrahim, L. 'A. (1978), 'The Zāwiya of 'Zain ad-Dīn Yūsuf in Cairo', *Mitteilungen des Deutschen Archäologishen Institut, Abteilung Kairo* 34: 79–110.

Leiser, G. (1985), 'The *Madrasa* and the Islamization of the Middle East: The Case of Egypt', *Journal of the American Research Center in Egypt* 22: 29–47.

MacKenzie, N. D. (1992), *Ayyubid Cairo: A Topographical Study*. Cairo.

Maqrīzī, Taqī al-Dīn (trans. R. J. C. Broadhurst) (1980), *A History of the Ayyūbid Sultans of Egypt*. Boston.

Maqrīzī, Taqī al-Dīn (1270/1853–4), *Kitāb al-mawā'iz wa'l-i'tibar fī dhikr al-khiṭaṭ wa'l-āthār*, 2 vols. Bulaq.

O'Kane, B. (2000), 'Domestic and Religious Architecture in Cairo: Mutual Influences', in D. Behrens-Abouseif (ed.), *The Cairo Heritage: Studies in Honor of Laila Ali Ibrahim*, Cairo, pp. 149–82.

Rabbat, N. (1997), 'My Life with Salāḥ al-Dīn: The Memoirs of 'Imād al-Dīn al-Kātib al-Iṣfahānī', *Edebiyât* 7: 267–87.

Rabbat, N. (1995), *The Citadel of Cairo. A New Interpretation of Royal Mamluk Architecture*. Leiden.

Raymond, A. (2001), *Cairo: City of History*. Cairo.

Raġib, Y. (1977), 'Les sanctuaires des gens de la famille dans la Cité des Morts au Caire', *Rivista degli Studi Orientali* 50: 47–76.

Sayed, H. (1987), 'The Development of the Cairene Qā'a: Some Considerations', *Annales Islamologiques* 23: 31–53.

Taylor, C. S. (1999), *In the Vicinity of the Righteous: Ziyāra and the Veneration of Muslim Saints in Late Medieval Egypt*. Leiden.

Terrasse, H. (1968), *La mosquée al-Qaraouiyin à Fès*. Paris.

Weill, J. D. (1931), *Catalogue général du Musée Arabe du Caire. Les bois à épigraphiques jusqu'à l'époque mamlouke*. Cairo.

Wiet, G. (1933), 'Les inscriptions du mausolée de Shāfi'ī', *Bulletin de l'Institut d'Égypte* 5/2: 167–85.

Wilber, D. (1955), *The Architecture of Islamic Iran: The Il Khānid Period*. Princeton.

CHAPTER 10

The Nine-bay Plan in Islamic Architecture: Its Origin, Development and Meaning

'As so often when one type of building is said to "change" or be "converted" into another, the statement means no more than that the metamorphosis can be effected on paper.'[1]

The warning above is particularly apt in the case of this piece, which concerns itself with tracing connections and continuities in a particular ground plan, the square or slightly rectangular room with four piers or columns, over millennia. To take the example of two buildings even closely related in time and place, al-Ashraf Barsbay (1432) and Mahmud Pasha (1567) are small Cairene mosques with this type of nine-bay plan (Figures 10.1, 10.2), sharing even a corridor through their central space, yet their elevation (Figures 10.3, 10.4)[2]

Figure 10.1 *Cairo, al-Ashraf Barsbay complex, mosque/madrasa, 1435, plan (after Fernandes)*

Bernard O'Kane (2006), 'The Nine-Bay Plan in Islamic Architecture: Its Origin, Development and Meaning', in Abbas Daneshvari (ed.), *Studies in Honor of Arthur Upham Pope*, Survey of Persian Art Vol. XVIII, Costa Mesa, 189–244.

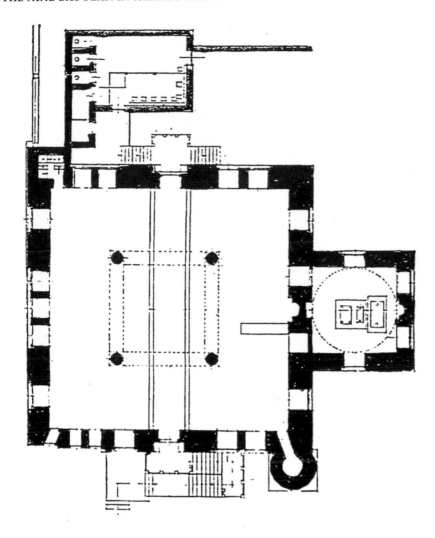

Figure 10.2 *Cairo, Mahmud Pasha mosque, 1567, plan (after El Rashidi)*

shows that they have radically different concepts of space. For several early buildings in the series the evidence of excavations reveals only the similarities in plan and nothing of the system of roofing where these differences might emerge. This needs to be kept in mind, although I should admit from the outset that the discontinuities between apparently similar plans are as much a part of my conclusions as the continuities.

With the discovery of the Hajji Piyada mosque at Balkh in the 1960s came the realisation that the nine-bay plan was widely distributed in the later 'Abbasid period, with examples occurring, for example, in Toledo, Qayrawan, Susa, Cairo, Aswan and Transoxiana

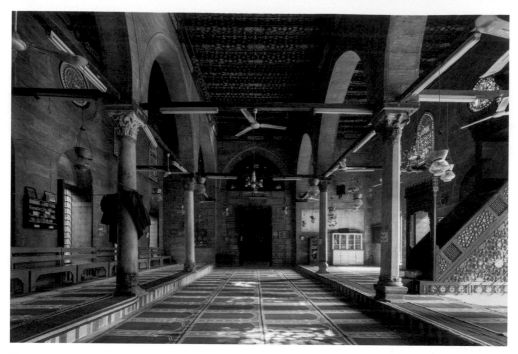

Figure 10.3 *Cairo, al-Ashraf Barsbay complex, mosque/madrasa (1435), interior*

(see Table 1 below). The first discussions of its diffusion occurred in connection with the publications of this mosque, and were primarily concerned with establishing typological relationships between similar examples.[3] Two more recent studies have argued for particular meanings for the nine-bay plan. Terry Allen has suggested that it was a new architectural type which was created by reproducing the most essential part of a congregational mosque plan, the bays in front of the mihrab (as in the Great Mosque in Wasit, Iraq). This space, the core of the mosque, it is argued, is that which marked off the space in which official ceremonial took place, and this ceremonial function was linked with the form of the nine-bay plan.[4] Another article, by Geoffrey King, has stressed the common descent of the type from the bath hall of Khirbat al-Mafjar, invoking it as an example of an honorific building type and suggesting that this honorific connection was passed on to the nine-bay type.[5] Writing ten years ago, it was still possible to say that 'the exact origin of the nine-domed form unfortunately remains a mystery'.[6]

In this piece I will suggest that the explanation for its popularity is simpler. I propose that the form is much more widespread than has been previously thought, and that, rather than being an ʿAbbasid invention, it should be seen as a variation on Umayyad and pre-Islamic plans. I submit that the extraordinary geographical and temporal diversity within which the nine-bay plan is found (which

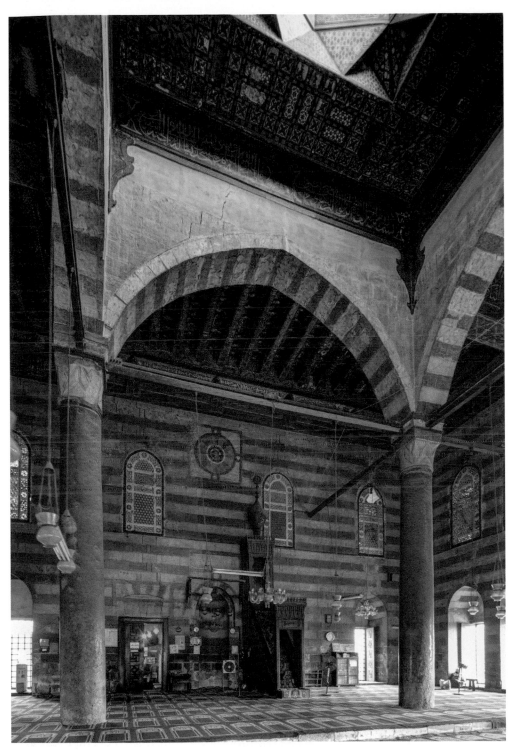

Figure 10.4 *Cairo, Mahmud Pasha mosque (1567), interior*

by no means stopped in the medieval period) is caused not so much because of a necessary interrelationship between all of the examples, but because the plan's inherent practicality, economy and aesthetic appeal (especially in terms of symmetry) is such that builders must have been intuitively drawn to it.

Neighbourhood mosques

I will begin by considering a separate but related topic. Almost all nine-bay mosques are neighbourhood as opposed to congregational ones. As already noted by Terry Allen, much of the early evidence for the nine-bay plan comes from the Darb Zubayda, the caravan route from Kufa to Mecca whose monuments are thought to have been built by Zubayda, the wife of Harun al-Rashid, in the late eighth century. They provide us with an unrivalled corpus of twenty-five more or less complete neighbourhood mosques (Figures 10.5–10.7).[7] Although the origins and development of the congregational mosque (*jami'*) in the Islamic world have been the subject of continuous study, very little attention has been devoted to early neighbourhood mosques (*masjid*s). There are good reasons for this, chief among them being survival, prestige and artistic value. However, with the increase of Islamic archaeology in recent decades, sufficient material has become available to analyse typologies and formulate hypotheses regarding the development of smaller mosques and the role that nine-bay plans played in their development.[8] In addition to the Darb Zubayda examples the slightly later group of six neighbourhood mosques from Samarra has also never been considered in its entirety,[9] and to them we can add the corpus of eighteen neighbourhood mosques dating from the ninth to the twelfth centuries excavated at Siraf.[10]

'Abbasid neighbourhood mosques

The simplest mosque plan, as one would expect, is an undivided room. Along the Darb Zubayda this occurs in one case as a single component of a larger building (Figure 10.5.11), or, in several instances, as an isolated rectangular structure (Figure 10.5.1–2 [in both of these the wall opposite the qibla has not been preserved], Figures 10.5.3–4), usually with three entrances on the side opposite the qibla (Figures 10.5.5–7). At Samarra this plan is found in the smaller of the two mosques at the Balkuwara palace, in the eastern courtyard.[11] The mosque at site F at Siraf had two entrances leading into a square room, while that at site P2, period 1, was rectangular with, exceptionally, the mihrab on the narrow side.

In other cases courtyards have also been preserved, at least in part, in front of a single room (Figures 10.5.8–10), and in two examples the piers of the wall opposite the qibla show that the three entrances corresponded to a division of the interior into three bays perpendicular

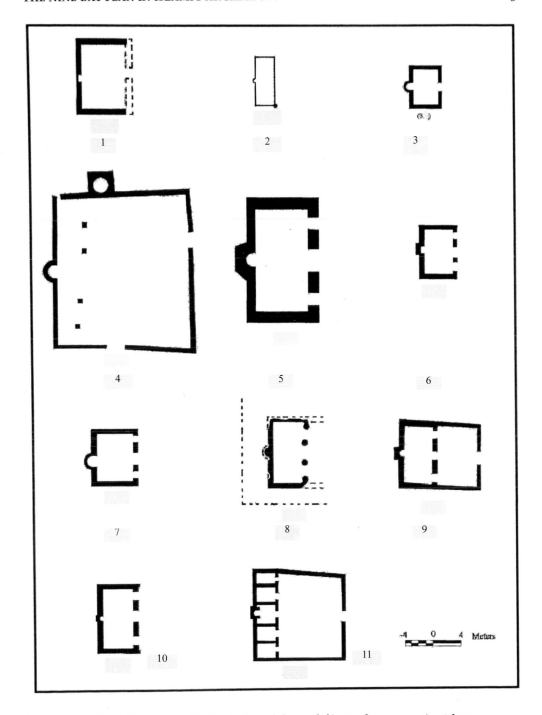

Figure 10.5 *Darb Zubayda, Table of plans (after* Atlal*): single rooms: a) without courtyard 1 al-Bida', 2 Fayd (near Qasr Khrash), 3 Shamat Kibd, 4 Zubala 1, 5 al-Makhruqa, 6 al-Humayma South, 7 Hurayd; b) with courtyard 8 al-Kharaba, 9 al-Humayma North, 10 Abu Rawadif; c) single room in larger building 11, al-'Amya'*

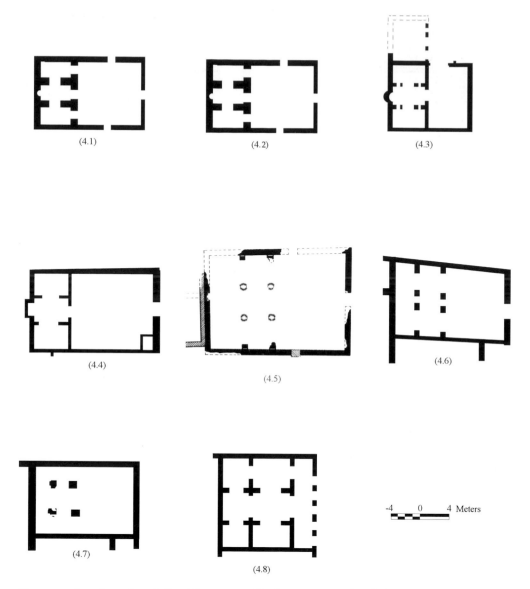

Figure 10.6 *1 three-bay (all with courtyard) al-Saqiyya; 2 al-Jaffaliyya B; 3 al-'Ara'ish South; 4 al-Qa', six-bay, two-aisle; 5 al-Dariba; 6 al-'Ara'ish Middle; 7 al-Thulayma; 8 al-Zafiri*

to the qibla (Figures 10.6.1–2). The four mosques within the Dar al-Khilafa at Samarra all seem to have been single rooms with triple entrances preceded by a courtyard; the tripartite entrance is clearly preserved in one example, and partially preserved in another.[12] At Siraf a courtyard is present definitely in only one example and the

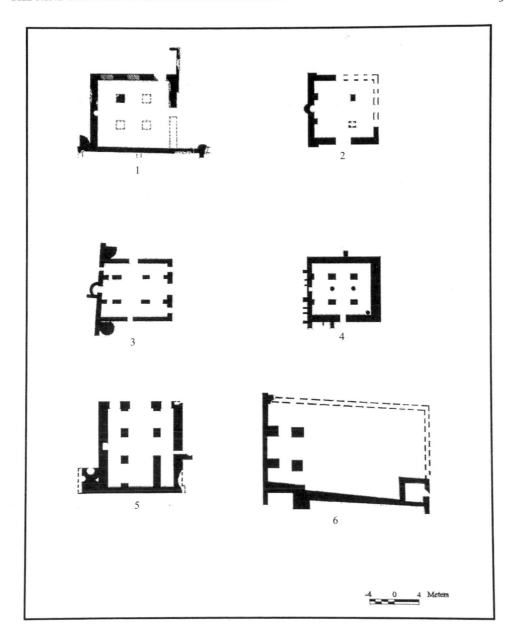

Figure 10.7 *1 nine-bay, piers remaining or excavated (at least in part) Umm al-Damiran; 2 Sinaf al-Lahm; 3 Kura*; 4 al-Rabadha; 5 al-'Aqiq; 6 al-Qa'*

number of entrances (from one to three) and the interior division of space (arcades parallel to the qibla with one, two or four columns) is more variable.[13]

Two other mosques of the Darb Zubayda show the tripartite interior division, but with only one entrance from the courtyard

(Figures 10.6.3–4).[14] What could be considered a natural expansion of this plan appears in the mosque at al-Dariba (Figure 10.6.5): a courtyard preceding a prayer hall of six bays, with an arcade of three arches on the courtyard façade and another within the prayer hall, both springing from engaged columns on the side.[15] This plan is also found as major element in three complexes which, while smaller than the usual *qasr* on the route, were the largest buildings of their site (Figure 10.6.6–8). In one of the three (Figure 10.6.8) the room enclosing the four piers is square rather than rectangular, which at first suggests that it might have been a nine-bay mosque without a courtyard. However, the T-shaped piers which are furthest from the qibla suggest that a façade was present at this point, fronted by a diminutive courtyard[16]

It is the nine-bay plan which seems to have been most common for the largest mosques on the route, those built on to the *qasr*s. In five of the *qasr*s the nine-bay plan is well or fairly well preserved, although in none of them to the extent that the elevation can be

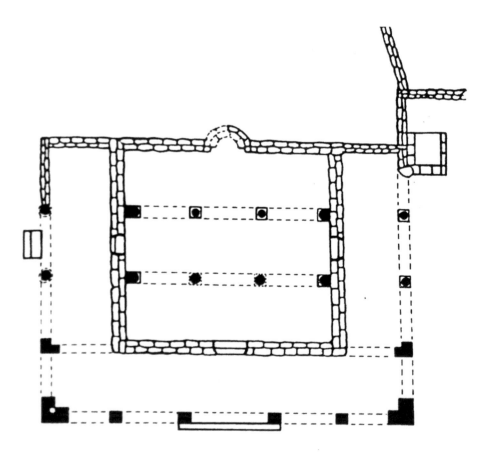

Figure 10.8 *Qusayr al-Hallabat (after Bisheh)*

deduced.[17] Two of them are roughly square (Figures 10.7.1–2), while four are distinctly basilical (Figures 10.7.3–6), two of which (Figures 10.7.3, 10.7.5) have with engaged piers to either side of the four central ones emphasising the division into a wider nave and two aisles.[18] At al-ʿAqiq (Figure 10.7.5) the basilical derivation is the more obvious in that it is misaligned, the qibla being at right angles to the basilical orientation. The single nine-bay plan at Siraf[19] also has arcades parallel to the qibla, but with arcades of equal width. In six other cases along the Darb Zubayda not much more than the outlines of the corresponding room could be traced, with or without

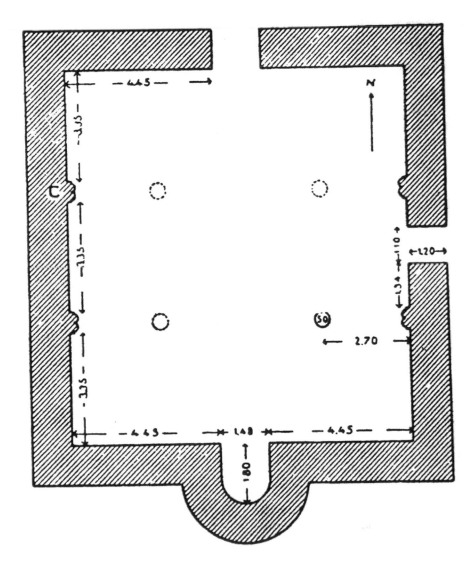

Figure 10.9 *Khan al-Zabib (after Brünnow and von Domaszewski)*

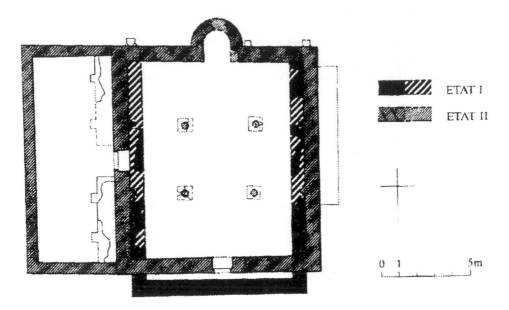

ETAT I

ETAT II

0 1 5m

Figure 10.10 *Umm al-Walid II (after Bujard and Trillen)*

a mihrab (al-Wausayt West, al-Wausayt East, al-Makhruqa, Maʾdan Bani Sulaym, Barud, al-Saqʿa, al-ʿAshar). At al-ʿAshar, and possibly at Umm al-Damiran, the mosque may have been preceded by a narrow court or narthex.[20]

Surprisingly, only one variant of the 'standard' hypostyle, with the qibla on the widest side of the building, was found along the Darb Zubayda. The western congregational mosque at al-Rabadha, one of the largest settlements along the route, has a prayer hall divided into two aisles by six columns parallel to the qibla, preceded by a courtyard with an arcade on each side. Finally, the larger of the two mosques at the Balkuwara palace at Samarra is an interesting hybrid consisting of a hypostyle prayer hall with two rows of eight columns, but, like many of the smallest mosques in our corpus, lacking a courtyard and with only three entrances on the side opposite the qibla.

It can be seen that the most important of the Darb Zubayda mosques, those attached to the *qasr*s, seem to have had prayer halls with nine bays. Should one see them as building on the smaller three-bay or six-bay examples, or should the latter be seen as reductions of the larger plan?

Before attempting to answer this it would be prudent to bring into the discussion the Umayyad precedents.

Umayyad neighbourhood mosques

What light does the smaller corpus of Umayyad *masjid*s throw on the ʿAbbasid examples? We have no record of what the mosques of the early Muslim armies must have looked like, but as an alternative to prayers in the open air, the use of low stone courses as a directional marker is a likely early development. Not far removed from this are the hypaethral mosque plans at Wadi Jilat, a camp site where there are the remains of two stone walls with a mihrab between, or at al-Risha, a rectangle with three entrances and again a mihrab, where shade over the lows walls may have been provided by means of tenting when the site was in use.[21] The incorporation of a niche mihrab in these two examples is no barrier to a date even before the reign of al-Walid (the usually assumed period of its introduction), as Noha Khoury has shown recently.[22] The plan of Umm al-Walid I cannot be completely verified, although the excavators assume that its rectangular walls may also have served as the basis for erecting tenting on one side.[23]

The mosques at Qastal (reign of ʿAbd al-Malik, 685–705) and Qasr Muqatil (late Umayyad or early ʿAbbasid, c. 762) are also rectangular, but the latter is similar to many of the Darb Zubayda examples in that it incorporates a courtyard which has a triple entrance leading into the covered area.[24] The Jabal Says mosque (c. 700–10) is a roofed square room,[25] but has a surprising feature: a single central column, which formed an arcade with two engaged columns on the side wall. This is logical from a structural point of view, but it has a severe drawback in that it obscures the view of the mihrab from the entrance opposite it.

The importance of an unrestricted view of the mihrab may be seen in the plans of three other Umayyad *masjid*s, as Qusayr al-Hallabat, Khan al-Zabib and Umm al-Walid II (Figures 10.8–10.10).[26] All of these are nine-bay plans, where in addition to the four piers in the centre of the square space, there are engaged piers or columns on the side walls linking the arcades to form a division into three aisles, recalling basilicas.[27]

This basilical form, is, we may recall, also present in several of the Darb Zubayda nine-bay examples, making it less likely that they should be seen as a further agglomeration of the smaller three- or six-bay mosques.

In fact, the compartmentalised plans of some of the three-bay examples (Figures 10.6.2–4) would indicate that they are mere enlargements of the single room which was the simplest plan used.

Pre-Islamic nine-bay plans

The hall with four columns occurs as early as the beginnings of trabeate architecture. It is found in the second millennium BCE

in a number of sites: at Lachish, near Jerusalem, in the fourteenth century, where it appears as the enlarged cella of a temple[28] and in the twelfth-to-eleventh-century megaron at Tiryns,[29] an example of a pre-Hellenic dwelling unit. As to be expected, it appeared in civilisations which used the hypostyle hall for some of their grandest architectural expressions. The temples of Ramsis II at Thebes and Ramsis III at Medinet Habu (thirteenth to twelfth century BCE) have various combinations of pillared halls in which rooms with four piers figure frequently.[30] These temples could also be seen, as least partially, as examples of domestic architecture writ large, and indeed four-columned rooms also occur frequently in Pharaonic domestic architecture, for example at Thebes, Kahun and Amarna.[31]

The Achaemenid architecture of Susa and Persepolis is most famed for its multi-pillared apadanas, but the four columned room occurs there not only in the complex of small rooms of the harem at Persepolis[32] but also in other important contexts: in two buildings probably connected with religious use (Figures 10.11.1, 10.11.3)[33] and in the major gateways of each site.[34] That of Persepolis, the Gate of All Lands, possibly also served as a royal audience hall.[35]

The temple at Kuh-i Khvaja (Figure 10.11.2) is now most often thought to be another Achaemenid example of this plan, while a near contemporary may be the temple of the Oxus at Takht-i Sangin, most recently dated from the fourth to the third century BCE (Figure 10.11.4).[36] Another nearby Hellenistic example from northern Afghanistan is that of Dilberjin (first century CE).[37]

A Parthian religious example is the cella of the second-century CE temple at Bard-i Naishanda, Khuzistan,[38] while evidence of its popularity in neighbouring territories comes from Georgia in the Dedopolis Mindori temple of the second to first century BCE (Figure 10.11.5)[39] and at the Kushan site of Surkh Kotal in Afghanistan (c. 50–150 CE).[40] Parthian architects also employed the plan in a variety of other contexts. At Nysa (second century BCE) four quatrefoil columns were used to support the roof of an immense palatial hall some 20 m square.[41] The later palaces of Nippur and Assur (Figure 10.12) contained rooms which were slightly rectangular but which also had four columns dividing them into nearly equal spaces.[42] In the case of the latter we notice an important change: the roofing, instead of the formerly usual flat roof of wooden beams, was of barrel vaults which divided the interior space into three aisles, a conception which appears in many later Islamic examples.

Contemporary with the Parthian period are the Nabatean temples of the Hauran, four of which have identical plans of the nine-bay hall surrounded, like many of the above temples, by an ambulatory (Figure 10.13).[43] This layout, as we shall see, is reinterpreted in various ways in the Islamic period.

The typical Sasanian fire temple is smaller than Achaemenid examples and none has a four-columned interior, but the latter form

Figure 10.11 *(not to scale), Pre-Islamic nine-bay temples (after Shkoda): 1 Persepolis, temple, 2 Kuh-i Khvaja, 3 Susa, 4 Temple of the Oxus, 5 Dedopolis Mindori, 6 Panjikent*

Figure 10.12 *Assur, palace (first century CE) (after Reuther)*

survived in Sogdian religious architecture in the temples of Panjikent (fifth century CE).[44] A recently excavated Sasanian complex (datable to 440 CE) near Darragaz, north of Mashhad near the border with Turkmenistan, has a four-columned hall that served as an antechamber to a fire temple (Figure 10.13A).[45] Narshakhi informs us that the Friday Mosque of Bukhara was built on the site of its fire temple, as was one of Bukhara's suburban mosques, that of Makh.[46] Given the tendency of the early Islamic settlers at first simply to convert existing buildings to places of worship rather than to destroy and rebuild them,[47] the nine-bay form may have lived on as a core element of the

Figure 10.13 *Seeia (Siʿ), Baʿalshamin and Dushara temples (late first century* BCE*) (after Ward-Perkins)*

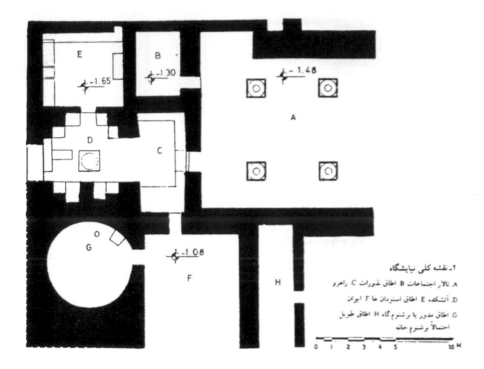

Figure 10.13A *Bundian, Darragaz, Sasanian complex (440 CE) (after Rahbar)*

mosque in several important early settlements. Direct evidence for this comes from the Sasanian caravansaray at Dayr-i Gachin south of Rayy (Figure 10.14).[48] This has a nine-dome mosque with signs of three building periods, Sasanian, Saljuq and Safavid. The evidence suggests that a Sasanian dome with surrounding ambulatory (e.g. a fire temple) was converted into the nine-bay mosque, a telling example of this conversion in the heartland of Iran. It must have been seen by numerous travellers, but this is less important to the possibility of its dissemination than that a similar transformation occurred at many other Iranian and Central Asian sites.

A variety of nine-bay plans was also incorporated in domestic architecture of Sogdia. These range from both smaller and larger residences with four-columned reception rooms (sixth to eighth century) at Panjikent (Figure 10.15.1), Shahristan and Jumalak Tepe[49] to the main hall of the Buddhist monastery at Ajina Tepe (seventh to eighth century CE).[50]

As the roots of the nine-bay plan are found in trabeate architecture, it is to be expected that later versions would treat the roofing as a template upon which to experiment. The barrel vaults of the four-columned hall of the palace at Assur above are the earliest example of this, while two Central Asian fortified buildings, one at Chil Hujra

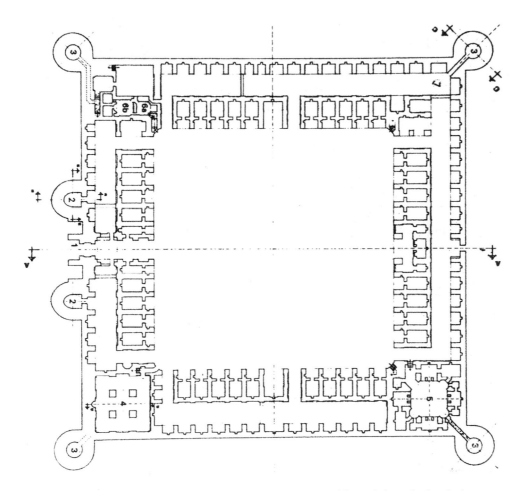

Figure 10.14 *Dayr-i Gachin, caravansaray, Sasanian and later (after Shokoohy)*

(seventh to eighth century?) (Figure 10.15.2) near Shahristan,[51] the other at Aultepe (sixth to seventh century) (Figure 10.15.3) in the Kashkadarya,[52] indicate further experimentation. The large audience hall at Chil Hujra has been reconstructed as having cross-vaults with a hexagonal dome over the central bay, while at Aultepe the central unit of the upper floor of the palace had a central dome larger than the four domed corner bays, leaving four rectangular spaces.

The quincunx

This important development, the vaulting (by domes, barrel or cross-vaults) of the central and outer four bays, became routine in Christian architecture from the ninth century on, frequently accompanied by an emphasis on the domed central bay of the nine-bay plan. This emphasis can take the form of an enlargement of the central bay,

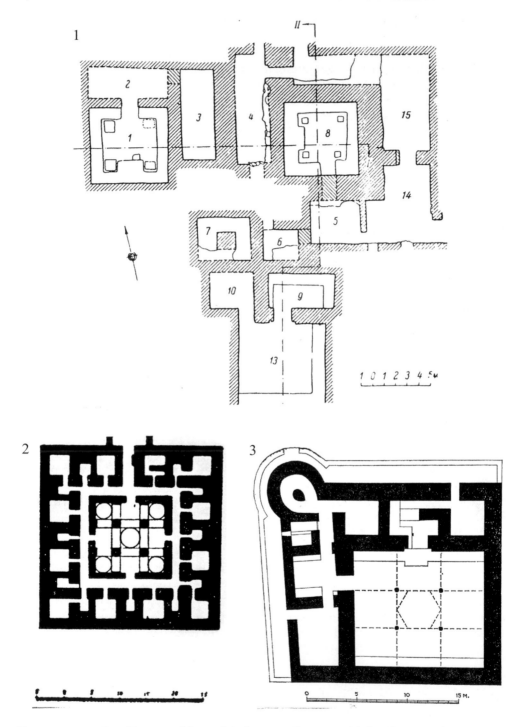

Figure 10.15 *1 Panjikent, residence (sixth–seventh century) (after Voronina), 2 Chil Hujra, fortified residence (after Chmelnizkij), 3 Aultepe, fortified residence (after Chmelnizkij)*

producing the so-called quincunx or cross in square plan, one of the most popular in middle Byzantine architecture. The origins of the quincunx are still debated: it could have been produced by surrounding a dome with a slightly larger enclosure, or by increasing the size of the central bay of a nine-bay plan. An early version of the plan is in a Nabatean building, the so-called Praetorium at Mismiya (160–9 CE), which had a large cloister vault in the central bay, supported on slender columns which provided minimum interruption of the interior space, suggesting a derivation from an apadana type of building (Figure 10.16).[53] A dome in a central bay of the same diameter as the surrounding eight is to be seen in the fifth century cathedral of Echmiadzin, although in elevation, with a tall drum, it clearly dominates the composition.[54] More typical of later Byzantine plans is the church of St Gaiane at Echmiadzin (630) (Figure 10.17) which has an enlarged central bay and an apse with two flanking rooms, thus forming an overall rectangular plan. A western narthex, a feature found in many medieval examples, was added to this church in the seventeenth century.[55] In the west the Romanesque Oratory of St Germigny-des-Près (806) has a central dome only slightly larger than the other bays, but with an elevation similar to the quincunx examples.[56]

Another approximation of the quincunx plan can be arrived at in a different fashion: by decreasing the size of a dome surrounded by an ambulatory. This is the form of the Sasanian *chahartaq*, and when the four piers are reduced in size and the corners of the ambulatory domed, as in the late Sasanian or early Islamic near Fasa in Fars[57] a connection between the two plans seems clear. However, this may be, as in our opening quotation, a case where the resemblances are more on paper than in fact: the concept of two distinct spaces, central dome and surrounding ambulatory, would have made it difficult to make the mental leap of designing it to be one room.

In addition to the Praetorium at Mismiya mentioned above, we find another two early variations of the quincunx in Syria. The first, the so-called audience hall of al-Mundhir at Rusafa (569–82) is now thought more likely to have been a church dating from c. 575; here, unlike Mismiya, heavy L-shaped piers are used for the supports of the central bay, suggesting that the dome was the starting point for the plan.[58] The other is the first Islamic example of this type, the bath at Khirbat al-Mafjar (before 743), where it is surrounded by an ambulatory with apsidal recesses.[59]

Early Islamic nine-bay plans

However, it is arguable that the first intimations of an Islamic interest in the nine-bay plan may have come, as Allen has remarked, with the heavier foundations for the bays in front of the mihrab of the Great Mosque at Wasit (c. 86/705).[60] Although the exact number

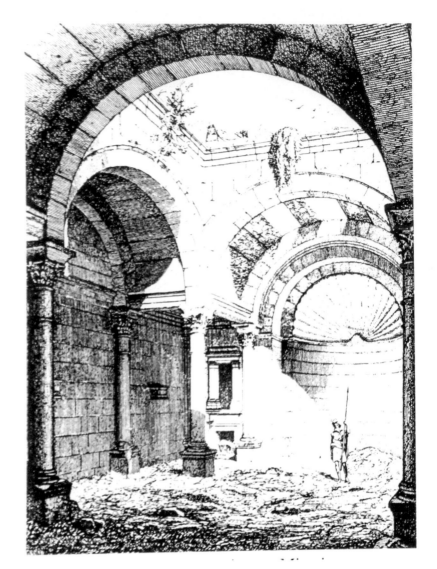

Figure 10.16 *Praetorium at Mismiya (AD 160–9) (after De Vogüé)*

of bays with heavier foundations was unfortunately not confirmed by the limited excavation soundings, it suggests that nine (or more) ante-mihrab bays had a special architectural emphasis, which may well have been related to the *maqsura* which the mosque was known to have.[61]

Other Umayyad appearances of nine-bay plans appear to have different antecedents. Four of these are the bath at Anjar[62] and the three neighbourhood mosques mentioned earlier (Qusayr al-Hallabat, Khan al-Zabib and Umm al-Walid) (Figures 10.9–10.11).[63] In each

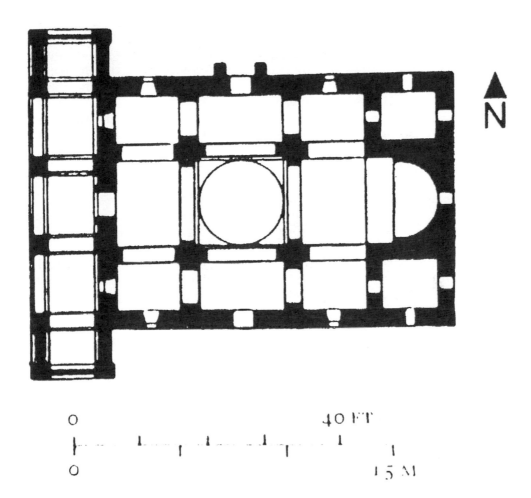

Figure 10.17 *Echmiadzin, St Gayane church (630) (after Krautheimer)*

case, in addition to the four piers in the centre of the square space, there are engaged piers or columns on the side walls linking the arcades to form a division into three aisles recalling basilical plans.[64] The origin of the nine-bay plan at Anjar is underlined by the similar bath at Qasr al-Hayr East, where the corresponding main undressing area is indeed a basilica.[65] The fifth Umayyad example, the great hall of the Dar al-'Imara at Kufa (c. 665) is likewise basilical in plan, but may also reflect different antecedents.[66] The hall looks on to a courtyard, and is divided into a central nave and two aisles by six columns, two of which are on the edge of the courtyard, while there are two further engaged columns at the rear. The use of columns in this way underlines its similarities with Sasanian audience halls,[67] but it differs from them in the spacing of the columns to produce

a nave only slightly wider than the flanking aisles, suggesting the influence of more conventional basilicas.

Even with regard to this small number of Umayyad nine-bay plans it is clear that a variety of sources seems to have been adapted by their designers: the quincunx in the case of Khirbat al-Mafjar, the hypostyle at Wasit, and the basilica for the others, partially modified by Sasanian practice at Kufa.

We have seen above that the earliest ʿAbbasid period witnesses the proliferation of the nine-bay plan in the mosques of the Darb Zubayda. It will be recalled that the nine-bay mosques are mostly found near the main entry of the qasrs which were located at regular intervals along the route. It has been argued by Terry Allen that these qasrs were built for the accommodation of the court, and that the nine-bay plan employed in them, as at the Wasit Friday mosque, represents the minimum architectural form required for official ceremonial (i.e. formally led prayer and religious oration).[68]

However, the extent to which the mosques attached to the qasrs should be considered a setting for 'official' ceremonial is a matter for debate. Whether the qasrs should be seen as the lodges for members of the court, or rather as caravansarays for a larger public remains open.[69] Even if the qasrs were built by Zubayda for members of court, visits by them would surely not have been all that frequent. The economic benefits of renting the space within them to commercial traffic over the route must have been obvious, and one feature strongly suggests that the mosques were built after a change in status with a more numerous clientele in mind: they are almost all additions to the original plan (Barud is an exception). The apparent lack of decoration in the mosques (and qasrs) is also a reason to disassociate them with royal clientele. Another problem with linking these mosques with the hypothetical nine-bay ante-mihrab space in Wasit is their vaulting. Although this has not been preserved, enough information remains from the disposition of the piers to show that basilical plans are the models for the Darb Zubayda group: the rectangular piers and engaged piers indicate that the vaulting was always in two parallel rows, forming three aisles, and the ground plans are usually rectangular rather than square, with the arcades parallel to the long side.

Even though it might weaken the argument that the mosques were not built exclusively for official ceremonial, it is still worth noting the resemblance which many of the Darb Zubayda mosques have to the audience hall of the Dar al-ʿImara at Kufa, one of the towns on the Darb Zubayda itself.[70] Kuraʾ and al-ʿAqiq both have triple entrances, a wider central aisle, and engaged piers at the rear. But instead of necessitating a ceremonial link between these structures, it rather serves to underline the blurring of the meanings of forms which naturally arose from the reuse by Islam of earlier prototypes.[71]

As mentioned above, it was in connection with the publication of one of the most recently discovered of Abbasid nine-bay mosques, the Hajji Piyada of Balkh, that recent discussions of the origins of the nine-bay plan have taken place.[72] The comparative material available at the time can now be considerably expanded. I have divided the material chronologically into two periods, the first up to 1200, by which time the major developments of the nine-bay form are apparent and a summary of its spread can be attempted. I have divided each chronological division further into broad geographical categories.

Table 1: Nine-bay structures in the Islamic world, c. 800–1200

The Maghrib

Susa, Bu Fatata mosque, 838–41
The prayer hall is reached from a narthex by a single doorway opposite the qibla; another door leads in from the east. The interior is divided into cross arcades by cruciform piers and roofed by barrel vaults parallel to the qibla.[73] Cross arcades on cruciform piers are also used in two nearly contemporary earlier monuments: the cistern at Ramla (789) and, closer to hand, the mosque within the Ribat of Sousse.

Qayrawan, Muhammad ibn Khayrun mosque, 252/866 (Figure 10.18)[74]
Although Creswell and Marçais thought the interior was modern or dated from the time of the addition of the minaret (844/1440–1), Kircher has shown that the four columns with their Kufic inscriptions and the smaller columns flanking the mihrab are likely to be original. As at Khan al-Zabib and Umm al-Walid II, the four columns are aligned with engaged piers on the sides forming two arcades parallel with the qibla wall. The present roofing of groin vaults replaced an earlier wooden roof. There are three entrances on the side opposite the qibla.

Cordoba, Great Mosque, cistern under courtyard, al-Mansur, 987–8 (Figure 10.19)[75]
This combined some of the features of the two previous monuments, being divided into cross arcades by cruciform piers with each bay covered with a cross-vault. Apart from the cruciform piers the scheme is identical to the cistern of the early Christian Basilica Majorum at Carthage (Figure 10.20).

Toledo, Bab al-Mardum mosque, 999/1000[76]
Four central columns, cross arcades. Each bay is domed with intersecting arches, the central one being higher than the others. Three of the sides had three entrances, while the qibla side may have two entrances flanking the mihrab.

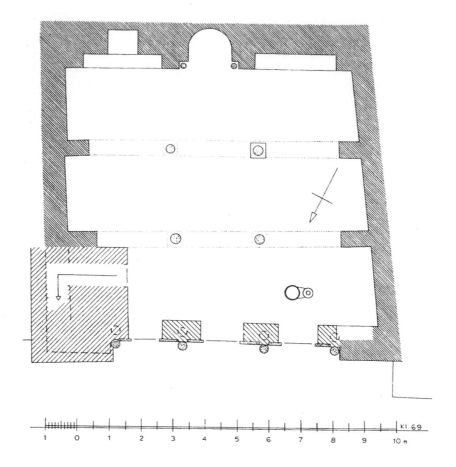

Figure 10.18 *Qayrawan, Muhammad ibn Khayrun mosque, 252/866 (after Kircher)*

Toledo, Las Tornerías, eleventh to twelfth century[77]
Both the date and the function of this building have been the subject of much controversy. Since it is clearly a simplified version of the Bab al-Mardum in plan and elevation, it has been assumed that it was also a mosque. However, its upper storey location and wildly inaccurate qibla orientation (a little west of south) would make the suggestions of a palace at least as likely.

Central Islamic Lands, Arabian Peninsula

Cairo, Dayr Anba Shinuda, refectory, post-Islamic conquest (Figure 10.21).[78]
The excavators of this site note that the four central pillars are a later insertion in the room. Buttresses on the side walls suggest the presence of two arcades. According to a personal communication to

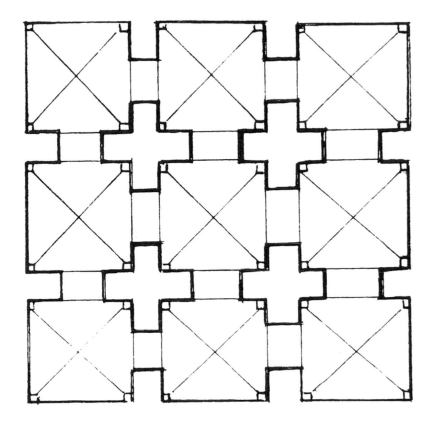

Figure 10.19 *Cordoba, Great Mosque, cistern under courtyard, al-Mansur, 987–8 (after Maldonado)*

the authors from G. Castel, the unpublished monastery of Dayr al-Fakhuri has a similar refectory. A similar building of indeterminate date at Dayr Anba Bishoi, Wadi Natrun, was a kitchen.[79]

Khirbat al-Mafjar, bath hall, c. 730–43[80]
Ettinghausen has recognised that bath hall can be interpreted as a nine-bay plan surrounded by an ambulatory on each side, and is also related to the quincunx plan with its taller and wider bay upon which the dome was placed.

Sudan, Old Dongola, audience hall (?), c. 850[81]
This building was transformed into a mosque in 717/1317. The square structure with four columns and cross beams is set within the walls on the upper storey of the building. Although it now has a flat roof, its original roofing is uncertain, both at the time of its foundation and at the time of its use as a mosque.

Figure 10.20 *Carthage, Basilica Majorum, cistern (after Maldonado)*

Al-Raya, Sinai Peninsula, mosque, ninth century[82]
The mosque's four-pillared plan is evident from a published photograph, and its date and form has been confirmed in a personal communication by one of the excavators of the site, Yoko Shindo.

Cairo, Sharif Tabataba mashhad, tenth century[83]
When Creswell surveyed the building the walls stood only to a level of c. 1 m. His restoration of cross arcades is certainly suggested by the central cruciform piers, although the domes above this suggested by Creswell could equally be replaced by tunnel vaults or groin vaults, as at the Bu Fatata and Muhammad ibn Khayrun mosques. The entrances are at least certain: three on each side with the exception of the qibla which has a mihrab in the central bay, that is, identical to the Bab al-Mardum mosque.

Geoffrey King's argument that the building was a funerary mosque rather than a tomb is plausible; his re-dating of it to the Fatimid period on the grounds that the other Egyptian examples of the type (the Sab'a wa Sab'in Wali and Jami' al-Fiyala) are eleventh-century

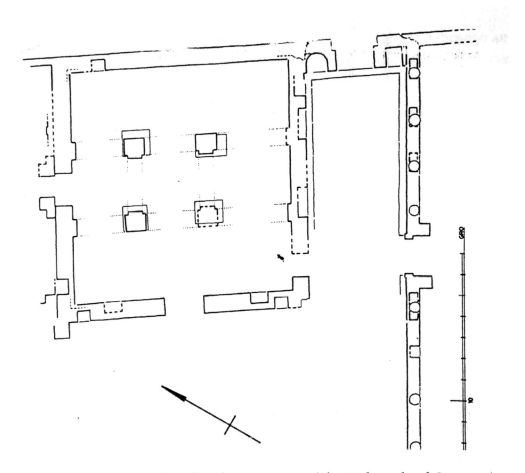

Figure 10.21 *Dayr Anba Shinuda, refectory, post-642 (after Mohamed and Grossman)*

is unconvincing.[84] Given the existence of earlier examples from Ifriqiya to Central Asia, there is no reason why the plan should not have been employed in Egypt in the tenth century.

Aswan, Sab'a wa Sab'in Wali mausoleum, eleventh century (?)[85]
This now destroyed building is known only from its plan. It indicates that it had cross arcades surmounted by nine domes. There was one entrance opposite the qibla, another in the middle of the east side. It is not known whether the adjacent minaret was contemporary, but it showed that the building functioned as a mosque.

Al-Qusiyya, Dayr al-Muharraqa, eleventh century (?)[86]
The Church of the Virgin seems originally to have had a nine-bay plan with cross arcades, although some of the domes are now elliptical.

Tamit, Nubia, Saint Raphael (or Sheikh) church, tenth to fourteenth century (Figure 10.22.1)[87]
The *naos* of the church is supported by four cross-shaped piers. Six domes cover the western part, the three bays on the east being barrel-vaulted.

Mediq, near Gerf Husayn, Nubia, church, tenth to fourteenth century (Figure 10.22.2)[88]
The *naos* of the church is supported by four cross-shaped piers. The domed central bay is slightly larger, the others being roofed with elliptical vaults.

Kaw, Nubia, church, tenth to fourteenth century (Figure 10.22.3)[89]
Four square piers support the nine-domed *naos*.

Cairo, Jami' al-Fiyalah, 498/1104[90]
Although all discussions of this monument have assumed that the mosque contained nine domes and nothing else, Maqrizi states that there were nine specially decorated domes at its highest point on its qibla side (*fi qiblatihi tisa' qubab fi a'lahu*). While this could mean either that the main (or only) prayer hall had only nine domes, it is more likely, especially with the qualifier 'at its highest point', to mean that only these nine bays had this special form; the parts of the mosque with a lower roof had some other form. This would suggest a *maqsura* with distinctive vaulting, perhaps analogous to that postulated by Terry Allen for Wasit. This is made more likely by the fact that it is described as a congregational mosque (*jami'*) and was one in which Friday prayers were certainly held, as Maqrizi specifically mentions its first khutba. The other congregational mosques of Cairo have courtyards that could accommodate much larger numbers than any nine-bay mosque.

Qaydan, near Mahawit, Bani al-Tayyar mosque, twelfth century (?)[91]
This is a flat-roofed mosque with two entrances in which the four piers support large beams perpendicular to the qibla. However, the highly decorated coffers, which are the main dating criteria, do not follow the nine-bay scheme, instead dividing the central bay into four parts and the side aisle into five parts.

Sarmin (near Aleppo), Friday mosque, pre-fourteenth century[92]
Ibn Battuta reported that the inhabitants of this town reviled The Ten Companions and even the number ten, saying 'nine plus one' instead and that their Friday mosque accordingly had nine domes instead of ten. While this makes a good story, the much more common occurrence of nine- than ten-domed mosques in the Islamic world suggests that it was indeed one that fitted into this series.

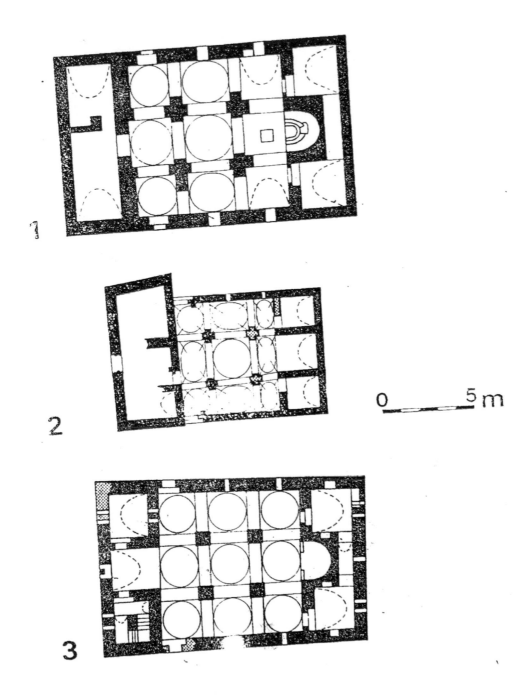

Figure 10.22 *1 Tamit, Nubia, Saint Raphael (or Sheikh) church, tenth–fourteenth century (after Gartkiewicz); 2 Mediq, near Gerf Husayn, Nubia, church, tenth–fourteenth century (after Gartkiewicz); 3 Kaw, Nubia, church, tenth–fourteenth century (after Gartkiewicz)*

Harran, small mosque, twelfth century (?)[93]
Cross arcades supported on small columns, groin vaults, barrel-vaulted narthex. When Preusser recorded the mosque in 1907 (it has since disappeared) the roofing had fallen, although his plan shows it as being cross-vaulted. King argues, noting the almost completely fallen roof in Preusser's photograph, that the bays were domed rather than cross-vaulted originally, but Preusser is specific in his text about the shallow cross-vaulting, perhaps using evidence from a part of the building not visible in the photograph.

Mosul, Jami' al-Nabi Jirjis (twelfth–thirteenth century)[94]
Cross arcades supported on octagonal piers, cross vaults. The building serves as a mosque and is adjacent to the probably older tomb of al-Nabi Jirjis; there were no entrances on the qibla side, but there may have been multiple entrances on the other three sides.

King argues that the poorly finished cross vaulting may have replaced earlier domes. Even if it is reconstructed, however, as he suggests, it may equally have replaced earlier cross-vaulted examples, like the mosque at Harran.[95]

East Africa

Kenya, Shanga, Friday mosque, c. 1000 CE (Figure 10.23)[96]
In its final phase the main rectangular prayer hall had four wooden columns supporting a thatched roof.

The Mashriq

Bust, pavilion of Abu'l-Hasan Tahir (r. 288–96/901–8)[97]
The anonymous author of the *Tarikh-i Sistan* relates that the Saffarid Abu'l-Hasan Tahir ordered a nine-domed building surrounded by gardens and open spaces to be erected, all at great expense. A few lines later in the text it mentions that he erected another *kushk* (pavilion or palace) at Bust, confirming the function of the first building.

Balkh, Hajji Piyada mosque, ninth century[98]
Cross arcades on circular piers, three entrances on each side other than the qibla. Although no domes nor squinches have survived, they are certainly likely to have been present originally

Tirmiz, Chahar Sutun mosque, ninth–tenth century.[99]
Circular piers, three entrances on the west and north sides, one on the east. It probably, like the Balkh Hajji Piyada, had domes on cross arcades.

The minaret of Tirmiz dated to 423/1032, mentioned as a terminus ante quem by King, was not connected with the Char Sutun, the latter being situated closer to the Shrine of Hakim-i Tirmizi, west of

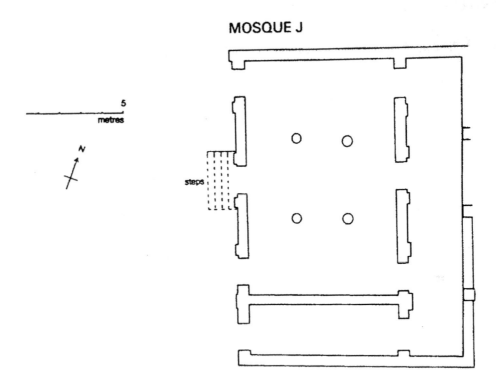

Figure 10.23 *Kenya, Shanga, Friday mosque, c. 1000 CE* (after Horton)

the old town. The remains had unfortunately become indistinguishable with the surrounding ground at the time of my visit in 1997.

Bukhara, Maghghak-i 'Attari mosque, tenth century (?)[100]
In its first phase the rectangular building had four pillars in the interior, rather than the present six.

Khazara, Diggaran mosque, tenth–eleventh centuries[101]
Cross arcades, brick piers, larger and higher central dome, smaller domes in the four corners, squinch vaults in three of the other four bays and a groin vault remaining one. Three entrances on the side opposite the qibla (north-east), one on the south-east.

Siraf, mosque at Site P1, ninth–twelfth centuries[102]
Rectangular with the qibla on the narrow side; two arcades parallel to the qibla, flat roof.

Kirman, Malik mosque, eleventh–twelfth centuries[103]
This area, to the south of the qibla dome chamber, is dated by the presence of a Saljuq mihrab. Schroeder, considering it to be the oldest

part of the mosque, surmised whether it might not have been a separate entity originally. It is roofed by very shallow groin vaults.

Dayr-i Gachin, mosque in caravansaray, twelfth century (Figure 10.14)[104]

The present squinch vaults on cross arcades are Safavid; it is thought the building was converted from a fire temple to a mosque in the Saljuq period.

We have seen that the nine-bay plan was used for a variety of building types in pre-Islamic times: domestic architecture both small and large, audience halls, gateways, temples and churches. To these we may add a further range of functions within the Islamic period: refectory, kitchen, cistern, mosque, and tomb or funerary mosque.

As mentioned above, the basic pre-Islamic template could be altered (sometimes simultaneously) in two ways: by substituting vaulting and by altering the size of the bays, primarily to emphasise the central one. This is apparent at the Diggaran mosque, which stands out as a rare early Islamic example of the quincunx type. Robert Hillenbrand, while discounting Byzantine influence, has already remarked on this similarity to Byzantine domical architecture.[105] But there is no need to invoke even the earlier Syrian examples of quincunxes mentioned above (including Khirbat al-Mafjar) as prototypes. We have seen already that Sogdian residential architecture modified the nine-bay plan to the quincunx type at Aultepe (Figure 10.15.3). The rounded piers which support the central dome at Khazara are closer to the nearby mosques of Balkh and Tirmiz than the L-shaped piers of the audience hall at Rusafa and their Byzantine and Armenian successors, suggesting indeed that this is a local variation of the regular nine-bay plan.

Another variation occurs in a residential *kushk* at Tahmalaj (ninth–tenth centuries).[106] While this has a nine-dome plan, it is one in which each room is distinctly separated from its neighbour by walls, with little inter-communication except on the central row of three bays. Perhaps this residential model was the one adopted for the palace of Tahir at Bust, noted above.[107] We should remember the likelihood mooted above that fire temples, which as we have seen, especially in Central Asia, frequently had nine-bay plans, were turned into or incorporated within mosques. Once the nine-bay plan had been established as a possibility for mosques, nine-bay residential buildings such as Aultepe could have encouraged architects to adapt them in ways as different as the Balkh or Khazara examples.[108]

Many of the other mosques in Table 1 have features which set them apart from the examples we have considered earlier: open façades and cross arcades. Should these be seen as a natural development of previous plans, or as an entirely new type of structure? It may be remembered that in the Darb Zubayda, the most frequently occurring series of nine-bay mosques to date, they had all been

attached to another building. This attachment obviously interfered with the number of entrances which it was possible to have, and also therefore with symmetry. The predilection for symmetry has always been a strong force in architecture, not least in that of Islam.[109] When erecting freestanding buildings of this type, the very symmetry of the building plan was probably enough to commend the idea of having up to three identical façades (e.g. Balkh and Tabataba, Cairo, or two, as at Tirmiz and Toledo) and of having arcades parallel to all four, instead of just two walls. We have seen that in the case of one of the earliest on the list, the Bu Fatata in Susa, there was in fact a slightly earlier mosque in the same town which had just such cross arcades, that of the Ribat (c. 771–88). But it is not necessary to assume that the architects of the examples in the eastern Islamic world were aware of those further west. Such a cross arcade system had already been used for the cistern at Ramla (172/789),[110] and its employment in such a utilitarian context (as in the cistern of the Cordoba great mosque) makes it likely that it was a familiar option for architects, despite the lack of other surviving examples.

When analysing the Christian examples of Nubia, Gardiewicz has argued that their cross-axiality shows influence from Islamic hypo-style buildings, and King, referring to the Dayr al-Muharraqa, says that it is 'a remarkable instance of the transfer of these types of structures out of the Islamic context into that of Coptic Christianity'.[111] Guiseppe Bellafiore, when discussing the twelfth-century churches of Sicily, likewise compares the nine-bay examples to earlier Islamic ones.[112] But as we have seen, the nine-bay examples of the Darb Zubayda themselves come out of a basilical tradition, and it does not take much modification to transform the single axis of the basilical *naos* to the double axis of the symmetrical nine-bay form, or to regularise the spaces within the quincunx into nine-equal ones. Utilitarian buildings such as the refectories and kitchens of monasteries could easily have provided a model for cross-axiality.

The nine-bay plan: explanations

Geoffrey King has argued that the nine-bay form was popular because it had an inherent honorific connotation: 'Thus, there is a recurrent connection between buildings of the nine bay design and individuals prominent in religion and society.'[113] He goes on to demonstrate this with reference to the founders of the various mosques of this type. But the argument is circular – the founder of any medieval mosque who can be identified will by definition be someone prominent in religion and society, otherwise he would not have been in a position to found a mosque. The utilitarian contexts of the nine-bay plan rather suggest that it is no more nor less an honorific form than the single dome or the iwan, a building block to be used as convenience dictates.

But there is a reason why convenience often did dictate this plan, one found within an extraordinary geographical and temporal range. As mentioned above, the diversity comes not so much because all of the examples are necessarily interrelated, but because the of the plan's inherent practicality, economy and aesthetic appeal (especially in terms of symmetry). Suppose that an architect wishes to roof an area in the most economical way possible. Four piers or columns at the corners will enable him to roof it by either a flat roof or a dome (Figure 10.24.1), the dimensions of which are determined by the maximum length of timbers available for the flat roof,[114] or the maximum diameter of the dome, the latter depending both on the materials available and the skill of the dome maker. Then add two columns on each of the four sides of the dome (Figure 10.24.2) and one can now have four extra bays. If only one pier is now added at each corner (Figure 10.24.3), four more bays, making nine in all, can be roofed. The matter could also be considered in reverse. An architect wants to place a roof on a square building. How can he support a roof with minimum interruption of the interior space? The most economical solution of one column will produce four bays of equal size, but this has the ugly result of encumbering the centre of the room, and preventing movement in a straight line from a doorway, usually in the middle of the wall, to the opposite side of the room. This is particularly unfortunate in a mosque, where the pier would block the view of the centrally placed mihrab.[115] Two or three columns in a square building cannot produce bays of equal size. Four is thus the minimum number of supports needed to provide the focus on centrality and emphasis on axiality which a square plan implies – and has the added felicity of resulting in a plan of heightened symmetry, nine equal bays in three rows of three.

Whether one starts from the central dome or from the outer square may depend on the wish to emphasis part of the plan. Where the central dome is of greatest importance, one obviously starts from the inside out, varying the size of the surroundings, if necessary. It is this procedure which may have been followed in the quincunx plan, where the central dome is usually of greater height and diameter than the others, although there is still a major difference between this and the *hasht bihisht* type, with greater compartmentalisation, which I have therefore deliberately excluded from consideration in this piece.[116] Beginning from the outside, on the other hand, may produce a plan which more closely resembles the apadana, where the whole space is least encumbered by supports – an idea that would have appealed particularly to mosque builders, where the faithful line up in rows for prayer. There are also several possibilities within this latter approach, depending on the vaulting, or lack of it. In the case of a flat roof, there may be no directional emphasis from the architecture within the building. A similar lack of directional emphasis results when cross arcades are formed, parallel to each

1

2

Figure 10.24 *Stages of expansion of domed unit*

wall, supporting shallow domes or cross-vaults. As we have seen however, many examples have arcades parallel to only one wall, betraying a basilical orientation, and possibly origin, for their plan.

Ground plans generated on paper by the various approaches can look very similar although quite different elevations can result, making it harder to estimate the influences which the different types may have exerted on one another. But it is as well to remember that earlier studies have obscured the potential for influence between different building functions by concentrating on the interrelationships between just one function; the mosque, and downplaying the possibilities of the influence of nine-bay forms in domestic architecture, basilical and temple plans on mosques.

The surviving examples beyond 1200 are naturally much greater.

Table 2 is not meant to be comprehensive, especially with regard to later examples, but is designed to give some idea of the ubiquity and persistence of the plan in Islamic architecture.

Table 2: Nine-bay structures in the Islamic world, after 1200[117]

Maghrib

Tilimsan, Sayyidi Abu'l-Hasan mosque (696/1296)[118]
Four columns support arcades perpendicular to the qibla, flat roof.

Tunis, Muntasiriyya madrasa (1437–50)[119]
Four columns support arcades perpendicular to the qibla, flat roof.

Tunis, Sidi Qasim al-Zaliji zawiya (before 1496)[120]
Four columns support arcades parallel to the qibla, flat roof.
Each of the three examples above is rectangular, showing their derivation from basilical plans.

Granada, Tomasas cistern (undated)[121]
Cross arcades support cross vaults.

Málaga, Marmuyas cistern (ninth–tenth centuries)[122]
Cross arcades support cross vaults.

Granada, Alhambra, Lluvia cistern (thirteenth–fourteenth centuries)[123]
Four L-shaped piers support a central dome and four groin vaults, barrel-vaults in the intervening bays.

Libya, Tripoli, Saray al-Hamra mosque (1044/1633)[124]
Cross arcades, nine equal domes.

Egypt and Syria

Aleppo citadel, room added above main gate (807–20/1404–17)[125]
Cross arcades, domed. The history of this room is a cautionary tale with regard to planning a nine-bay space: make sure you have beams of the necessary length (the span of each bay is 9 m). Sayf al-Din Chakam, who ordered the room to be built, was unable to carry on when the beams brought from Baʾalbak were too short; only when al-Muʾayyad ordered beams from 'the region of Damascus' (i.e. another part of Lebanon) were they sufficient for the job.

Cairo, northern cemetery, complex of al-Ashraf Barsbay (1432) (Figure 10.1)[126]
The mosque in this complex (according to its *waqfiyya* it also functioned as a madrasa for four *hanafi* students) is a square room with four columns supporting arcades parallel to the qibla and a flat roof. This basilical orientation is made even more evident by lowering the floor of the central aisle, providing a passageway to the adjacent tomb. Surprisingly, the two raised prayer areas are termed *iwan*s in the *waqfiyya*.[127]

Cairo, Mahmud Pasha mosque (1567) (Figure 10.2)[128]
Four columns, flat roof. This shares with the complex of al-Ashraf Barsbay above the unusual lowered corridor running across the middle of the mosque (in this case leading to the ablutions area), but, as mentioned in the introduction above, it has a unique approach to the central bay, framing it by four arches that give the impression of a reduced four-*iwan* plan.

Cairo, Masih Pasha mosque (1575)[129]
Four T-shaped piers support arcades parallel to the qibla, flat roof.

Cairo, Murad Pasha mosque (1578)[130]
Arcades parallel to the qibla, flat roof.

Cairo, ʾAbdin Bey mosque (1660) (Figure 10.25)[131]
Four piers with cross arcades, large dome over mihrab bay, central skylight, six domes on the two sides.

Cairo, Ribat al-Athar (1667)[132]
Arcades parallel to the qibla, flat roof.

Damascus, Khan Asad Pasha (1753)[133]
The square courtyard of this khan is roofed with nine equal domes supported on four piers.

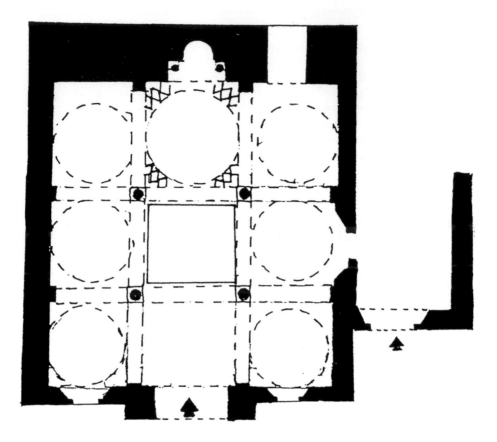

Figure 10.25 *Cairo, ʿAbdin Bey mosque (1660) (after El Rashidi)*

Cairo, Shajarat al-Durr complex, mosque (1877)[134]
This mosque, now lost, was reconstructed by the Comité. It seems to have had four columns supporting arcades parallel to the qibla and a flat roof.

Cairo, al-Rifaʿi mosque (1869–1911)[135]
The central core is of nine bays, the central one domed, those surrounding flat roofed. Piers with engaged columns support cross arcades.

Arabian Peninsula

Yemen, al-Mukha, ʿAli b. ʿUmar al-Shadhili mosque (842/1418)[136]
Four columns, cross arcades, higher central dome.

Oman, Nizwa, al-Shawadna mosque (936/1530)[137]
Four columns, arcades parallel to qibla, flat roof.

Yemen, Madar, al-Hadi mosque[138]
No dating is given for this mosque which has a flat roof and four piers supporting arcades parallel to the qibla.[139]

East Africa

Mogadishu, Fakhr al-Din mosque (thirteenth century) (Figure 10.26)[140]
This is a remarkable example where nine bays occur at vaulting level only and are supported on two columns by means of cross beams. The central bay is domed.

Tanzania, Kilwa, small domed mosque (fifteenth century)[141]
Four piers support cross arcades and domes. The three central bays on the mihrab axis are square, those to either side slightly rectangular. Entrances to every bay except the mihrab.

Tanzania, Kilwa, Jangwani mosque (fifteenth century)[142]
Four piers support cross arcades and domes. One entrance on each side other than the qibla.

Kenya, Mnarani, small mosque (sixteenth century)[143]
Nine slightly rectangular bays, four octagonal piers.

Shengeju, mosque (sixteenth century)[144]
Four rectangular columns.

Songo Mnara, main mosque (mid-sixteenth century) (Figure 10.27)[145]
Porch, four octagonal piers support arcades parallel to the qibla.

Ukutani, mosque (sixteenth century ?)[146]
The plan is markedly rectangular, with the qibla on the narrow side. Four square piers.

Utondwe, mosque (seventeenth century ?)[147]
The plan is slightly rectangular, with the qibla on the narrow side. Four square piers.

Kua, three small mosques (eighteenth century)[148]
Each had arcades parallel to the qibla, two on octagonal, one on square piers.

Chole/Kaole Mafia, mosque (late eighteenth century)[149]
Four octagonal piers and engaged columns on the side walls support arcades parallel to the qibla.

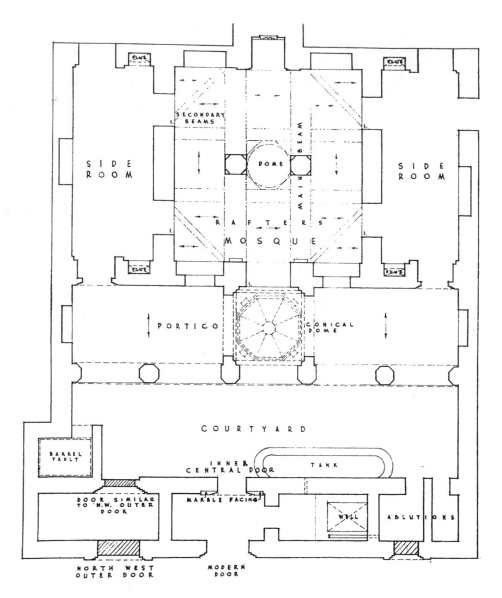

Figure 10.26 *Mogadishu, Fakhr al-Din mosque (thirteenth century) (after Garlake)*

Kipumbwe, Mji Mkuu, mosque (nineteenth century)[150]
Four octagonal piers and engaged columns on the side walls support arcades parallel to the qibla.

Kisikimto, mosque (nineteenth century)[151]
Four octagonal piers and engaged columns on the side walls support arcades parallel to the qibla.

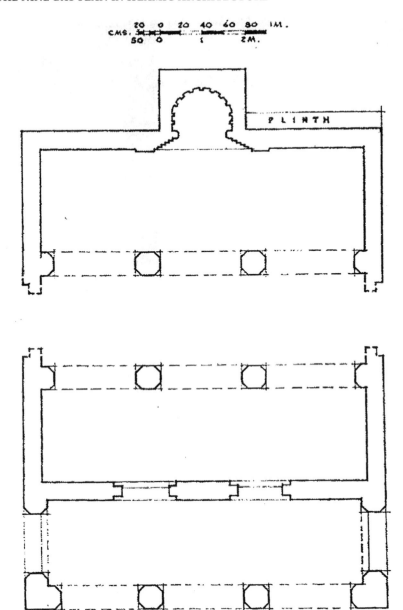

Figure 10.27 *Songo Mnara, main mosque (mid-sixteenth century) (after Garlake)*

Tundwa, mosque (nineteenth century)[152]
Four rectangular piers support arcades parallel to the qibla.

Turkey

Bor, Sari mosque (1205–6)[153]

Rectangular prayer hall, four small columns support arcades parallel to the qibla, flat roof.

Kemer Hisar, great mosque (thirteenth–fourteenth century)[154]
According to Gabriel, this has the same plan as that of the Sari mosque above.

Kastamonu, Mamhud Bey mosque (1366)[155]
Four wooden piers, wooden roof.

Edirne, Eski Cami (805–16/1403–14)[156]
Four stone piers support cross arcades and nine equal domes.

Dimetoka, Çelebi Sultan Mehmed mosque (825/1421) (Figure 10.28)[157]
Quincunx: four piers support a large central dome, corner cross vaults, axial barrel vaults; three bay narthex. King notes Aslanapa's references to parallels with the Diggaran mosque for this building. However, this is surely a case of Turkish nationalism ignoring geographically and chronologically closer parallels, the numerous Byzantine quincunxes in the area.

Elbistan, great mosque (1498)[158]
Quincunx: four piers, large central dome, axial semi-domes.

Bor, Sari 'Ali mosque (c. fifteenth century)[159]
Rectangular prayer hall, four small columns support arcades parallel to the qibla, flat roof.

Diyarbakir, Fatih Pasha mosque (1516–20)[160]
Quincunx: four piers support a large central dome, smaller corner domes, axial semi-domes.

Istanbul, Shezade mosque (1544)[161]
Quincunx: four piers support a large central dome, smaller corner domes, axial semi-domes.

Karapinar, Sultan Selim complex, caravanserai (1563–4)[162]
The conjectural restoration of the caravanserai shows it as having two nine-bay units, each with cross arcades and barrel vaults.

Adilcevaz, Zal Pasha mosque (sixteenth century) (Figure 10.29)[163]
Four piers, cross arcades, nine equal domes, three-domed porch.

Istanbul, Yeni Valide mosque (late sixteenth century)[164]
Quincunx.

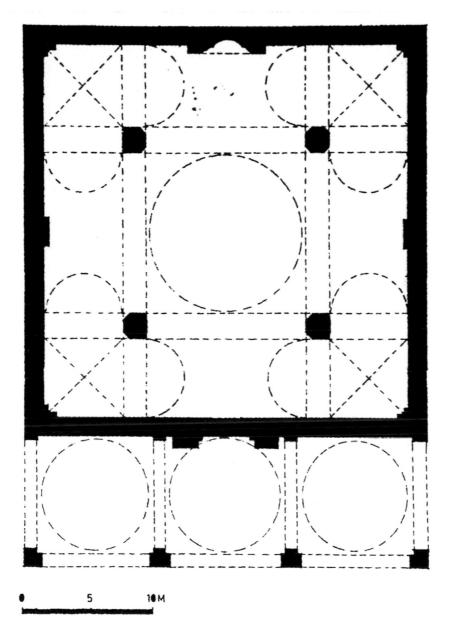

Figure 10.28 *Dimetoka, Çelebi Sultan Mehmed mosque (825/1421) (after Kuran)*

Diyarbakir, Nasuh Pasha mosque (1015–20/1606–11)[165]
Quincunx: large central dome, surrounding areas all cross-vaulted.

Bitlis, Adilcevaz Pasha mosque (sixteenth century)[166]
Cross arcades, nine equal domes, three-domed porch.

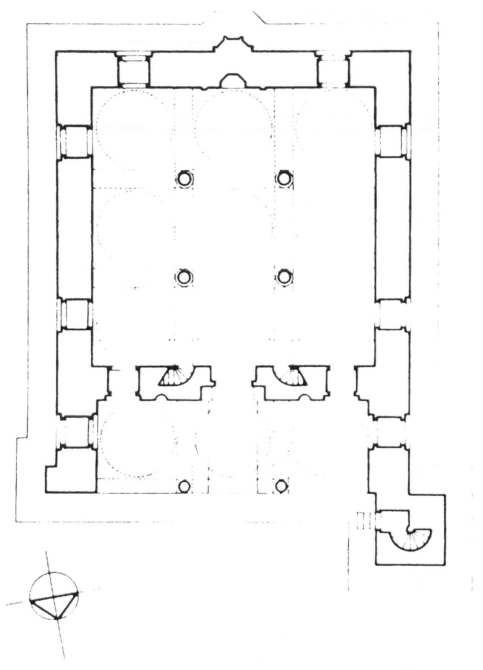

Figure 10.29 *Adilcevaz, Zal Pasha mosque (sixteenth century) (after Kuran)*

Barsema, mosque (974/1567) (Figure 10.30)[167]
Four square piers support arcades parallel to the qibla. The roof, now
destroyed, would have been flat.

Ankara, Aktash mosque (sixteenth–seventeenth centuries)[168]
Rectangular prayer hall, four small columns support arcades perpen-
dicular to the qibla, flat roof.

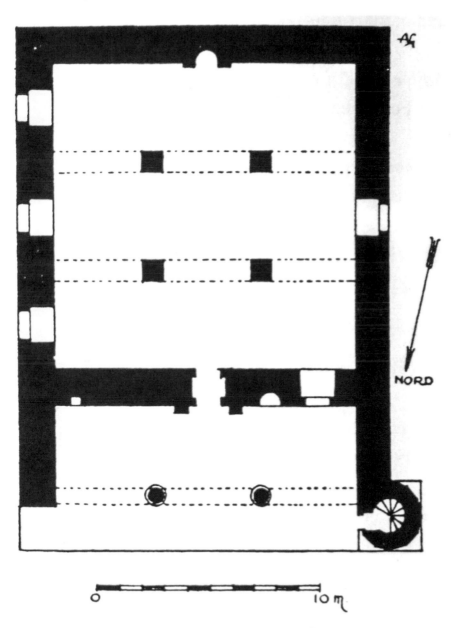

Figure 10.30 *Barsema, mosque (974/1567) (after Gabriel)*

Dogubeyazid, Ishakpasha palace, mosque (1784)[169]
Cross arcades. The nine-bay room is adjacent to the main dome chamber and could have functioned as a lecture hall or for overspill. Its bays are irregular, particularly so in that the central bay is rectangular.

Antalya, Boztepe Köyü Haci Hasan Aga mosque (1236/1820)[170]
Four columns support cross arcades; large central dome, other bays barrel vaulted.

Artvin-Ardanuç, Iskenderpasha mosque (1281/1864)[171]
Four piers support a large central dome.

Iran

Takht-i Sulayman, large four-columned room (thirteenth century) (Figure 10.31.1)[172]
Suggested functions for this room have been as varied as assembly hall, residence, mausoleum, city hall, courthouse and Buddhist temple. Given the versatility of the nine-bay plan, none of these could be ruled out on the basis of the form alone. The column bases have survived; Kleiss has proposed that it was roofed with a central wooden dome and flat roof elsewhere. If so the 7.5 m span of the central bay would make this one of the largest examples.

Takht-i Sulayman, small four-columned room (post thirteenth century?) (Figure 10.31.2)[173]
This was similar to the larger room, but the bases and drum were apparently reused.

Natanz, Kucha-yi Mir mosque (early fourteenth century)[174]
Four square piers, two arcades parallel to the qibla.

Asnaq, Friday mosque (733/1332–3)[175]
Four stone columns support a flat roof.

Quhrud, 'Ali mosque (700–36/1300–35)[176]
Four octagonal piers support cross arcades and nine roughly equal shallow domes.

Hurmuz, site K103, mosque (thirteenth century)[177]
The building is an irregular rectangle enclosing four piers.

Khurs, mosque (fifteenth century or later)[178]
This has brick walls and stone piers, cross vaulting and nine equal domes. There are three entrances on each side except the qibla, which has two. Kleiss dates it to the fourteenth century or later, but the vaulting suggests a Timurid date at the earliest.

Figure 10.31 *Takht-i Sulayman, large four-columned room (thirteenth century) (post-fourteenth century) (after Kleiss)*

Saravar, Friday mosque (c. 811/1409)[179]
Four wooden columns support a flat roof.

Varkand, mosque (fourteenth–fifteenth century ?)[180]
Siroux's datings are often optimistically early, and unfortunately no photograph is given of the building. The four piers that support the dome are closer to the qibla than the entrance, forming eight other bays of varying sizes.

Echkarand (ʿIshqarand?), mosque B, shabistan (Ilkhanid ?)[181]
Four square piers supported cross arcades and probably nine domes. Although the break in bond on the lower walls shows that the *shabistan* was started later than the adjacent prayer hall,

the communicating upper walls indicate that it was finished at nearly the same time. The same caveat on the dating above applies here.

Baku, Shirvan Shah complex, Kay Qubad mosque (fifteenth century)[182]
This no longer extant building, built against an earlier tomb, was itself built on earlier foundations. It had a quincunx plan, with four squat piers supporting cross arcades and a large central dome; the surrounding bays were flat-roofed.

Kuhpaya, Husayniyya, mosque (sixteenth–seventeenth century)[183]
Nine shallow domes, cross arcades, four brick piers.

Shiraz, 'Atiq mosque (sixteenth–seventeenth century ?)[184]
Like the earlier Malik mosque in Kirman, this area of a much larger mosque seems to have been conceived as a *shabistan* or winter mosque. Judging from the squinch-nets of the domes (roughly equal in size, cross arcades on brick piers), this part is not likely to be earlier than Safavid.

Firuzkuh, Gaduk, caravansaray (seventeenth century)[185]
The central area is roofed with nine equal domes on cross arcades.

Kirman-Sirjan, Sangtaw, caravansaray (Safavid) (Figure 10.32)[186]
The central area is roofed with nine equal domes on cross arcades.

Kirman-Sirjan, Khana-yi Surkh, caravansaray (Safavid)[187]
The central area is roofed with nine equal domes on cross arcades.

Khurasan, Ribat-i Fakhr Dawud (Safavid)[188]
The central area is roofed with nine equal domes on cross arcades.

Sabzivar, Ribat-i Sarpush (Safavid or Qajar)[189]
This is essentially a quincunx, the central bay being square and the others rectangular. The vaulting is not marked on the plan, but is likely to be brick squinch vaults.

Bandar Abbas-Lar, Tang Dalun, caravansaray (nineteenth century)[190]
Cross arcades, nine equal domes.

Azerbaijan, houses (nineteenth century)[191]
Two are illustrated; each has a single room with a porch; each room has four wooden columns supporting a flat or sloping roof. Useinov notes that this type is of great antiquity and is widespread throughout the Caucasus.

Figure 10.32 *Kirman-Sirjan, Sangtaw, caravansaray (Safavid) (after Kleiss)*

Subzivar, Pamanar mosque (undated)[192]
Maulavi discusses mainly the long history of this mosque, which has a Saljuq minaret. Its portal has modern tilework, but no photographs of the interior are shown. It has nine equal domes resting on piers with cross arcades. The photographs of the exterior suggest a fairly recent date.

Central Asia

Bishdagh, Golden Horde state tent (fourteenth century)[193]
'At this place there has been erected a huge *barka* (*bargah*), a *barka* in their language being a large tent supported by four wooden columns covered with plaques of silver coated with gold, each column having at its top a capital of silver gilt that gleams and flashes ... In the centre of the *barka* is set up an immense couch which they call the

takht . . . upon which sit the sultan and principal khatun.' It should not be surprising that portable architecture should also make use of the ability of the nine-bay form to create an interior as unimpeded as possible, and to accentuate the central bay sufficiently to complement the royal entourage.

Astanababa, mausoleum of Ubayd and Zubayd, annexe (undated)[194]
The annexe, consisting of nine equal domes supported on four square piers, was built against an earlier possible Saljuq period mausoleum. No photographs have been published that might permit an estimate of the date.

Fudina, Husam-Ata complex, mosque (sixteenth century or later?)
(Figure 10.33)[195]
Like the above, this is an addition to an earlier (eleventh-century) mausoleum. Cruciform piers support cross arcades; only six of the bays are now domed, in an irregular pattern.

Khavrizm, Khanka, madrasa and mosque (eighteenth century)[196]
This unusual hybrid has a self-contained mosque with nine equal domed bays supported on cross arcades.

Vakhshuvar, mosque and hall (1713) (Figure 10.34)[197]
This complex boasts a four wooden-columned mosque with a flat roof and a wooden-columned porch on two sides, and a southern terrace with a four-columned hall open on two sides to the terrace and supported on its open sides by wooden columns aligned with those on the interior.

Ayli, mosque (nineteenth century)[198]
This is similar to the mosque of Vakhshuvar above, but with a porch on three sides.

Khiva, Old Ark, winter mosque (nineteenth century)[199]
The adjacent summer mosque is dated to 1838. This has four wooden columns supporting a flat roof.

Khiva, Ata Murad mosque (1800)[200]
This mosque has two halls; in that on the qibla side four wooden columns support the flat roof.

Kirghizstan, mosque (nineteenth–early twentieth century)[201]
Among the mosque types illustrated in Kirghiz are those with one, two or four-columned interiors. These are almost certainly flat-roofed, with wooden pillars; the examples shown have a columned porch on three sides.

Figure 10.33 *Fudina, Husam-Ata complex, mosque (sixteenth century or later?) (after Mankovskaya)*

Figure 10.34 *Vakhshuvar, mosque and hall (1713) (after Rempel)*

Panjikent, houses (nineteenth century)[202]
Wooden four-columned reception rooms figure frequently in these plans.

Tajikistan, Ainiski district, bath (early twentieth century)[203]
The main outer room is rectangular with four wooden columns.

Nuristan, houses (nineteenth–twentieth century) (Figure 10.35)[204]
The standard house plan in Nuristan is one with a (wooden) four-columned interior; the central bay is frequently covered with a corbelled dome of successively smaller squares. Its popularity in this region may be due to the confluence of two factors: the tradition of four-columned rooms in central Asia houses (see above) and the concepts of ideal planning in Hindu architecture (see below).

Indian Subcontinent

Before listing the Islamic examples of this type, it is worth noting the importance which the nine-bay plan played in the conception of

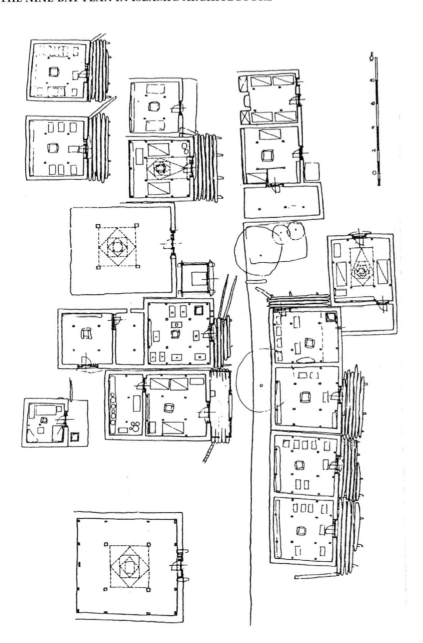

Figure 10.35 *Nuristan, houses (nineteenth–twentieth century) (after Wutt)*

the ideal Hindu temple and palace. The mandala, a sacred geometric diagram of the essential structure of the universe, governs the ideal plan. Although this could take several forms, that which was considered most auspicious was a mandala of nine squares, each square of which in turn was divided into nine squares.[205] The popularity of this scheme is reflected in the plans of numerous Hindu and Jain

temples from the early medieval period onwards (Figure 10.36)[206] to such late manifestations as the city plan of Jaipur.[207]

Junagadh, al-Iraji mosque (685/1286–7) (Figure 10.37)[208]
In its original state this treabate building the main prayer hall had nine equal, slightly rectangular, bays, preceded by a six-bay narthex.

Delhi, Jahanpanah mosque (c. 1343)[209]
The royal *maqsura* on the north-east side of the mosque has a quincunx plan with a central and four corner domes, the other bays being groin vaulted.

Baltistan, Chakchan, Friday mosque (mid-fourteenth century)[210]
Although the building has been repaired many times, Dani suggests that the local reports associating the building with the fourteenth century are credible.
Circular wooden columns, corbelled.

Hisar, palace of Firuz Shah (1356)[211]
On the east side of the north court is a roughly square room with four piers.

Hisar, Gujari Mahal (after 1356) (Figure 10.38)[212]
Four reused marble temple columns support cross arcades and nine equal domes on pendentives. There are three entrances on each side.

Hisar, Jahaz Kothi (madrasa?) (after 1356)[213]
The main hall on the west of the building has four monolithic columns; each of the nine bays is roofed by cross vaults.

Delhi, Malcha Mahal (c. 1360) (Figure 10.39)[214]
This bears a close resemblance to the ideal Hindu palace and temple plan. It consists of nine units, with each of them further subdivided, although only the central one of these nine units is divided into nine bays, the surrounding ones being composed of six or four bays.

Bengal, Pandua, Adina mosque (fourteenth century)[215]
This structure, of the qibla side of the mosque, is now a tomb, but is thought to have been originally a royal entrance. Four piers support nine small domes on pendentives.

Delhi, Bahlul Lodi tomb (1488)[216]
Three entrances on each side except the qibla, which has two (with a mihrab in the centre bay). Quincunx with large central dome and four smaller ones at the corners.

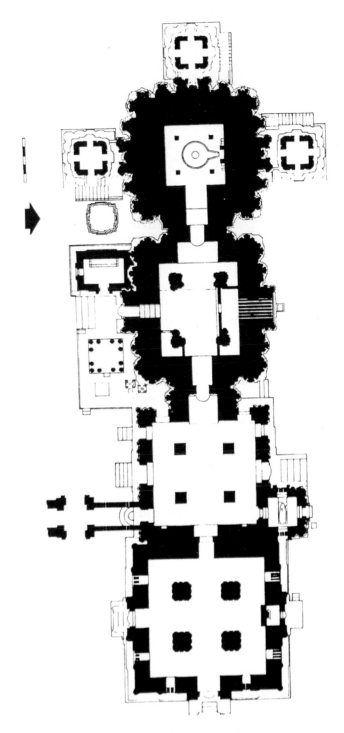

Figure 10.36 *Bhubaneshwar, Lingaraja temple (eleventh century) (after Michell)*

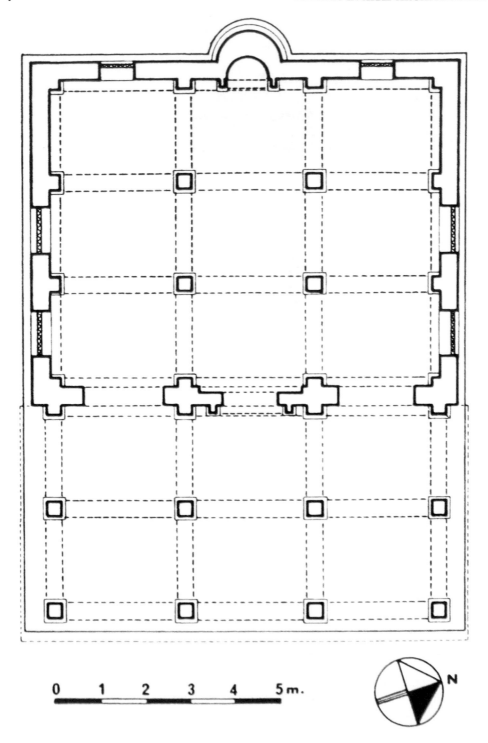

Figure 10.37 *Junagadh, al-Iraji mosque (685/1286–7) (after Shokoohy)*

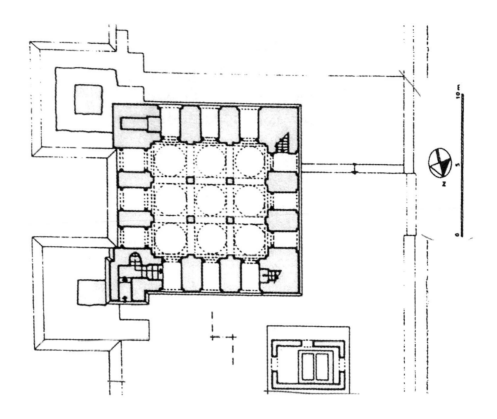

Figure 10.38 *Hisar, Gujari Mahal (after 1356) (after Shokoohy)*

Madura, 'Ala' al-Din mosque (late fourteenth or early fifteenth century)[217]
In this trabeate building the main prayer hall has nine equal bays supported on four stone columns, preceded by a four-bay narthex.

Madura, Qadi Taj al-Din mosque (late fourteenth or early fifteenth century)[218]
Trabeate, with a slightly rectangular nine-bay antechamber similar to the prayer hall of the 'Ala' al-Din mosque; the inner prayer hall has a nine-bay plan with a rectangular raised central bay.

Tiruparangundram, shrine of Sikandar Shah (late fourteenth or early fifteenth century) (Figure 10.40)[219]
The plan is virtually identical to the Qadi Taj al-Din mosque immediately above; here the two rooms are square rather than rectangular. Instead of a mihrab in the qibla wall is the entrance to a tomb.

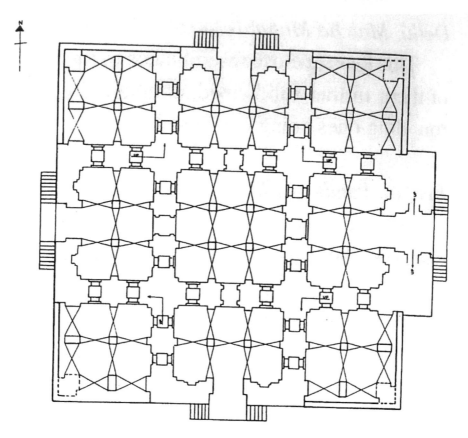

Figure 10.39 *Delhi, Malcha Mahal (after Welch and Crane)*

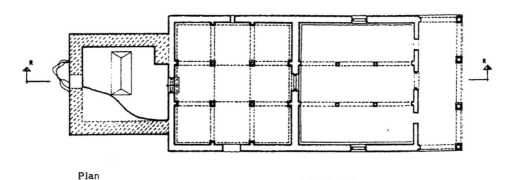

Plan

Figure 10.40 *Tiruparangundram, shrine of Sikandar Shah (late fourteenth or early fifteenth century) (after Shokoohy)*

Calicut, Muchchandipalla mosque (c. 1480)[220]
This has a plan similar to the ʿAlaʾ al-Din mosque at Madura above; here the columns are spaced quincunx fashion, giving a much larger central bay.

Bengal, Bagherat, mosque (mid-fifteenth century)[221]
Square piers, cross arcades, nine equal domes, three entrances on each side other than the qibla, which has three mihrabs.

Bengal, Khulna, Mashjidkur mosque (mid-fifteenth century)[222]
Square piers, cross arcades, nine equal domes, three entrances on each side other than the qibla, which has three mihrabs.

Bengal, Kawshba mosque, Barisal (Borishal) (mid-fifteenth century)[223]
Octagonal piers, cross arcades, nine equal domes, three entrances on the side opposite the qibla, two on the sides, three mihrabs on the qibla side.

Bengal, Shatoir mosque, Faridpur (late fifteenth century)[224]
Octagonal piers, cross arcades, nine equal domes, three entrances on each side other than the qibla, which has three mihrabs.

Bijapur, Nau Gumbaz mosque (early seventeenth century)[225]
An alternative name for the Hajji Piyada mosque in Balkh is indeed the Nuh Gunbad, i.e. the nine dome mosque. Cross arcades support a wider central dome which, like the four corner domes, is segmental, the other being pyramidal.

Gulbarga, Dargah of Shaykh Siraj al-Din Junaidi, gateway (fifteenth or sixteenth century)[226]
Cross arcades, nine equal domes.

Hunza, Altit fort, first and second floors (sixteenth century)[227]
Each of these reception rooms has four wooden columns. Dani describes them as 'a typical Hunza style of sitting-cum sleeping room', suggesting that the Nuristan examples have a long regional heritage.

Baltistan, Shigar, Mir Yahya khanqah (1023/1647)[228]
Of the nine bays on the interior, only the central one now has the corbelling which originally covered all of the bays, according to Dani.

Gulbarga, Afzalpur, Afzal Khan mosque (before 1071/1659)[229]
Quincunx, central dome and four elliptical corner domes supported on cross arcades.

Baltistan, Kiris, Mulla khanqah (1118/1706)[230] (Figure 10.41)
This has an interesting variation on the usual nine-bay plan. The larger central bay is subdivided into four bays by a central column, and each side of this central bay is bordered by three columns, making nine in all. One can see why it was seldom used, however:

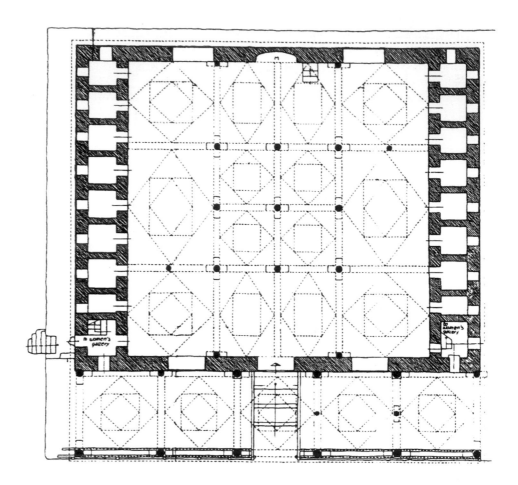

Figure 10.41 *Baltistan, Kiris, Khanqah-i Mulla (1118/1706) (after Dani)*

the central aisle, on the axis from the door, is thus effectively split
into two, obscuring the view of the mihrab opposite the entrance.
Each of the bays is roofed with corbelling.

Ahmadabad, Nana Aidrus mosque (undated) (Figure 10.42.14)[231]
Quincunx plan; no details are available on the vaulting.

Southeast Asia

Java, Jatinom, small mosque (first half of the seventeenth century)[232]
Trabeate; the main prayer hall is supported by four wooden columns
on stone socles.

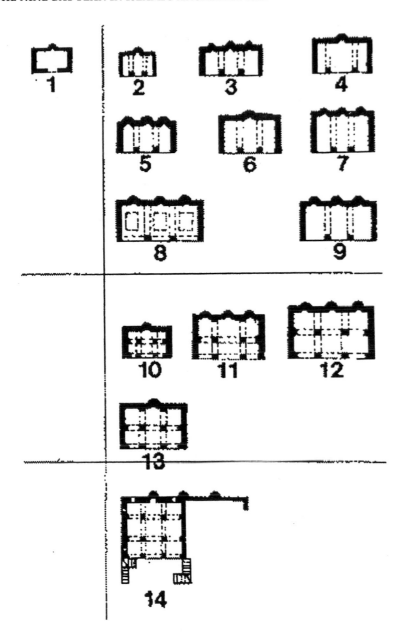

Figure 10.42 *Ahmadabad, table of mosque plans (after Sohan Nilkanth)*

Later nine-bay plans: conclusions

It will be obvious that the relationships between the above examples (if any) are extremely varied. Before considering these further, we should remind ourselves of the range of functions in nine-bay plans. To those evident from the period 800–1200 (see above) we can add

caravansarays, both urban and rural, and the first Islamic examples
of gateways. By far the majority of surviving examples are mosques,
but this imbalance probably does not reflect the original distribution
of the plan. Of all medieval buildings in the Islamic world moques
are the ones most likely to have survived, whether from endow-
ments through the *waqf* system, or because they were valued and
continually maintained by the community.

Being made of wood, no examples of medieval housing in the area
stretching from Uzbekistan through Afghanistan to Pakistan have
survived. But the late examples that do survive from this area suggest
that there may have been continuity between the very numerous
examples of pre-Islamic domestic architecture with four-columned
rooms and the modern period. It is not surprising to find the plan
reflected in the wooden-columned mosques of the area, although
again, because of their perishable material, no examples earlier than
Vakhshuvar (1713) have survived.

Should one also consider the four-columned tent of the Golden
Horde in this context? Tempting as it may be to relate the archi-
tecture of the sedentary community to that of the numerous sur-
rounding nomadic tribes, state tents did not have much in common
with typical nomad ones, and the practicality and stability of the
four-column plan was probably of more importance to those who
designed and erected state tents as its palatial parallels.

Another major group within which there is obvious correlation
is that of Ottoman quincunx mosques, so large a number that I
have listed merely some of the earlier examples. It is not neces-
sary in the case of the great imperial Ottoman mosques to assume
a direct derivation from Byzantine quincunxes: the preoccupation
of earlier Ottoman architecture with the large dome, and with the
gradual encirclement of it by first one, and then two half domes
(Fatih, Beyazid) shows that another route was possible (although this
other route was also clearly based on Byzantine models like Haghia
Sophia). But the presence of models in the many Byzantine quin-
cunx churches within the realm could have made local architects
particularly receptive to the plan, as in the case of the numerous
Christian and Islamic examples around Diyarbakir. It is also as well
to remember the requirements of the Ottoman quincunx architect,
irrelevant to his Christian counterpart, for a space at ground level
as unencumbered by supports as possible, and which therefore need
not reflect the complexities of the upper vaulting. In this way they
reflect accurately the aims of the earliest trabeate four-columned
structures: to roof as large a space as possible with minimal supports.

The East African group shows considerable homogeneity, although
the frequency with which architects in mosques not of the nine-bay
type placed pillars on the door–mihrab axis[233] makes one wonder just
how much thought went into the planning of these buildings. Garlake
has characterised the style as 'limited in its aims and satisfied with

a standardised and unadventurous technical competence sufficient only to such aims, never seeking the imaginative or inventive new solution'.[234] This is certainly not incompatible with the repeated use of the nine-bay plan.

Another area with obvious interrelationships is the Indian subcontinent. Four-column trabeate mosques are among the earliest (Junagadh) and latest (Kiris) examples of the type, and it may be hard initially to resist the idea that, as with many other features of Islamic architecture in India, Hindu architecture provided a model. The Muslim architect would of course have shrunk in horror at the idea of his mosque being related to a temple, but even with a similar ground plan there was little chance of them being mistaken for each other as, apart from the dearth of figural imagery, the horizontality of the Islamic trabeate examples sets them apart from the vertically piled masses of the temples. But it may be wondered why there is such a gap between the appearance of this plan at Junagadh in 1286 and the late fourteenth–early fifteenth-century examples in southern India. Perhaps architects truly did see the connection, and fearful of just such an accusation of copying temple plans, used trabeate architecture only for larger plans and for nine-bay mosques only arcuate examples which in their spatial qualities are far removed from Hindu architecture. In palaces more leeway was given architects to adapt Hindu models (although see the Khirki mosque below). This should now be evident not only from the Mughal examples of Fathehpur Sikri or the Jahangiri Mahal at Agra, but also from the Gujari Mahal at Hisar and the mandala plan of the Malcha Mahal. The *maqsura* of the Jahanpanah mosque and the gateway of the Adina mosque at Pandua could also be seen in this context of domestic architecture, rather than as, for instance, a variant of the superficially similar space in the Malik mosque at Kirman.[235]

There is one Indian building with a nine-bay element that I have not included in the table above, the Rajput palace of Govind Mandir at Orchha (c. 1620). Its nine-bay part, a trabeate quincunx, is one of the storeys of its imposing central tower and is not particularly significant in itself, but its context does provide a wonderful idea of the relatedness of the nine-bay and *hasht bihisht* plans (Figure 10.43).[236] The upper storey has a pavilion in the form of a *chahartaq* (even, if coincidentally, with diminutive domes at the corner like the Samanid tomb at Bukhara), its corners corresponding to the placement of the piers on the lower storeys. These, depending on the openness of the interior, can be nine-bay like the middle storey (no. 6 on the plan) or *hasht-bihisht* like the others (nos 4, 5 and 7 on the plan).

Table 3: Possible derivations of the nine-bay plan

Given that the nine-bay plan is one variation of the hypostyle hall, what variations of it should be considered as offshoots of the nine-bay plan, and what as part of the infinitely flexible hypostyle tradition?

Figure 10.43 *Orchha, Govind Mandir, the five stories of the central tower (c. 1620)*
(after Tillitson)

There are three candidates that at first sight can be related to the nine-bay tradition. Take away one aisle and a six-bay plan results, add one for a twelve-bay plan, and if an aisle is added on each side (and squared off) a twenty-five bay plan results. I will consider each of these in turn.

Six-bay plans

Unless otherwise mentioned, it may be assumed that two piers or columns support six domes of equal size on cross arcades.

Maghrib

Monastir, Sayyida mosque (eleventh century)[237]
Two cruciform piers support six cross-vaulted bays.

Egypt

Shillal, Qibli mashhad (before 534/1139)[238]

Arabian Peninsula

Ta'izz, Mu'tabiyya complex (before 796/1393)[239]

Juban, Mansuriyya madrasa (1482)[240]
The six domes are in the main prayer hall.

Madina, al-Ghumama mosque (nineteenth century?)[241]
It is not clear whether the present plan with a six-domed prayer hall reflects earlier foundations.

Mighlaf, al-Haddadiyya, Friday mosque (undated)[242]

al-Munira, Friday mosque, annexe (undated)[243]
In addition to the later six-domed annexe, the main prayer hall has six domes, although from the plan it looks as if three were added on to the original first group of three.

Turkey

Beyshehir, Eshrefoğlu khan (Beylik period)[244]

Istanbul, Zincirlikuyu mosque (late fifteenth century)[245]
A three-domed porch is now missing.

Diyarbakir, Ibrahim Bey mosque (late fifteenth–early sixteenth century)[246]
The two square piers of the prayer hall now support three domes and three cross vaults, but originally would have been domed throughout. Three-domed porch.

Gelibolu, khan (sixteenth C?)[247]

Diyarbakir: Arab Shaykh mosque (1054–60/1644–50)[248]
This has the same basic form as the Zincirlikuyu in Istanbul (including the porch), but with a barrel-vaulted side extension to the prayer hall.

Iran/Central Asia

Siraf, Site C, mosque (ninth–tenth century)[249]
The two piers, aligned with engaged piers on the walls, probably supported an arcade and a flat roof.

Lashkar-i Bazar, southern palace, room XXI, mosque (eleventh century) (Figure 10.44)[250]
A courtyard preceded the triple-arched entry to the prayer hall. The latter was roofed with barrel vaults parallel to the qibla.

Marand, Friday mosque (seventeenth century?)[251]
The Saljuq dome chamber here was redecorated in the Ilkhanid period, and a twelve-domed winter mosque built to one side (see below). In the Safavid period five domes were built around the original, forming two rows of three bays. Whether the Safavid domes replaced an earlier construction is not clear.

Eschkarand ('Ishqarand?), mosque 'C', shabistan (after 1300?)[252]
Siroux has suggested an earlier date for this, but in the absence of any specific criteria, it may be prudent to place it closer in date to the main mosque on the site.

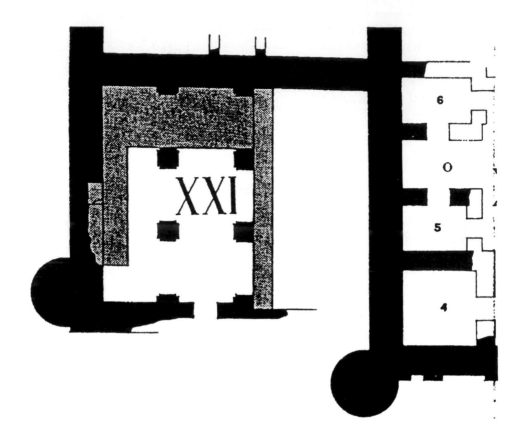

Figure 10.44 *Lashkar-i Bazar, southern palace, room XXI, mosque (eleventh century)*

Uba, Friday mosque (832/1420)[253]
The mosque is more recent than the date of the inscription, but may reflect a more ancient plan.

Nakhichivan area, annexe to Shaykh Khurasan mausoleum (fifteenth century)[254]
The annexe was added to the original late twelfth- or early thirteenth-century mausoleum.

Indian Subcontinent

Dhaka, Muazzampur, mosque (836–9/1432–6)[255]

Gulbarga, Langar Ki mosque (c. 837/1434)[256]

Two barrel-vaulted aisles.

Basirhat, Salih mosque (871/1466)[257]

Dhaka, Muazzamabad, Old mosque (1466–7)[258]

Jessore, Sailkupa (mid-fifteenth century)[259]

Chittagong, Faqir mosque (1474–81) (Figure 10.45)[260]

Dhaka, Rampal, Baba Adam mosque (1483)[261]

Gaur, Dhan Chawk mosque (late fifteenth century)[262]

Bagerhat, Rezai Khan mosque (early sixteenth century)[263]

Gulbarga, Dargah of Shaykh Siraj al-Din Junaidi, mosque (fifteenth or sixteenth century)[264]

Raichur, Kali mosque (early sixteenth century)[265]

Gaur, Jahaniyan mosque (941/1535)[266]

Rajshahi, Kushumba, mosque (1558)[267]

Osmanabad, Naldrug, Fort, mosque (958/1560)[268]

Gulbarga, Dornhalli, mosque (978/1570)[269]

Belgaum, Sampgaon, Friday mosque (third quarter sixteenth century)[270]

Bidar, tomb of Sultan 'Ali Barid, gatehouse (1577)[271]

Bijapur, Malika Jahan Begum mosque (c. 1586)[272]

Gulbarga, Yadgir, Sagar Darwaza mosque (early seventeenth century)[273]

Ahmadabad area: four mosques, undated (Figure 10.42)[274]

Six-bay plans: conclusions

As the table of Ahmadabad mosques shows, the number of three-bay (8) and six-bay (4) mosques in the area is substantially more than the single nine-bay example. Even in Bengal, which has one of the highest concentrations of nine-bay mosques (4), there are ten six-bay mosques and, dating from the fifteenth to the nineteenth century, a full thirty-nine examples of single-domed mosques. This suggests that for the Indian subcontinent, at any rate, the six-bay type should be seen as

Figure 10.45 *Chittagong, Faqir mosque (1474–81) (after Hasan)*

an agglomeration of the smaller units. This, it may be remembered, was also the conclusion reached in studying the Darb Zubayda and Siraf examples above, where the nine-bay mosques betrayed basilical origins, and the four six-bay examples could more easily be connected with the numerous three bay mosques. In Yemen three-bay mosques

are also common,[275] and given that the six-bay examples are more numerous than the nine-bay ones, again one can argue that a process of agglomeration rather than reduction is more likely for the six-bay plans there.

With the Ottoman examples it is striking how three of the four incorporate porches with three domes so that the total outline is of a regular nine-bay building. Unlike the areas above, three-bay mosques are not common in Turkey. This also applies to Egypt and Ifriqiyya, where, on the contrary, nine-bay plans are relatively numerous. In the case of these three regions, then, the small number of six-bay buildings could more readily be seen as deriving from the nine-bay examples.

Twelve bays

Unless otherwise mentioned, it may be assumed that six piers or columns support twelve domes of equal size on cross arcades.[276]

Egypt

In the examples of nine-bay monuments in Egypt churches whose *naos* was of nine-bays figured prominently. It is but a small step to configure the apse and two adjoining room as the east end of churches as a triple domed area joined on to the nine domes of the *naos*, resulting in twelve domes in all. The coincidence of the number with that of the apostles may be one reason for the dozens of examples of this form that appeared in eighteenth-to-nineteenth-century Egypt, although the transformation from nine to twelve bay form could well have occurred earlier.[277]

Iran/Central Asia

Marand, Friday mosque, shabistan (731/1330)[278]
The portal to the winter prayer hall is dated to the Ilkhanid period.

Shapurabad, Friday mosque (fourteenth century?) (Figure 10.46)[279]
Siroux dates it to the period eighth–ninth century, but, by his own admission, the tomb of Shaikh Sa'd near Isfahan presents one of the closest parallels to its shell-shaped mihrab. The latter is usually dated to the fourteenth century.

Haraz, caravansaray (Safavid)[280]

The Twelve-bay plan: conclusions

The plan of the Shapurabad mosque shows why it is an exceedingly rare one for mosques: the mihrab is on the long side, and hence has

Figure 10.46 *Shapurabad, Friday mosque (fourteenth century?) (after Siroux)*

to be off-centre. For the mihrab to be centred the prayer hall must be much deeper than it is wide, a rarely favoured configuration in small mosques.

In churches, however, the move from nine- to twelve-bay did not alter the basilical character of the space, and could be achieved by a fairly simple change to the apsidal recesses.

Twenty-five bays

Turkey

Saljuq caravanserais (thirteenth century):
Dolay han
Ishakli han
Haci Hafiz han
Susuz han
Horozlu han
Sari han
Çinçinli Sultan han
Çay han[281]

These all have the requisite number of piers, sixteen, but their basilical origins are evident in the barrel vaults that cover almost all of the interiors. None of them has more than one dome, found at the centre if present.

Suhut, Friday Mosque (818/1414)[282]

India

Delhi, Khirki Mosque (c. 1352–4) (Figure 10.47)[283]
The best way to view this plan is as a twenty-five-bay one, with four
bays opened for lighting purposes. Each of the remaining covered
twenty-one bays is in turn a self-contained nine-bay plan.

In some ways we have kept the best to the last, for this is the
ultimate in symmetry, guaranteed to send the nine-bay buff into par-
oxysms of delight, and such indeed must have been the appeal to its
architect. But the result shows how the desire for symmetry can do a
disservice to aesthetics. The mihrab bay projects from the main wall
of the mosque in such a way as to mirror the entrance units, but,
unlike them, its provision for lighting is minimal. The arrangement
of four courtyards within the mosque is again, on paper, a beauti-
fully symmetrical answer to the problem of bringing light into the
interior, but only at the cost of casting a tenebrous gloom over what
should be the focal point: the axis from entrance to mihrab.

It is hard to think of this plan, a mandala-based religious counter-
part to the Malcha Mahal, being conceived anywhere other than in
India.

Southeast Asia

Java, Demak, Agung mosque (early seventeenth century)
The plan has four very large central pillars and a partially walled
nine-bay area.

Conclusions

The permutations of the nine-bay plan and its relatives (or deriva-
tives) are innumerable, and the uses to which it has been put, if not
innumerable, are at least extremely varied, ranging from religious
architecture such as temples, churches, mosques, tombs, zawiyas
and madrasas to utilitarian buildings – cisterns, baths, refecto-
ries, gateways and caravansarays, and finally to residential archi-
tecture in all its diversity: tents, living rooms, audience halls and
palaces.

The interrelationships between all of these examples are equally
varied. Some clear cases of filiation have been remarked upon
above, but there is an equally large number that are not clearly
connected with other examples. In the vast world of Islam, extend-
ing from western Europe to southeast Asia, it is inevitable that
local building traditions were conservative in some parts, while in
others greater receptivity to outside ideas could emerge. The pre-
Islamic architecture of different regions also played varying roles.

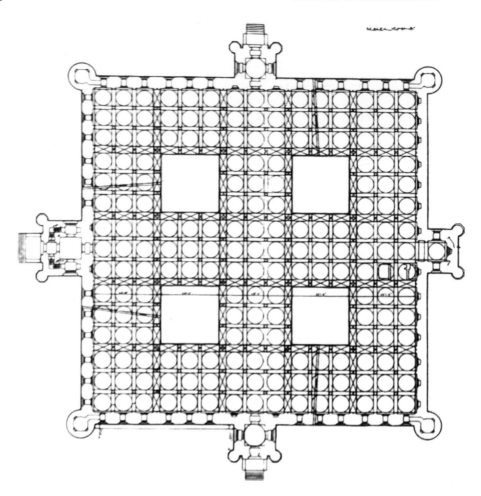

Figure 10.47 *Delhi, Khirki Mosque (c. 1352–4) (after Welch and Crane)*

With regard to this, it is worth considering the appearance of two four-columned rooms in an area quite outside the Islamic world, at the pre-Columbian site of Tula in Mexico. Among the rooms within a location that has been described as a domicile for priests are two of the above type, one of which may have been a kitchen (Figure 10.48).[284] By bringing attention to these I am not trying to give encouragement to the pyramidiologists to find links between Giza and Palenque. What I suggest is that, paradoxically, the more examples of the nine-bay plan that occur over space and time, the less the likelihood of there being a single origin or meaning for the form, and the greater the possibility that they should be seen as separate cultural developments.

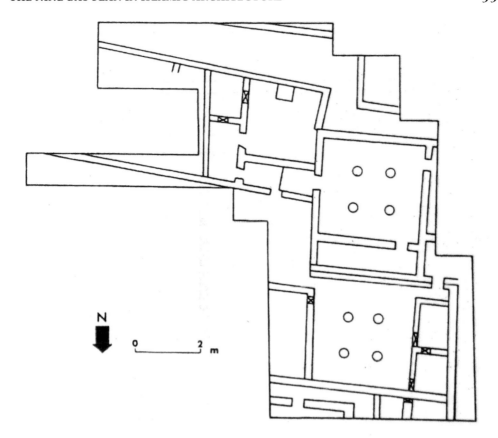

Figure 10.48 *Mexico, Tula, Toltec domicile (eleventh century) (after Diehl)*

Notes

1. Henri Frankfort, *The Art and Architecture of the Ancient Orient* (Harmondsworth, 1970), 410n. 56.
2. Rather than round up the usual suspects, which have been frequently published in other discussions of the nine-bay plan, I have preferred to illustrate, for the most part, lesser-known buildings here.
3. Lisa Golombek, 'Abbasid Mosque at Balkh', *Oriental Art*, N.S. 15 (1969), 173–89; G. A. Pougachenkova, 'Les monuments peu connus de l'architecture médiévale de l'Afghanistan', *Afghanistan* 21 (1968), 18–27; A. S. Melikian-Chirvani, 'La plus ancienne mosquée de Balkh', *Arts Asiatiques*, 20 (1969), 2–20; Richard Ettinghausen, *From Byzantium to Sasanian Iran and the Islamic World: Three Modes of Artistic Influence*, The L. A. Mayer Memorial Studies in Islamic Art and Archaeology 3, ed. R. Ettinghausen and O. Kurz (Leiden, 1972), 55–8; Christian Ewart, 'Die Moschee am Bab al-Mardum im Toledo. Eine "Kopie" der Moschee von Cordoba', *Madrider Mitteilungen* 18 (1977), 329–51.
4. Terry Allen, *Five Essays on Islamic Art* (n.p., 1988), 70–83; *idem*, 'Early Nine-Bay Mosques', unpublished manuscript – I am most grateful to the author for sending me a copy of the latter.

5. Geoffrey R. D. King, 'The Nine Domed Mosque in Islam', *Madrider Mitteilungen* 30 (1989), 332–90.
6. James W. Allan and K. A. C. Creswell *A Short Account of Early Muslim Architecture* (Cairo, 1989), 418.
7. James Knudstad, 'The Darb Zubayda Project: 1396/1976. Preliminary Report on the First Phase', *Atlal* 1 (1977), 41–68; Khalid al-Dayel, and Salah al-Helwah, 'Preliminary Report on the Second Phase of the Darb Zubayda Reconnaissance 1397/1977', *Atlal* 2 (1978), 51–64; Khalid al-Dayel, Salah al-Helwah and Neil MacKenzie, 'Preliminary Report on the Third Season of Darb Zubaydah Survey 1978', *Atlal* 3 (1979), 43–54; Neil D. MacKenzie and Salah al-Helwah, 'Darb Zubayda Architectural Documentation Program. a. Darb Zubayda– 1979: a Preliminary Report', *Atlal* 4 (1980), 37–50; Craig A. Morgan and Salah M. al-Helwa, 'Preliminary Report on the Fifth Phase of Darb Zubayda Reconnaissance 1400 A.H./1980 A.D.', *Atlal* 5 (1981), 85–107; Salah al-Helwah, Abdalaziz A. al-Shaikh and Abduljawwad S. Murad, 'Preliminary Report on the Sixth Phase of the Darb Zubaydah Reconnaissance 1981 (1401)', *Atlal* 6 (1982), 39–62; Sa'ad bin 'A. al-Rashid, *Darb Zubaydah. The Pilgrimage Road from Kufa to Mecca* (Riyadh, 1980); Sa'ad bin 'A. al-Rashid, *Al-Rabadhah* (Riyadh, 1986). For additional examples see now Chapter 5 in this volume.
 For convenience the sites with mosques are listed alphabetically:

Abu Rawadif: *Atlal* 4, 46, Pl. 49A
al-'Amya': *Atlal* 6, 61, Pl. 78
al-'Aqiq: *Atlal* 2, 62, Pl. 51; al-Rashid, *Darb Zubaydah*, 276
al-'Ara'ish Middle: *Atlal* 5, 104, Pl. 108C
al-'Ara'ish South: *Atlal* 5, 102, Pl. 108B
al-'Ashar: *Atlal* 6, 43, Pl. 64
Barud: *Atlal* 1, Pl. 39A
al-Bida': *Atlal* 5, 98, Pl. 106B
al-Dariba: *Atlal* 2, 59, Pl. 59B
Fayd (near Qasr Khrash): *Al-Rabadhah*, loose plan
al-Humayma North: *Atlal* 4, 41, Pl. 38
al-Humayma South: *Atlal* 4, Pl. 35
Hurayd: *Atlal* 4, 41, Pl. 40A
al-Jaffaliyya B: *Atlal* 4, 44, Pl. 42
al-Kharaba: *Atlal* 2, 63, Pl. 50
Kura': *Atlal* 3, 46, Pl. 32A
Ma'dan Bani Sulaim, *Atlal* 3, 47, Pl. 34A
al-Makhruqa, *Atlal* 4, 44, Pl. 45; 45, Pl. 47
al-Qa': *Atlal* 6, 60, Pl. 77A
al-Rabadha: *Al-Rabadhah*, figs 35–7
al-Saq'a: *Atlal* 3, 52, Pl. 38
al-Saqiyya: *Atlal* 4, 49, Pl. 53B
Shamat Kibd, *Atlal* 5, 95, Pl. 105
Sinaf al-Lahm: *Atlal* 4, 38, Pl. 36
al-Thulayma: *Atlal* 6, 58, Pl. 76
Umm al-Damiran: *Atlal* 1, 65, Pl. 47
al-Wausayt East: *Atlal* 5, 92, Pl. 104
al-Wausayt West, *Atlal* 5, 94, Pl. 103
al-Zafiri, *Atlal* 6, 62, Pl. 79
Zubala, *Atlal* 6, 54, Pl. 72.

8. A preliminary discussion of these was published in Bernard O'Kane, 'Mosque', *The Oxford Encyclopaedia of Archaeology in the Near East*, ed. M. Meyers (Oxford, 1997), 4:55–8. See now Chapter 14 in this volume.

9. K. A. C. Creswell, *Early Muslim Architecture*, 2 vols (Oxford, 1940–69) (henceforth *EMA*), 2, fig. 214; Alisdair Northedge, 'An Interpretation of the Palace of the Caliph at Samarra (Dar al-Khilafa or Jawsaq al-Khaqani)', *Ars Orientalis* 23 (1993), fig. 2, H335.

10. David Whitehouse, *Siraf III. The Congregational Mosque and Other Mosques from the Ninth to the Twelfth Centuries* (London, n.d.), 30–57.

11. Creswell, *EMA*, 2, fig. 214.

12. Northedge, 'An Interpretation', fig. 2, H 287 and H335; shown in greater detail in Creswell, *EMA* 2: fig. 194.

13. Whitehouse, *Siraf*.

14. It is difficult to interpret the mosque at al-ʿAmya, which has a courtyard preceding five cells, the middle one of which has a mihrab. The central location of the mihrab would make an unlikely plan for a multifunctional building – could it be a five-bay mosque with later compartmentalising walls?

15. The mosque at Zubala 2 is anomalous in that it had the six bays in one aisle, resulting in the mihrab being obscured by a pier.

16. A problem in identifying these rooms as mosques is that most of them do not appear to have traces of a mihrab. Arguments for their identification as mosques are 1) the plan type is one that is more closely associated with recognised mosques on the Darb Zubayda than with any other type of building; 2) they are all qibla oriented (unlike many of their surrounding buildings); 3) there is a parallel with the rooms that were added on to the *qasr*s: the mihrabs in many of the latter prove they were mosques; the placement and similarity of ground plans in those without traces of a mihrab suggest they too were mosques. As noted by Allen, 'Early Nine-Bay Mosques', n. 8, the published plans only represent the low stone course on which mudbrick walls were built. It is thus possible that the mihrabs were present within the thickness of the mudbrick walls above the stone courses.

17. Donald Whitcomb has published a very useful table of these *qasr*s, which he notes have plans similar to caravanserais: 'The Darb Zubayda as a Settlement System in Arabia', *Aram* 8 (1995), 31–2 and Fig. 2.

18. At Sinaf al-Lahm and Rabadha and al-Qaʿ engaged piers in line with the central ones are preserved on the qibla wall. The plan of al-Qaʿ shows only these engaged piers and two others; given their large size it seems reasonable to assume that the complete plan was of a nine-bay mosque similar to the others in the series.

19. Ibid., fig. 25.

20. Although at Umm al-Damiran the thinner walls of the narthex suggest that it might have been a later addition.

21. Svend Helms et al., *Early Islamic Architecture of the Desert: A Bedouin Station in Eastern Jordan* (Edinburgh, 1990), 73–82. Jeremy Johns, 'The "House of the Prophet" and the Concept of the Mosque', in *Bayt al-Maqdis: Jerusalem and Early Islam* (Oxford Studies in Islamic Art 9/2) (Oxford, 1999), refers to other possibly seventh-to-eighth-century hypaethral mosques in the Negev and at Wadi Shira in the Jordanian Hisma: 81 and Fig. 17.

22. Noha Khoury, 'The Mihrab: From Text to Form', *International Journal of Middle East Studies* 30 (1988), 1–27.

23. Jacques Bujard and Wilfried Trillen, 'Umm al-Walid et Khan az-Zabib, cinq qusur omeyyades et leurs mosquées revisités', *Annual of the Department of Antiquities of Jordan* 41 (1997), 355–6.

24. Helms, *Early Islamic Architecture*, fig. 26.

25. Allan and Creswell, *A Short Account*, fig. 72.

26. Bujard and Trillen, 'Umm al-Walid et Khan az-Zabib', 356; J. Bujard, 'Umm al-Walid', *Encyclopaedia of Islam*, 2nd edn, 10:859 and Fig. 3.

27. Cf. the basilica of Theodosius I (379–95) at Baʾalbak: Creswell, *EMA*, vol. 1 part 1, 193, fig. 97.

28. P. Amiet, *Art of the Ancient Near East* (New York, 1980), 472–3, fig. 836. The four columned room was the enlarged cella of a temple.

29. André Godard, *The Art of Iran* (London, 1965), fig. 127.

30. W. S. Smith and W. K. Simpson, *The Art and Architecture of Ancient Egypt* (Harmondsworth, 1981), figs 355–6.

31. E.g. in the harem of the palace of Amenhopis III at Thebes (fourteenth century BCE), in the Middle Kingdom worker's town at Kahun and in larger houses there: Alexandre Badawy, 'La maison mitoyenne de plan uniforme dans l'Égypte pharaonique', *Bulletin of the Faculty of Arts, Cairo University* 16/2 (1953), figs 26, 8–9, respectively; and in a bureaucrat's house at Amarna (fourteenth century BCE): Donald Preziosi, *The Semiotics of the Built Environment* (Bloomington, 1979), Pl. IX.

32. Edith Porada, 'Classic Achaemenian Architecture and Sculpture', in *The Cambridge History of Iran, II, The Median and Achaemenian Periods*, ed. I. Gershevitch (Cambridge, 1985), fig. 1/C and C'.

33. Godard, *The Art of Iran*, figs 139–40. For the most recent discussion of the so-called 'Fratadara' temple at Persepolis see I. Pichikyan, 'The Fire-Temple at Persepolis (Composition, Dating, Attribution)', *Information Bulletin, International Association for the Study of the Cultures of Central Asia* 16 (1989), 55–73.

34. Susa: Porada, 'Classic Achaemenian Architecture', figs 6–7. Persepolis: ibid., fig. 1/buildings K, M'.

35. This is suggested in David Stronach, 'Pasargadae', in *The Cambridge History of Iran, II, The Median and Achaemenian Periods*, ed. I. Gershevitch (Cambridge, 1985), 843.

36. I. Pichikyan, 'The Oxus Temple Composition in the Context of Architectural Comparison', *Information Bulletin, International Association for the Study of the Cultures of Central Asia* 12 (1987), 42–65, fig. 1.

37. Günkut Akin, *Asya merkezi mekan geleneği* (Ankara, 1990), 192, fig. 3.

38. Susan B. Downey, *Mesopotamian Religious Architecture: Alexander Through the Parthians* (Princeton, 1988), fig. 58.

39. V. Shkoda, 'Iranian Traditions in Sogdian Temple Architecture', in *The Art and Archaeology of Ancient Persia*, ed. Vesta Sarkhosh, Robert Hillenbrand and J. M. Rogers (London, 1998), 126, fig. 2.5.

40. Klaus Schipmann, *Die iranischer Feuerheiligtümer* (Berlin, 1971), fig. 81. Schippmann's conclusions (476–515) give an overall view of many buildings discussed here.

41. Georgina Herrmann, *The Iranian Revival* (Oxford, 1977), 34–5; D. Schlumberger, 'Parthian Art', in *The Cambridge History of Iran, III, The Seleucid, Parthian and Sasanian Periods*, ed. Ehsan Yarshater (Cambridge, 1983), fig. 5.

42. O. Reuther, 'Parthian Architecture. A. History', in *A Survey of Persian Art*, ed. A. U. Pope and P. Ackerman (Oxford, 1938), I, figs 106, 108.

43. E.g. at Sahr, first century BCE, ibid., fig. 112b, and the sanctuary of Ba'alshamin (33–32 BCE) and the adjacent Dushara Temple at Seeia (Si'), J. B. Ward-Perkins, *Roman Imperial Architecture* (Harmondsworth, 1981), fig. 220. For the temple at Sur, first century BCE–first century CE, see the references in Schippmann, *Feuerheiligtümer*, 481.

44. Shkoda, 'Iranian Traditions', fig. 1.

45. Mihdi Rahbar, 'Mu'arrifi-yi Ardian (niayishgah) – i makshufa-yi daura-yi sasani dar Bundian-i Darragaz va barrasi-yi mushkilat-i in bana', in *Duvummin Kungira-yi tarikh-i mi'mari va shahrsazi-yi Iran* (Tehran, 1379/2000), 2:315–41.

46. *The History of Bukhara*, trans. Richard N. Frye (Cambridge, MA, 1954), 21, 48–9.

47. For some examples of surviving converted fire temples, see Bernard O'Kane, '*Chahartaq*, Islamic period', *Encyclopaedia Iranica* IV/6, 639–42.

48. Mehrdad Shokoohy, 'The Sasanian Caravanserai of Dayr-i Gachin, south of Ray, Iran', *Bulletin of the School of Oriental and African Studies* 46 (1983), 445–61.

49. V. G. Veselovsky et al., *Arkhitektura Sovyetskogo Tadzhikistana* (Moscow, 1987), 16 (small houses); V. L. Voronina, 'Arkhitektura Drevnego Pendzhikenta', in *Trudi Tadzhikskoi Arkheologicheskoi Ekspeditsii, 3, 1951–3 gg.*, Akademiya Nauk SSSR, Materiali i Issledovaniya po Arkheologii CCCR 66) (Moscow and Leningrad, 1958), Fig. 3 (Panjikent); Sergej G. Chmelnizkij, 'Peshtak und Mihrab: Zur Frage der Herkunft der Portalformen in der zentralasiatischen Architektur', *Istituto Universitario Orientale, Annali* 47 (1987), fig. 2 (palace at Shahristan); *idem*, 'Zur Klassifikation der frühmittelalterlichen Burgen in Mittelasien', *Istituto Universitario Orientale, Annali* 45 (1985), 25–47, fig. IV.3 (Jumalak Tepe).

50. B. A. Litvisky and T. I. Zeymal, *Adzhina-Tepa* (Moscow, 1971), 18, 221.

51. Chmelnizkij, 'Zur Klassifikation', 45–6.

52. Ibid., 37–8.

53. Ward-Perkins, *Roman Imperial Architecture*, fig. 221. The building is now thought to have been a Roman temple originally: Klaus S. Freyberger, 'Das Tychaïon von as-Sanamaïn. Ein Vorbericht', *Damaszener Mitteilungen* 4 (1989), 89n. 15.

54. It has been established that the transformation to its present cross-shaped plan was in 483 and not 628, the latter date marking the substitution of a stone for a wooden dome: O. Kh. Khalpakhchian, *Architectural Ensembles of Armenia 8 B.C.–19 A.D.* (Moscow, 1980), 102–3, fig. 2.

55. Numerous examples are given in Richard Krautheimer, *Early Christian and Byzantine Architecture* (Harmondsworth, 1975), chs 16–17; for a discussion of the origin and development of the quincunx plan see ibid., 359–62. For two later examples of the regular nine-bay plan in Armerian architecture, at the monasteries of Ahpat (thirteenth century) and Varak Vank (seventeenth century) see Akin, *Asya merkezi mekan*, 201–2, figs 19–20.

56. K. J. Conant, *Carolingian and Romanesque Architecture 800 to 1200* (Harmondsworth, 1978), figs 11–12; Matthias Untermann, *Der Zentralbau in Mittelalter* (Darmstadt, 1989), 122–3. Untermann cites

St Germigny-des-Près in connection with the nine-bay core of the Frauenkirche at Nürnberg (1349): ibid., Fig. 60.

57. Dietrich Huff, 'Chahartaq I. In Pre-islamic Iran', *Encyclopaedia Iranica* 4:637, Fig. 36.

58. Gunnar Brands, 'Der sogennante Audienzsaal des al-Mundir in Resafa', *Damaszener Mitteilungen* 10 (1998), 211–35.

59. Its relationship with other nine-bay plans has been discussed in Ettinghausen, *From Byzantium to Sasanian Iran*, 49–58 and King, 'Nine Domed Mosque', 385–6.

60. See n. 4 above.

61. Creswell, loc. cit. Assuming symmetry, the number of bays with special emphasis could have been from nine to twenty-five.

62. Creswell, *EMA*, I/2, 481, fig. 542.

63. Creswell, *EMA*, I/2, 505, figs 560–1.

64. Cf. the basilica of Theodosius I (379–95)) at Ba'albak: Creswell, *EMA*, I/I, 193, fig. 97.

65. Creswell and Allan, *Short Account*, 161, fig. 92.

66. The plan in Creswell and Allan, *Short Account*, 12, is more useful than that of the reprint of *EMA*, I/I, as it is contained on one page, and thus permits the proportions to be seen more faithfully.

67. E.g. those of Damghan and Kish, reproduced in J. Suaveget, *La mosquée omeyyade de Médine: étude sur les origines architecturales de la mosquée et de la basilique* (Paris, 1947), 163–4, figs 27–8.

68. Allen, *Five Essays*, 81–2.

69. On this point see MacKenzie and al-Helwah, 'Darb Zubayda Architectural Documentation Program', 50. The excavators of the *qasr* at al-Rabadha regard the area simply as the main residential part of the town. Whitcomb, 'Darb Zubayda', 32, notes that the main buildings have 'administrative (palatial) functions, combined with religious (mosques) and commercial (khan) aspects'.

70. See n. 66 above.

71. The basilica itself had earlier undergone a change from a large meeting hall under the Romans to a Christian church plan; for a study of its further influence on Islamic mosques and palaces, see Sauvaget, *La mosquée omeyyade*.

72. See n. 2 above.

73. Creswell, *EMA*, II, 246–8; King, 'Nine Bay', 332–3.

74. Gisela Kircher, 'Die Moschee des Muhammad b. Hairun ('Drei-Tore-Moschee') in Qairawan/Tunisien', *Mitteilungen des Deutschen Achäologische Instituts, Abteilung Kairo* 26 (1970), 141–67. Pl. Lva-b shows clearly the groin vaulting of the bays. Discussion of this monument is susprisingly omitted by King, presumably on the ground that it is not domed, although its groin vaulted bays are closer to his domed examples than the barrel-vaulted Bu Fatata which he does discuss.

75. Basilio Pavón Maldonado, *Tratado de Arquitecture Hispanomusulmana, I: El Aqua* (Madrid, 1990), 20–2. Fig. 10, p. 22, illustrates both the Cordoba and Carthage cisterns.

76. Ewert, 'Die Moschee am Bab al-Mardum', 287–351; King, 'Nine Bay', 339–42.

77. M. Gomez-Moreno, *El arte árabe hasta los Almohades: arte mozárabe, Ars Hispaniae*, 3 (Madrid, 1951), 210–12; King, 'Nine Bay', 342–5; Clara Delgado Valero, *Toledo islamico: cuidad, arte e historia* (Toledo, 1987), 303–17.

78. Mahmoud Ali Mohamed and Peter Grossman, 'On the Recently Excavated Monastic Buildings in Dayr Anba Shinuda: Archaeological Report', *Bulletin de la Société d'Archéologie Copte* 30 (1991), 53–63.

79. Hugh G. Evelyn-White, *The Monasteries of the Wâdi 'n Natrûn. Part III. The Architecture and Archaeology*, ed. Walter Hauser (New York, 1933), 165, Pl. XXXVII.

80. *From Byzantium*, 50–3.

81. Wlodzimierz Godlewski, 'The Mosque Building in Old Dongola', *New Discoveries in Nubia: Proceedings of the Colloquium on Nubian Studies, The Hague 1979*, ed. Paul van Moorsel (Leyden, 1982), 21–8; King, 'Nine Bay', 358–60. Anotehr Nubian church design may also be relevant. At Abu Sir (750–850) and Tamit (800–1250) the central core of the church is again a square, supported at Abu Sir by four columns and at Tamit by four L-shaped piers: Przemyslaw M. Gartkiewicz, 'An Introduction to the History of Nubian Church Architecture', *Nubia Christiana* 1 (1982), fig. 2. Gartkiewicz sees this plan as deriving from a basilical one, e.g. Buhen, 650–800 (ibid., loc. cit.), or Kageras (ibid., fig. 19/3) which have rectanglar sanctuaries with four rectangular piers, similar to many of the examples on the Darb Zubayda.

82. *Chukinto Bunka Senta no kaigai hakkutsu chosa (Excavations Abroad Conducted by the Middle East Cultural Center)* (in Japanese) (Tokyo, 1999), Fig. 35.

83. Creswell, *MAE* 1, 11–15.

84. King, 'Nine Bay', 345–51.

85. Creswell, *MAE* 1, 144–5; Ugo Monneret de Villard, *La Nubia Medioevale, Mission Archéologique de Nubie, 1929–1934* (Cairo, 1957), 56–7, King, 'Nine Bay', 351–3.

86. Monneret de Villard, *La Nubia Medioevale*, 29, fig. 22; King, 'Nine Bay', 356–8.

87. Gartkiewicz, 'Introduction', fig. 24.1.

88. Gartkiewicz, 'Introduction', fig. 24.2.

89. Gartkiewicz, 'Introduction', fig. 24.3.

90. Al-Maqrizi, *Al-mawa'iz wa'l i'tibar bi-dhikr al-khitat wa'l-athar* (Bulaq, 1270/1853), 2:289–90. Maqrizi's date of 478/1094 results from confusion between Arabic 7 and 9; the correct date is given by al-Nuwayri, after al-Juwwani and Ibn Khallikan: Ayman Fu'ad Sayyid, *La capitale de l'Égypte jusqu'à l'époque fatimide: al-Qahira et al-Fustat* (Beiruter Texte und Studien, 48) (Beirut, 1998), 471. As the founder of the mosque, al-Afdal, only succeeded his father in 487/1094, the date of 498H is much more likely. The building is also discussed in Golombek, 'Abbasid Mosque', 188; O. Grabar, 'The Earliest Islamic Commemorative Structures', *Ars Orientalis* 6 (1966), 10; King, 'Nine Bay', 353–6. Pace King, 'Nine Bay', 353n. 41, Golombek is certainly right in stating that its name was derived from its piers, *pilpaya* being the Persian for elephant foot, i.e. a large pier. While it is true, as King states, that 'the text does not seem to support this interpretation', Maqrizi's explanation that the nine domes resembled elephants with warriors on top is as likely as his explanation that the design for the minaret of Ibn Tulun's mosque came from the ruler's twisting a piece of paper around his finger.

91. U. Scerrato, G. Ventrone, P. Cuneo, 'Report on the 3rd Campaign for Typological Survey of the Islamic Religious Architecture of North

Yemen', *East and West* 36/4 (1986), Fig. 59. Barbara Finster, 'Islamic Religious Architecture in Yemen', *Muqarnas* 9, 126, ascribes the mosque to the thirteenth to fourteenth century.

92. *The Travels of Ibn Battuta* A.D. *1325–1354*, trans. H. A. R. Gibb, 3 vols (Cambridge, 1958–71), 1:94; the reference is first noted in Allen, 'Early Nine-Bay Mosques', n. 6.

93. C. Preusser, *Nordmesopotamische Baudenkmäler altchristlicher und islamischen Zeit* (Leipzig), 62, pl. 77; King, 'Nine Bay', 364–5.

94. Herzfeld and Sarre, *Archäologische Reise*, 236–8. King, 'Nine Bay', 360–4.

95. Or like the cross-vaulted six-bay mosque at Monastir (see below).

96. M. Horton, 'Primitive Islam and Architecture in East Africa', *Muqarnas* 8 (1991), 108, fig. 5.

97. *Tarikh-i Sistan*, ed. Malik al-Shuʿara Bahar (Tehran, 1314/1935), 280. The passage has been translated as 'nine new dome[d building]s' (Milton Gold, *Tarikh-i Sistan* [Rome, 1976], 223), but Bahar's emendation (loc. cit., n. 3) of *nau* to *tu*, as in *tu dar tu*,-fold, i.e. nine-fold, makes more sense. Writing in the fifteenth century Ahmad b. Husayn b. ʿAli Katib, *Tarikh-i Jadid-i Yazd*, ed. Iraj Afshar (Tehran, 1345/1966), 130, records a village near Yazd by the name of Nuh Gunbad. Which building gave rise to this name is not specified, but it could argue for a well-known type.

98. See n. 2 above.

99. G. A. Pugachenkova, *Termes, Schahr-i Sabz, Chiwa* (Berlin,1981), 14, fig. 1; King, 'Nine Bay', 338.

100. V. A. Nilsen, *Monumentalnaya Arkhitektura Bukharskogo Oazisa XI–XII vv.* (Tashkent, 1956), 70–83; Allen, 'Early Nine-Bay Mosques', n. 6.

101. The best drawings and illustrations are in V. Voronina, 'Nekotorie Dannie o Pamyatnikakh Zodchestva Uzbekistana', *Arkhitekturnoe Nasledstvo* (3) 1953), 107–19.

102. Whitehouse, *Siraf*, 45–8.

103. *A Survey of Persian Art*, ed. A. U. Pope and P. Ackerman (London and New York, 1939), 2:994, 1033–4, fig. 367; Allen, 'Early Nine-Bay Mosques', n. 6.

104. Shokoohy, 'The Sasanian Caravanserai'.

105. ''Abbasid Mosques in Iran', *Rivista degli Studi Orientali* 59 (1985), 203–4.

106. See G. A. Pugachenkova, *Puti Razvitiya Arkhitektury Yuzhnogo Turkmenistana Pory Rabovladeniya i Feodolizma, Trudy Yuzhno-Turkmenistanskoi Arkheologicheskoi Komplekskoi Ekspeditisii* 6 (Moscow, 1958), 166–7. It has been discussed by both Golombek ('Abbasid Mosque', 188) and Hillenbrand (''Abbasid Mosques', 202).

107. See n. 97 above.

108. The likelihood of the influence occurring in reverse, from religious to residential architecture, is rather less probable. It is not necessary to assume, as does Golombek ('Abbasid Mosque', 188), that the adaptation was of a foreign model.

109. Ernst Herzfeld, in remarking on the prevalence of aesthetic over practical considerations, remarked that 'nowhere is the urge for multiple symmetry so strong as in Iran' ('Damascus: Studies in Architecture – I', *Ars Islamica* 9 [1942], 34). His remarks were à propos of the plans of two buildings which indeed have nine-bays plans: the Sasanian Qalaʾ-i

Kuhna, Sarpul (ibid., 32, fig. 21), and the fifteenth-century mausoleum of Baba Munir (ibid., 31, fig. 20). These have been excluded from the examples in the main body of the piece as their plans are extremely compartmentalised (to a much greater degree than the *kushk* at Tahmalaj, see n. 106 above), the bays taking up less space than the walls surrounding them. Herzfeld appropriately compares their plans to that of the Sasanian fire temple (that of Gira, southern Fars, ibid., 33, fig. 22; for other examples see Huff, 'Chahartaq', 4:635–8).

110. Creswell, *EMA*, 2, 161–4.

111. Gardiewicz, 'Introduction', 96–7; King, 'Nine Bay', 388.

112. *Architettura in Sicilia nelle età islamica e normanna (827–194)* (Palermo, 1990), Santa Maria dell'Ammiraglio, 126–9; Santa Maria Maddalena, 132–3; San Cataldo, 136–8.

113. 'Nine Bay', 386.

114. The importance of this is demonstrated most vividly in the Islamic architecture of the East African coast: 'The planning of every building is restricted by the span of the timber rafters – which never exceeds 2.80 m. This places the plans in a dimensional 'strait jacket', so restrictive that it is a universal feature of every space – even the vaulted buildings conform to it', P. S. Garlake, *The Early Islamic Architecture of the East African Coast* (Oxford, 1966), 11.

115. Despite this impracticality, the form is still occasionally found: Jabal Says, mosque, c. 710–5, Creswell, *EMA*, 1/2 (Oxford, 1969), 476, fig. 538; Siraf: mosque at Site P2, ninth–twelfth centuries: Whitehouse, *Siraf*, 48, fig. 26; Bitlis: Dört Sandik Cami, 950–60/1543–52, Vakiflar Genel Müdürlügü, *Türkiye'de Vakif Abideler ve Eski Eserler*, 2 (Ankara, 1977), 152; Bitlis, Asagi Kale Cami, eighteenth century, ibid., 153, Bitlis, Taş Cami, eighteenth century, ibid., 155. A bedesten in Amasya, 888/1483, is also recorded with the same plan: Vakiflar Genel Müdürlügü, *Türkiye'de Vakif Abideler ve Eski Eserler*, 1 (Ankara, 1983), 285. When the only entrance is from the side of the mosque, as in the al-ʿAli mosque at Manah, Oman (Monique Kervran, *'Mihrab/s omanis du 16e siècle: un curieux exemple de conservatisme de l'art du stuc iranien des époques seldjouqide et mongole'*, *Archéologie Islamique* 6 [1996], 145, fig. 37), the effect may have been less incongruous.

116. For studies of this see R. A. Jairazbhoy, 'The Taj Mahal in the Context of East and West: A Study in the comparative Method', *Journal of the Warburg and Courtauld Institutes* 24 (1961), 59–88; Akin, *Asya Merkezi Mekan*, 220–31.

117. I have usually commented on the entrances only if they are numerous.

118. R. Bourouiba, *L'Art religieux musulman en Algérie* (Algiers, 1973), Pl. XVIII/1, fig. 42.

119. A. Daoulati, *Tunis sous les Hafsides: évolution urbaine et activité architecturale* (Tunis, 196), 205, fig. 45.

120. Ibid., 225, fig. 58.

121. Maldonado, *Tratado*, 23, Fig. 11.

122. Ibid., 24, Fig. 12.

123. Ibid., 24, Fig. 9.

124. Salah Ahmad al-Bahnasi, 'Al-taʾthirat al-ʿuthmaniyya ʿala al-ʿimara wa'l-funun al-islamiyya fi Libya mundhu badayat al-ʿasr al-ʿuthmani al-awwal wa hatta nihayat al-ʿasr al-ʿuthmani al-thani (958–1330/1551–1911)', in *Actes du IIème Congrès du Corpus d'Archéologie Ottomane*

dans le Monde: architectures des demeures, inscriptions funéraires et dynamique de restauration, ed. Abdeljelil Temimi (Zaghouan, 1998), 77, fig. 8.

125. Ernst Herzfeld, *Matériaux pour un Corpus Inscriptionum Arabicarum, part II: Syrie du Nord; inscriptions et monuments d'Alep*, Mémoires de l'Institut Français Orientale du Caire, 76–7 (Cairo, 1954–5), 94–5, Pl. XXVI.

126. Leonor Fernandes, 'Three Sufi Foundations in a 15th Century *Waqfiyya*', *Annales Islamologiques* 17 (1981), plan opp. 146.

127. This is less surprising given the growing influence on domestic on religious architecture in the Mamluk period: see Bernard O'Kane, 'Domestic and Religious Architecture in Cairo: Mutual Influences', *Studies in Honor of Layla ʿAli Ibrahim*, ed. Doris Behrens-Abouseif (Cairo, 2001), Chapter 12 in this volume.

128. Seif El Rashidi, *Early Ottoman Architecture in Cairo: In the Shadow of Two Imperial Styles*, unpublished MA thesis, American University in Cairo, 1999, 18–20.

129. Ibid., 22–3.

130. Ibid., 23–4.

131. Ibid., 31–2.

132. Ibid., 34–5.

133. André Raymond, *Grandes ville arabes à l'époque ottomane* (Paris, 1985), 259, fig. 20.

134. Doris Behrens-Abouseif, 'The Lost Minaret of Shajarat ad-Durr at Her Complex in the Cemetery of Sayyida Nafisa', *Mitteilungen des Deutschen Archäologische Instituts: Abteilung Kairo* 39 (1983), Fig. 3.

135. Mohammad al-Asad, 'The Mosque of al-Rifaʿi in Cairo', *Muqarnas* 10 (1993), Fig. 11. The question of the plan is not addressed in this article, perhaps because, as I heard the author state in reply to a question at his lecture on the mosque, he thought it was European. The previous examples show that it is very much in the Cairene Ottoman tradition.

136. King, 'Nine Bay', 370–1.

137. Kervran, '*Mihrab*/s omanis', 152, fig. 47.

138. Scerrato et al., 'Report', fig. 55.

139. Finster, 'Islamic Religious Architecture', 126, writing of 'cubical mosques with only four or even two supports', includes 'the Masjid al-Dar in Jibla (mid-thirteenth century), the Masjid al-ʿArraf from 1081 (the constructional history of which is problematic), and the mosque of Qaydan near Tawila … later thirteenth or fourteenth century'. I have no further information on these monuments to indicate which might have two, and which four supports.

140. Garlake, *Early Islamic Architecture*, 13, fig. 66.

141. Garlake, *Early Islamic Architecture*, 138, fig. 17; King, 'Nine Bay', 371–3.

142. Garlake, *Early Islamic Architecture*, 138, fig. 17; King, 'Nine Bay', 373–4.

143. Garlake, *Early Islamic Architecture*, 56, 81, fig. 19.

144. Ibid., 41, 44, fig. 26.

145. Ibid., 71, fig. 48.

146. Ibid., 6, fig. 46.

147. Ibid., 6, fig. 45.

148. Ibid., 67, figs 43–4.

149. Ibid., 71, fig. 50.

150. Ibid., 71, fig. 53.
151. Ibid., fig. 54.
152. Ibid., fig. 61.
153. Gabriel, *Monuments turcs d'Anatolie* (1931), 155.
154. Gabriel, *Monuments turcs d'Anatolie* (1931), 155.
155. Behçet Ünsal, *Turkish Islamic Architecture: Seljuk to Ottoman* (London, 1970), fig. 1a.
156. Ünsal, *Turkish Islamic Architecture*, fig. 4b; King, 'Nine Bay', 366–8.
157. Oktay Aslanapa, *Turkish Art and Architecture* (London, 1971), 220, Plan 40; Aptullah Kuran, *The Mosque in Early Ottoman Architecture* (Chicago, 1968), 196, fig. 220; King, 'Nine Bay', 368–9.
158. Aslanapa, *Turkish Art and Architecture*, 215, fig. 164.
159. Gabriel, *Monuments turcs d'Anatolie* (1931), 154.
160. Aslanapa, *Turkish Art and Architecture*, 214–15, Plan 46; Kuran, *The Mosque*, fig. 221.
161. Kuran, *The Mosque*, fig. 222.
162. Aptullah Kuran, *Sinan, the Grand Old Master of Ottoman Architecture* (Washington and Istanbul, 1987), 167, fig. 175.
163. Ibid., 122, figs 109–10.
164. Godfrey Goodwin, *A History of Ottoman Architecture* (London, 1971), 341, fig. 340.
165. M. Sözen, *Diyarbakir'da Türk Mimarisi* (Istanbul, 1971), 104, fig. 31.
166. *Türkiye'de Vakif Abideler ve Eski Eserler*, 2 (Ankara, 1977), 231–7.
167. Gabriel, *Monuments turcs d'Anatolie. I. Kayseri-Nigde* (Paris, 1931), 92.
168. *Türkiye'de Vakif Abideler ve Eski Eserler*, 1 (Ankara, 1983), 487–8.
169. Ibid., 192.
170. Ibid., 583–5.
171. Ibid., 755.
172. Rudolph Naumann, *Die Ruinen von Tacht-e Suleiman und Zendan-i Suleiman und Umgebung*, Deutsches Archäologisches Institut, Abteilung Tehran, Führer zu archäologischen Plätzen in Iran, 2 (Berlin, 1977), figs 82–3; Tomoko Masuya, *The Ilkhanid Phase of Takht-i Sulaiman*, unpublished Ph.D. dissertation, New York University, 1997, 1:139–40.
173. Masuya, *Ilkhanid*, 1:140.
174. Plan in W. Kleiss, 'Hinweise zu einigen seldjuqischen und il-khanidschen Bauten in Iran', *Archeologische Mitteilungen aus Iran*, n.f. 10 (1977), 297, Fig. 5; for the date see Bernard O'Kane, 'Natanz and Turbat-i Jam: New Light on Fourteenth Century Iranian Stucco', *Studia Iranica* 21 (1992), 85–92.
175. Bernard O'Kane, 'The Friday Mosques of Asnak and Saravar', *Archaeologische Mitteilungen aus Iran* n.f. 12 (1979) (published 1980), fig. 1; also reprinted in *idem*, *Studies in Persian Art and Architecture* (Cairo, 1995), no. XI.
176. Oliver Watson, 'The Masjid-i Ali, Quhrud: an Architectural and Epigraphic Study', *Iran* 13 (1975), 59–74; King, 'Nine Bay', 366.
177. Peter Morgan, 'New Thoughts on Old Hormuz: Chinese Ceramics in the Hormuz Region in the Thirteenth and Fourteenth Centuries', *Iran* 29 (1991), fig. 5.
178. W. Kleiss, 'Bericht über Erkundungsfahrten in nordwest-iran im Jahre 1969', *Archaeologische Mitteilungen aus Iran* n.f. 3 (1970), 123, Fig. 12,

Pls 59.2, 60. The mosque's nine-bay context was first noted in Allen, 'Early Nine-Bay Mosques', n. 6.

179. O'Kane, 'The Friday Mosques', fig. 5.

180. Maxime Siroux, *Anciennes voies et monuments routiers de la région d'Ispahân* (Cairo, 1971), 211, Fig. 70; *idem*, 'L'évolution des antiques mosquées rurales de la région d'Ispahan', *Arts Asiatiques* 26 (1977), 78, Fig. 14; Allen, 'Early Nine-Bay Mosques', n. 6.

181. Siroux, *Anciennes voies*, 248–9, fig. 83.

182. Useinov et al., *Istoria arkhitektury Azerbaydzhana*, 205, fig. 193.

183. Siroux, 'Kouh-Payeh: la mosquée djum'a et quelques monuments du bourg et de ses environs', *Annales Islamologiques* 6 (1966), 158, Pl. XVI.

184. Donald Wilber, *The Masjid-i 'Atiq of Shiraz*, The Asia Institute, Monograph Series, 2 (Shiraz, 1972), 20–1, pl. 35, fig. 12.

185. Muhammad Yusuf Kiyani and Wolfram Kleiss, *Karvansarayha-yi Iran*, 1 (Tehran, 1362/1983), 41.

186. Ibid., 34.

187. Ibid., 35.

188. Ibid., 242.

189. Ibid., 242.

190. Muhammad Yusuf Kiyani, W. Kleiss, *Karvansarayha-yi Iran*, 2 (Tehran, 1368/1989), 82.

191. M. Useinov, L. Bretanitskii and A. Salamzade, *Istoria arkhitektury Azerbaydzhana* (Moscow, 1963), 10–11, figs 2–3.

192. 'Abd al-Hamid Maulavi, *Athar-i bastani-yi Khurasan* (Tehran, 1354/1975), 440.

193. *The Travels of Ibn Battuta*, 2:494.

194. Pugachenkova, *Puti Razvitiya Arkhitektury Yuzhnogo Turkmenistana*, 288; Allen, 'Early Nine-Bay Mosques', n. 6.

195. L. Mankovskaya, *Arkhitekturnie Pamyakniki Kashkadari* (Tashkent, 1971), 40–1.

196. *Idem, Tipologicheskie Osnovi Zodchestva Srednei Azii (IX–nachalo XXv.)* (Tashkent, 1980), fig. 15a.

197. L. I. Rempel, 'Narodnaya Arkhitektura Predgornoi Zoni Yuga Uzbekistana', *Iskusstvo Zodchikh Uzbekistana* 4 (Tashkent, 1969), 175, fig. 10.

198. Ibid., fig. 14.

199. L. Mankovskaya, V. Bulatova, *Pamyatniki Zodchestva Khorezma* (Tashkent, 1978), 54, fig. 44.

200. Ibid., 71, 142–4, fig. 66.

201. V. Nusov, *Arkhitektura Kirgizii s Dreveishikh Vremen do Nasikh Dnei* (Firunze, 1971), fig. 66.

202. V. G. Veselovski et al., *Arkhitektura Sovyetskogo Tadzhikistana* (n.p., 1987), 45.

203. Ibid., 46.

204. Akin, *Asya merkezi mekan*, 195–7.

205. George Michell, *The Hindu Temple: An Introduction to Its Meaning and Forms* (Chicago and London, 1988), 71–2, Fig. 27; G. H. R. Tillotson, *The Rajput Palaces: The Development of an Architectural Style, 1450–1750* (New Haven and London, 1987), 80–3, fig. 108; Stella Kramrisch, *The Hindu Temple*, 1 (Calcutta, 1946), 21, 32.

206. Michael W. Meister and M. A. Dhaky (eds), *Encyclopaedia of Indian Temple Architecture: South India, Upper Dravidadesa, Early Phase,*

A.D. 550–1075 (Philadelphia, 1986), figs 20–2, 26, 27–8; Michell, *The Hindu Temple*, 113, fig. 53, 138, fig. 74.

207. Tillotson, *The Rajput Palaces*, 171–3, fig. 210.
208. M. Shokoohy, M. Bayani-Wolpert and N. Shokoohy, *Bhadresvar, The Oldest Islamic Monuments in India* (Leiden, 1988), fig. 41.
209. A. Welch and Howard Crane, 'The Tughluqs: Master Builders of the Delhi Sultanate', *Muqarnas* 1 (1983), 131, fig. 1.
210. Ahmad Hasan Dani, *Islamic Architecture: The Wooden Style of Northern Pakistan* (Islamabad, 1410/1989), 144–6, fig. 31.
211. Mahrdad and Natalie H. Shokoohy, *Hisar-i Firuza: Sultanate and Early Mughal Architecture in the District of Hisar, India* (London, 1988), 20, fig. 5.
212. Ibid., 40–4, fig. 16.
213. Ibid., 47–51m, fig. 19.
214. Ibid., fig. 10, 153.
215. Catherine B. Asher, 'Inventory of Key Monuments', in George Michell (ed.), *The Islamic Heritage of Bengal* (Paris, 1984), 110.
216. Ara Matsuo, 'The Lodhi Rulers and the Construction of Tomb-Buildings in Delhi', *Acta Asiatica* 43 (1982), Fig. 4.
217. Mchrdad Shookohy, 'Architecture of the Sultanate of Ma'bar in Madura, and Other Muslim Monuments in South India', *Journal of the Royal Asiatic Society*, third series 1/1 (1991), 54, Fig. 7.
218. Ibid., 63, fig. 10.
219. Ibid., 68, fig. 11.
220. Ibid., 86, fig. 16.
221. Perween Hasan, *Sultanate Mosque-Types in Bangladesh: Origins and Development*, unpublished Ph.D. dissertation, Harvard University, 1984, 227–30, fig. 195. The author also discusses the relationship of this and the following three examples to earlier nine-bay examples, being the first to discuss the Darb Zubayda examples in this context: 222–6.
222. Ibid., 231–4, fig. 200; *idem*, 'Sultanate Mosques and Continuity in Bengal Architecture', *Muqarnas* 6 (1989), 62, fig. 5.
223. Ibid., 235–7, fig. 203.
224. Ibid., 238–41, fig. 206.
225. H. Cousens, *Bijapur and Its Architectural Remains, with an Historical Account of the 'Adil Shahi Dynasty* (Bombay, 1916), Pl. XXXVIII (plan).
226. E. Merklinger, *Indian Islamic Architecture: the Deccan, 1347–1686* (Warminster, 1981), 110, Plans 13–14; King, 'Nine Bay', 374.
227. Dani, *Islamic Architecture*, 156–62, figs 32–3.
228. Ibid., 126–8, fig. 26.
229. Merklinger, *Indian Islamic Architecture*, 127, Plan 32.
230. Dani, *Islamic Architecture*, 134–6, fig. 29.
231. John Burton, 'Mosques and Tombs', in *Ahmadabad*, ed. George Michell and Snehal Shah (Bombay, 1988) 117, no. 14.
232. Claude Guillot, 'La symbolique de la mosquée javanaise: à propos de la <<Petite Mosquée>> de Jatiinom', *Archipel* 30 (1985), 3–20.
233. Garlake, *Early Islamic Architecture*, Figs 5, 7–8, 13, 34, 38, 41, 50–2, 56–7, 60.
234. Ibid., 116.
235. The *maqsura* of the Jahanpanah mosque is popularly termed a *takht* and is rumoured to be the tomb of sultan Sikander Shah, but this

is by no means universally accepted: 'Considering its location in the mosque, the position of the four pillars in the interior, and the absence of any trace of a sarcophagus, it is more likely that the building was used as a resting and congregational place for the king and his company before their entry into the maqsura area of the mosque (Hasan, *Sultanate Mosque Types*, 222–3).

236. See n. 116 above.
237. Gaston Migeon, *Manual d'Art Musulman. L'Architecture* (Paris 1907), 110, fig. 56; Georges Marçais, *L'architecture musulmane d'Occident* (Paris, 1954), 77.
238. Creswell, *MAE*, 1:148–53; King, 'Nine Bay', 374–6.
239. Noha Sadek, *Patronage and Architecture in Rasulid Yemen, 626–858 A.H./1229–1454 A.D.*, unpublished Ph.D. thesis, University of Toronto, 1990, 192–200; King, 'Nine Bay', 379–80.
240. Finster, 'Islamic Religious Architecture in Yemen', 140, fig. 18.
241. King, 'Nine Bay', 378–9.
242. Scerrato et al., 'Report', 434, fig. 69.
243. Ibid., 434, fig. 65.
244. Ünsal, *Turkish Islamic Architecture*, 55, fig. 26A.
245. Kuran, *The Mosque*, 159, fig. 172.
246. Sözen, *Diyarbakir'da Türk Mimarisi*, 118, fig. 34.
247. Ünsal, *Turkish Islamic Architecture*, 55, fig. 26B.
248. Ibid., 106–8, fig. 32; Kuran, *Sinan*, 122, fig. 108.
249. Whitehouse, *Siraf*, 30–9.
250. Daniel Schlumberger, *Lashkari Bazar: une résidence royale ghaznévide et ghoride*, Mémoires de la Délégation Archéologique Française en Afghanistan, 18 (Paris, 1978), 69–70, pl. 4.
251. Maxime Siroux, 'La mosquée djoumeh de Marand', *Arts Asiatiques* 3 (1956), 89–97.
252. Siroux, *Anciennes voies*, 251–2, fig. 84; *idem*, 'l'évolution', 83, fig. 19.
253. Bernard O'Kane, *Timurid Architecture in Khurasan* (Costa Mesa, 1987), cat. no. 11.
254. Useinov et al., *Istoria arkhitektury Azerbaydzhana*, 95.
255. Hasan, *Sultanate Mosque Types*, 52–5.
256. Merklinger, *Indian Islamic Architecture*, 112, Plan 8.
257. Syed Mahmudul Hasan, 'Classification of Mosques According to Ground Plan', in George Michell (ed), *The Islamic Heritage of Bengal* (Paris, 1984), 153; Ahmad Hasan Dani, *Muslim Architecture in Bengal*, Asiatic Society of Pakistan Publication, 7 (Dhaka, 1961), 154.
258. Hasan, 'Classification', loc. cit.
259. Hasan, *Sultanate Mosque Types*, 56–8. Datable to the early sixteenth century according to Hasan, 'Classification', 153.
260. Hasan, *Sultanate Mosque Types*, 59–62.
261. Ibid., 63–6; Dani, *Muslim Architecture*, 155, fig. 14.
262. Ibid., 67–9.
263. Ibid., 70–3.
264. Merklinger, *Indian Islamic Architecture*, 110, Plan 13.
265. Ibid., 116, Plan 17.
266. Asher, 'Inventory', 76.
267. Hasan, *Sultanate Mosque Types*, 74–7.
268. Merklinger, *Indian Islamic Architecture*, 120, Plan 18.
269. Ibid., 120, Plan 22.
270. Ibid., 120, Plan 21.

271. Yazdani, *Bidar: Its History and Monuments* (Oxford, 1947), 153, Pl. LXXXIX.
272. Cousens, *Bijapur*, Pl. XXXVIII (plan).
273. Merklinger, *Indian Islamic Architecture*, 150, Plan 30.
274. Reproduced in Burton, 'Mosques and Tombs', 117, after an unpublished thesis by Sohan Nilkanth for the School of Architecture, Ahmadabad.
275. E.g. Scerrato et al., 'Report', 434, lists five (undated) examples.
276. I have omitted flat-roofed buildings from this account. Many six-columned cubical mosques are known in Yemen, where they have been seen as related to the plan of the Kaʿba.
277. The examples can most readily be found in Samuel al Syriany and Badii Habib, *Guide to Ancient Coptic Churches & Monasteries in Upper Egypt* (Cairo, 1990). Most of these have yet to be archaeologically investigated.
278. Maxime Siroux, 'La mosquée djoumeh de Marand', *Arts Asiatiques* 3 (1956), 89–97.
279. *Idem, Anciennes voies*, 227, fig. 77.
280. Kiyani and Kleiss, *Karvansarayha-yi Iran*, 1:34.
281. Kurt Erdmann, *Das anatolische Karvansaray des 13. Jahrhunderts*, Istanbuler Fosrchungen XX/1, 2 vols (Berlin 1961), cat. nos 8, 16–17, 30–1, 35, 37, 39.
282. *Türkiye'de vakif abideler ve eski eserler*, 1:142.
283. Welch and Crane, 'The Tughluqs', fig. 5.
284. Richard A. Diehl, *Tula: The Toltec Capital of Ancient Mexico* (London, 1983), 95.

CHAPTER ELEVEN

The Arboreal Aesthetic: Landscape, Painting and Architecture from Mongol Iran to Mamluk Egypt

ALTHOUGH THREE OF the earliest Islamic monuments, the Dome of the Rock and the Great Mosques of Damascus and Madina prominently figured naturalistic trees amongst their decoration, there is a long gap (with just one exception) in the surviving monuments until the frequent reappearance of trees in architectural decoration in the fourteenth and fifteenth centuries. In a recent study I showed how the late fourteenth-century landscape miniatures of a Muzaffarid-style manuscript, the Bihbihani *Anthology*, might have been related to landscapes with trees in two fourteenth-century monuments near Isfahan, the Ilkhanid shrine of Pir-i Bakran at Linjan (c. 1303) and the Muzaffarid Masjid-i Gunbad at Azadan (1365).[1]

The appearance of trees on paintings in Timurid monuments has previously been associated with funerary imagery. Recent discoveries in Uzbekistan have widened this corpus to include two mosques with similar examples, and trees have also been newly discovered (and sadly, destroyed) during the restoration of the Üç Şerefeli Camı in Edirne. This chapter will question whether the widespread appearance of trees on this and other monuments in Turkey and Egypt in the thirteenth and fourteenth centuries should be credited to the Timurid International Style, or whether they could be seen as being inspired by the prestige of the decoration of the main earlier monuments, the Dome of the Rock and the great mosques at Madina and Damascus. The relation of the decoration of those monuments to pre-Islamic arboreal lore is considered, although with the space at my disposal here, there is room only to tilt at this inexhaustible subject.[2]

Finally, I will address the reasons why the fourteenth and fifteenth centuries saw the reappearance of landscape in Iranian art and architecture, broaching a topic that has been largely ignored since it was promoted in the early twentieth century, namely the extent to

Bernard O'Kane (2005), 'The Arboreal Aesthetic: Landscape, Painting and Architecture from Mongol Iran to Mamluk Egypt', in *Studies in the Iconography of Islamic Art in Honour of Robert Hillenbrand*, Edinburgh, 223–51.

which Iran's pre-Islamic heritage might have encouraged landscape depiction in the Islamic period. The importance of two catalysts that may have contributed to the timing of the new popularity of trees in Iranian art in the fourteenth century will be discussed: the reverential attitudes of the Mongols towards trees and the importation into Iran for the first time of landscape paintings from China.

Wall-paintings of trees in Timurid buildings

Examples of these survive in the following five mausoleums: at the Shah-i Zinda in Samarqand, Shirin Beg Agha (1385–6) and Tuman Agha (1404–5), at the mausoleum of Saray Malik Khanum in her madrasa at Samarqand (c. 1397), at the mausoleum of Tuman Agha in her madrasa at Kuhsan (1440–1) (Figure 11.1) and finally at the Gunbad-i Sayyidan at Shahr-i Sabz (1437). The treatment of the setting in these examples varies from depictions of trees bearing fruits in naturalistic landscapes in the first four examples to individual waving trees set within polylobed or star-shaped medallions, the latter appearing only at the Gunbad-i Sayyidan.[3]

Recent restorations have uncovered further examples of each of these kinds of painting, but in mosques. The first is in the mosque of the madrasa of Ulugh Beg at Samarqand (820–3/1417–21) (Figure 11.2).[4] Plaster removed from one point of the lower walls of the mosque, above dado level, revealed a series of small blind-arched niches that probably led to muqarnas at the base of transverse vaults. At the bottom of these arcades were tall rectangular niches that alternated geometric patterns with naturalistic fruit-laden waving trees, painted in blue, almost identical to those of the mausoleum of Saray

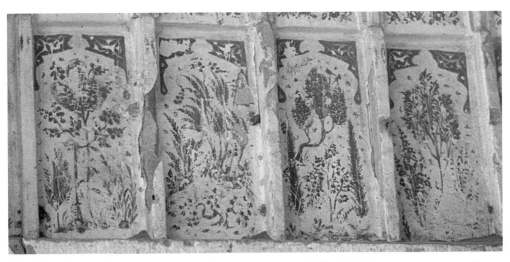

Figure 11.1 *Kuhsan, complex of Tuman Agha (1440–1), detail of painting in mausoleum*

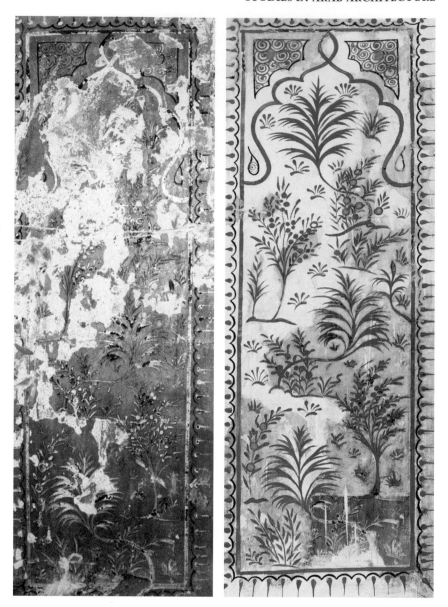

Figure 11.2 *Samarqand, madrasa of Ulugh Beg (820–3/1417–21), detail of painting in mosque, before and after restoration*

Malik Khanum. It has been suggested that the 'Master of Landscape', on the basis of the resemblance of the paintings in the Samarqand mausoleums to that at Kuhsan, accompanied Tuman Agha when she went to Khurasan,[5] but as this took place in 814/1411–12 before the decoration of the Ulugh Beg madrasa, it seems clear that, if indeed one person was responsible for this kind of decoration, he remained in Samarqand.[6]

Figure 11.3 *left: Samarqand, Shah-i Zinda, anonymous twin-domed mausoleum (c. 1440), detail of painting; right: Shahr-i Sabz, masjid-i jamiʿ of Ulugh Beg (839/1435–6), detail of painting*

The newly revealed painting on the interior of the masjid-i jamiʿ of Ulugh Beg at Shahr-i Sabz (839/1435–6) in part shows a decorative scheme identical to that of the Gunbad-i Sayyidan opposite: waving palm trees with smaller vegetation at the base of their trunks, set within star medallions (Figure 11.3, right).

It is significant that whereas the previously known examples were all in mausoleums, these new discoveries are in mosques. The pervasiveness of this imagery under the Timurids can now be seen to be associated not only with its most obvious manifestation, paradisial imagery in a funerary context, but with their major religious buildings as well.

The popularity of the tree motif in architecture may have encouraged artists to adapt it later for use on objects. It appears for instance, on Turkman underglazed painted pottery;[7] inside a metal Safavid wine bowl,[8] and on Gujarati inlaid mother-of-pearl work (Figure 11.4).[9] Post-Timurid examples on architecture within or influenced by the Iranian world are relatively few.[10]

Ottoman landscapes

It is also in mosques that most examples of early Ottoman mural landscapes appear. The early Ottoman state was one in which Persian language and literature played a major role, as indeed it had in the earliest major Turkish state in the region, that of the Anatolian Seljuks. Evidence of Timurid taste is clearly present in early Ottoman architecture and architectural decoration, the most obvious example being the Yeşil complex in Bursa, where a Tabrizi

Figure 11.4 *Detail of inlaid mother-of-pearl tray, Gujarati, sixteenth century (after Bonhams)*

workshop was involved and where the builder of the mosque, Hajji Ivaz, is known to have been a prisoner of Timur.

The earliest example of landscape painting may be at the Eski Camı in Bursa (805–16/1403–14), although I will first discuss the other Ottoman examples because of the problems interpreting the remaining evidence there. Better known are the wall paintings

of the Muradiye mosque in Edirne (1436), although before its detailed publication in 1985 it was little known that its painted landscapes, revealed in restoration work between 1953 and 1960, were part of the original decoration of the building.[11] These include an impressive variety of trees and vegetation (Figure 11.5) that filled most of the three walls of the qibla *ayvān* above dado level, showing cypresses wound with creepers, fruit trees and a version of the floral sprays that emerge from vases in Timurid tilework, and for which preparatory drawings have been preserved in the Topkapı albums.[12]

The next major royal mosque in Edirne, the Üç Şerefeli (1438–47), was restored in the 1990s. I was fortunate to visit it in 1994 when the restoration was in progress, and the plaster was newly stripped away from most of the walls, revealing extensive wall-painting. In addition to the central dome the mosque has four smaller domes at the corners. I was able to photograph two of these, those at the SE and NE corners. Each of the domes' facets or flutes are decorated with arabesques similar to those that have been revealed on the domes

Figure 11.5 *Edirne, Muradiye mosque (1436), detail of wall painting*

Figure 11.6 *Edirne, Üç Şerefeli mosque (1438–47), detail of painting in dome*

of the Yeşil Camı at Bursa, although at Edirne there is greater use of sinicising flowers (Figure 11.6). The greatest surprise was in the zone of transition of the south-east dome, where the area between the muqarnas elements was shown to have had painted trees, some with twisted trunks, in the tallest portions nearest to the windows, and smaller shrubs and vegetal elements in the smaller areas next to the lowest tier of muqarnas (Figure 11.7). There is no reason to doubt that these formed part of the original decoration of the mosque. On my subsequent visit to this mosque in 2001, I was appalled to find

Figure 11.7 *Edirne, Üç Şerefeli mosque (1438–47), detail of painting in zone of transition*

that the landscape elements had been whitewashed over, and the original arabesques restored in garish fashion (Figure 19.4).

I was not able to visit the earlier Eski Camı at Edirne at the period during its restoration after 1994 when plaster was removed to reveal the original painting. In its present restored form trees are to be seen on several of the pendentives of the domes, and also around the bases of some domes (Figure 11.8). They were not visible before the restoration of the 1990s, and although they have been completely restored or at least heavily repainted, I assume that enough traces of them were found in the original to permit restoration in this way. They are not nearly as naturalistic as those of the Muradiye or Üç Şerefeli at Edirne, but this could be due to the heavy-handedness of the restorers. Perhaps some other lucky visitor, if not the restorers who were able to witness the paintings after they had been first revealed, may be able to shed more light on this matter.

The next surviving example of this arboreal series is the Yeşil Imaret Camı (also known as the Yahşi Bey Camı) (845/1441) at Tire in western Anatolia. This is also based on a T-plan, where the qibla area is in the form of a semi-dome. The four recesses at the base of this semi-dome are each decorated with a large arabesque medallion surrounded with cypresses or naturalistic floral forms.[13] The final example, from the Tiled Kiosk in the Topkapı Palace, is no longer extant and thus it is impossible to say whether or not it was related to the others in style. In 861/1456–7 the Ottoman poet and vizir, Ahmad Pasha, wrote '(as for) that cypress which the illuminator has painted on its wall, the Tuba tree [in paradise] could serve as a simile for it', showing that he equated the symbolism of the painting with

Figure 11.8 *Edirne, Eski mosque (805–16/1403–14), detail of painting*

that of the foundation inscription which compares the palace as a whole to a heavenly mansion.[14] The architecture and decoration of the Tiled Kiosk are quintessentially Iranian,[15] and the trees presumably carried on the traditions we have seen in the earlier examples in Ottoman territory.

The tilework atelier that was responsible for the decoration at the Yeşil Camı in Bursa has been also credited with work at the Muradiye and Üç Şerefeli mosques in Edirne. The question of whether there are similar links between the painted programmes of these mosques has yet to be addressed. This is not the place for a full discussion of this matter, but from these preliminary observations the possibility arises that an allied team of artists could also have been responsible for designing the painted decoration at all three buildings.[16] If the Edirne Eski Camı murals are based on original designs, then these would represent the surviving earliest decoration of trees on Ottoman buildings, perhaps showing that the International Timurid style had penetrated far to the west of the Islamic world even in advance of its further diffusion by a Timurid atelier working on Ottoman territory.

Evidence for continuing Ottoman interest in this type of decoration may be shown by some paper-cuts with landscapes of trees, one including birds, in the album H. 2153 of the Topkapı Saray Library. Their similarity to the Bihbihani miniatures has already been remarked on by Michael Rogers.[17] An Aqquyunlu provenance has been suggested for them, but there is little like them in surviving Aqquyunlu painting. Their more delicate and intricate branches are perhaps closer to the landscapes of the Edirne Muradiye mosque, and could just as well be elaborations of them, painted by Ottoman artists.

The receptivity to this type of decoration in Ottoman territory may have been enhanced by the reports of a dream that the founder of the dynasty 'Uthman had, in which a moon arose from the breast of his host and sank in 'Uthman's breast, whereupon a tree sprouted from his navel whose shade encompassed the world, including mountains and streams from which people drank and gardens were watered. The dream was interpreted as a sign of 'Uthman's forthcoming imperial success, and was retold in many sources.[18]

Mamluk landscapes

At about the same time as the Ilkhanid images emerge, we also find trees appearing on several Mamluk buildings and objects. The Qubbat al-Zahiriyya in Damascus (1277–81) contains mosaic decoration in a frieze running around the walls above dado height. In addition to stylised vegetal motifs, some buildings and large naturalistic trees feature prominently in it (Figure 11.7). The mausoleum itself is situated not far from the Great Mosque of Damascus, which, like the Great Mosque of Madina, was also renovated by the Umayyad ruler al-Walid in the early eighth century. Part of the original decoration in glass mosaic of trees and buildings which covered most of the upper walls of the building is still present in the mosque in Damascus.[19] Regarding the mosque of Madina we have descriptions which tell

us that equally extensive mosaics of fruit-laden trees and buildings survived at least until the twelfth century.[20]

Excavations in 1985 in the citadel in Cairo uncovered the remains of a reception hall (*qāʿa*) that has mosaic decoration on its upper walls in mosaic representations of architecture and trees. The latter use both mother of pearl and golden balls outlined in black to indicate the copious fruits on their branches.[21] In the latest study of the citadel by Nasser Rabbat this has been identified as the Qaʿat al-Ashrafiyya, built in 1292.[22] The author relates it to a description of another building in the citadel built by the father of Ashraf, Sultan Qalaʾun. Qalaʾun had built at the citadel the Qubbat al-Mansuriyya which, according to Ibn ʿAbd al-Zahir, had walls on which were depicted the likeness of Qalaʾun's castles and citadels surrounded by mountains, valleys, rivers and seas.[23] The perhaps similar depictions on the Qaʿat al-Ashrafiyya may also have been a celebration of al-Ashraf's conquests and the extent of the lands under his dominion. At the end of the eighteenth century murals were still to be seen on the walls of parts of the citadel: in what he calls the women's apartments of the Palace of Joseph Niebuhr recounts that they were decorated with representations of trees and houses, etc., in fine mosaic and mother of pearl.[24]

Trees are also found in two other Mamluk buildings. The first is the Taybarsiyya madrasa (1309–10), attached to the mosque of al-Azhar. On its mihrab, also in mosaic, the winding branches of a pomegranate tree in fruit elegantly fill up each spandrel (Figure 11.10). In the mosque of al-Maridani (1340) trees in stucco decorate the qibla dome chamber, two being found beside each corner at the base of the pendentives in the zone of transition, with another four appearing on the qibla wall below, two on either side of the window above the mihrab. Some of these are also depicted with pomegranate-like fruits, while their naturalism is increased by showing smaller adjacent shrubs

Figure 11.9 *Damascus, Qubbat al-Zahiriyya (1277–81), detail of mosaic*

Figure 11.10 *Cairo, Taybarsiyya madrasa (1309–10), mihrab, detail of mosaic*

springing from their horizon line (Figures 11.11–11.12). Judging from the account of a fourteenth-century physician from Damascus, trees in a naturalistic garden setting with flowers may also have been common in public baths, although he mentions the trees as one of three categories (the others being warriors and lovers) that were designed to restore animal, spiritual and natural power.[25]

At almost the same time trees very similar to those on the walls of the al-Maridani mosque also become popular in the decoration of Mamluk metalwork. They appear on a ewer made for al-Malik al-Nasir Ahmad (d. 1342), now in the Islamic Museum in Cairo (Figure 11.13), and later on a box (datable to 1371) for Aydamir

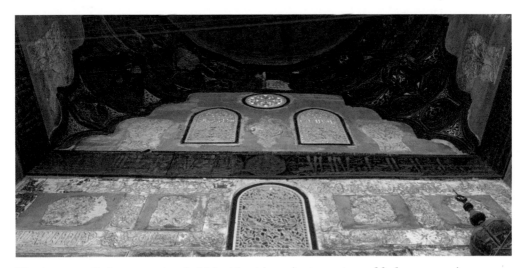

Figure 11.11 *Cairo, mosque of al-Maridani (1340), stucco in and below zone of transition*

Figure 11.12 *Cairo, mosque of al-Maridani (1340), detail of stucco below zone of transition*

al-Ashrafi, the governor of Tripoli and Aleppo (d. 1374).[26] On the neck and base of the ewer of al-Malik al-Nasir Ahmad the swaying trunks and branches of the trees are depicted with unusual freedom of movement. On Aydamir's box two trees appear amidst a chinoiserie vegetal background; flying birds and a lion chasing a quadruped also appear on each side of the trees.[27]

Figure 11.13 *Cairo, Islamic Museum, ewer made for al-Malik al-Nasir Ahmad (d. 1342), detail of decoration*

Six fifteenth-century examples of Mamluk metalwork also display trees, mostly, however, in a much more stylised manner rather similar in fact to the painted examples that now adorn the Eski Cami in Edirne.[28] A seventh example, on a bowl in the Museo Nazionale in Florence, is unique in incorporating, like the earlier mosaics, trees with pavilions. Three two-storey pavilions appear between a wide variety of fruit-laden trees, including pomegranate, orange, palm and cypress trees.[29]

Before investigating further what are the links, if any, between the reappearance of trees as decoration in Mamluk, Timurid and Ottoman architecture it is first necessary to revisit the Umayyad examples and their precedents.

Earlier arboreal lore

Tree cults were common in many pre-Islamic religions in the Middle East. An initial stage consisted of worship of individual trees, followed by those planted as an act of consecration in holy ground. In both cases the sacred tree could symbolise the divine spirit and the knowledge of good and evil. In a third stage sacred groves where religious rites were performed supplemented the sacred space of temple enclosures.[30] Throughout the Graeco-Roman world that preceded Islam, the paradisial iconography of the tree-filled garden was a message that was readily understood, and need not be laboured here.[31] In Iran a similar message was implicit, derived from the Zoroastrian principle that all plants are sacred and possess the gifts of health and immortality, and that they are therefore venerable.

Even before the coming of Zoroaster the Elamites, the principal dynasty in Iran before the arrival of the Achaemenids, situated their temples most frequently within sacred groves, where the holy precinct was fenced in and an altar formed the cult centre.[32]

In the *Shahnama* is a Zoroastrian tradition that Gushtasp commemorated his conversion to Zoroastrianism by planting a cypress sapling which soon attained a height and diameter of forty cubits.[33] Hamd Allah Mustaufi, the Ilkhanid historian writing in fourteenth-century Iran, identified this as a cypress then growing in Kashmar.[34] He also mentions a cypress, which, incidentally, is still standing and still celebrated, at Abarquh in southern Iran.[35]

Concomitant with tree worship is a belief in tree oracles. Also in the *Shahnama* is the account of Alexander's conversation with the tree of male and female heads which prophesied his imminent death.

The several references to trees in the Quran connote a variety of desirable attributes. Various kinds are mentioned in the context of paradise, where they provide shade and fruit (56:28–30), specifically palm and pomegranate trees (55:68), and where one in particular, the

sidra al-muntahā (the lote-tree) is situated near the Throne of God (53:14–16). A Quranic parable also compares the goodly word (probably to be interpreted as the Word of God) to a fruit-laden tree with firm roots whose branches reach to the heavens (14:24–5).[36]

Given these connotations of shade, fertility, nourishment and paradise,[37] it is not surprising that trees should figure prominently in the decoration of several of the earliest Islamic monuments. When the Prophet entered the Ka'ba in 629–30 he found on the wall, besides figural representations of angels and prophets, those of trees.[38] The Ka'ba was rebuilt under the Umayyads in 693, and again by al-Walid I, who sent columns, marbles and mosaic.[39] We have no indication of what the mosaic decoration was like, but ironically, it was in the marble slabs that images of trees and branches were seen by Ibn Jubayr and which were, according to him, 'fashioned by God'.[40]

In the Dome of the Rock, we may speak of two types of trees in the mosaic decoration; those on the outer arcade which have been interpreted as a 'ring of non-terrestrial trees surrounding a shrine';[41] and those on the inner face, usually more realistic, although sometimes with trunks studded with jewels. The naturalistic examples recall al-Tabari's account of the building of the temple by Solomon, who each morning found trees growing spontaneously on the site. In another version the trees were artificial ones made of gold, but which miraculously produced fruit; these may be equated with the bejeweled examples.[42]

The extensive mosaics of trees at the great mosques of Madina and Damascus in al-Walid's rebuilding have been mentioned above. Most recent commentators have suggested that their connotations are primarily paradisial in accordance with the eschatological nature of the Quranic verses that were to be found within the Damascus mosque, although this has been recently been questioned by Nasser Rabbat.[43] He points out that the themes of the Quranic verses are related as much to the Day of Judgment as to Paradise, that they were on the qibla wall and thus the culmination of a visit to the mosque, coming after rather than being identified with the mosaics on the courtyard, and that most medieval commentators saw the mosaics as representing worldly scenes, whether of Damascus, Syria or the Islamic world. Specifically, he quotes verses that had formerly been unnoticed of the court poet of al-Walid, al-Naghiba, as follows:

On every approach, (as if) decorated by God,
 Its interior was surrounded with Syrian marble (or: its interior
 was of marble, surrounded by al-Sham)
at the center of the earth bounded by its quarters
 surrounded by rivers and the countryside.
In it is the beginning of the Quran (*al-mathānī*) and (other)
 excellent verses

> Here (in the verses) are Our Lord and (His) promises and
> threats.[44]

Rabbat interprets the first distich as a possible reference to the depic-
tion of Syria (or Damascus, al-Sham) in the mosaics, although it is
at least as likely that *al-Shām* is an adjective here referring to Syrian
marble.[45] The second verse, as he points out, could refer to the literal
rivers and countryside surrounding the mosque, or could be a meta-
phor for the mosaic scenes. However, if is referring to the mosaic, it
is surprising that the trees or the buildings are not mentioned; the
later commentators, regarding whom Rabbat gives a comprehensive
overview, refer to at least one or the other.[46] In any case, Rabbat is
surely right, as Flood has done before him,[47] in calling for a multi-
layered approach to the mosaic's iconography rather than presuppos-
ing that only a single explanation is correct. But one need not lose
sight of paradisial explanations in the process. The twelfth-century
writer Ibn al-Najjar wrote of the (evidently very similar) mosaics on
the mosque of Madina (also restored by al-Walid) that images of trees
and the palaces of paradise were to be found there.[48] Flood's analy-
sis of the building types in the Damascus mosaics has shown how
indebted they were to Byzantine representations of heavenly cities;
and elsewhere in the mosque its celebrated vine scroll, the *karma*,
underlines this association.[49] If al-Nabigha interpreted the mosaics
as worldly scenes, and as we have seen, it is far from certain that he
is referring to them at all, his juxtaposition of them with the descrip-
tion of the Quranic verses on the walls leaves open the possibility
that in other's minds a connection may indeed have been made
between the verses and the mosaics. Lastly, there is a fine distinc-
tion between the emphasis of the *sura*s on the Day of Judgment as
opposed to Paradise. Whether or not the deliberate absence of figures
ruled out representation of the Day of Judgment, Paradise, one of the
'promises' of God in the Quranic verses mentioned in al-Nabigha's
poetry, could well have been connected with the mosaics by many
viewers.

A more conventional representation of trees from close to the
same period (late seventh century?)[50] may be in the images of
mosques from the trove of Quran pages from the Great Mosque
of San'a.[51] Two folios depict mosques with mihrabs flanked by
naturalistic trees of various kinds on a grassy verge. Although these
trees have been interpreted as representations of a garden that was
situated at the back of the mosque,[52] it is unlikely that the artist
would have considered a feature that was outside the walls of the
mosque as being worthy of illustration. Just as the doors are shown
in elevation at the bottom of the paintings, it is probable that at the
top we are shown the qibla wall in elevation with a representation
of its decoration to either side. Whether this decoration of trees
was in mosaic or another medium is of course unknowable. The

pages have been associated before with al-Walid's work at Madina and Damascus, but whether or not they date from his reign or from slightly before, we can agree with Barry Flood, that 'the design of the frontispiece and the decoration of al-Walid's mosques at Damascus and Medina belong, at least conceptually, to the same tradition'.[53]

The representation of trees may also reflect the actual practice of planting them in mosque courtyards, a not surprising way of providing shade for the faithful. The Great Mosque of Cordoba was provided with trees in the ninth century,[54] and an eleventh-century foundation inscription of a no longer extant mosque in Cairo contained the following: 'these palm trees (nakhl) which are in this mosque, are food for the Muslims; they should neither be sold nor bought.'[55]

Although their stylisation places them at some remove from the naturalism of the majority of examples that are discussed in this chapter, the paintings in the Kharraqan I tomb tower (460/1067–8) of pomegranate trees should be remembered. The paradisial resonances of these and other aspects of its painting have been explored at length by Abbas Daneshvari, and need not be repeated here.[56] It should also be mentioned that the birds on the branches of the trees are paralleled in some of the later Timurid architectural examples.

The portrayal of realistic trees, often in a landscape setting, thus occurs over a wide chronological and geographical range. With the partial exception only of the Kharraqan tomb tower,[57] there is a large gap in the surviving works of art between the Umayyad monuments and the second half of the thirteenth century, when they appear simultaneously in Iran and Syria. The trajectory in the two areas is rather different, with the architectural examples found in the Mamluk dominions only until the middle of the fourteenth century, while they appear increasingly in Iran, and in related examples in Anatolia, from the fifteenth century onwards.

The sequence of landscapes or trees on Mamluk buildings starts with the mausoleum in close proximity to the Great Mosque of Damascus. It and most of the later Mamluk examples are in mosaic, a medium rarely employed in Fatimid and Ayyubid times.[58] This makes it more likely that the revival in Mamluk monuments and artifacts should be associated first and foremost with the attempts to revive the glories of the Umayyad monuments through this technique. As Nasser Rabbat has pointed out, both Baybars and Qala'un (who completed Baybars's mausoleum) spent considerable time in Damascus in proximity to the Umayyad mosque. By then, the eschatological associations of the mosaics seem to have been submerged by interpretations of them as worldly scenes, leaving the way open to the reuse of the medium as a vehicle for expressing the vastness of the sultan's dominions.[59]

Iran: the catalysts

As we have seen above, perhaps the most pervasive use of naturalistic landscapes with trees in Islamic architecture began in Iran in the Ilkhanid period. Why should it have happened at this time, and why particularly in Iran?

We noted earlier how the Ilkhanid historian Hamd Allah Mustaufi was aware of the reverence paid to trees in pre-Islamic Iran in his account of the cypress tree by which Gushtasp commemorated his conversion to Zoroastrianism. This reverence continued in the Islamic period, as revealed in his account of a tree which stood above the grave at the town of Bastam, on the road from Tehran to Mashhad, in the north of Iran:

> At Bastam is the shrine of the Shaykh of Shaykhs Abu ʿAbd Allah Dastani and on his tomb stands a withered tree. Now when any one of the descendants of the Shaykh comes to be on the point of death, a branch of this tree breaks off. In certain documents it is stated that this tree was originally the staff of our prophet ... and generation after generation it was inherited by his descendants, till it came to the Imam Jaʿfar al-Sadiq. The Imam Jaʿfar gave it to Bayazid of Bistam, and Bayazid stated in his testament that 200 years after his day a certain darvish would come out of Dastan and the staff would be his. Therefore when the Shaykh of Shaykhs Dastani made his appearance this staff became his, and after his death, by the provisions of his will, it was planted in the earth of his grave, above his breast. The same forthwith became a tree, and put forth branches. During the incursion of the Ghuzz one of its branches was cut off, and the tree withered; but of those who had thus cut off its branches most of them perished that same day, and from that time onwards the tree has always had the terrible property aforesaid inherent in it (of killing all who cut it).[60]

The echoes with the dream of ʿUthman, recounted above, may be noted.[61] Mongol Shamanistic rituals surely also played a part in maintaining or resurrecting reverence for trees. Genghis Khan himself so liked the shape of one tree that he dismounted and spent some time in its shade, experiencing an 'inner joy'. He selected it as his burial site, and it was reported that innumerable trees grew there after his burial.[62] Ögedei Khan, his son, is reported to have planted thickets there for the repose of the Genghis's soul; severe punishment was prescribed for anyone cutting branches from them.[63] Another fascinating episode is related by Rashid al-Din: in 1302, near Bisitun, Ghazan Khan remembered that on a previous journey at the same spot a revelation had come to him beside a tree and given him relief from his worries concerning rebels. On this he occasion he performed two rakʿats of prayer (i.e. in the Islamic manner) by the tree and then 'all

those present tied tokens to the tree, and it became like a shrine'.[64] An amir related that Qutula Khan, one of Chengiz Khan's ancestors, had once in Mongolia similarly tied pieces of coloured cloth to a tree in thanks to God for a victory that he had been granted, and had danced with his soldiers beneath the tree 'so hard that the area around the tree sank a yard into the earth'. Ghazan himself then danced beneath the tree at Bisitun.[65] The syncretistic nature of Ilkhanid beliefs, even after their conversion to Islam, could hardly be clearer.

The links of landscape painting to the Ilkhanids can be strengthened when we note that the first independent landscapes to occur in Islamic book painting were produced under Ilkhanid patronage. The earliest of these is in an Arabic *Kalila and Dimna* from the Royal Library in Rabat which on stylistic grounds has been convincingly attributed to Baghdad in the third quarter of the thirteenth century, shortly after it was captured by the Mongols. One of its illustrations is to a story in which a bee enjoys the perfume of the water-lily so much that it forgets to fly away and is trapped when the flower closes at night. The painting in the manuscript is of a pool in which the flowers are growing (in the available reproductions there is no sign of the bee).[66] Would such a subject have been countenanced before the importation of Chinese landscape-dominated painting by the Mongols? Clear evidence for the importance of the latter occurs in two paintings in the *Jami' al-tavarikh* of Rashid al-Din (714/1314–15). These are pure landscapes, one depicting the mountains of India, the other the Jevatana, the grove of trees where Buddha achieved enlightenment.[67] Both show a clear debt to the style of contemporary Chinese painting.[68]

The importance of poetry, both secular and mystical, in Iranian society is well-known, as is the centrality of the garden to Persian poetry. A detailed consideration of the garden would clearly be out of place here, even if there were space for it, but the connotations of the garden and the arbour cannot be entirely divorced. Trees may be explicitly part of garden imagery, as in Fakhr al-Din Gurgani's *Vis u Ramin*:

> I saw a tree atop a hill, all green,
> that clears the heart from rust of grief and pain;
> A tree that lifts its head to Saturn's sphere;
> whose shadow falls on all the world; so fair,
> Its beauty gives it likeness to the sun;
> the whole world hoping in its fruit, its bloom.
> Beneath it, a bright wellspring gushes forth,
> its pebbles lustrous pearls, its waters sweet.
> Upon its banks, tulips and roses bloom,
> and violets, gilly-flower and hyacinth.
> A grazing bull of Gilan, by its verge,
> now drinks its water, now eats of its flowers.

May it endure, that shadow-spreading tree;
 and may that shade more sweet than heaven be!
May ever flow the water of that spring.
 and Gilan's bull there find his pasturing.[69]

The metaphor of the 'family tree' is a recurring one in Persian literature. The Saljuq historian Ravandi praises the sultan Kaikhusrau as 'the fruit of the tree of Saljuq: a tree whose root is the strengthening and propagation of the faith, and whose fruit is the building of charitable foundations . . .'. Ravandi then quotes from the *Shahnama*:

A tree in greenest Paradise I've sown
 its like not planted e'en by Faridun
In autumn when the cypress sends froth shoots,
 those branches green will reach palatial height.
A tree rejoices in its lofty height,
 observed by men of fortune and clear sight.[70]

This use of the image of the tree as a symbol of fertility and lineage echoes those recounted above in the accounts of the dream of 'Uthman and the staff of Bayazid. It is also used by Nizami in his description of Majnun's father:

. . . Anxious that his fortune's hand might make
from his dry tree spring forth a supple branch;
That should his noble cypress be cut short,
another tree might from its root sprout forth.[71]

Nizami in particular is celebrated for his use of imagery interweaving humankind and nature.[72] It has been argued that Nizami 'based the quest for poetic imagery and vocabulary partly on scientific knowledge of the geographical spread, agricultural needs and pharmaceutical properties of the trees', and that his use of trees in poetic imagery is exceptional, being 'building elements of the story itself, rather than mere pretty exercises of poetic imagination':[73] Given this, it may be no surprise that the tree-filled landscape paintings in the Bihbihani *Anthology* appear between the chapters of Nizami's *Khamsa*. While they thus do not explicitly illustrate the text, it may be no accident that they appear within this text rather than the others within the anthology, and thus afforded an opportunity for the painter to mirror the concerns of the poet.

It has been suggested by Hushang A'lam that the animistic attitude towards venerable trees has continued in Iran with the transfer of devotion to Muslim saints, particularly Shi'i ones. Distinguished trees have often generated belief in their sacred origin and association with saints, who grant wishes or work miracles through the

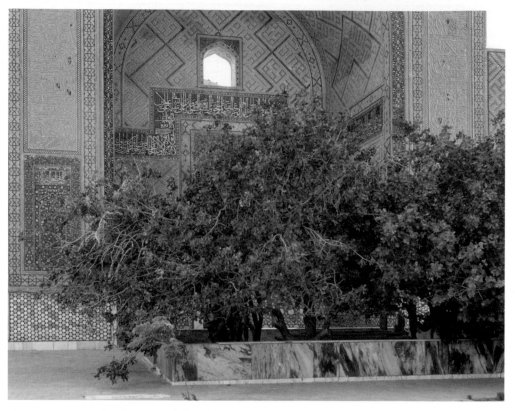

Figure 11.14 *Taybad, grave of Shaykh Zayn al-Din with pistachio tree*

intermediary of their trees.[74] Manuchihr Sutuda saw this process at work in Gilan where old tress are generally venerated by candles and lamps lit before them and by wishes for intercession tied to their branches. He noted that in Gilan in the space of fifty years ten remarkable trees which were recorded by Rabino, British consul at Rasht, as standing alone, had been each flanked by a constructions named the Imamzada Hasan, Imamzada Ibrahim, etc.[75] Even today in many parts of Khurasan trees of great antiquity can be seen to be associated with the graves of many saints, such as the shrines at Taybad, Turbat-i Jam (Figures 11.14–11.15), and at Gazurgah near Herat. An indication of the importance of trees in the historical consciousness of even contemporary Iranians is provided by the noted historian Iraj Afshar, who in his gazetteer of monuments in the Yazd region ranks eleven ancient trees as worthy of inclusion with the built examples.[76]

Conclusions

The syncretism that characterises Iranian Islam in general, or Ilkhanid Islam as practised by Ghazan in particular, is by no means

Figure 11.15 *Turbat-i Jam, grave of Shaykh Ahmad with pistachio tre*

unique. The holding of picnics by the burial site of one's family was long a custom in pre-Islamic Egypt and is still popular today. Another obvious manifestation of this is the boats which were associated with many tombs in Cairo – clearly a reference to the Pharaonic past.[77] In general, it has been suggested that 'Islam was adopted by ethnic groups in their own milieu, while maintaining their own cultural identity. There was hardly a break with past traditions, and pre-Islamic customs and beliefs survived.'[78]

One can believe, as Henri Corbin did, that the landscapes of the Bihbihani *Anthology* are infused with the spirit of the reverence for nature in the Zoroastrian *Bundahishn* without necessarily subscribing to his view that the painter was Zoroastrian.[79] It can be suggested however that it is likely that the celebrations of nature we have seen on fourteenth- and fifteenth-century Iranian art and architecture, whether or not they were coupled with Islamic ideas of paradise or were sparked by Mongol Shamanistic notions, are to be found in greater numbers in Iran and Iranian-influenced areas such as early Ottoman Turkey, because of these transformations of pervasive and long-lasting pre-Islamic beliefs.

Finally, although we have seen that the Arab and Perseo-Ottoman landscape representations are examples of divergent stylistic strains, the Umayyad Mosques of Damascus and Madina may nevertheless be key to the development of each. They showed that eschatological

images were appropriate not only in a funerary context but also for mosques, such as those of Ulugh Beg at Shahr-i Sabz and in his madrasa at Samarqand, and of course in numerous later examples, including the Ottoman landscapes at the Madina mosque.[80] We thus finally come full circle, not just at Madina, but with a reversal of the 'migration of paradisial symbol from mosque to mausoleum' that has been elucidated previously by Barry Flood.[81]

Notes

1. Bernard O'Kane, 'The Bihbihani *Anthology* and its Antecedents', *Oriental Art* 44/4 (1999–2000), 9–18. Another Timurid manuscript with landscapes has recently come to my attention. The *Divan* of Salman Saviji, Cairo, Dar al-Kutub, adab fārisī *mīm* 156, dated 841/1437–8, has one miniature (f. 245a) of two figures in a garden, but also two paintings (ff. 196a, 202b) in gold on a plain ground, each with two sinuous chinoiserie trees and other vegetation, one with a deer and a stag, on rocks in Shiraz style, the other with a deer and a single bird above the horizon. The latter is illustrated in Sayyid Mohammad Bagher Najafi, *Iranische Kunstschätze in Äegypten* (Cologne, 1989), fig. 199.

2. 'I have been frequently induced to make it [the reverence paid to trees] the object of personal inquiry among Asiaticks, and of literary research at home. The result now before me, would constitute a volume of no inconsiderable size. For the subject may be traced from the present day to the earliest ages of which written records furnish an account; through every country of the old, and even of the new world. The sacred Hebrew scriptures, allude to it in many places; we find it mentioned by Greek and Roman authors; various anecdotes respecting it occur in Eastern manuscripts, and it has been noticed by several European travellers and antiquaries': William Ouseley, *Travels in Various Countries of the East; More Particularly Persia*, 3 vols (London, 1819–23), 1: 314. In general, see A. J. Wensinck, *Tree and Bird as Cosmological Symbols in Western Asia* (Amsterdam, 1921); for China see Silvia Freiin Ebner von Eschenbach, 'Trees of Life and Trees of Death in China', *Zeitschrift der Deutschen Morgenländischen Gesellschaft* 152 (2002), 371–94.

3. Lisa Golombek, 'The *Paysage* as Funerary Imagery in the Timurid Period', *Muqarnas* 10 (1993), 242–52.

4. I am most grateful to Galina Asanova for showing me the drawings of the restoration. She has published a preliminary account of the paintings, 'Zhivopis' mecheti medrese Ulugbeka v Samarkande', *Obshchestvennie Nauki v Uzbekistane* 5 (1994), 45–7.

5. Golombek, 'The *Paysage*', 250.

6. Hafiz Abru, *Zubdat al-tavarikh* ed. Sayyid Kamal Hajj Sayyid Javadi, 2 vols (Tehran, 1372/1993), 1: 435–6. Other examples of mural landscapes may yet be discovered; recent work has revealed wall painting of trees in landscapes in the anonymous twin-domed mausoleum (c. 1440) at the entrance to the Shah-i Zinda in Samarqand (Figure 11.3, left).

7. Best illustrated in a painting from the 'Big-Head' *Shahnama* of 899/1493–4: Glenn Lowry, *A Jeweler's Eye: Islamic Arts of the Book from the Vever Collection* (Washington, DC, 1988), Pl. 22; Lisa Golombek,

Robert B. Mason and Gauvin Bailey, *Tamerlane's Tableware* (Costa Mesa, 1966), 136.

8. Assadullah Souren Melikian-Chirvani, *Islamic Metalwork form the Iranian World: 8th–18th Centuries* (London, 1982), no. 117, Fig. 117A.

9. I am indebted to Julian Raby for the provenance and dating of this piece, which according to him is one of several with trees. He informs me that Simon Digby is preparing a catalogue raisonné of the complete corpus.

10. A remarkable example containing buildings resembling kiosks amidst trees is the painting of the *dārskhāna* of the madrasa of 'Abd al-'Aziz Khan at Bukhara (1062/1651–2): Yves Porter, 'le *kitâb-khâna* de 'Abd al-'Azîz Khân (1645–80) et le mécénat de la peinture à Boukhara', *Cahiers d'Asie Centrale* 7 (1999), Pls 8–9. By the nineteenth century the copying of photographs and their landscapes had become common in Qajar tiles: Jennifer M. Scarce, 'Function and Decoration in Qajar Tilework', in *Islam in the Balkans; Persian Art and Culture of the 18th and 19th Centuries*, ed. Jennifer M. Scarce (Edinburgh, 1979), 77, Figs 3–4. The Aba Khwaja Mosque (eighteenth century or later) at the shrine complex near Kashgar has many painted landscapes in a 'chocolate-box' style that suggests they may be nineteenth-century at the earliest: Bernard O'Kane, 'Iran and Central Asia', in *The Mosque*, ed. Martin Frishman and Hasan-Uddin Khan (London, 1994), 136. One stunning example in India should also be noted: the carved window grilles of the Sidi Said mosque (1572) at Ahmedabad, best illustrated in Alfieri, Bianca Maria Alfieri and Federico Borrromeo, *Islamic Architecture of the Indian Subcontinent* (London, 2000), 104. The contemporary city of Fathepur Sikri has one pavilion with dadoes of carved sandstone displaying trees and vegetation in a naturalistic setting: Michael Brand and Glenn Lowry, *Akbar's India: Art from the Mughal City of Victory* (New York, 1985), 106. The tilework panels in the Wazir Khan mosque at Lahore are also unusual not only in the number of naturalistic trees that they display but also in that they are all portrayed as emerging from a horizon provided with plants that intertwine with the trunks of the trees: J. Burton-Page, 'Wazir Khan's Mosque', in *Splendours of the East*, ed. Mortimer Wheeler (London, 1970), 99.

11. Elisabetta Gasparini, *Le pitture murali della muradiye di Edirne*, Quaderni del Seminario di Iranistica, Uralo-Altaistica e Caucasiologia dell'Università degli Studi di Venezia 18 (Padua, 1985).

12. The drawings are illustrated in Bernard O'Kane, 'Poetry, Geometry and the Arabesque: Notes on Timurid Aesthetics', *Annales Islamologiques* 26 (1992), Pl. 14b-c.

13. Gasparini, *Le pitture*, figs 72–5; Ekrem Hakki Ayverdi, *Osmanli Mi'marisinde*, 4 vols (Istanbul, 1989). *Çelebi ve Sultan Murad Devri 806–855 (1403–1451)* 2: figs 948–9.

14. I am most grateful to Walter Andrews for this reference and for the translation.

15. Bernard O'Kane, 'From Tents to Pavilions: Royal Mobility and Persian Palace Design', *Ars Orientalis* 23 (1993), 252.

16. For Persian–Ottoman links in illumination in the early fifteenth century, see Zeren Tanındı, 'An Illuminated Manuscript of the Wandering Scholar Ibn al-Jazari and the Wandering Illuminators between Tabriz, Shiraz, Herat, Bursa, Edirne, Istanbul in the 15th

Century', in *Art Turc/Turkish Art, 10th International Congress of Turkish Art, Geneva 17–23 September 1995, Proceedings*, ed. François Déroche et al. (Geneva, 1999), 647–51.

17. J. M. Rogers, 'Ornament Prints, Patterns and Designs East and West', in *Islam and the Italian Renaissance*, Warburg Institute Colloquia 5, ed. Charles Burnett and Anna Contadini, 135–6, figs 8–9.

18. Cemal Kafadar, *Between Two Worlds: The Construction of the Ottoman State* (Berkeley, 1995), 8–9. Wensinck has discussed the links between navel, mountains and the provision of water in Jewish and Arabic literature: *The Ideas of the Western Semites Concerning the Navel of the Earth*, Verhandelingen der Koninklijke Akademie van Wetenschappen 17 (Amsterdam, 1917). As in Iran, the nineteenth century saw the use of landscapes based on European prototypes. Among the most impressive is a small mosque enlarged in 1810 with very realistic forest scenes: Evin Docu, 'A Hidden Gem in Bademli: Kılcı Mehmet Aca Camii', *Skylife* 207 (October, 2000), 168–77. The Mevlevi *sam 'akhāna* in Cairo, redecorated in 1857, is another example. Bodo Rasch, the designer of the retractable umbrellas recently installed in the Madina mosque, has also informed me that naturalistic landscapes from the Ottoman period are still to be seen in parts of it.

19. For a twelfth-century description of the mosaics which marvels at their emerald trees with incorruptible fruit, see Ibn 'Asakir, *Tarikh madinat Dimishq*, trans. Nikita Elisséeff as *La description de Damas d'Ibn 'Asakir* (Damascus, 1959), 58.

20. Jean Sauvaget, *La mosquée omeyyade de Médine* (Paris, 1947), 80–1.

21. Nasser O. Rabbat, *The Citadel of Cairo: A New Interpretation of Royal Mamluk Architecture*, Islamic History and Civilization, Studies and Texts 14 (Leiden, 1995), 163, fig. 23.

22. Ibid., 156. Mosaic depictions of trees, including palms, and hieratic animals survive at the Capella Palatina: Kenneth Clark, *Landscape into Art*, 2nd edn (New York, 1976), 7, Fig. 5. Elsewhere in this volume Jonathan Bloom has argued that the mosaic pavements could be related to now lost Cordoban examples. Whether this should also apply to these figural examples, or whether they should be related to Fatimid prototypes, as had been assumed for the paintings of the muqarnas ceiling, remains a moot point.

23. Ibid., 166; Ibn 'Abd al-Zahir, Muhyi al-Din, *Tashrif al-ayyam al-'usur fi sirat al-Malik al-Mansur*, ed. Murad Kamil and Muhammad 'Ali al-Najjar (Cairo 1961), 139.

24. Carsten Niebuhr, *Voyage en Arabie* (Amsterdam, 1776), 1: 94, quoted in K. A. C. Creswell, *The Muslim Architecture of Egypt*, 2 vols (Oxford, 1952–9), 2: 261.

25. 'Ali al-Ghuzuli, *Matali' al-budur*, quoted in Thomas W. Arnold, *Painting in Islam* (New York, 1965), 88.

26. D. S. Rice, 'Studies in Islamic Metal Work-IV', *Bulletin of the School of Oriental and African Studies* 15 (1953), 489–99; Pls I–V.

27. Ibid., Fig. 6.

28. Ibid., 500–1; Pls VI–VII.

29. Ibid., Pl X and Fig. 11.

30. Thomas Barns, 'Trees and Plants', in J. Hastings, ed., *Encyclopaedia of Religions and Ethics* (Edinburgh, 1980), 448–57.

31. Annemarie Stauffer, *Textiles d'Égypte de la collection Bouvier* (Bern, 1991), 49; George Lechler, 'The Tree of Life in Indo-European and

Islamic Cultures', *Ars Islamica* 4 (1937), 368–420; Vicenzo Strika, 'The Turbah of Zumurrud Khatun in Baghdad: Some Aspects of the Funerary Ideology in Islamic Art', *Annali, Istituto Orientale di Napoli* 38 (n.s. 28) (1978), 286–94.

32. Heidemarie Koch, 'Theory and Worship in Elam and Achaemenid Iran', in *Civilizations of the Ancient Near East*, ed. Jack M. Sassoon, 4 vols (New York, 1995), 3: 1959–69. I am grateful to David Stronach for this reference.

33. Hushang A'lam, 'Derakht', *Encyclopaedia of Iran*, 7: 317.

34. *The Geographical Part of the Nuzhat-al-qulub Composed by Hamd-Allah Mustawfi of Qazwin in 740 (1340)*, E. J. W. Gibb memorial series 23/2, trans. G. le Strange (Leiden and London, 1919), 142.

35. Ibid., 120; Iraj Afshar, *Yadgarha-yi Yazd*, vol. 1 (Tehran 1348/1969), 356, fig. 213.

36. For a further elaboration of this parable, comparing the soul to the seed of a tree that the 'Gardener of Paradise' has planted, see Shihab al-Din Yahya Suhrawardi, *The Philosophical Allegories and Mystical Treatises: A Parallel Persian–English Text*, ed. and trans. Wheeler M. Thackston (Costa Mesa, 1999), 73.

37. For the ways in which later commentators expounded on these themes (and their relationship to the themes of earlier religions) see A. J. Wensinck, *Tree and Bird as Cosmological Symbol in Western Asia* (Amsterdam, 1921); John McDonald, 'Islamic Eschatology. VI. Paradise', *Islamic Studies* 5/4 (December 1966), 349–52 and al-Ghazali, *Kitab dhikr al-mawt wa ma ba'dahu*, trans. T. J. Winter as *The Remembrance of Death and the Afterlife* (Cambridge, 1989), 239–40. For an overview of the parallels between earthly and heavenly gardens see Annemarie Schimmel, 'The Celestial Garden in Islam', in *The Islamic Garden*, Dumbarton Oaks Colloquium on the History of Landscape Architecture 4, ed. Elisabeth B. MacDougall and Richard Ettinghausen (Washington, DC, 1976), 11–40.

38. Avinoam Shalem, 'Made for the Show: The Medieval Treasury of the Ka'ba in Mecca', in Bernard O'Kane (ed.), *Studies in the Iconography of Islamic Art in Honour of Robert Hillenbrand* (Edinburgh, 2005), 274.

39. Barbara Finster, 'Die Mosaiken der Umayyadenmoschee von Damaskus', *Kunst des Orients*, 7/2 (1970–1), 129–30.

40. See Marcus Milwright, '"Waves of the Sea": Responses to Marble in Written Sources (9th–15th Century)', in Bernard O'Kane (ed.), *Studies in the Iconography of Islamic Art in Honour of Robert Hillenbrand* (Edinburgh, 2005), 211–22.

41. Oleg Grabar, *The Shape of the Holy: Early Islamic Jerusalem* (Princeton and New Jersey, 1996), 88.

42. The latter account is by al-Muhallabi; both accounts are discussed in Priscilla Soucek, 'The Temple of Solomon in Islamic Legend and Art', in *The Temple of Solomon*, ed. Joseph Gutmann (Missoula, 1976), 87; 97. Myriam Rosen-Ayalon, *The Early Islamic Monuments of al-Haram al-Sharif: an Iconographic Study*, Qedem: Monographs of the Institute of Archaeology, the Hebrew University of Jerusalem 28 (Jerusalem, 1989), 52, shows that in the fifteenth-century *Mi'rajnama* the illustration of the Emerald Tree in Paradise also displays a bejewelled trunk. However, given the Muslim associations we have pursued in the text above, her contention (ibid., 60) that the 'tree motif appears in place of the Cross' would appear to be redundant.

43. Nasser Rabbat, 'The Dialogic Dimension of Umayyad Art', *Res* 43 (2003), 79–94.

44. My translation, from *Diwan Nabighat Shaiban* (Cairo, 2nd edn, 1995), 53.

45. Rabbat, 'Dialogic Dimension', 90. For what it is worth, the editor of the published text vowels it as: *mubaṭṭan^{un} bi-rukhām^i al-shām^i maḥfūf^{u.}*, i.e. reading Syrian marble.

46. Rabbat, 'Dialogic Dimension', 91–2; expanding on his previous remarks in 'The Mosaics of the Qubba al-Zahiriyya in Damascus: A Classical Syrian Medium Acquires a Mamluk Signature', *Aram* 9–10 (1997–8), 237–9.

47. Finbarr Barry Flood, *The Great Mosque of Damascus: Studies in the Makings of an Umayyad Visual Culture* (Leiden, 2001), 33.

48. Jean Sauvaget, *La mosquée omeyyade de Médine: étude sur les origines architecturales de la mosquée et de la basilique* (Paris, 1937), 81.

49. Flood, *Great Mosque*, Chapters 2–3.

50. I am grateful to Robert Hillenbrand for the information that carbon testing has substantiated this date.

51. Hans-Caspar Graf von Bothmer, 'Archittekturbilder im Koran – eine Prachthandschrift der Umayyadenzeit aus dem Yemen', *Pantheon* 45 (1987), 4–20; Oleg Grabar, *The Mediation of Ornament* (Princeton, 1992), Pls 16–17.

52. Grabar, *Mediation*, 157.

53. Flood, *Great Mosque*, 64 (although there he was commenting on the vegetal frieze). One other Umayyad representation may be mentioned here, although its secular context gives it a different symbolic charge from the other examples. This is the diwan of Khirbat al-Mafjar, where the most important mosaic is dominated by a large fruit-bearing tree. The tree has been seen as encompassing the world, both the Dar al-Islam and the Dar al-Harb, or alternatively as an erotic embrace and a representation of the verse 'Salma, you were a paradise and its fruits in all their kinds near ripe for harvesting'; Doris Behrens Abouseif, 'The Lion-Gazelle Mosaic at Khirbat al-Mafjar', *Muqarnas* 14 (1997), 16 and Fig. 3.

54. D. Fairchild Ruggles, Gardens, *Landscape and Vision in the Palaces of Islamic Spain* (University Park, 2000), 216, although she also notes that jurists argued against their permissibility.

55. Gaston Wiet, *Catalogue général du Musée de l'Art Islamique du Caire: Inscription historiques sur pierre* (Cairo, 1971), 36, with references to other sources that mention trees in mosque courtyards. I will add just one later reference, that of Ibn Battuta to the mosque of ʿAlishah at Tabriz, who states that its courtyard was filled with trees, vines and jasmines: *The Travels of Ibn Battuta A.D. 1325–1354*, trans. H. A. R. Gibb, 3 vols (Cambridge, 1958–71), 2: 345. As Ibn Battuta visited it not long after its foundation (1318–22), the plantings must have been an integral part of the design for the courtyard.

56. *Medieval Tomb Towers of Iran*, Islamic Art and Architecture, 2 (Costa Mesa, 1986), 41–64. One may also mention here that trees were considered suitable decoration for tombstones, e.g. two from Egypt dated 248/862 and 250/864 each of which has an arch with a tree in each spandrel: Gaston Wiet, *Steles Funéraires*, vol. 2 (Cairo, 1936), nos 9129, 1274. Of course not every foliage in Islamic art can be related to paradise; for the dangers inherent in such an approach see Terry Allen, *Imagining Paradise in Islamic Art* (Sebastopol, 1993), updated version

at <http://www.sonic.net/~tallen/palmtree/ip.html> (last accessed 23 August 2003).

57. Partial in that they are more stylised than naturalistic.

58. The obvious exception of the Fatimid mosaics at the Mosque of al-Aqsa reinforce the links with the Umayyad examples.

59. Rabbat, 'The Mosaics of the Qubba al-Zahiriyya'.

60. *Nuzhat-al-qulub*, trans. le Strange, 272–3.

61. See n. 12 above. A'lam notes that Herodotus recounted another dream of prophetic import: 'Xerxes, contemplating an invasion of Greece, saw himself in a dream crowned with an olive branch from which other branches spread over the earth, a vision that the Magi interpreted as portending not only victory over Greece but also conquest over the world', 'Derakht', 318.

62. Rashid al-Din Fadl Allah, *Jami' al-tavarikh*, trans. W. M. Thackston as *Rashiduddin Fazlullah's Jami'u't-tawarikh: Compendium of Chronicles*, Sources of Oriental Languages and Literatures, 45, 3 vols (Cambridge, MA, 1999), 2: 264.

63. V. V. Barthold, trans. J. M. Rogers, 'The Burial Rites of the Turks and Mongols', *Central Asiatic Journal* 14 (1970), 210.

64. Rashid al-Din Fadl Allah, *Jami' al-tavarikh*, 3: 653.

65. Ibid., 3: 654; see also Reuven Amitai-Preiss, 'Ghazan, Islam and Mongol Tradition: A View from the Mamluk Sultanate', *Bulletin of the School of Oriental and African Studies* 59/1 (1996), 1–10.

66. Marianne Barrucand, 'Le *Kalila wa Dimna* de la Bibliothèque Royale de Rabat', *Revue des Études Islamiques* 55 (1986), Fig. 7.

67. Sheila S Blair, *A Compendium of Chronicles*, The Nasser D. Khalili Collection of Islamic Art 27 (London, 1995), Figs 42, 44.

68. Rashid al-Din's use of Byzantine models for his illustrations has been noted (ibid., 50–3), and it is interesting that an *Octateuch* for Isaac Comnenus (twelfth century), now in the Topkapı Saray Library, depicts a scene of the Earthly Paradise in the form of a landscape with a river flowing beneath trees populated by a variety of birds: Filiz Çağman, 'The Topkapi Collection', *Aramco World Magazine* 38/2 (1987), 16. However, its Byzantine style is markedly different from the Chinese style of the landscape paintings in the *Jami' al-tavarikh*. In the second half of the thirteenth century we also have evidence for mural landscape painting in sultanate Delhi, where Firuzshah Tughluq ordered his palace rooms decorated with various kinds of *bustān*, i.e. flowering orchards, rather than with the figural scenes which had previously been the norm there: B. N. Goswamy, 'In the Sultan's Shadow: Pre-Mughal Painting in and around Delhi', in *Delhi Through the Ages: Essays in Urban History, Culture and Society*, ed R. E. Frykenberg (Delhi, 1986), 133.

69. Trans. Meisami in ibid., 260–1.

70. Julie Scott Meisami, 'The *Šâh-Nâme* as Mirror for Princes: A Study in Reception', in *Pand-o Sokhan: Mélanges offerts à Charles-Henri de Fouchécour*, Bibliothèque Iranienne 44, ed. Christophe Balaÿ, Claire Kappler and Zhiva Vesel (Tehran, 1995), 268.

71. Trans. Meisami in 'The Body as Garden', 265. Trees, like gardens, have been used for an enormous variety of metaphorical meanings: Just as the Quran compares the Word to a good tree (see n. 29 above), Nasir-i Khusrau adapts the simile to men, comparing them to good and bad trees: Annemarie Schimmel, 'Some Notes on Naser-e Xosrow as a Poet',

in *Pand-o Sokhan: Mélanges offerts à Charles-Henri de Fouchécour*, Bibliothèque Iranienne 44, ed. Christophe Balaÿ, Claire Kappler and Zhiva Vesel (Tehran, 1995), 263.

72. Hellmut Ritter, *Über die Bildersprache Nizamis* (Berlin and Leipzig, 1927), esp. section 3, 'der Mensch und die Natur', 41–66.

73. Christine van Ruymbeke, 'Niẓāmī's Trees: An Arboricultural Investigation of the Miniatures of Shāh Ṭāhmāsp's *Khamsa* (British Library OR 2265)', *Edebiyāt* 11 (2000), 215–16.

74. Ouseley noted, on his journeys in Iran, the trees covered with votive offerings of rags and termed *dirakht-i fāṣl* (excellent or beneficial tree): *Travels*, 1: 313. I have seen many of these on my own travels in Iran and Afghanistan.

75. A'lam, 'Derakht', 316–19; Manuchihr Sutuda, *Az Astara ta Astarabad* (Tehran, 1347/1970, repr. 1374/1995), 6 (introduction).

76. *Yadgarha-yi Yazd*, figs 100, 137/1, 145, 155, 213, 229 (mistakenly captioned 239), 232, 239, 252, 255/1, 266.

77. See J. van Reeth, 'La barque de l'Imām al-Šāfiʿī', in *Egypt and Syria in the Fatimid, Ayyubid and Mamluk Eras II*, ed. U. Vermullen and D. de Smet (Orientalia Lovaniensia Analecta, 83) (Leuven, 1998), 249–64. In addition, in Cairene monuments, the minaret of the mosque of Ibn Tulun had a boat-shaped finial, and a model of a boat hung until recently in the mausoleum attached to the mosque of Sulayman Pasha on the citadel in Cairo; one still hangs in the symbolic tomb within the Ribat al-Athar.

78. Nehemia Levtzion, *Conversion to Islam* (New York and London, 1979), 19, *apud* Amitai-Preiss, 'Ghazan', 9.

79. Henri Corbin, trans. Nancy Pearson, *Spiritual Body and Celestial Earth: From Mazdean Iran to Shīʿite Iran* (Princeton, 1977), 31, 281. For earlier interpretations of the same paintings see the list of previous publications in O'Kane, 'The Bihbihani *Anthology*', n. 52; and Ernst Diez, 'Die Elemente der persisichen Landschaftmalerei und ihre Gestaltung', in *Kunde, Wesen, Entwicklung*, ed. Joseph Strzygowski (Vienna, 1922), 116–36.

80. See n. 18 above.

81. *Great Mosque*, 243; *idem*, 'Umayyad Architecture and Mamluk Revivals: Qalawunid Architecture and the Great Mosque of Damascus', *Muqarnas* 14 (1997), 57–79.

CHAPTER TWELVE

Domestic and Religious Architecture in Cairo: Mutual Influences

THE STUDY OF domestic architecture in Islamic societies is severely handicapped by its poor survival rate. This is hardly surprising, since while religious institutions such as mosques, *madrasas* and *khan-qahs* had *waqfs* that supported them up to centuries after the death of their founder, grand residences were subject to the notoriously fickle fortunes of the government officials usually responsible for their erection. Occasionally some of these grand houses or palaces escaped ruin by being transformed into religious buildings. This piece will document some of these examples in medieval Cairo and examine the corresponding mutual influences of these two usually contrasting spheres of architecture.[1]

We are fortunate that Cairo is the city with the highest concentration of Islamic monuments, and one in which both the extant and archaeological records of domestic architecture give us an almost full picture of its development from Fatimid to modern times. In many cases information lacking from the monuments can be supplemented from the uniquely voluminous historical sources pertaining to Cairo: chronicles, biographies, *waqfiyyas* (endowment deeds), and other court deeds.

Early domestic architecture

The results of the excavations of the domestic architecture of Tulunid and Fatimid Fustat have been masterfully summarised by Ostrasz.[2] He shows how, contrary to previously accepted views, the most common living unit plan was of a courtyard with three plain walls and a *majlis* on the fourth.[3] A *majlis* in this context is to be understood in its technical sense as described by Mas'udi (d. 957):

> During his reign al-Mutawakkil constructed a building according to a plan unknown at that time, which became known as al-Hiri,

Bernard O'Kane (2000), 'Domestic and Religious Architecture in Cairo: Mutual Influences', in Doris Behrens-Abouseif (ed.), *The Cairo Heritage: Essays in Honor of Laila Ali Ibrahim*, Cairo, 149–82.

with two wings and porticoes (*kummayn wa arwiqa*). The idea was suggested to him by one of his courtiers who told him that a king of Hira, of the dynasty of Nu'man of the tribe of Bani Nasr, has a passion for war and, wishing always to have it constantly in mind, has constructed at his capital of Hira a building which would evoke an army drawn up in battle lines. The portico had in it the king's reception room (*majlis*) representing the centre of the army (*sadr*). The two wings (*kummayn*, lit. sleeves) symbolised the left and right flanks and were for the use of the most important members of the court. The righthand wing was the royal wardrobe (*khazanat al-kiswa*), while the left-hand one served as a repository for drinks. The portico stretched over the centre (*sadr*) and the two wings, and the three doors led to it. This is the building which is still called to this day 'the *hiri* with two wings' in reference to the town of Hira. The people has similar structures built in imitation of that of al-Mutawakkil, and it has remained famous down to this day.[4]

Although this account is extremely useful in giving us the contemporary terminology for the spaces within the *bayt*s, its mythical status is emphasised by resorting to the forced analogy with 'the army drawn up in battle lines', which, although it might have explained why it appealed to al-Mutawakkil, would not tell us why it attained such popularity in middle-class housing after his time. That it did become the accepted terminology, however, is shown by references to '*al-majlis al-hiri bi kummayn*' in two thirteenth-century Cairene documents.[5]

Although the gap between the houses excavated at Fustat and the early Mamluk *qa'a*s cannot be completely filled by the examples of which we have plans (for which see below), Hazem Sayed's analysis of archival documents has shown that between roughly 1150 and 1400 there was a steady progression from living units with a single or double *majlis* to ones with a single or double *iwan*, with an intermediate type, the *majlis-iwan*, appearing after 1150, gaining popularity from 1250 to 1350 (although the single *iwan* was the most popular in this stage), and declining rapidly thereafter.[6]

Early *qa'a*s

The single securely dated pre-Mamluk *qa'a* known is that of the palace of Sultan Salih on Rawda island (638/1240–1) (Figure 12.1), fortunately described by Marcel in the *Description de l'Égypte*.[7] It had two vaulted *iwan*s[8] facing each other and a dome in the centre supported by four groups of three columns. Marcel does not specify the material of the dome, but from its oblong base and relatively flimsy supports it is safe to assume that it was wooden, an early form of the *shukhshaykha* that survives in Ottoman houses.[9]

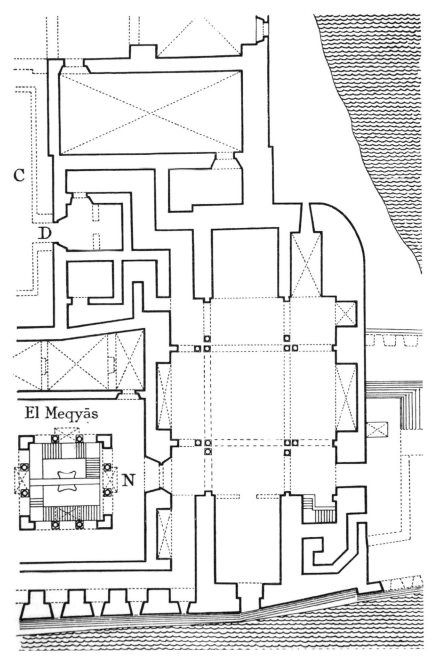

Figure 12.1 *Palace of Sultan Salih (638/1240–1), plan (after* Description de l'Égypte)

The two other candidates for pre-Mamluk *qaʿa*s are those of al-Dardir and Dayr al-Banat. The *qaʿa* of al-Dardir was dated to the Fatimid period by Creswell, relying on two features, the keel-arched niches on the lateral walls, and the form of the flat pendentives

with a squinch below, which he compared to the spherical examples of the mosque of al-Aqsa added by al-Zahir (436/1035).[10] Lézine, however, ascribed it to the fifteenth century, arguing that the form of the keel-arches should not be used as a dating criterion, as they arc similar to archaic Mamluk examples. He also suggested that the pendentives resemble Mamluk ones such as those of the mausoleum of Barquq, and that the shape of the small squinches below them should be compared to those of fourteenth-century examples. Finally, he noted the plan type, similar to those from the early fourteenth century onward, and different from those before. Revault plumped for an Ayyubid date without discussing any criteria for it,[11] while Garcin, although discussing it within a pre-Mamluk context, noted that the necessary historical inquiries had not yet been made.[12]

The uniqueness of the *qaʻa* of al-Dardir is one reason for the difficulties we have in dating it: no other monument has remotely the same form of pendentives.[13] Lézine's claim that its plan resembles fourteenth-century *qaʻa*s is basically true, but the other examples from this period all have more in the way of niches or deeper widening of the *iwan*s or the *durqaʻa* than al-Dardir.

Its vaulting relates it to pre-Mamluk examples, such as the *qaʻa* of al-Salih mentioned above. All other Mamluk *qaʻa*s have flat roofs. On the other hand, Hazem Sayed's archival studies show that, while single-*iwan qaʻa*s were very common from c. 1250 onward, double-*iwan qaʻa*s did not appear regularly in the documents until 1300.[14] But of course, the *qaʻa* of al-Salih (638/1240–1) is itself a double-*iwan qaʻa*, if on a grander scale than al-Dardir. On balance, a pre-Mamluk date has much to recommend it – Sayed's studies show that archaic and new plans were constantly intermingled in Cairo's domestic architecture, with single-*majlis*, *majlis-iwan and* single-*iwan qaʻa*s being built continuously from c. 1150–1400.

The Kufic inscription that adorns the lower walls of the *durqaʻa* may also be a relevant dating criterion. It is similar in style to late Fatimid examples, but has been accepted as having been moved from elsewhere as it contains Quran 9:18, a verse that pertains to mosques and prayer and which, it has been claimed, 'was only used in mosques'.[15] However, if was also used on gateways, one of which, the Alai gateway in Delhi, admittedly led into a mosque complex, although another, the Kharput gate in Diyarbakir, was part of the town walls.[16] Given the fact that the few Mamluk domestic monuments whose inscriptions have been read do have other Quranic inscriptions, and that the verses following Quran 9:18 refer to paradise, also mentioned in the Quranic verse on the palace of Qaytbay,[17] it would be wrong to dismiss out of hand the possibility of this frieze being part of the original decoration.

The other candidate for a pre-Mamluk *qaʻa* is that of Dayr al-Banat, part of the Convent of St George within the Roman fortress

in Old Cairo. This has a *majlis-iwan* plan, and is particularly valuable in that it has retained the very impressive folding doors that lead into the central portion (*sadr*) of the *majlis*.[18] These doors are divided into rectangular panels that have carvings of figures almost identical to those found on Fatimid doors re-used in the Qalawun complex, on account of which Lézine dated it to the eleventh century.[19] Revault repeated this view,[20] but Laila Ibrahim, without specifying why, ascribed it to the Ayyubid period.[21] It is typical of her charity to assume that everyone knew what was obvious to her (and what she confided to me): that the panels that surmount the frame of these doors have been cut through their carved surface to make them fit in position (Figure 12.2), showing that they have also been re-used and have no bearing on the date of the monument.

Recently the ceilings of the *iwan* and *majlis* have been cleaned, revealing some unsuspected ornamentation. Just below the coffered

Figure 12.2 *Dayr al-Banat (c. 1275–1325), detail of folding doors of* majlis

and beamed ceiling of the *iwan* ran two inscriptions, both unfortunately almost illegible (Figure 12.3). The lower was naskh, the upper, on the concave cornice, was apparently Kufic with intricately knotted uprights.[22] More surprising, at the four corners of this upper inscription were addorsed winged lions (or panthers), depicted walking with their heads turned backward. Mention of lions calls to mind the blazon of Baybars, some versions of which resemble those of Dayr al-Banat,[23] but as the latter are winged, they fall into a broader category, that of auspicious animals suitable for decorating the accoutrements of a patron with princely aspirations. Like the knotted Kufic inscriptions, parallels are most easily found in late Ayyubid and early Mamluk metalwork.[24]

Figure 12.3 *Dayr al-Banat (c. 1275–1325), detail of ceiling of* iwan

Dating by comparing different media is fraught with dangers, however. There are stronger grounds for an early Mamluk date for the *qaʿa* of Dayr al-Banat, namely the designs of the carved wood-work in the ceilings. The outer frame of both the *iwan* and *majlis* ceilings (Figure 12.4) have a pattern of reciprocal polylobed arches whose design and carving matches very closely those of the Qaʿat al-ʿIrsan, itself situated not five hundred metres away within the old Roman fortress. Admittedly the *qaʿa* of Irsan is also undated, but unlike the earlier examples all commentators have agreed that it is likely to be fourteenth-century.[25] There is another dated fourteenth-century monument whose ceiling frames show very similar patterns: the mosque of Ulmas (730/1329–30) (Figure 12.5), published in detail in this volume. We may recollect that Hazem Sayed's work has shown that *majlis-iwan*s continued to be built until the end of the fourteenth century, so there is no difficulty in assigning Dayr al-Banat to the Bahri Mamluk period.

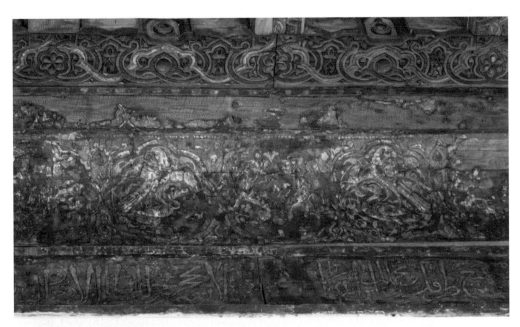

Figure **12.4** *Dayr al-Banat (c. 1275–1325), detail of ceiling of* majlis

Figure **12.5** *Mosque of Ulmas (730/1329–30), detail of ceiling of arcade*

The influence of domestic on religious architecture

Hazem Sayed has also pointed out one clear instance of the influence of domestic on religious architecture in the plan of the *khanqah* of Baybars al-Jashankir, whose *waqfiyya* described the large halls to the sides of the courtyard as *majlis*es. The space within these halls is undivided, showing a development from the *sadr* and *kummayn* normally associated with this term, but the tall central door flanked by two smaller ones leading to it is enough to show its derivation from the secular examples.

Another example of influence from domestic architecture is visible in its *qibla iwan*: its widening by means of two wings, termed in this instance by the *waqfiyya* as *janahayn*.[26] This is a frequent feature of large-scale early Mamluk *qaʿas*, a good example known being that of the palace of Alin Aq (before 736/1336) (Figure 12.6).

What was the reason for this widening of the *iwan* in domestic architecture? Before discussing this further, let us look at some other examples of its appearance in Mamluk religious architecture, in association with some other features derived from domestic architecture. The combination of widened *qibla iwan*, covered or reduced courtyard, vestigial side *iwan*s and flat rather than vaulted *iwan*s are all typical of religious monuments in Cairo from the third decade of the fifteenth century onward, with most of these features occurring in such monuments as the mosque-madrasas[27] of Jawhar al-Lala, Jawhar al-Qunuqbayi, Qadi Yahya at Shariʿ al-Azhar, Inal, Qaytbay (northern cemetery and Qalʿat al-Kabsh), Qijmas al-Ishaqi, Azbak al-Yusufi, al-Ghawri and Qurqumas.

The culmination of these factors finally resulted in the homogeneity of the main spaces of domestic and religious architecture, but it is worth examining the rates at which these various elements were adopted from domestic architecture.

Flat ceilings in *iwan*s

The most difficult to date accurately is the incorporation of flat ceilings in *iwan*s. This is a constant feature in all of the extant Mamluk *qaʿas* from the earliest surviving examples: Bashtak (736–40/1335–9), Alin Aq (before 736/1336) and Qawsun (738/1337–8). The *iwan* appeared in domestic architecture much earlier: single-*iwan* plans appeared in houses from the middle of the twelfth century onward,[28] and the main Fatimid palace is known to have had one major *iwan* that was used as an audience hall and probably several others.[29] We do not know how these or later domestic *iwan*s were roofed, but in the context of small-scale domestic architecture they may well have been flat-roofed rather than vaulted. A search of earlier documents will probably reveal evidence in support of this.

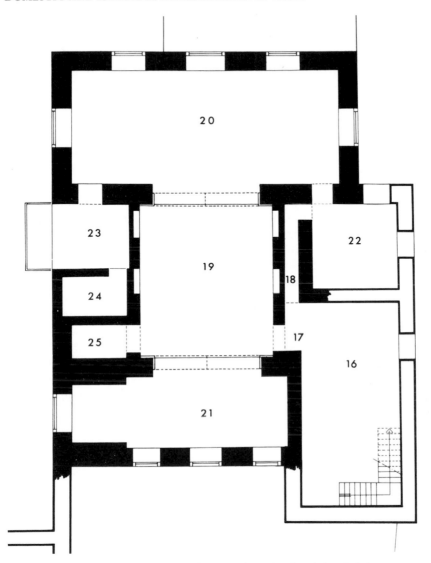

Figure 12.6 *Palace of Alin Aq (before 736/1336), plan (after* Palais et Maisons du Caire*)*

In religious architecture the move from vaulted to flat ceilings appears at the end of the thirteenth century. While the *iwan* of the *ribat* of Mustafa Pasha (c. 667–72/1269–73) in the southern cemetery was vaulted, the *qibla iwan* of the madrasa of Qalawun was flat-roofed, as were those of the madrasas of Turuntay (689/1290) and al-Nasir Muhammad.[30] Wooden roofs continued to be the norm in later religious architecture, although, as Laila Ibrahim has pointed out, they were limited by the size of imported beams to a maximum span of eleven metres – hence the vaulted *iwan*s of Sultan Hasan, for instance.[31]

Another probable instance, related to flat ceilings, of influence
from domestic architecture is the adoption in religious architecture
of *kurdi*s behind the *iwan* arch. I write only probable in this case
because the introduction of this feature cannot be dated accurately
in domestic architecture, although it is present in all the *qaʿa*s
that are presumed to be of the fifteenth century (Muhibb al-Din,
Zaynab Khatun, Bayt al-Razzaz),[32] and is mentioned in a document
dated 889/1484 related to the palace of Shihab al-Din.[33] In religious
architecture *kurdi*s appear in the madrasa of al-Ashraf Barsbay *intra
muros* (1425) behind the stone arch of the *qibla iwan* – an awkward
and redundant combination that suggests that it was imported from
another context, such as domestic architecture. The infrequent
later juxtapostion of *kurdi*s and arches, as in the *qibla iwan*s of the
madrasa of Jamal al-Din al-Ustadar (811/1408) and the mosque of
Sultan Jaqmaq at Darb Saʿada (855/1451), for instance, suggest that it
was an experiment that never quite worked.

The only usage of *kurdi*s found in domestic architecture is as a
substitute for an arch at the opening of an *iwan*. This first appears
in surviving religious architecture in the madrasa of Jawhar al-
Qunuqbayi at al-Azhar (844/1440), framing the recesses of the *qibla
iwan*.[34] Shortly afterward it appears in the mosque of Qaraquja al-
Hasani (845/1441–2) in the *iwan* opposite the *qibla*, and is specified
as a *kurdi* in its *waqfiyya*.[35] Later and of course grander examples are
in the madrasa of Qaytbay in the northern cemetery (877–9/1472–4),
where this time the *kurdi*s flank the recesses of the *iwan* opposite
the *qibla* (Figure 12.7).[36]

Covered courtyards

Again, we are hampered in our search for the origins of this feature,
ubiquitous in Mamluk domestic architecture from the earliest exam-
ples (such as Bashtak, 736–40/1335–9) onward, by the lack of earlier
examples documented either archaeologically or textually. As noted
above, the palace of al-Salih had a dome in the centre of its *qaʿa*.
As this was supported on clusters of relatively flimsy columns it is
likely that the dome was made of wood and that the areas between
it and the *iwan*s were covered with a flat wooden roof (they are not
marked with vaulting lines in the *Description de l 'Égypte* print).

Sayed, viewing the adoption of the *iwan* as a process that went
in tandem with the roofing of the courtyard, has suggested that
two related underlying factors were responsible: decrease in size
and increasing externalisation of houses.[37] Roofing the courtyard
of *qaʿa*s meant that the doors of the *majlis* that formerly kept out
the dust were no longer needed and that the open space of the *iwan*
became more practicable.[38]

Three religious buildings from the early fourteenth century have
covered courtyards: Almalik al-Jukandar, Ahmad al-Mihmandar and

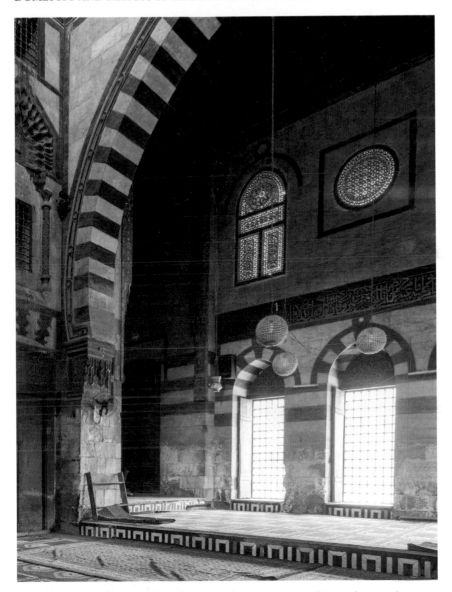

Figure 12.7 *Madrasa of Qaytbay, northern cemetery (877–9/1472–4),* kurdis *of* iwan *opposite the* qibla

Aslam al-Silahdar.[39] However, there is no convincing evidence in the case of any of them to show that the roofing was original. All were restored by the Comité, who in the cases of Almalik al-Jukandar and Aslam al-Silahdar specified that vestiges of earlier roofing were to be seen. But the reports do not mention whether these vestiges had any decoration to show that they were original, or whether they might have been added at an intermediate stage.[40] In the case of Aslam al-Silahdar, the building was completed in stages, showing that a roofed

courtyard was not part of the plan as first envisaged. One might be tempted to make something of the fact that these three buildings are all ones that were designated as mosques in their foundation inscriptions, but that we know from other sources were also used as madrasas, anticipating the practice that became the norm later in the fourteenth century.[41] All are practicable candidates for roofed court-yards in that they are of small dimensions and are of limited height – one would not expect to find covered courtyards, for instance, in the *qaʿa*s of the four madrasas at the corners of the complex of Sultan Hasan, as their great height necessitated a *manwar* (lightshaft) if the interior was to receive sufficient illumination. But the evidence against the possibility of these three having been originally roofed is the large gap between them and the next surviving examples, which were not built until the end of the fourteenth century.

The first example might be the mosque of Aytmish al-Bajasi (785/1383). It has a very irregular plan – for mosques – consisting of only one *iwan* and a covered *durqaʿa*, but this, it could be argued, is a variation of a plan that was by far the most common type in domestic architecture from c. 1250 to 1400.[42] Examples of the two-*iwan* plan with covered *durqaʿa*s are the adjacent mosques of Inal al-Yusufi (794–5/1392–3) and Mahmud al-Kurdi (797/1394–5). Their affinity to domestic architecture may be gauged from the appearance of their side *iwan*s for which vestigial is almost too strong a word. At Inal al-Yusufi they are extremely shallow niches, while at Mahmud al-Kurdi they have been eliminated altogether.

Given that there is another gap between these and the time when covered ceilings appear regularly, from the 1430s onward (see above), it is safer to point to the late rather than the early fourteenth-century examples as being the first of their kind.

Another possibility is that courtyards were capable of being tem-porarily roofed with matting on ropes, depending on the season. The courtyard of the mosque of Qaraquja al-Hasani is now roofed, but its *waqfiyya*, like that of several other fifteenth-century examples, men-tions that its *durqaʿa* was surrounded by a *darabzin* (balustrade),[43] which might have facilitated the erection of a temporary roof. The courtyard of the madrasa of al-Ghawri has such a balustrade that must have made it easy to install the metal grille which, accord-ing to the *waqfiyya*, prevented rubbish and birds from entering the courtyard.[44]

One feature that is concomitant to covering the courtyard is a greater outward orientation of the building. It has long been rec-ognised that the domestic architecture of Cairo is exceptional in this outward orientation.[45] Even early houses that had a courtyard usually had windows on the street façade,[46] a feature that clearly became more common when the court was supplanted by the covered *durqaʿa*.[47] Doris Behrens-Abouseif has noted how the living units of madrasas gradually turned from an introverted orientation to one in

which they faced the street,[48] echoing the earlier transformation of domestic architecture.

Iwan extensions

We have seen above that the *iwan* of the *khanqah* of Baybars had two wings, known in its *waqfiyya* as *janahayn*. The term used for these widenings seems to have varied in the documents. At the *khanqah* of Barsbay the smaller openings in the *iwan* opposite the *qibla* are termed *martaba*,[49] also found in *waqf* documents relating to domestic architecture,[50] and *sidilla* and *suffa* were used in similar ways.[51] Richmond has argued that the widening of the *qibla iwan* in Cairene madrasas happened because they were used primarily as places of prayer. But as noted earlier, the plan of Baybars's *khanqah* is closely related to domestic architecture, and its widening of the *iwans* is seen in the early Mamluk examples, that of Bashtak (736–40/ 1335–9), Alin Aq (before 736/1336) and Qawsun (738/1337–8).

Why was this plan adopted in the case of Alin Aq, for example? One possible reason is linked to the covered *durqaʿa* in the same building: because it reduced the light coming into the *iwans*, the widened space enabled the wall to be safely opened with more windows to compensate for the loss through the courtyard; the five windows at the ground level of the *iwan* and the seven above may be contrasted with the single example seen in each of the *iwans* of the *qaʿa* of al-Dardir, for example.[52]

By the fifteenth century the widening of the *qibla iwan*, and frequently the *iwan* opposite, became the norm in religious architecture, even when, as in the madrasa of al-Ashraf Barsbay *intra muros* or the madrasa of Janibay, the courtyard was open.

Vestigial *iwans*

Creswell has argued that the two-*iwan* madrasa plan, as present in the Kamiliyya (622/1225), itself was evidence of the influence of the domestic *qaʿa* plan. It is certainly not unlikely that this was a factor, but one should also recognise that in this still formative period of madrasa design in Egypt, it could also have been an adaptation of one of the possible madrasa designs of Anatolia of which Creswell was unaware.[53] Even as early as the madrasa of Qalawun (684/1284–5) the side *iwans* (only one has survived) could be called vestigial. But this could represent a variation or expansion of the Kamaliyya and related Anatolian types. The fourteenth-century madrasa plan soon standardises itself with relatively large side *iwans*.[54] At the end of the century we see in the mosque of Inal al-Yusufi the first occurrence of what could be said to be mere apologies for side *iwans*: shallow niches inserted merely to indicate their location in the standard plan. Another example of this is at the mosque of Kafur al Zimam

(829/1426),[55] although the later examples, which appear regularly from the 1440s onward in combination with the covered courtyard, are usually a little deeper. Surprisingly, this coincides with the more common appearance in *qaʿa* plans of deeper side niches (*qaʿa*s of Muhibb al-Din and Qaytbay at Bayt al-Razzaz)[56] – perhaps an indication of influence of religious on domestic architecture. The side *iwan*s are occasionally even dispensed with completely, as in the madrasa of Mahmud al-Kurdi (Figure 12.8) and that of Qaytbay's Gulshani complex (Figures 12.9, 12.10).[57] The *waqfiyya* of the madrasa of al-Ghawri shows how far the thinking of those designing or describing *qaʿa*-style courtyards had become infused with concepts from domestic architecture: its two vestigial side *iwan*s, although scarcely smaller than most fourteenth-century examples, are described as *martaba*s, the niches that characterise the *durqaʿa* in the normal fifteenth century two-*iwan qaʿa* plan.[58]

Aghanis

The *Aghani*s (singers' galleries) as the grilles of upper-storey spaces overlooking the *qaʿa* are referred to in archival documents,[59] are common features of both fourteenth- (*qaʿa*s of Bishtak, Sharaf al-Din, Irsan and Tashtumur) and fifteenth-century Mamluk domestic architecture (Qaytbay, Bayt al-Razzaz).[60] Only one clear instance of this is found in religious architecture, in the madrasa of Mithqal, in both the side *iwan*s and in the extensions of the *iwan* opposite the *qibla*, but it echoes so exactly the disposition of Sharaf al-Din that its origin in domestic architecture cannot be doubted.[61] One other related example can be cited: the side walls of the *durqaʿa* of the madrasa of Mahmud al-Kurdi (797/1395) (Figure 12.8). Instead of side *iwan*s student cells occupy this space in such a way that their three tiers of windows form a regular series of metal grilles. However, the windows at the intermediate tier incorporate wooden grilles that strongly resemble the *Aghani*s of the *qaʿa* of Irsan.[62]

Landscape decoration

In the zone of transition of the main dome chamber of the mosque of al-Maridani are naturalistic representations of trees in stucco that are unknown elsewhere in religious architecture in Cairo (Figure 12.11). The lack of comment that they have elicited[63] may have been from a suspicion that they are later restorations, although they would be even more out of place in Ottoman architecture. The trees on the brass ewer of Shihab al-Din Ahmad (d. 742/1342), a near-contemporary of the mosque, present extremely close stylistic parallels.[64] Altinbugha al-Maridani had spent a considerable period as ruler of Aleppo, and his familiarity with the decoration of such Syrian monuments as the Great Mosque of Damascus or the Dome of the

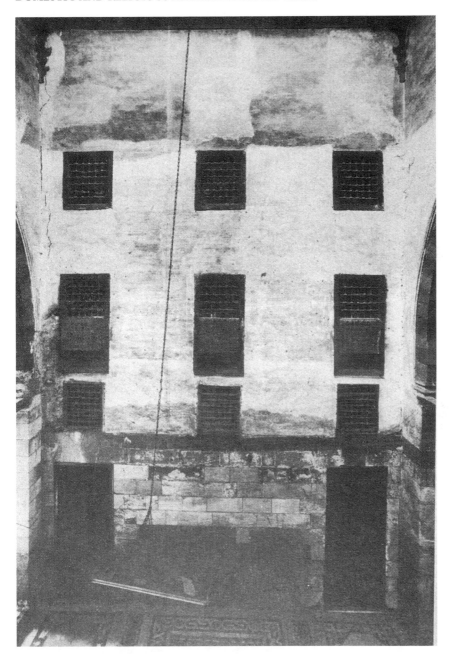

Figure 12.8 *Mosque of Mahmud al-Kurdi (797/1393), side of courtyard (after Mostafa)*

Rock may have inspired these examples. But it would be as well to remember that parallels for such decoration were even closer at hand in the mosaics depicting buildings set amidst trees in the *qaʿa* of al-Ashraf at the Citadel.[65] These may also ultimately owe their

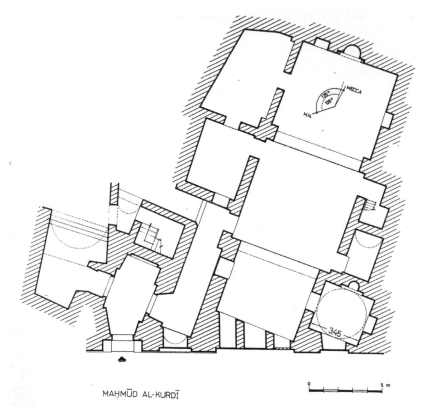

MAḤMŪD AL-KURDĪ

Figure 12.9 *Mosque of Mahmud al-Kurdi (797/1393), plan (after Kessler)*

Figure 12.10 *Complex of al-Gulshani (c. 879/1494–5), plan (after Kessler)*

Figure 12.11 *Mosque of al-Maridani (739–40/1339–40), zone of transition of dome chamber, stucco decoration*

inspiration to Damascus, but their proximity may have facilitated their adoption in al-Maridani's mosque.

The influence of religious on domestic architecture

This will take up less of our time, so one-sided is the interplay of mutual influences. We have referred above to the deepening of the side *iwan*s in fifteenth-century *qaʿas*, the only example I can think of where religious architecture might have influenced the plans of domestic architecture. It is probably inevitable that decoration, or at least non-figural decoration, would have been shared by both types. The octagonal wooden coffers that occur in a series of religious buildings from the mausoleum of Imam Shafiʿi onward are first found in domestic architecture in the *qaʿa* of Bashtak. But this ceiling, of course, is also one of the earliest original wooden ceilings to have survived in Cairo,[66] the lack of earlier examples making it difficult to be certain of its priority in religious buildings.[67] An unusual motif shared by the upper circular windows of the mausoleum of Sultan Hasan (757–64/1356–62) and the frame of the *iwan* extension of the palace of Tashtumur (768/1366–7) is that of the wooden fleur-de-lys, giving an impression from a distance of a toothed surround (Figures 12.12, 12.13). The short span of time between the two again makes it uncertain whether absolute priority should be ascribed to the religious examples, although it is striking that no other surviving monuments display this decoration. One final example will at least show how decoration was shared between both religious and secular buildings: the stucco medallions of the tomb of Kujuk in the mosque of Aqsunqur and the very similar ones of the Qaʿat al-ʿIrsan.[68] What circumstances led to these extraordinary similarities between domestic and religious architecture in Cairo? Not just

Figure 12.12 *Complex of Sultan Hasan (757–64/1356–62), mausoleum, detail of window*

Figure 12.13 *Palace of Tashtumur (768/1366–7), detail of arch in qibla iwan*

their proximity, but their juxtaposition and the fluidity of use must have been paramount. These can be examined under the following categories: religious buildings within houses, houses adjacent to religious buildings by the same patron, living quarters within religious

buildings, and houses converted into religious buildings. I include by no means all possible examples within these categories, but enough I hope to make the main developments clear.

Mosques and madrasas built in houses

Tax breaks have been one factor in the frequently-seen phenomenon in modem Cairo of incorporating mosques within apartment buildings. However, the apartment complexes of early Fustat were so large that one, the *dar* of ʿAbd al-ʿAziz, had five *masjid*s within it.[69] Also in Fustat, the amir Yazkuj built, towards the end of the twelfth century, two *rab*ʿs opposite one another and incorporated a madrasa into the upper storey of one of them.[70] Later examples are not common, although Bashtak, who demolished eleven *masjid*s and four oratories (*maʿabid*) to make way for his palace, compensated by rebuilding one within the new fabric, the Masjid al-Fijl.[71] In the early fourteenth century the physician Fath Allah built a magnificent palace near the canal of which al-Maqrizi gives an unusually enthusiastic description, also mentioning that he included within it an elevated mosque that had its own *imam*.[72]

Houses adjacent to religious buildings

From the earliest period of the foundations of madrasas in Egypt it was common for them to be built near the residences of their patrons. In 580/1184–5 the *qadi* Fadil Abd al-Rahman built his eponymous madrasa in al-Qahira next to his palace (*dar*),[73] an action paralleled by another *qadi* in the fourteenth century, Badr al-Din ibn al-Kharubi, who built his madrasa in Fustat.[74] An inscription dated 710/1310 from a mosque built by the amir Sanjar the *jumak-dar* mentions that the *qaʿa*s and what was above them were made *waqf* for the adjacent mosque, obviously referring to the founder's property.[75]

Most early Mamluk palaces are termed *makan* (place) in their inscriptions, and Laila Ibrahim has pointed out that the examples of religious buildings that use this term were probably near their patron's dwelling.[76] These religious examples consist of the madrasa of Salar, the tomb of Safi al-Din Jawhar and the *khanqah* of Shaykhu. In the case of the madrasa of Salar we know from al-Maqrizi that it was indeed next to his house,[77] while the *khanqah* of Shaykhu may have merited the term because of its incorporation of a large two-*iwan* *qaʿa* adjacent to the *qibla* prayer hall, presumably for the founder's visits or his family's residence.

Two Bahri Mamluk patrons who erected madrasas near their houses are Tatar al-Hijaziyya and al-Zayni ibn al-Jiʿan.[78] The even intimate connections possible between house and madrasa are best demonstrated by the upper storey of the madrasa of Mithqal

(763/1361–2) to which no staircases led from the madrasa's ground floor. Instead, the patron and the madrasa personnel must have reached it from the adjacent palace of Mithqal, underlining the fluidity of the boundaries between the two.[79]

Living quarters in religious buildings

Under this heading we can distinguish between three different types of living quarters: those for students or sufis, those for the upper level personnel of the foundations, and those for founders. The evolution of student cells has been studied in detail elsewhere,[80] so my remarks here are confined to the other two categories.

In the case of the *khanqah* of Shaykhu mentioned above, for example, the two-*iwan qaʿa* was presumably for the founder, while the cells for the sufis were arranged in rows around the courtyard. But even earlier we have examples of *qaʿas* within *khanqahs* that were built for the shaykh and his family: in the complexes of al-Nasir Muhammad (at Siryaqus, near Cairo) and of Mughultay al-Jamali (730/1329).[81] Al-Nasir Muhammad and later Bahri Mamluk sultans made annual pilgrimages to the *khanqah* there, although they would have stayed in the residences (*qusur, manazil*) that he had earlier built for himself and his amirs.[82] Other founders may have arranged for special accommodation within their complexes by this time: Chahinda Karim has suggested that a large upper room within the complex of Aslam al-Silahdar was for the use of the amir on his visits.[83] Definite evidence for this comes from the *waqfiyya* of the complex of Barquq at Bayn al-Qasrayn (788/1386). In addition to three *qaʿas* for the religious personnel, one near to the mausoleum was reserved for the descendants of the founder and for their descendants in turn.[84]

This *qaʿa* could have served two purposes: for accommodation for the founder in his lifetime when participating in the religious life of his foundation, and afterward by his descendants for the same purpose and for paying their respects to the deceased. Barquq himself visited the madrasa often to pay his respects to his deceased father Anas whom he had had buried in the dome chamber, and he reinterred his sons who had pre-deceased him there.[85] Visiting the graves of one's family has remained popular in Egypt since pre-Islamic times.[86] Al-Maqrizi has a small section in his *Khitat* on *jawsaqs*, buildings that were erected in the cemeteries for celebrations on feast days when visits to family graves were made.[87] They seem to have been freestanding constructions, however. An early example of one attached to a tomb is mentioned in the *waqfiyya* (dated 698/1299) of the amir Sayf al-Din Aqqush, which states that the living quarters adjoining the founder's tomb (*turba*) in the cemetery were built for the founder's family if they wished to live there, or could be rented otherwise.[88]

The fifteenth century sees numerous examples of complexes both within the city and in the cemeteries that had accommodation for the founder or his family. Those within the city included the madrasa of Jawhar al-Lala (833/1430), built beside a residence of the amir, but which nevertheless included a *qaʿa* for his use that reverted to the imam of the madrasa after his death.[89] Another that seems to have gone unnoticed until now is a two-*iwan qaʿa* on the upper floor of the *ribat* of the wife of Inal (c. 860/1456) (Figure 12.14). The mosque of Azbak al-Yusufi (900/1494–5) has the remains of a

Figure 12.14 Ribat *of the wife of Inal (c. 860/1456), upper floor* qaʿa

substantial *qaʿa* attached to it,[90] while at the complex of al-Ghawri
(909–10/1503–4) a *maqʿad qibti* (a closed *maqʿad*) was provided for
the founder.[91]

As one would expect, founders' accommodations became even
more common in complexes erected within the cemeteries, as
patrons both visited the graves of dead relatives and participated
in the life of the religious institutions there. Although we cannot
be sure, as the waqf has not survived, the two large living units
on the side opposite the qibla of Faraj ibn Barquq's complex in the
northern cemetery are imposing enough to have been the sultan's.[92]
The *waqfiyya* of al-Ashraf Barsbay's complex has survived, however,
and specifies that of the three *riwaq*s (an upper-storey dwelling unit)
one was for the founder.[93] The *maqʿad qibti* of al-Ghawri's complex
within the city, which was designated for the female members of his
family,[94] is preceded by Qaytbay's in the northern cemetery that was
also for his family's use.[95] Amirial foundations within the northern
cemetery also included extensive accommodation, one of the most
impressive being that of Qurqumas, where an idea of the grandeur of
the upper-storey residential suite may be gauged from the term used
for it in the *waqfiyya: qasr*.[96]

Domestic buildings converted into madrasas

The ultimate measure of the compatibility between domestic and
religious architecture must be the instances of houses being con-
verted to madrasas, *khanqah*s and mosques. Of these categories, the
madrasa is the most numerous, Creswell having published a list of
fifteen examples in Cairo dating from 550–774/1156–1372.[97]

For Damascus alone, this list could be extended from historical
sources to more than fifty examples, as Chamberlain has shown.[98] In
Aleppo Ibn Shaddad mentions seven *khanqah*s that were originally
residences.[99] At least another four examples from historical sources
can be added to Creswell's examples in Cairo,[100] and to the two
well-known extant examples that he gives (the *qaʿa* of Tashtumur/
mosque of Khushqadam al-Ahmadi, and the Ghannamiyya madrasa),
we can add one other definite example, that of Sharafal-Din (*Index*
no. 176) – and another possibility. This possibility is the mosque of
al-Jamali Yusuf in Darb Saʿada (c. 845/1441–2) (Figure 12.15).[101]

This is now a two-*iwan* mosque in which the *qibla iwan* has wide
extensions, side *iwan*s are completely absent and the *iwan* opposite
the *qibla*, like that of Qaraquja al-Hasani, is bordered by *kurdi*s that
were restored in the nineteenth century. Above the doors are rectan-
gular wooden inscription panels with Quranic extracts (21:102 and
39:73), both of which relate to paradise.[102] Although the refurbishing
of the mosque in 1291/1874–5 makes it harder to understand its
earlier history, the difficulty of deciding from its plan and elevation
whether it definitely was a house before it became a mosque is a

Figure 12.15 *Mosque of al-Jamali Yusuf (c. 845/1441–2), plan (after Tantawy)*

reflection of how closely the two became intertwined in the fifteenth century.

Why were so many houses converted into madrasas? It is as well to realise that the house was often the setting for more informal lessons than those in madrasas *or* mosques. This was a custom that was found as early as the ninth century in Baghdad[103] and certainly continued in Cairo, being especially common for teaching women and young girls.[104] The practicality of giving lessons there was obvious, but the collateral benefits made it all the more attractive. The desirability and benefits of establishing a *waqf ahli* (family *waqf*) are too well-known to dwell on here,[105] but I will give a resumé of them since they are particularly relevant to the conversion of houses. Private wealth was easily confiscated by the state, but wealth that was tied up in *waqf* was much harder to expropriate. This was so even if, as was usually the case with a family *waqf*, the founder's family was the administrator of the *waqf* and surplus revenue – which could

even be as much as 80–90 per cent of the total[106] – reverted to the family's control.

Why convert a house rather than endow a purpose-built complex? Expediency must be the answer here. It was much cheaper to convert an existing building that one owned than to incur the costs of a new one,[107] and therefore a way for the pious but not too wealthy to endow their wealth for the good of the community (and also, frequently, for the good of their families). It was also possible to specify in the *waqf* that the endower would be able to live in the house until his or her death.[108] Attaching a tomb to a madrasa was often an extra reason for its foundation, and this, together with the *baraka*-bestowing benefits of Quran readers and a window open to the prayers of passers-by, would also have encouraged those short of funds to convert their houses. Jonathan Berkey has recently shown how expediency must have been uppermost in the minds of many Mamluk amirs and non-Mamluk holders of high governmental positions who founded madrasas: their foundations coincided with a personal crisis in the form of worsening relations with the government, and hence the threat of imminent confiscation of wealth.[109] Such a looming crisis must have inspired many patrons to take the shortest route to endowment by converting a house that they had already built.

Conclusion

The convergence of religious and domestic architecture in Cairo can readily be seen under the Burji Mamluks in the similarity of numerous architectural and decorative elements. The interchangeability of their components must have been inspired by their frequent juxtaposition and by an almost equally frequent conversion from one to the other. These conversions were encouraged not only by personal piety but also by the laws of *waqf* which enabled the property to be under the control of the family but beyond the threat of confiscation by the authorities.

Two examples from *waqfiyya*s best illustrate the radical changes in thinking about interior spaces of religious buildings at this time. One has been referred to above, the description in the *waqfiyya* of al-Ghawri of the madrasa's side *iwan*s as recesses (*martaba*s). The derivation of the plan from the four-*iwan* type, so obvious to the contemporary art historian, is denied in favour of the domestic two-*iwan* *qaʿa* plan. Even earlier, in the madrasa (which was also used as a congregational mosque) attached to the *khanqah* of al-Ashraf Barsbay in the northern cemetery (835/1432), the two arcades separated by a corridor are described as two *iwan*s with a *durqaʿa* in between.[110] The description is glaringly inconsistent to the modern art historian – couldn't they distinguish between an arcade and an *iwan* (Figure 12.16)? How could a space much wider than it

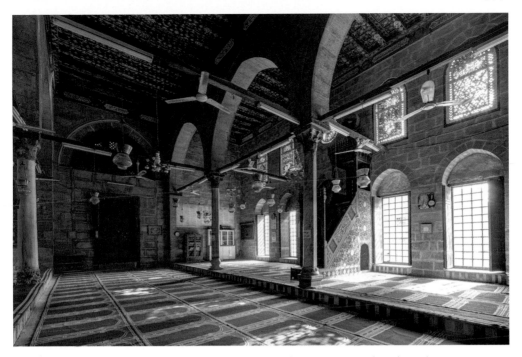

Figure 12.16 *Complex of al-Ashraf Barsbay, northern cemetery (835/1432),* iwan *of* madrasa

is deep be thought to resemble a domestic *qu'a* plan? That it is indeed described as such is indicative of the way in which domestic architectural plans permeated concepts of interior space in Mamluk religious buildings.

Addendum

Reading this now much later, I realise I should have been more aware of the extraordinary flexibility of the term *iwan* in later Egyptian *waqfiyya*s, where, as for instance in the spaces surrounding the courtyard of the al-Mu'ayyad mosque, the term is used to indicate a raised prayer space, and thus the equivalent of a *riwaq*.

Notes

1. The topic of domestic architecture is one of many to which Laila Ibrahim has made major contributions: 'Residential Architecture in Mamluk Cairo', *Muqarnas* 2 (1984), 47–59; 'Middle-Class Living Units in Mamluk Cairo: Architecture and Terminology', *AARP* 14 (1978), 24–30; with Muhammad Amin, *Architectural Terms in Mamluk Documents (648–923H) (1250–1517)* (Cairo, 1990). In this as in many other aspects of the study of Cairene architecture I am happy to record my gratitude for her unstinting generosity in sharing her knowledge and time with me.

2. Antoni A. Ostrasz, 'The Archaeological Material for the Study of the Domestic Architecture at Fusṭāṭ', *Africana Bulletin* 26 (1977), 57–86. In the redrawn plans of houses excavated by earlier scholars such as Gabriel and Bahgat, Ostrasz has most helpfully eliminated the conjectural added doorways of rooms where the excavations were below floor level.

3. Ibid., 76. He refers to the *majlis* as an *iwan* unit.

4. I have used the translation of Paul Lunde and Caroline Stone, *The Meadows of Gold: The Abbasids* (London and New York, 1989), 240. See also Alexandre Lézine, 'Les salles nobles des palais mamelouks', *Annales Islamologiques* 10 (1972): 75–6; Ibrahim, 'Residential Architecture', 59 n. 32.

5. Donald Richards, 'Arabic Documents from the Karaite Community in Cairo', *Journal of the Economic and Social History of the Orient* 15 (1972): 109, 112; Sayed, 'The Development of the Cairene *Qa'a*: Some Considerations', *Annales Islamologiques* 23 (1987): 37.

6. Sayed, 'Development', fig. 3.

7. J. J. Marcel, 'Memoire sur le méqyâs de l'île de Roudah', in *Description de l'Égypte, État moderne* (Paris, 1812), vol. 2, pt 2, 150.

8. K. A. C. Creswell, *The Muslim Architecture of Egypt*, 2 vols (Oxford 1952–9) (hereafter *MAE*), 2: 87, states that they were tunnel-vaulted (cross-vaults on original: *Atlas*, pl. 23) but Lezine, 'Salles nobles', 66, writes that this appears to be not at all evident. In the original plan of the *Atlas*, pl. 23 of the *Description de l'Égypte* (my Figure 12.1), however, as Creswell remarks, the presence of crossed lines within the *iwan* (not shown on Creswell's redrawn plan, *MAE*, vol. 2, fig. 38) indicates a vaulted space (but not necessarily a cross-vaulted one).

9. A view already put forward in Nasser Rabbat, *The Citadel of Cairo: A New Interpretation of Royal Mamluk Architecture* (Leiden, 1995), 258, although his surmise that the space was covered by a dome is explicitly confirmed by Marcel's description. Mona Zakarya, *Deux palais du Caire mediéval* (Paris, 1983), 127 illustrates the term *kushk* by a wooden domed lantern above a *dūrqā'a*; in Amin and Ibrahim, *Architectural Terms*, 96, rectangular and pyramidal lanterns are shown; it is possible that in Mamluk usage it could encompass both designs.

10. *MAE*, 1: 262–3.

11. Jean-Claude Garcin, Bernard Maury, Jacques Revault and Mona Zakariya, *Palais et maisons du Caire. I. Époque mamelouke (XIIIe–XVIe siècles)* (Paris, 1982), 80, revising his earlier acceptance of Lézine in Jacques Revault and Bernard Maury, *Palais et maisons du Caire du XIVe au XVIIIe siècle*, I (Cairo, 1975), 1–10.

12. *Palais et maisons du Caire. I. Époque mamelouke*, 171–2. The illustration in ibid., fig. 45 of painted ornamentation from the soffit of the *iwan* arch is misleading; rather than being original it is probably eighteenth-century work, like that of the wooden cornice inserted into the northern *iwan*.

13. Despite Lézine's suggestion ('Salles nobles', 122), those of the mausoleum of Barquq are in no way comparable (the reference he gives for comparison to Creswell (*MAE*, vol. 2, pl. 159), does not exist, there being no such plate in the latter).

14. Sayed, 'Development', fig. 3. He admits, however (43, n. 6), that his research emphasised *majlis* units within houses, which had led him to devote less attention to *iwan*-based units in the same deeds.

15. Creswell, *MAE*, 1: 263, n.l. It should also be admitted that the style of the inscription also bears similarities to the fragments of one that ran along the four walls of the mausoleum of Shajarrat al-Durr of 1250.

16. Erica Cruickshank Dodd and Shereen Khairallah, *The Image of the Word*, 2 vols (Beirut, 1981), 2: 43, 48.

17. The *qaʿa* of Ghannam contains Quran 2:255–9 (K. A. C. Creswell, 'A Brief Chronology of the Muhammadan Monuments of Egypt to A.D. 1517', *Bulletin de l'Institut Français d'Archéologie Orientale* 16 (1919): 114. The Palace of Qāytbāy contains Quran 3:197; and 54:46; the *maqʿad* of Mamāy contains 2:256 and several verses of the beginning of sura 48, Max van Berchem, *Matériaux pour un Corpus Inscriptionum Arabicarum, part 1: Égypte*, Mémoires de la Mission Archéologique Française du Caire (Cairo, 1894–1903) 19: 516, 518, 542, 546.

18. These are commonly mentioned in contemporary documents: S. D. Goitein, *A Mediterranean Society: The Jewish Communities of the Arab World as Portrayed in the Documents of the Cairo Geniza*, 5 vols, vol. 4, *Daily Life* (Berkeley, 1983), 64.

19. Lézine, 'Salles nobles', 77–8.

20. *Palais et maisons du Caire. I. Époque mamelouke*, 76–8, although in ibid., 172, Garcin attributed it to the twelfth century.

21. Ibrahim, 'Residential Architecture', 53.

22. For examples on late Ayyubid and early Mamluk metalwork see Esin Atil, W. T. Chase and Paul Jett, *Islamic Metalwork in the Freer Gallery of Art* (Washington, DC 1985), no. 18 (basin for al-Ṣāliḥ) Ayyūb, c. 1240) and Esin Atil, *Renaissance of Islam, Art of the Mamluks* (Washington, DC, 1981), nos 10 (candlestick dated 1269) and 16 (c. 1290, candlestick made for Kitbughā). Recently the naskhi inscription within the *majlis* has been read as containing verses from the 91st Psalm: *St. Georges Convent Old Cairo in Photos* (Cairo, 1997), unpaginated.

23. L. A. Mayer, *Saracenic Heraldry* (Oxford, 1933), pl. 1.

24. Atil et al., *Islamic Metalwork*, no. 18 (basin for al-Ṣāliḥ Ayyūb, c. 1240), and on a ewer in the Museum of Islamic Art, Cairo, c. 1300: Atil, *Renaissance*, no. 19.

25. Its stucco medallions, similar to those of the tomb of Kujuk (743/1343), for instance, provide a reliable dating control – see n. 71 below.

26. Leonor Fernandes, 'The Foundation of Baybars al-Jashankir: Its Waqf, History and Architecture', *Muqarnas* 4 (1987): 24.

27. The two become indistinguishable in later Mamluk use and terminology: see van Berchem, *Corpus*, 532–6; Doris Behrens-Abouseif, 'Change in Function and Form of Mamluk Religious Institutions', *Annales Islamologiques* 21 (1985): 73–93; Jonathan Berkey, *The Transmission of Knowledge in Medieval Cairo: A Social History of Islamic Education* (Princeton, 1992), 50–60.

28. Sayed, 'Development', fig. 3.

29. Nāṣir Khusraw, *Safarnāma*, ed. Vahīd Dāmghāni (Tehran, n.d.), 89, in his description of the interior of the palace mentions *iwan*s in addition to other structures; the *iwan* in the Fatimid palace was the main audience hall of al-Muʿizz, Paula Sanders, *Ritual, Politics and the City in Fatimid Cairo* (Albany, 1994), 46–7.

30. Creswell, *MAE*, 2: 178–80 (Muṣṭafa Pāshā), 198–9 (Qalāwūn), 218 (Turuntāy), 234–9 (al-Nāṣir Muḥammad).

31. Ibrahim, 'Residential Architecture', 52.

32. Garcin et al., *Palais et maisons du Caire. I. Époque mamelouke*, 98–125.

33. Zakarya, 126. A thorough study of the *waqf* documents, for domestic and religious architecture, should resolve this question (the examples listed in Amin and Ibrahim, *Terms*, 94, are unfortunately neither assigned nor dated).

34. Illustrated in Michael Meinecke, *Die mamlukische Architektur in Ägypten und Syrien (648/1250 bis 923/1517)* (Abhandlungen des Deutschen Archäologischen Instituts Kairo, Islamische Reihe, 5) (Glückstadt, 1992), pl. 100d.

35. ʿAbd al-Laṭīf Ibrāhīm, 'Wathīqat al-amīr ākhūr kabīr Qaraqujā al-Ḥasanī', *Majallat Kulliyyat al-Ādāb* 18/2 (1956), 201. The mosque of Timrāz al-Aḥmadī has a very irregular plan with *kurdi*s framing the *iwan* opposite the *qibla* and a space to the side which is partly hypostyle. However, it was restored in the Ottoman period (in 1113/1701–2 and 1180/1766–7, van Berchem, *Corpus*, 430) and a detailed study of the building to determine the chronology of its different parts has yet to be made.

36. L. A. Mayer, *The Buildings of Qāytbāy as Described in His Endowment Deed, Fascicule I, Text and Index* (London, 1938), 11, lines 17, 21. J. M. Rogers has pointed out to me that architectural features similar to *kurdi*s can be seen in paintings of the *Masnavī*s of Khvājū Kirmānī, produced in late eighth-/fourteenth-century Baghdad, reproduced in Thomas W. Lentz and Glenn D. Lowry, *Timur and the Princely Vision*, exh. cat. (Los Angeles and Washington, DC 1989), 55.

37. Sayed, 'Development', 51–3.

38. It is argued in Rabbat, 117–18, that the covered *qaʿa* was the norm by the early Mamluk period by inference from the use of the term (relating to several buildings from the time of al-Ẓāhir Baybars) of *qaʿa ḥurmiyya*, probably designating a *qaʿa* in which the central space, the *durqaʿa*, was open to the sky. However, one reference to a *qaʿa ḥurmiyya* in Amin and Ibrahim, 36, mentions that it had a roofed *durqaʿa*.

39. *Comité de Conservation des Monuments de l'Art Arabe, Rapports de la Deuxième Commission, Exercises* 1 (1882–3): 47; 32 (1915–19): 48, 82; Creswell, *MAE*, 2: 270–4; Chahinda Karim, 'The Mosque of Aṣlam al-Bahāʾi al-Silaḥdār (746/1345)', *Annales Islamologiques* 24 (1988).

40. The mosque of Aḥmad al-Mihmandār, for instance, was restored under the Ottoman Sultan Aḥmad III in 1135/1722–3: Creswell, *MAE*, 2: 272.

41. 'It is significant that this feature should first appear in a *madrasa*, for we have seen that many early madrasas were the *qaʿa*s of houses converted for the purpose, and *qaʿa*s are normally covered by a ceiling with a lantern', Creswell, *MAE*, 2: 271.

42. Sayed, 'Development', fig. 3. Qānībāy al-Muḥammadī (816/1413) could arguably fit into this category, although it has a vestigial *iwan* opposite the *qibla*.

43. A *darabzin* is specified in the *waqfiyya* of the mosque of Qarāqujā al-Ḥasanī (Ibrāhīm, 'Qarāqujā', 202). Others are also mentioned in the *waqfiyya*s of Qarājā bint ʿAbd Allāh (733H), al-Sayfī Jānim (864H), Bardbak al-Muḥammadī (879H) and Qāytbāy (885H): ibid., 230; and in the *waqfiyya* of the complex of Qadi Zayn al-Din at al-Azhar: Laylā al-Shafiʿi, 'Munshaʾāt al-qāḍī Yaḥyā Zayn al-Dīn bi'l-Qāhira' (Ph.D. thesis, Cairo University, 1982), 31, line 47.

44. Shahira G. Mehrez, 'The Ghawriyya in the Urban Context: An Analysis of Its Form and Function' (MA thesis, American University in Cairo, 1972), 11, *waqfiyya* reproduced as Index 1, lines 68–9.

45. Ibrahim, 'Living Units', 28, Doris Behrens-Abouseif, 'Quelques traits de l'habitation traditionelle dans la ville du Caire', in *La ville arabe dans l'Islam, histoire et mutations*, ed. Abdelwahab Bouhdiba and Dominique Chevalier (Tunis, 1983), 451–2; Garcin, *Palais et maisons du Caire I. Époque mamelouke*, 173–4.

46. On the *rawshan*, the bay window above the main entrance and other windows in the main façade, see Goitein, 61–2.

47. Zakarya, figs 7–8.

48. Behrens-Abouseif, 'Change', 80.

49. Fernandes, 'Foundation', 24. *Martaba* is also the term used for the widening of the *iwan*s in the complex of al-Ghawrī, Mehrez, 11.

50. Zakarya, 131; Amin and Ibrahim, 103.

51. For *ṣuffa* see Rabbat, 121; Amin and Ibrahim, 73; for *sidilla* see Mayer, *Buildings*, 11, line 3 and Amin and Ibrahim, 62. They suggest (following Lane, *Arabic–English Lexicon*) that *sidilla* is derived from the Persian *sih dāla*, literally 'three hearts'. However, this term is unknown to me in Persian architectural vocabulary; a more likely derivation is from the Latin *sedile*, meaning seat or bench, i.e. a synonym for *martaba*.

52. I am indebted to Loay Omran for the observation regarding the lighting in Alin Aq. For the earlier argument see Ernest Tatham Richmond, *Moslem Architecture 623 to 1516: Some Causes and Consequences* (London, 1926), 147–8.

53. Creswell, *MAE*, 2: 129–31. Creswell's ignorance of the multiplicity of Anatolian madrasa designs further undermines his arguments regarding the originality of the four-*iwan* plan of Cairene madrasas: Robert Hillenbrand, *Islamic Architecture: Form, Function and Meaning* (Edinburgh, 1994), 183–6. The Zinjiriyya *madrasa* of Diyarbakr (1198) and the hospital of Kaykā'us at Sivas (1219) have plans closely related to that of the Kāmiliyya, as does the undated thirteenth-century example at Karahisar Demirci, for which see Kurt Erdmann, 'Vorosmanische Medresen und Imarcts vom Medresentyp in Anatolien', in *Studies in Islamic Art and Architecture in Honour of Professor K. A. C. Creswell* (Cairo, 1965), 51, fig. 1.

54. For example, those of al-Nāṣir Muḥammad, Ṣarghitmish, Barqūq, Aljāy al-Yūsufī and al-Ashrāf Barsbāy *intra muros*. It should be remembered that the *iwan*s round the central courtyard of the Sultān Ḥasan complex belonged to a congregational mosque (*jāmiʿ*), according to its *waqfiyya: Dār al-Wāthāʾiq al-Qawmiyya*, Cairo, no. 40/6, d. 761H., published by Muḥammad Amin (without the *mawqūfāt*) as appendix to Ibn Ḥabīb, *Tadhkirat al-nabīh fī ayyām al-Manṣūr wa banīh* 3 (Cairo, 1986), 386.

55. Meinecke, *Mamlukische Architektur*, pl. 101c.

56. See n. 35 above.

57. For the *madrasa laṭīfa* attached to the Gulshanī complex, see Mayer, *Buildings*, 16, line 10.

58. Mehrez, 11. They are not very different from those of Qāytbāy's complex in the northern cemetery, which are still described as *iwan*s in the *waqfiyya*, ibid., 10.

59. Amin and Ibrahim, 15–16.

60. Sharaf al-Din (*Index* no. 176) is also known as Muḥibb al-Dīn Yaḥyā: Lézine, 'Salles Nobles', 89–93.

61. The parallels are discussed and illustrated in Michael Meinecke, *Die Restaurierung der Madrasa des Amīrs Sābiq al-Dīn Mitqāl al-Ānūkī und die Sanierung des Darb Qirmiz in Kairo* (Mainz am Rhein, 1980), 39, pls 17b, 19c.

62. Meinecke, *Mamlukische Architektur*, pl. 101b.

63. A rare mention is in Doris Behrens-Abouseif, *Islamic Architecture in Cairo: an Introduction* (Cairo, 1989), 114.

64. Illustrated in *The Arts of Islam*, exhibition catalog, Hayward Gallery, 8 April–4 July 1976 (London, 1976), no. 221.

65. Rabbat, 161–9; Qalāwūn's depictions of his citadels surrounded by landscape features (mountains, valleys rivers and seas) at his *Qubbat Manṣūriyya* in the citadel may have been in the same tradition: ibid., 166.

66. The earliest may be the *qaʿa* of Kuhya: Lézine, 'Salles Nobles', pls 28a–b, 29a.

67. For examples in fourteenth- and fifteenth-century domestic architecture in Cairo see ibid., pls 31a–b, 32b.

68. Cf. Michael Meinecke, 'Die Moschee des Amirs Āqsunqur an-Nāsirī in Kairo', *Mitteilungen des Deutschen Archäologischen Instituts, Abteilung Kairo* 29 (1983): pl. 9a and Lézine, 'Salles Nobles', pl. 25a.

69. Al-Maqrīzī, *al-Mawaʿiz wa'l-iʿtibār fī dhikr al-khiṭaṭ wa'l-āthār*, 2 vols (Būlāq, 1854), 1: 334; Laila ʿAli Ibrahim, 'Mamluk Monuments of Cairo', *Quaderni dell'Istituto Italiano di Cultura per la R.A.E.* (Cairo, 1976), 20.

70. Sylvie Denoix, *Décrire le Caire: Fusṭāṭ-Miṣr d'après Ibn Duqmāq et al-Maqrīzī*, Institut Français d'Archéologie Orientale du Caire, Études urbaines 3 (Cairo, 1992): 127.

71. Al-Maqrizi, *Khiṭaṭ* 2: 70.

72. Ibid., 2: 62; on the founder see Doris Behrens-Abouseif, *Fatḥ Allāh and Abū Zakariyya: Physicians under the Mamluks*, suppléments aux *Annales Islamologiques*, 10 (Cairo, 1987).

73. Al-Maqrīzī, *Khiṭaṭ* 2: 266.

74. Denoix, *Décrire le Caire*, 131.

75. Comité de Conservation des Monuments de l'Art Arabe, *Rapport de la Deuxième Commission* 9 (1892): 42; *Répertoire Chronologique d'Epigraphie Arabe*, ed. E. Combe, J. Sauvaget and G. Wiet, vol. 14 (Cairo, 1944): 82–3; Gaston Wiet, *Inscriptions historiques sur pierre*, Catalogue général du Musée de l'art islamique du Caire (Cairo, 1971), 66–7, pl. 17.

76. *Mamluk Monuments*, 19. In the foundation deed of the madrasa al-Kārimiyya in Damascus (623/1226), which was a house converted into a madrasa, the term used for the building is *makan*. Michael Chamberlain, *Knowledge and Social Practice in Medieval Damascus, 1190–1350* (Cambridge, 1994), 54, n. 87.

77. Al-Maqrīzī, *Khiṭaṭ* 2: 398.

78. For the madrasa of Tatar al-Hijāziyya, which was next to her palace (*qasr*), see ibid., 2: 382. For the madrasa of Ibn al-Jiʿān see Leonor Fernandes, 'Mamluk Architecture and the Question of Patronage', *Mamluk Studies Review* 1 (1997): 109.

79. Meinecke, *Restaurierung*, 39.

80. Behrens-Abouseif, 'Change'. It is also noticeable how even these in the later Mamluk period evolved to include *tabaqa*s, like those of the *rab*'s which were the dwellings of the middle-class: ibid., 97–8.

81. Fernandes, *The Evolution of a Sufi Institution in Mamluk Egypt: the Khanqah* (Berlin, 1988), 31, 34.

82. Al-Maqrīzī, *Khiṭaṭ* 2: 199.

83. Karim, 'The Mosque', 244.

84. Saleh Lamei Mostafa and Felicitas Jaritz, *Kloster und Mausoleum des Farağ ibn Barqūq in Kairo*, Abhandlungen des Deutschen Archäologischen Instituts Kairo, Islamische Reihe, 5 (Glückstadt, 1968): 125, lines 742–7 of the original *waqfiyya*.

85. Berkey, 144.

86. The custom should be distinguished from *ziyarat al-qubur*, the visitation of graves of saints for the purpose of acquiring *baraka*: on the latter see Christopher Taylor, *In the Vicinity of the Righteous: Ziyāra and the Veneration of Muslim Saints in Late Medieval Egypt* (Leiden, 1999).

87. Al-Maqrīzī, *Khiṭaṭ* 2: 452–3.

88. Ibrahim, 'Residential Architecture', 56. For a later example, consisting of a *qaʿa* adjacent to an *iwan* flanked by two rooms erected by the physician Abū Zakariyyā in the northern cemetery (c. 871–2/1476–8) see Behrens-Abouseif, *Fath Allāh*, 37–8, 48. Other non-extant mausoleums in the northern cemetery which had private residential accommodation attached to them include those of Qadi ʿAbd al-Bāsiṭ (which had a *qaʿa*, a *riwaq* and a *maqʿad*), Jamāl al-Dīn al-Ustādār and the historian Ibn Taghrībirdī: see Hani Hamza, 'The Northern Cemetery of Cairo' (MA thesis, American University in Cairo, 1997), 167.

89. Jean-Claude Garcin and Mustafa Anouar Taber, 'Les waqfs d'une madrasa du Caire au XVe siècle: les propiétés urbaines de Ğawhar al-Lālā', in *Le waqf dans l'espace islamique: outil de pouvoir socio-politique*, ed. Randi Deguilhem (Damascus, 1995), 164. Being a eunuch, he would have had no descendants to inherit the residence.

90. Best published in Jacques Revault, Bernard Maury and Mona Zakariya, *Palais et maisons du Caire du XIVe au XVIIIe siècle*, 3 (Cairo, 1979): 21–30.

91. Ibid., 31–46.

92. Mostafa, 39–44.

93. Leonor Fernandes, 'Three Ṣūfī Foundations in a 15th Century Waqfiyya', *Annales Islamologiques* 17 (1981): 148.

94. This is a rare reference in Mamluk sources to sexual segregation: Mehrez, 23–4. The *maqʿad* also had a *mabit* (room for sleeping) and two *riwaq*s (upper-storey apartments) beside it for accommodation, and for the presumably male visitors, on the opposite side of the court (*hawsh*), was another *mabit* with a *khazana nawmiyya* (sleeping room) (ibid., 25).

95. This *maqʿad*, although it is closed, is not specifically termed a *maqʿad qibti* in the *waqfiyya*. It, and two adjoining *riwaq*s, the stable and the kitchen were assigned for the founder and his family and descendants and for his wife and her family and descendants: Mayer, *Buildings*, 62.

96. Fernandes, *Evolution*, 45.

97. *MAE*, 2: 129–31. One of these, the Qamariyya madrasa, no. 3 on Creswell's list, does not qualify, as, unlike Ibn Duqmāq (Creswell's source), al-Maqrīzī specifies that the *dar* (which was actually a *qays-ariyya*) was destroyed before the madrasa was built: 2: 264.

98. Chamberlain, *Knowledge and Social Practice*, 57, n. 101.

99. Cited in Ernst Herzfeld, *Matériaux pour un Corpus Inscriptionum Arabicarum, part 2: Syrie du Nord, Inscriptions et monuments d'Alep*, Mémoires de l'Institut Français d'Archéologie Orientale du Caire 76–8 (Cairo, 1954–5) 1: 304–5.

100. The additions are as follows: The madrasa ʿĀshūriyya was built in the *hāra* of Zuwayla by ʿĀshūra, the wife of Yāzkūj who was an amir of Salāḥ al-Dīn, on the site of a palace (*dar*) of the Jewish physician Ibn Jamīʿ: Al-Maqrīzī, *Khiṭaṭ* 2: 368, lines 17–21.

The madrasa Sayfiyya was built in Qāhira by Sayf al-Islām (d. Shawwāl 593/August-September 1197) on the site of the *Dār al-Dibāj* and was, according to ʿAbd al-Ẓāhir, part of the *dar*. Ibid., 2: 368, lines 2–15.

The madrasa Taybarsiyya was located in Fusṭāṭ, it was constructed in Dhū'l-Ḥijja 677/April–May 1279 by ʿAlāʾ al-Dīn Ṭaybars from a *qaʿa* which had formerly been converted from a *majlis-iwan* into a two-*iwan* plan, Ibn Duqmāq, *Kitāb al-intiṣār li-wāsiṭat ʿiqd al-amṣār*, parts 4–5 (Cairo, 1893), 96–7.

The madrasa Kharūbiyya at Giza was founded by Sulṭān al-Muʾayyad in 822H. It consisted of a house to which he added a *mihrab*, a minaret and cells: Muḥammad b. Aḥmad Ibn Iyās, *Badāʾiʿ al-zuhūr fī waqāʾiʿ al-duhūr*, ed. Muḥammad Muṣṭafā, 5 vols (Cairo and Wiesbaden, 1960–72), 5: 48 and Fernandes, *Evolution*, 42.

In al-Maqrīzī's notice on the madrasa of al-Nāṣir Muḥammad he mentions that Kitbughā had originally wanted to make the house of amir Sayf al-Din Balbān al-Rashīdī into a madrasa: *Khiṭaṭ* 2: 382, line 11.

Al-Muʾayyad also made a house that he had started to construct at the Citadel as an amir into a mosque and *khanqah* after he became sultan, ibid. 2: 327; Paul Casanova, 'Histoire et description de la citadelle du Caire', in *Mémoires publiés par les Membres de la Mission Archéologique Française au Caire*, 4, 6 (1894–7): 681–2.

Some of the conversions of houses to madrasas in Aleppo, Damascus and Cairo have also been noted by Lucien Golvin, 'Madrasa et architecture domestique', in *l'Habitat traditionel dans les pays musulmans autour de la Méditerranée 2: l'Histoire et le milieu* (Institut Français d'Archéologie Orientate, études urbaines 1/2) (Cairo, 1990), 447–58. However, his contention that the madrasa ʿAdiliyya at Damascus was originally a house is unconvincing (for the latest discussion and most up-to-date bibliography on the monument see Terry Allen, *Ayyubid Architecture*, <http://www.sonic.net/~tallen/palmtree/ayyarch/> [last accessed 20 April 2021]). He also suggests (458) that the unusual disposition of the Salihiyya madrasa in Cairo might have been due to a transformation of the *qaʿa* of the Fatimid palace that existed on the site. However, as recent work at the madrasa has shown (Nairy Hampikina and Monica Cyran, 'Recent Discoveries concerning the Fatimid Palaces Uncovered during the Conservation Works on Parts of the al-Salihiyya Complex', *L'Égypte fatimide: son art et son histoire*, ed. Marianne Barrucand (Paris, 1999), 649–57), the Ayyubid madrasa did not at all follow the orientation of the earlier palace.

101. Al-Jamālī Yūsuf died in 862/1458; on the style of the portal decoration Meinecke attributes it to the period 1440–4: *Mamlukische Architektur*, 2: 362.

102. The inscriptions have been read in Shams El-Din Tantawy, *Architectural Patronage in the Reign of Sultān Jaqmaq* (MA thesis, American University in Cairo, 1994), 45.

103. Johannes Pedersen, *The Arabic Book*, trans. Geoffrey French, ed. Robert Hillenbrand (Princeton, 1984), 20–1.

104. Berkey, 87–8, 171–3.

105. See, among others, Muḥammad Muḥarnmad Amīn, *al-Awqāf wa'l-ḥayāt al-ijtimāʿiyya fī Miṣr* (Cairo, 1980), 116–20; Berkey, 134–5; and Chamberlain, 51–9.

106. Carl F. Petry, 'A Geniza for Mamluk Studies? Charitable Trust (Waqf) Documents as a Source for Economic and Social History', *Mamluk Studies Review* 2 (1998): 51–60.

107. R. Stephen Humphries, 'Women as Patrons of Religious Architecture in Ayyubid Damascus', *Muqarnas* 11 (1994): 46, makes the same point, quoting the sixteenth-century historian Ibn Ṭūlūn, who criticises an endower for building her madrasa before she had bought the endowment, and thus almost running out of funds, as opposed to her sister who first purchased the *waqf* and then used the funds to build the madrasa.

108. Chamberlain, 54, n. 87.

109. Berkey, 137–42.

110. Fernandes, *Evolution*, 186 (excerpts from the *waqfiyya*), part 23. Even earlier, the mosque of al-Muʾayyad is described in its *waqfiyya* as having four *iwan*s, each with a certain number of *riwaq*s around a *durqaʿa* (quoted in Fahmī ʿAbd al-ʿAlīm Ramaḍān, *Jāmiʿ al-Muʾayyad Shaykh* (MA thesis, Cairo University, 1975), 85–6).

CHAPTER THIRTEEN

The *Ziyāda* of the Mosque of al-Ḥākim and the Development of the *Ziyāda* in Islamic Architecture

SINCE HIS PUBLICATION of it nearly fifty years ago, Creswell's identification of the monument known today as the *zāwiyya* of Abu'l-Khayr al-Kulaybātī with the gate to the *ziyāda* of the mosque of al-Ḥākim has not been questioned.[1] Creswell based his identification on a reading of al-Maqrīzī's *Khiṭaṭ* which is demonstrably wrong. A re-reading of al-Maqrīzī's text shows that the monumental gateway must be one of the gates to the ablutions area of the mosque of al-Ḥākim. Acceptance of this further leads to the conclusion that the entrance to the *ziyāda* of the mosque mentioned by al-Maqrīzī must have been considerably more to the south, and the *ziyāda* hence much larger than was previously thought. This piece will discuss the evidence to support these conclusions, and in addition review the putative purposes of the *ziyāda* in this and other mosques, a topic that so far has not been the subject of any systematic study.

When it was built (990–1003) the mosque of al-Ḥākim was outside the Fatimid city walls of al-Qāhira, the main entrance being just to the north of the original bāb al-Futūḥ. Between the years 1087 and 1092 the wazir Badr al-Gamālī rebuilt the walls in stone instead of their original mudbrick and at the same time enlarged the enclosed area so that the mosque of al-Ḥākim now was within the city.

Two separate medieval sources mention that the *ziyāda* of the mosque of al-Ḥākim was built by al-Ḥākim's son, al-Zāhir (r. 1020–35).[2] As we shall see from subsequent accounts of its surroundings, it must have been located to the south of the mosque and have taken up a considerable amount of space. But as the mosque originally abutted the city wall on the south, it is clear that either the wall must have been destroyed to make way for the *ziyāda* or else it must have decayed rapidly in the fifty years in which it had been built. The latter may well have been the case, as the Persian traveller Nāṣir-i Khusraw who visited the city in 1047 reported that it was unwalled.[3]

Bernard O'Kane (1999), 'The *Ziyāda* of the Mosque of al-Ḥākim and the Development of the *Ziyāda* in Islamic Architecture', in Marianne Barrucand (ed.), *L'Égypte fatimide: son art et son histoire*, Paris, 141–58.

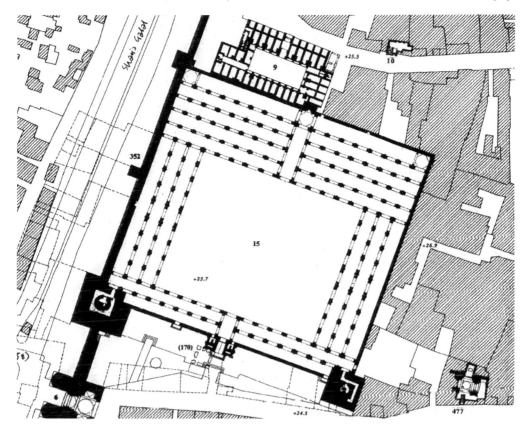

Figure 13.1 *Map of Cairo: areas adjoining the mosque of al-Ḥākim (ARCE/FAP; Warner, N 1997. For the American Research Center in Egypt; Copyright 1997 ARCE. Prepared under a USAID grant)*

The basis for Creswell's identification of the *zāwiyya* of Abu'l-Khayr al-Kulaybātī (no. 477 on Figure 13.1) as the gate to the *ziyāda* is a passage from al-Maqrīzī's *Khiṭaṭ* which, as he says, takes the reader on a walk from bāb Zuwayla to bāb al-Futūḥ. Creswell's summary of al-Maqrīzī is as follows:

'He mentions the mosque of al-Aqmar, and the lane to the north of it leading to the Khānqā of Baybars al-Gāshankīr in Gamālīya, then, on the left, the entrance to Ḥāret Bargawān (at the side of which today is the Silāḥdār Mosque), then the Sūq al-Mutai'yichīn, formerly called Sūq Emīr al-Guyūsh. At the extremity of this bazaar on the right was a cul-de-sac (which still exists), and on the left a road leading to the Suweiqat Emīr al-Guyūsh (the Sūq Margush of today), which leads to Bāb al-Qanṭara. Then, continuing north, came the Gamalūn lbn Ṣairām (evidently a bazaar with a gable roof). There stood the Madrasa of Ibn Ṣairām, and at the end of the *Gamalūn* (gable roof) on the right, was the entrance to the *Ziyāda* of the mosque of al-Ḥākim. Then came one of the gates of the Gāmiʿ

al-Ḥākimī',[4] 'then "passing on one finds on the right another of the gates of the Gāmiʿ al-Ḥākimī," then "going on one finds on the right the grand entrance of the Gāmiʿ al-Ḥākimī . . .".'[5]

Unfortunately Creswell or his translators omitted much of great significance in al-Maqrīzī' s text. Let us take up the text after his mention of the *ziyāda* of al-Ḥākim:

At the end of the Jamalūn is the door of the *ziyāda* of the mosque of al-Ḥākim. At its door was a number of shops which sold wooden locks for doors. Two routes lead from the Jamalūn: one to the cul-de sac of the Franks (*darb* al-Firānjiyya), to the *wakāla* residence (dār al-wakāla) and to bāb al-Naṣr avenue (*shāriʿ*), the other leads to *darb* al-Rashīdī, which opens on to *darb*[6] al-Jawwāniyya [Figure 13.2]. Following this route, one finds on the right the window of the madrasa Sayramiyya, in front of which is the door of the market hall (*qaysāriyya*) of the princess (*khawand*) Ardakīn al-Ashrafiyya. Then, going ahead, one crosses the suq of the sellers of merchandise for caravans (*al-muraḥḥilīn*) which had two rows of shop with everything needed for harnessing camels. This suq is in ruins and now little remains of it. In the suq on the left is a lane (*zuqāq*) called *ḥārat*[7] al-wirāqa; opening on this lane is one of the gates of the market hall (*qaysāriyya*) of the abovementioned princess and a number of dwellings; its location was known formerly as *istabl* al-Ḥujariyya. Then continuing, on the right is one of the doors of the mosque (*jāmiʿ*) of al-Ḥākim and its ablutions area (*mīḍaʾa*) and then the old bāb al-Futūḥ, of which there remains only an arch and part of its supports. Beside it, on the left, an avenue (*shāriʿ*) leads to the Bahāʾ al-Dīn quarter and bāb al-Qanṭara. Then following the main route and passing the suq al-Mutaʿayyishīn one finds on the right another door of the mosque of al-Ḥākim. Then continuing, one finds on the left a lane with a covered passage (*sābāṭ*) which leads to the Bahāʾ al-Dīn quarter where there are many dwellings. Continuing, one finds on the right the main door of the mosque of al-Ḥākim.[8]

This more complete passage makes the identification of the *zāwiyya* of Abu'l-Khayr alKulaybātī secure. Its location was clearly between the lane of *ḥārat al-wirāqā*. which still stands, and the old bāb al-Futūḥ, which must have been just to the south of the mosque of al-Ḥākim. The non-alignment of the *zāwiyya* of Abu'l-Khayr al-Kulaybātī with the mosque of al-Ḥākim might lead to the suspicion that it could in fact be the old bāb al-Futūḥ, but three arguments weigh against this. Firstly, the old bāb al-Futūḥ was on the main street where on the left an avenue lead to bāb al-Qanṭara, a location still clearly recognisable as the avenue now to the southwest of the southern minaret of the mosque of al-Ḥākim. Secondly, already in the fifteenth century, as we know from al-Maqrīzī's

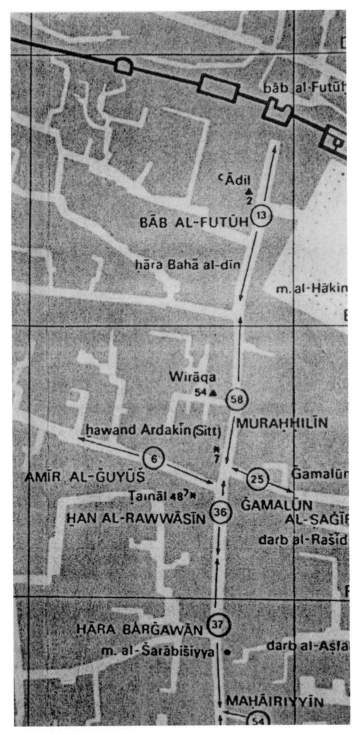

Figure 13.2 *Map of Cairo: markets to the south of bāb al-Futūḥ (after Wiet and Raymond)*

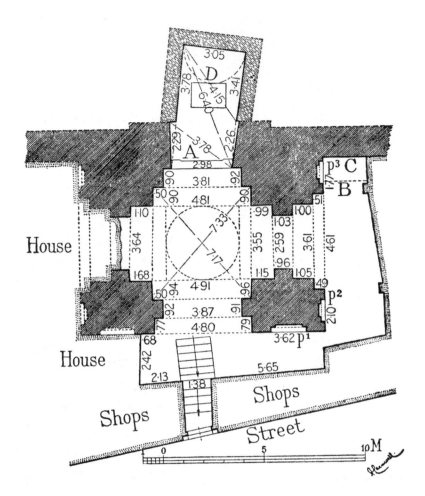

Figure 13.3 *Cairo, gate to the ablutions area of the mosque of al-Ḥākim (the* zāwiyya *of Abu'l-Khayr al-Kulaybātī), plan (after Creswell)*

description, it was much more ruined than the condition of the *zāwiyya* of Abu'l-Khayr al-Kulaybātī in the twentieth century (Figures 13.4–13.5). And thirdly, the *zāwiyya*, as Creswell convincingly showed (Figures 13.3–13.6), is oriented in the form of a gateway on an east–west axis, and not a north–south one, as the old bāb al-Futūḥ must have been.

The *zāwiyya* of Abu'l-Khayr therefore must be 'one of the doors of the mosque of al-Ḥākim and its ablutions area (*mīḍa'a*)' mentioned above by al-Maqrīzī. The location of the main door to the *ziyāda* is confirmed by al-Maqrīzī's description elsewhere of the suq al-Jamalūn, which he says leads from the entrance of the *suwayqat* (little suq) of amir al-Juyūsh to the Jawwāniyya quarter and bāb al-Naṣr. and then to *raḥbat* bāb al-'Īd; beside it is the cul-de-sac (*darb*) Farḥiyya, where one can find the, Sayrami madrasa and the

Figure 13.4 *Cairo, gate to the ablutions area of the mosque of al-Ḥākim (the zāwiyya of Abu'l-Khayr al-Kulaybātī), interior, before restoration*

gate to the *ziyāda* of the mosque of al-Ḥākim.[9] It thus seems that the entrance to the *ziyāda* was considerably further south than originally thought. The entrance to the *mīḍaʾa* is likely to have been adjacent or even within the *ziyāda*, and so the present *zāwiyya* of Abu'l-Khayr could also be seen as another, subsidiary door into the *ziyāda* of the mosque.

Acceptance of these findings means that the *ziyāda* was also much larger than has been previously thought (Figure 13.7). What

Figure 13.5 *Cairo, gate to the ablutions area of the mosque of al-Ḥākim (the zāwiyya of Abu'l-Khayr al-Kulaybātī), interior, before restoration*

could such a large extension have been used for? Before review-ing the evidence from the five other mosques which we know to have had *ziyāda*s, I will quote from some of the medieval sources which mention the *ziyāda* of al-Ḥākim and matters which may be pertinent to it.

The earliest source is Qalqashandī, who gives the following information:

Figure 13.6 *Cairo, gate to the ablutions area of the mosque of al-Ḥākim (the* zāwiyya *of Abu'l-Khayr al-Kulaybātī), interior, after restoration*

The *ziyāda* which is adjacent to the mosque was built by al-Zāhir b. al-Ḥākim, then it was determined in the reign of al-Ṣāliḥ Najm al-Dīn Ayyūb that it was part of the mosque and that it had a mihrab. They accordingly confiscated it from the owner and added it to the mosque. It was built in the fashion in which it now stands by al-Muʿizz Aybak the Turcoman [r. 1250–7], and it is not roofed.[10]

In al-Maqrīzī's account of the mosque in the *Khiṭaṭ* he enlarges upon the account of Qalqashandī.[11] After saying that it was repaired

Figure 13.7 *Cairo, sketch plan of areas adjoining the mosque of al-Ḥākim, showing approximate location of* ziyāda

by al-Ṣāliḥ, he mentions that the Franks had been imprisoned there, that they had built churches inside it (indicating a very lengthy stay) and that al-Ṣāliḥ had destroyed the churches. He also says that on a separate occasion stables had been built in it, and that the horses too were expelled by al-Ṣāliḥ. Al-Maqrīzī also mentions elsewhere that Friday prayer was eliminated at al-Azhar in 1171 by al-Ṣāliḥ.[12] Since the mosque of al-Ḥākim was left as the only congregational mosque of al-Qāhira, the need to accommodate more worshippers would have been an obvious reason for his reinstatement of the *ziyāda* as a place for prayer.

The mosque suffered substantial damage in the earthquake of 1302, and Baybars al-Jāshankīr was appointed by al-Nāṣir Muḥammad to repair it.[13] Badr al-Dīn al-ʿAynī's account is rather different from others in this respect.[14] According to him Baybars warned his team to be careful when repairing the minarets in case they should find a cache of gold put there by al-Ḥākim for this very eventuality: repairs in case of damage. This recalls a later account repeated by al-Maqrīzī and Ibn Taghrībirdī that in 1437 al-Ashraf Bārsbay, having heard of the story of concealed gold (although in this version the money was in one of the piers) rode to the mosque in order to pull the piers down, but was dissuaded when he was told that by the time he had pulled down a number of piers the price of

rebuilding them would exhaust the value of any gold found within them.[15] Could this partly explain the poor state of the building by the nineteenth century, when very few piers, apart from those on the qibla side, were still standing?

Returning to al-ʿAynī, he then adds that Baybars rebuilt the mosque as we see it now, and added a wide ziyāda for the *muṣallīn* (for those praying). No other source records Baybars's building of a *ziyāda*, so I am inclined to be sceptical of this – it is more likely that Baybars simply repaired the existing ziyāda at this time.

On three occasions in the fifteenth century, 1420, 1437 and 1464, funerary prayers were said for members of the same clan, the Bulqīnīs, whose family vault was in the madrasa of Sirāj al-Dīn ʿUmar al-Bulqīnī in the Bahā al-Dīn quarter opposite the mosque on the west.[16] Nothing very remarkable about this, one would think, except that on one of these occasions, for the funeral of the chief qadi in 1420, his coffin, according to Ibn Taghrībirdī, was taken in through the door of the al-Ḥākim mosque which is on the street near bāb al-Naṣr and carried out after prayers through the door which is near bāb al-Futūḥ and taken to his burial place.[17] It was not the custom to bring coffins into mosques in Muslim funerals, although occasionally, as in the Qarawiyyin mosque in Fez, a mosque for the dead could be an annexe to the main structure.[18] Perhaps there was less objection to the presence of a coffin in a *ziyāda*.[19] This would necessitate, according to Ibn Taghrībirdī's account, a door in the *ziyāda* on the bāb al-Naṣr and bāb al-Futūḥ sides of the mosque. There was a door in the qibla wall of the mosque to the right of the mihrab, as another passage in al-Maqrīzī informs us,[20] and fortunately, in his description of the area beside Bāb al-Naṣr, he mentions that there were two doors to al-Ḥākim on this side, the second presumably being that of the *ziyāda*.[21] The exit door for the coffin could have been the main door of the *ziyāda* on the south mentioned by Maqrīzī, but was more likely, since it was closer to the Bahā al-Dīn quarter, the side door leading to the *mīḍaʾa* (e.g. the *zāwiyya* of Abu'l-Khayr al-Kulaybātī).[22]

In 1412 we read of an unusual purpose for the *ziyāda*: The Jews and Christians were rounded up within it for the payment of the poll tax (*jizya*). Their wealth was assessed and they were kept within the *ziyāda* until their families were able to pay the appropriate amount.[23]

The presence of multiple gates in the mosque is indirectly attested by two reports in the fifteenth century, in 1418 and 1440. The *muḥtāsib* in 822/1419–20 forbade women and children to cross the mosque,[24] while in 1440 Dawlat Bey al-Dawādār, when restoring the mosque, closed all the doors, except two, for several days, then reopened them all, but forbade anyone to cross the mosque with their shoes on. He also rebuilt the *mīḍaʾa*.[25]

The last mention of the *ziyāda* that I have found comes in 1452, when according to Ibn Iyās someone informed the sultan that a

crystal box had been found in the *ziyāda* of the mosque of al-Ḥakim;
in it were papers which purported to guide the finder to a cache
of hidden treasure. The sultan ordered the *nāẓir al-khāṣṣ* Yūsuf to
investigate further; he in turn ordered the chief judge to be present,
and they made several guards dig down as far as the water table, but
without finding anything.[26]

Having reviewed some of the uses which the *ziyāda* of the mosque
of al-Ḥakim was put to and its later history, we should also con-
sider the motivations which al-Zāhir had when ordering it in the
first place. Initially his aunt, who may well have been responsible
for the death of her brother al-Ḥakim, acted as regent for him, but
unfortunately, the meagre sources on his reign have nothing else to
say regarding his or her building activities. Al-Zāhir did continue (at
least initially) his father's practice of holding Ramaḍān processions
to the congregational mosques of al-Azhar and al-Ḥakim.[27] Could the
ziyāda have been connected with these?

Initially, one would think that it is unlikely that the *ziyāda* would
have figured in any of the attendant ceremonies. Although the gate
to the *ziyāda* of the mosque of al-Ḥakim was closer to the Fatimid
palace than the main gate of the mosque, the main gate provided
an axial approach to the mihrab aisle with its architecturally prom-
inent clerestory. One would also naturally assume that the gate
of the *ziyāda* was less imposing than the main gate. The evidence
of the gate to the *mīḍaʾa* (Figures 13.3–13.6) may suggest otherwise,
however: if this subsidiary gate was built on such a grand scale, then
the main gate to the *ziyāda* would surely have been even grander.
There must have been substantial property in the north part of al-
Qāhira which would have had to be purchased and cleared to make
way for this *ziyāda*; and a prominent gate would have been a logical
architectural and political response to this large expenditure. That
something other than just provision of extra space was involved
is suggested by the urban setting of the mosque at the time: it was
built outside the walls, and so extra worshippers could easily line up
in the open space outside the main door (as they did at the mosque
of ʿAmr, for which see further below). In fact, adding a *ziyāda* to the
mosque would have been easier on any of the three sides, all outside
the former walled city, other than the one on which it was actually
built. This underlines the pressing reasons, whatever they may have
been, for building the *ziyāda* on the southern side. Perhaps a review
of the earlier mosques which had *ziyādas* will help us understand its
potential functions.

The great mosque of Samarra

The first mosque with planned *ziyādas* around it seems to have been
the great mosque of Samarra, built by al-Mutawakkil in the middle
of the ninth century.[28] When built, and even today, this was the

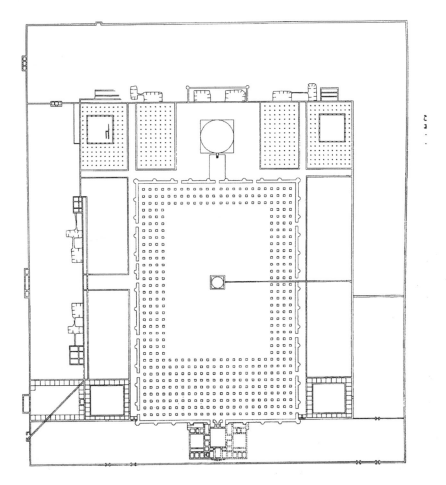

Figure 13.8 *Samarra, jamiʿ of al-Mutawakkil, plan (after Herzfeld)*

largest mosque in the world, with an area of 38,000 sq metres. What then could be the point of surrounding it with *ziyāda*s whose area in themselves (without the enclosed mosque) is 128,944 sq m, almost three and a half times that of the mosque itself?[29]

They are clearly visible in a previously unpublished plan of the mosque (Figure 13.8) from the Herzfeld archive.[30] The plan shows four hypostyle areas, two with and two without courtyards, flanking the minaret: presumably spaces that were used to give cover to those praying. However, this must only have been a sketch plan. Excavations by the Department of Antiquities of Iraq in the northeast corner revealed a plan (Figure 13.9) which shows that only a small part of this area was hypostyle, the remainder consisting of rooms of varying sizes around a courtyard, the north and south sides of which were arcaded.[31] One can assume on symmetrical grounds

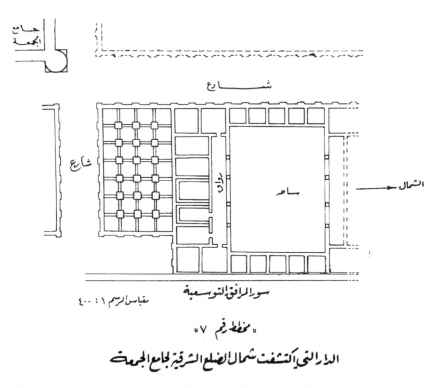

Figure 13.9 *Samarra,* jami' *of al-Mutawakkil, plan of excavations in* ziyāda *(after Rabī')*

that the area to the north-west of the mosque was similarly arranged. On Herzfeld's plan (Figure 13.8) there are other courtyards surrounded by small rooms flanking the southern covered hall of the mosque, and a larger such courtyard building is shown further to the west. These courtyard areas perhaps would have been used as temporary or even in some cases permanent accommodation for members of the huge staff that would have constantly been in attendance at the mosque.

Behind the qibla wall was a slightly smaller building with three courtyards, presumably for the exclusive use of the caliph and his retinue when he went to lead prayers. It is likely that the whole *ziyāda* on the qibla side was off limits to anyone but the caliph and his entourage. A variety of smaller rooms are to be seen in the north and west outer *ziyāda*s, presumably storage rooms of different kinds and ablutions areas, including toilets.

That the sheer force of numbers present at Friday prayers was more than enough to fill the *ziyāda*s can be inferred from contemporary sources. Ya'qūbī informs us that the original reason for the construction of the mosque of al-Mutawakkil was that the previous one built by al-Mu'taṣim was too small.[32] He writes that it was

built in a broad space beyond the houses and not in contact with the allotments and markets. Access to it was provided by means of three wide rows of shops, each 100 black cubits wide, in order that the approaches should not be too narrow for the caliph when he visited the mosque on Fridays with his troops and followers, cavalry and infantry.[33] The presence of the army alone, some 37,000 strong in the reign of al-Mutawakkil, would have been enough to fill all of the mosque and *ziyāda*s.[34]

The mosque of Abu Dulaf

The mosque of Abu Dulaf dating to 860, also built by al-Mutawakkil, is our second example, only slightly smaller than the first.[35] Direct evidence of overcrowding is provided by the results of excavations by the Iraq Department of Antiquities, which uncovered double arcades added on the outside of the mosque on the west north and east sides, within the space of the inner *ziyāda*. They were definitely an addition, as they were not bonded with the walls, and the need must have been great, for this can only have happened within the extremely short life span of the building of a year and half, before al-Mutawakkil was murdered in 961 and the city was abandoned.[36] This short life of the building also shows that the *ziyāda*s were planned integrally with the mosque; there is no question of them being later additions. In the *ziyāda* behind the qibla wall another courtyard building surrounded by small rooms was found, one with direct access to the mihrab of the mosque, and so clearly another suite reserved for the caliph.[37]

Al-Ṭabarī has some interesting comments on the prayers in the month of Ramaḍān just before al-Mutawakkil died. On the first day of Ramaḍān it became common knowledge that the caliph would lead the prayer at the end of the month. The significance of this was that it was an opportunity for people to present petitions and air grievances, for al-Ṭabarī goes on to say that the people assembled in order to see the caliph, thronging together, and that the Hashemites left Baghdad to present petitions to him and to speak with him when he went out riding. His ministers advised him not to go because of the crowds and his son al-Muntaṣir was given the job instead. Nevertheless, it was reported that on the day of the holiday of the breaking of the Ramaḍān fast the crowds were so great that they formed lines four *mīl* (8 km) long.[38] If this was one's only chance to right a grievance then perhaps it was no wonder that enormous spaces had to be planned to accommodate the crowds at Friday prayers.

The whole of the *ziyāda* area of the mosque of Abu Dulaf has not been excavated, but the published sketch plan (Figure 13.10) reveals a regular series of structures which are not likely to be the result of later encroachment, given their regularity, and the abandonment of the site and its neighbourhood.

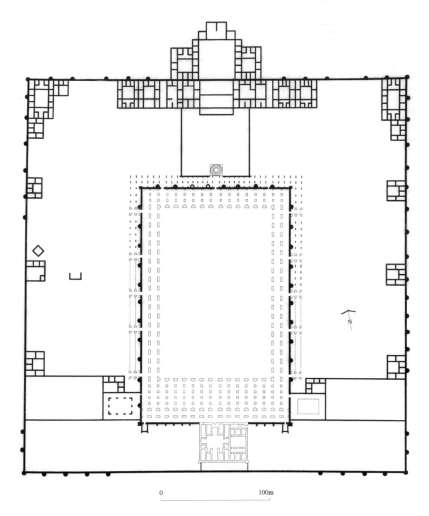

Figure 13.10 *Samarra, al-Jaʿfariyya,* jāmiʿ *of Abū Dulaf, plan (after Northedge)*

In 860 it is recorded that al-Mutawakkil performed the prayer of Breaking the Fast in al-Jaʿfariyya and that ʿAbd al-Ṣamad b. Mūsā prayed in its Friday mosque.[39] Where then did al-Mutawakkil perform the prayer in this year? I presume this must be a reference to a *muṣallā* in the area, and shows that the number of worshipers at its greatest would have been more than could be accommodated in the great mosque and its *ziyāda*s. Shown on aerial photographs[40] and marked on some plans of the area[41] to the east of the Dār al-Khilāfa is a qibla-oriented structure which has been labelled a *muṣallā*, its area being close to that of the great mosque of al-Mutawakkil including its *ziyāda*s. If it too was considered necessary for prayers on feast days in addition to those held at the great mosque of al-Mutawakkil,

then it is no wonder that *ziyāda*s were considered necessary for the mosques of Samarra.

The mosque of ʿAmr

In the mosques of Egypt a complication arises: that of the *rahba*, defined by al-Maqrīzī as a spacious area (*mawḍiʿ wāsiʿ*).[42] How can this be differentiated from the ziyāda? My initial impression is that, like those of the mosque of Ibn Ṭūlūn, the *ziyāda* is distinguished by high walls (Figure 13.13), whereas a *rahba* would have had either low walls to mark its limits, or none at all, being defined by the surrounding buildings. Another problem thrown up by the sources is a terminological one: the use of ziyāda itself. Its literal meaning of extension can be applied to any later extension that might simply enlarge a mosque,[43] as well as to the normally unroofed courts with high walls that we might first think of as *ziyāda*s, on analogy with the best preserved examples, those of the mosque of Ibn Ṭūlūn (Figure 13.13).

The first mention of a *rahba* in connection with mosques in Egypt is one added to the mosque of ʿAmr in 791 by Mūsā b. ʿIsā al-Hāshimī on the side opposite the qibla (Figure 13.11).[44] The whole mosque was

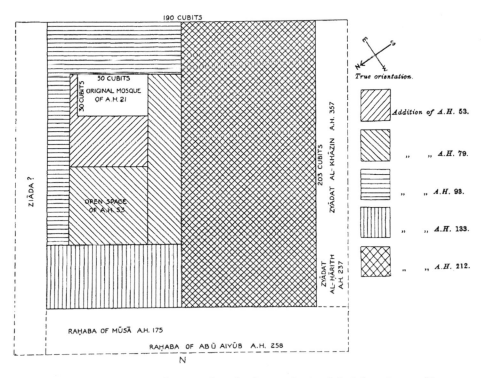

Figure 13.11 *Cairo, mosque of ʿAmr, sketch plan with* ziyāda's *(after Creswell)*

almost doubled to its present size in 827. Twenty four years after this we learn that qadi al-Ḥārith built a *raḥba* on the south-west side of the mosque, 'to accommodate the people within it' (*li-yatasiʿa al-nās bihā*). On Fridays the people used to negotiate sales within it. The date when this took place, 237/851–2,[45] is perhaps not coincidentally that of the building of the great mosque of Samarra, whose planned *ziyāda*s may have struck observers as an efficient way of dealing with crowding at Friday prayers. In 258/871–2 Abū Ayyūb also built another *raḥba* which must have been an extension of the first by Mūsā b. ʿIsā, to enable it to encompass the width of the enlarged façade on the side opposite the qibla.[46] We have a report that in 357/967–8 Abū Bakr al-Khāzin added on to the *raḥba* of al-Ḥārith a *ziyāda* consisting of an arcade (*riwāq*) with a mihrab and two windows. This was an extension outside the main walls of the mosque, but the mention of windows suggests that it would have been roofed, and the presence of a mihrab indicates some sort of retaining wall. However, it was only a small extension, being just five metres (9 cubits) in length.[47] A *ziyāda* must have been added at some stage on the north-east side, as three are mentioned by Ibn al-Mutawwaj (d. 730/1329–30).

These additions would certainly have been a response to growing crowds, for Muqaddasī, writing in 985, tells of arriving late for Friday prayer to find the lines of worshippers extending for more than one mil (c. 2 km) from the mosque.[48] By the early Mamluk period, however, the mosque had become neglected, as in the reign of Sultan Qalaʾūn his amir ʿIzz al-Dīn al-Afrām cleared out the rubbish that had accumulated in the *ziyāda*s.[49] Around this time also we read that Bahāʾ al-Dīn al-Sukkarī was put in charge of the mosque of ʿAmr and roofed the north-east *ziyāda*.[50] After the earthquake of 1302 amir Salār was appointed to carry out repairs at the mosque of ʿAmr, in the course of which, according to al-Maqrīzī, he added to the roofed part of the south-east *ziyāda* two arcades, evidently an extension to that of al-Khāzin mentioned above.

Another use for the *ziyāda* is indicated by Ibn al-Mutawwaj, who notes that twice a week the chief judge (*qāḍī al-quḍḍāt*) used to hold court in the north-east one.[51] All traces of the *ziyāda*s apparently disappeared before the twentieth century.

The mosque of Ibn Ṭūlūn

This mosque borrowed many features from Samarra – its piers, building material, use of stucco, spiral minaret, style of ornament, and its *ziyāda*s. Within the *ziyāda* on the side opposite the qibla was the *mīḍaʾa* and a store where potions and medicines of every kind were kept, and where servants and a doctor were on hand every Friday in case of accident happening to the worshippers.[52]

Maqrīzī gives an account of the house of Shaykh Zayn al-Dīn Muḥammad b. al-Naqqāsh in the *ziyāda* of the mosque of Ibn Ṭūlūn

being destroyed in 1438.[53] Zayn al-Dīn had received the post of *khaṭīb* of the mosque and had built an opening into the mosque, and later opened a window from his place of work in his house into the mosque so that he could see inside it while he worked. He also later added a stable and a cistern. Although his enemies tried to get it destroyed in his lifetime, it was only in the time of his children, the legatees of the buildings, that it was ordered to be destroyed, just as, Maqrīzī adds, the house of Quṭb al-Dīn Muḥammad b. al-Hurmās in the *ziyāda* of al-Ḥākim had been destroyed at the time of Sultan Ḥasan. This last report admittedly shows the care that we have to take with the terminology of al-Maqrīzī, for in all other instances he reports that the house of al-Hurmās was in the *raḥba* of the mosque of al-Ḥākim,[54] apparently being where the *wakāla* of Qaytbāy is now. Qaytbāy also encroached on the *ziyāda* of the mosque of Ibn Ṭūlūn, building a *sabīl* on its southwest side (Figure 13.12). Domestic dwellings also came creeping back in later centuries, as Creswell's early twentieth-century plan shows (Figure 13.12).

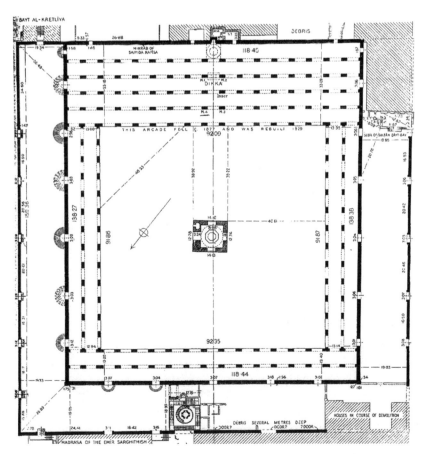

Figure 13.12 *Cairo, mosque of Ibn Ṭūlūn, plan (after Creswell)*

The mosque of al-Azhar

Having seen that four of the five early congregational mosques of
Cairo and Fustat had *ziyāda*s, we may wonder why the fifth, that of
al-Azhar, supposedly did not have one. It did, of course, have a *raḥba*
opposite its north-east side, between it and the Fatimid palace, the
place where the retinue of the caliph dismounted at the time of the
procession to Friday prayer.[55] Maqrīzī does not mention a *ziyāda* in
his account of the mosque in the *Khiṭāṭ*, and nor does the account
of any other historian that I have come across. But direct evidence
for a *ziyāda* at al-Azhar is provided by Maqrīzī in his *Kitāb al-
sulūk*, where he reports that in 590/1194 the *muḥtāsib* demolished
the shops and stables which Ṣadr al-Dīn b. Dirbās had built in the
ziyāda of the mosque of al-Azhar next to his house (*dār*). Ṣadr al-Dīn
removed the debris to his house.[56] It was Ṣadr al-Dīn b. Dirbās who,
at the beginning of Ayyubid rule, enforcing the Shafiʿī regulation per-
mitting only one congregational mosque in each town, had ordered
al-Azhar to be closed to Friday prayer in favour of al-Ḥakim.[57] This
makes it more likely that the *ziyāda* there did indeed date from the
Fatimid period, although whether it was a part of the original plan or
was added we do not know.

It is also difficult to determine whether it was on the north-east
side, in which case it would have formed part of the *raḥba*, or on the

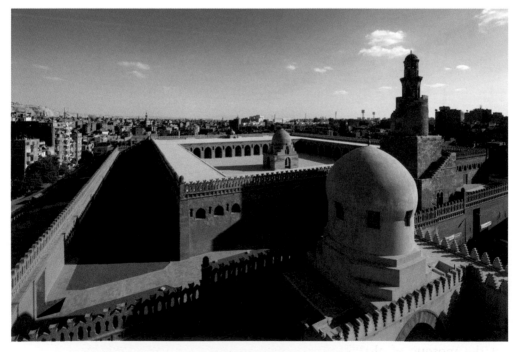

Figure 13.13 *Cairo, mosque of Ibn Ṭūlūn, existing* ziyāda

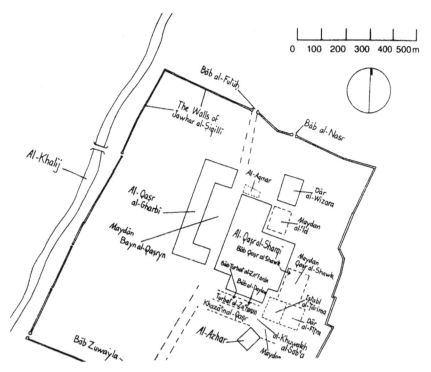

Figure 13.14 *Cairo, mosque of al-Azhar and surroundings (after Rabbat)*

north-west. The fact that there are two substantial buildings dating from the Mamluk period on the north-west side – the Aqbughāwiyya madrasa of 1329, built on the site of the palace (*dār*) of the Mamluk amir Aydamur al-Ḥillī, and the Ṭaybarsiyya madrasa of 1309, suggests that there was also originally a substantial open space on front of the mosque on that side (Figure 13.14).[58] In 988 the caliph al-ʿAzīz had ordered other dwellings to be built beside (*bi-jānib*) the mosque for the jurists who first taught there.[59] The Arabic preposition 'beside' (*bi-jānib*) is as ambiguous as the English here: it could mean contiguous or nearby. But since the houses were expressly built for those working in the mosque then an obvious location would have been against the outer wall, within – or creating – a new *ziyāda*.

Al-Maqrīzī also mentions that the mosque did not originally have a *mīdaʾa*, and that one had been built on the location of the Aqbughāwiyya madrasa. However, one must have been built shortly after the foundation of the mosque, for among the endowments that al-Ḥakim made in 1009 to the mosque of al-Azhar, the dar al-ʿIlm and two other mosques was a sum of twelve dinars for cleaning the *mīdaʾa*.[60] We have seen that the *mīdaʾa* of the mosque of Ibn Ṭūlūn was within the *ziyāda*, and probably also the *midaʾa* of the mosque of al-Ḥakim; this may suggest that the *ziyāda* of

al-Azhar was located on the north-west side of the mosque (where
the Aqbughāwiyya madrasa now stands). Circumstantial evidence
for storerooms attached to the mosque comes from the same endow-
ment of al-Ḥākim, which included funds for incense, candle wax,
charcoal, ropes, buckets, brooms, water jars, oil, etc., and a bequest
of two lanterns (tannūrān and twenty smaller ones which were for
use in Ramaḍān and were to be stored at other times.[61] These store-
rooms, which must have been substantial, might also have been
situated in the ziyāda.

The purposes of the ziyāda

I will return to the uses that have been made of ziyādas below, but
it is worth asking ourselves what the original purpose of the ziyāda
might have been. Creswell, writing of the ziyādas of the mosque of
Ibn Ṭūlūn, gave the answer in these terms:

> These ziyādas must be regarded as corresponding to the outer
> temenos of a Semitic sanctuary, such as the Arab conquerors
> met when they captured Damascus. The object of such an outer
> temenos was doubtless to separate the sanctuary proper from
> the outer buildings of the town. As for the layout of the town
> itself, the arrangement in the Hellenistic cities of Syria gener-
> ally was that the four streets from the four gates, placed at the
> cardinal points, struck the centre of the four sides of the temenos
> as at Damascus. Similarly, in the earliest mosques of Islam, for
> example at Kūfa, the four main streets converged on three sides
> of the mosque, the qibla side of course being occupied by the Dār
> al-Imāra. The same condition hold good for the mosque of ʿAmr,
> and it is clear from the names of the doors . . . that (they) were at
> the end of bazaars . . .
>
> One must therefore conclude that the outer doors of the Mosque
> of Ibn Ṭūlūn likewise marked the ends of bazaars converging on
> its outer walls, and that the ziyādas served to isolate the mosque
> proper from contact with them. It follows that the clearing, in
> recent years, of a large area round the mosque at enormous expense,
> so that the ziyādas are also isolated, is based on a misconception
> . . .[62]

Creswell's point about the unnecessary clearing around the mosque
of Ibn Ṭūlūn is well taken (and can be applied to the similar recent
clearance around the temenos of the great mosque of Damascus),
but it may be wondered whether isolation of the mosque proper
was initially thought to be necessary or desirable. It did not stop
major mosques, such as, for instance, the great mosques of Isfahan
and Tunis and the Qarawiyyīn mosque at Fez from acquiring bazars
which abutted on to the mosque proper.

The main distinguishing factor between the mosque and the *ziyāda* is that the latter is unroofed. As such the *ziyāda* is a compromise between having a larger roofed mosque and a smaller one that abuts on to an open space that may or may not remain available for overspill at times of Friday prayers. The outer walls of a *ziyāda* ensured that the intervening space would not be built on, and extended the space available for worshippers at minimal cost.

The problem, if such it was, of keeping the outer walls free from encroachments, disappeared with the change of style in later centuries which brought decorated façades to mosques. Already under the Fatimids a small number of monumental entrances had replaced the large number of identical ones of the mosques of Samarra and Ibn Ṭūlūn, and the continuously decorated façade of the Ṣāliḥiyya madrasa in Cairo (begun 1242) was obviously a message that it was not to be built against. Even earlier, the mosque al-Aqmar had the best of both worlds: a decorated façade and shops in a basement below.[63]

Only in the major Ottoman monuments of Istanbul and elsewhere, such as the Fatih, Şezade and Suleymaniye complexes, do we find anything resembling *ziyāda*s. There, they were clearly not needed to prevent the encroachment of surrounding buildings, as the surrounding buildings were already planned as part of the complex. Several factors may have been at work in the planning of these spaces. The space around the Fatih mosque was apparently used as a camping ground, and it is even large enough to review troops.[64] Some 7,000 Janissaries accompanied Sultan Suleyman to Friday prayer and would certainly not have been able to squeeze inside the domed mosque of his complex or even its main courtyard.[65] But the verticality of these complexes needs room from which to appreciate their monumentality, and without the outer courtyards the surrounding buildings would have impinged upon the spaciousness of the planning.

The adaptive reuse of buildings is a concept much employed in recent literature on architectural conservation. It is a concept that seems to have been discovered before its time by those using *ziyāda*s, who have managed to transform them into, or with, ablutions areas, storerooms, medical dispensaries, prisons, courts, churches, houses, stables, shops, a mosque for the dead, cisterns, *sabīl*s (water dispensaries), passageways, areas for the temporary incarceration of the *ahl al-dhimmī*, rubbish dumps[66] and putative locations of treasure troves.[67]

This catalogue does at least emphasise one feature of the *ziyāda* that might have been designed from the start, its versatility. It may also have been the case that not all *ziyāda*s were intended to perform the same function, the equivalent of the caliph's retinue at Samarra, for instance, not being found on the same scale anywhere in pre-Fatimid Egypt, although Ibn Ṭūlūn may have tried to replicate it.

Egyptian *ziyāda*s may have worked differently from Sarnarran ones, and pre-Fatimid from Fatimid ones. Could the corresponding emphasis on Fatimid ceremonial have played any part in those of al-Azhar and al-Ḥākim? While it would be pleasing to find such a link, the evidence seems to be against it: they were not built by the time the early Fatimid caliphs had transformed Cairo into a ritual city. At al-Azhar, the *ziyāda*, even if it was on the north-west side, is unlikely to have had such a monumental entrance as that of the mosque proper. As the out of alignment walls of the door to the *mīḍa'a* (and probably also to the *ziyāda*) of al-Ḥākim show (Figure 13.1), it was an afterthought that never quite integrated itself into the life of the mosque. But we should not let its near total oblivion obscure from us the interesting part which it had to play in the history of the mosque of al-Ḥākim and in the history of this still enigmatic part of early mosques, the *ziyāda* itself.

Notes

1. K. A. C. Creswell, *The Muslim Architecture of Egypt*, 2 vols (Oxford, 1952–9) (hereafter *MAE*), vol. I, pp. 115–17.
2. Al-Qalqashandī, *Ṣubḥ al-a'shā fī ṣina'at al-inshā*, 14 vols (Cairo, repr. 1963), vol. 3, p. 360–1; Taqī al-Dīn Aḥmad al-Maqrīzī, *Kitāb al-mawā'iz wa'l-i'tibār bi dhikr al-khiṭaṭ wa'l-āthār*, 2 vols (Bulaq, 1270/1853–4), vol. 2, p. 278.
3. *Safarnāma*, ed. Vaḥīd Dārnghānī (Tehran, n.d.), p. 74, trans. W. M. Thackston as *Nāṣer-e Khowsraw's Book of Travels* (New York, 1986), p. 46.
4. Creswell, *MAE*, vol. I, p. I 17.
5. Ibid., p. 73.
6. As pointed out by A. Raymond and G. Wiet, *Les marchés du Caire* (Cairo, 1979), p. 105, *darb* is written in error for *ḥāra* (quarter) here.
7. According to ibid., *loc. cit.*, one should read *khān* here instead of *ḥāra*.
8. *Khiṭaṭ*, vol. I, pp. 375–6.
9. Ibid., vol. 2, p. 101; Raymond and Wiet, *marchés*, pp. 184–5.
10. See n. 2 above.
11. *Khiṭaṭ*, vol. 2, p. 278, II. 5–9.
12. Ibid., vol. 2, p. 275, I. 39.
13. Ibid., vol. 2, p. 278, I. 35.
14. *'lqd al-jumān fī tārīkh ahl al-zamān*, ed. Muḥammad Muḥammad Amīn, 4 vols (Cairo, 1987–92), vol. 4, P. 264.
15. Al-Maqrīzī, *al-Sulūk li-ma'rifat duwal al-mulūk*, ed. Muḥammad Ziyāda et al., 4 vols (Cairo, 1934–72), vol. 4, part 2, p. 1029; Jamāl al-Dīn Yūsuf Ibn Taghrībirdī, *al-Nujūm al-zāhira fī mulūk Miṣr wa'l-Qāhira*, trans. W. Popper as *Egypt and Syria under the Circassian Sultans 1382–1468 A.D.*, 7 vols, University of California Publications in Semitic Philology, 13, 16–19, 22–3 (Berkeley, 1954–62), vol. 18, p. 144.
16. Ibn Taghrībirdī, *al-Nujūm*, trans. Popper, vol. 14, p. 113; vol. 17, p. 174; vol. 23, p. 104, al-Maqrīzī, *Sulūk*, vol. 4, part 2, p. 600.
17. Ibn Taghrībirdī, *al-Nujūm*, trans. Popper, vol. 23, p. 104.
18. See Henri Terrasse, La *mosquée al-Qaraouiyyin à Fès* (Paris, 1968), pp. 45–6.

19. There was one, presumably wholly exceptional occasion when coffins were permitted inside the mosque of al-Ḥākim itself: on the occasion of prayers during the great plague of 1348. The coffins were laid out in pairs from the door of the *maqṣūra* to the main door; the imam stood on the threshold so that the people outside could follow him: *Sulūk*, vol. 2, part 3, p. 782.

20. *Khiṭaṭ* vol. 2, p. 280, I. 34.

21. Ibid., vol. 1, p. 277, I. 6. Creswell, *MAE*, vol. 1, p. 74, perhaps forgetting the later existence of the *ziyāda*, argues that this would have been another door beside the mihrab.

22. These multiple doors could also have been relevant when, in 1388, horsemen managed to enter the city and open the gates of bāb al-Naṣr and bāb al-Futūḥ which had been shut by rebels, by entering the mosque of al-Ḥākim from the north side (marked on the plan in Creswell, *MAE*, vol. 1, Fig. 32) and then taking diverging paths towards the two gates: al Maqrīzī, *Sulūk*, vol. 3, part 2, p. 620.

23. Al-Maqrīzī, *Sulūk*, vol. 4, part 1, p. 247.

24. Ibid., vol. 4, part 1, p. 511.

25. Ibid., vol. 4, part 3, p. 1223.

26. Muḥammad b. Aḥmad Ibn Iyās, *Badā'i' al-zuhūr fī waqā'i' al-Duhūr*, ed. Muhammad Muṣṭafā, 5 vols (Cairo and Wiesbaden, 1960–72), vol. 2, p. 317.

27. Paula Sanders, *Ritual, Politics, and the City in Fatimid Cairo* (Albany, 1994), p. 64.

28. It has been suggested that the rebuilding of the congregational mosque of Qayrawān by Ziyādat Allāh in 221/836 may have involved a *ziyāda*, but this remains to be confirmed by excavations: Jonathan Bloom, *Minaret: Symbol of Islam*, Oxford Studies in Islamic Art, 7 (Oxford, 1989), p. 91; Bernard O'Kane, 'The Rise of the Minaret' *Oriental Art* n.s. 38/2 (Summer, 1992), p. 113, n. 6.

29. The basic treatment of the mosque is in K. A. C. Creswell, *Early Muslim Architecture*, 2 vols in 3 parts (Oxford, 1969) (henceforth *EMA*), vol. 2, pp. 254–65.

30. I was unaware of the existence of this plan until Alastair Northedge most kindly made it available to me.

31. Rabi' al-Qaysī, 'Jāmi' al-jum' a fī Sāmarrā': takhṭīṭ waṣiyāna', *Sumer* 25 (1969), pp. 143–62.

32. *Kitāb al-buldān*, trans. G. Wiet as *Les pays* (Cairo, 1937), pp. 52–3.

33. Cited in Creswell, *EMA*, vol. 2, p. 254.

34. The non-Turkish troops have been estimated at the end of the reign of al-Mutawakkil as 20,000 cavalry and 13,000 infantry; at the beginning of his reign the Turkish troops numbered 3,000–4,000: Hugh Kennedy, *The Prophet and the Age of the Caliphates: The Islamic Near East from the Sixth to the Eleventh Century* (Harlow, 1986), p. 169.

35. Creswell, *EMA*, vol. 2, pp. 278–82.

36. The report is most easily accessible in K. A. C. Creswell and James W. Allan, *A Short Account of Early Muslim Architecture* (Cairo, 1989), pp. 370–2.

37. Ibid., *loc. cit.*

38. *Ta'rīkh al-rusul wa'l-mulūk*, trans. Joel L. Kraemer as *Incipient Decline*, Bibliotheca Persica, *The History of al-Ṭabarī*, vol. 34 (Albany, 1989), pp. 171–3.

39. Ibid., p. 170,

40. Herzfeld, *Geschichte des Stadt Samarra* (Berlin, 1948).

41. Most easily available in Alastair Northedge, 'An Interpretation of the Palace of the Caliph at Samarra (Dar al-Khilafa or Jausaq al-Khaqani)', *Ars Orientalis* 23 (1993) (pub. 1994), Fig. 9.

42. *Khiṭaṭ*, vol. 2, p. 47, l. 16.

43. E.g. al-Maqīzī, *Khiṭaṭ*, vol. 2, p. 249, l. 26, referring to the incorporation by Sāliḥ b. ʿAlī of the palace (*dār*) of al-Zabīr into the mosque in 136/753–4 and ibid., l. 37, referring to the enlargement of the mosque by ʿAbd Allāh b. Ṭahīr in 212/827.

44. Al-Maqrīzī, *Khiṭaṭ*, vol. 2, p. 249, ll. 27–9.

45. Ibid., p. 250, ll. 2–4; quoting al-Kindī with regard to the phrase 'to accommodate the people within it'.

46. Ibid., p. 250, ll. 6–8.

47. Ibid., p. 250, ll. 22–4.

48. Cited in Creswell, *EMA*, vol. 2, p. 172.

49. Al-Maqrīzī, *Khiṭaṭ*, vol. 2, p. 252, ll. 22–5.

50. Ibid., p. 252, l. 38–253, l. 1: *fa-suqifat al-ziyāda al-baḥriyya al-sharqiyya*, Creswell, EMA, vol. 2, p. 171, perhaps reading *suqiṭat*, interprets this as saying the north-west and north-east *ziyāda*s were in ruin, although *ziyāda* here is in the singular.

51. Ibid., p. 253, ll. 24–5. The mosque itself had been used for the court of the chief judge in Fatimid times: Nāṣir Khusraw, *Safarnāma*, trans. Thackston, p. 53.

52. Al-Maqrīzī, *Khiṭaṭ*, vol. 2, p. 277, ll. 30–2.

53. *Sulūk*, Vol 4, part 3, pp. 1106–7.

54. E.g. *Khiṭaṭ*, vol. 2, pp. 76–7.

55. Ibid., vol. 2, p. 47: under '*raḥbat jāmiʿ al-Azhar*'.

56. Vol. 1, part 1, p. 150.

57. *Khiṭaṭ*, vol. 2, p. 275, ll. 33–8.

58. Ibid., vol. 2, pp. 383–4. Ṭaybars made his madrasa a (neighbourhood) mosque for God as an extension to the (congregational) mosque of al-Azhar (*jaʿalahā masjid Allāh taʿālā ziyāda fīʾl-jamiʿ al-Azhar*): ibid., p. 383, l. 13. It is difficult to know whether al-Maqrizi's use here of the term *ziyāda* in its sense of extension precludes the madrasa having been situated in a *ziyāda* in the sense of Samarran *ziyāda*s and their Egyptian parallels. The passage is interpreted by Nasser Rabbat, 'Al-Azhar Mosque: An Architectural Chronicle of Cairo's History', *Muqarnas* 13 (1996), p. 57, to mean a 'complementary mosque'.

59. *Khiṭaṭ*, vol. 2, p. 273, ll. 29–30.

60. Ibid., vol. 2, p. 275, ll. 5–6.

61. Ibid., vol. 2, p. 274, l. 27–p. 275, l. 8.

62. EMA, vol. 2, p. 340.

63. *Khiṭaṭ*, vol. 2, p. 290, ll. 6–7.

64. Godfrey Goodwin, *A History of Ottoman Architecture* (London, 1971), pp. 122, 128.

65. André Thevet, *Cosmographie de Levant*, cited in Gülru Necipoğlu-Kafadar, 'The Süleymaniye Complex in Istanbul: an Interpretation', *Muqarnas* 3 (1985), p. 98.

66. In addition to the rubbish in the *ziyāda*s of the mosque of ʿAmr mentioned above (n. 48), Creswell noted that the *ziyāda*s of the mosque of Ibn Ṭūlūn had been used for dumping builders' refuse: *EMA*, vol. 2, p. 340.

67. Uses hardly more varied than that of the interior of mosques, of course, for which see J. Pedersen, 'Masdjid', *Encyclopaedia of Islam*, first edn. For just one later example, see the expulsion in 828 by the amir Sūdūn of 750 indigent people who had been living in the mosque of al-Azhar: al-Maqrīzī, *Khiṭaṭ*, vol. 2, p. 276, l. 34 – p. 277, l. 3. For madrasas used in Ayyubid Syria as amirial residences, collection points for booty, jails, arms storehouses and centres for the training of civilians in military skills, see Michael Chamberlain, *Knowledge and Social Practice in Medieval Damascus, 1190–1350* (Cambridge, 1994), p. 58.

Addendum: for additional materials on the *ziyāda* and corrections to my reconstruction of the *ziyāda* of the mosque of 'Amr see Hani Hamza, 'The Turbah of Tankizbughā,' *Mamluk Studies Review* 10 (2006), pp. 167–71.

CHAPTER FOURTEEN

The Mosque

To the beginning of the eleventh century CE in the Near East, mosque typology is dominated by the plan of the hypostyle (many-columned) courtyard, which in this context is sometimes also referred to as the 'Arab' plan. Numerous models from the pre-Islamic period had this layout, but there is little doubt that the Prophet's house in Medina played a key role. This building was not designed to be an exclusive place for prayer. It contained rooms for Muhammad and his wives, and its large open courtyard was used for various social, political and military functions of the whole Muslim community.

The Prophet led the faithful in prayer on the southern side of the courtyard, facing the shrine at Mecca (that is, the *qiblah*). Here there were two rows of palm tree columns covered with a palm-thatched roof. The collective memory of the significance of this may be thought sufficient for the form's later popularity. Two additional factors may well have contributed to its pervasiveness. The first was its technological simplicity. Trabeated structures (featuring beams or lintels) required little in the way of masonry skills, and reused columns provided a further saving of labour. The second was the flexibility of the hypostyle plan, which permitted expansion in any direction without necessarily altering the overall character of the building.

The expansion of the Prophet's house to become the Great Mosque of Medina shows this process in action. It was one of three major mosques (the others being those of Damascus and Jerusalem) which were built or expanded by Caliph al-Walid (705–15). The Medina mosque was the first to incorporate a *mihrab* (concave niche), which was situated not at the centre of the *qiblah* wall but to one side, corresponding to the axis at which Muhammad led the prayers in the original building. Its first appearance at this site, where it was richly decorated, and its ubiquity in subsequent mosques are strong arguments that it should be seen as a commemoration of the place where the Prophet led the prayers as the first imam. The more frequent

Bernard O'Kane (1997), 'The Mosque', in Eric M. Meyers (ed.), *Encyclopedia of Near Eastern Archaeology*, New York, Vol. 4, 55–8.

explanation, that it indicates the direction of prayer, is less likely for two reasons. First, the *mihrab* is usually invisible from a substantial portion of the interior of the mosque. Second, the *qiblah* is normally immediately apparent from the direction of the largest roofed area, which is the main prayer hall.

The mosque at Medina was also the first to be provided in al-Walid's rebuilding with tall towers at its corners. These have normally been considered minarets, places from which the call to prayer was given, although recent work by Jonathan Bloom (*Minaret: Symbol of Islam*, Oxford, 1989), has argued that this is a problematic interpretation, and that the minaret did not become a standard feature of mosque architecture until the 'Abbasid period. Two other features of al-Walid's works at Medina were also widely imitated in other mosques: a finely decorated axial nave and a domed ante-*mihrab* bay. The rebuilding of the Aqsa mosque in Jerusalem by al-Walid is now thought to have included these two features, although it differs from all early congregational mosques in its lack of a courtyard. This configuration is to be explained by its location within the Haram (the former Temple Mount), where its forecourt could easily have served the same purpose.

Unlike other major early mosques, the Great Mosque of Damascus is essentially basilical in plan rather than hypostyle. The prayer hall has three bays parallel to the *qiblah* wall, interrupted by a transverse nave. It is not certain whether there was originally a dome within this nave; if so, it may have been above the bay in front of the *mihrab*, rather than the central bay where it is today. The gable that rises above the nave on the courtyard façade is possibly derived from Byzantine palaces. The courtyard is surrounded by one arcade on each side; the combination of basilica and adjacent peristyle courtyard was also common in Roman forums. The Roman temple enclosure, which bounded the mosque, prevented it from being subsequently enlarged. Its already massive size and sumptuous decoration of mosaic landscapes, however, enhanced its prestige and led to frequent copies, the mosques in Khirbet al-Minyeh and the *medina* of Qasr al-Hair ash-Sharqi being two Umayyad examples.

Smaller Umayyad mosques

Although it is clear that the prestigious congregational mosques of the Umayyads set the fashion both for later periods and for lesser mosques within their own period, the variety of smaller mosques that has survived has not been fully appreciated. At its simplest the place of prayer could be indicated by a niche in the wall facing Mecca. This *mihrab* is found, for instance, in the entrance corridor of the caravanserai at Qasr al-Hayr ash-Sharqi. A passageway also used by animals is an unlikely setting for prayer, but there is a tradition that a mosque is formed wherever one prays, and therefore blocking

off this area to other traffic would have been sufficient to form one. The larger enclosure at Qaṣr al-Ḥayr ash-Sharqi has a more substantial courtyard mosque; the mosque of the caravanserai was never designed for many people. In the contemporary caravanserai at Qaṣr al-Ḥayr al-Gharbi the mosque is only slightly more formal, consisting of a wing projecting from the entrance façade. [See Qaṣr al-Ḥayr ash-Sharqi; Qaṣr al-Ḥayr al-Gharbi.]

The mosque at Jabal Says is of the simplest type – a single room – although a central pier awkwardly interrupts the axis between the mihrab and door opposite. Single rooms fronted by a larger courtyard are found at Qasṭal and Qaṣr Muqatil; the latter is distinguished by a triple entrance to the prayer hall. A possible prototype for these examples or an example that may have occurred concurrently with them is seen at Qaṣr Burquʾ, which consists now only of a low stone wall, but which may well have had a tent erected over it to provide the covered space for prayer. [See Qaṣr Burquʿ.]

Three Umayyad mosques, at Khan al-Zabib, Umm al-Walid and Qaṣr al-Ḥallabat, contain the germ of the nine-bay plan, which was to become widespread under the ʿAbbasids. They are square, with an interior whose roof is supported by four piers, although the irregular spacing of the piers and the roofing, either flat or barrel-vaulted and parallel to the *qiblah* distinguish them from the later examples. [See Qaṣr al-Ḥallabat.]

ʿAbbasid congregational mosques

The major mosques of the ʿAbbasids continued to be courtyard hypostyle buildings, but several features appeared or became standard at this time. The first is the minaret, which usually took the form of a single tower in the middle of the wall opposite the *qiblah* (Siraf, Harran, Samarra). The examples at Samarra are helicoid (spiral shaped), most likely inspired by the then more numerous and better preserved ziggurats of Mesopotamia. The minaret of the mosque of Ibn Tulun in Cairo was probably of the same shape.

The second feature is the *ziyada*, a space that surrounded the mosque on all sides except the *qiblah*. Its purposes are not yet fully understood, especially when to judge from the aerial photographs of the Great and Abu Dulaf Mosques of Samarra, it more than doubled the size of what were already enormous buildings. It is difficult to imagine that these huge buildings (the Great Mosque remains the largest ever built) could ever have been filled for Friday prayers, but recent excavations at Abu Dulaf have shown that double arcades were added to most of the outer walls to accommodate the overflow. The mosque was abandoned before it had been in use for one year. Therefore, these additions must have been a response to a contemporary need. The *ziyada* of Ibn Tulun's mosque is much smaller, but there at least we have some indications of how it was used. The

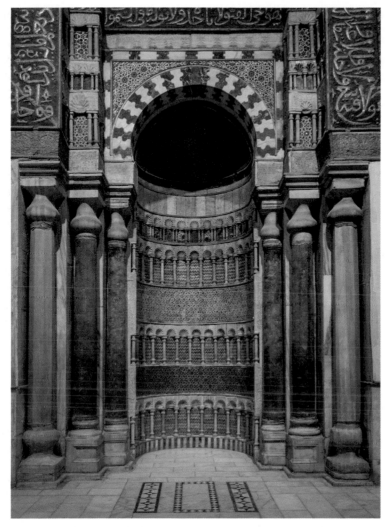

Figure 14.1 *Marble and semi-precious stone* miḥrab *(niche). Mausoleum of Qalawun, Cairo, 1283 (photo: O'Kane)*

sources mention facilities for ablutions and a small clinic for those attending Friday prayers. The *ziyada* may also have functioned to isolate the prayer area from the noise of the urban surroundings.

The third feature was the use of stucco as a decorative medium. Although this was found on Umayyad palaces, the ʿAbbasid use of brick rather than stone as the medium of construction must have encouraged its proliferation. The poor state of preservation of the Samarra mosques means that the Ibn Tulun mosque is the place where its effects can be best admired. The soffits (undersides) of the arches each have a different pattern based on abstract vegetal ornament within simple geometric frameworks of intersecting circles

and squares, the so-called Samarra B style. The painting which would
have adorned these and the friezes that run continuously around the
arcades would have made the patterns even more striking.

The state of preservation of the mosque of Ibn Tulun also makes
it one of the best places to assess the spatial qualities of the large
hypostyle mosque. The repetition of the basic building unit, the
arch on piers, allows endless vistas through the arcades to spring up
simultaneously in multiple directions. The hypnotic effect that this
repetition induces results in the sense of quiet contemplation which
pervades the building.

Smaller ʿAbbasid mosques

The largest corpus of smaller ʿAbbasid mosques is those of the sta-
tions of the Darb Zubaydah, the pilgrimage route from Kufah to
Mecca which was endowed by Zubaydah, the wife of Harun al-Rashid.
More than twenty-five mosques have been recovered in excavations.
The simplest plan, as expected, is an undivided room, which occurs
both as a single component of a larger building (al-ʿAmyaʾ) and in
several instances as an isolated rectangular structure, usually with
three entrances on the side opposite the *qiblah* (e.g., al-Makhruqa).
In other cases courtyards have also been preserved, at least in part, in
front of this room (al-Kharaba) and the piers of the wall opposite the
qiblah show that the three entrances clearly correspond to a division
of the interior into three bays (al-Saqiyya).

The most common mosque plan which was added to the *qaṣrs*
on the route was a nine-bay type, possibly related to those of Khan
al-Zabib, Umm al-Walid, and Qaṣr al-Ḥallabat mentioned above.
In five of the *qaṣrs* the nine-bay plan is well-preserved, although
in none of them to the extent that the elevation can be deduced.
Three of these are roughly square (e.g., Umm aḍ-Ḍamiran), and two
are distinctly basilical with engaged piers to either side of the four
central ones emphasising the division into a wider nave and two
aisles (al-ʾAqiq).

It is worth noting the resemblance that many of the Darb Zubaydah
mosques have to the basilical audience hall of the Dar al-ʾImarah at
Kufah, one of the towns on the Darb Zubaydah itself. Rather than
necessitating a ceremonial link between these structures, however,
it serves to underline the blurring of the meanings of forms which
naturally arose from the reuse by Islam of earlier prototypes.

The later ʿAbbasid period sees widespread diffusion of the nine-
bay plan. Three Persian examples are known at Balkh, Hazara and
Tirmiz. These were all vaulted; the Hazara example resembles a
quincunx (which has central and four corner domes plus four barrel-
vaulted bays). That of Balkh is impressive for its stucco decoration.
Like the adornment of the mosque of Ibn Tulun, the stucco at Balkh
is in Samarra B style, its most easterly diffusion.

Figure 14.2 *Courtyard of the Great Mosque, Damascus, 705–15 (photo: O'Kane)*

Persian variations

The only well-documented example of a Sasanian four-arched building, that is, a *chahartaq*, being converted into a mosque is that of Yazd-i Khvast. A similar history has been postulated for several others, raising the question whether dome chambers were later built to stand alone as mosques (i.e., 'kiosk' mosques). Most of the discussion has centred around Seljuk monuments, although one ʿAbbasid possibility is the mosque of ʿAli Qundi in Fahraj, a small town that also possesses an ʿAbbasid hypostyle congregational mosque. Whether converted or built anew, it is likely that the presence of these dome chambers stimulated one of the most radical developments in later mosque plans, the incorporation of very large dome chambers in the mihrab area of the hypostyle mosque.

The other radical development of Persian mosques was the incorporation of another pre-Islamic form: the *ayvan*. The Friday Mosque at Nayriz has a large *qiblah ayvan* whose stucco *mihrab* indicates that it replaced a tenth-century predecessors. It has been suggested that this *ayvan* originally stood alone, although it may be more likely that it was inserted into a hypostyle plan. The real revolution came later, in the eleventh or twelfth century, when the ʿAbbasid plan of the Isfahan Friday Mosque was transformed by the addition of four *ayvans* around its courtyard and became the model for countless others.

At another mosque in Isfahan, the Ḥakim, the remains of an entrance portal decorated in brick and stucco were uncovered in 1955. The style of its inscriptions accords with the textual evidence

identifying this as the portal of the Jurjir mosque built by a Buyid vizier about 960–85. Its significance lies in its role as advertising the presence of the mosque through both its elaborate decoration and the multiple reveals of its architecture. This is one of the earliest monumental entrance portals of any Near Eastern mosque.

Fatimid Cairo

The monumental portal soon became widespread. The late tenth-century mosque of al-Ḥakim in Cairo has a projecting axial portal, itself modelled on the earlier mosque in the previous capital of the Fatimids at Mahdiyya. The early Fatimid mosques in Egypt also borrow some features from other North African prototypes, such as the T-plan and the ante-*mihrab* dome chamber. However, those features in turn may have been inspired by our first example, the Great Mosque of Medina as restored by al-Walid, where it will be recalled that a shallow dome stood in front of the *mihrab* and that the arcades were arranged to emphasise the aisle leading to the *mihrab*.

Addendum

Essam S. Ayyad, 'The "House of the Prophet" or the "Mosque of the Prophet"?', *Journal of Islamic Studies*, 24 (2013), 273–334 argues convincingly (following an earlier article by Jeremy Johns) that the main courtyard building in Madina should be interpreted as the mosque rather than the house of the Prophet.

Bibliography

Creswell, K. A. C. (1969), *Early Muslim Architecture*. 2 vols. Oxford, 1932–1940. Rev. edn. Oxford. The most detailed treatment of the early mosque.
Creswell, K. A. C. and J. W. Allan (1989), *A Short Account of Early Muslim Architecture*. Aldershot. Essential revision and expansion of Creswell's earlier study (above).
Frishman, Martin and Hasan-Uddin Khan (eds) (1994), *The Architecture of the Mosque*. London. The most comprehensive work on the subject.
Grabar, Oleg (1987), *The Formation of Islamic Art*. Rev. and enlarged edn. New Haven. Chapter 5 deals with the mosque.
Hillenbrand, Robert (1960–), 'Masdjid', in *Encyclopaedia of Islam*, new edn, vol. 6, pp. 677–84. Leiden. The most thoughtful extended summary of mosque architecture yet published.
Hillenbrand, Robert (1987–), 'Archaeology VI. Islamic Iran', in *Encyclopaedia Iranica*, vol. 2, pp. 317–22. London. Includes a thorough bibliography of the archaeological record.
O'Kane, Bernard (1987–), 'Čahārtāq, Islamic Period', in *Encyclopaedia Iranica*, vol. 4, pp. 639–42. London, The most recent discussion of the theory of the 'kiosk' mosque.
Pedersen, Johannes (1960–), 'Masdjid', in *Encyclopaedia of Islam*, new edn, vol. 6, pp. 644–77. Leiden. Covers the liturgical and historical background.

CHAPTER FIFTEEN

Monumentality in Mamluk and Mongol Art and Architecture*

AT THE START of the fourteenth century four dynasties – the
Marinids, Mamluks, Ilkhanids and Tughluqs – controlled most of
the Muslim world, chief among them in terms of contemporary
prestige being the centrally located pair, the Mamluks and Ilkhanids.
The only one of these dynasties not to last the course of the century
was the Ilkhanid, but its artistic output in the period leading up to
its demise in 1336 was outstanding, as was that of the longest-lasting
dynasty of the four, the Mamluk. A comparison of Mamluk and
Ilkhanid patronage of art and architecture with that of their contem-
poraries and predecessors can help to elucidate the reasons for the
large discrepancies between them in terms of monumentality.

Was this a concept that was remarked upon by the contemporary
sources? They are frequently frustrating in their treatment of artistic
matters, with major extant monuments passed over in silence, and
others described in the bombast of panegyrics. However, we are for-
tunate in having the testimony of the religious scholar Ibn Battuta,
who traversed the territories of all the dynasties mentioned above in
the second quarter of the fourteenth century. He was responsive to
architecture (if, understandably, biased towards his native Maghribi
style), and his comments on the monuments of the major dynasties
provide a unique source for comparisons.[1] Despite the limitations
of the main sources and the absence of any exact equivalent to the
concept of monumentality, the size and cost of major projects are
frequently commented on, and comparisons are made with famous
monuments of the past.

This element of competition, as we shall see, is of essential impor-
tance to the aesthetics of the Mongols and Mamluks, and the concept
of monumentality. Writing at the end of the fourteenth century, the
historian Ibn Khaldun remarked that the size of monuments erected

Bernard O'Kane (1996), 'Monumentality in Mamluk and Mongol Art and
Architecture', *Art History* 19/4, 499–522.
* An earlier version of this piece was delivered at a panel on *Fourteenth-
Century Art in the Islamic World* at the Annual Meeting of the College of
Art Association, New York, February 1994.

by dynasties was proportional to their original power.[2] It is easy to see this now as a cliché, but this written analysis of the relationship between power and architecture was then new to the Islamic world. What has been termed the competitive discourse of Islamic architecture has been studied before, chiefly in relation to the early modern period.[3] This piece attempts to bring into clearer focus its manifestations in early and medieval Islamic art. The reasons why it re-emerged as a major factor in the artistic expression of the two main fourteenth-century dynasties will be examined after considering the works themselves.

Rivalry in pre-fourteenth-century Islamic architecture

I write 're-emerge' advisedly, as the expression of monumentality was by no means a new one in the medieval Islamic world. The prestige which ancient monuments still enjoyed then can be gauged from the list of thirty wonders of the world provided by al-Jahiz, the ninth-century author, quoted approvingly by al-Maqrizi. Of the ten outside Egypt, nine were pre-Islamic.[4] Most of these have not survived, but from those which do, the Iwan Kisra (Ctesiphon) (Figure 15.1), the bridge at Sinja and the temples at Baʿalbak and Palmyra, the impressiveness of the monuments in the list as a whole can scarcely be doubted. The one Islamic monument on the list, the Great Mosque of Damascus, is significant not only for its monumentality, but

Figure 15.1 *Al-Madaʾin, Iwan Kisra (after J. Dieulafoy,* La Perse *[Paris, 1887], p. 557)*

also for the reasons why this element was an important part of its character. It was a response to pre-Islamic Christian architecture. A well-known passage of Muqaddasi relates how the Great Mosque of Damascus and the Dome of the Rock were built in splendour in order to compete with the beautiful churches of Syria. Muqaddasi also wrote that the al-Aqsa mosque was even more splendid than the Great Mosque of Damascus, due to a desire to outdo the Church of the Holy Sepulchre.[5] Imperial rivalry clearly played a major part in early Umayyad building campaigns. In terms of its shape, its interior and exterior[6] decoration, and its epigraphic programme, the Dome of the Rock was a very calculated response to earlier Byzantine architecture.[7] The success of the Damascus mosque in this respect may be measured by the encomium of Ibn Battuta, who even in the fourteenth century thought it the 'greatest mosque on earth in point of magnificence'.[8]

On a much larger scale, the foundation of the city of Madinat al-Salam (Baghdad) by the Abbasid caliph al-Mansur can be seen as an attempt to rival another monument on al-Quda'i's list of the wonders of the world: the Iwan Kisra, or rather the Sasanian urban ensemble of which it was the most conspicuous part – al-Mada'in. Although most commentators mention the climatic and strategic advantages of Madinat al-Salam, the desire for association with, and the eclipse of the greatest Sasanian city, situated only 30 km from Baghdad, may have been a significant factor. Tabari records that al-Mansur asked one of his advisers, Khalid b. Barmak, whether he should destroy the Iwan Kisra in order to use the rubble for building Baghdad. The adviser replied that it should stand, because it was proof of the victory of Islam over the Sasanians, and because 'Ali had prayed in it'. Al-Mansur accused him of Persian partiality, and ordered the destruction of the White Palace at the site. However, he was soon informed that the cost of destruction and transportation would be greater than that of making new materials. Khalid b. Barmak then advised him to carry on, lest it be said that al-Mansur was unable to destroy it, but al-Mansur stopped the demolition.[9] It has been suggested that this report could indicate that al-Mansur was aware of the implications that al-Mada'in had for the former subjects of the Sasanian empire, subjects who were among the most loyal partisans of the new Abbasid dynasty.[10] These implications may have been strengthened by the connotation which the area had as the locus of cities founded by great kings of the past. Thus, Yaqut explained the name al-Mada'in (cities) as deriving from the cities adjacent to one another which not only Sasanian rulers had built there, but also such former kings as Zab, who ruled in the era after Moses and Alexander the Great.[11]

Like some other Sasanian cities, Ctesiphon had a round plan that might have provided the immediate model for Baghdad.[12] However, the form which the city of Baghdad took could also be seen as a

challenge to earlier royal residences, in that its central caliphal abode, its gates, which served as audience pavilions, and its only sparsely inhabited tracts could be viewed as a 'symbolic and ceremonial palace' which symbolised the 'total rule of the Muslim prince'.[13] What more appropriate form for a city that was the culmination of the cities of al-Mada'in, than a palace which would eclipse the Iwan Kisra?[14] The need to outdo the Abbasids' Umayyad predecessors is also relevant in this atmosphere of competition. At a stroke, al-Mansur achieved the building of a palace on a metropolitan scale, far exceeding any built by the first Islamic dynasty, and created ex nihilo a capital which distanced the Abbasids from the Umayyads in more ways than one.

Later, on the banks of the Tigris at Samarra, the Abbasids created a series of palaces and mosques that remained unsurpassed in size, as caliphs vied with their predecessors in reminding posterity of their greatness. Al-Mutawakkil, upon finishing the city of Ja'fariyya, is supposed to have remarked: 'Now I know I am indeed a King, for I have built myself a city [madina] and live in it.'[15] In both his Great Mosque and the Mosque of Abu Dulaf at Samarra the circular minaret has an external spiral ramp. In the ninth century the Mesopotamian plain was still dotted with the remains of ziggurats[16] whose design has been seen as the inspiration for the minarets. The extreme height of the minarets (50 m in the case of the Great Mosque), however, can also be seen as an attempt to eclipse these vestiges of former rulers.

The empire ruled by the Abbasids in the ninth century was still one of immense size. Even if the fortunes of booty were no longer of major consequence to the rulers' purses, the growth of trade within the empire resulted in a boom economy, the taxation on which provided the wherewithal for the enormous expenses of the caliphs' building campaigns.

After the fragmentation of the empire in the tenth and eleventh centuries, the economic base of the following major dynasties, the Seljuqs and Fatimids, was by no means comparable to that of the earlier imperial powers. Although the dome chamber of Sultan Sanjar at Marv (c. 1157) was the most massive[17] mausoleum then erected in the Islamic world, Saljuq and Fatimid architecture as a whole[18] did not emphasise the concept of monumentality to the degree that either their Abbasid predecessors or their successors, the Mongols and Mamluks, did.

Mongols and Mamluks: economic factors

What of economic conditions under the Mongols and Mamluks? The Mongols wreaked great devastation on the cities of Iran in their invasions of the 1220s. This had obvious repercussions for industry and agriculture, both in the reduction of available manpower and the destruction of irrigation facilities which often accompanied their campaigns.

Agricultural reform only began in the reign of Ghazan Khan, in the late thirteenth century. Even so, Hamd Allah Mustaufi, writing in the reign of Abu Saʿid, estimated that it would not be possible in the future to bring the country back to the agricultural prosperity that it had enjoyed before the arrival of the Mongols.[19] But already, before the reign of Ghazan Khan, trade had been revived by merchants availing themselves of the new opportunities for importing goods from China, which was also under Mongol rule, and for re-exporting some of these further west to European markets. For instance, Marco Polo observed on his travels numerous skilled industrial producers and traders, many of the latter being Muslims who had quarters in Peking.[20] It is difficult to estimate the extent to which this revival or even increase in trade compensated for the decreased agricultural output. The funds which must have been lavished upon Ghazan Khan's suburb of Shanb near Tabriz and Uljaytu's capital of Sultaniyya, discussed below, make it clear that if the will to build a monumental complex were there, the funds could be found somehow. This could have been at the expense of other parts of the realm, however; in the case of palaces, bazaars, towns and canals erected by earlier Ilkhanid sultans, Rashid al-Din wrote that they were only achieved by ruining other provinces whose inhabitants were forcibly removed to the new settlements.[21] His comments preface his praise of what he described as Ghazan Khan's more successful urban policies, although the possibility remains that the gain of the capital (Tabriz) may have been achieved through the gouging of some other part of the realm.

What has been called the territorially vast human web of the Mongol dominions,[22] which facilitated trade, may have had another unintended consequence: the rapid spread, from China westwards, of the Bubonic plague pandemic in the second third of the fourteenth century. The destabilising effect which this had on the population of the Il-Khanid realm was probably a major reason for its political demise. In Mamluk territories it also had a long-term effect, that of seriously depleting the resources of manpower; although paradoxically it may have been a factor which contributed to the funds being available to the ruler to build the single most impressive Mamluk complex, that of Sultan Hasan (Figure 15.2).[23]

The economic bases of the Mamluk dynasty were its strategic position on the spice route from the East to Europe, its natural resources, including agriculture, and its production of manufactured goods, particularly those pertaining to the textile industry. As well as finished garments, raw cotton was one of Egypt's and Syria's main medieval exports. Egyptian sugar was another important export commodity to Europe. Although we know of several private families who were involved with wholesale trade, the control of the Mamluks over the economy was such as to prevent them becoming of significance, with expropriation, fines and monopoly of particularly profitable

Figure 15.2 *Cairo, complex of Sultan Hasan, exterior (photo: O'Kane)*

markets being some of the methods by which the Mamluks kept economic power to themselves.[24]

Obviously, a prosperous economy was a necessary precondition to erecting buildings on a monumental scale. But their realisation also depended on the presence of a certain *folie de grandeur* on the part of a patron, a determination to be regarded by contemporaries and successors as leaving a mark upon history. A brief account of the other contemporary fourteenth-century dynasties, the Marinids and the Tughluqs, may bring this into sharper relief.

The Marinids

The Marinids too oversaw a prosperous economy with flourishing agriculture and urban industry, as well as trade with Europe and sub-Saharan Africa;[25] but their geographical base was much narrower than that of the Almohads which they succeeded, and than that of the other three major fourteenth-century dynasties. This could be one way to explain the small scale of their surviving major monuments (Figure 15.3). Another suggested explanation is the dominant *madhhab* (legal rite) of the Maghrib, the Maliki which, unlike the predominant Shafi'i in Egypt or the Hanafi in Persia and India, did not permit the setting up of family endowments (*waqf ahli*).[26] This would certainly explain why there were fewer religious foundations as a whole than in, say, Mamluk Egypt, but it would not necessarily

Figure 15.3 *Fez, madrasa of Abu Inan, courtyard (photo: O'Kane)*

explain why Sultan Abu Inan built ten madrasas in ten different cities rather than concentrating his resources on one larger building.[27] As the surpluses guaranteed by large endowments for a small building would not be of relevance, there would have been, in general, just as much incentive for a patron to amalgamate funds in a single building. In any case, the sultan would not have had the same worries as lesser patrons of his family's wealth being dissipated after his death, a factor which encouraged endowments in areas where the Shafiʿi or Hanafi *madhhab*s predominated.

Two further reasons for the preference for small buildings could be adduced. Firstly, the dangers of trying to outdo one's predecessors with a huge project might have been all too obvious to them from the Mosque of Hasan in Rabat (c. 1195), designed to be even larger than the Great Mosque of Cordoba; its massive scale proved to be too ambitious, and it was never finished.[28] Secondly, and perhaps more importantly, the dominant aesthetic of the time seems to have been in favour, as in the period of the Mamluk sultan Qaytbay, of reducing scale and increasing ornament. As the internal sources are quiet on the matter it is impossible to be sure, although the testimony of the Maghribi traveller Ibn Battuta is again significant. He compared al-Nasir Muhammad's *khanaqah* at Siryaqus with the madrasa of Abu Inan at Fez, which 'has no equal to it in the inhabited world for perfection of architecture, beauty of construction and

plaster carving such as no Easterners can accomplish'.[29] Although this is the largest surviving madrasa of Abu Inan, it may be noticed that Ibn Battuta's description emphasises quality of finish rather than scale, and it is indeed the plethora of ornamentation which is the most striking feature of Marinid architecture (Figure 15.3). Ibn Battuta's praise for the quantity of monuments in Cairo, rather than singling out any for their size,[30] is another indication that his aesthetic leant as much to the appreciation of refinement as to the monumental.

The Tughluqs

The Tughluqs controlled much of the Indian subcontinent, a much larger territory than that of the Marinids. But unlike the Maghrib, this was an area which, for the most part, had recently been brought under Muslim rule. The booty available from expansion must have been counterbalanced to some extent by the frequent rebellions with which the rulers had to contend. The main agent of expansion, Ghiyath al-Din Muhammad Tughluq (r. 1325–51), was a poor administrator who spent the second half of his reign overseeing the decline of his empire. This may go some way to explaining the generally indifferent quality of even the finest surviving Tughluq monuments. Again, Ibn Battuta is our most reliable guide to those buildings which have not survived. Although he was very impressed by the ceremonies surrounding the sultan and his retinue, he is almost totally silent on Tughluq architecture,[31] a rare exception being his mention of the painted and exquisitely carved wooden pillars and roof of the main audience hall of Ghiyath al-Din Muhammad's palace.[32] Indeed, despite the apparently large number of madrasas which existed in Delhi at the time of Ibn Battuta's visit,[33] when searching for comparable examples of architectural beauty to the madrasas of Fez, he mentions those of Khurasan, the two ʿIraqs,[34] Damascus, Baghdad and Cairo, significantly omitting those of Delhi.[35] This lack of architectural impressiveness is reinforced by the surviving monuments of the Tughluqs. It also reinforces an idea which frequently underlies some of Ibn Battuta's aesthetic references: that fineness of finish, as well as size, is necessary for architecture to impress. Large though such monuments as the Jahanpanah (Figure 15.4) and Khirki mosques and the madrasa complex of Firuz Shah at Hauz Khas are, their decoration never seems to have been of the quality associated with the buildings of the other major fourteenth-century dynasties.[36] Earlier Muʿizzi or Khalji monuments, such as the tomb of Iltutmish or the Alai Darvaza, had finely carved stonework, a far cry from the mostly blank walls of plaster-covered rubble masonry favoured by Tughluq patrons.[37] If this was a result of a deliberate decision to impress by size at the expense of materials or decoration, it seems to have misfired.

Figure 15.4 *Delhi, Jahanpanah, mosque, courtyard (photo: O'Kane)*

That the Tughluqs *were* aware of the potential of architecture for inviting comparisons with the past, and for asserting their ascendancy, is suggested by Firuz Shah's re-use of an Asokan pillar (third century BC) in the minaret of his mosque at Firuzabad. This itself paralleled an earlier re-use of a similar pillar by Qutb al-Din Aybak in the first Friday mosque of the Delhi area, the Quwwat al-Islam mosque.[38] In addition to their references to the pre-Islamic Indian past, the Tughluqs were also conscious of the building activities of their fourteenth-century neighbours, the Ilkhanids. Ibn Battuta was given the task of supervising construction of a complex which included a mausoleum for the immediate predecessor of the Tughluqs, the Khalji sultan Qutb al-Din Mubarak Shah (r. 1316–20).[39] He was told that the current sultan, Ghiyath al-Din Muhammad, wanted it to be made 20 cubits higher than the tomb of Ghazan Khan, itself 80 cubits high, a building which Ibn Battuta himself had visited.[40] If this was ever finished,[41] it did not survive, and the possible tomb of its patron, Ghiyath al-Din Muhammad, is considerably less monumental than those of his Ilkhanid rivals.[42]

Mongol and Mamluk monuments

The most impressive element of Ghazan Khan's complex near Tabriz was indeed his tomb. Rashid al-Din describes it as follows:

> It was founded in the west of Tabriz at the place called Shanb; he [Ghazan Khan] himself drew the plan. At this time it has been in the course of construction for several years. It was built to be more magnificent than the tomb of Sultan Sanjar in Marv, which he [Ghazan] had seen, and which is the most magnificent building in the world.[43]

This passage is significant on several counts. It shows the personal involvement of the ruler in a building which he himself designed to eclipse that of his dynastic predecessor. While Ghazan Khan's detailed knowledge of architectural matters may be doubted, it is certainly creditable that he specified that his mausoleum should be made bigger than Sanjar's. It also indicates that Ghazan had actually been in Marv and seen the mausoleum of Sultan Sanjar, and was therefore aware of the importance and prestige which would accrue to him in contemporary eyes for erecting a building which could now claim to be the most magnificent in the world. Other historians confirm its importance. Shams al-Din Kahsani in his *Shahnama* starts with conventional praise: 'Thousands of *tuman*s of gold were expended on it/In its height it was the measure of the heavens.'[44] He then produces figures which are meant to give an idea of the immensity of the undertaking: 300,000 trees were used to make scaffolding, and 200 ladders facilitated movement from top to bottom on it.[45] Given these figures, it is no wonder that the scaffolding crumpled under its own weight.[46] Vassaf too gives figures designed to impress the reader: the number of workers on the complex was 14,400 of whom 13,000 were full-time and 1,400 part-time.[47] For the decoration of the ceiling of the tomb, 300 *man* (approx. 250 kg) of lapis lazuli was used.[48] He gives measurements of the tomb which show that it was indeed larger than Sanjar's: its height was the equivalent of 54.6 m and the diameter of 21 m.[49] He also transcribes its Arabic foundation inscription which, after listing Ghazan's titles, praises the complex and particularly the tomb. While this description is for the most part in typical hyperbole – equating the height and diameter of the dome to the heavens, for instance – one comparison stands out: 'the pyramids are belittled beside it.'[50] This is not a common point of reference in Ilkhanid sources; perhaps Ghazan specified it to show his superiority not only to the Pharaohs, but also to the Mamluks who occupied their lands and who had not themselves built anything comparable.

Although the tomb was the focal point of Ghazan's suburb, the number of buildings around it was impressive. The complex consisted of a congregational mosque, a Hanafi and Shafi'i madrasa, a *khanaqah*, a *dar al-siyada*,[51] an observatory, a hospital, a library, a *bait al-qanun* (serving as a repository for Ghazan Khan's promulgations) an academy of philosophy, a house for the overseer, a cistern and a bath.[52] These were just the foundations supported by *waqf*; in addition there was a palace and garden. This easily amounted to the most comprehensive group of buildings (other than the construction of an actual city) yet founded by a Muslim ruler, and is thus an important landmark in the history of the complex.[53] Even in the fifteenth century the author of the *Tarikh-i Yazd* wrote that the world had no equal to the buildings of Shanb.[54]

Ghazan's brother Uljaytu earned equal fame as the founder of a capital city, Sultaniyya, where his tomb was also the focal point of

a surrounding religious complex.[55] Hafiz Abru remarks of the tomb that its equal was not to be seen even in the most distant countries.[56] Hamd Allah Mustaufi, too, wrote that the like of the great buildings in Sultaniyya were to be found in no other city, except in Tabriz[57] – an important rider, for in his section on Ghazan's tomb he claims that it was bigger than any other in Iran. The Mamluk historian al-Yusufi also wrote a detailed account of the founding of the city in which the numbers of workers involved – 5,000 stone cutters, carpenters and marble workers, 3,000 metal workers – serve to indicate the impressiveness of the undertaking.[58]

The dome of the mausoleum of Uljaytu at Sultaniyya (Figure 15.5), 25 m wide and 50 m high, remains the largest in the Islamic world and shows that contemporary claims for the city were no

Figure 15.5 *Sulcaniyya, mausoleum of Uljaytu, exterior (photo: O'Kane)*

exaggeration. Its reputation almost caused its destruction in 1399, when Timur's son Miranshah was governor of western Iran. According to Ruy Gonzalez de Clavijo, the ambassador of the King of Castile to Timur, Miranshah said that as he would not be remembered as a builder, he might as well be thought of as the destroyer of the finest buildings in the world, and he determined to pull down Sultaniyya, including Uljaytu's tomb. He may have already demolished many buildings before Timur arrived in time to put a stop to his plans.[59] The account is an ironic parallel to that related above concerning al-Mansur and the Iwan-i Kisra; both earlier monuments may have been spared because they could bear witness to superior accomplishments: al-Mansur's city palace of Baghdad and Timur's vision for Samarqand.[60]

Another building which Hamd Allah Mustaufi would have had in mind in his comparison of Sultaniyya and Tabriz is the complex in Tabriz built by Taj al-Din ʿAlishah (Figure 15.6), the vizir of the Ilkhanid sultans Uljaytu and Abu Saʿid. This complex in turn may have been built as a rejoinder to that which another vizir of Uljaytu, Taj al-Din's rival Rashid al-Din, had built in a suburb to the east of Tabriz.[61] The most impressive part of Taj al-Din's complex, which also included a khanaqah and madrasa, was its congregational mosque, which had an enormous qibla *iwan* as its focal point. This was renowned for being larger than that of the Iwan Kisra. The

Figure 15.6 *Tabriz, mosque of Taj al-Din ʿAlishah, qibla iwan (photo: O'Kane)*

claim is made by the dawadar (secretary) of the Mamluk ambassador Aitamish who was sufficiently impressed by the complex to make detailed notes on it in 722/1322, and who says that ʿAlishah ordered it to be made 10 cubits wider and taller than the Iwan Kisra.[62] ʿAlishah had spent considerable time in Baghdad, supervising the imperial textile factory there, and therefore may well have been familiar with the monument he was rivalling: the Iwan Kisra. He may also have known of the visits to it of two Ilkhanid sultans, Hulagu and Uljaytu, and of their reported awe of the building.[63] The 30 m span of the qibla *iwan* of ʿAlishah's mosque is actually wider than that of Ctesiphon, as the remains show,[64] although this may have proved its undoing, as Mustaufi records that it fell from being built too hastily.[65]

One Mamluk monument that was also supposedly erected in competition with the Iwan Kisra was the complex of Sultan Hasan in Cairo (1356–61).[66] Maqrizi claimed that its main *iwan* was 5 cubits larger than the Iwan Kisra.[67] As in Shams al-Din's account of the tomb of Ghazan, Maqrizi emphasises its importance by mentioning the exceptional building expenses. The extravagance of the scaffolding of the iwan, costing 100,000 silver dirhams, was underlined by indicating that it was thrown down in a heap when the arch of the *iwan* was finished.[68] He also gives a figure for daily expenditure of 20,000 dirhams, which presumably continued for the three years, without a day being missed, which he says its construction took.[69] Writing at about the same time (the second quarter of the fifteenth century), the Mamluk author Khalil al-Zahiri was more specific on its relationship with the Iwan Kisra:

> Sultan Hasan ... asked the architects which is the highest building in the world? He was told: Iwan Kisra. So he ordered it should be measured and recorded exactly and that his madrasa should be 10 cubits higher.[70]

This account is very close to that of the *dawadar* regarding the Mosque of ʿAlishah, suggesting that Khalil al-Zahiri may simply have paraphrased the earlier account. In the event, however, the qibla *iwan* as built was considerably smaller than the Iwan Kisra,[71] although what was important was that Sultan Hasan and his contemporaries *thought* it was bigger.

Unlike the ʿAlishah mosque, the main *iwan* of Sultan Hasan's complex is not the dominant feature of the exterior. The qibla *iwan* is disguised on the rear by the presence of the largest mausoleum in Cairo (and one of the Islamic world's biggest dome chambers), dominating the square in front of the Mamluk sultans' palaces in the citadel (Figure 15.2). Maqrizi wrote that there was no dome chamber like it in Egypt, Syria, ʿIraq, the Maghrib and Yemen, significantly omitting Azerbaijan, the location of the domed tombs of Ghazan and Uljaytu. No other Mamluk complex has its tomb

located behind the qibla *iwan*, and it has been suggested that an Ilkhanid model such as that of the Rashidiyya or Sultaniyya are possible sources.[72]

It has been claimed that Sultan Hasan's complex is, in many ways, anomalous in Mamluk architecture,[73] and while this may be partially true, it was certainly not the first Mamluk attempt at a monumental freestanding building. Immediately opposite it, dominating the citadel and hence Cairo itself, was one of the largest dome chambers in the city, the Great Iwan of al-Nasir Muhammad, occupying the site where the Mosque of Muhammad 'Ali now stands (Figure 15.7). This was built as an audience and reviewing hall. It has two unusual features: its designation as an *iwan*, even though its principal component was a dome, and its basilical plan. The use of the term *iwan* can be seen as a reflection of the glory and prestige still commanded by the Iwan Kisra,[74] although it might also be a continuation of the designation of the main feature of the first major building on the site,

Figure 15.7 *Cairo, Citadel, Great Iwan of al-Nasir Muhammad (after* Description de l'Égypte, État moderne, *planches, vol. 1 (Paris, 1809, pl. 70)*

an audience hall probably built by the Ayyubid sultan al-Kamil.[75] Its basilical plan has also been interpreted as a perpetuation of the plan of palaces of the Umayyads, echoing a golden age of Islam.[76] Its dimensions are preserved in a plan in the *Description de l'Égypte*, its nearly 20 m diameter easily surpassing that of the mausoleum of Imam Shafi'i (15 m) and the mosque of Baybars (15.37 m), previously the two largest dome chambers in Egypt.[77] The impression it made may be gauged from a report that the Ottoman sultan Selim forbade the governors of Egypt from holding their audiences there lest its grandeur tempt them into independence.[78]

Of the palaces which al-Nasir Muhammad built on the citadel, some of which would also have been visible to the populace below, we have unfortunately only the glowing descriptions of historians to rely on.[79] Some idea of their splendour may be gauged from the ruins of the residential palace known as the *istabl* of Qausun (Figure 15.7).[80] This was also in view of the citadel. Although the amir Qausun first lived in it, it was almost certainly paid for out of the Sultan's purse and would have reverted to the Sultan after the tenure of the amir. This has the loftiest entrance portal in Cairo (Figure 15.8),[81] with the sole exception of Sultan Hasan's complex, and on its upper floor a reception hall (*qa'a*) which must have been over 40 m long, and even higher than the soaring roof of the finest surviving example, that of the amir Bishtak.[82] The visit of Ibn Battuta to Cairo coincided with al-Nasir Muhammad's reign. Given his comments on the multitude of buildings in Cairo,[83] it is not surprising that it has been suggested that this was a period characterised by architectural programmes of such extravagance that the Mamluk economy never fully recovered from them.[84]

The expression of imperial might is a theme that can also be seen in the art as well as the architecture of the time. As far as illustrated manuscripts of the Mongols are concerned, this subject has been treated in detail recently by Sheila Blair.[85] She shows, for instance, that the utility of historical manuscripts such as the *Jami' al-tavarikh* of Rashid al-Din for polemical purposes was exploited by their new larger format and increased number of illustrations. One can add that, as copies of the book were supposed to be displayed in the mosque of Rashid al-Din's complex and then sent to all the major cities of the Ilkhanid realm, these innovations could have been appreciated by a wide audience. The matter is less clear for the most luxurious illustrated manuscript of the period, the *Shahnama*, which was planned to have around two hundred illustrations. The unusual emphasis on such episodes as the cycle depicting Alexander the Great, paralleling the conquest of Iran by the non-indigenous Ilkhanids, shows that the illustrations were, at least in part, carefully selected for their relevance to Ilkhanid history.[86] However, one wonders who would have appreciated this other than the Mongol ruler. Given the very restricted readership that such a manuscript

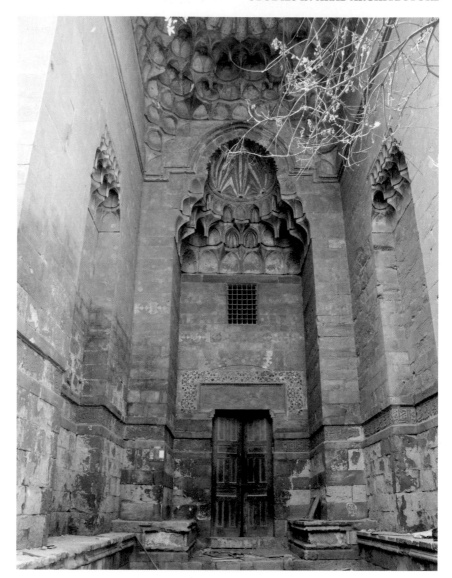

Figure 15.8 *Cairo, palace of Qausun, main portal*

would have had, it is difficult to understand how, as has been suggested, the formerly private art of the book took on a more public function.[87]

There are no illustrated history texts of the Mamluks, while their illustrated literary texts that survive are perfunctory compared with either Iranian or thirteenth-century Arab examples. It could be argued that the imperial aspirations of the Mamluks with regard to the art of the book were realised in their production of Qurans. These are outstanding, not only, as to be expected, in their sumptuous calligraphy, but also for their size and wealth of illumination. The

largest, dated 1374, is slightly over 1 m tall (105×75 cm).[88] Earlier llkhanid examples were also much bigger than those produced for previous dynasties, even if the largest known (72×50 cm) is still less than the Mamluk examples from the second half of the fourteenth century. One imperial Ilkhanid Quran, made for Sultan Uljaytu, reached Cairo in 1326. It used to be thought that it had a major stylistic influence on later Mamluk examples, but this has been disproved by David James.[89] However, its size may have been an incentive for Mamluk patrons to compete with it: all earlier Mamluk Qurans are smaller than its 56×41 cm; but the four dated examples that we have from the period after its arrival in Cairo, between 1329 and 1334, are all slightly larger.[90] These dimensions show that the enormous *kursis*, such as those in the mausoleums of Sultan Hasan and Qaytbay, on which readers and their Qurans were perched, were no mere conceit; they really needed to be that large to support the huge manuscripts of the time.[91]

They are paralleled by the metal and glass lamps and the bronze-revetted doors which adorned Mamluk complexes. They form an extraordinarily rich corpus,[92] although those of Sultan Hasan are again the most grandiose of all.[93] His doors were considered such a splendid piece of work that in the early fifteenth century Sultan Mu'ayyad paid the compliment of removing them and installing them in his own complex.[94] If the jewel-encrusted golden lamp and monumental candlesticks that are depicted in the Great Mongol *Shahnama* are a reliable guide to contemporary Ilkhanid artefacts in their most important buildings (and they probably are),[95] the interiors of Mongol complexes were equally lavishly outfitted.

Conclusions

It seems clear that the Mamluks as much as the Mongols were aware of the prestige that monumental architecture and the artefacts within it conferred on their patrons. Trying to outdo one's predecessors called attention not merely to the success of the new work of art, but also to the sense of kinship that it brought to the glories of the older dynasties. It is clear why the first Islamic dynasties, as outlined above, felt it necessary to compete with their predecessors.

But why should the Mamluks and Mongols have felt compelled to return to the monumental? Perhaps a renewed historical consciousness was at work here. As victors over their newly conquered enemies and as witnesses to the imperial monuments of the Byzantines and Sasanians which were still thick on the ground, the Umayyads and Abbasids hardly needed reminding of the immediate historical past. But historiographical interest was a notable feature of both Mongol and Mamluk rule. Two of the most prominent vizirs of the Mongols, 'Ala' al-Din Juvayni and Rashid al-Din, produced histories which were commissioned by the ruling elite, and which commemorated

the Mongols' status as the dynasty which was the culmination of the rightful rulers of Iran. As mentioned above, the histories of Rashid al-Din were given special distinction in being designed to be distributed to a wide audience within the Ilkanid realm. Unlike earlier histories of Iran, they were written in Persian instead of Arabic, which would have increased the readership of their intended audience.[96] The historiography of the Mamluk era is also famous for its richness and variety.[97] The numerous histories, while not normally commissioned by a ruler, were produced for court audiences, sometimes by high-ranking officers of the Mamluk state. As an example of royal Mamluk interest in history, one can cite the early fifteenth-century sultans al-Zahir Tatar and al-Ashraf Barsbay, who employed the historian Badr al-Din al-'Ayni to translate histories and other Arabic texts into Turkish for them.[98] The Mamluk rulers' consciousness of history is also shown by their promotion and retention of the Abbasid caliph as a figurehead, although this admittedly dates from near the inception of the Mamluk sultanate, in the reign of Baybars.[99] Finally, the lengthy account of the Mosque of 'Ali Shah on behalf of a Mamluk amir by his *dawadar* and its subsequent appearance in a Mamluk history are themselves evidence of the interest, quite new in the Islamic world, in the detailed recording of architectural information on monuments in foreign countries. This, of which other Mamluk examples also exist,[100] has been justly cited as an example of the Mamluks' openness to the world around them,[101] but it is also evidence of their appreciation of some of the most impressive expressions of monumentality of their contemporaries and predecessors.

Is there any factor other than a renewed historical consciousness which might explain the phenomenon of monumentality in the art of the Mamluks and Mongols? Both dynasties comprised rulers who were alien to the local population, and who therefore required their legitimacy to be validated. Both were recent converts to Islam and, for the most part, expressed the concept of monumentality in buildings which were dedicated to the faith.[102] By stressing this link with the population, but at the same time dominating it by overpowering architecture, their right to rule was thereby underlined.[103] Conscious of their status as parvenus in Islamic society and controllers of vast resources of men and money, the Mamluks and Mongols endeavoured to ensure that their monuments would leave a mark upon society similar to those of the great dynasties of the past.

Glossary

bait al-qānūn	repository for legal decrees
dawādār	secretary
dār al-siyāda	residence for sayyids, i.e. descendants of Muhammad
dinār	unit of currency

dirham	unit of currency
īwān	hall, usually vaulted, closed on three sides
khānaqah	residence for Sufis
kursī	table or platform for Qur'ans
madhhab	legal rite
madrasa	college of religious education
madina	city
man	unit of weight, here c. 250 kg
qāʿa	reception hall
qaṣr	palace, citadel
qibla	the direction of Mecca
tumān	unit of currency equal to 10,000 dinars
waqf	religious endowment
waqf ahlī	family endowment
waqfiyya	deed specifying the waqf

Notes

1. The reliability of Ibn Battūta has sometimes been called into question, but 'too close attention to his errors can distract from the astonishing accuracy of the *Rihla* on the whole, as both a historical document and a record of experience', R. E. Dunn, *The Adventures of Ibn Battuta*, Berkeley and Los Angeles, 1986, p. 313. He was not blind to the faults of those to whom he owed gratitude for hospitality, or to their buildings (see the section on the Tughluqs, below). His bias towards the monuments of the Marinid Sultan Abū Inān can be put in the context of a work which was commissioned by the same sultan, and who obviously had to be flattered as a result.

2. *The Muqaddimah: An Introduction to History*, trans. F. Rosenthal, 3 vols, 2nd edn, Princeton, 1967, vol. 1, p. 356; vol. 2, p. 241.

3. G. Necipoğlu, 'Challenging the Past: Sinan and the Competitive Discourse of Early Modern Architecture', *Muqarnas*, vol. 10, 1993, pp. 16–80.

4. The one Islamic monument was the Great Mosque of Damascus; the others were the bridge at Sinja (by a copyist's error this has been transcribed as Sinjar; on the Roman bridge at Sinja see G. Le Strange, *The Lands of the Eastern Caliphate*, Cambridge, 1905, pp. 12.3–4), the church at Edessa (al-Ruhā), Ghumdān palace, the church (of St Peter) at Rome (al-Rūmiya), the statue at al-Zaytūn, the Īwān of Kisrā (Ctesiphon), the House of the Winds in Palmyra, (the palace of) Khawarnaq, the (palace of) Sadīr at Ḥīra and the three stones (of the temple of Bacchus) at Baʿalbak: al-Maqrīzī, Taqī al-Dīn Aḥmad ʿAlī, *Kitāb al-mawāʿiz waʾl-iʿtibar fī dhikr al-khiṭāṭ waʾl-āthār*, 2 vols, Bulaq, 1270/1853–4, vol. 1, p. 31; II. 1–3. Al-Maqrīzī mentions that the list was given by al-Qudāʿi on the authority of al-Jāḥiẓ.

5. Ibid., p. 168.

6. In a lecture at the Metropolitan Museum of Art, New York, 3 December 1993, Julian Raby suggested that the description of the exterior by the fifteenth-century traveller Falix Fabri as cherubim may well have been correct, corresponding to what he sees as depictions of winged angels in the interior.

7. For the iconography of the Dome of the Rock, see N. Rabbat, 'The Dome of the Rock Revisited: Some Remarks on al-Wasiti's Accounts', *Muqarnas*, vol. 10, 1993, pp. 67–75 and *Bayt al-Maqdis: 'Abd al-Malik's Jerusalem*, ed. J. Raby and J. Johns, Oxford, 1992. Given the very self-conscious challenge of the Dome of the Rock, the mosque of al-Aqsa and the Great Mosque of Damascus to Byzantine monuments, one could argue that not only in the early modern period (fourteenth century onwards) did monuments 'more frequently allude to the past in order to challenge it and affirm the superiority of their own time' (Necipoğlu, 'Challenging the Past', op. cit. [note 3], p. 170).

8. *The Travels of Ibn Baṭṭūṭa, A.O. 1325–1354*, trans. H. A. R. Gibb, 3 vols, Cambridge, 1958–71, vol. 1, p. 124.

9. *The History*, vol. 29, trans. H. Kennedy, Albany, 1990, pp. 4–5.

10. J. Lassner, *The Topography of Baghdad in the Early Middle Ages*, Detroit, 1970, pp. 130–1.

11. Yaqut, *Muʿjam al-buldān*, ed. Muḥammad Amīn al-Khānijī, Cairo, 1324/1906, vol. 7, p. 413; Lassner, *Topography* op. cit. (note 10), p. 131; Saleh Ahmad el Ali, 'Al-Madāʾin and Its Surrounding Area in Arabic Literary Sources', *Mesopotamia*, vols 3–4, 1968–9, p. 423; idem, 'Al-Madāʾin fī maṣādir al-ʿarabiyya', *Sumer*, vol. 23, 1967, p. 52.

12. K. A. C. Creswell, *Early Muslim Architecture*, 2 vols, Oxford, 1932–40, vol. 2, p. 19. To be more accurate, the round city was the twin city of Ctesiphon, Veh-Ardashir: J. M. Fiey, 'Topography of al-Madaʾin', *Sumer*, vol. 23, 1967, p. 14. The Iwan Kisra was, in reality, in a suburb of Ctesiphon, Aspānbūr: ibid., pp. 28–30; el-ʿAli, 'Al-Madāʾin and Its Surrounding Area', p. 427; idem, 'Al-Madāʾin fī maṣādir', p. 55.

13. O. Grabar, *The Formation of Islamic Art*, New Haven and London, 1987, p. 67. The concept of the city as a symbolic and ceremonial palace was first mooted by J. Lassner, 'The Caliph's Personal Domain: The City Plan of Baghdad Reexamined', *Kunst des Orients*, vol. 5/1, 1968, p. 33.

14. Not to mention, of course, those of their Umayyad predecessors.

15. Yaʿqūbī, *Kitāb al-buldān*, Najaf, 1957, p. 31; trans. G. Wier as *Les pays*, Cairo, 1937, p. 61.

16. For example, the Babylon ziggurat: Creswell, *Early Muslim Architecture*, op. cit. (note 12), vol. 2, pp. 263–4.

17. The tallest, at 51 m, versus the approx. 40 m of the mausoleum of Sultan Sanjar, would still have been the Gunbad-i Qābūs: see A. Godard, 'Islamic Architecture. D. Gurgan and the Gunbad-i Qābūs', in *A Survey of Persian Art*, ed. A. U. Pope and P. Ackerman, London and New York, 1939, p. 971 and A. Karriev (ed.), *Pamyatniki Arkhitektury Turkmenistana*, Leningrad, 1974, p. 148.

18. No Saljuq or Fatamid palaces have survived, of course. Nāṣir-i Khusrau's description of the Fatamid palace suggests that, while great wealth had been lavished on its decoration, the individual pavilions of which it was composed, surrounded by a tall exterior wall, would not have conveyed any great impression of monumentality: *Safarnāma*, trans. W. Thackston as *Book of Travels*, Albany, 1986, pp. 45–6, 56–7. The dome chamber erected by the Saljuq sultan Malikshah in the Isfahan Friday mosque (1086–7) was then the largest masonry dome in the Islamic world; it may have been inspired by the dome of the Great Mosque of Damascus: S. S. Blair, *The Monumental Inscriptions from Early Islamic Iran and Transoxiana, Studies in Islamic Art and*

Architecture, vol. 5, Leiden, 1992, p. 162; Necipŏglu, 'Challenging the Past', op. cit. (note 3), p. 170.

19. Ḥamd Allāh Mustaufī, Nuzhat al-qulūb, ed. and trans. G. Le Strange, E. J. W. Gibb Memorial, vol. 23, part 2, Leiden and London, 1915–19, text, p. 27; trans. p. 34.

20. J. L. Abu-Lughod, Before European Hegemony: The World System ad 1250–1350, New York and Oxford, 1989, p. 167.

21. K. Jahn (ed.), Geschichte Gāzān-Ḥān's aus dem ta'rīḫ-i-mubārak-i ġazānī, E. J. W. Gibb Memorial, new series, vol. 14, London, 1940, pp. 350–1; A. K. S. Lambton, Continuity and Change in Medieval Persia, Columbia Lectures on Iranian Studies, vol. 2, Albany, 1988, pp. 176–7.

22. W. H. MacNeil, in Abu-Lughod, Before European Hegemony, op. cit. (note 20), p. 171.

23. J. Inamorati, 'The Black Death and Institutional Building in Cairo: the Funerary Complexes of Sultans Qalaoun and Hasan', apud N. Rabbat, 'The Iwans of the Madrasa of Sultan Hasan', ARCE Newsletter, vols 143–4, Fall/Winter 1988–9, p. 6.

24. Abu-Lughod, Before European Hegemony, op. cit. (note 20), pp. 230–6.

25. M. Shatzmiller, 'Marīnids', Encyclopaedia of Islam, 2nd edn, vol. 6, p. 573.

26. S. Blair and J. Bloom, The Art and Architecture of Islam 1250–1800 New Haven and London, 1994, p. 114. Allowing one's family members to be the supervisors of a trust which frequently generated surplus income was a way of safeguarding the family funds from arbitrary confiscation, and was an obvious incentive to Mamluk and Ikhanid patrons. Their foundations also frequently included mausoleums; their patrons were undoubtedly attracted by their potential for attracting blessings (baraka), and given the greater care which was frequently taken with the orientation of these structures than with their adjoining prayer halls (C. Kessler, 'Funerary Architecture within the City', in Colloque international sur l'histoire du Caire, ed. A. Raymond, M. Rogers and M. Wahba, Cairo, n.d., pp. 260–7), the desire to build a mausoleum may sometimes have taken precedence over the pious wish to endow a religious foundation.

27. Those of Fez, Meknes, Sale and al-'Ubbad beside Tlemcen still survive; for the others see M. Shatzmiller, 'Waqf Khayrī in FourteenthCentury Fez: Legal, Social and Economic Aspects', Anaquel de Estudios Arabes, vol. 2, 1991, p. 198. (I am grateful to the author for sending me a copy of this.) The Marinid sultans Abu Saʿid and Abu'l-Ḥasan also erected madrasas in Fez: ibid., p. 196.

28. For plans of the mosques of Cordoba and Hasan drawn to the same scale, see L. Golvin, Essai sur l'architecture religieuse musulmane, 4 vols, Paris, 1970–9, L'art hispano-musulman, vol. 4, p. 263. Selective analogues were adopted to stress the links of the Spanish Umayyads with their Syrian forebears: J. Bloom, 'The Revival of Early Islamic Architecture by the Umayyads of Spain', in The Medieval Mediterranean: Cross-Cultural Contacts, Medieval Studies at Minnesota, vol. 3, ed. M. Chiat and K. Reyerson, St Cloud, 1988, pp. 35–41. The view expressed by Creswell, Early Muslim Architecture, op. cit. (note 12), vol. 2, p. 146, that the Cordoba mosque was oriented exactly north and south because that was the orientation of the Damascus mosque must be discounted; the actual orientation is closer

to south-east rather than south: Golvin, *L'art hispano-musulman*, p. 40. This is still some way from the correct qibla orientation, which should be closer to the east than south-east, but Michael Bonine has shown how medieval qibla directions in neighbouring Morocco were frequently influenced by the topography of the site, in particular the prevailing slope: 'The Sacred Direction and City Structure: A Preliminary Analysis of the Islamic Cities of Morocco', *Muqarnas*, vol. 7, 1990, pp. 50–72. This may well have been of decisive influence at Cordoba also, as the qibla wall parallels that of the bank of the adjacent Guadalquivir river.

29. *Travels*, op. cit. (note 8), vol. 1, p. 53. His regard for this building is such that he also praises it extravagantly in a later passage: ibid., vol. 3, p. 584.

30. Ibid., vol. 1, p. 43. Exceptionally, lbn Baṭṭūṭa notes the beauty of the Mārisrān of Qalāʾūn; its complex included a mausoleum which today is the most impressive part of the ensemble, but it is not surprising that Ibn Baṭṭūṭa makes no mention of it, as he would not have been allowed inside it: access was heavily restricted by the eunuchs who were guardians of the comb. See D. Ayalon, The Eunuchs in the Mamlūk Sultanate', in M. Rosen-Ayalon (ed.), *Studies in Memory of Gaston Wiet*, Jerusalem, 1977, n. 3.

31. *Travels*, op. cit. (note 8), vol. 3, pp. 659–70, 686–9.

32. Ibid., p. 660. It is not surprising that this wooden structure should not have survived; lbn Baṭṭūṭa wrote when describing the ruined splendour of the palace of the first Khalji sultan Jalāl al-Dīn that 'it is their custom in India to abandon a Sultan's palace when he dies, with all that is in it, leaving it untouched, and his successor builds a palace for himself' (p. 685).

33. Al-ʿUmari, cited in A. Welch and H. Crane, 'The Tughluqs: Master Builders of the Delhi Sultanate', *Muqarnas*, vol. 1, 1983, p. 160, n. 61.

34. I.e. ʿIraq-i ʿArab and ʿIraq-i ʿAjam, the latter being the medieval name of the province of Persia adjacent to the former.

35. *Travels*, op. cit. (note 8), vol. 3, p. 584.

36. The sole extant exception may be the tomb of Fīrūz Shah at Hauz Khās, which displays some fine painted stucco on the interior: Welch and Crane, 'The Tughluqs', op. cit. (note 33).

37. None of the mihrabs of the surviving Tughluq monuments is finely decorated, a good indication that the patrons considered decoration unimportant.

38. Both are discussed at length in W. J. McKibben, 'The Monumental Pillars of Fīrūz Shāh Tughluq', *Ars Orientalis*, vol. 24, 1994, pp. 105–18; A. Welch, 'Architectural Patronage and the Past: the Tughluq Sultans of India', *Muqarnas*, vol. 10, 1993, pp. 311–22.

39. Nothing remains of this today.

40. *Travels*, op. cit. (note 8), vol. 2, p. 344. Surprisingly, Ibn Baṭṭūṭa did not refer to the size of the tomb of Ghazan when he described his visit to the site, but one suspects that it was he who furnished the information that it was the one to be outdone. If this is the case, he underestimated its height by some 28 cubits (assuming he used the common cubit of 0.462 m; on this see W. Popper, *Systematic Notes to Ibn Taghrî Birdî's History of Egypt*, University of California Publications in Semitic Philology, vol. 16, Berkeley, 1957, p. 33).

41. If it was not, it may have been because the scheme was abandoned as being over-ambitious.

42. Welch and Crane, 'The Tughluqs', op. cit. (note 33), p. 143, identify the tomb known as the Lal Gunbad as the possible tomb of Ghiyath al-Dīn Muḥammad.

43. Jahn op. cit. (note 21), p. 208. D. N. Wilber, *The Architecture of Islamic Iran: The IL Khānid Period*, Princeton, 1955, p. 125, wrote that according to Abu'l-Qāsim al-Kāshānī, Tāj al-Dīn ʿAlīshāh was the designer. This, however, is a misreading of M. Bahrami, *Recherches sur les carreaux de revêtement lustré dans la céramique persane du xiiie au xve siècle (étoiles et croix)*, Paris, 1937, p. 81, who was describing Abu'l Qāsim's account of Sultaniyya, not of Shanb.

44. *Apud* Muḥammad Javād Mashkūr, *Tārīkh-i Tabrīz tā pāyān-i qarn-i nuhhum hijrī*, Tehran, 1352/1973, p. 476.

45. Ibid.

46. Ibid., p. 477; C. Adle, 'Le prétendu effrondrement de la coupole du mausolée de Qâzân Xân à Tabriz en 705/1305', *Studia Iranica*, vol. 15, 1986, pp. 267–70.

47. Shihāb al-Dīn Vaṣṣāf, *Tārīkh-i Vaṣṣāf*, Tabriz, 1959, p. 382.

48. Ibid., p. 384.

49. Ibid., p. 382. Sheila Blair has shown by using the known height of the mausoleum of Uljaytu at Sultaniyya that the cubit used by Ḥāfiz Abrū, based on figures taken from Ḥamd Allāh Mustaufī (in his *Zafarnama*, British Library, London, Or. 2833, f. 711a), was equivalent to 0.42 m: 'The Mongol Capital of Sulṭāniyya, "The Imperial"', *Iran*, vol. 24, 1986, p. 143. I have assumed that Vaṣṣāf was using the same measure here. The original height and width of this building have been surrounded with considerable confusion because Wilber estimated that Vaṣṣāf's figures would have resulted in a building some 42 m high and wide: *Architecture*, op. cit. (note 43), p. 125. However, a re-examination of Vaṣṣāf's text can provide a more plausible interpretation. The following figures are given by him for the various parts of the tomb: the walls were 33 bricks thick, each brick being 15 *gaz* thick. The height of the dome was 130 *gaz*. The height of the walls was 80 *gaz*, the height of the inscription and the height of the muqarnas cornice were each 10 *gaz*; the cup of the dome (ṭās-i qubba, i.e. the height measured from the springing point of its internal base) was 40 *gaz*, the circumference of the dome was 530 *gaz*, the diameter of the dome was 50 *gaz*. The height of the walls (80) and the height of the dome (40) together make 120 *gaz* rather than the 130 given for the total height, but this can be explained by a section in which the base of the dome on the interior is disguised on the exterior by the muqarnas cornice, a not unlikely profile in a 12-sided tomb tower. The only figure in this list which does not make sense is that of the circumference, which would yield a figure for the diameter of 168.7 *gaz*, equivalent to 70 m, an obvious impossibility. Fortunately, a good approximation of the original diameter may be obtained from the seventeenth-century traveller Tavernier, who described it as approximately 50 paces wide: Jean-Baptiste Tavernier, *Les six voyages de Turquie et de la Perse*, ed. S. Yerasimos, 2 vols, Paris, 1981, vol. 1, p. 109. He gives a figure (ibid., p. 105) for the diameter of the main dome of the Muzaffariya (the Blue Mosque) at Tabriz as 36 paces (in reality, 16.75 m); so his 50 paces for Ghazan's tomb would be equivalent to 23.25 m. This is not far from

Vaṣṣaf's figure for the diameter of the dome of 50 *gaz*, equivalent to 21 m, indicating that we may rely on the latter. Vaṣṣaf's computations in figuring the circumference are as follows: ammā misāhat-i quṭr-i dā'ira-yi gunbad bi-burhān-i ḥisābī pānṣad u sī gaz bāshad cha quṭr-i dā'ira-yi ān panjāh dar panjāh ast ki maḍrūb-i ān du hizār u pānṣad bāshad va chun sab' u niṣf sab' u ān dar ān zarb va az ān vaz' kunand taqrīban hamīn miqdār dar ḥisāb āyad ('but the extent of the circumference according to reckoning is 530 *gaz* as its diameter is 50 by 50 whose multiplicand is 2500, and since seven and half seven of it is multiplied and then subtracted, it amounts to roughly this figure'). Now a circle of 50 *gaz* diameter would have a circumference of 157 *gaz*, and an area of 1963. Vaṣṣaf is evidently confusing diameter with radius and possibly area with circumference; even though I have not understood the mathematical procedure by which he arrived at the figure of 530, it is clear that no further reliance should be placed on it (I am grateful to George Saliba for his comments on this passage of Vaṣṣaf).

50. Vaṣṣaf, *Tārīkh*, op. cit. (note 47), p. 384, ll. 10–12. Vaṣṣaf leaves the date at the end of this inscription incomplete, indicating that he may have been using a chancery copy that had been drawn up before it was put on the building (ibid., p. 384, l. 13).

51. The exact function of this institution has long been obscure, but a passage in an early sixteenth-century text shows unequivocally that it was used to accommodate visitors: 'In the Daru's-Siyada were a naqib, servants, and a cook to prepare food for visiting sayyids passing through' (Khvandamir, *Habibu's-siyar, Tome Three*, Central Asian Sources, vol. 1, trans. and ed. W. M. Thackston [Cambridge, MA, 1994], p. 187).

52. My list is a conflation of the two main sources: Vaṣṣaf, *Tārīkh*, op. cit. (note 47), pp. 382–3 and Rashid al-Dīn in Jahn (ed.), *Geschichte Ġāzān Ḫān's aus dem ta'rīḫ-i-mubārak-i-ġāzānī*, op. cit. (note 21), pp. 209–11.

53. For the concept, see G. Goodwin, 'Külliye', *Encyclopaedia of Islam*, vol. 5, Leiden, 1980, p. 366, although the author mostly restricts his analysis to Ottoman Turkey. The closest prototype to Shanb in terms of complexes would have been the Madrasah al Mustansiriyah in Baghdad (in Ilkhanid territory), which housed the four orthodox schools of law along with a bath, a hospital and dispensary, a dār al-hadīth, a dār al-qur'ān, and a dār al-kuttab: Gurgis Awad, 'Al Mustansiriyah College, Baghdad', *Sumer*, vol. 1/1, 1945, pp. 15–18, *idem*, 'Al-madrasa al mustansiriyya bi-Baghdad' (in Arabic), *Sumer*, vol. 1/1, 1945, pp. 86–96.

54. Aḥmad b. Ḥusayn b. 'Alī Kātib, ed. Īraj Afshār, Tehran, 1345/1966, p. 77.

55. On this see S. Blair, 'The Mongol Capital of Sulṭāniyya', *Iran*, vol. 24, 1986, pp. 139–51.

56. Khānbābā Bayānī (ed.), *Zayl-i jāmi' al-tavārīkh-i Rashīdī*, Tehran, 1350/1971, p. 68.

57. *Nuzhat al-qulūb*, op. cit. (note 19), text, p. 55, trans., p. 61.

58. D. P. Little, 'The Founding of Sulṭāniyya: A Mamlūk Version', *Iran*, vol. 16, 1978, p. 173.

59. Ruy Gonzalez de Clavijo, *Historia del Gran Tamorlan*, trans. G. le Strange as *Clavijo: Embassy to Tamerlane*, London, 1928, pp. 162–3.

60. As it happened, the largest dome chambers which Timur erected in Samarqand, those of the Gur-i Mir and the Friday mosque (also known as the mosque of Bībī Khānum), were smaller than that of Uljaytu.

61. The most convenient guide to this is S. Blair, 'Ilkhanid Architecture and Society: An Analysis of the Endowment Deed of the Rabʿ-i Rashīdī, *Iran*, vol. 22, 1984, pp. 67–90.

62. The background to this mission is explored in D. P. Little, 'Notes on Aitamiš, a Mongol Mamlūk', in U. Haarman and P. Bachmann (eds), *Die islamische Welt zwischen Mittelalter und Neuzeit, Festschrift für Hans Robert Roemer zum 65. Geburtstag*, Wiesbaden, 1979, pp. 387–401. I am most grateful to the author for sending me a copy of the passage of Badr al-Dīn al-ʿAynī's *ʿIqd al-jumān fī taʾrīkh ahl al-zamān*, Istanbul Ahmed III MS, which contains the passage of the *dawādār* in question (f. 358a). For a detailed analysis of this passage and of the complex of ʿAlishah, see Bernard O'Kane, 'Taj al-Din ʿAlishah: The Reconstruction of His Mosque Complex at Tabriz,' in *idem, Studies in Persian Architecture*, (Edinburgh, 2021), 616–36.

63. Abu'l-Qāsim ʿAbd Allāh b. Muḥammad al Qāshānī, *Tārīkh-i Ūljāytū*, ed. Mahin Hambly, Tehran, 1348/1969, pp. 87–8.

64. The arch at Ctesiphon is 25.63 m wide, 43.72 m deep (48.40 including the frontal screen) and 25.62 m high: F. Sarre and E. Herzfeld, *Archäologische Reise im Euphrat- und Tigris Gebiet*, Berlin, 1911–20, vol. 2, p. 74.

65. *Nuzhat al-qulūb*, op. cit. (note 19), text, p. 77, trans., p. 80. This did not prevent it from being used by Jānī Beg of the Golden Horde in 758H. as the place most suitable for victory prayers to be offered: Ḥāfiẓ Abrū, *Zayl-i jāmiʿ al-tavārīkh*, op. cit. (note 56), p. 236. In technological terms, the increase in size that it represented did not demand any new techniques. Although the trend in Ilkhanid architecture was for structures to become more slender with less supporting masonry, the architect here relied on sheer mass, with walls 10.4 m thick (cf. the 7.32 m walls of the Iwan Kisra: Sarre and Herzfeld, *Archäologische Reise*, op. cit. (note 64), vol. 2, p. 71.

66. The comparison of monuments with the Iwan Kisra had become a cliché by this period: for example, when Maqrīzī quotes a chain of authorities to suggest that one of the palaces of the Fatimids in Cairo was built to be as large as the Iwan Kisra: Maqrīzī, *Khiṭaṭ*, op. cit. (note 4), vol. 1, p. 366, quoting Ibn Saʿīd (thirteenth century), on the authority of Bayhaqī (second half of the twelfth century). The fame of the monument as a symbol of decaying greatness was further increased by it being the subject of two well-known poems, the *Iwān Kisrā* of al Buhturī (d. 897) in Arabic and the *Madāin Qasīda* of Khāqānī Sharvānī (d. 1202) in Persian (see J. W. Clinton, 'The Madaen Qasida of Xaqani Sharvāni, I', *Edebiyat*, vol. 1, 1976, pp. 153–70, *idem*, 'The Madāen Qasida of Xāqāni Sharvāni, II: Xāqāni and al-Buhturī', *Edebiyat*, vol. 2, 1977, pp. 191–206.

67. *Khiṭaṭ*, op. cit. (note 4), vol. 2, p. 316, ll. 11–12. It is, in fact, far from square and is much smaller than the Iwan Kisra (see note 61 above), measuring some 26.5×21.25 m.

68. Ibid., vol. 2, p. 316, ll. 9–10.

69. Ibid., vol. 2, p. 316, ll. 7–8.

70. P. Ravaisse (ed.), *Zubdat kashf al-mamālik fī bayān al-ṭuruq wa'l-masālik*, Paris, 1984, p. 31, trans J.-M. Venture de Paris, Beirut, 1950,

pp. 47–8. The passage is also discussed in M. Herz, *La mosquée du Sultan Hassan au Caire*, Cairo, 1899, p. 16; Rabbat 'The Iwans', p. 6; M. Meinecke, *Die mamlukische Architektur in Ägypten und Syrien (Abhandlungen des Deutschen Archäologischen fostituts Kairo, Islamische Reihe*, vol. 5), 2 vols, Glückstadt, 1992, vol. 1, p. 116. Later Mamluk historians also repeat the comparison with the Iwan Kisra. Ibn Taghrībirdī merely mentions that its *īwān* was equal or greater in length to that of the Iwan Kisra: *Al-Nujūm al-zāhira fī mulūk Miṣr wa'l-Qāhira*, 16 vols, Cairo, 1929–72, vol. 10; p. 306. Ibn Iyās conflates the accounts of al-Maqrīzī and al-Ẓāhirī; he notes that the Iwan Kisra was measured, but says that it was made 5 cubits bigger: Muḥammad Muṣṭafā (ed.), *Bada'i' al-zuhūr fī waqā'i' al-duhūr*, Cairo, 1960–75, vol. 1, part 1, pp. 559–60.

71. See note 64 above.

72. Blair, 'Ilkhanid Architecture and Society', *idem*, 'The Mongol Capital of Sulṭāniyya', p. 148.

73. O. Grabar, 'Reflections on Mamluk Art', *Muqarnas*, vol. 2, 1984, p. 9. Elsewhere, Grabar claimed that the building's 'very magnitude and monumentality attest to the growing strength of the folk tradition in relation to that of the aristocracy': 'Architecture and Art', in J. R. Hayes (ed.), *The Genius of Arab Civilization*, 2nd edn, Cambridge, MA, 1983, p. 108. Grabar supports this argument by stating that Sultan Hasan was a weak ruler, at a time when the Mamluks had shaky control and the urban bourgeoisie had considerable bureaucratic and financial power within the state and by noting the modern folk piety which has woven legends around Sultan Hasan. But Sultan Ḥassan was quite capable of realising *his* ambitions in building his monumental complex, as evidenced by his stated desire to eclipse the Iwan Kisra. He, and certainly not the 'urban bourgeoisie', was also very much in charge of the state's financial apparatus, reducing the Mamluks' pay and siphoning off money from the state treasury and into the crown estates in order to support his building activities, a move which unsurprisingly caused resentment and contributed to his downfall: R. Irwin, *The Middle East in the Middle Ages, The Early Mamluk Sultanate 1250–1382*, Beckenham, 1986, p. 143. If, however, by the 'urban bourgeoisie' Grabar means the *awlād al-nās* who, unusually, held governorships and high amirial positions at the time, this is because they received their appointments from Sultan Hasan himself, another move which aroused the resentment of the Mamluks: P. M. Holt, *The Age of the Crusades: The Near East from the Eleventh Century to 1517*, London and New York, 1986, pp. 124–5.

74. N. Rabbat, 'Mamluk Throne Halls: Qubba or Iwān', *Arts Orientalis*, vol. 23, 1993, pp. 208–9. One of the connotations of *īwān* in medieval Persian sources, such as the *Shahnāma*, was still that of a palace: A. S. Melikian Chirvani, 'Le Livre des Rois, miroir du destin. II – Takht-i Soleyman et la symbolique du ShāhNăme', *Studia Iranica*, vol. 29, 1991, pp. 44, 51.

75. N.O. Rabbat, *The Citadel of Cairo: A New Interpretation of Royal Mamluk Architecture*, Leiden, 1995, pp. 128–9, 255–6. However, it should also be pointed out that the use of the term *īwān* for this building is unique in Mamluk sources, which otherwise almost invariably use the word in the sense of a hall which is open on one side: M. M. Amin and Laila A. Ibrahim, *Architectural Terms in*

Mamluk Documents (648–923H) (1250–1517), Cairo, 1990, p. 17. A rare exception is the madrasa which was part of the complex of al Ashraf Barsbay in the part of Cairo now known as the northern cemetery; there the *waqfiyya* used the term *īwān*s to describe the raised prayer areas beside the mausoleum which are fronted by an arcade of three arches: L. Fernandez, 'Three Sūfī Foundations in a 15th Century Waqfiyya', *Annales Islamologiques*, vol. 17, 1981, p. 145.

76. Rabbat, 'Mamluk Throne Halls', op. cit. (note 74), p. 209. Al-Nāṣir's father, Qalā'ūn, had earlier used a Syrian model for the qibla *īwān* of his madrasa, and more specifically an Umayyad model (the Dome of the Rock) for his mausoleum: ibid., p. 207.

77. The dome chamber of the *maqṣūra* of the mosque of Baybars had purposely been built to rival that of Imam al-Shafi'ī: Maqrīzī, *Khiṭat*, op. cit. (note 4), vol. 2, p. 300, I. 5.

78. P. Casanova, 'Histoire et description de la citadelle du Caire', in *Mémoires de la Mission Archéologiques Française au Caire*, vol. 6, 1894–7, pp. 708–9; Rabbat, *The Citadel of Cairo*, op. cit. (note 75), p. 246.

79. Rabbat, *The Citadel of Cairo*, pp. 199–213.

80. This structure was so-called because a stable had been in existence on the site before the palace was built: Rabbat, ibid., p. 2124, n. 74; he has shown that in other Mamluk palaces the stables were not in the vaulted space under the upper floor *qā'a*, but were in another separate unit: ibid., p. 246.

81. J.-C. Garcin, B. Maury, J. Revault and M. Zakariya, *Palais et maisons du Caire, vol. 1, Époque mamelouke (XIIIe–XVIe siècles)*, Paris, 1982, fig. 1. Despite the caption to that effect, the portal was not built in two parts, with Yashbak responsible for the outer section. The inscription which goes round the outer and inner sections shows two styles of carving; the second, beginning halfway along the left face of the outer part, is shallower than the first. This second part was evidently commissioned by Yashbak to replace the original when he occupied the palace in the fifteenth century: see H. Roe, *The Baḥrī Monumental Mamluk Entrances of Cairo. A Survey and Analysis of Intra Muros Portals 648–784/1250–1382*, MA thesis, The American University in Cairo, 1979, pp. 114–15. On stylistic grounds also, the *muqarnas* dome of the outer section is much closer to known early fourteenth-century examples than to any from the fifteenth century, as has been pointed out by Meinecke, *Die mamlukische Architektur*, op. cit. (note 70), pp. 92–5.

82. Garcin et al., *Palais et maisons*, op. cit. (note 81) figs 35–7.

83. *Travels*, op. cit. (note 8), vol. 1, p. 43.

84. D. Ayalon, 'The Expansion and Decline of Cairo under the Mamluks and Its Background', in R. Curiel and R. Gyselen (eds), *Itinéraires d'Orient: hommages à Claude Cahen (Res Orientales*, vol. 6), Bures-sur-Yvette, 1994, pp. 14–16; A. Levanoni, 'The Mamluk Conception of the Sultanate', *International Journal of Middle East Studies*, vol. 26, 1994, pp. 383, 391 n. 85.

85. 'The Development of the Illustrated Book in Iran', *Muqarnas*, vol. 10, 1993, pp. 266–74.

86. See O. Grabar and S. Blair, *Epic Images and Contemporary History: The Illustrations of the Great Mongol Shāhnāma*, Chicago, 1980, chap. 2. Two other scholars, Robert Hillenbrand and Abolala Soudavar, have also underlined this theme in recent public lectures.

87. Blair and Bloom, *Art and Architecture of Islam*, op. cit. (note 26), p. 30. Supporting their theory for the rhetorical use of such manuscripts, however, is the fact that later *Shahnama* manuscripts, such as that of Baysunghur, have had the illustrations selected to reflect the circumstances of the patron: ibid., p. 59.

88. D. James, *Qur'āns of the Mamluks*, London, 1988, cat. no. 34. This is surpassed only by the Timurid example with a page size of 177 × 101 cm: T. W. Lentz and G. D. Lowry, *Timur and the Princely Vision: Persian Art and Culture in the Fifteenth Century*, Los Angeles and Washington, DC, 1989, cat. no. 6; Blair and Bloom, *Art and Architecture of Islam*, op. cit. (note 26), p. 57. Despite the presence of marginal notations mentioning Timur's grandson Baysunghur, there is still uncertainty about the patron of this Quran. A compelling case can be made for Timur, who was no slouch when it came to equating size with imperial might. The increase in paper sizes has also been commented on recently by J. Bloom: 'The Role of Paper in Fourteenth-Century Art and Architecture', symposium on *The Art of the Mongols*, Edinburgh, August 1995. It is not clear whether any technical innovation, such as larger moulds, was responsible for the consistently larger paper used at the time, rather than it simply reflecting imperial aspirations. Full-size (*Baghdādī*) sheets seem to have been known from several centuries earlier (G. Bosch, J. Carswell, G. Petherbridge, *Islamic Bindings and Bookmaking*, Chicago, 1981, p. 30), so the latter explanation may still be valid.

89. *Qur'āns of the Mamlūks*, op. cit. (note 88), pp. 103, 135.

90. Ibid., cat. nos 13–17; for the Uljaytu Quran which reached Cairo see ibid., cat. no. 45.

91. Nothing similar to the Mamluk *kursī* has survived from Ilkhanid Iran, but perhaps the short minbars (*manābir-i mukhtaṣar*) on which readers of the Quran sat at the tomb of Rashid al-Dīn (Blair, 'llkhanid Architecture and Society', op. cit. [note 61], p. 81) were comparable.

92. For the doors see H. Batanouni, 'Catalogue of Mamluk Doors with Metal Revetments', MA thesis, The American University in Cairo, 1975; for the glass lamps see G. Wier, *Catalogue général du musée arabe du Caire, Lampes et bouteilles en verre émaillé*, Cairo, 1929; for the metal lamps, idem, *Catalogue général du musée arabe du Caire, Objets en cuivre*, Cairo, 1932), pp. 1–12, 28–51 and pls VII–XXIII. A monograph on Mamluk metal lamps by Doris Behrens-Abouseif is in production.

93. Wier, *Objets en Cuivre*, op. cit. (note 92), pl. XII.

94. Maqrīzī, *Khiṭat*, op. cit. (note 4), vol. 2, p. 329.

95. The lamp and candlesticks are to be seen in 'The Bier of Alexander', B. Gray, *Persian Painting*, Geneva, 1961, p. 32. It has been argued that the manuscript is indeed a most useful guide to contemporary material culture: R. Hillenbrand, Kevorkian Lectures, New York, February 1993.

96. These characteristics are noted by D. O. Morgan, 'Persian Historians and the Mongols', in D. O. Morgan (ed.), *Medieval Historical Writing in the Christian and Islamic Worlds*, London, 1982, pp. 109–24. In addition to the unusual bulk of Ilkhanid historical writings, he also notes the wide-ranging interests of the historians.

97. The best guide to the earlier period is D. P. Little, *An Introduction to Mamluk Historiography (Freiburger lslarnstudien, vol. 2)*, Wiesbaden,

1970; for the fifteenth century see C. Petry, 'Scholastic Stasis in Medieval Islam Reconsidered: Mamluk Patronage in Cairo', *Poetics Today*, vol. 14/2, 1993, pp. 323–48.

98. L. Ibrahim and B. O'Kane, 'The Madrasa of Badr al-Dīn al-'Aynī and Its Tiled Miḥrāb', *Annales Islamologiques*, vol. 24, 1988, p. 254.

99. See Irwin, *Early Mamluk Sultanate*, op. cit. (note 73), pp. 43–4. While lbn Baṭṭūṭa, like most of his countrymen, understood it to be a pretence, he notes that Ghiyāth al-Dīn Tughluq sought and obtained a decree of appointment from the Abbasid caliph in Cairo: *Travels*, op. cit. (note 8), vol. 3, p. 674.

100. For example, descriptions of the caravansaray of Jalāl al-Dīn Qarāṭāy in Anatolia by al-'Umarī and Qalqashandī, and the notation which must have existed of an Anatolian Seljuk façade for it to be copied in the main portal of the complex of Sultan Ḥasan in Cairo: see J. M. Rogers, 'Evidence for Mamliik–Mongol Relations, 1260–1360', in A. Raymond, M. Rogers and M. Wahba (eds), *Colloque international sur l'histoire du Caire*, Cairo, n.d., p. 400.

101. Ibid., Persian historians did not reciprocate. The reasons may lie in their panegyric nature. They give extensive accounts of royal foundations, e.g. Shanb and Sultaniyya, but not those of viziers, such as the Rashidiyya, which would be virtually unknown had its *waqfiyya* not survived, or the complex of 'Alīshāh in Tabriz.

102. Our view of the monumental is coloured by the surviving buildings; the palaces of the Mamluks on the citadel and of the Mongols in Sutaniyya and Tabriz would have provided examples of grandeur equal to the religious buildings. Though they have not survived, the description of their tents show that they could be equally monumental; for Mongol examples, see B. O'Kane, 'From Tents to Pavilions: Royal Mobility and Persian Palace Design', *Arts Orientalis*, vol. 23, 1993, pp. 249–50. For the Mamluk sultan's celebration of the Prophet's birthday in Cairo 300–500 men were needed to erect a tent consisting of a dome which surmounted four halls: K. Stowasser, 'Manners and Customs at the Mamluk Court', *Muqarnas*, vol. 2, 1984, p. 17.

103. The conception of domination by overpowering monuments must also have been present, whatever the faith of the population. The Tughluqs, for instance, had been Muslim for some time, while their subject population was largely non-Muslim. It could be argued that they had a similar agenda of monumentality in their architectural campaigns, even if by the standards of the Mamluks and Mongols they were found lacking. In terms of race, culture and language the Tughluqs were also less differentiated from their predecessors than the Mamluks and Mongols; their desire for continuity may be seen in the decision of Ghiyath al-Din Muhammad to respect the immediate predecessor of the Tughluqs, the Khalji sultan Qutb al-Din Mubarak Shah, by constructing a mausoleum for him (see note 39 above).

CHAPTER SIXTEEN

The Madrasa of Badr al-Dīn al-ʿAynī and its Tiled Miḥrāb (with Laila Ibrahim)*

AS A GLANCE at the list of Mamluk monuments built in Cairo will confirm, the most frequent patrons other than the ruling Mamluk hierarchy and its amirs were *qāḍī*s. This is a reflection of the practice whereby the chief *qāḍī*s frequently held other governmental administrative posts which contributed to their wealth and influence. As examples one can point to Qāḍī ʿAbd al-Bāsit (d. 854/1450), who erected buildings in Cairo, Damascus, Jerusalem, Mecca and Medina, and held several positions before his promotion to controller of the army (*nāẓir ǧayš*),[1] or Qāḍī Yaḥyā (d. 874/1469), the builder of three mosques in Cairo, who rose to the eminence of major-domo (*ustādār*), but paid for this eminence with his life at the hands of Qayt Bāy.[2]

The builder of the present monument, Maḥmūd b. Aḥmad Badr al-Dīn al-ʿAynī or al-ʿAyntābī, in addition to being chief judge (*qāḍī al-quḍāt*) for several years, also frequently held the lucrative posts of controller of trust properties (*nāẓir al-aḥbās*) and market inspector (*muḥtasib*). It is thus surprising that this is the only structure which he is known to have built.

ʿAyntāb, Al-ʿAynī's birthplace in 762/1361, is the modern Gaziantep, located some 90 km north of Aleppo. After studying religious sciences there and in Aleppo and Damascus, his first stay in Cairo was in 788/1386–1387 as a Sufi in the newly built complex of Barqūq.[3] He went back destitute to ʿAyntāb shortly thereafter, but returned to Cairo to continue religious studies and was appointed *muḥtasib* in 801 H., displacing the historian Maqrīzī in the process.[4] Three years later he was also made *nāẓir al-aḥbās*.[5] Although regularly dismissed and reappointed to these positions in the succeeding years, his continuing favour was manifested in his appointments as teacher of *ḥadīṯ* in Sultan al-Muʾayyad's complex at Bāb Zuwayla from its foundation (819/1416), and from 829/1426 as chief judge

Bernard O'Kane (1988), with Laila Ibrahim, 'The Madrasa of Badr al-Dīn al-ʿAynī and its Tiled Miḥrāb', *Annales Islamologiques* 24, 253–68.
* An earlier version of this piece was delivered at the 8th International Congress of Turkish Art, Cairo, September 1987.

(qāḍī al-quḍāt) of the Ḥanafīs.[6] In the meanwhile the opportunity had arisen for him to show his diplomatic skills: the continuing weaknesses in Anatolia after Tīmūr's passage in the early fifteenth-century were finally exploited by the Mamluks in a push into Karamanid territory, their capital Laranda (the modern Karaman) being occupied in 822/1418–19.[7] In 823/1420–1 al-ʿAynī was sent into the newly occupied territory in order to take the oaths of allegiance from the commanders of the fortresses there.[8] Undoubtedly a strong reason for the choice of al-ʿAynī for this task must have been his fluency in Turkish. This was evidently sufficiently close to the Central Asian dialects spoken by the Mamluks (who were frequently ignorant of Arabic[9]) to be readily understood by them, since in the reigns of al-Ẓāhir Ṭaṭar and al-Ašraf Barsbāy he used to personally translate histories and other texts for the Sultan from Arabic to Turkish to the extent that the latter claimed that his knowledge of Islam would have been faulty were it not for al-ʿAynī.[10] His knowledge of Turkish too must have been a strong factor in Barsbāy's choice of him as a companion for a trip to Amid (modern Diyarbakr).[11]

Al-ʿAynī's complex is not mentioned by Maqrīzī in his Ḫiṭaṭ, undoubtedly on account of the enmity between the two.[12] There were two reasons for this, firstly al-ʿAynī's displacement of Maqrīzī from the post of muḥtasib, mentioned above, and secondly his gaining of the unofficial but prestigious position of court historian. The reason for his success in the latter sphere was also undoubtedly due to his native knowledge of Turkish, of which Maqrīzī was ignorant.[13] It was thus to al-ʿAynī's advantage to stress his associations with his homeland, and we shall see that this is reflected in the decoration of his madrasa. When he reached eighty-eight (in 853/1449) he was understandably removed from the office of controller or trust properties (nāẓir al-aḥbās) on account of his age.[14] He died in 855/1451 and was buried in his madrasa after funerary prayers were held in the nearby al-Azhar – ironically, since he had established a ḫuṭba in his own madrasa, claiming that one should not attend al-Azhar on account of its Shīʿī foundation.[15]

Al-Ṣayrafī mentions that al-ʿAynī's complex near al-Azhar was finished in Ramaḍān 814/December 1411–January 1412, and that the complex was near to both al-ʿAynī's house and the house of Ibn al-Gannām.[16] Across the street from al-ʿAynī's madrasa on the east[17] is a medieval residence which is known as Manzil Zaynab Ḥātūn. On the north-east side of the latter is the only remaining section of the house of Ibn al-Gannām, separated from Zaynab Ḥātūn by a distance of, at present, not more than twelve metres. The Manzil Zaynab Ḥātūn is largely Ottoman, but it has a fifteenth-century Mamluk qāʿa on an upper floor.[18] It has been suggested that the builder of this was Miṭqāl al-Sūdūni (d. 895/1490), who bought and restored a house near al-Azhar.[19] Given that it fits al-Sayrafī's mention of its location exactly, the possibility should be considered that the Zaynab Ḥātūn

residence was erected on that of al-ʿAynī's, and that the *qāʿa* was built by al-ʿAynī, whether or not it was later altered by Miṭqāl al-Sūdūnī.[20]

The madrasa of al-ʿAynī

The exterior

The building has two façades, each of which is articulated by recessed window niches topped by two tiers of stalactites, with trefoil crenellations above. The main entrance portal on the east façade is vaulted with a tri-lobed arch containing four rows of stalactites leading to a shallow semi-dome (Figure 16.1). The stonework below this area has been plastered over recently. While the stone lintel is original, the Quranic inscription set in cartouches on either side of the portal below it seems a later reworking.

A minaret rises from the façade to the right of the entrance. The solid mass of masonry below this point on the ground plan (Figure 16.2) indicates that the complex was always intended to have a minaret here. The relaying of the roof has made it impossible to determine whether

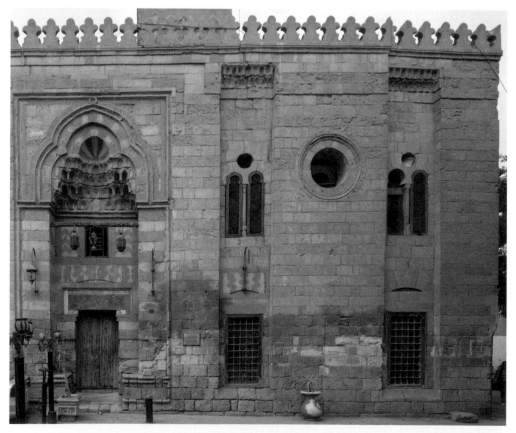

Figure 16.1 *Madrasa of al-ʿAynī: east façade*

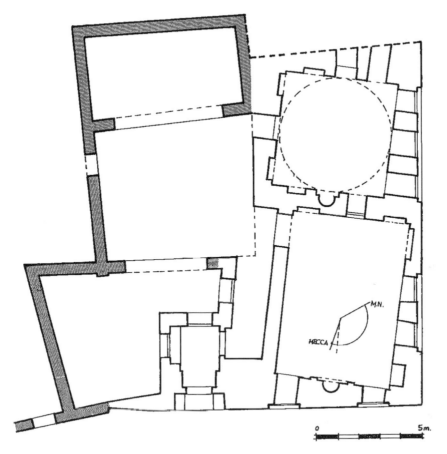

Figure 16.2 *Madrasa of al-ʿAyni: ground plan (after Kessler); hatching indicates later work*

the present base is part of the original, but the flaccid detailing above points to an Ottoman pastiche of Mamluk style.[21]

The vestibule

The frieze immediately below the ceiling of the vestibule contains the foundation inscription painted on wood. In its present state it has been rendered almost illegible through splashing from the repainting of the lower walls; the present reading of Laila Ibrahim was recorded some decades ago before this happened. The foundation inscription is followed by extracts from Qurʾān XXXIX/73 and VII/43 as follows:[22]

أمر بتجديد هذه المدرسة السعيدة . . . العبد الفقير إلى الله تعالى الشيخ أبو محمد محمود بن أحمد العيني – الحنفي قاضي (القضاة)
الفاضل وذلك بتاريخ الثالث والعشرين من شهر // ربيع الاخر سنة احد وثلاثين . . . // وصلى الله عليه وسلم ورضي الله
عن اصحاب رسول الله . . . حسب الله ونعم الوكيل

بسم الله الرحمن الرحيم ادخلوها خالدين // الحمد لله الذي هدانا لهذا وما كنا لنهتدي لولا ان هدانا الله

Ordered the renovation of this fortunate madrasa the poor slave of God most high, Abū Muḥammad Maḥmūd b. Aḥmad al-ʿAynī al-ḥanafī the eminent chief judge ... and that in the month of Rabīʿ II year (eight hundred) and thirty one/March-April 1428 ... may God pray for him and the peace and contentment of God on the companions of the Prophet ... the love and favour of God ... basmala, so enter ye (the garden of delight) to dwell therein. The praise to God, who has guided us to this. We could not truly have been led aright if God had not guided us.

The wooden ceiling of the vestibule is decorated with a series of intersecting eight-petalled rosettes.[23] Within four of these are circular shields divided into two with a penbox in the upper field and what seems to be a vase flanked by two six-petalled rosettes (Figure 16.3).[24] The vase is of an unusual shape, having a small ring above the foot and curving inwards to a narrow neck before widening sharply at the top. The penbox is well-known as the heraldic emblem of the secretary (dawādār), although in the later Mamluk period it was consistently used in the middle of a three-part field, sometimes, as here, with other decorative devices added, for non-Mamluk dignitaries such as qāḍī-s.[25] According to Qalqašandī, however, the penbox of the qāḍī al-quḍāh was more magnificent than that of other office holders, and was placed upon a special stand.[26] This account is echoed by Maqrīzī, who mentions that he was the most important of the non-military office holders (arbāb al-ʿamāʾim wa arbāb al-aqlām), and that his penbox was inlaid with silver from the citadel treasury, had a bearer who was paid a monthly salary by the government, and that it had a special stand.[27] While there is no indication of a stand in al-ʿAynī's emblem, one may be depicted in another artifact of a Marnluk qāḍi, an underglaze-painted blue and white tile in the Islamic Museum in Cairo (Figure 16.4).[29] This has a vase which is of the same unusual shape as that of al-ʿAynī[28], underneath which is a kūrsī, although the presence of a comb to one side is a puzzling feature. The two grilled grave surrounds which flank the vase are illustrations of the graves (qubūr) mentioned in the inscription above which stresses the transitoriness of life.[30]

The plan

The vestibule leads with two turns to a courtyard flanked by two īwāns on one side, and a rectangular room with a miḥrāb on the other. A square mausoleum occupies the north corner.

As a glance at the plan (Figure 16.2) will affirm, there is a strong contrast between the mausoleum and its adjoining prayer hall, and the courtyard with two īwāns. This is manifested clearly in the care with which the mausoleum and the prayer hall are aligned to the qibla, with windows and recesses of varying widths compensating

Figure 16.3 *Madrasa of al-ʿAynī: ceiling of vestibule*

for the slightly different street axis, while the courtyard and *īwān*s are aligned to neither of these directions. Moreover, the *īwān*s are of differing width and their centres are not on the same axis. They have obviously been added at some later stage. They are decorated with a simple neo-Mamluk moulding which could date any time from the

sixteenth to the early twentieth centuries. The entrance vestibule with its inscription is clearly original, but to the left of the main entrance portal the wall changes direction noticeably. Although at this point the upper courses of stone are keyed together, a cursory examination of the lower courses shows a clear break in bond, indicating that the wall beyond this point was added on at some stage. Exactly when this occurred is difficult to say, as the added section is, like the *iwān*s, in the form of a Mamluk pastiche. From Figure 16.2 it can also be seen that the break in bond of the façade coincides with a line extrapolated from the side of the present courtyard, strongly suggesting that this line formed the original boundary of the complex. If this section was added on, what did the original building consist of? The remaining space may have contained a small courtyard with one *iwān*, similar, for instance, to those of the madrasas of the complex of Sultan Ḥasan, although unlike them the *iwān* here could only have been on the side opposite the *qibla*. The area further south could have contained, as today, space for ablutions.[31] There would have been an awkward remaining space to the south of the vestibule, although it is possible that a common element of contemporary complexes, the *sabīl-kuttāb*, could have fitted here. The natural place for this on the plan would have been the space to the left of the portal. There are signs here of the wall having been altered, particularly towards the top, although it must be admitted that the seemingly original lower section shows no sign of having accommodated a *sabīl*.

The resulting plan would have been an idiosyncratic one – no other madrasa complex has a plan which is exactly comparable, with a vestibule and corridor leading to a small rectangular prayer hall, the main room of the madrasa, on one side, and to a courtyard on the other. But Cairo is full of contemporary buildings whose chief characteristic is the ingenuity with which they have been fitted into the irregular spaces which were the only building land available in the crowded medieval city.[32] These demanded individual solutions to individual building problems, so it need be no surprise that the complex of al-ʿAynî is unlike any other. However, its siting of the mausoleum on the corner of the building, where it was visible on two sides, is typical of earlier funerary architecture within the city in its maximum exposure of the mausoleum to the potential *baraka* of the prayers of passers-by.

The mausoleum

Within the mausoleum itself, the only part which conserves any original decoration is the wooden *muqarnas* of the zone of transition. The three tiers which encircle the base are extended to five at the corners, forming *muqarnas* pendentives (Figure 16.5). These have the remains of gilded arabesques and foliate scrolls against a dark

(probably originally dark-blue) background (Figure 16.6). In a notice of al-Muʾayyad's death, al-Ṣayrafī gives a list of his constructions, and mentions the gilded dome which he built over the mausoleum of al-ʿAynī's madrasa, of which (meaning the dome) there was not the like.[33] Despite the latter qualification, it would be unprecedented for a dome to be gilded on the exterior in Mamluk Cairo, so it is probably to the painting on the *muqarnas* (or possibly to now vanished painting on the interior of the itself) that this passage refers. In

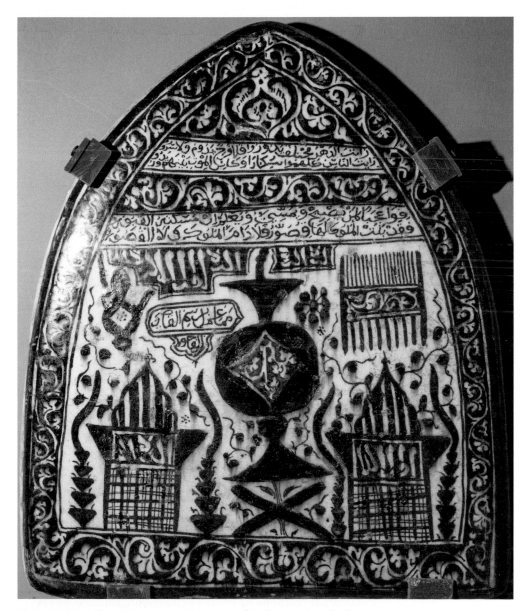

Figure 16.4 *Islamic Museum, Cairo: underglaze-painted tile*

Figure 16.5 *Madrasa of al-ʿAynī: zone of transition of mausoleum*

addition to the founder, Šaiḫ Aḥmad al-Qasṭalānī was buried in the mausoleum in 913/1517.[34]

The Miḥrāb (Figures 16.7–16.10)

The glory of the complex was, until recently, the tiled *miḥrāb* of the prayer hall adjacent to the dome chamber.[35] This had already gained some fame in the nineteenth century after its copious illustration by Bourgoin in his *Précis de l'art arabe*.[36] Bourgoin in his notes to the plates did not suggest any possible date for the *miḥrāb*, but the next person to comment on it, Herz Bey, regarded it as an addition to the original at an unspecified time in Maghribī or Spanish style.[37] This is perhaps what influenced Prost in his monograph on Egyptian tile revetment to classify it as Maghribi work of the eighteenth

Figure 16.6 *Madrasa of al-ʿAynī: detail of zone of transition of mausoleum*

century,[38] an attribution which has remained uncontested up to the present.

This *miḥrāb* has many features which show that it is foreign to the artistic traditions of Cairo. First is the technique, one of tile-mosaic in a limited range of colours, white, and light-and dark-blue.

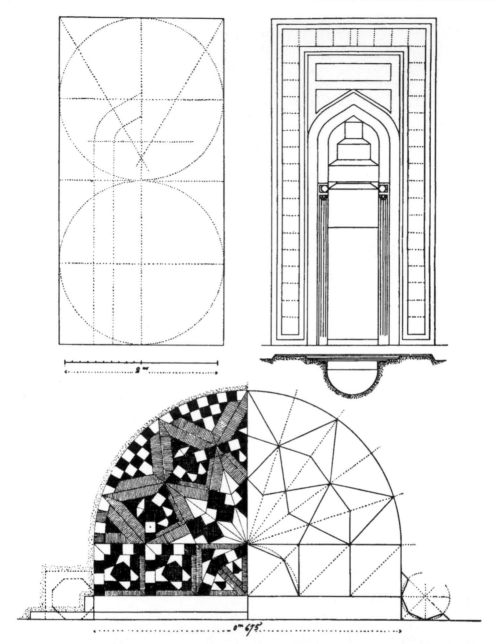

Figure 16.7 *Madrasa of al-ʿAynī: plan and elevation of* miḥrāb *(after Bourgoin)*

Secondly, there is the form of the stalactite conch of the *miḥrāb*, consisting of rows of stalactites which regularly decrease at the top to a single stalactite, unlike the more usual Cairene practice of having a larger semi-dome taking the place of the last several rows. Thirdly is the placing of the major inscription, just above the arch instead of following the rectangular frame, and fourthly is

Figure 16.8 *Madrasa of al-ʿAynī: square Kufic of* miḥrāb *(after Bourgoin)*

Figure 16.9 *Madrasa of al-'Aynī: prayer hall, present state*

the content of the inscription, a spurious *ḥadīt* instead of the more usual Quranic excerpt. A fifth oddity is the style of the letters of the inscription, with the teeth of the *sīn* of *sā'a* completely flattened. Sixth, clearly visible in earlier drawing of the lower concave niche of the *miḥrāb* (Figure 16.8), its use of a repeated motif of *Allāh* in square Kufic. Although square Kufic is used occasionally in Mamluk architecture,[39] it is entirely absent from other Cairene *miḥrāb*s. The reciprocal design of the square Kufic (Figure 16.8) caught the attention of Gombrich, and one can do no better than to repeat his words: 'it shows the letters for *Allah* arranged in such a way that they appear both as figure and ground, as if to proclaim that God is everywhere. There is a touch of sublimity here which may remind one of the mighty canons by a master of church music.'[40]

The use of tiled revetments in Egyptian architecture was known in the Pharaonic period,[41] and there are several earlier Mamluk examples of it known. What is surprising is not that it appears, but that it does not appear more often. In Iran and Anatolia tilework had been featured prominently on buildings from the end of the twelfth

Figure 16.10 *Madrasa of al ʿAynī: original* miḥrāb

century onwards, but it somehow failed to capture the imagination of
the patrons or of the public in Egypt. This is all the more surprising
when the flourishing state of the contemporary local pottery industry
is considered, showing that lack of technique was hardly a factor.

The closest work in Egypt to that of our *miḥrāb* is that which
was undertaken by the Tabrīz workshop in the second quarter of the
fourteenth century.[42] Direct evidence for its work comes in Maqrīzī's
statement that the architect (*bannā'*) of the *ǧāmi'* of Qawsūn was a
Tabrīzī who built its minarets in the style of those of the Mosque of
'Alī Šah in Tabrīz.[43] These are likely to have been very similar to the
minarets of the Mosque of al-Nāṣir Muḥammad in the citadel, whose
tile-mosaic summits are indeed like contemporary Il-Ḫānid work.[44]
Full tile-mosaic is also seen in the inscriptions on the drums of the
mausoleums of Amīr Aṣlam al-Silāḥdār (745–6/1344–5) and Ḥawand
Tuġāy (749/1348).[45] The work of this school, however, seems to have
died out with the complex of Sultan Ḥasan (757–64/1356–62), where
the use of tile is restricted to strips outlining the hexagons of the
tympanum of a window.[46]

In the Burǧī Mamlūk period colour was achieved by more tradi-
tional methods of marble mosaic and glass paste, methods which had
remained popular in Mamluk Cairo since their first use in the complex
of Qalāwūn (683–4/1284–5). For example, the complex of al-Mu'ayyad
at Bāb Zuwayla (818–23/1415–20) has a *miḥrāb* which uses light-blue
faience extensively, but it is the solid faience which had been popular
since Pharaonic times, not the thin surface glaze of the tiles of al-'Aynī.
The strapwork which frames the entrance to the complex has large
insets of turquoise and red glass paste, while a variation of this pattern
with turquoise insets is found in two panels to either side of the window
at the back of the entrance portal of his hospital (821–3/1418–20).[47]
There are, however, two rectangular panels of square Kufic on the
sides of this portal which have what seem to be blue tiles inset into
the stone. Close examination of these has not been possible, but the
possibility exists that rather than being glass paste, they have a surface
glaze like the tiles of al-'Aynī. In several other square panels on the
portal, what now looks like a brick-like substance, has been inset into
the stone to make interlacing patterns. The colour of these is now
almost indistinguishable from the surrounding stone, but the possibil-
ity can be raised that the insets were also glazed originally. Although
the resulting effect would still have been far from the tile mosaic of
al-'Aynī, it represents the closest parallel to it in Cairo.

Given the obvious need to look for parallels to al-'Aynī's *miḥrāb*
outside Egypt, where else in the Islamic world was glazed tilework
used in the early fifteenth century?

There are three main traditions which can be compared, Iranian,
Maghribī and Anatolian.

Contemporary Maghribī work can certainly be ruled out as an
influence. The colour scheme of tile-mosaic there is very different,

consisting mainly of green, brown, black and white. The arch pro-
files are usually rounded and horseshoe-shaped, unlike the stalac-
tite niche of al-ʿAynī. Finally, tile-mosaic almost never appears on
*miḥrāb*s there, painted stucco being the norm.

Iranian tilework had developed the techniques which are seen in
the *miḥrāb* of al-ʿAynī in the early fourteenth century; by the early
fifteenth century different styles were in fashion. In addition to occa-
sional uses of underglaze-painted and *cuerda seca* tiles, tile-mosaic
with arabesque and floral, as well as geometric patterns and in a much
greater range of colours than the blue and white of al-ʿAynī, was the
norm.[48] The large tiles in square Kufic (in bannāʾī-technique[49]) in
al-ʿAynī's *miḥrāb* are usually found in Iranian tilework only on exte-
riors, as their patterns have maximum impact when viewed from a
distance.

The two main powers in contemporary Anatolia were the
Ottomans and the Karamanids. The early fourteenth century had
seen an importation of Iranian-style tile-mosaic and *cuerda seca*
in the Yeşil Cami in Bursa (822–7/1419–24), while the contempo-
rary Muradiye (824/1421) in Edirne featured chinoiserie underglaze-
painted tiles. Probably the finest example of Karamanid tilework is
also *cuerda seca* technique: the *miḥrāb* from the Imaret of Ibrahim
Bey in Karaman (836/1432).[50]

The closest examples of tilework and tiled *miḥrāb*s to al-ʿAynī
are indeed in Anatolia, but they date mostly from the Seljuk period.
Over a dozen are known, in varying states of preservation.[51] All of
them share at least three features with al-ʿAynī's *miḥrāb*: the tech-
nique of tile-mosaic, the colour scheme of white and two shades
of blue, and the use of regularly decreasing tiers of stalactites. The
latter are mostly set within a rectangular surround, although two
examples are framed by a four-centered arch like that of al-ʿAynī
(Figure 16.11).[52] Several also have analogues to al-ʿAynī's angular
engaged columns.[53] The fragmentary remains of a tiled *miḥrāb* from
the madrasa of Emir Mūsā in Karaman (c. 1350) show stalactites of
identical colour and design to many Seljuk examples and indicate
that the same decorative tradition was still being carried on in
the fourteenth century.[54] Even though the Karamanids used *cuerda
seca* for their most prestigious projects, their appreciation of the
earlier style is shown by the addition, probably in the early fifteenth
century, of some underglaze-painted tiles to the Seljuk *miḥrāb* of
the Kazimkarabekir Ulu Cami.[55] Even more important for our pur-
poses, however, is the *miḥrāb* of the Hasbey Dalülhuffaz in Konya
(Figure 16.12). This building has an inscription on the exterior dated
to 824/1421. The *miḥrāb* is so similar to Seljuk examples that it
had been suggested that the Karamanid work on the building was
confined to a redoing of the façade, but the latest study suggests that
it is rather an archaic work in Seljuk style.[56] If the Karamanid crafts-
men were capable of reproducing a Seljuk *miḥrāb* in Konya, there is

Figure 16.11 *Kayseri:* miḥrāb *of Külük Cami*

Figure 16.12 *Konya: miḥrāb of Hasbey Darülhuffaz*

no reason why a craftsman imported from Anatolia by al-ʿAynī into Cairo could not have worked in the same style.

The inscription on the *miḥrāb* also points to possible Anatolian influence (Figure 16.8).

It reads as follows:

الدنيا ساعة فاجعلها طاعة

Life is short, spend it in obedience (to God).

This phrase is unknown on other Cairene monuments. We know of only two other occurrences of it on architecture, one on the mausoleum of Uljaytu at Sultaniyya (713–16/1313–116), the other on the Mosque of Gauhar Šād in Mašhad (821/1418).[57] Sheila Blair has pointed out that while this is not listed among the canonical *ḥadīṯ*s, a paraphrase of it is contained in Ǧalāl al-Din's *Maṯnavī*.[58] But in the above instances it was preceded in the first case by *ṣadaqa rasūl Allāh*, and in the second by *qāla'l-nabī*, indicating that it had gained orthodox acceptance by the fourteenth century. Studies on *ḥadīṯ*s are just beginning to be made and recorded on monuments, but it is surely significant that with the limited number published, the links are with Anatolia and Iran.

We have seen that there are three building periods connected with the madrasa: 814/1411–12, the date of its foundation, restoration by al-Muʾayyad to the dome at an unspecified time (815–24/1412–21), and 831/1428, when restoration works which included the renovation of the vestibule were carried out. Since with the *miḥrāb* we are dealing with a case of archaism, it is unfortunately impossible on stylistic grounds to decide between these dates. On historical grounds, however, it may have been later in his career that al-ʿAynī realised the desirability of stressing the Turkishness of his building. Apart from the obvious cachet which a form of decoration unique to Cairo would give him, al-ʿAynī, as mentioned above, owed much of his power and influence over successive Mamluk sultans, especially al-Ašraf Barsbāy, to his Turkish background, both in his ability to function as an ambassador in Mamluk-controlled Anatolia, and to his ability to translate historical and religious sources from Arabic to the Turkish which was the spoken language of the court. The reasons for his undertaking of a restoration of his complex in 831/1428 may also be relevant here. Having enjoyed the favour of the post of *qāḍī al-quḍāh* for three years perhaps he felt it was time that his new status was reflected in the decoration of his building. Given the fact that he was removed from the office in the following year (although he was subsequently reinstated)[59] this could indeed be seen as a timely move. The painted emblem in the vestibule is the most obvious evidence of his new-found status, while a tiled *miḥrāb* with (for Cairo) unique decoration might serve to emphasise this. The date of 831/1428, could therefore be selected as the most likely one on historical grounds for the *miḥrāb*, although it should be stressed that this can only be speculation.

An early twentieth-century writer described the *miḥrāb* 'as more bizarre than artistic'.[60] While it may be easy to dismiss this remark as that of an amateur of the traditional fashions of Cairene decoration, and of one who was totally ignorant of those of Anatolia, such, in fact could well have been the reaction of many of al-ʿAynī's contemporaries. Indeed, its strangeness in the context of Mamluk decoration could have been the reason for its failure to convince

Cairenes of the desirability of decoration in tile-mosaic, rather than any technical difficulties which the technique involved. But this had been the case previously with the work of the Tabriz master in the time of al-Nāṣir Muḥammad. If those state-sponsored buildings had failed to make the technique fashionable, we should be less surprised that one erected by a *qāḍī* should have no impact. Nevertheless, it still remains an interesting example where a religious patron may have tried to underline his non-native origins by stylistic means, in order thus to stress his affinities with the ruling class.

Notes

1. See M. van Berchem, *Matériaux pour un Corpus Inscriptionum Arabicarum, Égypte, Le Caire* (Cairo, 1900), pp. 345–6.
2. Ibid., pp. 387–8.
3. The most complete biographies are those of Šams al-Dīn Muḥammad al-Saḫāwī, *al-Ḍawʿ al-lamiʿ li-ahl al-qarn al-tāsiʿ*, IX (Cairo, 1354/1935), pp. 131–5; *al-Ḍayl ʿalā rafʿ al-iṣr*, ed. ʿA. al-Baġāwī (n.d., n.p.), pp. 428–40; for a shorter account see W. Marçais, 'al-ʿAyni', *EI²*, pp. 790–1.
4. Saḫāwī, *al-Ḍayl*, p. 432; al-Maqrīzī, Ṭaqī al-Din Aḥmad ʿAlī b. ʿAbd al-Qādir Muḥammad, *Kitāb al-sulūk li-maʿrifat duwal al-mamlūk*, ed. Saʿid ʿAbd al-Fattaḥ ʿAšūr (Cairo, 1970–73), III/3, p. 970.
5. Al-Maqrīzī, *Kitāb al-sulūk*, III/3, p. 1080.
6. Saḫāwī, *al-Ḍayl*, p. 433.
7. A. H. de Groot and H. A. Reed, 'Laranda', *EI²*, p. 677.
8. Saḫāwī, *al-Ḍayl*, p. 433; al-Maqrizi, *Kitāb al-sulūk*, IV/1, p. 524.
9. This is emphasised in C. Petry, *The Civilian Elite of Cairo in the Late Middle Ages* (Princeton, 1981), p. 70.
10. Saḫāwī, *al-Ḍawʿ*, p. 132; idem, *al-Ḍayl*, p. 433; al-Maqrīzī, *Kitāb al-sulūk*, IV/2, p. 698; Ibn Taġrībirdī, *al-Nuǧūm al-zāhira fi mulūk Miṣr wa-l-Qāhira*, trans. W. Popper as *History of Egypt, 1382–1469 A.D.*, University of California Publications in Semitic Philology, XVIII (Berkeley and Los Angeles, 1958), pp. 157–8.
11. Saḫāwī, *al-Ḍawʿ*, p. 132; idem, *al-Ḍayl*, p. 434.
12. Ibn Taġrībirdī gives another example of this enmity: he notes that Maqrīzī records one occasion when al-ʿAynī was *muhtasib* and persuaded al-Ašraf Barsbāy to order reprisals against the populace who had participated in bread riots, but that Maqrīzī had failed to mention al-ʿAynī's stoning at the hands of the people as a legitimate cause for his action: *al-Nuǧūm*, trans. Popper, XVIII, p. 29; al-Maqrīzī, *Kitāb al-sulūk*, IV/2, p. 698.
13. Petry, *op. cit., loc. cit.*
14. Ibn Taġrībirdī, *al-Nuǧūm*, trans. Popper, XIX, p. 118.
15. Saḫāwī, *al-Ḍawʿ*, p. 133; idem, *al-Ḍayl*, p. 434; Ibn Taġrībirdī, *al-Nuǧum*, trans. Popper, XVIII, p. 29.
16. Ġawharī, ʿAlī ibn Dāwūd al-Ṣayrafī, *Nuzhat al-nufūs w-al-abdān fī tawārīḫ al-zamān*, ed. Ḥ. Ḥabaši, II (Cairo, 1970–74), p. 290. For the remains of the house of Ibn al-Ġannām, see A. Lézine, 'Les salles nobles des palais mamlouks', *Annales Islamologiques* X (1972), pp. 112–15.
17. For convenience directions are given on the assumption that the *qibla* faces east.

18. The building is described in detail in J. Revault and B. Maury, *Palais et Maisons du Caire*, III (Cairo, 1979), pp. 1–12.

19. Ibid., p. 1, after al-Saḫāwī.

20. There is unfortunately a dearth of dated *qāʿa*s between that of Ibn al-Gannām (774/1372–3) and those of the late fourteenth century (i.e. that of the period of Qāytbāy in the Bayt al-Razzāz; see J. Revault and B. Maury, *Palais et Maisons du Caire*, v. 1 (Cairo, 1975), pp. 57–60). This makes it more difficult to say whether, on stylistic grounds, the *qāʿa* in Manzil Zainab Ḥātūn should be located in the first or second half of the fifteenth century.

21. It was omitted from discussion in D. Behrens-Abouseif, *The Minarets of Cairo* (Cairo, 1985), an indication that the author did not think it original.

22. The reading of Yūsif Aḥmad in K. A. C. Creswell, 'A Brief Chronology of the Muḥammadan Monuments of Egypt to A.D. 1517', *Bulletin de l'Institut Français d'Archéologie Orientale*, XVI (1919), p. 120, was reproduced in abridged form in L. A. Mayer, *Saracenic Heraldry* (Oxford, 1933), p. 150. It erroneously includes 'ḥāḏā'l-saqf bāni ḥāḏā' after 'taǧdīd'; and gives the date as 835 (Creswell) or 853 (Mayer, in the translation only) instead of 831.

23. The pattern, and the floral decoration within the rosettes, can be compared with the frontispiece of a Qurʾān made waqf in 770/1369 by Sultan Šaʿbān: see M. Lings, *The Quranic Art of Calligraphy and Illumination* (London, 1976), Pl. 69.

24. See Mayer, *Heraldry*, p. 150, Pl. LXI/3; M. Meinecke, 'Zurn mamlukischen Heraldik', *Mitteilungen des Deutschen Archaologischen Instituts – Abteilung Kairo*, XXVIII/2 (1972), pp. 284–5, fig. 13, no. 63. The latter does not show the shape of the vase accurately, missing the ring above the foot.

25. Mayer, *Heraldry*, pp. 12–13; Meinecke, 'Heraldik', pp. 250–2, 281–5; idem, 'Die Bedeutung der Mamlukischen Heraldik für die Kunstgeschichte', *XVIII. Deutscher Orientalis tentag*, ed. W. Voight, *Zeitschrift der Deutschen Morgenländischen Gesellschaft*, Supp. II (1974), pp. 238–40.

26. Al-Qalqašandī, ed. Abū'l-ʿAbbās Aḥmad b. ʿAlī, *Ṣubḥ al-aʿša fī ṣināʿat al-inšā* (Cairo, 1340/1922), III, p. 486.

27. *Ḫiṭaṭ*, I, p. 403. The term used is *kursī al-dawāḫ*, lit. the stand of the penbox, indicating that it was like no other.

28. Registration no. 14394.

29. Meinecke, 'Heraldik', p. 284 n. 427 compares al-ʿAynī's vase with those of early Mamluk blazons, but these are consistently different, without the narrow neck of al-ʿAynī's.

30. It reads as follows:

رأيت الدهر مختلف يدور　　　فلا فرح يدوم ولا سرور

رأيت الناس كلهم سكارا　　　وكأس الموت بينهم يدور

فواعجبا لمن يصبح ويمسي　　　ويعلم أن مسكنه القبور

فقد بنت الملوك لها قصورا　　　فلا دام الملوك ولا القصور

I saw time passing, and no happiness or pleasure persists,
I saw all the people drinking while the cup of death moves about each one,

How strange that one who rises and goes to bed each day forgets that his (final) dwelling is the grave, The kings built palaces, but nothing remains of the kings or the palaces.

In the cartouche below:

مما عمل بر سم القاضي . . . الفاخور (؟)

That which was ordered by the Qāḍī . . . al-fāḫūr (?). [The last word is not clear.]

31. The present ablutions area is modern; poor maintenance of pipes in these areas of medieval buildings is often responsible for subsidence of adjacent structures.

32. Examples include the funerary complexes of Aḥmad al-Qāṣid (c. 735/1335, No. 10), Aydumur al-Bahlawān (before 747/1346, No. 22) and Aytmiš al-Baǧāsī (785/1383, No. 252), each of which has a single irregularly shaped prayer hall in addition to a mausoleum. For a discussion of the principles which underlay the siting of the various parts of complexes in crowded spaces, see C. Kessler, 'Funerary Architecture within the City', *Colloque international sur l'Histoire du Caire*, ed. A. Raymond, M. Rogers and M. Wahba (Gräfenhainichen, 1972), pp. 257–67.

33. Ǧawharī, ʿAlī ibn Dāwūd al-Ṣayrafī, *Nuzhat al-nufūs*, II, p. 492: 'wa minhā al-qubba al-muḏahhabiyya allatī waḍaʿahā ʿalā al-madfan illaḏī bi-l-madrasati-l-badriyya bi-l-ǧarb min al-ǧāmiʿ al-azhar illatī lā naẓīr lahā'.

34. ʿAli Mubārak, *al-Ḥiṭaṭ al-ǧadīda al-tawfīqiyya li Miṣr al-Qāhira* (Būlāq, 1306/1888) VI, p. 11.

35. After part of the ceiling had fallen on it, it was destroyed in the summer of 1980 to make way for a more modern one.

36. II (Paris, 1892), Pl. I–IV.

37. M. Herz, *Catalogue raisonné des Monuments exposés dans le Musée national de l'Art arabe* (Cairo, 1906), p. 233 n. 1.

38. C. Prost, *Les revêtements céramiques dans les monuments musulmans de l'Égypte*, Mémoires de l'Institut Français d'Archéologie Orientale du Caire, XL (Cairo, 1916), pp. 44–5. His conclusions in the text are all the more remarkable for having ignored the similarity to two Anatolian Seljuk miḥrābs which he pointed out in p. 44 n. 6. M. S. Briggs, *Muhammadan Architecture in Egypt and Palestine* (Oxford, 1924), p. 233, attributed it to workers from Morocco and Tunis in the middle of the eighteenth century; H. R. Devonshire, *Rambles in Cairo* (Cairo, 1931), p. 38, wrote that 'Experts agree in ascribing the work to North African craftsmen who came to Egypt in the XVIIIth century; it certainly is more recent than the mosque itself'.

39. E.g. in the Mausoleum of Qalawun and on the portals of the Complex of Sultan Ḥasan, of al-Muʾayyad at Bāb Zuwayla and of the Māristān of al-Muʾayyad.

40. E. H. Gombrich, *The Sense of Order: A Study in the Psychology of Decorative Art* (Oxford, 1979), p. 292. The comparison with music may not be entirely out of place in Islamic architecture – Mehmet Agha, the architect of the Sultan Ahmet Mosque in Istanbul, was learned in music, and his biographer expiated at length on the tones produced by

the marble used for the decoration of the mosque. See Caʿfer Efendi *Risāle-i miʿmāriyye*, trans. H. Crane, Studies in Islamic art and architecture, v. 1 (Leiden, 1987), pp. 25–8, 68–9.

41. W. Smith, *The Art and Architecture of Ancient Egypt* (Harmondsworth, 1981), p. 288.

42. This has been exhaustively researched by Michael Meinecke in 'Die Mamlukischen Fayencemosaikdekorationen: eine Werkstätte aus Tabrīz in Kairo (1330–1350)', *Kunst des Orients* XI (1976–7), pp. 85–144.

43. *Kitāb al-mawāʿiz wa-l-iʿtibār fī dikr al-ḫiṭaṭ wa-l-ātār* (Būlāq, 1853–4/1270), II, p. 307; idem, *Kitāb al-sulūk*, ed. Muḥammad Ziyāda (Cairo, 1934–58), II/2, p. 320; Meinecke, 'Werkstätte', pp. 91–2.

44. Meinecke, 'Werkstätte', pp. 100–7.

45. Ibid., pp. 117–19, 121–4.

46. Ibid., p. 129, fig. 40.

47. Illustrated in L. Hautecreur and G. Wiet, *Les mosquées du Caire* (Paris, 1932), pl. 178.

48. A survey of tilework of the period is to be found in B. O'Kane, *Timurid Architecture in Khurasan* (Costa Mesa, 1987), pp. 64–71.

49. See ibid., pp. 67–8.

50. Now in the Çinili Köšk in Istanbul; see Tahsin Oz, *Turkish Ceramics* (n.p., n.d.), pl. XVII.

51. The most convenient reference to these is M. Meinecke, *Fayencedekorationen seldschukischer Sakralbauten in Kleinasien*, I–II, Deutsches Archäologisches Institut, Istanbuler Mitteilungen Beiheft 13 (Tübingen, 1976), from which the following plate and catalogue numbers are taken. The miḥrābs include those of the Misri Cami, Afyon Karahisar (Cat. no. 1; pl. 1/1); Ulu Cami, Akşehir (Cat. no. 7; pl. 3/1); Arslanhane Cami, Ankara (Cat. no. 18; pl. 8/3); Eşrefoğlu Cami, Beyşehir (696–9/1296–1300, Cat. no. 23; pl. 10/1); Ulu Cami, Birgi (Cat. no. 26; pl. 11/1); Ibn Arapşah Mescit, Harput (678/1279–80, Cat. no. 42; pl. 17/1); Külük Cami, Kayseri (Cat. no. 52; pl. 20/1); Ulu Cami, Kazimkarabekir (Cat. no. 54; pl. 20/2–3); Sirçali Mescit, Konya (Cat. no. 69; pl. 26/1; Sirçali Medrese, Konya (Cat. no. 71; pl. 29/3); Sahip Ata Cami, Konya (Cat. no. 77; pl. 32/4); Beyhekim Mescit, Konya (1270–80, Cat. no. 81; pl. 35/2); Sadreddin Konevi Cami, Konya (673/1274–5, Cat. no. 85; pl. 36/4).

52. The Külük Cami, Kayseri, and the Ibn Arapşah, Harput (see n. 51).

53. Misri Cami, Afyon Karahisar; Sahip Ata Cami, Konya; Beyhekim Mescit, Konya (see 11. 51).

54. Meinecke, *Fayencedekorationen*, Cat. 11 ° 46; pl. 18/1–3.

55. Ibid., Cat. 11° 54; pl. 20/2–3.

56. Ibid., Cat. No. 92; pl. 41/1.

57. For the former see S. Blair, 'The Epigraphic Program of the Tomb of Uljaytu in Sultaniyya: Meaning in Mongol Architecture', *Islamic Art* II (1987), inscription no. 49e; for the latter B. O'Kane, *Timurid Architecture in Khurasan* (Costa Mesa, 1987), p. 125, no. 22.

58. Blair, *op. cit.*, p. 56; Badīʿ al-Zamān Firūzanfar, *Aḥādīt-i Matnavī* (Tehran, 1347/1969), pp. 12–13, no. 28.

59. For his vagaries in this post, see Ibn Tagrībirdī, *al-Nuǧūm*, trans. Popper, XVIII, p. 31, 68, 82; XIX. p. 6.

60. Devonshire, *op. cit.*, p. 38.

CHAPTER SEVENTEEN

The Rise of the Minaret

WITH THE STUDY of Islamic art history in its relative infancy, it is only in recent decades that scholars have turned away from the chronological ordering of the field to allow themselves the luxury of iconographic studies. Within this subcategory, studies of architectural iconography are even fewer – understandably, since to make a contribution in this field,[1] which rarely has any textual material bearing directly on the issue, one has to cull evidence from a wide variety of sources, epigraphic, historical and literary. One of the main distinctions of the present work[2] is the width with which Jonathan Bloom has cast his net on such sources, and in particular the depth of the historical argumentation which is used to support the novelty of his theories. The enormous range is necessitated by his chosen theme, which encompasses monuments from Spain to India, and, in detail, from the foundation of Islam to the Seljuq period. Some of the material here has been covered in preliminary form by the author in previous articles, but he has meanwhile refined and in some cases even changed his views.

It is the theme itself which is both startling and original. Briefly stated, it purports to show that the tall minaret tower was not, as has been generally assumed, a standard feature of mosque architecture until the ʿAbbasid period. Furthermore, it was then, particularly in North Africa, seen as evidence of partisanship of the ʿAbbasids, and for this reason was eschewed by the Fatimids. Their rejection of it in turn led to its adoption by the Fatimid's enemies, the Umayyads of Spain.

Chapter one is devoted to a review of earlier literature on the subject, and it makes the crucial point that the various terms for minaret in Arabic – *manar*, *manara*, *sawmaʾa* and *miʾdhana* – were not likely originally to have been synonyms. Only in later centuries did they become interchangeable. Secondly, by discussing minarets with the functionally neutral word 'towers', one is better placed to answer the question of why towers were attached to mosques in the first place.

Bernard O'Kane (1992), 'The Rise of the Minaret', *Oriental Art* 38, 106–13.

After a discussion of the *adhan* (the call to prayer) – which he establishes as being more fluid in early Islam than is generally recognised – Bloom shows in chapter two how the earliest structures which were used for the call to prayer were *sawma 'a*s, small sentry-box-like structures on the roof of the mosque, usually reached by a staircase. Later writers may have used another term, which by then had become synonymous, to describe them, explaining why they were misconstrued as towers by early researchers on the subject. The earliest surviving staircase minaret is shown to be that of the mosque of 'Umar at Bosra. Its square tower, previously thought by Creswell to be original, is demonstrated by Bloom to be a later addition, probably of the thirteenth century. Even with the addition of towers to mosques, staircase minarets continued to be built. A notable early example is that of the Great Mosque at Sousse (mid-ninth century), while examples dating from the fifteenth and nineteenth centuries have been found on the Persian Gulf near Siraf.

Chapter three, on the use of the terms *manar* and *manara*, begins by showing that the terms were used in the early Islamic period to mean a lighthouse or a boundary marker. Only one early source, a poem by al-Farazdaq, uses *manar* in the sense of an attachment to a mosque, although the early date of this verse is suspect, as alternative readings are known. The remainder of the chapter is taken up with a discussion of the mosque of the Prophet in Medina and the *haram* in Mecca. According to an early tenth-century source, the mosque at Medina was provided with four *manar*s between 707 and 709, in the reign of the Caliph al-Walid. These were tall structures, about 4 m square and 25 m high. How can these be explained, if the only way in which the call to prayer was articulated architecturally at the time was by the staircase minaret or the sentrybox minaret? Should they be seen as a new form for the call to prayer (as a later story suggests), or should another explanation be provided? Bloom points out that boundary markers were used to delineate sacred spaces, such as the *haram* at Mecca, and that four-towered temples were associated with the worship of a supreme sky god. He equates the *manar*s of al-Walid with the towers which stood at the corners of Near Eastern palace-temples, such as that of Bel at Palmyra, or the temenos at Damascus. Since the mosque at Medina was also the house of Muhammad, it could also be seen as a palace-temple.

There are problems with this interpretation, however. It sits ill with Bloom's earlier statement that, 'given Islam's lack of interest in the pre-Islamic past and its abhorrence of idolatry, it is hard to imagine that Islam imitated any one of these [antique Mediterranean, South Arabian, Mesopotamian, Central Asian or Indian] tower traditions as long as their original connotations remained active' (p. 18). It also ignores the difference in shape of the earlier towers: squat and thick compared to the tall thin Medinan ones. However, it might be possible to forge a link with one of these palace temples in particular,

for since the reign of al-Walid and the building of the mosque within the temenos at Damascus, it is quite likely that the existing corner towers of the temenos – which were not demolished – were used as a base for the call to prayer (Figure 17.1).[3]

What more appropriate act for al-Walid to take than to distinguish the unique character of the mosque at Medina by giving it towers for the call to prayer which were much taller than those of Damascus, not to make the *adhan* more efficacious, since the opposite result would have obtained, but to monumentalise it, as Bloom suggests, and to reflect its unique status. This unique status was also reflected by the ʿAbbasid addition of four towers to their expansion of the Meccan *haram*, and by rebuilding two of the Medinan towers when they expanded the mosque to the north. Bloom is surely right in asserting that the massive construction in the holy cities by al-Walid and the ʿAbbasids was an attempt to signify their dynasties' prestige and power, but this does not, unfortunately, tell us what the primary function of the towers attached to the shrines were.

In chapter four Bloom identifies the earliest surviving mosque towers, all from the ninth century, and all located in the middle of the wall opposite the *qibla* (Siraf, Harran, Qayrawan, Damascus, two at Samarra). He then goes on to show how, with the exception of the shrines of Mecca and Medina, height until then had been a prerogative of secular Islamic architecture. Chapter five is devoted to an explanation of this. Their geographical spread makes it likely that a mosque at Baghdad was the model, and Bloom picks the mosque of al-Mansur as rebuilt by Harun al-Rashid as the most likely one. He follows Herzfeld's reconstruction of this as being on the *qibla* side of the palace (Fig. 34), and argues that the placement of the Qubbat al-Khadra, the eighty cubit high audience hall at the back of the palace, was in its relationship to the mosque a prototype for the placing of later minarets, particularly after the caliph abandoned the central palace for another in the suburbs.

There are several problems with this argument, the main one being that after careful consideration of the sources and of Herzfeld's reconstruction, both Creswell and Lassner argued convincingly that he was incorrect and that the palace was on the *qibla* side of the mosque. The placing of the Qubbat al-Khadra could not therefore have inspired the location opposite the *qibla* of the earlier minarets.[4] What is harder to credit is why, after the Caliph abandoned the central palace, there should have been a transformation of 'the semiotics of space in Islamic architecture. Where formerly the caliph had the exclusive right to height – only his palaces could tower over all other structures – now the mosque had that exclusive right and the ruler claimed instead the right to vast horizontal space' (p. 83). Why should an abandoned palace have transferred to an adjacent mosque its spatial qualities? Would the two buildings not have remained separate entities in the minds of the users of the mosque? And would

Figure 17.1 *Damascus, Great Mosque, showing original south-west tower of the temenos with later minaret of Qaytbay*

not the earlier addition of four tall towers to the Mosque of Medina, and later to Mecca, have been enough to provide a lasting association of height with Islamic religious architecture?

It would be more satisfactory to acknowledge that the sources do not provide even enough circumstantial evidence to suggest that the mosque of al-Mansur as rebuilt by Harun al-Rashid was the model for the minaret. Bloom is certainly right in suggesting that the provincial examples are likely to be copies of a Baghdad model,[5] but on our present knowledge its identification can only be pure speculation. He concludes the chapter by saying that although 'Abbasid Baghdad produced the minaret, the minaret was not produced for the call to prayer – 'It would remain the job of later generations to give it that task'. He interprets the tower as a sign of Islam, but in Baghdad, with its solidly Muslim population, what need would there have been for advertising the presence of a mosque in this way? It is admittedly impossible to say from the surviving sources when the tall tower *was* first used for the call to prayer, but why not in these early 'Abbasid examples? The two functions, a sign of a congregational mosque (and in the provinces, of 'Abbasid loyalty) and a place for the call to prayer are not mutually exclusive, and it is surely possible that the new single mosque tower could have supported both simultaneously. That there is some doubt in the chronology of the meanings and function of the tower seems to be acknowledged by Bloom when, discussing the tower at Tinmal (c. 1158), he reverses his previous chronology: 'no longer was it [the mosque tower] primarily the place for the call to prayer. It had finally become the externalised sign of Islam' (p. 120).

Chapters six and seven trace the development of the minaret in the Maghrib, an area where the author's familiarity with the bewildering, constantly changing political mosaic and the variety of sources is put to very good effect. He is able to quote a very interesting unpublished UNESCO excavation report that suggests that the Qayrawan minaret, built by an 'Abbasid client dynasty, the Aghlabids, originally stood outside the wall of the mosque, locating it in a *ziyada* similar to the Samarra examples.[6] The tower of the *ribat* at Sousse is shown to have been a lighthouse for the nearby harbour, on the grounds of its very pertinently chosen Quranic inscription. The depth of historical coverage enables him to show how the building of the Zaytuna congregational mosque in Tunis was not likely to have been an Aghlabid-sponsored work, contrary to previous opinion.

The documentation on early Fatimid architecture is crucial to his arguments. The most comprehensive source of early Fatimid law, the *Da'a'im al-Islam*, has been scoured to great effect, recounting a tradition that 'Ali, the Prophet's son-in-law, said that the call to prayer should not be given from a place higher than the roof of the mosque. This explains their absence in the Fatimid mosque of Mahdiyya, where a monumental portal is situated on the *qibla*

Figure 17.2 *Bukhara, minaret of Arslan Khan*

axis, the usual location for the ʿAbbasid tower. Bloom convincingly argues that the towers of the other early Fatimid foundations in Ajabiyya and Sirt in Libya were later additions. Given the Fatimids' rejection of the tower, he shows how it is understandable that their main enemies, the Umayyads of Spain, used it extensively from the tenth century onwards, and that their clients, the Zanata berbers, erected minarets in the Qayrawiyyin and Andalusian mosques of Fez.

One must raise the question here of the extent to which consciousness of the minaret as a symbol of political allegiance to the ʿAbbasids, or of non-allegiance to the Fatimids, is likely to have lasted. If the tower was proving useful as a place from which to call to prayer, then later builders could have built them with only this function in mind. Matters could only become more confused when the Fatimids adopted towers themselves. This question is taken up in chapter seven, which discusses the minaret in Egypt and Syria. Bloom remarks on the frequency of towers in late Fatimid architecture. Given that their first monuments in Ifriqiyya and Libya did not have towers, the most important question to be answered here is when did the Fatimids first begin to sanction their use?[7]

The most obvious candidate for an early Fatimid minaret is in the mosque of al-Hakim. This is a case where the use of the functionally neutral 'tower' rather than 'minaret' weakens the argument that the towers at either end of the main façade of the mosque were not minarets. For if originally they were merely towers, and if towers were found to be objectionable, it would be pointless to cover them up by bastions, that is, larger towers. It is Bloom himself who has provided the only rational motive for this action: the towers were minarets built, in their tiers of different shapes, in imitation of those of the

Figure 17.3 *Natanz, dome chamber of Friday Mosque*

haram at Mecca, an obvious visual reference of which al-Hakim no longer wanted to be reminded when in 1010 al-Rashid, one of the *sharifs* of Mecca, declared himself to be Caliph and thus independent of Fatimid control.[8] Even though al-Hakim was capricious in many of his actions, he was extremely astute in many others,[9] and if a rational reason can be found for covering the minarets, then it is to be preferred to Bloom's charge of inscrutability.

That the towers of al-Hakim's mosque were originally built as minarets is made more likely by a precedent mentioned in al-Maqrizi's account of the mosque of the Qarafa, built by the mother of the Fatimid caliph al-ʾAziz in 976–7.[10] The relevant passage could be translated as follows:

> It was built in the manner of the al-Azhar mosque in Cairo, and on its west was a fine garden and a cistern. The large gate by which one enters had two mastabas; at its centre was a lofty minaret (*manar*) covered with iron plates leading towards [i.e. on the axis of] the mihrab and *maqsura*. It had numerous gates, fourteen in all, of rectangular bricks. Every gate was faced with an arch . . .

Bloom translates *manar* here as axial bay with a clerestory, writing that it is to be understood as a variation of the modern *manwar*, light shaft, which was a form not permitted in classical Arabic. This is unlikely for several reasons. Firstly, he himself notes that the late tenth century Fatimid historian al-Kindi had used *manar* by this time as a term for the structure from which the call to prayer was given. Secondly, the word *manwar*, meaning light shaft rather

than clerestory, *was* used in classical Arabic – it is found in Mamluk waqfiyyas.[11] Thirdly, from the context of al-Maqrizi's account of the mosque, it is clear that he is describing the features of the gates here, and that the *manar* was a prominent feature of the main gate. It is unlikely that he would be so architecturally sophisticated as to find a clerestory worthy of mention, but a minaret, still a novelty at the period, was certainly noteworthy. The extent to which the mosque resembles that of al-Azhar is of course open to speculation, which brings us to its discussion in the book.

Bloom mentions that the muezzins gave the call to prayer from a *sudda* (gate or bench) in the courtyard of the Mosque of al-Azhar. The relevant passage of Maqrizi is as follows:

> They say that in this mosque there is a talisman so that spar-rows neither live nor breed there, and similarly with birds such as pigeons and doves and others, and this [talisman] is the images of three engraved birds, each image being on the capital of a column; of them two are in the front of the mosque in the fifth arcade (*riwaq*), being an image on the west face of the column, and another on one of the two columns on the front left side of the *sudda* of the muezzins; the third image is in the courtyard on the column on the qibla side towards the east.

The siting of the *sudda* is still not very clear from this description, but it leaves open the possibility that it should be translated as 'gate' rather than 'bench', and that the gate, in the front of the mosque (although 'in the fifth arcade' is a puzzle), might have been the main entrance which, had it been a minaret, could well have fitted the description of the text: the 'gate of the muezzins'. At any rate, it does not preclude the possibility that, as in the Qarafa mosque, there was a minaret over the main entrance.

The evidence then suggests that the Fatimids on two of their earliest mosques, that of al-Hakim and the Qarafa, and possibly also at al-Azhar, included one or more minarets, thus abandoning the policy which they had followed in the Maghrib. Why would this geo-graphical shift have occasioned a shift in official attitudes? Perhaps because, unlike Ifriqiyya, Egypt and Syria had a large non-Muslim population. This change in policy, as well as the large non-Muslim population and proximity of Byzantium, makes it easier to explain the evidence for two tenth-century minarets in Homs (p. 131).

The development of the minaret in the *mashriq* up to the Seljuq period is taken up in chapters nine and ten. Here again the author has been able to make good use of unpublished material, includ-ing Sheila Blair's corpus of early Arabic inscriptions in Iran, which clearly provides much refinement in the way of historical back-ground and chronology to many monuments.[12] He has also used an unpublished translation of a history by Abu Nasr 'Utbi, which

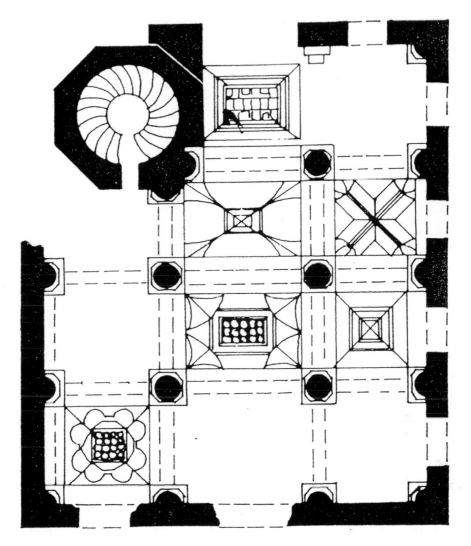

scala / scale 1:400

Figure 17.4 *Ani, plan of mosque of Minuchihr (after* Documents of Armenian Architecture*)*

furnishes the interesting information, otherwise unknown, on the use of the minaret as a place from which the name of a new ruler was proclaimed (p. 151). However, the name of the caliph had been mentioned in the *adhan*, not just in Umayyad and ʿAbbasid times, but, according to Maqrizi, by the Fatimids after the dawn prayer, from the top of the minarets.[13] Another association of the ruler with a minaret was of course provided by inscriptions on it. The opportunity this

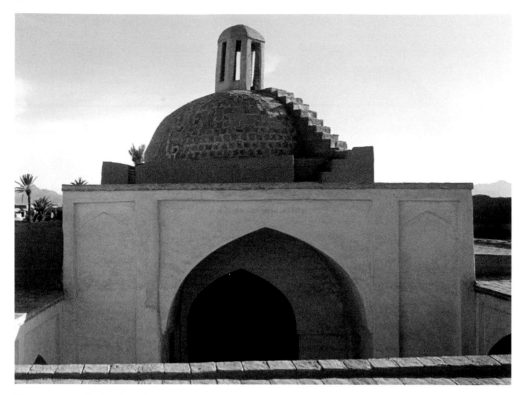

Figure 17.5 *Haftadur, Friday mosque, dome staircase minaret*

presented for a highly visible and more permanent advertisement of the munificence of the patron was taken up by many later rulers. The minarets of the mosque of al-Hakim are among the first extant examples of this; the first historical mention of it is in Ibn Duqmaq, who reports that, at the time Maslama ordered the four *sawma 'as* to be added to the mosque of 'Amr at Fustat and minarets to other mosques there, he commanded that his name be written on the minaret(s).[14] However, this passage seems to be an anachronistic gloss on al-Kindi, who omits it,[15] and would apply more to the minarets of the time and place of Ibn Duqmaq, Mamluk Cairo.

Bloom mentions that in 915 a spark set fire to a minaret in Baghdad, indicating that it may have been built of wood. Definite evidence for other early wooden minarets comes from Narshakhi's *Tarikh-i Bukhara*. He reports that a minaret which was built for the congregational mosque of Bukhara in 918 lasted until 1068, when during a siege the minaret (*manara*) was used as a vantage point from which to attack the adjacent citadel. The defenders retaliated with fire arrows which ignited the wooden top of the minaret, causing firebrands to fall and in turn set fire to the mosque.[16] The minaret was evidently rebuilt of wood, for when Arslan Khan ordered in 1121 that a new mosque should be built further away from the citadel, he arranged

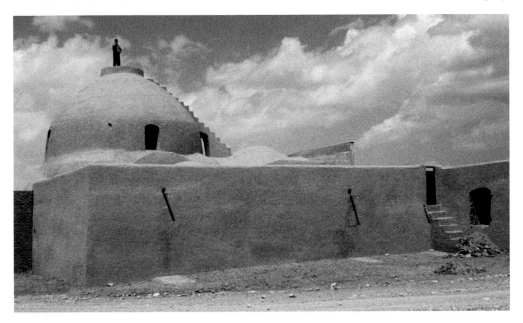

Figure 17.6 *Ashkidhar, Friday mosque, dome staircase minaret*

for the minaret to be transported from the old to the new site. This too, however, fell and destroyed one third of the mosque (which, if true, indicates that it must have been of considerable size), and broke the painted and carved wood (whether of the mosque or minaret is not clear, although previous remarks on the exquisite craftsmanship of the minaret suggest that it was being referred to). The still extant brick minaret with which he replaced it was only completed five years later, in 1127 (Figure 17.2).[17] In the nineteenth century this minaret gained notoriety as a symbol, not of Islam, but of the power of the Khan of Bukhara: from its top, criminals were thrown to their death. Interestingly, Narshakhi also uses a different term, *mil*, to describe the edifice which was erected in 360/970–1 at the *namaz-gah* (or *musalla*, place of the festival prayer) from which the call to prayer was given,[18] perhaps indicating a simpler structure than the elaborately decorated *manara*s which he described above.

The impact which the use of coloured glazes brought to minaret decoration is rightly emphasised by Bloom, although it is incorrect to say that the first use of coloured glazes is in the north dome of the Isfahan congregational mosque (p. 160). The reference to Adle and Melikian-Chirvani leads to Godard, who merely claimed that it was 'an attempt at colour decoration before the use of glazing'. The first example, which seems to have gone unnoticed until now, can be put back to 999, the date of the octagonal dome chamber in the congregational mosque of Natanz. Small turquoise-glazed hexagons are used to fill the loops of the mouldings which frame the eight lower

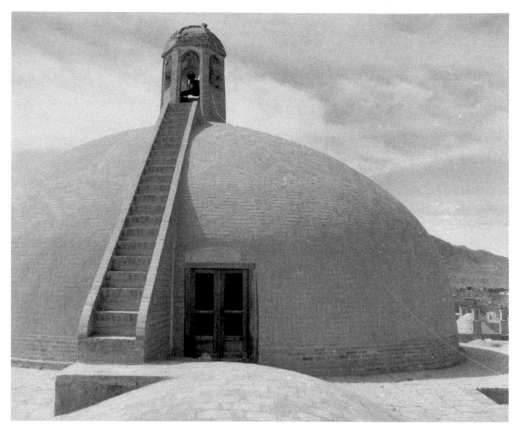

Figure 17.7 *Taft, Masjid-i Shah Vali, dome staircase minaret*

pointed arches, and are also found in two groups of three on the span-
drels of the broken-headed arches above the lower ones (Figure 17.3).
 The photograph of the minaret at Qal'at Ja'bar (p. 168) shows it in a
state typical of a large number of Seljuq examples: it stands isolated,
its base eaten away by the efforts of brick hunters (and not by wind
erosion, as is suggested by Bloom). Comparable isolated examples
include Ziyar, Rahravan, Firuzabad, Qasimabad, Khvaja Siyah Push,
Jar Kurgan, the minarets of Ghazni, and, most impressive of all, the
minaret of Jam. Were any of these originally built to stand alone?
In the cases of Qasimabad and Siyah Push we know that they were
originally attached to mosques built of mud brick.[19] In cases where
they might have been attached to a mosque of baked brick, the pre-
carious shaft of Qal'at Ja'bar shows how brick hunters would have
had safer pickings from the lower walls of the mosque. The absence
of a nearby mosque is therefore no proof that one was never there.
While it is impossible to deny that the superfluous height of the Jam
minaret made it a symbol of its builder Ghiyath al-Din's power, it
still seems unlikely that it would have been erected as such, as is
suggested, without an adjacent mosque. Its inspiration, the Qutb

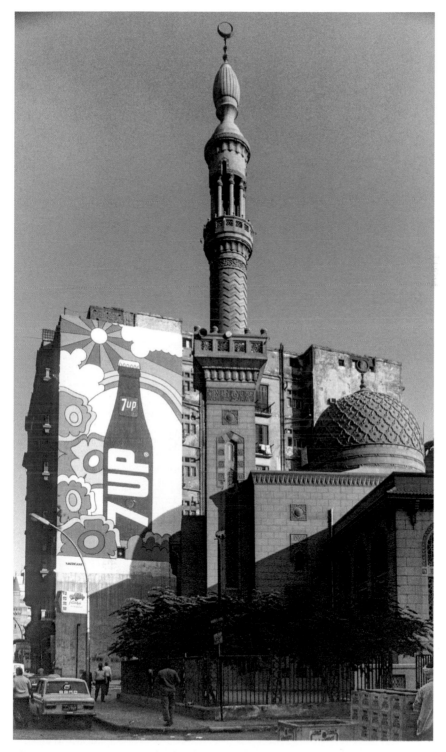

Figure 17.8 *Cairo, Masjid al-Rahma*

Figure 17.9 *Cairo, Masjid al-Shaykh Hamza*

Minar in Delhi, is the symbol of Islam par excellence, broadcasting its message to a largely non-Muslim population, but it was still built beside a mosque.

The final chapter offers a review of the minaret in later centuries, after it had been accepted as a sign of Islam. The paired minaret on a portal is a natural development, although the earliest extant examples are not those of Anatolia, as it stated, but the Iranian ones of Tabas and Ardistan (1143).[20] Further evidence that the form is of Iranian origin, as was suggested by Bloom, is provided by the no longer extant portal at Nakhchivan (twelfth century),[21] where the minarets sprang directly from the ground, rather than from the top of the portal, as was usual. Bloom has referred elsewhere to the earliest mention of a portal with two minarets (Mafarrukhi's *Mahasin Isfahan*), dating from c. 1030.[22]

One of the most peculiar phenomena of the call to prayer is the *guldasta*, the small wooden kiosk with a pyramidal roof which appears in several Iranian mosques from the Safavid period onwards. The explanation of Bloom, that it was a return to the requirements of Shi'i law that the call to prayer should be given from a place no higher than the roof of the mosque, is the most plausible one, although it still leaves problems. Were the numerous minarets which were still being built at the time never used for the call to prayer? If so, why was the usual location of the *guldasta* on top of an *aivan* facing into the courtyard of the mosque? – a good position for those within the building to hear, but not for the faithful outside. Another question arises with the spread of the *guldasta* – it was extraordinarily popular in Isfahan, but much less so elsewhere, being omitted entirely on many later mosques. Could it then be seen as an alternative rather than a replacement for the minaret, as primarily a fashion of central Iran which was followed to varying degrees elsewhere? Perhaps further publication of Safavid *waqfiyyas* will provide help on this score.

There is no mention, for the good reason that it occurs in virtually unpublished buildings and has not elicited comment up to now, of another very interesting Iranian variant of the *mi'dhana*, which one may call the dome staircase minaret. It consists of a staircase leading to the top of the highest point on the roof of the mosque, the top of the qibla dome chamber, sometimes with a small kiosk on top, perhaps a relic of the sentrybox-like *sawma'a* on the roofs of the earliest mosques. This form survives in three mosques in the vicinity of Yazd: the Friday mosques of Haftadur (mid-thirteenth century),[23] Ashkidhar (1477),[24] and the Masjid-i Shah Vali in Taft (1468)[25] (Figures 17.5–17.8). It is likely that these features have been repaired over the years, but the fact that they are found in only these three buildings, erected within two hundred years of each other, suggests that they could date from around the periods of foundation, rather than being much later additions. Unlike Isfahan, for instance,

Figure 17.10 *Cairo, Masjid ʿUmar b. al-Khattab*

the skyline of Yazd and its satellite villages is not regularly punctuated by lofty minarets. Both the builders of *guldasta*s and dome staircase minarets evidently wanted to have the best of both worlds, the prominence and greater visibility of an edifice above roof level, and the doctrinal rectitude – or simple economy – of abjuring a minaret.[26]

The use of the tower as a symbol is perhaps greater now than at any time in Islam's past, even though it has to compete with steel-framed structures which may be higher or have other claims on the attention of the passer-by (Figure 17.8). There are probably more medieval minarets in Cairo than in any other Islamic city, but with the tax incentives given to private builders for the incorporation of mosques in apartment blocks, and their consequent anonymous architecture, there is still a use for the minaret as an instantly recognisable Islamic sign, even in dwarf form (Figures 17.9, 17.10). At the other end of the scale, the enormous height of the minaret of the Masjid al-Fath in Ramsis Square (Figure 17.11) may be seen as a rival to the bell tower of the newly built cathedral in the neighbouring district of Damirdash (Figure 17.12). In a decade when Christians and Muslims in Egypt have been experiencing increased religious tension, one might hope that they will restrict their struggles to the world of symbols.

In conclusion, it remains to say a few words about the author's accomplishment. There have been few works published on Islamic architecture which have sought to reinterpret so radically the history of one of its most basic symbols. The work is clearly a product of both meticulous scholarship and broad vision. It is controversial, but while it may be possible to tinker with its internal chronology, there is little doubt that its main tenets will lead to a radically different view of the development of towers and the call to prayer in mosques. It shows the dangers of taking for granted received wisdom, and the merits of being able to question these by close study of the monuments in collaboration with the textual sources. It is to be hoped that it may encourage a similar re-evaluation of other basic architectural forms – the dome or the portal (to both of which Bloom has made substantial contributions in the present work), for instance. The author is to be commended for this stimulating contribution to Islamic iconography.[27]

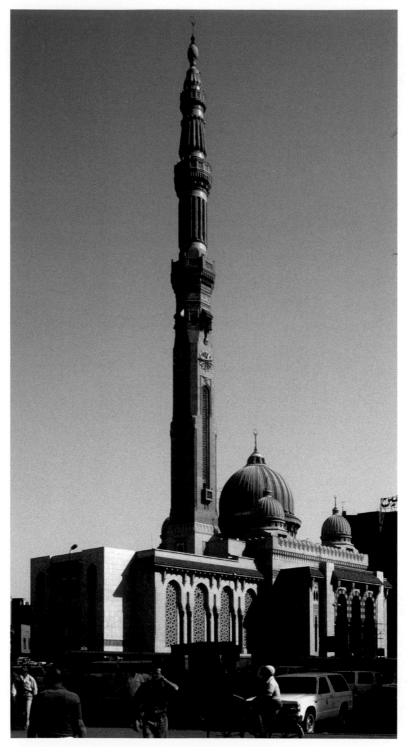

Figure 17.11 *Cairo, Masjid al-Fath, Ramsis Square*

Figure 17.12 *Cairo, Cathedral of Damirdash*

Notes

1. E.g. O. Grabar, 'The Umayyad Dome of the Rock in Jerusalem', *Ars Orientalis* III (1959), pp. 33–62; A. Daneshvari, *Medieval Tomb Towers of Iran: an Iconographical Study* (Lexington, Kentucky, 1986); S. Blair, 'The Epigraphic Program of the Tomb of Uljaytu at Sultaniyya: Meanings in Mongol Architecture', *Islamic Art* II (1987), pp. 43–96.

2. Jonathan Bloom, *Minaret: Symbol of Islam*, Oxford Studies in Islamic Art, VII, Oxford University Press, 1989 (pub. 1990).

3. See R. Hillenbrand, 'Manāmara, Manār', *EI²*, p. 363, for further discussion on this point. He suggests that the four *sawma'a*s of the mosque of 'Amr at Fustat could be used as evidence to show that the corner towers of the Damascus temenos were indeed used for the *adhan* after the mosque was built.

4. In fact it would have recalled an earlier one of the Umayyads, where the palace of Mu'awiya with a *qubbat al-khadra* was built against the *qibla* wall of the Great Mosque.

5. Terry Allen, in similar fashion, suggests a lost Baghdad prototype for the framing inscription: *Five Essays on Islamic Art* (n.p., 1988), p. 84.

6. However, the report of al-Muqaddasi that the fifth gate of ten was called the Bab al-Mi'dhana (the Gate of the Place of the Call to Prayer) does not confirm this, as is suggested (p. 91). The gate would have had the same name whether it lead to a tower in a *ziyada*, or was beside the tower in the wall. The edge of the Qayrawan minaret, not its centre, is aligned with the central axis of the mosque, making it likely that it had a gate beside it when it was built; although again, whether this was a gate in the mosque or in the *ziyada* will have to await the publication of the UNESCO excavations.

7. The Fatimids used the Mosque of Ibn Tulun in Cairo in the celebrations of the four Fridays of Ramadan, but we are unfortunately lacking direct evidence on whether or not they used its helicoidal minaret for the call to prayer. While a domed pavilion in its courtyard with a sundial for the timekeeper is evidence that the call to prayer was given from the centre of the courtyard, very few outside this vast structure would have been able to hear it. There is no reason why it should have been the only place from which the call to prayer was given (otherwise why have four *sawma'a*s at the corners of the mosque of 'Amr at Fustat?), and a muezzin on the minaret would have been able to observe the time-keeper's signals. Although at the celebration of the opening of the canal an acrobat is known to have performed for the Fatimid caliphs on a rope suspended from the minaret to the street, this need not have disqualified it from being a religiously significant form (p. 129). In 1425 similar feats were performed on ropes strung between the minarets of the complexes of Qala'un and Barquq: D. Behrens-Abouseif, *The Minarets of Cairo* (Cairo, 1987), p. 72.

8. J. Bloom, 'The Mosque of al-Hākim in Cairo', *Muqarnas* I (1983), pp. 15–36.

9. P. J. Vatikiotis, 'Al-Hakim bi-amrillah: the God-King Idea Realised', *Islamic Culture* XXIX (1955), pp. 1–8.

10. I would like to thank Nasser Rabbat for bringing this to my attention.

11. M. M. Amin and L. A. Ibrahim, *Architectural Terms in Mamluk Documents (648–923H) (1250–1517)* (Cairo, 1990), p. 117. This may also suggest that an inscription referring to the building of a *manar* in

the mosque of Seville in 214/829 (Bloom, p. 79, n. 28) is more likely to refer to a minaret than to an axial bay.

12. Some details can be added to the account of the minaret of Ani. The minaret was not destroyed a long time ago, as is suggested. It was still standing at the time of my visit in 1983, and an excellent plan and colour photograph of it were published in 1984, showing it to be a plain octagonal shaft rising to a *muqarnas* cornice (*Documents of Armenian Architecture, XII, Ani* (Milan, 1984), Pls 37–8; a photograph also appears in H. F. B. Lynch, *Armenia: Travels and Studies* [London, 1901], I, p. 377). However, the plan (Figure 17.4) shows that the minaret was added to a pre-existing building, for which a variety of uses is possible: council hall, palace, custom house or garrison (see L. Der Manuelian, *Armenian Architecture* [microfiche, ed. K. Maksoudian], I, p. 89; I am indebted to Professor Der Manuelian, whose contribution is not acknowledged in the publication, for sending me a copy of her entry on the Mosque of Minuchihr). There is no evidence of alteration to the building other than the addition of a minaret. The minaret thus takes on extra significance as the symbol by which an earlier Christian structure was converted into a mosque. This was enough for its builder Minuchihr to abrogate to himself in the inscription the building of a mosque as well as a minaret.

13. *Kitab al-mawa'iz wa'l-i'tibar fi dhikr al-khitat wa'l-athar* II (Bulaq, 1853), p. 271.

14. *Kitab al-intisar li-wasitat 'iqd al-amsar*, IV (Bulaq, 1309/1892), p. 62.

15. *Kitab al-wulat wa'l-Qudat*, ed. R. Guest as *The Governors and Judges of Egypt* (London, 1912), pp. 38–9.

16. Text, ed. M. Razavi (Tehran, 1363/1984), p. 70; trans. R. N. Frye (Cambridge, 1954), pp. 70–1.

17. Ibid., text, p. 71; trans., p. 51.

18. Ibid., text, p. 72; trans., p. 52.

19. B. O'Kane, 'Salğūq Minarets: Some New Data', *Annales Islamologiques* XX (1984), p. 85.

20. The Ardistan portal has never been published in detail, but meanwhile see A. Hutt, *The Development of the Minaret in Iran under the Saljūqs*, M. Phil. thesis, London University, 1974, p. 274. For Tabas, see A. Godard, 'Ardistān et Zawārè', *Āthār-é Īrān* I (1936), Fig. 197.

21. M. Huseinov, L. Bretanitsky, A. Salamzade, *Istoria Arkhitektury Azerbaidzhana* (Moscow, 1963), Figs 77–8.

22. J. Bloom, 'The Mosque of al-Hākim in Cairo', *Muqarnas* I (1983), p. 32, n. 38.

23. The mosque has several monochrome turquoise glazed epigraphic panels decorating the walls; one, a grave marker, has the date 655/1257–8: I. Afshar, *Yadgarha-yi Yazd*, I (Tehran, 1348/1969), p. 52. The *muqarnas* zone of transition of the main dome chamber supports a date close to this, which would make it one of the very few monuments in Iran surviving from this period.

24. This is the date on the marble slab within the mihrab: Afshar, *Yadgarha-yi Yazd*, I, p. 139. The form of the architecture is consonant with this date.

25. Again, this is the date on the marble slab within the mihrab: Afshar, *Yadgarha-yi Yazd*, I, p. 420. However, according to Muhammad Mufid Bafqi, *Jami'-i Mufidi*, ed. I. Afshar (Tehran, 1340/1961) III/I, p. 60, Khanish Begum, a wife of Shah Tahmasb, built a lofty mosque at the

(adjacent) *khanagah* of Shah Vali. Both the form and decoration of the present mosque make a late fifteenth-century date tenable, but it is possible that it was repaired in the Safavid period.

26. It is possibly as a combination of this feature and the similar *guldasta* that the pavilions on the pyramidal roofs of the Friday Mosque and the Mosque of Shah Hamadan in Srinagar, Kashmir should be seen: P. Brown, *Indian Islamic Architecture* (Bombay, n.d.), Pls LVII–LVIX.

27. Some minor annoyances must be laid at the door of the editors. One is the omission in the index of matters referred to in the footnotes. For instance, those looking for a discussion of the putative minaret base at Khirbat al-Mafjar will not find it in the index, although it is considered at length in the notes on p. 65. The reprinting of photographs from Creswell's negatives was an excellent idea, but their quality contrasts sharply with many others, notably those of the minarets of Semnan, Fez, Fahraj, Nayin, Sangbast, Sabzavar, Vabkent and Jam (Figs 3, 52, 93–4, 103–4, 106–7). Another irritation is the use of a lower case 'a' for the article 'al' at the beginning of a sentence. A second edition might also take care of the following: p. 89, n. 13: for '5335m.' read '53.35m.'; p. 90, n. 17: add 'p. 58', p. 90, n. 18: what does '*Ibid.*' refer to?; p. 132, 1.15: omit 'tapering'; p. 125, last line: for '976–79' read '876–79'; p. 149, 1. 28: for 'opposite' read 'above'; p. 157, 1.14: add 'are' after 'towers'; p. 172, 1.1: for 'square inscription panels' read 'inscription panels of square Kufic'.

CHAPTER EIGHTEEN

Review of Michael Hamilton Burgoyne and Donald Richards, *Mamluk Jerusalem: An Architectural Study*

THE TITLE PAGE of the very impressive volume mentions only two authors, but the names of 25 other architects and surveyors associated with the project since its conception in 1968 show to what extent the book is the result of a collaboration (list on p. vi). I am sure the two principal authors will not object if I say that the major contribution of the book is the magnificent corpus of architectural drawings that accompany the text. These, in addition to a series of plans at different levels and sections, contain many axonometric drawings, which are the easiest way to see at a glance all the information provided. There are still surprising omissions, such as the absence of elevations of the main façades of the ʿUtmāniyya (Cat. No. 57) (the plate and figure numbers are conveniently aligned with the monument catalogue numbers) and the Ribāṭ al-Zamanī (Cat. No. 61). Sometimes, on the contrary, the information borders on the supererogatory: would that the marble-inlaid pavements of Cairo had drawing of the same detail as that of the Faḫriyya (Fig. 22.10), and that is not even in its original state!

The photographs that accompany the drawings are unfortunately less impressive, and, in many cases, totally insufficient. In many cases the text refers to details of construction of decoration which are not visible on the small-scale reproductions.[1] Larger photographs would undoubtedly have increased the price of an already expensive book, but one could perhaps have economised on the colour photographs. The Dome of the Rock is undoubtedly the focal point of the Mamluk monuments of Jerusalem, but it is a little perverse to provide seven colour illustrations of it, and four more of Ottoman monuments (pls 9, 23, 25 and 32), while several important Mamluk buildings have none.

Bernard O'Kane (1990), review of M. Burgoyne and D. S. Richards, *Mamluk Jerusalem: An Architectural Study* (London, 1987), for *Bulletin Critique des Annales Islamologiques* 7, 187–92.

The second great advantage of the work is that its principal author, Michael Burgoyne, an architect, has collaborated with the historian Donald Richards, who has previously mined the archives of the Haram and the Ottoman tribunals. This collaboration greatly enriches the book's content, where one finds also not just a detailed history of each monument but also introductory chapters on the Mamluk State and on Mamluk Jerusalem. Richards demonstrates Jerusalem's unique status: many of the founders there were *baṭṭāl*s, i.e. exiles obliged to reside there. Other founders were certainly attracted by the Dome of the Rock and the surrounding complexes, shown most effectively in the axonometric drawing on p. 84, show clearly how proximity to the principal monument of Jerusalem was, in most cases, the deciding factor in the siting of the Mamluk additions. The motifs of the founders – a mixture of philanthropic piety, the desire to merit heaven in the afterlife (which one could also acquire posthumously through prayers of pilgrims for the founder) and the more worldly reason to assure their descendants' subsistence by making them administrators of family *waqf*s – are minutely examined. Similarly, these *waqf*s were in theory free from arbitrary confiscation, but Richards shows the various ways in which this rule could be, and was, overturned (p. 68). Sometimes popular piety turned the emirial founder of a complex into a saint (p. 126); this was also common in Cairo, where even the empty tomb of Sulṭān Ḥasan until recently regularly received pilgrims.

Many monuments contained tombs; the prestige of the city was such that many founders who died elsewhere had their bodies exhumed and transported to Jerusalem. The founder of the Kilāniyya was, as his name indicates, originally from Gīlān; he had specified in this will that his body be transported to Jerusalem. The existence of this practice permits us to think, in spite of Richards's doubts, that the body of Sayf al-Dīn Ṭāz was also exhumed after he had been buried in Damascus and transferred to his complex in Jerusalem (Cat. No. 36) – how otherwise to explain the inscription on his mausoleum that gives the date of death and specifies that the mausoleum was his burial place? The same must have been the case with Manklībuġa, the founder of the Baladiyya (Cat. No. 43). Although, according to Taġrībirdī, the latter was buried in Aleppo, and Ibn Ḥatīb al-Nāṣiriyya mentions that his body was exhumed and buried a second time in Damascus, the inscription on his mausoleum gives his name and date of death; it is therefore more plausible to assume that, if there was a second interment, it took place in Jerusalem.

One unusual feature of Jerusalem compared to other Mamluk towns is the number of *ribāṭ*s erected within the city. The inscription on the oldest of them, that of ʿAlāʾ al-Dīn (Cat. No. 3), indicates that it was erected for poor pilgrims to Jerusalem. It would be interesting to know when the word *ribāṭ* was used for the first time to indicate this function. Formerly it had other meanings: in

the Maġrib, a fortified building for *muǧāhid*s, in Iran, a caravanserai, and in Baghdad, a *ḫānqāh*.[2] It is true the sources are not consistent in their terminology, sometimes describing the same building as a madrasa, a *ḫānqāh* or a *ribāṭ*; but the two oldest *ribāṭ*s in Jerusalem, those of ʿAlāʾ al-Dīn and al-Manṣūrī (Cat. No. 5), have a similar plan consisting of cells around a courtyard, with one large hall. One would like to know how this hall might have been used.

The orientation of the main streets of the city towards the cardinal points meant that the architects, unlike those of Cairo, did not have to worry about any difference in axis of qibla and street. But the lack of space near the most prestigious sites around the haram necessitated ingenious solutions to the restricted space available for multi-functional complexes. The Taštimuriyya is a typical example: it consists of a mausoleum, a sabīl-maktab, a four-iwan madrasa, shops with living quarters above, and a large reception hall (*qāʿa*). All of this was crammed into a space only 20 × 22 m (and that was only possible through its greater than usual distance from the Haram), made possible by a three storey building using the roof of the madrasa below. Only in one case, that of the Baladiyya madrasa, was the four-iwan courtyard left open, and it is interesting to notice how later a large wall was built on the roof at the level of the cells and courtyard of the adjoining Ašrafiyya, in order to preserve the privacy of the open courtyard below. The hand of a Cairo architect is seen in the Ašrafiyya in the necessity, despite the location of the qibla iwan near the outer staircase, to enter the prayer hall by the *dūrqāʿa*. An entrance which led directly into the iwan, as at the Taštimuriyya or the Muzhiriyya, would never have been permitted according to the unwritten rules of Cairo which obliged the visitor to enter through the courtyard, permitting access to the ablutions area.

Burgoyne's chapter on the pre-Mamluk development of Jerusalem, in addition to the necessary outline, contains useful information on the state of the Haram under ʿAbd al-Mālik (p. 45). He confirms, through a careful examination of the masonry, the report of Nāṣir-i Ḥusrau on the presence of mosaics at Bāb al-Silsila (p. 46). He also confirms that the qubbat al-Miʿraǧ and the qubbat Sulaymān should be dated to the Ayyubid period rather than to the Crusades.

On the chapter on Mamluk developments Burgoyne gives very useful information that otherwise would have be gleaned from various other chapters. However, one might have wished for an attempt to compare this with that of the other main Mamluk urban centres. It is understandable that the author might not have wished to venture so farther afield, which means such a synthesis has to wait for the forthcoming survey of the whole of Mamluk architecture by Michael Meinecke. The following chapter, on construction methods, does indeed reference influences from the whole of the Mamluk world although here, as further on in the book, there are a few controversial points. One should surely be sceptical of the

report that the blind ʿAlāʾ al-Din al-Baṣīr drew the foundation plan
of a bath at Hebron (p. 97). The zig-zag ribs of the entrance portal of
the Tankiziyya and later buildings, as well as the teardop panels
of the palace of Sitt Ṭunšuq, are suggested to be in the architectural
tradition of Damascus. Certainly, there are examples of these older
than those of Jerusalem, but the earliest examples are to be found
in Cairo in the mausoleum of Sunqur Saʿdī (herring-bone ribs, 1315)
and amir Aqbuġa (teardrop panels, 1333–9).[3] Cairene parallels can
also be invoked for the decoration of the palace of Sitt Ṭunšuq (Cat.
No. 49) for which Burgoyne suggests an Iranian model (p. 509). By
the end of the fourteenth century stucco decoration was becoming
as rare in Iran as in the Mamluk world, but one can compare the
shallow arabesques of the mihrab (pl. 49.11) with similar work in
the mosque of al-Maridānī in Cairo. Square Kufic, since its introduc-
tion in the mausoleum of Qalāʾūn, became normal in Cairo in inlay
work. The closest parallels to the inlaid star pattern of the window
of the west entrance of the palace are on Cairene Mamluk minibars,
and the use or turquoise faience and glass paste is another Cairo
characteristic. Even if Sitt Ṭunšuq was a Muzaffarid, there is no need
to look for Iranian influence in her complex. Similarly, why invoke
the improbable influence of Yazd on the stucco decoration of Qawṣūn
(p. 97), when closer parallels are to be found in Syria?[4] And even if the
ultimate origin of the muqarnas voussoirs of the Bāsiṭiyya (pl. 53, 3)
is to be found in Anatolia, closer precedents are those of the Mamluk
mosques of al-Tawāšī and Uṭruš at Aleppo. The cylindrical form of
the minaret of Bāb al-Asbāṭ could be linked to Cairo examples; there
are enough to reject the hypothesis of an Ottoman restoration (p. 89).[5]
The technique of inlay of glass paste, rather than stone, is found only
in one monument in Jerusalem (Cat. No. 55). However, this tech-
nique was known before the end of the fourteenth century (p. 540): an
earlier fine example can be seen on the portal of the palace of Qawṣūn
(also known as the Palace of Yašbak) at Cairo (c. 738/1337).

The sabīl of Qāytbāy (Cat. No. 66) is one of the finest monuments
of Jerusalem; but the detailed seven-page commentary on it passes
in silence on its most original character: its form. Although it was
probably designed by the same Cairo team that was responsible for
the Ašrafiyya, one doesn't find any other similar example either
in Jerusalem on in any other Mamluk city. It strongly resembles a
Cairene tomb; it would be interesting to speculate why this form
was chosen.

Fig. 8.9 displays an interesting example of joggled voussoirs in
the Dawādāriyya. It seems to show, against all visual logic, that
a voussoir could be joggled simultaneously horizontally and verti-
cally. This only works, in theory, if the joggling pattern is the same
in both planes, but even more complicated asymmetrical examples
are known from the complex of Sultan Hasan in Cairo, an apparent
impossibility whose explanation is still awaited.

The final chapter on conservation is short but highlights a dilemma: most of the buildings are used as residences, and most often by those from the poorer sections of society. Although they represent an important part of Jerusalem's cultural heritage, it is very difficult to gain access to them. In support of Burgoyne's opinion that one would gain little by evacuating the inhabitants to make them museums for tourists, one has to admit that in general the interiors of most of them are of little aesthetic interest. In most cases the founders – or their architects – put their principal efforts into the façades. None of the interiors has the same aesthetic charge as, say, the palace of Bištak in Cairo or, naturally, the Dome of the Rock. The interior of the Ašrafiyya may well have been outstanding, but it is in ruins, and can only be imagined through the impressive reconstructions of Walls (figs. 63.6 and 63.9).[6] Even had it still been standing, it would have been hidden by the forest of television aerials that shoot from each terrace (pl. 27); in what remains one of the most beautiful and best preserved medieval Islamic cities (only Fez and Ṣanʿāʾ can rival it) this is an eyesore that could easily be remedied.

In case of a further edition some corrections could be made: p. 366, end of Section II: read 'western' instead of 'eastern'; fig. 54.10, read 'west' instead of 'east'; p. 558: exchange the references in the text to plates 58.23 and 58.3.

Notes

1. For example, Pl. 28.7 is out of focus. Pl. 18.17: the mosaics of the vault are not visible. Pl. 31.8: this needed to be bigger in order to see the unusual stucco decoration of the zone of transition. Pls 53.3 and 57.3 are too small.
2. For this last see Jacqueline Chabbi, 'La function du ribat à Baġdād du Ve siècle au début du VIIe siècle', *Revue des Études Islamiques* 42 (1974), pp. 101–21.
3. The most complete documentation of the portals of Cairo can be found in Hilary Roe, *The Bahri Mamluk Monumental Entrances of Cairo*, MA thesis, The American University in Cairo, 1979.
4. The Muristān al-Qaymarī and the Turbat al-ʿIziyya at Damascus, cf. Ernst Herzfeld, 'Damascus: Studies in Architecture – III: *Ars Islamica* 11–12 (1946), figs. 55–6.
5. The easiest source of reference is Doris Behrens-Abouseif, *The Minarets of Cairo* (London, 2010).
6. Why is there no reference in the bibliography to the doctoral thesis of A. G. Walls, *An Attempted Reconstruction of Design Procedures and Concepts During the Reign of Sultan Qaytbay (872/1468–901/1496) in Jerusalem and Cairo, with Special Reference to the Madrasa al-Ashrafiyya and the Minbar in the Khanqah of Faraj ibn Barquq*, Edinburgh College of Art and Heriot-Watt University, 1979?

CHAPTER NINETEEN

Widening the Horizons for the Study of Islamic Architecture

FOUR MAJOR REVIEWS of the field of Islamic art and architecture have been made in the past fifty years: one by Oleg Grabar in 1976,[1] a second by Robert Hillenbrand in 2003,[2] a third in the same year by Sheila Blair and Jonathan Bloom,[3] and the fourth by Gulru Necipoğlu in 2012.[4] While it is a little early for self-congratulation, it is surprising in the relatively short span of time since the latter how much progress has been made on many of the matters of earlier concern. I will deal first with what I consider to be the elephant in the room, i.e. the study of Western architecture,[5] and then move to the topic of geographical and temporal expansions within the study of Islamic architecture.

Without

A late concern of Western architectural historians has been the divorce of art and architectural history, a feature apparent since the methodological upheavals of art history in the 1960s and 1970s.[6] A recent study of this phenomenon makes a cogent plea for the re-integration of the disciplines.[7] Fortunately, this divorce never seems to have been threatened in Islamic art, where, as Grabar put it, 'architecture is *the* particularly characteristic genre of Islamic art'.[8] A new generation of Islamic art historians continues to incorporate the study of architecture, painting and decorative arts in their publications.[9]

The biggest challenge now, as previously, is to expand the horizons of those teaching and learning Western architectural history so as to include non-Western subjects. There has been progress as of late. In 2004, the US National Architectural Accreditation Board (NAAB) raised the standard of comprehension to understanding the parallel and divergent canons and traditions of architecture and urban design in the non-Western world, i.e. to a level comparable to that of Western architectural traditions. The publication of *A Global History of Architecture* by Ching, Jarzombek and Prakash followed shortly thereafter;[10] its timeliness is shown by the recent (2017) appearance of a third edition. Perhaps even more importantly, it has

led, through the initiative of two of its authors, to the foundation of the Global Architectural History Teaching Collaborative (GAHTC), which provides a library offering more than two hundred lectures on its free teacher-to-teacher platform. It benefits from continuing funding from the Mellon Foundation.[11]

Just as importantly, the publication of non-Western material in the field has surged. Arguably the most prestigious academic periodical for architectural historians is the *Journal of the Society of Architectural Historians*. Since 2000, it has published 23 articles directly related to Islamic architectural history. The Islamic architectural historian Zeynep Çelik articulated the journal's changes in policy in her 'Editor's Concluding Notes'; in her three-year editorship, she had specifically targeted the inclusion of more non-Western topics, as well as articles on a topic of implicit interest to everyone in the field: the teaching of architectural history in the context of studio architecture.[12]

The very existence of the *International Journal of Islamic Architecture* is evidence of the broadening of the field, as is the appearance, for example, of *Archnet-IJAR: International Journal of Architectural Research*, which in its review of its first ten years of publication showed that contributors from Malaysia, Turkey, Egypt and Qatar alone considerably outnumbered those from the US and Europe.[13]

However, a quick survey of the architectural books listed on the websites of the major publishing houses of universities with both architecture and art history schools still reveals huge imbalances. For instance, only six out of 423 books in Yale University Press's online heading of architecture are on Islamic topics, and another ten on non-Western ones. I had thought, this being the first one I looked at, that this poor showing might be affected by the numerous titles in their series on *The Buildings of England* (and more recently those of Ireland and Scotland), but lists on architecture from presses at Princeton, Harvard and MIT are equally or even more disappointing.[14] The figures from MIT (only two Islamic and another three non-Western out of a total of 733), whose publications seem to address a greater proportion of architects to architectural historians than the other presses, are particularly indicative of the still-remaining gap between good intentions and realities in the field.

Within

This journal, although focusing on urban design and planning, architecture, and landscape design in the historic Islamic world, has a special commitment to contemporary architecture and urban design. This is a refreshing development, for only recently has architecture from the nineteenth century onwards been getting the attention it deserved within our field. Perhaps one should not be too surprised;

the British Society of Architectural Historians, founded in 1956 as a chapter of the American Society of Architectural Historians, was initially uninterested in modern architecture.[15]

In 1994, it was still possible for the major textbook covering the second half of Islamic art and architectural history to stop at 1800.[16] Even then, this might not have been exclusively the authors' bias; when writing my own *Treasures of Islam: Artistic Glories of the Muslim World* (2007),[17] it was only over the strenuous objections of the publisher that I was able to incorporate a photograph of the Petronas Towers (Figure 19.1).

That building was one of the recipients of the Aga Khan Award for Architecture, an institution that has done much to widen everyone's idea of what Islamic architecture can and should be.[18] Its continuing strength is a matter for celebration, even if at times the jury's choices reveal some surprising omissions.[19] The single largest category of premiated building types is community development and improvement. Is the lower ranking of mosques a deliberate retreat from this category or a measure of their recent architectural conservatism?[20]

One of the unfortunate developments in contemporary mosque design, and in the use of older mosques in modern times, is a reduction in the sense of spaciousness, namely the frequent division of the interior into gender-separated areas. Was this initiated – or just accentuated – by Salafi ideology promoted by so many Saudi-funded mosques outside of the Arabian Peninsula?[21] Marion Katz has studied the historical background of women in mosques,[22] but its architectural manifestations, with their associated ideological underpinnings, unfortunately have yet to be the subject of any detailed study. This also raises the subject of gender studies, now long researched in Western architecture,[23] but which, in addition to the initial efforts that have been thoroughly chronicled by Heghnar Watenpaugh,[24] deserves more attention from within our field.

In 2003 Hillenbrand mentioned the difficulty in doing fieldwork in some countries, including Algeria, Libya, Iraq, Iran and Afghanistan.[25] Sixteen years on, and it is again possible to work in Algeria and Iran, although Libya, Iraq, and Afghanistan remain out of bounds, as do Syria and Yemen now too. The political turmoil has been accompanied by destruction of architectural heritage, savagely, as in the case of Aleppo, and heartbreakingly, as in the case of the deliberate destruction wrought by ISIS in Iraq, from the earliest dated *muqarnas* dome at Imam Dur to the monuments of Mosul.[26] The roots of the Salafist's scorn for heritage echo the Saudi government's policy of destruction of earlier buildings around the Meccan haram – bad enough in itself, even without their grotesque replacement, the Abraj al-Bait (Figure 19.2).[27] A different ideology, but just as destructive, has been manifested recently by the Chinese government's obliteration of Uighur heritage.[28]

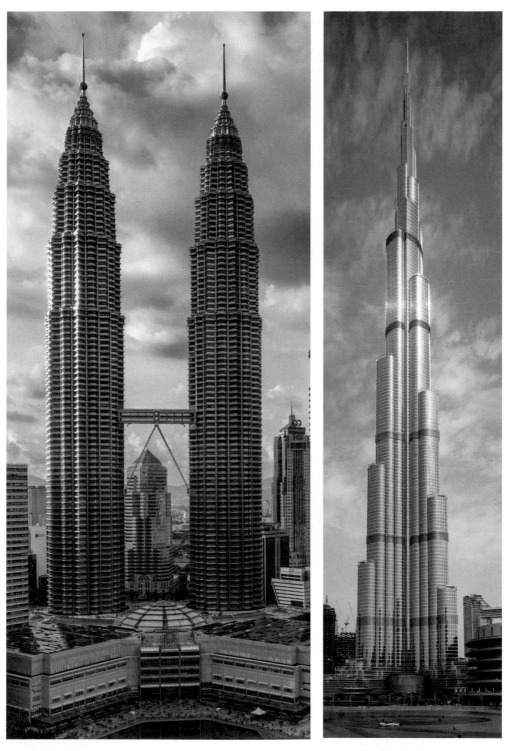

Figure 19.1 *Petronas Towers, Kuala Lumpur (left) and Burj al-Khalifa, Dubai (right)*

Figure 19.2 *Abraj al-Bait, Mecca*

Almost as much a cause for concern is the restoration policies in many countries. The over-restoration mentioned by Hillenbrand in Uzbekistan has continued with the lamentable work at the Shah-i Zinda (Figure 19.3), and even a formerly reputable state, such as

Figure 19.3 *Anonymous tomb, before (left) and after (right) restoration at Shah-i Zinda, Samarqand*

Turkey (which has the finest cohort of architectural historians of any Islamic country), has a mixed record, combining revelatory uncovering of original paintings behind later layers of plaster[29] with deadening over-painting[30] or even removal of original work (Figure 19.4).[31]

2017 saw the publication of the most recent survey of Islamic Art, *A Companion to Islamic Art and Architecture;*[32] two of its eight-part chronological divisions were on the periods 1700–1950, and one on 1950 to the present. In the same year, the editors of the 1994 survey held a conference on *Islamic Art: Past, Present, Future,*[33] acknowledging how much in the meantime thinking has changed on the importance of bringing research in the field up to the present time. The premier journal in the field, *Muqarnas*, has indeed, in accordance with its editor's policies, increased its chronological and geographical range,[34] although surprisingly twentieth- and twenty-first-century architecture seems to have been almost completely immune from this expansion.[35] Four panels out of nine at the 2018 Historians of Islamic Art Association were also related to subjects after 1800, including one on the use of digital technologies.

Digital technologies have indeed transformed our field, like so many others, in the period since the 2003 surveys. Not that the Internet did not exist before then, but the availability of material on the web, including museum collections,[36] archives of books, journals and photographs,[37] databases of various kinds,[38] publishers' websites and repositories of scholars' articles,[39] has grown at an astonishing

Figure 19.4 *Üç Şerefeli Mosque, Edirne, before (top) and after (bottom) restoration*

rate. No longer, on trips to Europe or North America, need I spend a day or two at the copying machine in libraries with obscure periodicals, thanks to digital document delivery.[40] One consequence of this is that English, for better or worse, has become even more dominant in publications, even by German and Italian authors.[41] This is even more of a problem for scholars writing in Arabic, Turkish, Persian, Urdu and Malay who wish to reach an international audience – although architectural historians will be expected to read the languages of the areas in which they specialise, this can hardly be expected to apply to international architects.

This growth has been matched by that of positions for scholars. The foundation of the Historians of Islamic Art Association reflects an unprecedented expansion in the last two decades of teaching and museum positions, as does the success of its biennial symposiums. Publications have increased accordingly,[42] covering sub-fields from mosques in the European diaspora[43] to those in China,[44] although some of those on more ostensibly mainstream topics, such as architecture in the Gulf, suffer from their highlighting of projects in development that are unlikely to be realised.[45]

The future

What of the future? The imminent and eagerly anticipated publication of Finbarr Barry Flood's *Islam and Image: Beyond Aniconism and Iconoclasm* perhaps shows the danger of predicting it, given the earlier opinion of Grabar on the surfeit of publications on the subject.[46] It can hardly be doubted that by now most scholars, no matter from which background, are sufficiently woke to be aware of orientalist tropes,[47] a topic that, forty years on from Edward Said's exposé, has become a publishing industry in its own right.[48] The physical expansion of the field, mentioned above, is paralleled by its methodological expansion, which means that we can look forward not only to the exploration of formerly little-known areas of the field, but also to viewing better-known subjects through an unfamiliar lens. So in terms of breadth, depth and methodological variety, there is much to be celebrated in current scholarship, even if on the ground in many Islamic countries the quality of most modern architecture leaves much to be desired.[49] The extent to which we are able to influence this is limited, but that need not stop us from trying.[50]

Notes

1. Oleg Grabar, 'Islamic Art and Archaeology', in *The Study of the Middle East: Research and Scholarship in the Humanities and the Social Sciences*, ed. Leonard Binder (New York: Wiley, 1975), 229–63.
2. Robert Hillenbrand, 'Studying Islamic Architecture: Challenges and Perspectives', *Architectural History* 46 (2003): 1–18.
3. Sheila Blair and Jonathan Bloom, 'The Mirage of Islamic Art: Reflections on the Study of an Unwieldy Field', *Art Bulletin* 85 (2003): 152–84.
4. Gülru Necipoğlu, 'The Concept of Islamic Art: Inherited Discourses and New Approaches', *Journal of Art Historiography* 6 (2012): 1–26.
5. To isolate it may in itself be seen as perpetuating the privilege that the 'Western canon' has exerted over the field since its inception, but in practice the categorization seems unlikely to be replaced any time soon. See Zeynep Çelik, 'Editor's Concluding Notes', *Journal of the Society of Architectural Historians* 62.1 (2003): 121–24; Sibel Bozdoğan, 'Architectural History in Professional Education: Reflections on Postcolonial Challenges to the Modern Survey', *Journal of Architectural*

Education 52.4 (1984): 207–15; Joe Nasr and Mercedes Volait, 'Still on the Margin', *ABE Journal* 1 (2012), http://journals.openedition.org/abe/304.

6. Alina Payne, 'Architectural History and the History of Art: A Suspended Dialogue', *Journal of the Society of Architectural Historians* 58.3 (1999): 292–9.

7. 'If we would like some more reflection on what it means to study architecture, we might also suggest, finally, that art history can offer something to the discipline of architecture. Drawing on art history's "crisis" of the 1980s, and the ensuing process of self-examination, this might include an understanding of buildings as art forms whose authorship is uniquely complex, involving not only the designers and builders normally understood to have agency, but the users and inhabitants too. It might also include an appreciation of the importance of (visual) representation in architecture, and the understanding that buildings are only one of a range of possible existences that architecture may have. And art history might offer an understanding of the architectural object in time, not only as historically produced, but also as an object with an afterlife during which its meaning and status, and even its material existence, may change. Art history has no monopoly on these approaches to the study of objects, but it has a lot of experience of deploying them, since its "crisis" of the 1980s. While we wouldn't be so presumptuous as to say that art history might be able to help make better architecture, we do think – as we hope this book has shown – that it can help us understand it better.' Mark Crinson and Richard J. Williams, *The Architecture of Art History: A Historiography* (London: Bloomsbury, 2019), 134.

8. Oleg Grabar,'Reflections on the Study of Islamic Art', *Muqarnas* 1 (1983): 5 (original emphasis).

9. Although it may not be obvious from their titles, the increasingly large range of surveys of Islamic art – too well known to be cited here – all include both art and architecture.

10. Francis D. K. Ching, Mark Jarzombek and Vikramaditya Prakash, *A Global History of Architecture*, 3rd edn (Hoboken: Wiley, 2017).

11. 'About GAHTC', Global Architectural History Teaching Collaborative, <https://gahtc.org/pages/about-gahtc/> (last accessed 27 January 2020); 'School of Architecture and Planning receives $1.5 million grant from Mellon Foundation', MIT News, 30 November 2016, <http://news.mit.edu/2016/school-of-architecture-and-planning-receives-mellon-foundation- grant-130>.

12. Çelik,'Editor's Concluding Notes'.

13. Ashraf M. Salama, Adel M. Remali and Farzad Pour Rahimian, 'A Decade of Architectural and Urban Research Published in *Archnet-Ijar: International Journal of Architectural Research*', *Archnet-IJAR* 11 (2017): 6–28.

14. Of 118 publications on the Princeton University Press website, two are Islamic, another four are non-Western; at the Harvard University Press there are nine Islamic and another twelve non-Western out of a total of 155.

15. Crinson and Williams, *Architecture of Art History*, 157 n. 8.

16. Sheila B. Blair and Jonathan M. Bloom, *The Art and Architecture of Islam 1250–1800* (New Haven: Yale University Press, 1994), but a revision of attitudes is signalled by the same authors' recent editing of *Islamic Art, Past Present and Future* (New Haven: Yale University Press, 2019).

17. Bernard O'Kane, *Treasures of Islam: Artistic Glories of the Muslim World* (London: Duncan Baird, 2007).

18. As with the definition of Islamic art, that of Islamic architecture has been the subject of intense debate. See Necipoğlu, 'The Concept of Islamic Art'; Nasser Rabbat, 'What is Islamic Architecture Anyway', *Journal of Art Historiography* 6 (2012): 1–15.

19. Given the award to the Petronas Towers, the omission of the SOM-designed Burj al-Khalifa looks like a failure of nerve.

20. See, for example, the Abu Dhabi Sheikh Zayed mosque, ironically the only one in recent years to have been the subject of a monograph: Robert Hillenbrand, *The Sheikh Zayed Grand Mosque: A Landmark of Modern Islamic Architecture* (Abu Dhabi: Shawati', 2012). I was less shocked about the omission of one of the most exciting buildings of recent years (admirably analysed in Berin F. Gür, 'Sancaklar Mosque: Displacing the Familiar', *International Journal of Islamic Architecture* 6.1 [2017]: 165–93), Emre Arolat's Sancaklar mosque, upon learning that the architect was on the jury when it first became eligible. Let us hope the omission can still be rectified.

21. The role of petro-dollars in funding charitable activities that promote not just mosque building, but Saudi ideology, is noted in Wendy Shaw, 'Review: *The Transnational Mosque: Architecture and Historical Memory in the Contemporary Middle East*, by Kishwar Rizvi', *Journal of the Society of Architectural Historians* 76.3 (2017): 395–7.

22. Marion Katz, *Women in the Mosque: A History of Legal Thought and Social Practice* (New York: Columbia University Press, 2014).

23. See the studies referenced in Crinson and Williams, *Architecture of Art History*, 160 n. 60.

24. Heghnar Zeitlian Watenpaugh, 'Art and Architecture', in *Women and Islamic Cultures: Disciplinary Paradigms and Approaches: 2003– 2013*, ed. Suad Joseph (Leiden: Brill, 2013), 37–50. See also the earlier D. Fairchild Ruggles (ed.), *Women, Patronage and Self-Representation in Islamic Societies* (Albany: SUNY Press, 2000). Fortunately, in our profession women are certainly not underrepresented – at the most recent HIAA conference in 2018 at Yale University, 32 out of 34 papers delivered were presented by women.

25. Hillenbrand, 'Studying Islamic Architecture', 9.

26. Even including, solely out of spite, the Nuri Great Mosque, as opposed to the shrines that were the normal target of ISIS.

27. See Muhsin Lutfi Martens, 'The Masjid al-Haram: Balancing Tradition and Renewal at the Heart of Islam', *International Journal of Islamic Architecture* 9.1 (2020): 119–32.

28. Rachel Harris, 'Bulldozing Mosques: The Latest Tactic in China's War Against Uighur Culture', *The Guardian*, 7 April 2019, <https://www.theguardian.com/commentisfree/2019/apr/07/bulldozing-mosques-china-war-uighur-culture-xinjiang>; Lily Kuo, 'Revealed: New Evidence of China's Mission to Raze the Mosques of Xinjiang', *The Guardian*, 6 May 2019, <https://www.theguardian.com/world/2019/may/07/revealed-new-evidence-of-chinas-mission-to-raze-the-mosques-of-xinjiang>.

29. As at the Ottoman tomb complex of the Muradiye at Bursa.

30. Most recently, at the Yeşil Cami at Bursa.

31. Such as at the Üç Şerefeli Mosque at Edirne. See Bernard O'Kane, 'The Arboreal Aesthetic: Landscape, Painting and Architecture from Mongol Iran to Mamluk Egypt', in *The Iconography of Islamic Art: Studies*

in Honour of Robert Hillenbrand, ed. Bernard O'Kane (Edinburgh: Edinburgh University Press, 2005), 229. This is not a new problem, with Grabar noting the 'sheer atrocity' of the Damascus Mosque mosaic restorations. Grabar, 'Islamic Art and Archaeology', 238.

32. Finbarr Barry Flood and Gülru Necipoğlu (eds), *Companion to Islamic Art and Architecture* (Oxford: Wiley, 2017), 2 vols. Unfortunately, at a price of ('just' – according to the Wiley website) $410.75, it is beyond the reach of most students.

33. Jonathan Bloom and Sheila Blair (eds), *Islamic Art: Past, Present, Future* (New Haven: Yale University Press, 2019).

34. See Gülru Necipoğlu, 'Reflections on Thirty Years of *Muqarnas*', *Muqarnas* 30 (2013): 1–12. The journal is also a showcase for the expansion of methodological approaches mentioned by her earlier. See Necipoğlu, 'The Concept of Islamic Art'.

35. With the exception of some articles in the special issue on 'History and Ideology: Architectural Heritage of the "Lands of Rum"', *Muqarnas* 24 (2007), and an article on the new Great Mosque of Granada, a building that is self-effacing to the point of the anodyne. See Olga Bush, 'Entangled Gazes: The Polysemy of the New Great Mosque of Granada', *Muqarnas* 32 (2015): 97–133.

36. Such collections often contain architectural material. The recent re-design of galleries of Islamic art and architecture in major institutions has been an opportunity to update museological practices, none more successfully than at the British Museum; major new museums of Islamic art, such as that of Qatar and the Aga Khan in Toronto, have also opened in the meantime.

37. Jstor.org, available through many institutions, and Hathitrust.org are prime examples. The Bibliothèque Nationale in Paris has been assiduous in making its out-of-copyright holdings available (see www.gallica.bnf.fr). The Creswell archive at the Ashmolean, now online and running again after a period of inaccessibility, and a Barakat Trust-funded initiative supervised by Omniya Abdel Barr are exploring ways to integrate Creswell material in various collections with a view to a searchable database. See 'K. A. C. Creswell's photographs of the Middle East', Victoria and Albert Museum, <https://www.vam.ac.uk/articles/ creswells-egypt-syria-and-palestine-photographs> (last accessed 27 January 2020).

38. Archnet (archnet.org), the usual first resource for our field, has greatly expanded recently, as has the *Thesaurus d'Épigraphie Islamique* (www.epigraphie-islamique.org). Other recently appeared databases related to architectural epigraphy include *The Monumental Inscriptions of Historic Cairo* (islamicinscriptions.cultnat.org) and the *Database for Ottoman Inscriptions* (ottomaninscriptions.com).

39. Academia.edu and Researchgate.net are the best known. Both are venture capital funded, and have been criticised for monetising their content, but an announced profit-free alternative (ScholarlyHub) has yet to materialise. See Jefferson Pooley, 'Metrics Mania: The Case Against Academia.edu', *Chronicle of Higher Education*, 7 January 2018, https://www.chronicle.com/ article/The-Case-Against-Academiaedu/242141.

40. For those without the back-up of an institution's inter-library loan service, an appeal to colleagues on the relevant scholarly Facebook page often produces results.

41. This is a little less so when it comes to Spanish and French scholars (with Yves Porter being a notable exception).

42. The recent donation of the CAA Charles Rufus Morey Award to Kishwar Rizvi, *The Transnational Mosque: Architecture and Historical Memory in the Contemporary Middle East* (Chapel Hill: University of North Carolina Press, 2015) is a welcome recognition from the broader field.

43. Ergün Erkoçu and Cihan Buğdacı, *The Mosque: Political, Architectural and Social Transformations* (Rotterdam: NAI, 2009); Azra Akšamija, *Mosque Manifesto* (Berlin: Revolver Publishing, 2015); Christian Welzbacher, *Europas Moscheen: Islamische Architektur im Aufbruch* (Munich: Deutscher Kunstverlag, 2017); Shahed Saleem, *The British Mosque: An Architectural and Social History* (Swindon: Historic England, 2018).

44. Nancy Shatzman Steinhardt, China's Early Mosques (Edinburgh: Edinburgh University Press, 2015); Qing Chen, 'Mosques of the Maritime Muslim Community of China: A Study of Mosques in the South and Southeast Coastal Regions of China' (Ph.D. diss., SOAS, University of London, 2015); George Lane (ed.), *The Phoenix Mosque and the Persians of Medieval Hangzhou* (London: Gingko, 2018).

45. E.g. Gesa Schönberg and Philip Jodidio, *Architecture in the Emirates* (Cologne: Taschen, 2007); Gesa Schönberg and Philip Jodidio, *Contemporary Architecture in Arabia* (Berlin: GBP Architekten, 2008). The work of even one of the most respected figures in the field, Mohammad al-Asad, *Contemporary Architecture and Urbanism in the Middle East* (Tallahassee: University of Florida, 2012), is not immune to this stricture.

46. Ibid., 254.

47. Although whether these scholars would agree that Said's work 'had the effect of reifying a category of modern discourse that masked deeper structures of what might be called non-Orientalist Orientalism' is another matter. See Wael B. Hallaq, *Restating Orientalism: A Critique of Modern Knowledge* (New York: Columbia University Press, 2018), 269–70. For a thoughtful analysis of how the field has developed in response see Zeynep Çelik, 'Reflections on Architectural History Forty Years after Edward Said's *Orientalism*', *Journal of the Society of Architectural Historians* 77.4 (2018): 381–7.

48. For example, see Edmund Burke III and David Prochaska (eds), *Genealogies of Orientalism: History, Theory, Politics* (Lincoln: University of Nebraska Press, 2008); Tugrul Keskin (ed.), *Middle East Studies after September 11: Neo-Orientalism, American Hegemony and Academia* (Leiden: Brill, 2018); Susannah Heschel and Umar Ryad (eds), *The Muslim Reception of European Orientalism: Reversing the Gaze* (Abingdon: Routledge, 2019).

49. This is the case worldwide, of course. The outside forces that dictate much modern mosque design are analysed in Rizvi, *Transnational Mosque*. With eleven winners of the Aga Khan Award for Architecture, Turkey heads the country list – perhaps a reflection of the extent to which the discipline is nourished there. Does the lamentable state of modern architecture in my adopted country of Egypt reflect the concomitant lack of pay and prestige of our profession within the governmental sectors of universities and museums?

50. This is the aim of Hassan Radoine, *Architecture in Context: Designing in the Middle East* (Chichester: Wiley, 2017).

Index